3950

Edward E. Marsin

Edward E. Marsin

A HISTORY OF PHOTOGRAPHY

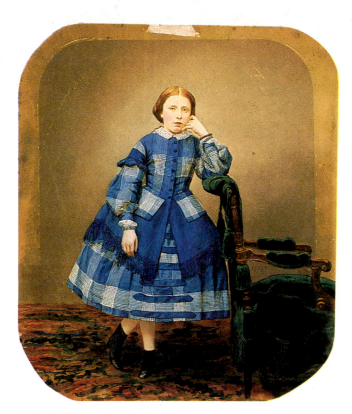

MAYER AND PIERSON
TEN YEARS, 1861.
Black and white handtinted with watercolour.

Collection of the Musée Français de la Photographie, Bièvres.

A HISTORY OF

PHOTOGRAPHY

SOCIAL AND CULTURAL PERSPECTIVES

Edited by
Jean-Claude Lemagny
and André Rouillé

Translated by
Janet Lloyd

The right of the
University of Cambridge
to print and sell
all manner of books
was granted by
Henry VIII in 1534.
The University has printed
and published continuously
since 1584.

CAMBRIDGE UNIVERSITY PRESS

Cambridge

New York New Rochelle Melbourne Sydney

Published by the Press Syndicate of the University of Cambridge
The Pitt Building, Trumpington Street, Cambridge CB2 1RP
32 East 57th Street, New York, NY 10022, USA
10 Stamford Road, Oakleigh, Melbourne 3166, Australia

First published by Bordas under the title
Histoire de la Photography

Printed in Germany by Mohndruck

British Library Cataloguing in Publication Data

A History of photography: social and
 cultural perspectives.
1. Photography − Social aspects − History
I. Lemagny, Jean-Claude II. Rouillé, André
770′.9 TR15

Library of Congress Cataloging in Publication Data

Histoire de la photographie. English
A History of photography.
 Translation of: Histoire de la photographie.
 1. Photography − History. I. Lemagny, Jean-Claude.
II. Rouillé André, 1948− . III. Title: History
of photography.
TR15.H5613 1987 770′.9 87−18205

ISBN 0 521 34407 7

Contents

Introduction

BERNARD FAUCON
UNTITLED, 1985.

© Bernard Faucon.
Photograph produced specially for this book.

Today, the writing of the history of photography has a history of its own. Faced with an accumulation of works, one is forced to make decisions, to choose among an abundant profusion of facts in order to distinguish the gradual movements and profound shifts that have shaped the field of photographic history.

From the start, photography was hailed as a historic invention. For many years, its history remained that of its technical progress, as evident in the work of J. M. Eder. But as the list of its achievements grew, photographers and critics because uneasy about its boundaries and its effects, its relations with art, and its social duties. When questions such as these were broached the historian's task became more complex. Not until two successive and contradictory aesthetic revolutions had taken place – pictorialism and the 'pure photography' of the twenties – did historians such as Lécuver, Gernsheim and Newhall emerge.

What makes the task of the historian of photography at once fascinating and impossible is that photography seems to relate to everything: technical progress, society, art. For a long time, historians were obsessed with the need to explain all that photography had drawn from or given to other fields – for example, its relations with painting, the press, or science. That was history *through* photography. To establish a history *of* photography, *photography would have to reflect upon itself*. Today, every creative photographer knows that it is he who makes photography what it is. Taken together, technical definition and aesthetic value confer unity upon photography. Without these, it becomes fragmented into as many different sectors as it has uses: information, fashion, leisure, and so on. Silver salts and a questioning of the works through the works themselves: these constitute the two points of anchorage that can prevent photography from fragmenting into a multitude of tiny parasitical stories.

This doesn't mean that we should first produce an *exclusively technical* history, then follow it by an *exclusively aesthetic* one. To do so would amount to little more than a history of a series of shibboleths. Aesthetic considerations set the history of photography going, but now the situation is such that we must take account of the full spectrum of economic and social factors in which photography is involved.

In this book, we would have liked to keep all these ideas in play at once, mirroring the richness of lived experience. That was not possible. We have at least tried not to assess each of the major phases of photography according to a single criterion, whether technical (first the daguerreotype, then collodion, and so on), aesthetic or human. We have also tried not to reduce our history to that of a number of key figures. As far as possible, we have aimed to keep everything in view, concentrating simultaneously upon both sides to the story: on the one hand, *photography seeking its own internal coherence*; on the other, *photography dependent upon everything that surrounds it*. The role of the historian is not to follow a single chain of causes but to take up a central position where they converge from all sides.

We have made out two major successive movements; photography spreading throughout the world; and photography seeking to understand itself better – that is to say, photography conquering first the world, then itself. First it came to penetrate every sector of modern life; then it increasingly devoted itself to a critical assessment of its own role and meaning. These two major movements, the one falling roughly within the nineteenth century, the other within the twentieth, are discussed in a number of different chapters, some historical, others more analytic. Those that are historical first chronicle the discovery of photography and its diffusion throughout the world in the nineteenth century. Then they study the the way in which photography took hold in people's minds, manipulating their image of the world, in the twentieth century. But two chapters in this book deliberately pause to take stock and attempt a measured assessement of the situation. These are Chapters 5 and 7, both of which are divided into extensive sub-chapters. Chapter 5 considers the various domains in which photography had become established by the end of the nineteenth century: science, the press, and so on. Chapter 7 examines the period between the two world wars, showing how photography bacame invested with a social role of such importance that communist, fascist and democratic regimes alike all turned it into a state tool.

Much of this work is devoted to technical questions but in the last two chapters the aesthetic aspects of photography take pride of place: first the invention itself, then reflection upon it. Over the past century and a half, the initial wonder provoked by the phenomenon of photography has turned into a questioning. This same process of photography, which at first seemed to present us with the world in its raw and naked state, has eventually provided the most positive proof of the relativity and limitations of our perception of the world. Its power to deceive is now recognised to be as great as its power to communicate. Only probing and disinterested research into the nature of these images can now steer us through these ambiguities and indicate the way for photography to master the truth.

Within these vast curves of evolution, we have divided the work among a number of authors. We felt that the time was past when a single individual could write the whole of such a history. It was never our intention to produce a weighty photography handbook. The reason for this is precisely because we believe photography to be a domain in which we need not only to learn but also to question. The first historians of photography were collectors (Gernsheim, for example). That was perfectly understandable, having also been the case where engraving was concerned. Then professors and scholars such as Beaumont Newhall were drawn to the subject. Now theses on specific areas are beginning to appear, with all that that implies in terms of specialization and – as the word 'theses' itself suggest – subjective views. If we are to leave open the important questions that photography has produced in the course of its evolution, from now on our best course is probably to consider each of its aspects through the eyes of a specialist in that particular area. In the interests of general coherence and coordination between the various texts, André Rouillé and I have had to make a few adjustments. But we have intervened as little as possible, in order to preserve the originality of these different approaches. Continuity was necessary if we were to establish the temporal and causal connections; but only a wide diversity of approaches could convey the equivocal nature of the roles which photography has played in the history of the world. We have ventured to aim for a fine balance between the two extremes. At all events, we believe that it was better to risk such an attempt than to allow photography to be regarded as a closed dormain where dormant problems could be left unexamined.

Jean-Claude Lemagny

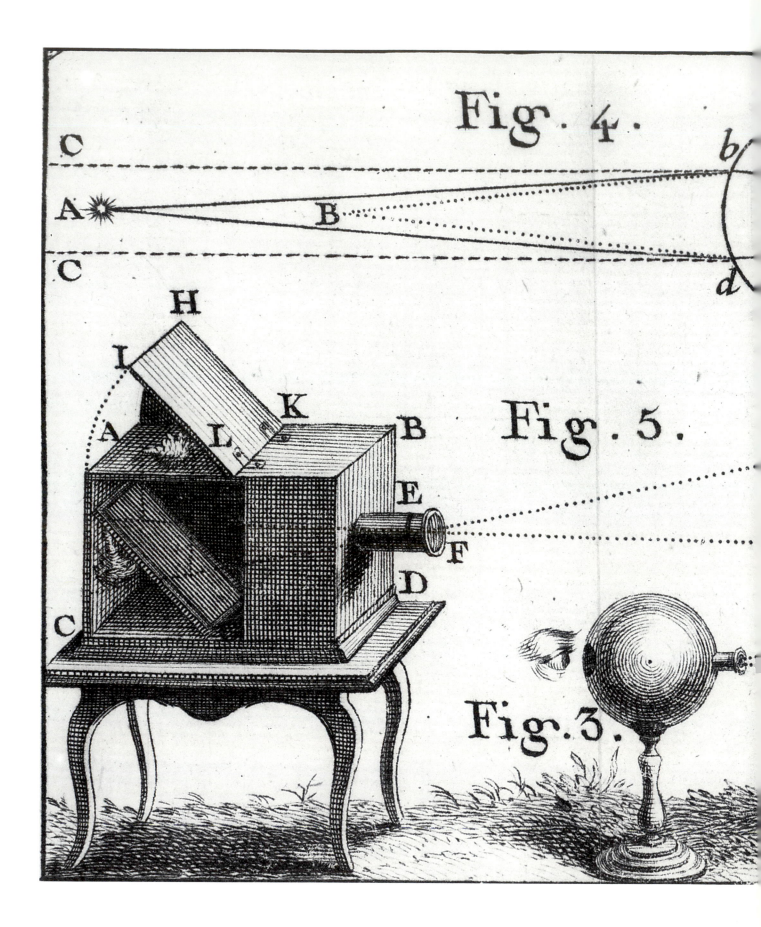

Fig. 4.

Fig. 5.

Fig. 3.

1

Towards the discovery

(before 1839)

CAMERA OBSCURA
Engraving from 'Leçons de physique expérimentale' by the Abbé
Nollet, Paris, 1755, vol. V, lesson XVIII, p. 480.

Bibliothèque Nationale, Paris.
Ph. Michel Didier © Photeb.

An invention is seldom a matter of chance: 'It is a response to a deep, general need which is at once economic and intellectual.'[1] Among the many inventions which followed one upon another during the nineteenth century, photography, that 'curious and sublime discovery',[2] was a historical necessity. The rapid and far-reaching progress made in agriculture, transport, industry and demography produced the upheaval now known as the industrial revolution. The domain of images was bound to be affected by these changes, particularly since the upheaval in society, which was initiated in England at the end of the eighteenth century and subsequently spread to France and the whole of the Western world, led to universal and totally new modes of communication and information. Unlike many other important innovations of the age, photography, a discovery of capital importance, had the air of a simple invention. Its introduction and success called for neither capital nor complex machinery, nor was it hard to find it a clientele: a potential one existed even before it burst upon the scene. The need for a new technique for representing reality prompted the appearance of a tool the basic principles of which had been known well before 1800.

The ambivalence of photography has provided much food for thought: it is inherent in its very nature and also in the ambiguity of its products. Depending upon whether the mind or the eye is struck by its capacities to record or to express, it is regarded now as a tool of documentation, now as an instrument of creation. Considering its historical antecedents and the age in which it saw the light of day, the invention seems neither out of place nor out of tune. Concerned as it was to reconcile art and industry, the nineteenth century might well have seen photography as just the instrument for that purpose or, better still, as the solution to that cultural problem. But for the most part it recognised only the utilitarian aspect of photography, failing to foresee the unique future reserved for it by those dealing in two parallel worlds: the world of images and the world of science.

A technical discovery

One of the basic elements of photography was first devised for scientific ends, then adopted and perfected over centuries within the field of drawing techniques. This was the camera obscura, the principles of which Aristotle had noted while engaged upon observing an eclipse of the sun. Between the eleventh and the sixteenth centuries many works by Alhazen, Roger Bacon, John Peckham, Guillaume de Saint-Cloud, Erasmus Reinhold and Gemma Frisius refer to the device and

its application to astronomy:[3] through a circular aperture pierced in the shutters of a darkened room, rays of light cast an inverted image of the sun onto the opposite wall.

The phenomenon was brought to the notice of the world of art in the Renaissance when the instrument was set on its path to fame. Leonardo da Vinci mentioned it in his manuscripts but these were not to be published until modern times.[4] The first published description of a camera obscura was probably provided in 1521 by Leonardo's pupil, Cesare Cesariano, in a note he appended to his translation of Vitruvius's treatise on architecture. But it was Giovanni Battista della Porta's exposition in a work frequently reprinted and translated from 1558 onwards that brought the camera obscura to general notice and prompted painters to make use of it.[5] Meanwhile, Girolamo Cardano suggested an important improvement: the aperture was now equipped with a lens which rendered the image more distinct.[6] In the seventeenth century, the camera obscura, until then described as an actual room, became portable, as is attested by a number of texts and a few illustrations produced by German mathematicians such as Friedrich Risner, Athanasius Kircher, Christoph Scheiner and Johann Sturm.[7] In 1657, Kaspar Schott[8] turned the room into a box and at Johann Zahn's hands[9] it took on an appearance suggestive of that of the cameras used in the early days of photography. The eighteenth century definitively adopted this optical instrument and from then on it was produced in all kinds of shapes and sizes: as a machine to be placed on a table, a book to be slipped into one's pocket, a cavity hollowed out in the knob of a walking stick, a sedan chair or the top of a building, such as the summit of the tower on Castle Hill in Edinburgh. Its amusing qualities caused it to be included in the range of scientific toys then available.[10] In short, by the time that Zahn's treatise appeared in 1685, the camera obscura was ready for photography. However, its metamorphosis into a camera which could take pictures did not take place for another 130 years.

The mathematicians' discovery of the physical properties of light and its recognition by artists would not have constituted the technical know-how that was indispensable for the future invention unless chemists, for their part, had noted how luminous rays affected certain substances. Here, too, knowledge advanced in a series of phases: first, the substances were identified; next, it was shown how they changed; finally, the physical causes of their transformation were discovered. Albertus Magnus in the thirteenth century and Georgius Fabricius in the sixteenth mentioned silver salts and noted some of their properties.[11] In the seventeenth century, it was noticed how they darkened but the change was attributed either to the air or to the heat of the sun, not to its

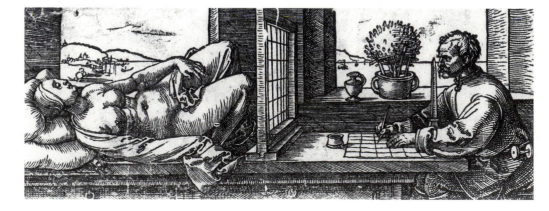

ALBRECHT DÜRER
Italian method for drawing a subject according to the principle of linear perspective.
Wood engraving, 7.5 × 21.5 cm, in 'Instruction in the art of measuring', Nuremberg, 1538.

On a squared sheet of paper, the artist copies the woman whom he looks at through a squared grating of the same dimensions as the sheet of paper.

Bibliothèque Nationale, Paris; Ph. © Bibl. Nat./Photeb.

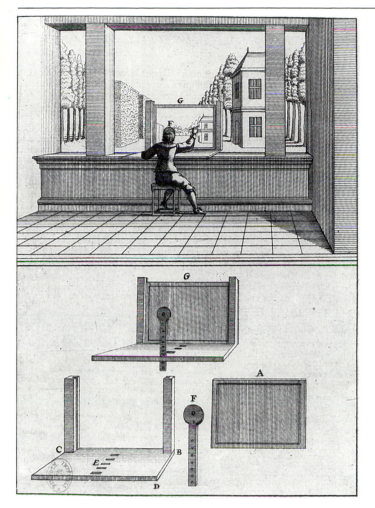

Father JEAN DUBREUIL
'A very fine invention, to reproduce perspectives naturally, without
ruled lines.'
Engraving from 'La perspective pratique' (Paris, 1642, vol. I).

Elements in Apparatus G: glass (A) mounted in a frame; grooved
battens (B and C) into which pane of glass slips; board with holes (E);
ruler (F) with viewing aperture which is fixed in one of the holes. The
artist marks on the glass everything he can see through the little hole
in (F), then traces it.

light. The experiments carried out in the eighteenth century
by the Italian Giambattista Beccaria, the German Johann
Heinrich Schulze, the Swede Carl Wilhelm Scheele and the
Swiss Jean Senebier revealed the action of light upon silver
salts;[12] and we should note in passing that Senebier also
established that resins are not dissolved by turpentine essence
wherever they are exposed to the light. Nicéphore Niépce
was to base his discovery upon a similar peculiarity. The
disclosure of the work of these men brought their ideas to the
attention of both men of science and educated amateur
enthusiasts. Scheele's treatise, for instance, which was pub-
lished in both Latin and German in 1777, was translated into
English in 1780 and into French the following year.[13]

The knowledge concerning light which scholars and artists
had thus accumulated over the centuries now began to reach
the more educated strata of society. It remained without effect
so long as it stemmed from preoccupations unconnected with
images or was used to supplement an age-old system of
representation. But once that knowledge was seized upon by
men who dreamed of reproducing reality in all its immediacy
or capturing the image reflected by a mirror, the breakthrough
occured.

The concept of an image

Until the dawn of the twentieth century, the quest for
resemblance ruled Western art. To be sure, the concept of
imitation set forth in treatises on art ever since Antiquity, and
in particular in the works published from the Renaissance
onwards, aimed for more than mere slavish reproductions of
nature: an artistic work should introduce the soul into a world
governed by supreme truth and ideal beauty. Often, the artist
could accomplish this only at the cost of exactitude: one
example out of many is provided by the extra vertebrae given
to Ingres's *Odalisque*, painted in 1814. The transcription of
reality was not an objective undertaking but a means,
available to man alone, of using the work which he produced
or contemplated to establish a correlation with a world of
infinity. Essentially, an image was the product of a mental
effort: whether figurative or abstract, it constituted the
substance of the only iconographical system that existed
before 1839, the system generically known as 'the arts of
drawing'.

However, the realistic basis of Western art was to
accommodate approaches and practices which were eventu-
ally to lead to a different concept according to which an image

Abbé JEAN-ANTOINE NOLLET
FOLDING CAMERA OBSCURA.
Engraving in 'Leçons de physique expérimentale', (Paris, 1755).

Fig. 6: the camera without the covering which provides darkness. The
adjustable mirror *o* reflects the subject (in this case, a woman) on the
tray GHK. Fig. 7: the same camera equipped with a curtain and placed
on a table covered with a sheet of paper.

Bibliothèque Nationale, Paris; Ph. Michel Didier, © Photeb.

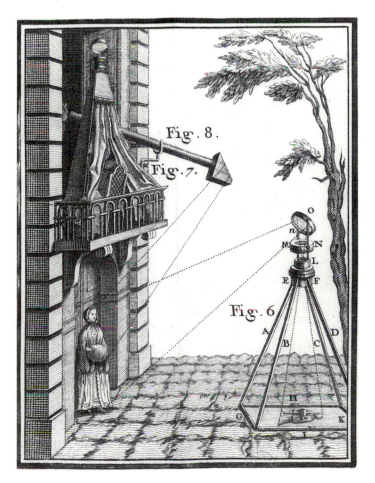

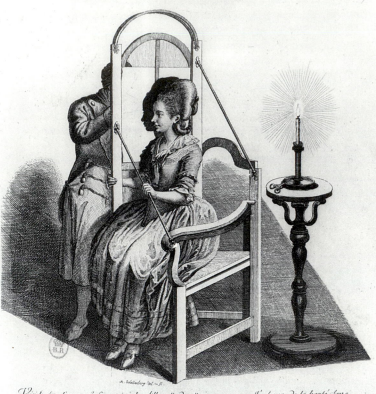

Machine sure & commode pour tirer des Silhouettes.

Voici le caractère que j'assignerois à la Silhouette de cette jeune personne. J'y trouve de la bonté sans beaucoup de finesse; de la clarté dans les idées, & le talent de les concevoir avec facilité; un esprit fort industrieux, mais qui n'est point dominé par une imagination bien vive, & qui ne s'attache guère à une exactitude scrupuleuse. On ne retrouve point dans la copie le caractère de gaieté qu'annonce l'Original; mais le nez a gagné dans la silhouette—il y exprime plus de finesse.

'RELIABLE AND CONVENIENT MACHINE FOR PRODUCING SILHOUETTES'.
Drawing and engraving by R. Schellenberg, in Essai sur la physiognomonie *by Jean-Gaspard Lavater.*

'SILHOUETTE' PORTRAIT BY LAVATER.
Engraving in L'art de connaître les hommes par la physiognomonie *by Jean-Gaspard Lavater.*

Bibliothèque Nationale, Paris; Ph. Michel Didier. © Photeb.

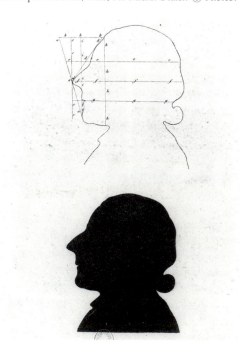

was constituted simply by what could be registered.

Trompe-l'oeil, the supreme illusion, whether a response to an exacerbated desire to imitate nature or to the delight afforded by consummate skill, was to prove a constant temptation. Pliny describes it in its most ancient form; Veronese, to take but one example, left a dazzling example of it in the Villa Barbaro at Maser, near Treviso, in 1561. Later, the fascination exerted by realism and the taste for *trompe-l'oeil* were to ensure success for the panorama invented by Robert Barker in 1787, Franz König's diaphanorama inaugurated in 1811 and Daguerre's diorama introduced in 1822.

It is also possible to describe as 'photographic' the manner both of arresting a gesture and of suspending time that is a feature of a number of paintings of the French school at this time. This is also true of the analytic vision of nature transmitted by painters, often of landscapes, in studies where the organisation depends more on the centring of the picture than on its composition.[14]

Furthermore, artists often resorted to techniques borrowed from outside the field of painting to represent space and volume on a flat surface. The Renaissance established the laws of geometric perspective, calculated on the basis of what was known of the functioning of the eye's vision. Albrecht Dürer was one painter who employed some of the current methods of applying these principles correctly.[15] It was within this context that the camera obscura, a sort of artificial eye, was to become widely used by the less skilful to make up for their artistic deficiencies, but 'wittingly controlled and subordinate always to aesthetic ends' when in the hands of genuine artists.[16] Many references in eighteenth- and nineteenth-century literature attest to the use of the camera obscura by artists and travellers: Johannes Vermeer, Joshua Reynolds and Johann Wolfgang von Goethe all used it; nor was it despised by painters of views, Canaletto among them.[17] However, the camera obscura was but one of many drawing devices. The camera lucida, which made it possible to trace the outline and details of a subject observed through a viewfinder, in full daylight, was improved by Wollaston at the beginning of the nineteenth century and later perfected by the Chevalier brothers, opticians in Paris. But early versions of it are already described in the much earlier treatises of Father Jean Dubreuil and the Abbé Jean Antoine Nollet.[18]

All these instruments for apprehending reality eventually suggested applications which amounted to so many harbingers of a new system of representation. One was the technique of producing silhouettes, which was discovered during the eighteenth century. These portraits, which the painter Rembrandt Peale called 'profilographs', owe their name of 'silhouette' profiles to a Controller General of Finance under Louis XV by the name of Etienne de Silhouette. Another, slightly later, product of the craze for portraits was the physionotrace. Gilles Louis Chrétien was the inventor of this machine for drawing profiles.[19] A single sitting guaranteed the model twelve engraved prints, to be delivered within twelve days.

The desire to give substance to the fleeting reflection spontaneously created by light is rooted at the deepest levels of the human imagination. It endowed all these optical curiosities with a magical attraction, as if people already sensed that one day one of these boxes would make it possible to capture or reconstitute, at will, any image, whatever its subject. When the magic lantern was first

described in 1646, in the works of Athanasius Kircher, its success was immediate and enduring.[20]

Such dreams inspired storytellers with tales which in many cases looked forward to photography or even beyond it. The *Cabinet des Fées*,[21] a storehouse of illusions introduced in Charles Perrault's stories in the reign of Louis XIV, made extensive use of them. The room full of windows imagined by Mme de Villeneuve in *La Belle et la Bête* and the great mirror in Mme Leprince de Beaumont's version of that same metamorphosis both anticipate the television set. The gallery with its painted figures 'which were active from dawn to dusk', into which the sisters in Mlle Lheritier's *L'Adroite Princesse* are led, puts one in mind of a continuous cinema performance. Tiphaigne de la Roche's account of an imaginary journey, entitled *Giphantie*, published in 1760, is not so much a story, more a prophetic vision.[22]

A new society

If photography did not see the light of day in the eighteenth century, it was not because the various pieces of the puzzle were too widely dispersed among artists and scholars, mathematicians and chemists, nor was it that the imagination capable of bringing the existing technical knowledge to fruition was lacking. The fact was, rather, that society was not ready for it. The elements of a situation which, thanks to evolutions in the economic position, mentalities and taste, became possible several decades later, still lay latent. Two factors were soon to stretch and complicate the needs of iconography to the point of forcing the emergence of a system capable of satisfying them. They were the rise of the bourgeoisie and the progress of science.

From 1789 onwards, the French bourgeoisie, on the strength of its financial successes, embarked upon its conquest of power, with a mixture of the liberal economic and political policies which lead to capitalism and to democracy. It did so in a positivist spirit, mincing no words and knowing the price of everything marketable. For the bourgeoisie, the value of any representation lay in its realism, for without this there could be no accurate inventory nor any complete investigation of the world which this class was now bent upon controlling. This surge of objectivity was to ensure the success of photography even as it was, by reaction, to steer painting into other channels. Furthermore, the bourgeoisie was to identify with this process that coincided with its own emergence and was capable of reflecting its own face and works as often as could be desired and at a reasonable cost.

Meanwhile, the upward surge of the sciences was leading to an unprecedented programme of investigation into the real world. What was needed was a mode of representation which could swiftly, accurately and comprehensively render visible and measurable even such bodies and phenomena as were invisible by reason of their substance, dimensions or inaccessibility. The arts of drawing could depict only those things in the sensible world that the artist's eye and hand could seize upon and translate: this constituted a technical flaw. Worse still, either deliberately or unconsciously, the artist transformed reality and distorted its image through the force of his own personality: that constituted an essential flaw. The rate at which society was changing made it impossible for art to continue to fulfil adequately the descriptive and narrative function it had hitherto performed. The rapid and unrelenting progress of science and technology called now for an

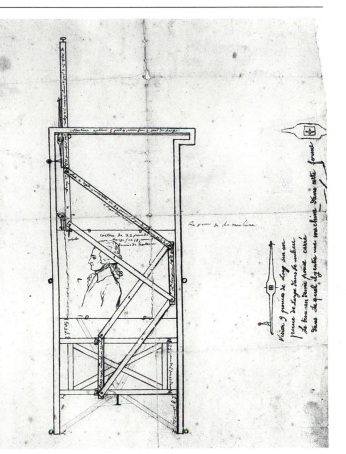

THE PHYSIONOTRACE, machine for drawing profiles, invented by GILLES-LOUIS CHRÉTIEN.
Drawing by Edme Quenedey (1786).
Bibliothèque Nationale, Paris; Ph. © Bibl. Nat./Photeb.

PHYSIONOTRACE PORTRAIT.
Maximilien de Robespierre.
Drawing by Fouquet, engraving by Chrétien; image 6.3 cm (Paris 1972).
Bibliothèque Nationale, Paris; Ph. © Bibl. Nat./Photeb.

iconographical system of a different kind, one that was capable of carrying it forward.

The invention

Now, at the end of the eighteenth century, the scene was set for photography to enter upon the role it was to play from 1839 onwards; the prologue came from the two countries most advanced economically and politically: France and Britain.

It was probably not so much the faltering health of Thomas Wedgwood, who died in 1805 at the age of thirty-four, as the over-positivist spirit of his compatriots that deprived him of the tenacity necessary for a venture such as his to succeed.[23] Subsequent events were to show that many of those who first conceived of photography and those who lent it encouragement were struck first and foremost by its artistic utility: in 1827, Nicéphore Niépce remarked that it could resolve 'a serious problem for the arts of drawing and engraving',[24] and in 1827 François Arago quoted the painter Paul Delaroche as declaring it to be 'an immense service rendered to the arts'.[25] England, less involved with the arts than France, was at this point less receptive to that particular attraction and, lacking

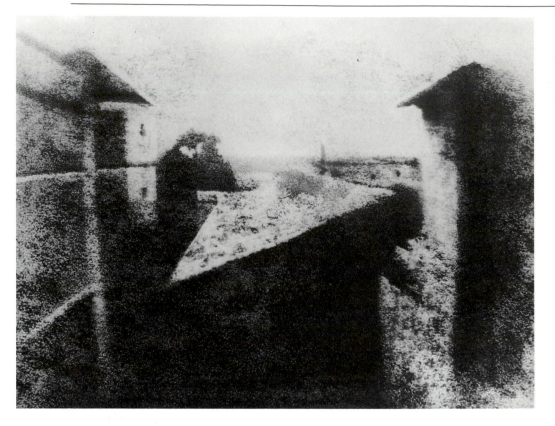

NICÉPHORE NIÉPCE
'Point of view' taken from a window of Le Gras in Saint-Loup-de-Varennes, ?1826. Tinplate 16.5 × 20 cm.
Helmut Gernsheim rediscovered the plate in 1952. It is the only print from nature by Niépce which has come down to us. Gernsheim dates it to 1826. The inventor's own correspondence informs us that he photographed this landscape dozens of times from 1816 onwards and that he was successful in producing a number of 'points of view' in 1826 and 1827.

© Gernsheim Collection.
Harry Ransom Humanities Research Center, University of Texas, Austin.

this stimulus, did not immediately seize upon the immense practical interest of a possible new form of representation.

The example of Hercule Florence, who arrived to settle in Brazil in 1824, demonstrates strikingly how impossible it was for such an invention to prosper where the combined economic, cultural and political aspects of the environment were not conducive to its success. This Frenchman discovered photography, both the word and the thing, between 1832 and 1834, after Niépce it is true, but shortly before Fox Talbot, who adopted a similar procedure. But outside Rio de Janeiro, the world was not to hear of it until 1977 and the invention of photography owes him nothing, either from the point of view of its elaboration or from that of its diffusion.[26]

However that may be, Wedgwood's abortive venture presents a number of features which were to characterise all subsequent endeavours in this field:

1. familiarity with the camera obscura and the notion of preserving the image formed there, without resorting to any manual intervention;
2. the choice of a substance sensitive to the action of light;
3. a series of experiments aimed at reproducing designs by means of contact prints on paper or some other material or of similarly imprinting objects such as plant leaves, butterfly wings or other tissues;
4. attempts – unproductive in Wedgwood's case – to use a camera obscura to obtain an acceptably visible image of the object represented, upon a sensitised base material, within a reasonable lapse of time;
5. a means of fixing the image in such a way that the light which created it would not destroy it when it was revealed.

It was this last problem that proved to be the stumbling block for Wedgwood who, in consequence, was never faced with the further question of how to *multiply* the image of reality starting with the single initial print which rendered it as a *negative*. Niépce and Fox Talbot, the two inventors of photography, each came up with a different solution.

With the unhurried tenacity of a member of the landed gentry with a gentleman's education, Joseph-Nicéphore Niépce (1765–1833), supported by his brother, launched himself upon the career of an inventor.[27] The idea of fixing the camera obscura image may have crystallised during his stay at Cagliari (Sardinia) in 1796[28] but it was in 1816 that he embarked upon a serious programme of experiments, on his estate of Gras, near Chalon-sur-Saône. The difficulties he had encountered in the field of lithography, recently introduced in France, probably alerted him to the advantages of a simpler process for reproducing and copying images of reality. It was a year of crucial importance since it was now that he obtained several prints of natural views (he was later to call them 'points of view') with the aid of a makeshift camera obscura. However, he was dissatisfied both with the process for turning the negative into a positive image and with the precarious nature of the fixed print.

In 1817 he accordingly embarked upon a new avenue of research which eventually enabled him to produce a positive image directly onto a metal plate and led to photogravure, using bitumen of Judea whose photosensitive properties he had discovered. The first successful results, which were copies of contact engravings and 'points of view' produced with the camera obscura, probably date from 1822. For the points of view the exposure time ran into whole hours.[29]

Having conceived the idea and discovered the principles of his invention, Niépce addressed himself to its application. He looked about for assistance from other quarters, with a view to perfecting the process and turning it into a commercial proposition. In 1825, Vincent Chevalier, an optician, arrived upon the scene and became deeply involved; also François Lemaître, an engraver, and Daguerre, a painter. All three were Parisians.[30] In 1827 Nicéphore Niépce was in Britain, visiting his brother, who had been living near London since 1817 and was now gravely ill. He was also convinced that his research would find an encouraging reception in this commercially

WILLIAM HENRY FOX TALBOT
LATTICED WINDOW, 1835.
Calotype negative 3.4 × 2.8 cm.

This print, which is the oldest known negative, shows the library window in Lacock Abbey, taken from inside, in Fox Talbot's home. It is accompanied by a handwritten note by the inventor.

Trustees of the Science Museum, London.

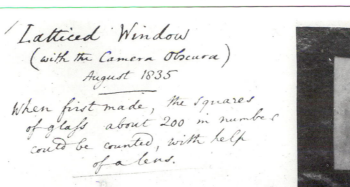

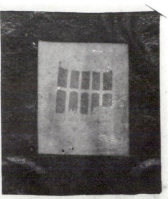

more advanced country and, if that was so, was 'determined to pursue it here rather than elsewhere'.[31] But despite making many contacts in Royal Society circles, he did not succeed in arousing the interest he had expected.

This relative setback opened the way for Niépce's co-operation with Daguerre, who had convinced him of the scope of his 'intelligence and talents', the serious nature of his research in the same field and the excellence of his own camera obscura. Their partnership was sealed by a legal agreement dated 14 December 1829 and supplemented by a *Notice sur l'héliographie*.[32] Niépce certainly made the major contribution to the partnership, with Daguerre playing a very minor role. However, that uneven balance was then substantially redressed since the inventor died before any significant progress had been made and it was only through his partner's tenacity that success was finally achieved.

It is worth noting that the path by which Niépce arrived at heliography sidestepped an idea for which the credit must go to Fox Talbot, who was also the first to apply it: turning the negative image into a large number of positive prints without destroying the original negative.

William Henry Fox Talbot (1800–77) was an extremely learned man with a gift for the sciences but little aptitude for drawing. His research work was rewarded in 1831 when he was made a member of the Royal Society and in 1833 he, like Niépce, was inspired by the Italian sun with the idea of representing reality without resorting to any manual talent. His lack of success with a camera lucida on the shores of Lake Como had the effect of reminding him of the reflected image of the camera obscura and encouraged him to take steps to fix it. During 1834 and 1835 progress was rapid and the first stage of his research was completed when he obtained imprints or 'photogenic drawings' of objects on paper sensitised with silver salts. Then, using small cameras he called 'mousetraps', he produced a series of views taken on his estate at Lacock Abbey. The time of exposure was about half an hour. The prints were fixed in a solution of cooking salt. Other studies then claimed his attention. But in 1839 the excitement surrounding the daguerreotype brought him back to his project and he succeeded in evolving the calotype, the earliest means of obtaining a positive image from a negative one. On the strength of this completely new process Fox Talbot deserves, along with Niépce, to be known as one of the two founders of photography.[33]

ISAAC BRIOT
CARDINAL GEORGES D'AMBOISE
Engraving, 1650.

Musée N. Niépce, Chalon-sur-Saône, Ph. S. Charles © Musée Nicéphore-Niépce.

NICÉPHORE NIÉPCE
Heliograph on tin plate 17.9 × 14.1 cm, 1826.

Musée N.-Niépce, Chalon-sur-Saône. Ph. S. Charles, © Musée Nicéphore-Niépce.

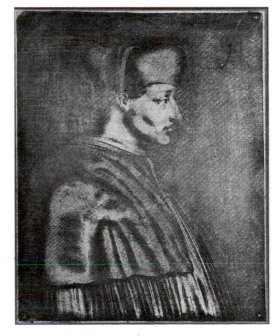

FRANÇOIS LEMAITRE
Print on paper from the original heliograph by Niépce, image 16.2 × 13.2 cm, 1827.

Collection Société Française de Photographie, Paris.

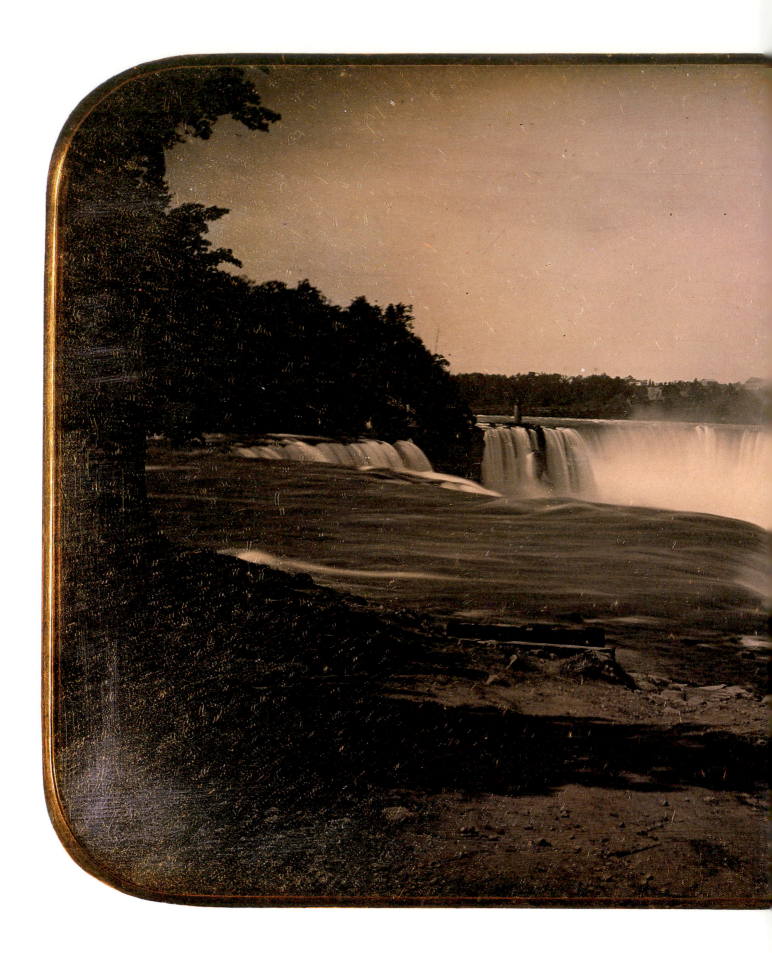

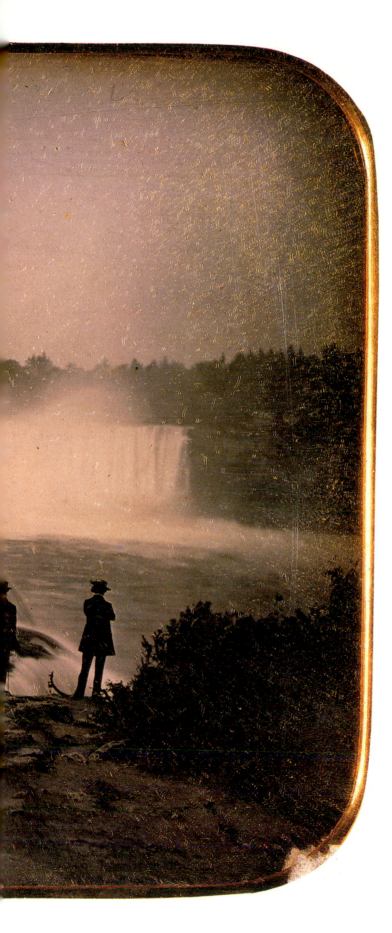

2

The new image takes its first steps

(1839–50)

ANONYMOUS
TWO TOURISTS SURVEYING THE NIAGARA FALLS.
Daguerreotype.

Collection Bibliothèque Nationale, Paris.

In 1839 a new image appeared, which was considerably to extend the field of representation and to wrest an important iconographical role from drawing, in particular in the area of documentation and illustration. By virtue of the date of its disclosure, photography may be included in the wave of innovations and events which took place between 1840 and 1850 and which represent an essential turning point in economic life.

The daguerreotype was the first concrete form of the new system of iconography and it exemplified its characteristics, marked out its points of anchorage and suggested its scope. Its immediate and universal success heralded a twelve-year period of supremacy. But, fully developed and rich in possibilities though it was, the process was eventually superseded by reason of its inability to adapt to economic demands. In the 1850s the silvered plate was easily ousted by the negative–positive process, which was faster, less expensive, just as accurate and easier to reproduce.

The event and its corollaries

Louis-Jacques-Mandé Daguerre (1787–1851) played the role of a catalyst. He was a skilled painter of dioramas and through this art had become familiar with the camera obscura. Soon he became obsessed with the idea of fixing the image that it produced. His lack of scientific training sidetracked him into making experiments which amounted to 'little more than objects of pure curiosity' up until the day when he became the partner of Nicéphore Niépce.[1] Two other names and three dates were to assure his success: Jean-Baptiste Dumas[2] was a distinguished chemist who, ever since 1833 or earlier, had been involved in every French scientific project of any note and it was his advice that at least set Daguerre upon the path to fame and fortune. In 1835 it was discovered how to reveal

VICTOR STRIDBECK
STRASBURG, THE CUSTOMS HOUSE
AND THE SMALL CRANES TAKEN
FROM QUAI SAINT NICOLAS, 1848.
Quarter-plate daguerreotype, 80 × 105 mm.

The photography of urban sites and monuments constitutes the other pole of daguerrian production.

Collection of the Cabinet des Estampes, Chateau de Rohan, Strasburg.

the latent image by exposing the plate to mercury vapour, thereby considerably reducing the necessary time of exposure. In 1837, a way of fixing the image was found, by immersing the print in a solution of sodium chloride. The scholar François Arago[3] took an interest in the invention, using his influence as permanent secretary to the Académie des Sciences and as a deputy to help it on its way. In 1839, in return for life annuities for Daguerre and Isidore Niépce, who had succeeded his father in the 1829 partnership, the state acquired the ownership of 'a discovery as useful as it was unexpected'[4] with a view 'to being in a position to make a present of it to the whole world'.[5] This was official recognition for photography: it was now sanctioned both by the national reward decreed in July and, on 19 August, by the solemn revelation of the process to the Institut de France before an audience that comprised both the Académie des Sciences and the Académie des Beaux-Arts.[6]

It was a turn of events both glorious and lucrative for Daguerre, rewarding him for all his ambition, expertise and enterprise. The invention whose development and popularisation he had so tenaciously promoted now benefited from the repercussions prompted elsewhere by the news of these initial revelations.[7] Amid the bitterness of those who had been beaten to the winning post and the enthusiasm of others who glimpsed its possibilities, photography was suddenly wrested from its infancy. In January 1839, William Henry Fox Talbot informed Arago and Jean-Baptiste Biot, also a member of the Académie des Sciences, of his own longstanding research work; in that same month he presented the Royal Society with several 'photogenic drawings' along with a number of negatives and several prints from each, and laid the foundations for the negative–positive system with the written announcement that a single negative could, in theory, produce an unlimited number of prints.[8] Also in England and also in 1839, the astronomer John Frederick William Herschel managed to produce his first photograph. Then, in rapid succession, he introduced a number of improvements to the new process: first, the use of sodium thiosulphate, whose fixative powers he had discovered in 1819; next, that of gallic acid, which soon became indispensable for producing pictures on paper; and finally, the actual word 'photography', which he entered in his laboratory notebook and used when addressing his colleagues in the Royal Society. Other names may also be included in the list of precursors and pioneers, foremost among them that of the Frenchman Hippolyte Bayard.

Announced within the very portals of the greatest institutions in the land, the Institut de France and the Chamber of Deputies, and discussed in the fashionable salons of the day,[9] the invention known in French as the *Daguerréotypie* (so styled by Daguerre's own wish[10]) between January and July 1839 became an inevitable subject of interest in all élite circles. The excitement aroused by the announcements of 19 August could perhaps be compared to the enthusiasm which greeted the landing of the first astronauts on the moon[11] in 1969. The Parisian happening was world-famous within the year.

Daguerre himself played no negligible part in the propagation of the process. He organised public demonstrations in a hall in the Ministry of the Interior and at the Conservatoire des Arts et Métiers; by September he was circulating a handbook; he commissioned his brother-in-law Alphonse Giroux to produce marketable cameras bearing his trade mark; he presented daguerreotypes to foreign potentates and entered into negotiations with potential promoters and even

future commercial agents such as Louis Sachse in Berlin, Samuel Morse and François Gouraud in New York, and Miles Berry and Antoine Claudet in London. But the importance of the invention was such that Daguerre's efforts were really not necessary to its acceptance and further development. Provincial newspapers and the press in general, then in the process of full expansion throughout the world, took over from the Institut and at last unveiled the secret whose existence had already been disclosed in the odd publication here and there. Motivated either by scientific curiosity or by commercial interests, institutions such as learned societies and private individuals such as opticians also played their parts in spreading the news. Many of the earliest daguerreotypes were produced by men who like Charles Chevalier were opticians: Barthélémy Bianchi in Toulouse, Philippe in Montpellier, Gaiffe in Nancy, Bloch in Strasbourg[12] and Theodor Dörffel in Berlin.

The daguerreotype received an enthusiastic welcome the world over, from Paris to Moscow, London to Naples, New York to Rio de Janeiro. But its effects varied depending upon the particular conditions in which it was introduced and the political and cultural circumstances that obtained in the nations or provinces concerned.[13] In England, the patent taken out on 14 August 1839 by Daguerre, in contravention of the spirit if not the letter of the law earlier passed in France, was to limit the success of the process. Elsewhere, many amateurs were anxious to perfect the original method, but here there were fewer such enthusiasts. As for the professionals, the development of the invention was dominated by the rivalry between Antoine Claudet, who acquired a licence as early as March 1840, and Richard Beard, who took over the patent in June 1841.[14] It was in the United States that the daguerreotype enjoyed its most astonishing and longest-lived success. It appeared at the moment when the American people was affirming its identity through its institutions, language and literature: it introduced an image as new as the country itself and benefited from that country's passion for

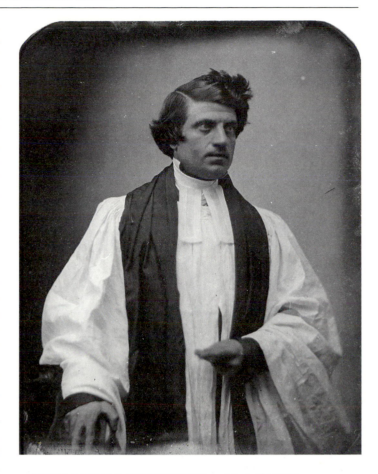

ALBERT SANDS SOUTHWORTH and J. J. HAWES
THE REVEREND WILLIAM T. SMITHETT, 1853.
Whole-plate daguerreotype, 19.5 × 15.25 cm.

The work from this studio in the field of portraiture was unequalled before Nadar, who also concentrated on 'the feeling of light' and 'the moral intelligence' of the subject.

Courtesy, Museum of Fine Arts, Boston. Gift of E. S. Hawes in memory of his father.

THEODORE MAURISSET
DAGUERREOTYPOMANIA, 1839.
Lithograph 25 × 36 cm approx.

This sally of wit gives some idea of the welcome extended to the invention by the public. It is prophetic: the new image was to spread throughout the world, aerial photography was to be introduced and the documentary engraving was to be superseded.

Bibliothèque Nationale, Paris. © Bibl. Nat./Photeb.

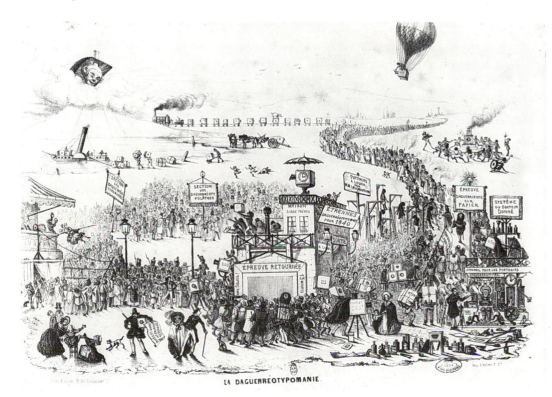

LA DAGUERRÉOTYPOMANIE.

ANONYMOUS
ACTOR DRESSED AS A TRAMP
Daguerreotype half-plate, 12 × 9 cm.

The self-confidence of the figure is that of
the actor, accustomed to project himself on
the stage — in this instance, the
photographer's studio.

Collection of the Bibliothèque Nationale, Paris.

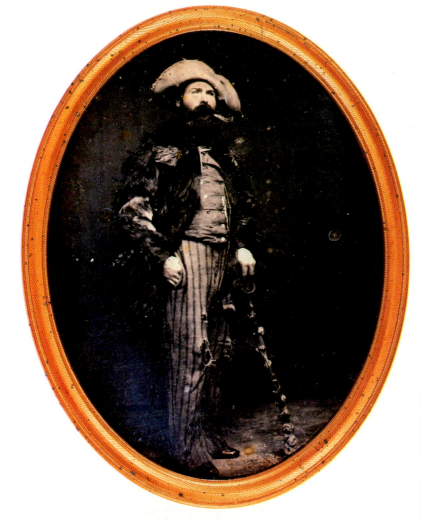

ANONYMOUS
A BLACKSMITH, before
1850.
*Daguerreotype 8 × 6 cm
(image).*

During the 1840s many
daguerreotypes were taken
by photographers who
travelled from town to
town: their pictures include
a wide range of typical
workers.

novelty and progress. The inventor of the telegraph, the
painter Samuel Morse, was the first to speak of it, in April
1839, and by 1840 had already produced a number of
portraits. That same year, in partnership with John William
Draper, he opened a studio which was to become the training
ground for a number of photographers, many of whom were
later well known: Edward Anthony, Mathew B. Brady and
Albert S. Southworth. In December 1839 in New York, and in
March 1840 in Boston, François Gouraud was exhibiting
plates executed by Daguerre and his imitators and was giving
demonstrations. The handbook he published in the spring of
1840, with instructions on how to take portraits, gave rise to
further experiments.[15] By 1841, every town could boast its
own studio or was visited by travelling photographers.

The prehistory of photography thus began with a round-
the-world trip which at a stroke made the invention available
to all those interested or wishing to practise it. Maurisset's
famous lithograph records that voyage of initiation, the
harbinger of all those to be enjoyed by later innovations,
always with huge success.

HIPPOLYTE BAYARD
STILL LIFE, 1839.

Direct positive.

In the early years, immobility on the part of
the subject was a necessary condition for an
acceptable shot. For that reason, the first
photographs 'composed' on metal or paper
were still-lifes. This one has been partly
tinted.

Collection of the Société Française de
Photographie.

LORY
WOMAN WITH SPECTACLES, about
1850.
Daguerreotype 15 × 11 cm (image).

An example of a studio portrait: its success
depended upon the brightness of the
lighting and the immobility of the subject;
the setting and accessories were
originally chosen with this in mind.

Collection of the Bibliothèque
Nationale, Paris.

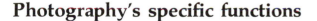

Photography's specific functions

Both amateurs, many of them scholars, and professionals,
often endowed with an artistic training, were soon attempting
to exploit the unique potentialities of the latest offspring
produced by the arts and sciences.

In itself, the method proposed by Daguerre was neither as
simple nor as perfect as had sometimes been promised before
the invention was made public, and there were some who
were not slow to pour scorn upon it.[16] The picture produced
by Daguerre's method was a shiny and inverted image but
one that was admirably clear provided the subject was suited

to an exposure time which might last from three to thirty
minutes, depending upon light conditions. One direct, and
consequently unrepeatable, positive could be obtained; the
image was fixed but the slightest friction damaged it as the
imprinted layer was very thin. The process was promptly
adopted for portraiture, with disquieting results. The plates
reflected figures seemingly in agony.[17] As for open-air
photography, it was a clumsy business, to put it mildly: the
equipment weighed 50 kilograms and all sensitizing, develop-
ing and fixing operations had to be carried out on the spot.

In 1840, Louis Hippolyte Fizeau managed to confer beauty
and permanence upon the image by the use of gold chloride;

HIPPOLYTE FIZEAU
PARIS, FAÇADE AND BELL-TOWERS OF SAINT-SULPICE AND
HOUSES, about 1842.
Helio-engraving, 7.5 × 9.8 cm (image).

One of Fizeau's first attempts at an acid engraving from a
daguerreotype. Only the advent of the negative–positive system
brought a halt to the development of this technique, which promised
excellent results.

Collection of the Bibliothèque Nationale, Paris.

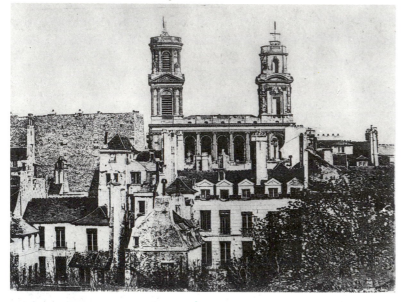

in 1841, plates were rendered more sensitive by means of
speeding-up substances recommended by Antoine Claudet,
John Frederick Goddard and Franz Kratochwila, all pioneers in
this field; and even in the same year similar progress was
being made in the domain of optics, thanks to Alexander S.
Wolcott and Henry Fitz, Josef Max Petzval and Friedrich
Voigtländer: the plate now received more light and the image
obtained was no longer reversed. In 1839, Baron Pierre-
Armand Séguier's bellows-camera reduced the weight of the
total equipment to 18 kilograms. In Paris, Charles Chevalier
and N. M. P. Lerebours introduced cameras that were easier to
handle, producing models at prices that varied according to
the type of view to be taken (landscapes or portraits) and the
size of the plate used.[18]

By 1843, the time of exposure was reduced to between one
second and two minutes, depending on sky conditions and
the format of the daguerreotype. The cause of the portrait was
by now won and, in a sense, the future of photography
assured, for its commercial application enabled the new
system of representation to take root in society.

Meanwhile, experimenters were applying themselves with
equal commitment to the problem of multiplying prints, a
possibility which Daguerre's process a priori excluded. In this
respect the daguerreotype was at a disadvantage as compared
with Niépce's discovery and also the arts of drawing:
engraving and, above all, lithography, which was a slightly
earlier invention than photography. In 1839 and 1840, Alfred
Donné in Paris, Joseph Berrès in Vienna and Jacoby in St
Petersburg all undertook experiments aimed at turning the
plate into an engraving or at producing facsimiles from it
through a process of electrolysis.[19] Alphonse Louis Poitevin
(1819–82), who was brilliantly to develop the aspect of
Niépce's invention which Daguerre had neglected, followed a
similar line.[20] Above all, between 1841 and 1844, Louis Fizeau

achieved results so promising that the problem could be
considered resolved. Within the space of less than five years,
the art of the daguerreotype had become a virtually perfected
process with a fine future ahead of it. Nevertheless, its days
were numbered.

The avenue opened up by Fox Talbot led to solutions
which in due course not only satisfied the demand for
instantaneity, resistance to deterioration and reproducibility,
but also provided the foundations for a much more re-
munerative commercial strategy, since the cost of producing
an image on a silvered copper plate remained prohibitively
high. On 8 February 1841, when Fox Talbot took out a patent
on the procedure which he himself named the calotype (from
the Greek for 'fine image') he officially launched the
negative–positive system. The discovery of the phenomenon
of the latent image, in September 1840, had enabled him to so
reduce the time necessary to take a picture that a commercial
application became feasible. He was not alone. Hippolyte
Bayard (1801–87) was a quite remarkable self-taught man
who, inspired solely by the announcement of these results,
within a few months covered on his own all the ground earlier
explored by Daguerre and Fox Talbot, although in the event
he did not leave any real mark upon the evolution of
photography. In February 1839 he obtained negative images
on paper and then, in March, direct positive images. In
October, he produced, again on paper, negatives obtained by
developing the latent image. Yet the attempts of this inventor
to attract attention to his work, chiefly by exhibiting thirty
prints in Paris on 24 June 1839, met with scant success.
Although Arago had been told in May of his experiments, he
offered him no encouragement, probably through fear of
having to carry through two ventures at the same time, on the
one hand promoting the daguerreotype while on the other
launching a new and different method. The Académie des
Beaux-Arts was virtually alone in recognising the interest and
aesthetic potentialities of the process.[21]

In the event, the calotype was little used and made slow
progress, for in France it received insufficient publicity while
in England it was impeded until 1852 by Fox Talbot's
determination to safeguard his own interests by restricting its
use to licensees. Nevertheless, paper prints were recognised
to possess 'precious faculties', 'by reason of the ease with
which they could be transported and handled and, above all,
their remarkable ability to receive colours';[22] furthermore
they could be tinted and also cost much less than daguerre-
otypes. All these were factors which, around 1847, combined
to prompt a series of experiments which were to have a
determining effect upon the future of photography. Between
1844 and 1847, Louis-Désiré Blanquart-Evrard (1802–72)
introduced a number of refinements essentially affecting the
negative. Between 1847 and 1850 he followed these up with
another series of improvements, this time on the positive. His
work provided the decisive spur to the development of the
paper image, winning acceptance for the logic of a method
which made it possible to obtain hundreds of positive prints
from a single snapshot. When, also in 1847, Claude-Félix-
Abel Niépce de Saint-Victor (1805–70), Niépce's nephew,
made known his method of producing negatives upon
albumenised glass, the daguerreotype lost its last claim to
superiority, that of its 'exquisite delicacy',[23] since a glass
transparency could now produce images of a virtually equal
precision.

The silvered plate continued on its commercial career but it

no longer commanded unanimous support. Experiments bearing upon either the handling of the negative or the binder used to keep the silver salts on the surface of the base material led directly to the collodion method and brought about the demise of the daguerreotype system during the 1850s. However, the direct positive image never did disappear completely, either for technical reasons or because the attractions of immediacy counterbalanced the impossibility of producing copies; it was called by a series of names: the ambrotype, the ferrotype, the autochrome. Today it is known as the positive transparency, or as the Polaroid.

Institutionalisation

Photography was now set upon the path which was to raise it to the rank of an essential constituent of modern civilisation. The nature of the newborn enterprise was immediately reflected in language. For several years, the terms 'daguerreotype', 'photograph' and 'heliograph' were in competition, frequently all used to denote the same thing. These ambiguities heralded the subsequent complexity of a vocabulary which was in part newly forged and in part an amalgamation of terms that already existed but were now sometimes given a different meaning.[24]

A new profession came into being. It was organised around an enclosed space, the studio, the result of a number of factors: society's demand for portraits; the technical necessity of a long exposure; and the cultural model of the painter's studio. Compared with enterprises being set up in other sectors of the economy, the photographer's studio was, for the time being, a very small-scale business, although the establishments of Claudet in London and Brady in New York, in the early 1850s, prefigured the splendours of subsequent temples of photography which were to employ as many as a hundred people. But in this domain, right from the outset and for more than half a century, the studio was the basic unit of production and the pivot of economic success.

The establishment of the studio was connected with the presence of a potential clientele which guaranteed it sufficient and steady profits. It came about extremely rapidly in the capitals and larger cities of the West (beginning as early as 1840–1), more slowly in other towns. The already existing market which supplied practitioners of the daguerreotype with various materials swelled the numbers of suppliers and stimulated the trade. The advertisements which appeared in almanacs of the time give some idea of the rapid advance of the profession: in Paris, the number of studios increased from twelve in 1844 to fifty-four in 1851.[25]

Wherever studios were not set up – or at least not yet – travelling photographers appeared, working on a seasonal basis. Coeulte, a native of Paris, visited Nancy nearly every year from 1843 to 1847 and again in 1853 and 1854. Johann Baptist Isenring toured southern Germany and northern Switzerland in a converted wagon which served him as home, studio and laboratory all in one. In the United States, Cyrus Macaire, who was later to set up a practice in Le Havre, travelled all over the southern states in 1841. Other photographers would be on the lookout for temporary mass gatherings; these were travellers such as one Vincent who in 1850 used the local news-sheet to announce his presence on the fairground where he would take 'daguerreotype portraits for a fee of 2 francs'.[26]

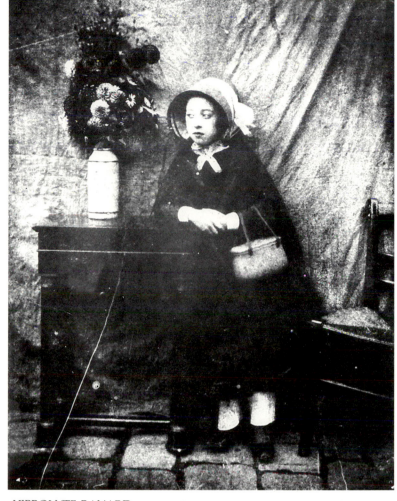

HIPPOLYTE BAYARD
PORTRAIT OF Mlle C., before 1850.
Printed from a paper negative 12.7 × 16.5 cm.

The natural restlessness of children did not prevent Bayard from obtaining this excellent print, using a slow technique (a variant of that used for the calotype).

Collection of the Société Française de Photographie, Paris.

You became a photographer by chance or through necessity and in some cases remained one because you enjoyed it. You might make your fortune at it but as often as not it was a hand-to-mouth existence; or you might be ruined. Many of these photographers had previously been engaged in an artistic profession: Charles Winter, from Strasburg, had been a lithographer; Henry Collen, from London, who worked briefly as a calotypist, had been a miniaturist. But, in truth, they came from many backgrounds. In the United States, for example, Edward Anthony had started as an engineer, Robert Cornelius as a maker of lampshades, Jeremiah Gurney as a watchmaker and Alexander Wolcott as a dentist.

In many cases lasting social acceptability depended upon legal considerations and had to be fought for in the courts. Photography was brought very early on to the attention of the judges, as a result of the suits brought by Beard and Fox Talbot, both determined to defend the rights attached to their patents. Other legal actions were to follow in the wake of the sixty patents taken out between 1839 and 1851.

Technical literature acquired a new section. Daguerre's handbook ran to at least thirty-nine editions and was

translated into eight languages in the space of eighteen months; in under six months, nine thousand copies had been sold.[27] The number of handbooks increased every year, Lerebours's treatise running into five editions between 1841 and 1846. The day of specialist magazines had not yet dawned. The very first journal devoted to photography came out in New York in November 1850 with the title of *The Daguerreian Journal*. But meanwhile the press was encouraging and the publications of scholarly societies purveyed whatever news came their way.

The wit displayed by a number of cartoonists and writers at the expense of the 'daguerreotypophiles'[28] and 'daguerre-opipeurs'[29] gave early warning of the future clash between art and photography: 'The truly original artists, far from feeling threatened, will be indebted to the new invention for the unexpected resources it provides and will take new inspiration from it. *The tradesmen and mechanics,* as they used to be called will be overwhelmed.'[30] The first to feel threatened, and with good cause, were the miniaturists and the engravers of reproductions. On the positive side, in some quarters recognition of the phenomenon of photography led to the creation of a number of short-lived amateur clubs: in Vienna in 1840; in London in 1847; and in Rome in 1848. They were the precursors of the associations which, from the next decade onwards, were to constitute one of the new iconographical system's sources of active support.

Here and there, exhibitions devoted to the traditional arts and the products of industry provided further glimpses of the new image. In Paris in 1844 close on one thousand plates were put on show in the Palais de l'Industrie, in the section reserved for commercial products; and in 1849 photographs on paper made their appearance there alongside the daguerreotypes.[31]

Production and creation

The propagation of photography throughout the social body was assured in the first place by the nature of the prints themselves, particularly given that, in most cases, they could be produced only in the physical presence of the client.

'Does a daguerreotype really constitute a portrait?' had been the cry that went up from a number of peers and deputies at the time of the co-operation between Arago and Gay-Lussac in 1839.[32] The display of such exacting attitudes towards a method as yet incapable of registering movement was to prove an essential stimulus to the progress of the invention. The years before 1841 had not produced many successful results, but 1841 marked the launch of what was to prove the major area of production for photography during the nineteenth century. Fifteen hundred portraits were produced in France during that year alone. With five or six clients each day, Claudet produced more than eighteen hundred plates between June 1841 and July 1842;[33] and the figures for the Parisian photographers Vaillat and Derussy, relating to the years 1846 to 1849, tell their own story: two thousand a year for the former, three thousand for the latter.[34]

Compared with the kind of expansion later made possible by the negative–positive system, these figures still seem to belong to the world of artisanry. They nevertheless mark a distinction between photography and the arts of drawing, situating the former within a framework which may already be termed pre-industrial. Projects of a kind that no sketch-artist could reasonably have envisaged earlier began to be set up. It was the daunting prospect of having to paint a gathering of over four hundred people that, in 1843, caused David Octavius Hill, a landscape painter, to ask Robert Adamson, who was already producing photographs on paper, to fix their features for him. The partnership of these two men lasted until 1847 and produced more than eighteen hundred calotypes.

The relatively high price of the daguerreotype plate and the fact that it was impossible to multiply the single image with ease and thus reduce costs slowed down the diffusion of the new type of picture but did not compromise its success. In the early days of the invention, a daguerreotype would cost between fifteen and thirty francs; ten years later, depending upon format, extras and presentation, the price had fallen to between two and twenty francs. The daily wage of a manual worker at the time fluctuated between 2.50 and 4 francs. Deeply conditioned by its familiarity with the methods of drawing, the public by and large did not understand how photography worked and, even when it did not regard it as pure magic, it still manifested an astonishment so naïve as to delight humorists and the photographic studios alike.[35]

Photography revived the taste for travel that had for so long been reflected and nurtured by literature and lithography. Lands previously explored by caravan and caravel were now rediscovered by the camera, which could record landscapes, sites and monuments with a hitherto unknown precision. The peregrinations of Joseph-Philibert Girault de Prangey between 1841 and 1844 and those of Jules Itier between 1843 and 1846 produced no less than one thousand plates of the countries they had visited: the former the Near East, the latter mainly China, and both of them Egypt.[36] The curiosity aroused in the public by such topographical views was not lost upon the professional photographers. For example, William and Frederick Langhenheim enjoyed much advantageous publicity in July 1845, when they produced a panorama of the Niagara Falls composed of five separate plates, of which they made eight copies to present to various sovereigns.

In the absence of any specifically photographic means of reproducing images, to secure a market of this kind it was necessary to fall back on engraving. Between 1842 and 1846 Lerebours brought out his *Excursions daguerriennes*, a collection of 112 views produced in parts, mostly as aquatints engraved from daguerreotypes.[37] Sacrificing photographic authenticity to picturesque qualities, the engravers added various details such as clouds, walkers and carriages, which the insufficiently sensitive plates could not record.

This work may be seen as representing a temporarily even balance in the competition that was developing between the two iconographical systems. Its formal identification with the camp of the arts of drawing proclaimed the superiority of the age-old system, which was affected by the invention disclosed in 1839 only to the extent that it lost its exclusivity. Meanwhile, three plates engraved using Fizeau's method appeared, providing a reminder of a principle established by Niépce, the refinement of which was, a few decades later, to guarantee photography a quasi-monopoly over iconography in the field of illustration. These first fruits of the reign of photo-mechanical methods stemmed from an aspiration to produce copies from the single image. The introduction of the negative–positive process was to reactivate that aspiration, in the first instance prompting attempts to find a direct solution. In 1843, in Reading, Fox Talbot set up a printing works that in

DAVID OCTAVIUS HILL AND
ROBERT ADAMSON
JAMES LINTON AND THREE YOUNG
BOYS GROUPED BY THE 'NEWHAVEN',
1845.
Printed from a calotype 20.8 × 15.7 cm.

The straightforward and fleeting moment of
reality, harmoniously arranged in space by
the photographer, is transformed into a
poetic and lasting representation.

Ph. © National Galleries of Scotland, Edinburgh.

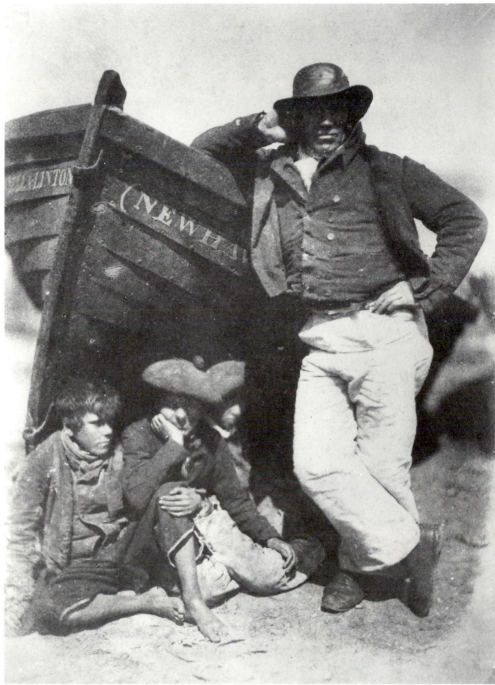

the course of the next three years pro-
duced the very first books to be illustrated
by original photographs. One was the
famous *Pencil of Nature*.[38]

Having won wide acceptance in society
through the portrait and attracted the
attention of the educated public through
the topographical view, photography was
now greeted with interest by scholars, as a
tool of investigation, although as yet
relatively little use was made of it. The
shiny surface of the image and the cram-
ped dimensions of the plate reduced its
value as a legible document. But there are a
number of instances of its use for scientific
purposes. The series of photomicrographs
produced in 1844 by Léon Foucault and
used as engraved illustrations for Alfred
Donné's *Cours de microscopie* represenst a
first step in the exploration of the world
that is invisible to the naked eye.[39]

The specially functional aptitudes of
photography masked the possibilities of
another specific and exciting role for it, an
aesthetic one. Absorbed as they were in
technical problems, the professional
photographers were unconscious of it. In
their studios, they continued to elaborate a
ritual they were to hand on to their
successors: it involved a combination of
practical refinements and elements of the
pictorial scenography that so preoccupied
them. Their handbooks provided instruc-
tions for producing such pictures, referring
to photography in purely utilitarian terms. The long exposure
times made necessary by the slow process encouraged
compositions of the type exalted by the arts of drawing. John
Jabez Edwin Mayall thus produced a number of plates to
illustrate the Lord's Prayer and the poems of Campbell. In
these circumstances, the work that came from the studio of
Albert Sands Southworth and Josiah Johnson Hawes in
Boston, between 1843 and 1862, was all the more remarkable.
Thanks to sophisticated techniques, an intuitive and rare sense
of timing and a dynamic use of light, it succeeded in
demonstrating the quintessential qualities of the daguerre-
otype. These portraits, overflowing with vitality, evoke the
whole of America in all its vigour and immensity.

As generally represented by the daguerreotype, pho-
tography appeared to be simply the invention of a technique
for registering reality. With the advent of the calotype, it
introduced a completely new aesthetic, or at least afforded a

glimpse of such a possibility. Those who expressed a
judgement at the time all agreed that, as a material, paper,
when played upon by light, produced a more subtle image
than that of the daguerreotype whose very precision gave it a
dry quality. Photography on paper was still a risky business
on account of the defective texture of the base material and
the complications involved in handling it, and was seldom and
only half-heartedly practised up until 1851. Fox Talbot,
Bayard and a number of other amateurs, including Victor
Regnault, demonstrated the expressive potentialities and
emotive force of the new art. The natural poses, understand-
ing of light and intelligent use of space that impress one in the
magnificent collection left by Hill and Adamson bear witness
to the creative power that the taking of a picture and the
production of a positive print from a negative image made
available to any photographer endowed with imagination and
confident in his equipment.

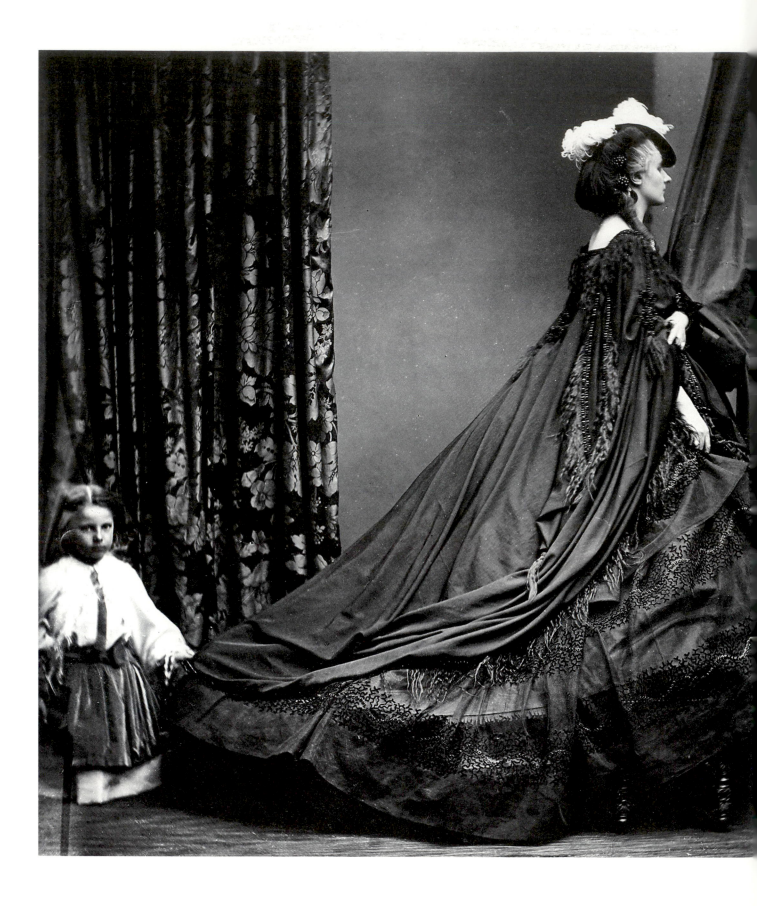

3

The rise of photography
(1851—70)

MAYER AND PIERSON
LA CASTIGLIONE
Collodion negative.

Collection of the Musée d'Unterlinden, Colmar, Archives Départementales du Haut-Rhin.
6 Fi/Ch. Kempf.

The photographic movement in 1851

The Great Exhibition held in London in 1851 marked symbolically the mid-point of the nineteenth century. In among the many machines and the multitude of industrial products, the Crystal Palace housed the first major exhibition of photography, presenting in particular the American works of Whipple, Mayall, Whitehurst, Root, Evans, Mead and Brady; those of the French Bayard, Flacheron, Gouin and Thierry; and those of the British Beard, Kilburn, Paine, Henneman and Malone, as well as those of the French Claudet, who was in business in London.[1] The event was an important one for photography, which thereby truly gained official recognition. The New York photographer Mathew Brady was well aware of the fact: he came in person to London and, working inside the exhibition hall itself, produced portraits of many well-known personalities, Victor Hugo and Lamartine among them.[2]

In Europe and America, the photographic movement thus took concrete form, although its methods and organisation were by no means uniform. The jury's report pronounced the most outstanding achievements to be the following: in the United States, daguerreotypes (unreproducible photochemical images on copper plates); in France, calotypes (prints on paper made from negatives on paper); and in Britain, photographs produced from negatives on glass. However, at the time of the exhibition, only the United States and France had as yet — recently and almost simultaneously — produced specialist reviews: *The Daguerreian Journal* appeared in New York in November 1850, to be followed, in January 1851, by *The Photographic Art Journal*; in Paris, the first issue of *La Lumière* came out on 9 February 1851 under the aegis of the fledgling *Société Héliographique*, founded in January by B. R. de Monfort, Hippolyte Bayard and possibly Abel Niépce de Saint-Victor (the nephew of Nicéphore Niépce), under the chairmanship of Baron Gros, a diplomat and amateur daguerreotype enthusiast. This society, which aimed 'to promote means of perfecting photography' soon rejoiced in the membership of the painter Eugène Delacroix, the art critics Champfleury and Francis Wey, the optician Charles Chevalier, the engraver Lemaître and Victor Regnault, who was a member of the Institut de France. In Britain, no society or journal yet existed in 1851, apart from the Calotype Club which since 1847 had been assembling a dozen or so friends — among them Frederick Scott Archer and Roger Fenton. But the situation soon changed: on 20 January 1853 the Photographic Society of London was founded. In his inaugural address, Roger Fenton, the honorary secretary, traced its birth explicitly to the twofold dynamic impulse provided by on the one hand the Great Exhibition of London and, on the other, the Parisian Société Héliographique which he had wasted no time in visiting, in 1851, to study its organisation. Even before the birth of their own organisation, the future members of the Photographic Society of London were setting up the first exhibition exclusively devoted to photography ever seen in the world. It opened on 22 December 1852 on premises belonging to the Society of Arts.

In the Germanic countries, the photographic movement got off to a slower start. The first German-language periodical, *Horn's Photographisches Journal*, first appeared in Prague in December 1853, under the direction of the painter Wilhelm Horn. In 1857, in Vienna, the photographer M. Weingartshofer launched his *Photographisches Album*. Then, from 1860 to 1896, Paul E. Leisegang presided over the important publication of the *Photographisches Archiv*. But it was not until 1861 that the first photographic society was formed, in Vienna, under the chairmanship of the amateur photographer A. Martin, who was also the librarian of the city's polytechnic institute.

The evolution of the negative

From the point of view of photographic technique, 1851, which saw the introduction of collodion, marked the end of the first stage in researches that had been begun well before 1847 and were aimed at obtaining from a negative photographic images that could be reproduced in fine detail and also at reducing the exposure time necessary for taking a picture.

Louis Désiré Blanquart-Evrard speeded up and increased the cost-effectiveness of the process which Fox Talbot had suggested in 1841 for producing negatives on paper (or calotypes), that is to say images that were reproducible. But Blanquart-Evrard continued to produce his negatives on paper, a material whose texture impaired the delicacy of the prints, so that from this point of view photography was still not in a position to compete successfully with the daguerreotype. With a view to combining the advantages of both reproducibility and precision, Niépce de Saint-Victor substituted glass for the paper and in June 1848 began to use albumen to retain the chemicals on its surface. The delicate precision of these prints equalled that of the daguerreotypes. Thanks to the negative–positive system, photographs that could be reproduced were now as clear and accurate as the unreproducible daguerreotype. Unfortunately, however, albumenised glass called for long exposures (lasting from five to fifteen minutes) and so could be used only for subjects that were immobile. In default of anything better, the daguerreotype retained its supremacy.

Photographic studios thus continued to depend upon the daguerreotype from which it was not possible to obtain any photochemical reproductions, which was why Mathew Brady, for example, was obliged to resort to manual engraving when he published his book of portraits, *A Gallery of Illustrious Americans*, in 1850.

So it is not surprising that, apart from the contributions of the Langenheim brothers of Philadelphia and those of the Frenchmen Frédéric Martens and Henri Le Secq, almost all the prints exhibited in London were daguerreotypes. However, it was during this same year, 1851, that Gustave Le Gray in France and, above all, Frederick Scott Archer in Great Britain found another material to use for negatives on glass, to take the place of albumen — which reduces the sensitivity of silver salts to light. The new substance was collodion, hitherto used only as an explosive and in surgery. It proved a decisive innovation. The photograph was now potentially in a position to oust the daguerreotype to which, it was felt, collodion 'dealt virtually a death-blow', since it reacted to the contact of luminous rays so rapidly that, thanks to its use, movements could be 'instantly seized upon'.[3] Of course, the immediate reactions of the day were somewhat exaggerated but they provide an indication of the importance of collodion, which was soon to transform professional photography in a radical fashion, by supplanting the daguerreotype in the studios. That is to say, all the equipment used both for taking the pictures and in the laboratories had to be changed, and the

collodion method became the dominant process. It was to remain so until the 1870s.

It was thus in London, a few months before the Great Exhibition of 1851, that the first stage in the evolution of the negative was brought successfully to its conclusion. Now it was possible to 'seize upon' space–time with unsurpassed 'exactitude' since on the one hand the glass now used instead of paper gave the negative greater delicacy while, on the other, the wet collodion fulfilled a condition that was essential for 'exactitude' in reproduction, namely speed. Nevertheless, despite the excellent qualities of collodion and the emphatic nature of many of the claims made for it at the time, 'instantaneity' was still far from achieved. It was to be the object of many research projects in the course of the next two decades for, as Disdéri correctly noted, without it there could be 'no exactitude in the reproduction of nature'.[4]

The evolution of the positive

1851 was also an important year in another respect, this time in France, as now a first attempt was made at multiple printing. This was the starting point for the evolution of the positive which was to continue, throughout the half-century, in the search for the 'popularisation' of photographic images.

The quest for reproducible and hence multiple images should be set within the framework of a series of other transformations introduced at this time by the industrial revolution taking place in the Western world. In more and more domains machines were increasingly taking over from manual labour; profit was becoming the foremost goal of economic activity, 'get rich' being the catch-phrase of the time; and a wave of upward social mobility shook the social hierarchy. Multiple printing, the aim of which was increased production at less cost and greater profit, was altogether in line with the principles of a market economy. But it was also a response to the demand for images coming from groups which were moving up the social ladder. A similar pheno- menon was affecting many other enterprises of the period: the newspaper press was being transformed in order to reduce the price of subscriptions and increase production, while cut-price copies were 'popularising' luxury products and inaugurating the age of the 'off-the-peg' imitation.

In theory, the negative–positive process allowed for the reproduction of images in large numbers, but it could not immediately fulfil the expectations that it had aroused. In March 1851, the Société Héliographique, founded the pre- vious January, tackled the problem by setting up a working party with a view to creating a 'photographic printing works', that is to say, an establishment for printing positives. Once again, the role played by Blanquart-Evrard was of the first importance. To make the project technically and economically viable, that is to say 'to enable industry to prosper',[5] he proposed a technical innovation. Since 1847, positive prints had been produced simply by exposing to the light a slide containing a sensitised sheet placed beneath a negative. 'The drawback of this procedure was that it was time-consuming and depended upon the state of the weather. . . . No more than three or four positives per day could be obtained from each negative print';[6] and, Blanquart-Evrard went on to ask, in a letter to *La Lumière*, 'What will the factory employees do on days when the light is poor, and to what extent will this enforced idleness reduce the profit made by the business?'[7] To

CLAUDE MARIE FERRIER
CLOCK IN THE GREAT EXHIBITION, LONDON, 1851.
Printed from albumen negative on glass.

This print is one of the 155 (produced by Ferrier and Hugh Owen) which illustrate the four volumes of the Exhibition's *Report by the Juries*.

Gernsheim Collection, Harry Ransom Research Center, University of Texas, Austin.

resolve these problems, he proceeded in 1851 to alter his printing method: he now exposed his slide to the light for no more than one minute, then developed the latent image thus obtained. Thanks to this new method, he declared, 'It is possible to increase the number [of positive prints produced in one day] to three or four hundred, so that in a factory where thirty to forty negative prints were treated each day, one could easily produce five or six thousand positive prints, which could be ready for delivery the very same day and at a very modest price.'[8] It was suggested that this might be as little as five to fifteen centimes, depending upon the size of these 'industrially' produced prints, instead of the five or six francs charged hitherto. Here again, as was often the case during this period of innovation and adaptation of earlier procedures, technical, economic and social motivations were all at work. But the often considerable gap that separated actual practice on the one hand from declared goals and promised successes on the other is an indication of the technical difficulties photography was encountering as it strove to meet the demands placed upon it. During the

summer of 1851, Blanquart-Evrard opened his 'photographic printing works' near Lille. His aim was 'to propagate photography on paper by reproducing prints in abundance'.[9] He employed about thirty women, many of them on a seasonal basis, rationalised printing operations by means of a strict division of labour and in this fashion continued in operation until 1855.

Photography in 1855

The first half of the 1850s was a period of conversion for the professional studios which now proceeded, with more alacrity in some countries than in others, to abandon the daguerreotype in favour of the wet collodion method. The switch-over was already quite far advanced in Europe as a whole and France in particular, with Disdéri, Mayer and Pierson all setting up their businesses in Paris; but in the United States it did not really get under way until 1855–60. Here, the daguerreotype reached the peak of its success around 1853, in the hands of such professionals as Jeremiah Gurney and Mathew Brady in New York, Alexander Hesler in Chicago

BISSON Brothers
MAIN ENTRANCE OF THE PALAIS DE L'EXPOSITION, 1855.
Printed from a collodion negative.

Louis-Auguste Bisson (1814–76) and his younger brother Auguste-Rosalie (1826–1900) had by 1855 already photographed many of the architectural treasures of France, Germany, Belgium and Italy. This is one example of their skill.

Collection of the Bibliothèque Nationale, Paris.

and the Southworth & Hawes studio in Boston. The second Great Exhibition, held in Paris in 1855, reflected these transformations. The jury drew attention to 'the virtually total disappearance of daguerrian prints (whereas) in London, in 1851, they were considerably more numerous than prints on paper'.[10] The Great Exhibition also afforded an opportunity to assess the state of photography world-wide, its developments over recent years and the difficulties yet to be faced. During this period of fertile experimentation, while the daguerreotype was declining in Europe, a number of different processes for producing negatives coexisted, sometimes all in use at once by a single photographer. However, there were two main tendencies: one was the progressive abandonment of albumen for prints on glass and its replacement by collodion, the other the persistence of the calotype (the paper negative) 'on account of its extreme convenience for travelling'.

Furthermore, the Great Exhibition provided an opportunity for a competition between France and Great Britain, the two countries which 'take the foremost place in this photographic display'. The collodion landscapes of the British Roger Fenton and Maxwell Lyte were set alongside the mountain views produced using the albumen process by the Frenchman Frédéric Martens and, above all, the great architectural prints of the Bisson brothers and Edouard Baldus and the genre scenes of Charles Nègre. Meanwhile, the jury noted that with the increasingly general use of collodion, 'the manufacture of portraits . . . has become an important industry; some studios in Paris make hundreds of thousands of francs each year from their sale, and one business is claimed to have produced 50 000 francs worth in a single month. Unfortunately, in this industry, good taste cannot always be said to reign supreme.'[11] All the same, they did go on to make special mention of the portraits of Mayer & Pierson, Disdéri & Co., and Tournachon-Nadar Junior & Co. in France; the work of Oscar Gustav Rejlander and John Lamb in Great Britain; and that of Franz Hanfstaengel in Bavaria.

'Popularisation'

A new phase in the evolution of the positive began in 1855, where the photographic process was concerned. Positives posed a double problem: the long and tricky business of producing them limited the reproduction of prints both technically and economically; furthermore, the prints themselves were subject to deterioration. Two events sparked off the new phase in the evolution of the positive: one was the closure of the Blanquart-Evrard printing works in Lille, the other the presentation of heliographic engraving at the Great Exhibition.

During his four years in operation, Blanquart-Evrard produced about one hundred thousand prints on commission.[12] They included archaeological subjects, reproductions of paintings and etchings, landscapes and artistic studies. He rationalised printing operations to the point of halving his overall costs, but his card-mounted photographs still, in 1855, shared many features in common with the de luxe illustration. Blanquart-Evrard also had to cope with the anxiety felt during this period over the tendency of prints produced using silver salts to deteriorate and fade.

Faced with the limitations of this first attempt at producing multiple copies of prints, the Exhibition suggested an alternative solution: heliographic engraving. With the aid of a

LOUIS ROUSSEAU AND ALPHONSE
POITEVIN
SEA-FAN, undated.
Photolithograph.

Louis Rousseau was an 'assistant naturalist
at the Jardin des Plantes'. Even before 1855
he had been trying to diffuse the 'admirable
collections of the Museum of Natural
History' by means of photography. To
speed up the process and to avoid the risk
of the prints deteriorating, he soon had
recourse to photomechanical methods using
heavy printer's ink. This is a
photolithograph executed and exhibited by
Alphonse Poitevin in 1855.

Collection of the Bibliothèque Nationale, Paris.

negative (or a positive, depending upon the process fol-
lowed), it was possible by the sole means of light and
chemicals, to produce a stone moulding (lithography) or a
metal one (photogravure, a copper-plate engraving), from
which prints could be run off in heavy printer's ink. The jury
stressed the advantages of 'heliography [which], by replacing
photographic prints by prints run off in ink, using a printing
press, could guarantee the indestructibility of the prints and
reduce their price to that of ordinary printed engravings'.[13]
Ernest Lacan, for his part, explained that 'photography,
complete though its results may be, is no more than a
transitory process; the future belongs to heliographic engrav-
ing or to photolithography . . . for these possess the great
advantage of adapting to the conditions of the printing
works, that great instrument of popularisation'.[14] By 1855,
the process had reached a crux in its evolution: reproducibility
was now possible but multiple reproducibility, that is to say
the 'popularisation' of photographic images, had yet to be
achieved.

The jury spelt out the conditions necessary for the
'popularisation' of prints produced with silver salts: they
were, first and foremost, to produce more, more cheaply, in
accordance with the laws of marketing. This involved
reversing the current attitudes of those in the trade, for 'in
general, the price of photographs is still too high; those who
produce them fail to see that by reducing their prices they

would considerably increase the sales of their products and,
by popularising photography, would also increase their total
profits.'[15] Another condition was that the prints produced
should satisfy demands and be of a high technical quality:
prints should not be subject to deterioration, for 'doubt is, in
itself, fatal to photography.'[16] At the same time, by rewarding
Edouard Baldus and Charles Nègre, the jury encouraged
heliographic engraving, for, like Ernest Lacan, they believed
photography to be incapable of popularising photochemical
images, a task that they considered to be of capital
importance.

Before 1851, underlying the issues of speed, clarity and
reproducibility was a problem that affected the processing of
the *negative*: that of perfecting an image which was clear and
judged to be exact and so could be used to produce a
representation of reality which, being reproducible, made
'popularisation' a possibility. *From 1851 onwards*, but espe-
cially in 1855, it became a matter of processing the *positive* in
such a way as to ensure the reliability of the method in terms
not of its figurative powers but of the durability of its
products. From an economic point of view, industrialists were
loath to invest in non-durable images; and meanwhile, the
threat of deterioration was making it impossible to acquire the
symbolic mastery over time that was so much sought after in
their period. In short, it was felt desirable to embark upon the
'popularisation' that the process sanctioned, accepting all the

Baron LOUIS-ADOLPHE HUMBERT DE MOLARD
THE TWO HUNTERS, 1851.
Printed from a calotype negative.

Collection of the Société Française de Photographie, Paris.

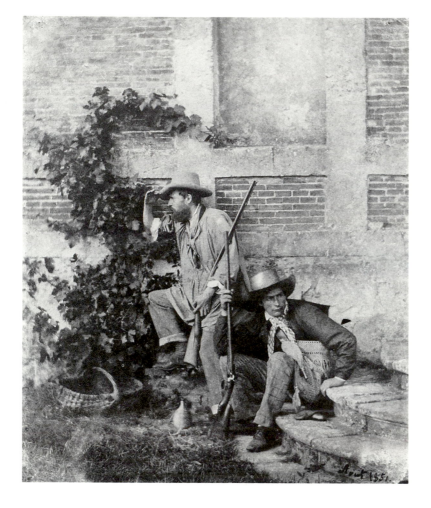

consequences that this implied in terms of profit, education and 'democracy'.

Divergences within the field of photography

The year 1855 was also marked by another event: the creation of the Société Française de Photographie (SFP). The first aim of this 'purely artistic and scientific association', which came into being on 15 November 1854, was to strengthen French photography following the disappearance of the short-lived Société Héliographique. It set itself up with a bulletin and a headquarters and secured the support of a number of eminent personages (five of its founders were members of the Institut de France). But a number of pointers suggest that the Société Française de Photographie was also the result of a number of internal divergences within the field of photography. Former members of the Société Héliographique and Ernest Lacan, the current director of *La Lumière*, made no attempt to hide them. Lacan described the new society as no more than a discussion

'club' and claimed that the important thing was 'above all to serve the interests of photographers by facilitating the sale of their works'.[17] It is true that the *Bulletin de la société française de photographie* had just, somewhat treacherously, accused 'the collections currently devoted to photography' of sacrificing 'the pure love of photographic art and science to private speculation'.[18]

The interest of this polemic lies in the fact that, within the field of photography itself, it uncovered the existence of a tension between 'private speculation' on the one hand and the 'pure love of art' on the other, a tension which affected the Société Française de Photographie itself to the point of orienting its activities. From the outset, it sought not only to develop the artistic potentialities of the photographic process but simultaneously 'by every means at its command, to encourage, protect and patronise the industries connected with the practice of the art of photography'.[19] This ambivalence of the SFP was given synthetic expression by two of its undertakings: in 1855, it organised its first exhibition, located on its own premises and also in the Palais de l'Industrie; in 1856, it launched the Duc de Luynes's competition.

The Duc de Luynes was an archaeologist and member of the Institut de France who in 1856 made 10 000 francs available to the SFP to enable it to organise a twofold competition. The 'minor competition', offering a prize of 2000 francs, aimed to stimulate research to resolve the problem of the instability of prints produced from silver salts and thereby to endow the processing of the positive with a reliability that it frequently lacked at the time. The closing date, originally set for July 1858, was extended to July 1861 and eventually, in March 1862, Alphonse Poitevin was awarded the prize for his method of producing prints in which he replaced silver halides by the inert substance of carbon. This method certainly provided a solution to the problem of the evanescence of the prints, but not to that of cost or that of multiple reproduction, for carbon printing was a lengthy and difficult process. Numerous attempts to simplify it were to meet with no success and the desired goal, namely to supplant processes dependent upon silver salts, was never reached. The Duc de Luynes's 'major competition', announced at the same time as the minor one, should be considered in the context of the current created by the Great Exhibition: it offered a prize of 8000 francs to encourage attempts, already initiated, to improve heliographic engraving. Victor Regnault, the chairman of the SFP and a member of the Institut de France, announced that this competition would 'hasten the desired moment when the methods of the printing works or of lithography will make it possible to reproduce the marvels of photography without any human hand intervening in its design'. He added, 'Enthusiasm is bound to be stimulated by the great importance of the goal to be reached and the industrial benefits which may stem from it.'[20] There were indeed many candidates, from France (Nègre, Poitevin, Placet among others), from Britain (including Fox Talbot, Pretsch, Woodbury and Schwan) and from Austria (Quaglio), and rivalry between them ran high, not only right up to the closing date, set originally for July 1859, then extended to April 1864, but even up to the prize's allocation, in April 1867. Again it went to Alphonse Poitevin.

The same 'desire to work for the progress of photography'[21] provided the inspiration for the exhibition held from 1 August to 15 November 1855, at the headquarters of the SFP in the Rue Drouot in Paris. It paid homage to the

pioneers of photography by presenting two collections, one of prints, the other of cameras, accessories, optical devices and chemical products. The exhibition reflected the preoccupations of the SFP: to establish an archaeology of the photographical process, the better to measure the progress achieved; to encourage attempts aimed at reducing technical constraints; to make known the latest materials, products and skills; and, equally importantly, to defend the artistic status of photography, as indeed Eugène Durieu did in his report on the exhibition.[22]

The technique of the calotype

This exhibition, put on only a few months after the foundation of the Société Française de Photographie, was probably prompted partly by a desire to make the most of the impetus created by the Great Exhibition, but also by the wish to present photography in a different light from that proposed by the Palais de l'Industrie, and to set art above 'utility'. The emphasis was laid upon prints from calotypes, most of them produced by wealthy amateurs or former artists: Gustave Le Gray, Vicomte Joseph Vigier, Fortuné Joseph Petiot-Groffier, Maxwell Lyte and Stéphane Geoffroy in the domain of landscapes and, in that of 'genre' photographs, Charles Nègre, Louis Adolphe Humbert de Molard and Julien Vallou de Villeneuve.

This exhibition provides us with an opportunity to correct two widespread misconceptions concerning the use of the calotype. The first is that 'the age of the calotype' can be isolated and slipped neatly in between those of the daguerreotype and collodion; the second tends to establish a relation of equivalence between the calotype and art photography. Unfortunately, these ideas are not borne out by the facts. In the first place, although the 'calotype' method was indeed introduced by Blanquart-Evrard at a time when the daguerreotype reigned supreme and before the introduction of collodion, it certainly did not constitute a transition between the daguerreotype and photography on collodion-treated glass. The paper negative, which was easily transportable (being light and unbreakable) and the texture of which tended to soften outlines, answered two often interconnected ends: one, the needs of travel or landscape photography, the other the quest for 'artistic' effects through the use of chiaroscuro and the 'fogginess' that was peculiar to calotypes. Such practices, generally the preserve of wealthy amateurs, certainly fell outside the commercial logic of the studio portrait; nevertheless, one should not suggest too close a connection between the calotype and 'art', as is attested by the case of Gustave Le Gray, a determined practitioner of 'photographic art', who worked with both collodion and the calotype but who, above all, used dry glazed paper, seeking to obtain 'just as much precision'[23] as with negatives on glass. In contrast to authors such as Francis Wey, who hailed the calotype above all for its capacity 'to disregard detail in the manner of a skilful master', Gustave Le Gray suggested no contradiction between art and the precision that is such a feature of collodion-treated glass. He thus invalidates all attempts to assimilate the calotype to art on the basis of its supposed capacity to conform perfectly with the 'theory of sacrifices'.[24]

These conclusions are largely confirmed by British photography. Even before Fox Talbot had completed *The Pencil of Nature* (1844–6), the Welshman Calvert Richard Jones and, above all, the Scotsmen David Octavius Hill and Robert Adamson were producing calotypes with consummate skill. By the early 1850s, Roger Fenton was using the paper negative in Russia (1852); and throughout the decade Benjamin Bracknell Turner used it for his landscapes and architectural studies, as did the painter William John Newton for his views of trees. After 1854, the Scottish surgeon Thomas Keith, following Hill and Adamson, was for his part using glazed paper to photograph Edinburgh and the

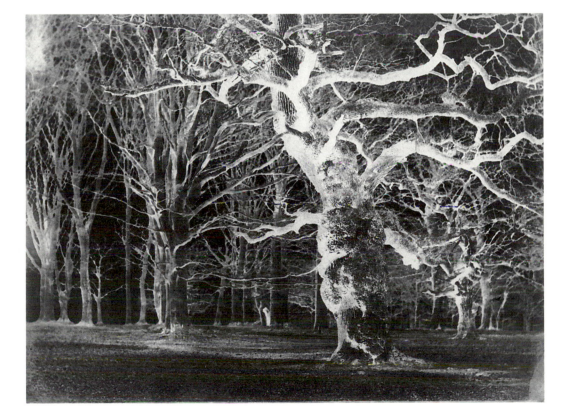

GEORGE SHAW (1818–1904)
FOREST OF OAKS IN WINTER, about 1852.
Printed from a calotype negative.

Shaw, from Birmingham, is a representative of the first generation of educated amateurs who, like Victor Regnault in France, took to photography in the early 1850s, using the calotype. His landscapes, which are strongly influenced by English painting, were exhibited in London in 1852 and 1853.

Collection of the Musée d'Orsay, Paris.

surrounding countryside, while in 1852 George Shaw of Birmingham was already exhibiting in London. At the same time, the British photographers appear to have established no antinomy between artistic photography and the use of collodion, as is confirmed by the Great Exhibition of 1855, in which the landscapes of Roger Fenton, John Llewellyn and Henry White elicited such admiration from the jury that it even spoke of 'an English school which, through its use of collodion, produces quite extraordinary effects of transparency, perspective and light'.[25] In other words, although the calotype may often have been associated with artistic experiments, there was nothing systematic about that connection, for the calotype was also frequently used for documentary purposes; nor was it an exclusive association since collodion was also extensively used in art photography. What really happened was that the calotype, which could not possibly rival the collodion print when it came to speed and precision, became the basis of an alternative method for those who reacted against photographic notions of 'utility' and 'profitability' (speed, precision, multiple reproductions) and regarded it as a means of engaging in photography without betraying their own system of values. On these grounds, they felt justified in granting it a monopoly in the field of art photography.

Technical coexistence

The truth is that photography was practised in two quite different ways during the 1850s. One method, chiefly employed for the studio portrait, aimed at speed in execution, a clear image and a large output. This was above all the domain first of the daguerreotype, then of photography using wet collodion. The second method was employed for a limited production, chiefly for outdoor work, and *sometimes*, for convenience's sake or on particular aesthetic grounds, it might resort to the use of the calotype. Thus, a single operator would, in many cases, use either the one process or the other, depending upon the circumstances. While wet collodion may have taken over directly from the daguerreotype in the studio, for outdoor photography a number of alternative processes were available, depending upon what kind of image was desired. From 1850 onwards, many photographers of monuments such as Henri Le Secq and Charles Marville, and archaeologists such as the Englishman Roger Fenton in Russia (1852) and Thomas Sutton in Italy (1853), made use of the calotype because it was lighter, robust and cheap; but to obtain more delicate prints they adopted the Le Gray method, using glazed paper. This involved filling in the pores of the paper negative with wax to obtain a finer grain, that is to say making its texture and transparency more like those of glass. In 1851, when photogravure was being so strongly promoted, Edouard Baldus obtained similar results by applying iodised gelatin to paper negatives. To obtain clarity in his architectural pictures, Hippolyte Bayard employed glass treated with albumen, at the same time preferring to use the paper negative for his still-life studies. The paper negative was thus used when documentary accuracy was less sought after than a particular artistic effect or texture. The calotype method was the one favoured by amateurs such as Victor Regnault, Edouard Loydreau, Baron Louis-Adolphe Humbert de Molard, Paul Jeuffrain, Louis-Rémy Robert, and others, as it also was by professionals such as Charles Nègre and William

John Newton who, being painters as well as photographers, entertained the hope of combining commercial activity with photography which aimed to be artistic.

The advantages of dry glazed paper over glass were considerable (it was both lighter and less fragile), as they were over the calotype (increased precision of detail). But, above all, in contrast to the wet processes (Blanquart-Evrard's calotype method and that of collodion on glass), the advantage of dry glazed paper was that it did not need to be prepared and developed at the very same time as the picture was taken, and thus relieved the photographer from having to carry an elaborate field-laboratory about with him. Unfortunately, dry glazed paper, which requires a lengthy exposure, could not satisfy all the figurative demands of the period, with the result that, following the example of Roger Fenton in the Crimea in 1855, during the later 1850s even photographers as attached to the calotype as Gustave Le Gray and Charles Nègre were forced to resort to the use of wet collodion to produce their 'reportage' of, respectively, the camp at Châlons in 1857 and the imperial convalescent home at Vincennes in 1858.

While the inconvenience of having to treat wet collodion at the actual moment of taking a picture was a very real one during outdoor work, in the studio it was much diminished. For that reason, the glass plate treated with wet collodion was, by virtue of its relative speed and delicacy of texture, still widely favoured among the portrait studios of Europe in 1855.

The portrait studios

In the United States, however, the daguerreotype, which also called for a laboratory close at hand, was so well established that it did not give way to collodion until the second half of the 1850s. Official statistics indicate a total of 938 daguerreotypists for the country as a whole; but a closer estimate would be 2000, at least 71 of whom worked in New York. As for production, according to the *Daily Tribune* of New York, this exceeded three million daguerreotypes per year. Studios such as Mathew Brady's, which opened on Broadway amid great publicity in June 1853, were incredibly luxurious, catering for a clientele of industrialists, doctors, lawyers, merchants and politicians, all prepared to pay either $2.50 for a sixth-plate portrait or else $4.50 for a quarter-plate. Meanwhile, by standardising the operations of studio and laboratory, Edward Anthony, for example, was able to cut the price of his daguerreotype portraits to 25 cents and thereby to extend the social range and increase the number of his clients. If we are to believe John Werge,[26] in Anthony's studio the client was often obliged to wait in line for his turn to pose. The camera operator received his metal plates ready sensitised and, as soon as they had been exposed, passed them on directly to the developing room: his own role was thus limited to taking the picture, the preparation, developing, fixing and mounting of the daguerreotype being delegated to other employees. A few minutes later it was possible for the model to leave, taking his portrait with him.

Unreliable though they may be, John Werge's accounts confirm the fact that, unlike in Europe, on the east coast of the United States the portrait constituted a flourishing business well before the mid-1850s and was still the virtually exclusive preserve of the daguerreotype. The American scene also

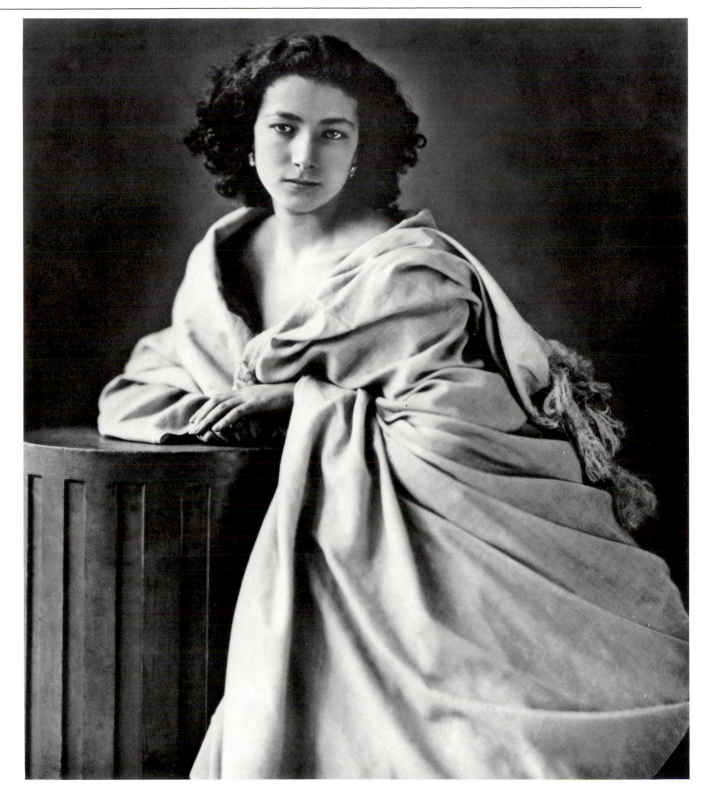

presented other peculiarities: the progressive abandonment of the daguerreotype for portraiture did not immediately result in the adoption of the wet collodion method of photography. Instead, in the United States more than anywhere else, another process – that of the ambrotype – enjoyed a veritable vogue in 1856 and 1857. The ambrotype was a picture produced from a negative on collodion-treated glass which, when slightly underexposed and placed against a dark background (a piece of black velvet, for example), gave a positive image. It thus presented features in common with both collodion photography and the daguerreotype since, as

NADAR (FÉLIX TOURNACHON)
SARAH BERNHARDT, 1855.
Printed from a collodion negative.

In contrast to many other portraitists of the nineteenth century, Nadar (1820–1910) rejected accessories and painted backcloths. He used a plain, dark background against which the model alone — his or her gaze, appearance, attitude, hands — holds the attention of the spectator.

Collection of the Caisse Nationale des Monuments Historiques et des Sites, Paris.
Félix Nadar © Archives Photographiques, Paris/SPADEM.

in the latter, no printing was required, only developing, and only one picture could be produced, often sold in a frame of embossed cardboard. Its two principal advantages were that the glass plates used were much less expensive than the copper ones necessary for daguerreotypes and that it dispensed with the printing that was necessary for photographs on paper. Ambrotype photography was thus an economical process but a hybrid one and, in the United States at least, it was a transitory practice. In France it provoked little reaction, despite the facts that Leborgne used it for a small plate in 1853[27] and Henri de La Blanchère mentioned it in *La Lumière* in 1856, referring to it as the 'amphitype'.[28] Nevertheless, Disdéri produced a few examples for the Great Exhibition of 1855 and, according to the jury's report, 'frequently' used this method.

This Disdéri may have done in the course of his earliest attempts to fulfil his cherished ambition of reducing the price of his photographic portraits and extending his clientele. The advantage of collodion over the daguerreotype was that it could produce on paper prints that could be multiplied for the same cost even in a larger format. All the same, the portraits' price and the clientele did not significantly alter with the adoption of this new process. Nadar, who set up his business at 113 Rue Saint-Lazare at the end of 1853, initially catered for a clientele of writers, composers, journalists, actors and intellectuals drawn from among his own friends – Daumier, Nerval, Philippon, Berlioz, Rossini, Sarah Bernhardt, Doré, etc. – and for a bourgeoisie which could afford as much as 100 francs for a portrait. Nadar, who was himself a journalist, sketch artist and caricaturist, sought to combine business with his artistic aspirations and on that account refused to resort to retouching, a practice that was extremely common at the time among photographers with more commercial preoccupations. In contrast, Louis and Ernest Mayer, who set up their joint company of Mayer Frères in 1850, specialised in the tinted portrait. Although they incurred criticism from the 'austere priests of photographic virginity',[29] they enjoyed considerable success among a clientele rich enough to afford the services of an artist–retoucher over and above the cost of the photographic print. In May 1853, Mayer Frères produced a portrait of the Emperor. This had the double advantage of procuring them a clientele drawn from court circles and from amongst the dignitaries of the Empire and also of allowing them to style themselves 'Photographers to the Emperor' and exploit a kind of tacit imperial backing. Eventually, in January 1855, the Mayer brothers, who, as well as their Parisian studio, controlled branches in Lyons, Brussels and London, entered into partnership with the photographer Louis Pierson and proceeded to open one of the foremost studios of the Second Empire, at 5 Boulevard des Capucines, in Paris.

There were apprec ublican convictions but who, faced with the competition of the carte-de-visite, was nevertheless obliged to compromise on his aropen one of the foremost studios of the Second Empire, at 5 Boulevard des Capucines, in Paris.

There were apprecions, the latter was always at pains to establish his dissociation from the regime while, as a professional photographer, he tried to avoid an over-commercial attitude. Meanwhile, half-way through 1854 André-Adolphe Disdéri set up in business in Paris. He was soon at the head of a flourishing enterprise and was to play a decisive role in the evolution of photography. In contrast to many photographers of the period, who had received a thorough artistic training, Disdéri embarked upon a commercial career after no more than a brief course of drawing lessons.

Disdéri's studio was situated at 8 Boulevard des Italiens, at the heart of the Parisian life of the Second Empire, where businessmen, theatre people, intellectuals, women from the *demi-monde* and idlers all rubbed shoulders. According to *La Lumière*, 'the studios which Monsieur Disdéri has just opened are the largest in Paris so far. . . . His premises occupy two floors. The first comprises shops, framing workshop and reception hall. Above, there are two spacious levels for slides, an elegant salon for the ladies and separate laboratories for handling the plates, the collodion and the printing of positive images.'[30] In November 1854 Disdéri organised an exhibition of his own work on these large premises, as a publicity stunt. The exhibition included both daguerreotype portraits and portraits on paper as well as 'a few positive prints on glass', that is to say ambrotypes, which were less expensive than the pictures produced by the other two processes. His determination to put cheaper products on the market is borne out by the fact that, in that same month of November 1854, he took out a patent on the famous 'carte-de-visite'. Eventually, in December 1854, Disdéri turned his business into a joint-stock company – Disdéri & Co. – and, having obtained permission to photograph every article on display at the Great Exhibition, he set up the Société du Palais de l'Industrie, which by 1855 was employing as many as 77 people. Disdéri recognised the advanta of the financial circumstances in which the carte-de-visite became so fashionable. In 1862, the price of a single non-tinted ages of producing cheap portraits and demonstrated a keen business sense in his skilful exploitation of the dynamic provided by the Great Exhibition.

In contrast to many of his fellow professionals, who called themselves 'Photographer–Painter' or 'Photographer–Artist', he styled himself 'Photographer for the Palais de l'Industrie et des Beaux-Arts, and member of the Société d'Encouragement'. His primarily commercial motives led him both to abandon his republican convictions and draw closer to the Empire and also to extend his clientele to include the lower strata of the bourgeoisie. His attitude stands in strong contrast to those of a number of other Parisian portraitists of the period: Gustave Le Gray, who clung to the past and the mythology of the artist but was forced out of business in 1860; the Mayer brothers, who had become supporters of Louis-Napoleon Bonaparte as early as 1850 and were soon 'Photographers to the Emperor', anxious to recruit their clientele from 'the elite of the aristocracy and the well-to-do';[31] and, finally, Nadar, who remained faithful to his republican convictions but who, faced with the competition of the carte-de-visite, was nevertheless obliged to compromise on his artistic intentions.

The carte-de-visite

The craze for the carte-de-visite began in France in 1858 and soon spread to most professional studios all over the world. Ludwig Angerer of Vienna wasted no time in introducing it in Austria, while in Britain, 'Portraits of the Queen were selling in hundreds of thousands [and] after the death of Prince Albert, the house of Marion & Co, in Regent Street, sold 70 000 picture cards of the Prince.'[32] In the United States, it was not until 1860 that Charles D. Friedricks and George G.

Rockwood began to produce such cards in New York. In a collection of records published in 1861, Disdéri recalls the patent that he took out seven years earlier: 'The chosen format [for portraits] was, by reason of its costliness, not accessible to the public masses. It was this obstacle to the progress of photography, constituted by the costs inherent in the production of large prints, that led us to reduce the portrait to the dimensions of a carte-de-visite. Nobody [in 1861] can be unaware of the success of this application, which has become so popular that such portraits are to be found in everybody's hands.'[33]

The cartes-de-visite were produced by means of a camera with four (or six) lenses. With a fixed slide, the operator was able to include on a single plate four to six identical snapshots; when a mobile slide was used all the pictures could be different. The essential economy stemmed not so much from the quantity of products used for each print as from the reduction in the lengthy and costly operations involved in printing it. Now, the same operations previously necessary to produce a single print resulted in as many as four (or six) cartes-de-visite, which were admittedly smaller (about 6 by 9 cm) but also cheaper and more numerous. Once printed, the pictures were divided up and each snapshot glued onto a piece of stiff card. Displayed on the back of the card, often in elaborate lettering, would be the name and address of the studio, the photographer's charges and, in some cases, some information about his work.

Pierre Petit's 'general charges', in Paris, give some idea of the financial circumstances in which the carte-de-visite became so fashionable. In 1862, the price of a single non-tinted portrait ranged from 25 to 150 francs, depending on size, whereas cartes-de-visite cost 15 francs a dozen or 70 francs for a hundred. A comparison of these prices with a worker's daily wage (3.58 francs in the building trade, 2.50 francs in the mines of northern France and 1.82 francs in agriculture) nevertheless suggests that the so-called 'democratic' nature of the carte-de-visite calls for some qualification, for they were clearly limited to the various categories of the bourgeoisie which now began to use photography as a means of making a good impression or even, among the lower strata, as a symbolic if illusory way of demonstrating the upward social mobility of their members. Their aspirations would be expressed sometimes through equestrian photographs, which were now becoming popular, and above all through the ritual of the photograph album into which would be slipped a few portraits of famous personages to give (to the album's owners, as much as to anyone else) the illusion of intimacy with these celebrities. For the advent of the carte-de-visite was accompanied by a new phenomenon: 'portraits were no longer purchased only by their subjects and their acquaintances'; they now fulfilled more than a purely private function and became a form of mediation between the 'masses' and the 'well known'.[34] The vogue of the carte-de-visite should thus be understood in the context of the changes

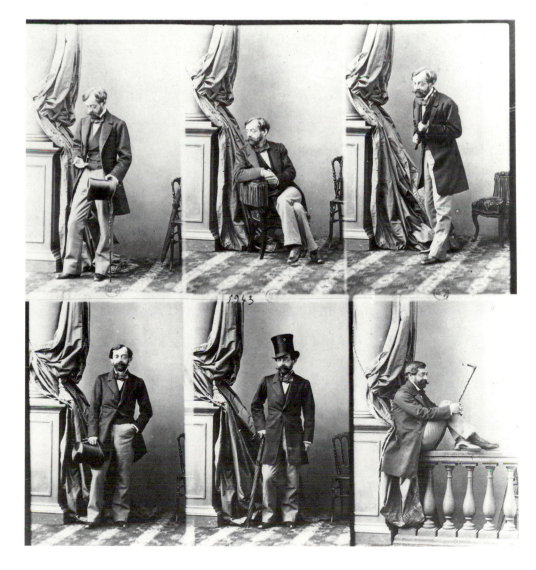

ANDRÉ-ADOLPHE DISDÉRI
CABANÈS, 1858.
Printed from a collodion negative.

It was prints of this type, cut out and pasted on cardboard, that were used for the cartes-de-visite. This plate, which has remained intact, shows the changes of pose, costume and points of view used by the photographer and also his model's active co-operation in the production of the portrait.

Collection of the Bibliothèque Nationale, Paris.

OLYMPE AGUADO
SELF-PORTRAIT IN HIS OWN STUDIO IN PARIS, about 1855.
Printed from a collodion negative.

This print by Count Aguado (1827–94) shows clearly how the early
portrait studios were organised and functioned: their use of scenery,
the reverential treatment of the subject and the manner in which they
could heighten the dignity and impressiveness of the model.

Collection of the Bibliothèque Nationale, Paris.

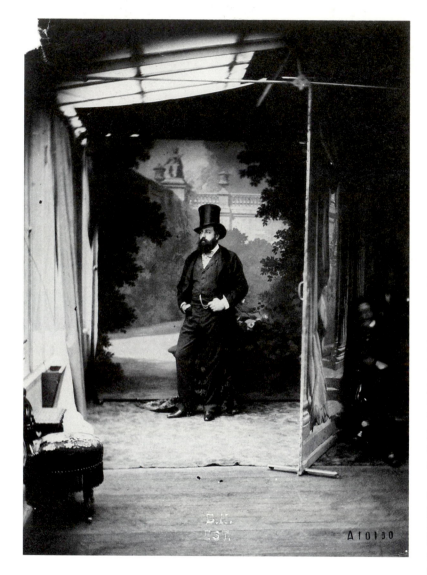

brought about by the industrial revolution in the West,
around the mid-nineteenth century. A movement of ascend-
ant social mobility was widening the pyramid of the
bourgeois hierarchy from its base upwards, and producing
new sections of the population who were eager to display
tangible signs of their new circumstances and inch up a few
more rungs of the social ladder and who possessed the
relatively modest financial means to satisfy their yearning for
visible representations. These lower strata of the bourgeoisie,
'the public masses' as Disdéri called them, constituted an
important clientele and it was for them that the carte-de-visite
initially catered. Subsequently, its format, price and avail-
ability in dozens, or hundreds, in other words its ability to
make its subject (and its studio of origin) known as it
circulated and exchanged hands, won it a new clientele: this
was composed of celebrities in the worlds of politics, the arts,
the press, the clergy and the army and it also included those of

the world of the theatre and the *demi-monde* and – a fact of
crucial political importance – heads of state such as the
Emperor Napoleon III, Queen Victoria and President Lincoln,
who all regularly posed for photographers and promoted the
sale of their portraits 'in hundreds of thousands'. The success
of the cartes-de-visite also stemmed from reasons that were
peculiar to photography, still regarded with suspicion by
'industrialists' on account of the supposedly perishable nature
of photographic prints. That fact forced photographers now
won over to the economic logic of marketability to 'con-
centrate their efforts upon the production of portraits . . . for
the public does not generally attach great importance to the
indefinite durability of these images, since it can replace them
again and again, following the fashion of the day, and
reproduce them at low cost.'[35]

In the studios, designed to make 'the most respectable
people feel at home',[36] the bourgeois portrait followed the
rules of a veritable ritual, in the course of which the portraitist
strove to give his model 'an imposing air' and simultaneously
to portray him as an individual, that is to say to capture not
only his 'physical' but also his 'moral' likeness, in line with the
principles of physiognomy, much revered at the time. To this
end, the photographer could make use of a number of signs
relating to the bourgeois world (the stout physique and mode
of dress of the model, various accessories, and so on). In taking
his photograph, he would combine these with a whole
panoply of other significant elements (the pose, the angle, the
framing, the lighting, the depth of field, and so on). However,
he would be operating not so much as his own fancy took him
but rather in conformity with a popularised pattern of
aesthetics, the principles of which stemmed from Van Dyck,
Rubens, Rembrandt and Titian and are immediately de-
tectable in most of these photographic works. The dictates of
profitability which governed the production of these portrait-
cards undermined the photographers' declared intentions to
work on their clients' particular characteristics so as to
produce symbolic representations of their personalities, for
now those personalities could be apprehended only through a
standard formalisation of their common bourgeois status.

The same commercial imperatives flung open the studio
doors to the *demi-monde*, and to actors and actresses whose
portraits enjoyed an undeniable success in this, the heyday of
boulevard theatre. Here too a reversal took place: whereas the
bourgeois portrait was so often severe, straightlaced, stiff,
austere and chaste, actors would often adopt extravagant
poses, dressing up and poking fun at the studio accessories.
As for the actresses, they would frequently lay bare their
charms or at least allow them to be hinted at and would adopt
provocative poses. And, for a few francs, women from the
lower classes, laundry-workers and washerwomen, would be
prepared to pose naked or in 'titillating' positions, for cards
which would be sold 'under the counter'. In short, on every
side, the norms of bourgeois photography were transgressed
and shown up for what they were.

A 'revolution in the business'

By the end of the 1850s, in France and throughout Europe, a
little later in the United States, there were more cartes-de-
visite being produced than any other type of portrait.
Throughout the 1860s, even before the introduction of the
album card (which was slightly larger), the success of the

ROGER FENTON
FRUIT AND FLOWERS, 1862.

This stereoscopic still life, which appeared
in *The Stereoscopic Magazine*, was one of the
last photographic works by Fenton
(1819–69) who abandoned photography in
1862, having been one of the foremost
photographers in Great Britain since the
middle of the century.

Gernsheim Collection, Harry Ransom Humanities
Research Center, University of Texas, Austin.

carte-de-visite was giving business a significant boost. The
statistics tell the story. In the 1850s, the number of Parisian
photographic firms increased fourfold (from forty-eight to
207) and the number of people employed by them increased
twelvefold; between 1860 and 1870 these figures were, in
their turn, multiplied by two-and-a-half times in the case of
studios and by three times in the case of employees. There are
other indications too: by 1860, the number of Parisian
photographic businesses had multiplied almost twenty times
since 1848.[37] At the height of the carte-de-visite's popularity
nearly three hundred studios were in operation in London, at
least thirty-five of them located in Regent Street. As for the
United States, there the number of photographers more than
trebled between 1850 and 1860 and in the course of the next
decade more than doubled again.

The situation was such that by 1862 Mayer and Pierson
could write: 'Photography today is a great industry.'[38] In
1863, in New York, where Anthony & Co. were producing
3600 cards featuring celebrities per day, *Humphrey's Journal*
was, for its part, talking of a revolution in the photographic
business.[39]

The success of the carte-de-visite portraits at the turn of the
1860s marked the beginning of a new phase in photographic
activity. Actually, the first major surge in the photographic
business took off, in Britain in particular, as early as 1857–8,

with the vogue for stereoscopic cards. These, produced by
juxtaposing two views taken simultaneously but from slightly
different angles, made it possible to simulate relief, using a
binocular viewer or stereoscope. In Paris, in 1857, they
retailed at 15 francs a dozen and were sold as series
representing little plays, often of a humorous or risqué nature,
landscapes, travel views or street scenes. Studios were
converted or even newly created in response to the growing
demand for such views, destined for use in the drawing rooms
of the day. Between 1858 and 1865, Lovell Reeve, in London,
produced *The Stereoscopic Magazine*, each issue of which
contained three cards by Ernest Edwards, Roger Fenton or
Robert Howlett. He also published a book entitled *The
Conway in the Stereoscope* (1860), illustrated by twenty views
taken by Roger Fenton. Photographs of landscapes, travel
scenes and monuments thus acquired a market outlet as
stereoscopic cards rather than as large prints such as those
produced earlier by the Bisson brothers, Gustave Le Gray and
Edouard Baldus in France, and by Francis Frith and Roger
Fenton in Great Britain. Photographers such as these were
now forced either to adapt to the market as Frith did, or to go
out of business like Le Gray. Portraitists had to face up to a
similar situation with the advent of the carte-de-visite, a
challenge which led many of them to reorganise their method
of work fundamentally.

ADOLPHE-EUGÈNE DISDÉRI
A SECOND EMPIRE PORTRAIT STUDIO,
about 1865.
Printed from a collodion negative.

This print shows how a large Parisian
studio was organised. The area, marked out
on the floor by the perimeter of the carpet,
with all its accessories, truly resembled a
stage complete with its own equipment and
personnel: glass roofing and windows with
adjustable curtains, for the lighting, several
cameras, a camera operator and an artist to
retouch the picture. The studio shown here
comprises two areas for posing: one in the
background of the picture, the other to the
left, with a seated model who is reflected in
the mirror. The whole place is dominated
by the Emperor's coat of arms displayed in
a prominent position from the ceiling of the
glasshouse.

Trustees of the Science Museum, London.

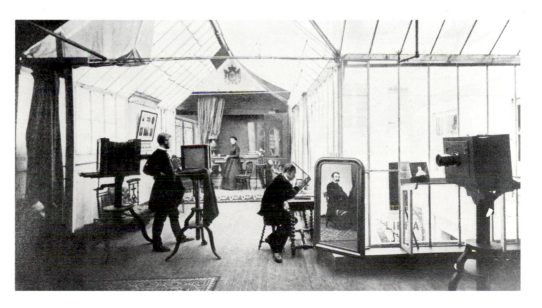

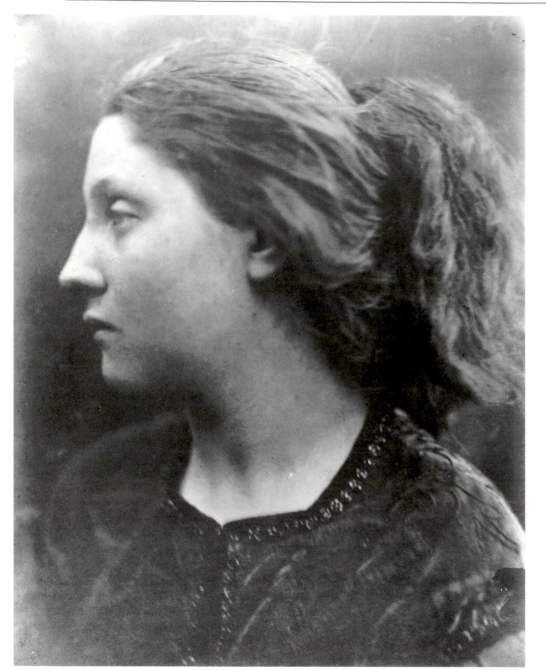

JULIA MARGARET CAMERON
ADRIANA, about 1864.
Printed from a collodion negative.

Left profile of Mary Ann Hillier, aged
thirty-seven, Cameron's maidservant and her
favourite model. Lewis Carroll's comments
on the photographs of Margaret Cameron
(1815–79) were not very enthusiastic; in
June 1864, he noted in his diary: 'Visit to
the photographic exhibition; very thin and
mediocre; I did not at all like the large
blurred portraits by Mrs Cameron.'
However, in October he changed his tune:
'I visited Mrs Cameron, who asked me to
take her my photographs this evening; she
showed me hers, some of which are
certainly very beautiful.'

Collection Musée d'Orsay, Paris.

In every country, the field of photography was trans-
formed. Most photographers deeply committed to their
artistic principles simply gave up. Others, such as Henry
Peach Robinson in England, and Nadar in France, attempted
to combine the career of a commercial portraitist with other,
more aesthetic preoccupations. William Mayland in London
and Cambridge, Alexander Gardner in Washington, the
Alinari brothers in Florence and Samuel Bourne in India used
the profit that they made from portrait-cards to finance
photography of their own choice: topography, war rep-
ortage, or landscape photography. Finally, the carte-de-visite
dealt a death blow to the daguerreotype, forcing its best
practitioners to convert to other methods: John Edwin Mayall
in London, Mathew Brady in New York and Alexander Hesler
in Chicago. Above all, the carte-de-visite opened up the way
for a large category of photographers concerned first and
foremost to make a profit. This included, in London, Cundall,
Downes & Co. and Luigi Caldesi & Co.; in New York, E. and
H.T. Anthony & Co. and Mathew Brady, of course, but also
Charles D. Friedricks & Co., who ran another branch in Paris,
and Jeremiah Gurney & Son; in Boston, Southworth &
Hawes; in Berlin, Breslain; and in Cologne, L. Haase & Co.; in
Munich, Joseph Albert and in Vienna, Rabending: these were
but a few of the large concerns which at this time shared the
world photographic market with the great houses of Paris.
The changeover which took place during the early 1860s is
symbolically marked by the transformation of the Disdéri
studios and above all by Nadar's move to the Boulevard des
Capucines. He was now seeking to extend his existing
clientele of intellectuals and artists to take in the Parisian
bourgeoisie as a whole, and that meant accepting the cut and
thrust of competition and commercialisation. The Nadar of
the Boulevard des Capucines sold cartes-de-visite most of
which he did not handle himself. The famous red 'N' of his
signature, which appeared the length of his studio's facade,
now became the trade mark of a factory which employed at
least thirty-six workers. Mayer and Pierson meanwhile
claimed to be employing a workforce at least sixty strong.[40]

LEWIS CARROLL (Charles Lutwidge
Dodgson)
KATIE BRINE (niece of Dr Pusey, Master
of Christ Church), 1866.
Printed from a collodion negative.

Lewis Carroll (1832–98) noted in his diary,
on Friday 15 June 1866: 'Mrs Brine brought
me her little girl, Katie, six years old, to
have her photograph taken.'

Gernsheim Collection.
Harry Ramson Humanities Research Center,
University of Texas, Austin.

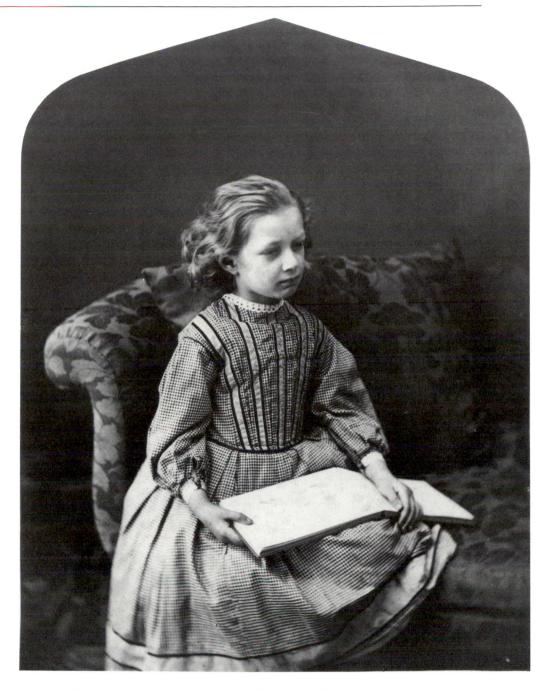

Of course, not all studios were so large, nor could they all boast an organisation with 'a select staff (and) perfectly rational division of labour',[41] but competition between them was fierce. It forced photographic studios to produce more and work quickly, and this resulted in a noticeable fall in the quality of images which, in its turn, led to severe criticism. Nadar's case provides a good example of the contradictory situation of the 'photographers – artists in many cases – who were at the same time the heads of businesses'[42] and who, if they were not to go under, found themselves obliged to accept the logic of competition and to sacrifice quality to quantity.

The success of the photograph 'industry' thus tended to be won at the expense of 'art' and, as business developed, the demands of 'trade' and 'art' became increasingly difficult to reconcile. Whereas previously many photographers had attempted to combine the two, after 1860 'art photography' became largely the province of amateurs. The English portraitists Julia Margaret Cameron and Lewis Carroll are two

famous examples: for them, photography was a means of artistic expression, not a source of income. With complete financial independence, they were in a position to choose their own models and enjoyed an absolute freedom quite unknown among professional photographers. While the latter were more or less obliged by their clients to produce pictures with clear and precise outlines, Julia Margaret Cameron, for one, even at the risk of bitter controversy showed no hesitation at presenting in the many international exhibitions of the time (London in 1864, Edinburgh, Berlin and Dublin in 1865, Paris in 1867, Vienna in 1868) portraits of less than total precision, often with pronounced contrasts of light and shadow. Artistic values were all the more important to her, given that her models were also her friends and she seldom sold her photographs. The same went for Lewis Carroll, an Oxford lecturer in mathematics and author of *Alice in Wonderland*, who took a passionate interest in photography from 1856 to 1880. Although he, in contrast to Julia Margaret Cameron, paid particular attention to the technical aspects of his work,

his pictures, like hers, express an intimate — or even, in his case, sentimental — relationship with the models, most of whom were little girls.

Is photography an art?

The coexistence of practices with, in many cases, contradictory demands, poses the question of the status of photography and in particular that of its relationship to art. The period 1850–70 saw the earliest developments in a debate which pervades the entire history of photography but the terms of which, varying from one situation to another, cannot be understood outside their own particular context. France, the major arena for the debate,[43] provides us with the best illustration for this period.

The question of the status of photochemical images was not really posed until the 1850s, that is to say not until photography supplanted daguerreotype. But for the next twenty years it oscillated between the two extreme poles of art and industry, invariably setting in specific opposition the partisans and adversaries of the two camps.

The argument over photography's artistic position flared up around the mid-nineteenth century over the question of whether a chemical–mechanical image obtained through remote physical contact with its subject could legitimately be considered as a work of art. Some regarded that physical connection between the photographic image and its subject as an essential element in the specific nature of 'photographic art'. On the other hand, the adversaries of photography regarded it as totally incompatible with art. It was on the basis of that necessary contiguity between the image and its subject that they proceeded (not always openly) to justify their denial of any role to the photographer as an individual, their denial (or refusal to recognise) that 'photographic work' was real work, and their denunciation of the hegemony of the photographic process and consequent conclusion that its products were of a purely automatic nature. In the eyes of these critics, the photographic image was irremediably flawed since it was not produced directly by the artist (by his hand, mind and imagination), but instead resulted from a process that produced images upon matter simply through the intermediaries of light, physics and chemistry.

This debate on the status of photographic images was confused, or sometimes overlapped, with the question of the proper use of the specific properties of the process, namely its uncontested 'exactitude' and the reproducibility of the prints. At this point, it was the question of the use to which the process should be put that gave rise to disagreement: some of the most determined opponents of 'photography as art' found themselves on the same side as those members of photographic circles who were most alerted to the economic and social possibilities of the process. Many of the pronouncements made on the subject of photography at this time thus reflect two interconnected arguments, one relating to the status of photographic images — that is to say their relation to art — and the other concerned with the use to which the photographic process should be put in industry. It is worth noting that many different areas of life (journalism, society as a whole, etc.) were affected by both debates, as indeed were private individuals, and that divergent views on the two were frequently adopted.

In 1851, the subtitle of La Lumière ('Review of photogra-phy: fine arts — heliography — sciences, non-political magazine published every Saturday') was already underlining photography's twofold links with the fine arts on the one hand and with science on the other. In the columns of the paper, opinions that were both ambivalent and divergent were expressed: for example, Blanquart-Evrard tried to set the production of prints on an industrial and profitable footing yet at the same time repeatedly insisted upon the artistic status of photographic images.[44] A similar but reversed duality is reflected in the pronouncements and practice of Gustave Le Gray, who published one of the period's foremost treatises on photographic techniques[45] and rationalised the organisation of his 'studios', in the hope of satisfying his clientele of 'publishers', yet who meantime refused to consider photography from a commercial point of view and 'expressed the wish that, instead of falling into the domain of industry and commerce, it should enter that of art [for] that is its only true place.'[46] As for Francis Wey, while he gave photography a sympathetic welcome, he remained reserved on the subject of its status; he assigned it the — in his view — salutary 'mission' of purifying the fine arts, but at the same time insisted that its position was only marginal to them.[47]

1855, the year of the Great Exhibition and also of the foundation of the Société Française de la Photographie, marked a new phase in the conflict, with the photographic exhibitions mounted by both. First, the SFP, with its bulletin, its prestigious backers, its businesslike organisation and the exhibition it held immediately, played an important role in reinforcing the pro-photography camp. It adopted the middle-of-the-road position of 'a pure love of the art and science of photography', which allowed it to encourage a wide spectrum of opinions while at the same time opposing the kind of 'private speculation' that it considered La Lumière to represent.[48] The Great Exhibition then left its mark upon the conflict: by extending a welcome to photography it provided it with an audience of unprecedented dimensions; on the other hand, by denying it access to the Palais des Beaux-Arts it specifically relegated it to the side of industry. While the SFP exhibition tended to favour the artistic potentialities of the photographic process, that of the Palais de l'Industrie definitely favoured 'utility' as opposed to 'curiosity': industry as opposed to art. In 1855, the Great Exhibition jury in effect took the side of Ernest Lacan and Disdéri and proposed adapting the photographic process to cater for quasi-Saint-Simonian social ends:

1. it should serve the figurative needs of science, art and industry;
2. it should popularise, to the profit of all and sundry, what had hitherto been the monopoly of a small élite[49] — works of art, for example — and thus become 'par excellence, a democratic tool';
3. it should provide instruction and education for 'the masses, so as to elevate and improve them';[50]
4. in the interests of progress, it should strive for 'a moral effect' upon the 'working class': this would prove 'both morally and materially useful to employers and workers alike';[51]
5. finally, the photographic process should be able to guarantee substantial 'profits', provided that sales were large and prices low. At this point so much emphasis was being laid upon the supposed (and over-estimated) capacities of the process-as-a-tool, as opposed to its specific

achievements, that, along with Ernest Lacan, the Great Exhibition jury were prepared to replace photography – which they regarded as a 'transitory process' – by heliographic engraving, to which, in Ernest Lacan's view, the future belonged.[52]

The encouragement given to photography in 1855 provoked virulent attacks from its opponents, in particular from engravers, whose part Henri Delaborde took in April 1856[53] without however eliciting a particularly determined response from the partisans of photography. Neither the Great Exhibition jury nor Ernest Lacan nor Disdéri really tackled the question of the artistic status of photography. Paul Périer did give the subject pride of place, but always with painting as his absolute point of reference: if photographic images were to be recognised as art, he considered that they should conform with painting to the point of imitating it. As for the SFP, it again manifested its dual inclinations. In 1856, it organised the Duc de Luynes's competition, with its specifically industrial aims (to produce photographic prints, using printers' ink); then, in 1857, it entered into negotiations to win acceptance for photography in the Salon des Beaux-Arts.

In 1859, following protracted and difficult bargaining with the Ministry, the SFP obtained permission to hold its exhibition at the same time as the Salon des Beaux-Arts and in the same building, although in a separate area. This tricky compromise conferred upon photography a semi-recognition of its artistic status. In Louis Figuier's words, 'it accurately established the mutual situations of the two parties in litigation,'[54] namely photography and the fine arts. It was a perfect illustration of the fact that the status enjoyed by photographic images, a status which itself conditioned the manner in which they were exhibited, stemmed not simply from their inherent quality but also in part from the clout which the photography camp (in which the SFP, alongside the specialist magazines, the studios, the amateurs and the critics, was certainly an important element) wielded in opposition to the fine arts camp.

By the early 1860s, the surge of the industrial movement (meaning, so far as photography was concerned, not only the level of activity taking place in this domain but also the type of preoccupations absorbing it) further affected the terms of the debate. The major studios, which had always ignored the question of art in photography, suddenly took it up, with essentially commercial ends in view. In 1862, Disdéri, who had never so much as approached the matter in his previous publications, produced a book entitled, precisely, *L'Art de la photographie*. In it, he set out a careful argument aimed at 'improving the reputation of photography in the eyes of the public' and attracting 'the enlightened sections of the public', in other words, winning back a clientele by now alienated by the increasingly poor quality of pictures. Meanwhile, in 1862, Mayer and Pierson timed their book, *La Photographie considérée comme art et comme industrie*, to coincide with the lawsuit they were bringing for 'unfair competition' by fakers of several of their portraits of famous men: they hoped, by establishing the artistic nature of their prints, to benefit from the 1793 law on the exclusive ownership of works of art and thereby to foil their competitors. The opponents of photography were also changing their methods: in May 1862, a group of artists, assisted by Alfred Cadart, founded the Société des Aquafortistes to defend their own interests in the face of photography's incursions into the domain of artistic repro-

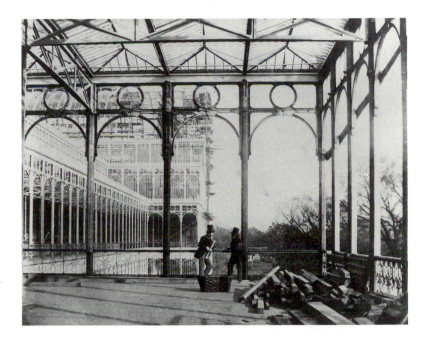

PHILIP HENRY DELAMOTTE
THE OPEN COLONNADE, GARDEN FRONT OF THE CRYSTAL PALACE, 1853.

Greater London Record Office and History Library

ductions, and in November, Ingres, Flandrin, Henriquel-Dupont and other well-known artists of the day all signed a petition against the assimilation of photography to art.

In the light of these various aspects of the debate concerning the status of photography, the views expressed by Léon de Laborde in 1851 assume a particular importance. In his view, there were no skills (painting, literature and sculpture included) that were artistic in themselves or whose products automatically belonged to the domain of art, nor of course were there any practices or products that could automatically be excluded from that domain. The dividing line did not make a vertical separation between some *practices* that were artistic and others that were not, but rather regrouped *products* of various origins in accordance with the sole criterion of quality. 'Below a certain level of excellence', he declared (without specifying what that level was), 'everything – be it art, science or literature – is industry.'[55] The fact is that the status of photography and its products was neither absolute nor definite but, at any point in time, resulted from the relationships between various types of competing images and, in particular, from the specific and fluid situation of photography within the wider sphere of representation in general or even that of society as a whole.

Photography and industry

Although at the time photography was largely dominated by the portrait, it included a number of other types of practice. In some, the nature of the print appeared to be, a priori, of less importance than the subject represented; the quality of the images produced mattered less than the figurative powers of the process seen as an instrument, which could come to the aid of science, art or industry, or even the power of the state.

CHARLES MARVILLE (1816–1879)
LAMPPOST, PONT DES SAINTS-PÈRES, PARIS, undated.
Printed from a collodion negative.

Marville produced many photographs in connection with Haussmann's renovation programme in Paris.

Collection of the Société Française de Photographie, Paris.

The partisans of 'utility' wished to see photography used far more widely than simply by a circle of private individuals. They wanted it to be put to the use of industrial development. A number of photographers, although not many, were quick to seize the opportunity. On the occasion of the 1851 Great Exhibition in London, Hugh Owen and G. Ferrier produced over 150 photographs with 115 copies of each, to illustrate some of the jury's reports on the products of industry. In 1853, Philip H. Delamotte recorded the various stages in the reconstruction of the Crystal Palace at Sydenham, in 160 snapshots: it was the first ever photographic documentation of the construction of an edifice. However, the albums of photographs that Disdéri produced for the Great Exhibition of 1855 were not as successful as he had hoped, probably partly because industrialists did not yet fully grasp the advantages to be gained from the use of photographs and also, certainly, because they were wary of the evanescence of photographic prints and feared to invest large sums of money in an ephemeral product. The orders that were forthcoming for his work thus came principally from the state or from the directors of a few very large concerns. In 1855, Baron James de Rothschild, who owned the Compagnie du Chemin de Fer du Nord, commissioned from Edouard Baldus twenty-five

copies of fifty photographs of the Paris–Boulogne section of line used by Queen Victoria when she visited the Great Exhibition. Still in France, 1857 saw the beginning of a regular collaboration between Collard and the Administration des Ponts et Chaussées: between 1857 and 1868 he turned out at least eight albums covering the construction of various bridges, styling himself 'Photographer by Appointment to the Ponts et Chaussées'. Many other photographers were also now employed by the public works up and down the country: the Bisson brothers, Blaise, Duclos and See, among others. In Britain, photography was allotting heavy industry a place of unprecedented importance. In 1857, Robert Howlett produced a series of views of the London shipyard where the *Great Eastern* was being constructed and in Newport, Gething produced photographs of the ironworks that showed the men at their work there. In 1862, a number of photographs were taken of the machinery (trains, boilers) used in the construction of the future site of London's Great Exhibition. Above all, in 1863 Patrick Barry published a book entitled *Dockyard Economy and Naval Power*, in London. It was illustrated by thirty-one anonymous photographs, some of which showed not only the top-hatted engineers but also — and this was relatively unusual at the time — the men themselves, at work on their machines. When the construction of the Paris Opéra was undertaken in 1864, Charles Garnier employed photographers on the great building site, for the first time in France: quite apart from their purely documentary function, the two hundred snapshots taken by Delmaët and Durandelle, like those of the *Great Eastern* and also Patrick Barry's book, are extremely revealing regarding the hierarchy that obtained on the building site. In these pictures social relations may have

AUGUSTE BERTSCH
PHOTOMICROGRAPH OF A FLEA, 1853.
Printed from a collodion negative.

This photomicrograph by Bertsch (d. 1871) was obtained by means of a combination of a solar microscope and a photographic camera, following the experiments carried out by Léon Foucault who was producing images obtained with a 'microscope-daguerreotype' as early as 1844.

Collection of the Société Française de Photographie, Paris.

ADOLPHE BRAUN
WREATH OF FLOWERS, 1856.
Printed from a collodion negative.

In 1855, the jury of the Great Exhibition
noted that Braun (1811–77) 'has had the
idea of using photography to reproduce
bouquets and wreaths of flowers which
may be used as subjects by fabric
manufacturers . . ., these plates belong
to a series of 300 prints intended for the
use of industrialists.'

Collection of the Musée d'Orsay, Paris.

been recorded unwittingly, simply as a result of the documentary power of the photographic process. In Collard's work, in contrast, they are reflected quite deliberately through the telling positioning of individuals at the time of the snapshot. Collard, who worked on the composition of his pictures to enhance their documentary value as well as to turn them into social metaphors, radically undermined the illusion that photographic images were transparent, clearly demonstrating how the very composition of a picture can convey a meaning. Up until 1870, only heavy industry, public works, large-scale architecture and departments of town planning (here Marville's work in Paris provides a good example) were making use of photography, while small-scale industry paid it scant attention. In this latter domain, photography was not fulfilling its earlier ambitions, although here and there, in a few isolated instances, it was successful in infiltrating certain processes such as cloth manufacture, which in 1855 used Adolphe Braun's series of flower studies as decorative motifs.

Photography and the sciences

As François Arago had predicted in 1839, and as was to be expected in a scientific milieu in the throes of upheaval, photography was used, with varying degrees of success, for a number of scientific purposes. Middle Eastern archaeology was incontestably one of its most dazzling successes, thanks to its exceptional figurative capacities and the current vogue for exoticism.[56]

Microscopic photography, also promoted by François Arago, appeared as early as 1839 in France. Later, in 1853,

thanks to a combined use of the solar microscope, the camera obscura and collodion, Auguste Bertsch, like the Rev. Towler Kingsley in England, obtained photomicroscopic snapshots of insects, followed in 1857 by pictures of crystals taken using polarised light. During the same period, John B. Dancer in London, followed by Prudent Dagron in Paris, was engaged in reducing prints to dimensions which allowed them to be inserted into rings or brooches. What thus began simply as a commercial gimmick acquired a much more important use in 1870, during the siege of Paris, when Dagron used his shrinking process to set up a pigeon post service between Paris and Tours. The messages to be transmitted were arranged in groups, photographed, then reduced on to 6 × 6 cm film and delivered by homing pigeons. When it reached its destination the film, which could carry three to four thousand messages, was enlarged and deciphered.

Microphotography became the subject of many research projects between the 1850s and the 1870s: Delves, Highly and Wenham worked on it in Britain, as did Mayer in Frankfurt, Albert in Munich, Helwig in Mainz, and Dean, Draper and Dr Brevet in the United States.

Astronomy also turned to photography. In 1852 Warren de la Rue, in London, became the first person to obtain photographs of the moon; he was followed by other English astronomers – J. Phillips in 1853, William Crookes and John B. Reader in 1854 – and by Lewis M. Rutherford in the United States in 1865. Eclipses of the sun were also photographed regularly. The eclipse of 14 March 1858 was recorded by Porro and Quinet in Paris, while in London Antoine Claudet used his photographometer in his attempts to measure

variations in the intensity of light rays.

1858 was also the year when Nadar produced the first photograph to be taken from a tethered balloon. In 1861, King and Black performed the same feat in Boston and by the following year the Union army was making use of balloon photography (and of telegraphy) to spy on the enemy at the siege of Richmond. Finally, in 1868, Nadar was successful in taking a picture of the Arc de Triomphe in Paris from a height of 200 metres. Meanwhile, in May 1861, Colonel Aimé Laussedat produced the first map based on aerial photography and thereby extended photography's domain of application still further to take in topography, used in the first instance by the army.[57] Aimé Civiale, a polytechnic graduate, for his part placed photography at the service of physical geography and geology. He spent two months in the mountains every year from 1859 to 1869, amassing a total of six hundred views and forty-one panoramas, to be used in studying the relative positions of different mountain ranges.

In the realm of natural history, Louis Rousseau and Achille Devéria in 1853 brought out a work illustrated with plates, entitled *Photographie zoologique*, which was produced in instalments. It contained pictures – from the collodion prints of the Bisson brothers – of the rarest animals to be found in the collection of the Paris Natural History Museum. For fear lest the silver salts prints should deteriorate, Louis Rousseau pressed the system of heliographic engraving into use. It was a method (devised by Niepce de Saint-Victor), which was as yet little used. In London, in 1855, the Comte de Montizon was photographing live animals in the Regent's Park zoo. Also in England, yet another field of application emerged for photography in the early years of the decade when Dr Hugh W. Diamond, the director of a 'mental hospital', took collodion portraits of his patients at the beginning of their treatment and throughout it, in the hope of 'thereby recording the successive phases of disease and the progress of the cure'.[58]

Meanwhile, between 1852 and 1856, Dr Duchenne from Boulogne, with the assistance of Adrian Tournachon (Nadar's brother), was producing photographs to illustrate his research into 'the mechanism of human physiognomy',[59] which he studied by sending electric impulses through the facial muscles. The print that he used for the book's frontispiece showed both his instruments and the subject of his experiments: 'a toothless old man whose physiognomy perfectly reflected his inoffensive character and his rather limited intelligence'. The composition of this print, like Duchenne's words, placed upon the same level and thus assimilated his instruments and his patient. So in this case scientific photography went beyond its strictly documentary brief to the point of suggesting relationships probably hitherto unimagined.

These examples of the many applications of photography to the sciences between 1850 and 1870 show that there existed within the scientific community a desire to make the most of the resources of this new tool and also that photographers were keen to satisfy such demands. They also testify to the interest that science was arousing during the second half of the nineteenth century. Finally, they demonstrate the existence, not so much of solid links between photography and the sciences, but rather of the committed but as yet fragile and irregular beginnings of what was to turn into a long collaboration, although it was not really to make its mark until the end of the century.

Photography and the arts

Very early on, art emerged as a sector in which photography had a role to play. While many questioned its claims to produce works of art, there were few who denied it the right to be used as an instrument in the service of art. Blanquart-Evrard, whose earliest publication, in 1851, was entitled, significantly enough, *Album photographique de l'artiste et de l'amateur*, sought to enter into competition with engraving and find photography a commercial outlet for its reproductions of works of art and artist's models. He suggested, as suitable, photographs of monuments, sculptures, bas-reliefs, famous archaeological sites, archaeological curiosities, landscapes, engravings and paintings, despite the technical problems presented by such studies by reason of the uneven sensitivity of colour emulsions. Between 1850 and 1870, photographic reproductions of works of art enjoyed a great success. For example, Gustave Le Gray photographed the Paris Salon of 1852, while Philip H. Delamotte covered the Manchester Exhibition of 1857.[60] Many photographers were reproducing works of art in large quantities: Thurlston Thompson and Luigi Calderi in Great Britain, Fierlants in Belgium, Bingham and Michelez in France, the Alinari brothers in Florence and Dovizielli in Rome. The photographs were themselves frequently exhibited. In 1861, almost half the participants in the exhibition of the Société Française de Photographie showed reproductions of works of art. By September 1863, the British Museum had acquired both a photographic studio and photographic material, placed in the care of Roger Fenton who for this activity alone in 1858 employed at least four laboratory printers.[61] Finally, many books illustrated by card-mounted photographs appeared. One such was the work by Benjamin Delessert published simultaneously by Goupil in Paris and Colnaghi in London, in 1853, and entitled *Notice sur la vie de Marc Antoine Raimondi, graveur bolonais, accompagné de reproductions photographiques de quelques-unes de ses estampes*. At the Great Exhibition of 1855, Benjamin Delessert noted the respective prices of engravings and their reproductions. In the words of Ernest Lacan, 'This comparison shows that by means of photography one can, for the price of 2 francs, obtain the facsimile of a plate which may have cost as much as 1000 or 2000 francs! The consequential importance of this for artists is easy to see: it places within their grasp riches that were hitherto buried inside the boxes of collectors lucky enough to possess a fortune. To the advantage of all and sundry, it popularises these admirable plates produced by the Bolognese master, over which the few used to hold a monopoly; for the photographic print costing 2 francs presents artists with everything they would have looked for in the original costing 2000 francs.'[62] The question of the photographic reproduction of works of art here passed well beyond the bounds of the debate surrounding artistic utility. For Ernest Lacan, it provided an opportunity to sketch in the outlines of a social project close to the aspirations of the Saint-Simonians. In practice, though, the attitude of artists towards photography does not appear to have been affected by such ideals. They regarded it first and foremost as an economical means of study, work and promotion. The formal similarities between a number of Julien Vallou de Villeneuve's photographic nudes and those portrayed on some of Gustave Courbet's canvasses show that the latter paid a certain attention to photography. Also famous are the nude studies produced in collaboration by Eugène Durieu and Eugène

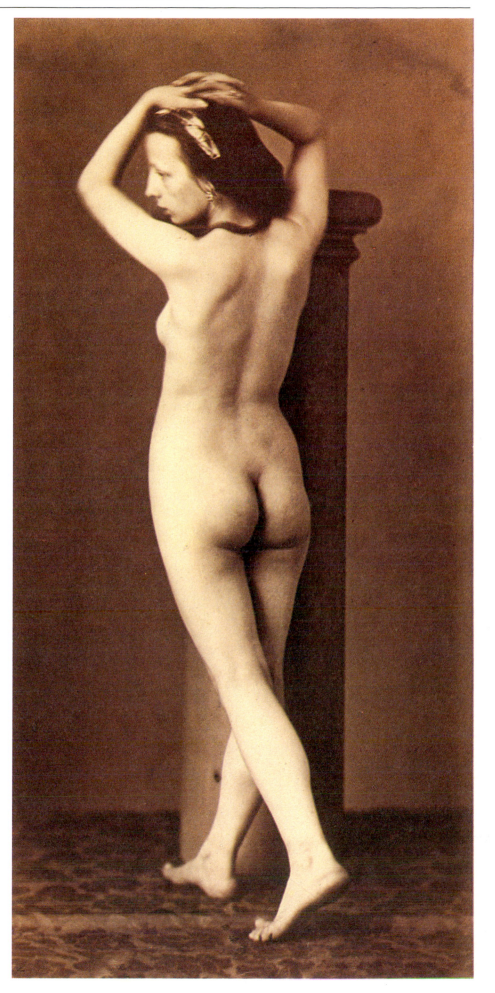

HENRY VOLAND
STUDY FROM NATURE, 1861.
Printed from a collodion negative.

This print is one of a series which Henry
Voland produced for painters. From 1859,
the major outlet for his prints was Alfred
Cadart, a seller of engravings and publisher
and, in 1862, the founder of the Société des
Aquafortistes.

Collection of the Bibliothèque Nationale, Paris.

Delacroix. Professionals such as B. Braquehais, Louis-Camille d'Olivier and even Marconi ('Photographer to the Ecole des Beaux-Arts') set up many academies for artists. Finally, traditional painters such as William Bouguereau used photography to make their own work known or even to assure themselves of an income from the sale of reproductions of their paintings: an analysis of his accounts reveals that sales were at their highest in December, which would suggest that such photographs were bought as presents for the festive season.[63] Alongside portraiture, the reproduction of works of art represented one of the most flourishing sides of the photographic profession of this period. Just as they produced portraits, most studios produced such reproductions which, in particular, gave an added boost to the trade in carte-de-visites.

Photography and the state

Finally, it was between 1850 and 1870 that photography established its earliest links with the power of the state. They were certainly promoted in part by overtures made by the many photographers convinced that the corridors of power could be favourable to business; but they were also encouraged by those in power who had some intuition of the political potentialities of the process. Thus, Emperor Napoleon III, Queen Victoria and President Lincoln all cooperated with photographer-portraitists and some rulers – Queen Victoria and Prince Albert in particular – even showed a special interest in photography. In January 1854, the Queen noted in her diary how pleased she had been with her visit to the exhibition of the Photographic Society. Meanwhile, at about this time Prince Albert was installing a photographic laboratory at Windsor and between April and June Roger Fenton produced forty-five portraits at Buckingham Palace. The Queen would pose either on her own or with the Prince, sometimes adopting attitudes quite unaffected by protocol. This was a phenomenon also noticeable where Napoleon III and, later on, Lincoln were concerned and it certainly represented something of a novelty in the representations of heads of state. Photography seems to have persuaded them, probably for the very first time, to accept that their image should convey something of their more intimate lives, over and above the figurative norms associated with their rank. Queen Victoria thus rests her arm tenderly upon Prince Albert's shoulders, while with the young Prince Imperial Napoleon III appears in the guise of a father far more than in that of an emperor; and in May 1861 in Washington, Mathew Brady took a picture of Lincoln which depicts not so much a president in charge of a great country but rather an ordinary man deep in thought.

The new trend in images of heads of state stemmed both from the hitherto undreamed of figurative possibilities introduced by the photographic process and also from the change in status undergone by such persons in the wake of the rapid development of an industrial and bourgeois society. Portraits of famous figures from the domains of politics, the army, the church and art (the house of Mayer and Pierson records taking over 80 000 of them) were diffused as a multitude of carte-de-visites, sold as 'contemporary portrait galleries' or to be collected in private albums: Queen Victoria could herself boast 110 in her own collection. However, the clumsiness of reproduction techniques and the imperfection of

photomechanical processes meant that it was impossible to make the multiple images of the foremost pillars of the state available to a really wide audience or even for them to reach the lower echelons of the bourgeois hierarchy (although this period did witness the beginnings of such a movement, which was to enjoy great success after the turn of the century). The period 1850–70 thus saw the first, rather special but very real links set up between photography and the state. The latter was, for its part, as the archives confirm, often doing no more than respond to the pressing solicitations coming from the photographers. Some official commissions may appear to be of an essentially technical order, but in reality they incorporated a political aspect: in particular, Edouard Baldus was hired by the Ministry of the Interior between 1855 and 1858 to photograph the rebuilding of the Louvre, 'stone by stone'. Copies of the resulting albums of photographs were sent to various European heads of state and presented to members of the court, to heads of official bodies and to the Emperor's ministers, who obviously used the photographs to foster his image as a renovator.[64]

Meanwhile, other governmental commissions had a more directly propagandist purpose. In 1854 an English publisher hired Roger Fenton to travel to the Crimea under the auspices of Her Majesty's War Office. His mission was to return with photographs of a kind to calm the fears that were being

MAYER Bros. & PIERSON
THE PRINCE IMPERIAL AND NAPOLEON III, about 1859.
Printed from a collodion negative.

The Prince Imperial, who was born in 1856, is here about three years old. He poses for Mayer & Pierson who were very much accepted in court circles.

Collection of the Musée d'Unterlinden, Archives Départementales du Haut-Rhin, 6 Fi/Ch. Kempf.

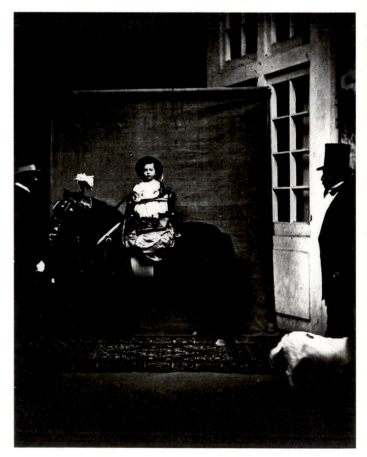

voiced in London regarding the situation of the British troops. His reportage, made up of over three hundred pictures, was made available to a wide public in Great Britain, in a series of exhibitions. It presented an idyllic and totally corpse-free view of this taxing and casualty-ridden war. Rulers were also trying to use photography to record images of the most important events of their reigns, although they were often foiled by the technical shortcomings of the process which at this period was often quite incapable of producing the instantaneous images required. Philip H. Delamotte's snap-shot of Queen Victoria and Napoleon III seated side by side at the inauguration of the Crystal Palace at Sydenham may be considered as a technical exception, testifying to considerable determination. But even if it could not always record events, photography was in demand as a means of reproducing the most prestigious national achievements, above all the most politically significant of them. Fine examples are provided by the photographs taken of the four Great Exhibitions held in London and Paris, as are the albums of photographs depicting the army camp at Chalons commissioned from Gustave Le Gray and those devoted to the Imperial Rest Home at Vincennes, which were commissioned from Charles Nègre in 1859, to be distributed to convalescent workers. One picture shows the workers lined up as a guard of honour to pay their respects to the Emperor's bust. But stereoscopic cards probably constituted the most efficient means adopted by this nascent type of photographic propaganda: these were sold as series and relatively cheaply, and produced an illusion of three-dimensional relief. They reached a wider audience than the albums but were still restricted to such bourgeois as could afford at least a stereoscope. The series produced by Furne and Tournier, depicting 'the Imperial château at Saint-Cloud', consisted of views of the 'private park' and private apartments and was designed to admit the public into the intimate life of the Emperor. Another series, entitled 'Souvenirs of Cherbourg, August 1858', showed views of the military port but concentrated mainly upon the town in festive mood, with all the triumphal arches which had been set up in honour of the imperial couple's visit.

Finally, photography was early on seen to be a possible means of controlling deviant sections of society. In 1855, Ernest Lacan pointed out the advantages of using photography in prisons, to take each prisoner's portrait with a view to checking escapes and recidivism. 'This system is already employed in certain institutions in England,' he observed.[65] However, up until 1870 photography used as a control in this fashion appears to have remained mainly at the level of an idea. The decisive turning point in this respect occurred during the Paris Commune, when the supporters of the Commune would often pose proudly and defiantly at the foot of the Vendôme column or on their barricades. When the Versailles repression clamped down, these snapshots of the barricades were used to identify the insurgents. The Paris *préfecture* acquired sixty albums of photographs, with written descriptions attached, which were then used to help in hunting down communards who had been sentenced in their absence. Meanwhile, Eugène Appert took individual photographs of some of those detained in the Versailles prisons: the format of these pictures and the very nature of Appert's undertaking prefigured the future gallery of photographs of the *préfecture* of the Paris police force and the system of identification to be introduced by Alphonse Bertillon.

Despite all these efforts, during the period 1850 to 1870

HIPPOLYTE AUGUSTE COLLARD
BARRICADE IN THE PLACE DE LA CONCORDE IN 1871.
Printed from a collodion negative.

Collard produced several albums of photographs for the Ponts-et-Chaussées Department. He was an enthusiastic photographer of urban rebuilding in Paris, but here he records it being undermined.

the keystone of the photographic profession remained the portrait. It was both profitable and compatible with the technical limitations which still affected the photographic process. This was a period when the many demands made upon photography exceeded its natural capacities. Its response to those demands took many individual forms, some of them truly inspired, and looked forward to some of the future uses to which photography would be put. 1850 to 1870 represents a decisive period in the history of photography, for it was then that a number of essential questions, such as that of the status of its images, were for the first time explicitly posed and thrashed out both in writing and in practice: the problem of producing copies by means of printer's ink, that is to say of moving on from simply reproducing prints to reproducing them in large numbers, was to some extent resolved in the late 1860s, although the method was not to be put into practice until the turn of the century; meanwhile, the dream of involving photography in the vast domain of 'utility', which for the moment was seldom fulfilled and remained largely a matter of wishful thinking, was to be realised in the course of the next few decades, which saw a new leap forward in the development of industrial society as a whole and photographic techniques in particular. In short, above all in Europe and North America, the period 1850 to 1870 was when photography truly became established within a field determined in each country involved by a number of variable elements: the level of development reached by photographic techniques, the clientele available and the photographic institutions and journals that existed; also the particular relations that obtained within the community of photographers, the degree of artistic or scientific legitimacy granted to the process and the ways in which it was put to social use; and, in general, the nature of the demands made upon it and the research undertaken in the area.

4

Exploring the world by photography in the nineteenth century

JOHN THOMSON
A PAGODA ON AN ISLAND IN THE ESTUARY OF THE MIN
RIVER, about 1870.

Stephen White Collection, Los Angeles.

The daguerreotype entered history in 1839, at the same time as the railway and the steamboat and just before the telegraph. Business was enjoying an unprecedented boom: with the progress of speed and means of communication, world trade doubled between 1800 and 1840 and increased by 160 per cent between 1850 and 1870. In 1839, eastern travel in the romantic tradition was on the increase, fuelled by the burgeoning vogue of painting in the oriental fashion. Travellers' tales such as those told by Victor Jacquemont and Xavier Marmier abounded. Accordingly, when Daguerre's discovery was announced, François Arago was at pains to emphasise the process's unparalleled ability 'to make copies of the millions and millions of hieroglyphs'[1] covering the great monuments of Egypt and he looked forward to photography being put to the service of archaeology.

Early attempts

Arago's advice was soon taken by a number of pioneers with the encouragement of Noël-Marie Lerebours, who in 1842 published a collection of fourteen engravings entitled *Excursions daguerriennes: villes et monuments les plus remarquables du globe*. Lerebours himself took the daguerreotypes in France and Italy, but also enlisted the co-operation of Pierre-Gustave Joly, who departed for Greece in October 1839, and Frédéric Goupil-Fesqué who, by the end of the very year in which the new process had been announced, was travelling with the painter Horace Vernet in Syria and Egypt. Unfortunately, daguerreotypes could only be produced singly and to publish 'these views taken in various parts of the world', Lerebours was forced to resort to manual engraving: 'a few minutes suffice to seize the images, but considerable time is required to reproduce them on metal in all their detail', he lamented.[2] All the same, his initiative helped to encourage the resumption of a whole series of works illustrated by engravings such as *Les Voyages pittoresques et romantiques dans l'ancienne France*, by Taylor and Nodier, which came out between 1820 and 1878, and Count Alexandre Laborde's *Voyage en Orient*, which was sold in instalments between 1838 and 1860.

By the early 1840s, travellers were beginning to include a camera obscura in their luggage, together with the necessary plates of silvered metal and chemicals. Thus, Baron Jean-Baptiste Louis Gros produced daguerreotypes in Bogotá in 1842, others in Athens, where he had been appointed ambassador, and yet others in London and Paris. J.-P. Alibert, from Montauban, who was exploiting a graphite mine in Russia, produced daguerreotypes of his miners in 1845. Joseph-Philibert Girault de Pranguey, a wealthy scholar, for his part returned with close on nine hundred plates from his travels first in Italy and Greece, and then from 1841 to 1845 in Palestine, Syria and Egypt.

Photography and orientalism

However, as Ernest Lacan was later to comment, 'the application of the daguerreotype process when travelling involved a number of difficulties of execution and did not answer the great need of our age, namely popularisation. In the first place, transporting a large quantity of silvered plates on a long journey was an awkward and costly business; and,

above all, the prints that were brought back could only be produced singly.'[3] So it was not until the late 1840s, when the calotype 'made it possible to replace metal by paper', that travel photography really took off. The Reverend George Bridges, from England, was a pioneer in the field. An assistant to Fox Talbot had initiated him into the calotype technique and between 1846 and 1852 he produced more than fifteen hundred paper negatives of the Mediterranean coast, Italy and Egypt.[4] He was soon followed by Maxime Du Camp who in November 1849 set off for Egypt 'on an archaeological mission'[5] in the company of Gustave Flaubert. Du Camp later wrote as follows: 'In my earlier travels to the East, I was conscious of losing precious time as I made drawings of all the monuments and views that I wished to remember . . . and I realised that what I needed was an accurate instrument that would enable me to bring back images from which I could produce exact reconstructions.' For such purposes, photography fitted the bill perfectly but was still not easy to use since, as Du Camp noted, 'Learning photography is an easy matter, but transporting the equipment by mule, camel or human porters is a serious problem.'[6] Indeed, Gustave Le Gray's list of materials that 'were essential' for operating out in the field filled three whole pages; and in 1856, Moulin arrived in Algeria with 1100 kilograms of luggage.[7] These difficulties, compounded by the heat, dust, insects and lack of the clean water that was necessary for the photographic process, etc., all combined to turn the photographic trips of the day into veritable expeditions, often of uncertain outcome. For instance, Maxime Du Camp was not successful in his attempts to work with dry glazed paper, despite having been taught how to use it by Gustave Le Gray, and was only rescued from his predicament when Baron Alexis de Lagrange put into Cairo on his way to India and initiated him into Blanquart-Evrard's wet process. Eventually, however, in 1885, he returned to France armed with over two hundred calotypes. *La Lumière*, recently launched, published an account of his travels and Blanquart-Evrard made prints from his calotypes for his work entitled *Egypte, Nubie, Palestine et Syrie* which was published in 1852 by Gide and Baudry, illustrated by 125 photographs mounted on card. Despite its costliness (it retailed at 500 francs), the edition ran to 150 or 200[8] – twenty of which were spoken for by the government – and it was well received, no doubt partly by reason of its subject, which was in tune with the strong 'intellectual movement directed towards the East' that existed,[9] but also thanks to its novelty: it was the very first book to be illustrated by original photographs.

Louis de Cormenin, to whom Maxime Du Camp's book was dedicated, wrote an article for *La Lumière* in which he pondered upon the relations between photography and space–time and also upon the great changes currently taking place. He wrote as follows: 'It will be the glory of this society, so fecund in discoveries of every kind, and also its reward to have reduced space and time in relation to man. By a happy coincidence, photography was discovered at the very same time as the railways . . . We need no longer embark upon perilous voyages: heliography, entrusted to a few intrepid practitioners, will make the world tour on our behalf, without our ever needing to leave our armchairs.'[10] Like many of his contemporaries, Louis de Cormenin believed in the *transparency* of photographic representations which, he claimed, by forcing 'the traveller to efface himself' would foil 'fantasy' and 'cheating' and present the spectator with 'the naked truth'.

Paradoxically enough, however, he also believed that such representations possessed a *consistency* which rendered the voyage in pictures 'visible and palpable' to such a degree as to 'transport the reader himself on a voyage'. Or, to be more precise, the consistency was attributed to that very transparency which it never occurred to Louis de Cormenin to question and which he used to justify the role that he assigned to photography: that of mediating between 'the universe' and the bourgeois ensconced 'in his armchair'. The photographer was expected to withstand danger and fatigue in order to establish contact – indirect to be sure, but of hitherto unparalleled intensity and comfortable to boot – between the 'readers' of the photographic images and the wonders of an expanding world. The reactions of mingled curiosity and fear evoked in the face of 'the universe' thus revealed, together with this faith in the transparency of photographic prints, help to explain the popularity that travel photography acquired by the mid-nineteenth century.

Other photographers, responding to the vogue for the East, followed in Maxime Du Camp's footsteps. In 1852, Félix Teynard returned from Egypt with over 160 calotypes: they were reproduced in Paris by the 'photographic printing works' of H. de Fonteny and published in instalments by Goupil & Co.[11] In 1854, Blanquart-Evrard published some of the two hundred photographs on paper taken by the young English archaeologist John B. Greene, in a work entitled *Le Nil, monuments, paysages photographiques*, but it was not until 1856 that the first explicitly archaeological work appeared: Auguste Salzmann's *Jérusalem*. It was published by Gide and Baudry and consisted of a volume containing a text accompanied by 174 photographic plates and designed to support Louis-Félicien Caignart de Saulcy's theses regarding the dates of the reign of Solomon. V. G. Maunier, the wealthy French consul at Luxor, and more particularly Théodule Devéria, the Louvre's Egyptologist, who accompanied Auguste Mariette to Cairo at the end of 1858, also photographed the archaeological treasures of Egypt. The last major edition of calotypes of the East to appear was *Voyages en Orient, 1859–1860* by Louis De Clercq.

During the early 1850s, Italy and Greece were also much favoured by amateur photographers. Eugène Piot, a member of the Institut de France passionately interested in archaeology, and a wealthy collector, set out to produce a photographic record of their ancient monuments. In June 1851, he published the first issue of his *Italie monumentale*, but the remainder of the projected twenty-five instalments never appeared. In Rome, a small circle of painters were practising photography: Count Jean-François Flacheron and Prince Giron des Anglonnes, the Venetian painter Giacomo Caneva, and Eugène Constant who, for his part, operated not with the calotype but with albumenised glass. Alfred-Nicholas Normand, a French architect resident in the Villa Medici, produced his first calotype early in 1851, probably shortly before his meeting in Rome with Gustave Flaubert and Maxime Du Camp, who were on their way home from Egypt. He printed a number of negatives for Du Camp and then set off for Pompeii, Palermo, Athens and Constantinople, whence he returned with close on 130 pictures[12] strongly influenced by the traditions of architectural drawing. Paul Jeuffrain, a cloth manufacturer and former French naval officer, was also working in Pompeii and Naples in 1852, one of the (admittedly still relatively few) wealthy amateurs of the time who would set off on their travels encumbered with cameras,

FÉLIX TEYNARD
KARNAK (THEBES), PALACE, 1851.
Printed from a calotype negative.

The 160 prints taken in Egypt in 1851 and 1852 by Félix Teynard (1817–92) were published in instalments comprising five plates each, between 1853 and 1858, when they were published as a complete collection together with an introduction and text.

Collection of the Bibliothèque Nationale, Paris.

phials and chemicals.[13] Italy was certainly one of the major halts in the traditional Mediterranean tour: in 1849–50 Dr Claudius Galen Wheelhouse, who was doctor on board a yacht hired by a group of the young English nobility, photographed Portugal, Spain, Egypt, Greece and Italy. Meanwhile, John Shaw Smith, a rich Irish aristocrat, produced over three hundred calotypes in the course of a journey which, as well as France and Italy, took in the Holy Land and Egypt.

The 'Mission héliographique'

During the summer of 1851, the photographers Edouard Baldus, Henri Le Secq, Gustave Le Gray, O. Mestral and Hippolyte Bayard were travelling throughout the length and breadth of France at the request of the Commission des Monuments Historiques. The undertaking was known as the 'Mission héliographique'. Their itinerary and programme were fixed by the commission, to fit in with its own programme of architectural restoration. But, in a less immediate

fashion, this mission, which visited over a hundred and twenty sites scattered through forty-seven departments, demonstrated a determination to put on show the whole of the French architectural inheritance and to promote a new understanding of it by means of photography from which 'no detail could escape'. Ernest Lacan was again in ecstasies: 'What beauties and marvels hitherto unnoticed have been revealed by these splendid cathedral reproductions!' The success enjoyed by archaeological and architectural photography during this period may be partly explained by the relevance of these photographs both to their subjects and to time which, for its part, was regarded as an agent of devastation. Photography 'collected together' all these monuments threatened with destruction and 'rendered them immortal', noted Lacan, who went on: 'Time, revolutions and natural upheavals may destroy them down to the last stone, but henceforth they will live on in our photograph albums.'[14]

Only Hippolyte Bayard was operating with plates of albumenised glass; the rest of the photographers were using the light paper negative which was unbreakable but, to obtain delicacy of detail, Henri Le Secq and O. Mestral adopted Le Gray's dry glazed paper method while Edouard Baldus was soaking the paper negative in iodised gelatine. It is difficult to determine the total number of photographs produced: only three hundred paper negatives have survived. In the event, the Commission des Monuments Historiques dashed the hopes of the members of the recently formed Société Héliographique by failing to publish the works ordered from the photographers. Nevertheless, the mission constituted a recognition of the documentary capacities of photography and for some of the photographers involved, such as Edouard Baldus and Gustave Le Gray, it was the precursor of a whole series of official orders.

ROGER FENTON
PHOTOGRAPHIC VAN WITH MARCUS SPARLING ON THE BOX, 1855.
Printed from a collodion negative.

The photograph shows Fenton's assistant, Sparling, taken in the Crimea, before the descent towards 'the Valley of the Shadow of Death'.

Trustees of the Science Museum, London.

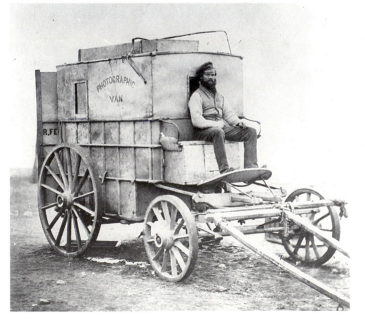

War photography

War photography started in about 1855 in the Crimea. Eugène Duriot proclaimed: 'Today, the triumph of photography will lie in pictures of lands hitherto unexplored throughout areas opened up by our victorious armies.'[15] Warfare became a subject for photography and provided photographers with an opportunity to extend the visual space of their contemporaries in a symbolic fashion. The English Roger Fenton was probably one of the most famous of the photographers operating in the Crimea. His 'reportage', which was commissioned by a publisher, for reasons of internal politics also benefited from the encouragement of the War Office and even of Prince Albert himself.[16] It was nevertheless no easy undertaking. Fenton worked on glass treated with wet collodion, which had to be prepared and developed on the spot when the picture was taken. So, before setting out, he equipped a horse-drawn waggon as a mobile laboratory. He travelled with a considerable load of equipment: five cameras, over seven hundred glass plates carried in thirty grooved boxes themselves deposited in crates designed as shock-absorbers, several boxes of chemicals, a still, basins and, carried on the roof of the waggon, two tanks, one holding distilled water, the other ordinary water. Thus equipped, he landed at Balaclava with his assistant Marcus Sparling, at the beginning of May 1855. He later described the difficulties encountered owing to the dust and heat which dried up the collodion even as the picture was being taken. He noted that exposure times varied from 'quasi-instantaneity' to twenty seconds, depending on the subject and the light, but that 'three seconds were often enough'.[17] Nevertheless, these difficult technical conditions do not account for the disparity between on the one hand the general calm conveyed by his collection of some three hundred pictures – most of them portraits or carefully arranged groups – and, on the other, the harsh realities of the war: the many casualties, whom Fenton certainly mentioned when he addressed the Photographic Society of London, and the sordid conditions of the troops which he also described in his correspondence and from which he himself suffered as a victim of cholera. Reality as perceived and experienced did not tally with its photographical representation. With a commercial commission from his publisher and a political brief (from the government and Prince Albert), Fenton made his formal choices (of subject, angle, framing and lighting) with a view to producing pictures which would satisfy his own aesthetic demands at the same time as the expectations (sometimes no more than implicit) of his customers. Better, perhaps, than his large collection of portraits or even his picture of soldiers asleep on an artillery battery, his *Valley of the Shadow of Death* shows how, in formal terms, Fenton managed to reconcile his aesthetic preoccupations with the need to evoke the war, albeit without revealing its horrific side: the cannon balls littering the path recall the fighting yet mask its real nature and its end result, namely death. To put it more precisely, the cannon balls are a metonymic representation of death, which is thus represented by, as it were, a shadow of its real self: the very title seems to express the telling economy of the picture, bestowing a mystical character upon it through its use of a biblical reference.

Roger Fenton was not the only photographer to work in the Crimea. Colonel Jean-Charles Langlois, a painter initially of battles and later of panoramas, arrived there in November

1855 and stayed for four months. Assisted by Léon-Eugène Méhédin, a young architect, he produced a panoramic photograph in the round, composed of fourteen different views and designed to provide a model for his large panoramic painting of *The Capture of Sebastopol*. He also put together several folders, each containing twenty-nine prints, entitled *Souvenirs of the Crimean War* and accompanied by a dedication 'in homage to His Majesty, Emperor Napoléon III' or to 'His Excellency, M. le Maréchal Pélissier, Commander-in-chief of the Eastern Army'. The plates, most of which bear the signatures either of Langlois or of Méhédin, or of both, are all also signed by Frédéric Martens, who appears to have been responsible for printing them. From November 1855 to March 1856, that is to say at the same time as Colonel Langlois was operating, Jean-Baptiste Durand-Brager, a naval officer, sketch artist and contributor to *L'Illustration*, aided by a photographer by the name of Lissimone, was engaged in producing a fine piece of photographic journalism consisting of at least forty-eight collodion views, subsequently printed by the 'Lemercier photographic printing works' in Paris.

James Robertson, an Englishman, together with his English-naturalised assistant, the Venetian-born Felice A. Beato, also went to the Crimea, from there passing on through Turkey, Greece and Egypt, on their way to India, to cover the 1857 Sepoy mutiny. Felice A. Beato then proceeded, on his own, to follow the Franco-British expeditionary force to China, a country which he was one of the first photographers to enter. His pictures of the surrender of the fortresses of Taku outside Peking, in contrast to the collection produced in the Crimea, show a mass of corpses, some of which he even made sure of including by having his coolies move them from one spot to another, so that they appear in a whole series of different pictures. It was thus within the framework of a typically colonial war and on the eve of the sacking of the Imperial Summer Palace in Peking by the French and British troops that, probably for the very first time, the illusion of photographic reality was used to suggest the presence of corpses. It was as if it was felt necessary to produce proof — of a spectacular kind, requiring theatrical organisation — that the Chinese actions taken against the representatives of

ROGER FENTON
THE VALLEY OF THE SHADOW OF DEATH, 1855.
Printed from a collodion negative.

France and Britain in China had been well and truly avenged.

During the following year, the Civil War broke out in the United States and, again, the photographs of the clashes between the armies of the North and the South show many corpses. For example, Timothy O'Sullivan's *A Harvest of Death*, taken at Gettysburg in July 1863 and published in *Gardner's Photographic Sketch Book of the War*, shows Southern soldiers slain on the field of battle. In his commentary to the photographs, Alexander Gardner, who was attached to the army of the North, described the Confederates as 'rebels'. He wrote as follows: 'They paid with their lives for their betrayal,' and went on to note that by depicting 'the profound horror and reality of war' the picture conveyed a 'useful

TIMOTHY O'SULLIVAN
A HARVEST OF DEATH, GETTYSBURG, July 1863.
Printed from a collodion negative.

Plate 36 in Gardner's *Photographic Sketch Book of the War*, published in 1866. The 100 copies printed included some photographs taken by Alexander Gardner but O'Sullivan was responsible for the majority.

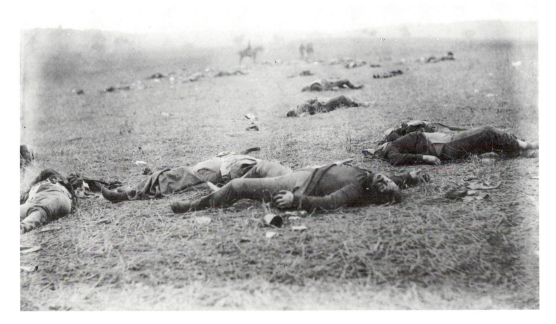

moral'.[18] A similar keen perception of the role that pho-
tography, even as it condemned warfare in general and
sometimes the enemy in particular, could play by recording
'for history' an important episode in the life of the country led
a large number of American photographers to document the
Civil War. By July 1861, Mathew Brady was at the front,
without however relinquishing control over his luxurious
studios in New York and Washington. He employed a team of
over twenty photographers to record the military operations
of the army of the North. It included Thomas C. Roche, David
Knox and, above all, Alexander Gardner and Timothy
O'Sullivan. Meanwhile, Andrew J. Russell, who was in charge
of the government's only photographic laboratory, and
George N. Barnard were employed as photographers on an
official or semi-official basis. George F. Cook and A. D. Lyte
were, for their part, working in the South where chemicals and
glass plates were delivered to them by the firm of Anthony &
Co., suppliers also to the photographers of the army of the
North. Despite the photographers' manifest efforts to make a
profit from their work by producing large numbers of
stereoscopic cards, their often dangerous operations were not
a financial success. Mathew Brady was obliged to sign over
part of his collection of negatives to Anthony & Co., his
suppliers.

F. J. MOULIN
THE EX-KHALIFAT OF CONSTANTINE, about 1856.
Printed from a collodion negative.

This print is plate 103 in Moulin's *Souvenirs d'Algérie*, the six volumes
of which contain 300 photographs taken from March 1856 onwards
'under the auspices of His Excellency, the Minister for War'.

Collection of the Service Historique de la Marine, Fort de Vincennes.

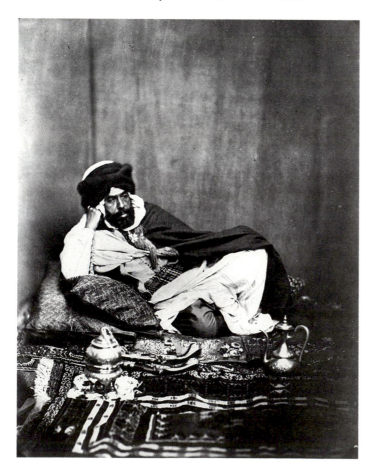

The colonial adventure

But not all photographers were so directly involved with
military operations and war. The movement of colonial
expansion had attracted a number of adventurers, some of
whom took photographic equipment along with them in their
luggage. One was the Frenchman, Désiré Charnay. Lured by
lands as yet unknown, in 1857 he set out to explore Mexico,
with the backing of the Ministry for Public Education. Upon
his return to Paris in 1861, he published *Cités et Mines
américaines*, a work accompanied by an atlas comprising forty-
seven large photographic plates showing the ancient monu-
ments of Mexico. Quite apart from the difficulties involved in
handling large glass plates treated with wet collodion, he was
sometimes – as at Uxmal – obliged to employ forty men over
a period of three days to clear the monuments' façades of
vegetation before he could take his photographs.[19] In 1863,
Désiré Charnay was photographer to the official expedition
sent to Madagascar to restore French influence there, recently
challenged by the island's new government. He reported that
'the Malgache' was perfectly prepared to recognise 'the
superiority of the white man' but, 'while accepting the yoke,
would not accept the work'.[20] The impeccable colonial
sentiments reflected in Charnay's reports also mark some of
his photographs. One such shows a European seated in a
conveyance borne on the backs of four native porters. Those
sentiments also explain his return to Mexico in 1864, with the
French troops sent to support Maximilian's rule. In Charnay's
view, the troops would guarantee a commercial outlet for
French industrial products and also speed Mexican precious
metals on their way to France.[21]

In 1856–7, it was also as a result of French colonial policies
that Moulin undertook his trip to Algeria, 'under the auspices
of His Excellency the Minister for War'.[22] But what is more
important is that those policies affected the very form of his
photographs. His portraits of French military figures and of
Algerians friendly to France are clearly distinguishable from
those depicting adversaries of the Emperor's policies. In these
Moulin deploys a kind of formal deprecatory rhetoric,
emphasising reclining postures, the absence of vertical lines,
low levels and areas that are blurred and indistinct. In other
words, the colonialist ideology is expressed in Moulin's
photographs not so much through the subject chosen, rather
through their figurative modalities and their composition.

Images of national unity

In the nineteenth century, regions as yet unexplored did not
necessarily lie abroad. Many photographs helped their
contemporaries to discover their own land. By the late 1850s,
their stereoscopic views, which could be bought at a relatively
reasonable price,[23] were playing a role of the first importance
in this domain. In France, L. Jouvain's series on Normandy and
the French 'Midi' each comprised almost five hundred cards.
In 1858, in Britain, Roger Fenton published his *Stereoscopic
Views in North Wales* and William Despard Hemphill brought
out his *Stereoscopic Illustrations of Clonmel and the Surrounding
Country*. However, it was in the United States, while the West
was being won, that the links between photography and a
movement of national unity were closest. In 1853, Colonel
John C. Fremont hired the daguerreotypist Salomon N.
Carvalho to accompany him on his expedition into the Rocky

CARLETON E. WATKINS
CATHEDRAL ROCK IN YOSEMITE
VALLEY, about 1866.
Printed from a collodion negative.

The first journey of Watkins
(1829–1916) to the Yosemite Valley
took place in 1861, when he was
obliged to take a dozen mules and a
waggon–laboratory along with him.
Watkins took many photographs of
the Yosemite Valley using glass
plates 40 × 50 cm.

Collections of the Library of Congress,
Washington.

Mountains and from 1850 onwards Charles Weed, Carleton E. Watkins and Eadweard Muybridge were all photographing the recently discovered Yosemite Valley. The Civil War then interrupted these explorations and early photographic expeditions in the West. Only with the end of the war and the great undertakings of the building of the Union Pacific and Central Pacific railroads did the movement pick up again: Andrew J. Russell, Alexander Gardner and Alfred A. Hart, all of whose training had been provided by the war, now worked for the railroad companies. From 1870 to 1878 William H. Jackson, a member of the team led by Dr Hayden, was photographing Yellowstone. 1867 found Timothy O'Sullivan already following the 'Geographical Exploration of the Fortieth Parallel'. In 1871, he began to work for the 'Engineer Corps' Geological and Geographical Surveys and Explorations West of the 100th Meridian'. Photographers were thus taking part in geographical, geological and ethnographical studies of the western areas of their country, studies that were essential if the mineral wealth was to be exploited and the Indians brought under control. Two types of picture were produced: large studies measuring roughly 40 × 50 cm, of which only a few copies would be printed, essentially for scientific use; and stereoscopic views which, in contrast, were sold in large numbers, diffusing a whole series of images of the American West throughout the United States and far beyond.

Photography records commercial, military and scientific trends

From the 1860s onwards photographs became partners in the great commercial, military and scientific movements which reached out from the West to affect the entire world. Between 1864 and 1869, the Englishman Samuel Bourne organised a series of huge photographic expeditions in the mountains of Kashmir and the Himalayas. Meanwhile, by 1868, his compatriot John Thomson was travelling in China. In 1869, Dunmore and Critcherson set out from Boston to follow an expedition to the North Pole and in 1875 the Brazilian photographer Marc Ferrez produced the first pictures ever taken of the Indians in the province of Bahia. The activities of these men prefigured the expanding photographic production triggered off by the large-scale intensification of colonialism during the 1880s and by new developments in the human sciences. All these changes were recorded in large collections of photographs such as that compiled by Roland Bonaparte who, between 1880 and 1890, collected thousands of photographs of an anthropological, geographical or geological nature, the subjects of which ranged from Lapps to Red Indians, from Hungary to Burma, from the 'indigenous types' of Australia to those of southern Africa and from 'Tonkin workers' to 'Cochinese soldiers' . . .

Between 1840 and 1890 the camera, which became increasingly light, in this way played a major role in providing images of a world in a state of great upheaval. It had moved from the artist's luggage to that of the Middle East archaeologist; it had recorded major wars and great discoveries and, from being a tool used by geographers and anthropologists, had eventually become a normal accessory for travellers of every kind. In short, photographic prints had recorded the progress of man's discovery of his own planet at a time when many rapid changes were taking place. But by reason of its specific modes of operation, the photograph also established a quite new kind of relationship with this wide world caught up in the process of change: it depicted it as no other type of image could do at the time, fostering in the minds of its spectators the reassuring illusion that they were controlling it even as they explored it.

5
Photography comes of age
(1870–1914)

In the history of photography, the 1870s represent an interlude characterised by a number of initiatives and coincidences which may be regarded as fulfilling many of the projects, aspirations and programmes of research of the preceding period.

So far as the photographic process itself went, the endeavours of the last twenty years or more to perfect dry negative plates were at last crowned with success, although at the price of breaking away from the old avenues of research. In 1871, Dr Richard Leach Maddox, an Englishman, abandoned collodion and instead began to use silver nitrate to sensitise an emulsion composed of cadmium bromide, gelatine and water, which he spread on glass and allowed to dry. By using this process, Charles Harper Bennett in 1878 obtained negatives at $\frac{1}{25}$ of a second. By 1880, wet collodion had been supplanted by the dry gelatine–bromide emulsion and exposure times of $\frac{1}{1000}$ of a second became possible.

But these important technical changes represent just one element in this period in the history of photography. All its various aspects will be tackled in the various sections of this chapter.

Anne McCauley was the first to make a study of the image of society presented by photography as a whole over the period lasting from 1870 to 1914. Hitherto, the straightlaced bourgeois posing in a studio had been the principal subject of photography. But now some important changes took place. Relatively few innovations were introduced in studio photography, where such portraits certainly continued to be taken. But meanwhile, two new social categories – the very rich and the very poor – burst upon the photographic scene.

The turn of the century was marked not only by technical changes in the photographic process (in particular the production of negatives using gelatine–bromide and the introduction of small portable cameras), but also by the emergence of a class avid for luxury and leisure amusements and by a new interest in the living and working conditions of the poorest classes. The double social trend is reflected in the photographs taken by rich amateurs as a leisure pastime and simultaneously in the photographic enquiries undertaken by social reformers, among those whom the general industrial expansion had passed by.

Thanks to the speed of the new emulsions, photography could at last be of real use in scientific experimentation. Institutions of research now equipped themselves with photographic laboratories: in the year 1882 alone, for example, not only was Marey's physiological station set up in the Parc des Princes, but also Albert Londe's laboratory at La Salpêtrière. Here photography was used to study the symptoms of hysteria, while Marey was using it to further his research into the mechanics of locomotion. In a word, it became 'the true retina of the scientist', a retina that could render the invisible visible, and, within a positivist scientific framework, it constituted knowledge stemming from the instrumentalisation of vision. But the 'positivist' use of photography existed alongside other more fictional, even magical or hallucinatory uses, as is perfectly illustrated by Georges Didi-Huberman.

The desire to diffuse large numbers of photographic images through the press had from very early on been a driving force within photographic circles; it had fuelled much research and even prompted competitions such as the international one promoted by the Duc de Luynes with the object of improving photomechanical processes. Between 1870 and 1914 practical applications were for the first time found for those processes. The goal was to pass beyond the existing limitations of photography which, to date, was reproducible but not yet infinitely multipliable and so could not, as it stood, become the 'mass medium' that the late nineteenth century societies needed.

Finally, in the last quarter of the century, two kinds of amateur photography existed side by side. The one, a product of the 1850s, stressed its artistic aspirations. Its practitioners formed societies, took part in exhibitions and, many of them having been trained as artists, struggled to get photography accepted within the domain of art. Reacting against the growing commercialism of photography, they constituted what Marc Mélon calls 'an international movement to promote the art of photography': pictorialism.

Rune Hassner draws attention to a new category of amateurs that emerged at the end of the 1880s along with the diffusion of light, portable cameras: they were interested not so much in producing artistic works but rather in recording images of their family or social life and their leisure or sporting activities. In short, these new photographers inaugurated a new and productive side to the photographic industry.

Photography during the period between 1870 and 1914 has a specific coherence of its own: it is characterised by the depiction of individuals and, by extension, society itself, by the new uses to which the process was put in the domains of science, the press and art and by its new popularity among amateurs. It was then that photography came of age.

A.R.

An image of society

During the last decades of the nineteenth century, as the new fields of anthropology, experimental medicine, psychology and sociology were institutionalised, photography assumed an even greater role in recording the diversity of human behaviour, customs and life-styles. In the realm of studio portraiture, the middle and upper classes continued to memorialise their bustles and top hats, although the fluted column and ornate papier-mâché furniture of the Second Empire and mid-Victorian period yielded to the cardboard canoes, bicycles and rustic fences considered chic by an age that re-establihed the Olympic Games. The carte-de-visite, whose small size made it a 'precious' object and

whose full-length poses celebrated material wealth, yielded to the cabinet or album print with its greater emphasis on the face. If the novelty of the visit to the photographer's studio, now graced with electric lights but also preserving its large vitrines, had disappeared in the Western world, the conquest of exotic places continued, as studios opened in Japan, Turkey, South America and elsewhere.

More innovative, however, were the photographs produced of the two extremes of the economic scale – the very rich and the very poor. Continuing the tradition of affluent amateurs such as Fox Talbot, Aguado or Regnault, thousands of Sunday photographers benefited from the development of small-format, hand-held cameras using gelatine dry plates to capture outdoor snapshots of their families at the sea-shore or climbing the Alps. In sharp contrast to these entertaining vignettes of endless leisure produced by a comfortable class for its own consumption were the series of 'scientific' visual documents of the working class illustrating reformatory texts, government reports or private charitable campaigns. The professional social-documentary photographer would occasionally turn his lens to municipal ceremonies or newsworthy events, but calls for reform in urban housing, working conditions and sanitation created a market for images that confirmed the need for change.

Unlike the staged, sentimental photographs of ragged children and pifferari sold by Rejlander, Nègre or Dr Barnardo, or the records of condemned neighbourhoods taken in the 1860s by Charles Marville or Thomas Annan, the views of lower-class life after the Franco-Prussian War reflect the value placed on non-interference with the subject and develop a rhetoric of objectivity manifested in accidental cropping, blurs, unadjusted sets and costumes, and, after 1887, the use of magnesium flash-powder to allow access to the real windowless rooms where poverty lived.

The first series of photographs published after 1871 with an implied goal of public enlightenment and social reform was John Thomson's *Street Life in London* (1877), with a text by Thomson and Adolphe Smith Headingly, a professional reporter and subsequent participant in the International Trade Union Congresses held between 1886 and 1905. Thomson, who had travelled in the Far East from 1862 to 1872 and had maintained studios in Singapore and Hong Kong, had already published archaeological photographs in *Antiquities of Cambodia* (1867) and a remarkably sensitive record of Chinese street-types, portraits, and genre shots in the four-volume *Illustrations of China and its People* (1873–4). By 1873 he was installed in London photographing for the Royal Geographical Society and reproducing private and public art collections. Although it has not been determined who funded or conceived the book on London street-types, it was modelled on Henry Mayhew's *London Labour and the London Poor* (1851–62), issued in seventy-nine weekly parts with Mayhew's melodramatic, Dickensian text accompanied by wood engravings after anonymous sketches and daguerreotypes by Richard Beard. Thomson's work, issued in twelve monthly parts with Woodburytypes from Thomson's negatives, echoed yellow journalism guides to the seedy East End such as James Greenwood's *The Wilds of London* (1874) or Mayhew's own *London Characters* (1870) but avoided their exaggerations, while the preface proclaimed the objectivity of both prose and illustrations: 'The unquestionable accuracy of this testimony [the photographs] will enable us to present true types of the London poor and shields us from the accusation of either underrating or exaggerating individual peculiarities of appearance.'

Assuming the role of modern Virgils leading rather hesitant Dantes through hell, Thomson and Headingly directed their well-to-do Victorian readers through a world inhabited by gypsies, cabmen, Covent Garden flower-girls, street hawkers, and ex-convicts. 'Never can we be too frequently reminded of the poverty that nevertheless still exists in our midst,' the preface warned: the goal of the book was to educate the 'haves' who would not venture alone into the homes of the 'have-nots'. The intended outcome of such an education, either social legislation or private charity, depended on the authors' faith in the public's generosity and the belief that the more fortunate were obliged to protect those who were honest and hardworking but trapped by circumstances beyond their control.

With its combination of first-person biographies and explanatory comments, the text is clearly sympathetic to its subject-matter, pro-union, and often critical of contemporary policies.[1] The photographs, however, are more ambiguous and need the text to clarify who the subjects are and how the reader should look at them. Thomson's compositions, whether single figures consistent with the graphic tradition of street types or *cris de Paris* or animated groups of clients gathered around a hawker, are shot from mid-distance in full sunlight with a rather open lens. The subjects are aware of the photographer's presence and hold a pose, although accidental blurring and movement occasionally occur. The only compositional exceptions are *Tickets the Card-dealer*, an interior half-length portrait, and *The Crawlers*, a view of a worn old woman holding an infant and seated on the workhouse steps. Other unusual photographs are those which deal not with street merchants but with the city's sanitary officers, the recruiting sergeants at Westminster who enlist unemployed young men, and the improvised Guy Fawkes Day parade which Headingly characterises as 'depressing merrymaking'.

Thomson's focus on pre-industrial street characters, necessitated in part by his slow plates which prevented interior views, makes his book traditional in its attitude toward London workers. Despite his references to pending legislation, he selects subjects which could have existed at any time during the past century: he avoids the more affluent neighbourhoods in the city and rarely shows men and women actually at work, driving cabs, washing windows, repairing roads, or serving as domestics. In a sense, his book is a transition between the old myth of the charming corner flower-girl singing as she offers her wares, and the real hardships described only in the text. The photographic depiction of suffering in the form of frowning children or visible physical deformities remained unsaleable. Thomson's photographs are admittedly shot on location, unlike the studio set-ups sold by Oscar Rejlander or Carlo Ponti, but they remain staged, often taken by appointment, conveying little sense of the personalities of the sitters, types in every sense of the word.

In 1887, when the American journalist-turned-photographer Jacob Riis began his 'ten-year war against the slums', he too carried with him visual and literary stereotypes of poverty. His focus, however, was not on traditional street trades but on the physical environment which he, like most medical men and social reformers of the late nineteenth century, thought was in large part responsible for the perpetuation of poverty and the root of physical and mental

degeneration. An educated Danish immigrant who came to America in 1870 to seek his fortune, Riis literally worked his way 'up from under', first in a mine, then on a Brooklyn paper, finally landing a reporter's post with the *New York Tribune* in 1877.[2] After several years accompanying the police on their nightly raids on illicit beer halls and opium dens and witnessing the unsanitary, crowded housing on New York's lower East Side, Riis decided to use his writing skills to wage a campaign to clean up physical corruption just as other journalists had exposed the political corruption of Tammany Hall.

First working with an amateur photographer and then hiring a professional to accompany him on his midnight visits into the slums, Riis purchased a 4 × 5 inch camera in 1888. Unlike Thomson, who was a skilful operator long before he turned to London street life, Riis claimed that he was a mediocre cameraman who learned through his own mistakes and twice even ignited a building with the flash-powder that enabled him to explore unlit hovels and basement tenements. His first photographically illustrated story, 'How the Other Half Lives', appeared in *Scribner's Magazine* in December 1889 and was published by the same firm the following year as a book with wood-engraved illustrations made by Kenyon Cox after his own and others' photographs and drawings. Between 1888 and 1898 Riis produced some 250 glass negatives which he used to illustrate his lectures and articles. After 1898 he abandoned photography, and by 1914 was better known as a writer and friend of the former president of the USA, Teddy Roosevelt, who had once also been president of the New York police board.[3]

Riis's photographs, taken during his brief flirtation with the medium, range from high-vantage-point street views to his innovative interior flash-shots of tenement stairways, police station lodgers, and sweatshops. Whereas his outdoor views of Mulberry Bend before and after renovation or even the

gang of toughs gathered near the West 37th Street dock are taken from a safe distance, his interiors such as the *Home of an Italian Ragpicker, Jersey St* show his subjects either avoiding the frightening and intrusive explosion of the flash or wincing at the light. The sitters, normally first-generation Italian, Jewish, Chinese or Irish immigrants whose social positions resembled Riis's own status some twenty years earlier, look shabby, unclean and unhappy under the cruel, revelatory light of burning magnesium. Although the ostensible purpose of Riis's work, like Thomson's, was to reveal to a middle class (with which Riis identified) the life-style of the 'other half' and to advocate changes in tenement construction, his attitude toward the inhabitants is ambivalent. On the one hand he paints the environment as the cause of poverty: 'The gap that separates the man with the patched coat from his wealthy neighbour is, after all, perhaps but a tenement.' More frequently, however, he outlines innate racial and national characteristics: the Chinese are 'in their very exclusiveness and reserve . . . a constant and terrible menace to society', the Italians are 'born gamblers' like the Chinese, the Jews make money their god, whereas the families of Northern European stock, like Riis himself, are neat, hard-working, and most likely to rise out of the slum.[4] Unaware of this contradiction between his reformatory goal, which depends on the premise that the construction of parks and workers' housing can eradicate poverty and thus crime, and his xenophobic depiction of foreign cultures, Riis establishes a documentary style which is sensationalistic in its violent exposé of poverty and at times dehumanising in its pictorial unwillingness to converse at close range with the contagious and unruly 'other half'.

The negative light Riis throws on the urban proletariat, perhaps justifiable in his attempt to shock the middle class into action but undoubtedly determined at an unconscious level by his scorn for those who had not, like him, made it as an

JACOB A. RIIS
ITALIAN MOTHER AND HER CHILD, JERSEY STREET, 1889.

J. A. Riis Collection, Museum of the City of New York.

American, becomes all too perceptible when his work is compared with that of his British contemporary, Paul Martin. Born in 1864 in Alsace-Lorraine, moving with his family to Paris in 1869 and then to London in 1872, Martin was apprenticed at sixteen to a wood-engraver. Turning to photography in 1884 as an amateur pastime, Martin continued to earn his living as an engraver until he opened a professional photographic studio near Wandsworth Common, London, in 1899.

Martin's photographs, taken first with a $6\frac{1}{2} \times 8\frac{1}{2}$ inch view camera and then after 1892 with a hand-held one, were not intended to be accompanied by texts or to serve as propaganda for housing reform but were personal snapshots which occasionally served as the bases for his wood engravings. Like Thomson, Martin selected London street-types as his subjects and produced lantern-slides with the backgrounds blacked out so that the resulting isolated figure was even more consistent with traditional graphic illustrations. More radical, however, were his holiday snapshots of lower-class couples embracing on the Yarmouth sands, children enthralled by a Punch and Judy show, or bathers clowning for the camera. Taken as a group, Martin's images reveal a good-humoured sympathy for the Sunday and bank holidays so fought for by the working class and a familiar interaction with his subjects who sport their festive hats and continue their merrymaking before the ambulant stroller with the mysterious box under his arm. The public displays of affection captured in Martin's small prints, so antithetical to late Victorian ideas of good breeding, seem natural, healthy fun rather than signs of the depravity and sexual promiscuity often associated with the close living and working conditions of the proletariat.

In Germany, the closest equivalent to Martin's snapshots of street and leisure scenes is the work of Berlin cartoonist Heinrich Zille. Like Martin, Zille began his career in 1872 as a graphic artist — a lithographer — but went on to produce freelance illustrations and cartoons until he obtained a professorial post late in life at the Preussischen Akademie der Künste. Between the late 1880s and about 1914 he produced hundreds of glass negatives and prints of genre scenes, parks, fairs and markets around his home in Charlottenstrasse, Berlin, as well as family photographs and views in artists' studios which he incorporated in his graphic work. Progressing from a 12×16 cm to a 9×12 cm camera in the 1890s, Zille often exploited the accidental cropping, spontaneous gestures and greater intimacy associated with the small, hand-held camera. On other occasions, his style is more distant, carefully posed, static. By combining pieces of photographs — lifting a woodgatherer from one print or a street corner from another — Zille generated his cartoons, which were analogous to L'Assiette au Beurre illustrations and focused on the world that had already been probed by naturalist writers such as Zola or Hauptmann or German painters such as Liebermann or Leibl. Although the photographs were conceived as means rather than ends in themselves, they have a directness and lack of sentimentality or melodrama that make them more credible social documents than either Thomson's or Riis's work.

The history of social documentary photography in France between 1871 and 1914 is rather puzzling because of the absence of proselytisers like Riis or Thomson. Although there are a plethora of government and academic studies of worker housing, factory conditions, and professional illnesses, they lack photographic illustrations. The restrictions on street

PAUL MARTIN
COUPLE ON YARMOUTH SANDS, 1894.
Snapshot taken with a portable camera.

Gernsheim Collection, Harry Ransom Humanities Research Center, University of Texas, Austin.

photography in Paris, which existed until 1890 and necessitated authorisation before shooting on 'la voie publique', may have deterred amateurs but certainly wouldn't have daunted professionals.[5] The individual who stands out in the 1890s as a consistent portrayer of professional types is Eugène Atget. Atget's interest in street life, concentrated between 1895 and 1900, was probably inspired more by his efforts to market old Paris than by his known socialist sympathies: he, like Thomson, isolated familiar and dying types, relics from an artisanal past rather than the new machine or factory workers. His women laden with bread, fishmongers, street-singers, bootblacks, rag-pickers, mattress-combers, lampshade sellers and Les Halles vendors are centrally posed, full-length characters often stopped in front of the same out-of-focus background and captured in frontal and profile views. Looking away from the camera and at times eerily dwarfed by the rushing perspective created by a wide-angle lens, Atget's figures are taxonomic specimens within a catalogue of urban antiquities.

An awakened interest in the value of all kinds of documentary photography occurred in western Europe during the 1890s. In England, the Warwickshire Photographic Survey was founded in May, 1890, with the intent of amassing amateur photographs of the customs and architectural monuments in the region. In 1892 Jerome Harrison, a science teacher and member of the Birmingham Photographic Society, lectured before the Royal Photographic Society on the need for the formation of a national photographic record and survey. Sir Benjamin Stone (1838–1914), a well-to-do owner of first a glass and then a paper manufactory and a Birmingham politician who had taken up photography by 1888, became the driving force behind the resulting National Photographic Record Association which was constituted in 1897. The organisation's goal was, in Stone's words, 'to show those who will follow us, not only our buildings, but our everyday life, our manners and customs'.[6]

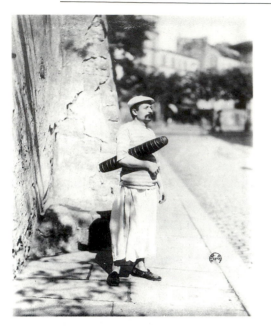

EUGÈNE ATGET
BAKER, taken from
VIES ET MÉTIERS A
PARIS, 1898–1900.
Collection of the
Bibliothèque Nationale,
Paris.

Stone's own photographs – some twenty-two thousand images now in the Birmingham Reference Library – fulfilled his conception of the eclectic amateur documentarian with a concern for his British heritage. Somehow finding spare moments between his responsibilities as a Member of Parliament (from 1895 to 1909) and his photographic trips around the world, the ageing Stone visited gypsy encampments, fairs, schools, public meetings, workers' homes, and, above all, local festivals near his home. His attitude toward his subjects, who were at the same time his constituency, was sympathetic, respectful and paternalistic, totally consistent with his age, position and anti-union voting record.

The French equivalent to the National Photographic Record Association, the Musée des Photographies Documentaires, was founded in Paris in 1894 by Léon Vidal and Fleury-Hermagis, both authors of photographic manuals and collectors. Vidal and Fleury-Hermagis saw the benefits to be derived from a central clearing-house of photographic records catalogued by subject. Works contributed by individuals throughout France to the Musée's temporary location in the 'Cercle de la Librairie in Paris would be available for consultation by members paying a twelve-franc subscription fee.[7] The success of this endeavour seems to have been largely determined by Vidal, whose death in 1906 led to the closing of the Musée and the deposit of its documents in the Bibliothèque Nationale. The registry of donations made to the organisation shows that few of the images were original prints: photomechanical reproductions appearing with increasing frequency in magazines in the 1890s, and, after 1901, picture post cards form the core of the collection. Types of images range from Reutlinger's portraits of actresses to gravures by the Photo-Club de Paris to reproductions of paintings. The list of members hoping to benefit from this early photothèque is equally eclectic: a few professional photographers such as Paul Boyer and the Lumière brothers, the head of the toxicology laboratory at the Paris Prefecture of Police, printers and publishers, archivists, engineers, and presidents of provincial photographic clubs are represented.[8]

Although few of the recorded images in the Musée des Photographies Documentaires can be classified as social documentation, the formation of this kind of organisation reflects the infiltration of photography at all levels of human activity. The type of photograph that fulfilled this desire to document the diversity of human experience and that rapidly dominated the commercial market during the Belle Époque was the picture postcard. Subject to postal regulations which varied from country to country,[9] the postcard, unlike other photographic formats, was intended to be sent through the mail and therefore directly reflected an increase in travel and tourism. It rapidly became an inexpensive, collectable item, with picture postcard clubs and magazines springing up in small towns throughout Europe and the United States in the 1890s. The subject-matter of photographic postcards was primarily landscape and historical monuments but also included regional folklore, picturesque types and rural labour. From the paucity of cards depicting industrial work, we can conclude that the public of 1900 was not so different from that of 1850 in its desire to commemorate ties to the past, the quaint Breton milkmaids or Provençal grape-pickers smiling contentedly at the normally urban, middle-class purchaser. Series of images of dirty miners, strikes, and charitable institutions with their poor clients, such as the one edited by Moraux Delannoy entitled *Au Pays Noir* ('In the Black Country') with workers' poems accompanying views of the hardships in the mine,[10] were intended as socialist propaganda and appealed to the working class itself and its political sympathies. In contrast to the overt political message of these *cartes*, the conservative ideology underlying the majority of ostensibly neutral outdoor scenes of regional festivals, harvests, and single-figure types is disguised by the long tradition and thus institutionalisation of such images not only in the graphic arts but also in the more recent peasant paintings by Bastien-Lepage, Lhermitte or Dagnan-Bouveret.

Even within the exhibitions devoted to 'documenting' the prevailing conditions of the working class, the myth of the happy labourer saved by the benefits charitably awarded to him by enlightened management persisted. Le Play, in his organisation of the 1867 International Exhibition in Paris, first conceived the idea that a section should be devoted to displaying evidence of the material and moral conditions of the workers. The Philadelphia Centennial Exhibition of 1876 included a small section on social questions, but it was only in the Paris International Exhibition of 1889 that a large display of graphs, drawings and some photographs dealing with hygiene, trades-unionism, apprenticeship, and state institutions etc. was included under the rubric 'Économie Sociale'. In the 1900 Paris Exhibition, the hundreds of photographs presented in the twelve parts of the 'Économie Sociale' section, and listed under the name of the company or institution without mention of the photographer, included views of the education of apprentices, American copper mines and small businesses, first-aid facilities, workers' housing, school and club interiors, and activities sponsored by private and public organisations to promote the 'well-being of citizens'. Within Classe 110 – 'Public and Private Initiatives to Promote the Well-Being of Citizens' – appeared the photographs of secondary schools for Black Americans taken by Frances Benjamin Johnston (1864–1952). An ambitious and

SIR BENJAMIN STONE
SMALLHOLDING TENANT, WORCESTER, 1910.

The impact of the photograph stems partly from the photographer's formal composition, in which the subjects are set in a dynamic context.

Reproduced by permission of the Sir Benjamin Stone Collection, Birmingham Public Libraries.

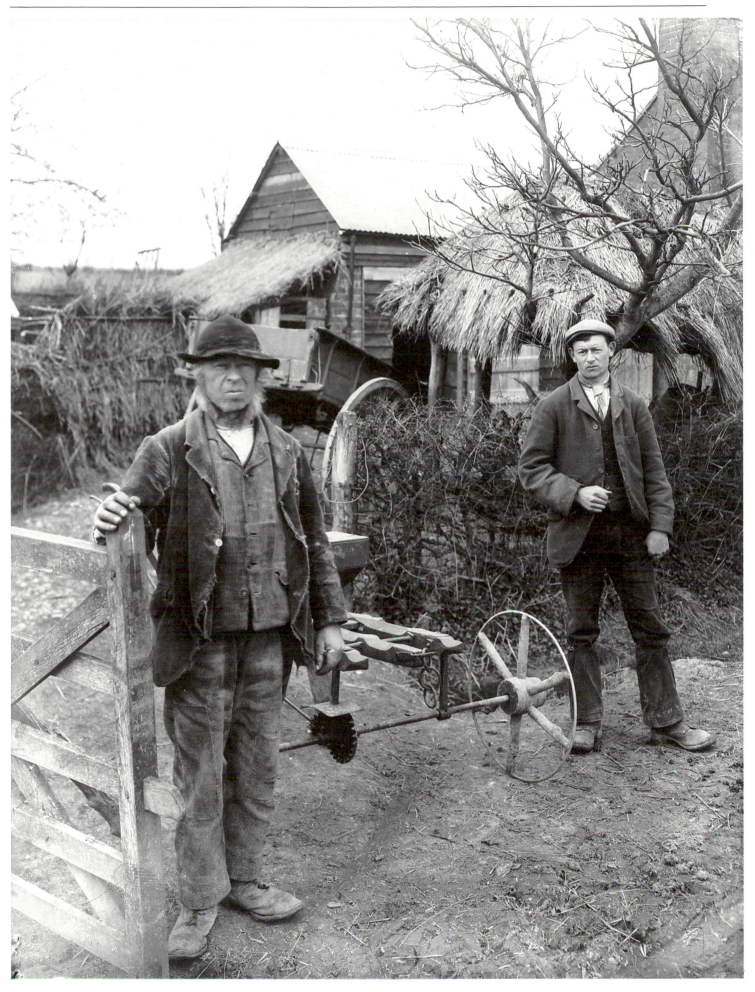

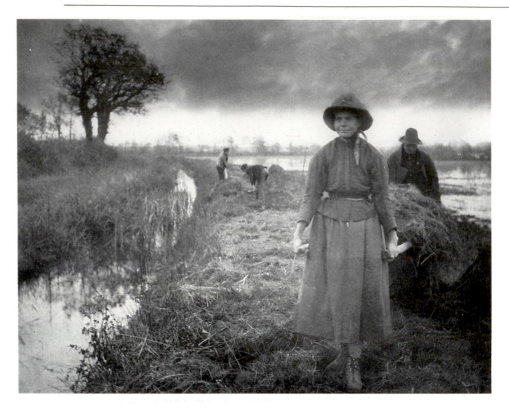

PETER EMERSON
POLING THE MARSH HAY in *Life and Landscape in the Norfolk Broads*, 1886.

Gernsheim Collection, Harry Ransom Humanities Research Center, University of Texas, Austin.

As the spokesman for 'naturalistic' photography and against hand-manipulation, Peter Henry Emerson comes closest in his writings and images to assuming a modern, documentary approach to rural subjects. A doctor, botanist, detective writer, and gentleman of means, Emerson began photographing in 1881 to complement his ornithological studies and shot scenes in the wetland region of East Anglia known as the Broads. Visiting first as a tourist, Emerson settled there in 1884 and was soon fascinated by the folklore, customs, flora and fauna of the area. The prints he produced, and the gravures he had made from them, were accompanied by texts in which he initially proclaimed an aesthetic rather than documentary interest in his subjects. As he explained in his preface to *Life and Landscape on the Norfolk Broads* (1886), his first illustrated book written with Thomas Goodall: 'Our aim has been to produce a book of art; and the text, far from being illustrated by plates, is illustrative and somewhat supplementary to them.'[11]

Emerson's claims that his primary concern was artistic has deflected historians from investigating the potential meanings of his photographs as social documents. The works themselves show fishermen, poachers and reed gatherers ignoring the camera and posed as if they were caught in mid-gesture against the mysterious and misty patterns of water and plant life. While it is true that his figure compositions are skilfully balanced masses of light and shadow often reinforced by the hand of the engraver, the descriptive texts of Emerson's books on the Broads published between 1886 and 1895 often graphically expose the hardships of East Anglian life. In his book *Pictures of East Anglian Life* (1888), containing thirty-two photogravures and fifteen half-tone illustrations, Emerson assumes a documentary tone in his explanation of his methods of note-taking, 'actual observation', and gathering data from the 'lips of specialists in various subjects'; at the same time, he persists in his assertion that his subjects were chosen because they 'appealed to me in Nature by their sentiment or poetry'. The topics covered in this text, however, include the relation of the Suffolk peasant to his landlord, his political enlightenment through '"the Labourer's Union" and the "penny press"', and the unduly harsh game laws which made poaching a crime. Emerson's concern for the East Anglian peasant, and his allusions to contemporary attacks on him as lazy, thieving and undisciplined, surface in passages where he describes a life not revealed in the photographs. Elsewhere, he, like Riis, addresses the 'Prosperous reader! . . . Have you ever thought what it must be to live in debt, and not have enough to feed the mouths at home, even with bread? Have you seen your children ill as well as starving?'[12] The intent of *Pictures of East Anglian Life*, more so than any of his other published books, is

independent-spirited woman, Johnston had originally intended to pursue an artistic career and attended the Académie Julian in Paris from 1883 to 1885. After her return to the USA, she moved to Washington, DC, studied photography with William Smillie, head of the Smithsonian Museum's Division of Photography, and opened a studio in a building constructed behind her family home in 1890. In addition to her portraits of Washington notables, Johnston wrote stories illustrated by her own photographs for *Demorest's Family Magazine*, *Harper's* and *The Ladies Home Journal*, and covered a Pennsylvania mine (1891), a Massachusetts shoe factory (1895) and the 1893 Columbian World's Fair, as well as White House events. She also specialised in taking photographs of public and private schools, including series commissioned by the District of Columbia school system, West Point, Annapolis, the Tuskagee Institute, and, in 1899, the Hampton Institute in Virginia. The Hampton photographs, exhibited in 1900 along with the Tuskagee works, depicted the practical classes and upward social mobility promoted by this Negro training school. Johnston contrasted the 'Old Time Cabin', showing a Southern shanty with an ante-bellum couple standing in the doorway, with 'A Hampton Graduate's Home,' a sparkling clean and bourgeois frame dwelling signifying the assimilation of the new educated Black into the mainstream of respectable America.

Although they considered their products as objects of aesthetic contemplation rather than social documents, pictorialist or art photographers during the late nineteenth century could not help recording real customs and folk costumes even though they filtered them through a haze of soft light. Whether they concentrated on Whitby fishermen, like the British pictorialist Frank Sutcliffe, or Breton peasants, like Alfred Stieglitz or Charles Lhermitte, son of the naturalist painter Léon Lhermitte, members of art photography clubs perpetuated the pastoral myth of the happy agricultural worker in endless views of silhouetted ploughmen and Milletesque shepherdesses.

LEWIS HINE
VANCE, A TRAPPER BOY.

International Museum of Photography
Collection at George Eastman House.

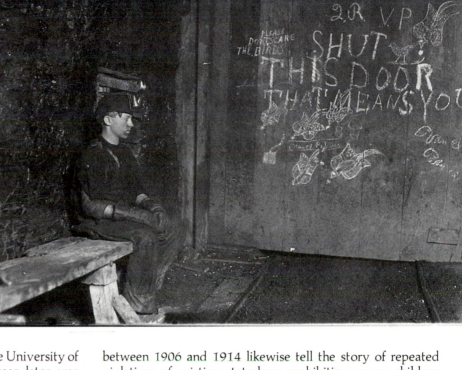

clearly polemical, and sparked criticism by the Tory press after its appearance. Perhaps as a result, his subsequent texts are no longer outspoken in their attack on the bourgeoisie and landowners but retreat into poetic evocations of the accompanying Whistlerian landscapes.[13]

The photographer who was most successful in his avoidance of the yellow-journalist sensationalism of Jacob Riis, the picturesque types of Atget, Martin or Thomson, the agricultural and folklorist myths of the pictorialists and postcard manufacturers, and the success stories of the world's fair exhibitors was the American, Lewis Hine. Born in 1874 into a petty-bourgeois Wisconsin family, Hine like Riis worked his way up, enrolled in the University of Chicago at the age of twenty-six, and a year later was convinced by his friend Frank A. Manny to move to New York to teach botany, geology and natural science at the Ethical Cultural School where Manny had just been appointed director. Taking courses in education and sociology at Columbia University, Hine met numerous liberal social reformers including Arthur Kellogg, the editor of *Charities and Commons Magazine*. In 1903 he was given a 5 × 7 inch box camera and began to take photographs for the school and to advocate photography as a pedagogical tool. Possibly inspired by a 1904 *Charities and Commons* article on immigration, Hine turned to New York immigrants in 1905 and recorded the bewildering experiences of foreign aliens being processed through Ellis Island.

Hine's photographs from the start were intended to promote legislative and governmental reform through a sympathetic but not sentimental view of his subjects. His portraits of immigrants, taken during a period when a million people were entering the country each year, were meant to break down the popular stereotypes of foreigners as ignorant, criminal, stealing jobs from unemployed Americans, and introducing inferior genes into an increasingly degenerate melting pot. Although some of Hine's immigrant families look lost and helpless as they search for lost baggage, wait in processing lines, and endure the startling flash accompanying his exposures, his sensitive series of close-up portraits preserve a solemnity and human dignity that he has carefully constructed using diffused lighting and directing his sitters to look at the camera and not move. As his 1909 lecture on 'Social Photography: How the Camera May Help the Social Uplift' confirms, he realised that the photograph was by no means a neutral slice of life but 'a symbol that brings one immediately in close touch with reality' and that tells a story 'packed into the most condensed and vital form'.[14]

Hine's equally famous group of photographs of child labourers produced for the National Child Labor Committee

between 1906 and 1914 likewise tell the story of repeated violations of existing state laws prohibiting young children from full-time employment. Travelling into mines and textile mills, farms and urban streets, Hine used various ruses to gain entry into the factories, measure the heights of the children and interview them. His subjects' names, ages, work histories and occupations were incorporated into his captions, but his eloquent images speak for themselves. Often shooting from beneath the eye-level of the child so that his physical weakness contrasts with the unending repetition of spindles or piles of coal, Hine suggests the mentally and physically debilitating consequences of long-term, pre-pubescent labour. In *Vance, a Trapper Boy* the dark, airless shaft and numbed stupor expressed in the profile view contrast with the graffiti-covered door where the childish writing recalls the school blackboards that the young worker never sees.

If the world of urban factory labour is one of confinement, mechanically repeated gestures and premature sophistication, the world of the aristocracy, as it is constructed by the lenses of amateurs and a new breed of professional society reporters, is a dizzy whirl of parties, sporting events, and outdoor amusements. The Italo-French Count Giuseppe Primoli (1851–1927), related to the Bonapartes and on intimate terms with the literary and artistic circle surrounding Princess Mathilde, used a small-format camera to record the weddings of his royal relatives, their stylish appearance at the Longchamps racetrack, and their leisure pastimes. With a talent for theatrical direction, he composed tableaux vivants featuring his artist friends Degas, Forain and Blanche. More puzzling, however, are the pictures he took of street life in Florence, Rome and Milan — emigrants, beggar children and a series of street vendors made in the 1890s which are comparable to those of Atget or Thomson. Without a more detailed analysis of his psyche and attitude toward the lower classes, we can only posit that Primoli felt a curiosity and concern for the poor whom he shows in an anti-picturesque, reportage style.

Nothing could be further removed from Hine's exposé of the lives of American child labourers than the carefree *bouffonerie* of Jacques Lartigue's contemporary snapshots of upper-middle-class leisure. The seven-year-old Lartigue was given a 13 × 18 cm camera by his financier father and rapidly demonstrated a precocious skill in catching his family and friends in awkward moments. Although his works were private records and can be considered documentary only in the sense that all family albums record social rituals, Lartigue, as an insider and inoffensive child, was able to pierce the privileged realm of the upper classes in a way that no peeping news photographer or celebrity portraitist could. His subjects were comfortable with him and often performed specifically for the camera. Their world is one of giggles, games, and, above all, movement – the heady, uncontrolled surge of a speeding automobile or the mid-air coast of an improvised glider. Whereas Hine's child (and adult) workers are static, imprisoned by their environment, frontal and iconic, Lartigue's figures, who are never shown working, are free from all restraints – gravity, propriety, self-consciousness. Hine's subjects suffer from a premature sophistication, a street-wise hardness expressed by cigarettes dangling from grinning mouths or limp, fatigued limbs. Lartigue's characters, on the other hand, seem eternally childish, thrill-seeking, ebullient. In direct contrast to the early silent films of D. W. Griffith which celebrated honest poverty and popularised the 'poor little rich girl', Lartigue's photographs forthrightly proclaim that the 'good life' is, in fact, better.

Commercial photographers of high life differed little from Lartigue in their choice of events to be covered. Firms like that of Jules and Henri Seeberger (founded in Paris in 1905) sold hundreds of regional genre scenes to postcard editors but after 1908 began taking full-length, outdoor studies of elegant ladies at Longchamps which were used as the bases for drawn fashion-plates published in *La Mode pratique*, *L'Excelsior*, and *Les Modes*. Like Henri Manuel's photographs of Poiret costumes taken in 1910, these images show society women rather than professional mannequins modelling clothes which they actually owned. In their reportage series on the playgrounds of the rich – taking the waters or frequenting Turkish baths – Seeberger Frères anticipate the photo stories appearing in the illustrated press in the twenties and thirties.

The vision of society presented by the vast array of late nineteenth-century commercial and amateur photographs remains an extremely fragmented one, defined in large part by the middle-class status of most operators and their clients.

Focusing on the lower classes who could no longer be politically or socially ignored, reformists like Riis and Hine revealed more often the negative rather than the more festive moments of working-class life and implicitly defended the values of Western capitalist societies by condemning the lack of cleanliness, order, nuclear family structure and education that they found there. Their goal, like that of numerous philanthropic and governmental organizations, was not to challenge the system but to work within it.

Representations of the wealthy and, by definition, powerful segments of society, whether taken by amateurs or by professionals, convey the message that happiness, beauty and health are the natural and deserved consequences of material gain. Constructing an ideal that would shortly be appropriated by advertisers attempting to associate a product with a life-style, society photographers obfuscated the real mechanisms whereby capital was accumulated by separating work from leisure.

What we are left with is less an objective insight into the daily lives of the people than a projection of what the photographer thought their existence was like based on a comparison with his own. Far from being a neutral record that introduced a new standard of truth into social documentation, the photograph remained, like the word and the pencil, a tool with multiple expressive potentials.

JACQUES-HENRI LARTIGUE
'ZISSOU ET MADELEINE THIBAULT, ROUZAT', 1911.

Association des amis de J.-H. Lartigue, Paris. ©
J.-H. Lartigue/SPADEM.

Photography – scientific and pseudo-scientific

Photography was born in a period which liked to think of itself as the age of absolute knowledge. Hegel died in 1831, just as Niépce and Daguerre entered their second year of partnership, and the first volumes of Auguste Comte's *Cours de philosophie positive* were beginning to appear. Photography undermined all the existing techniques of description, recording and representation and in so doing 'realised' or made possible something approaching an absolute knowledge of the visible world. Its scientific applications did not wait upon the perfection of its methods: they were immediately recognised and by well before 1870 photography was already playing its role in every field of knowledge. All the same, the period of 1870 to 1914 represents an age of development and *systematisation* that built upon all the efforts of the preceding years. Now the use of photography was to be stretched to the limit of its possibilities – perhaps, in a sense, beyond them.

The 'true retina of the scientist'

This, then, was an age in which photography was considered as the absolute tool of the observational sciences. 'The photographic plate is the true retina of the scientist,' announced Janssen, the astronomer.[1] Albert Londe took up the theme when he declared that 'in many cases, one ordinary print that speaks to the eye can disclose more than an entire description.'[2]

It is quite legitimate to wonder how a photograph 'can disclose more' – that is to say exceed or supplement a description, however complete the latter may be. Emile Zola declared: 'We cannot claim to have really seen anything before having photographed it.' That famous pronouncement of his reflects the huge hopes that were placed in photography in respect of getting to know the visible world. Not only does photography reproduce all that may be seen by the naked eye; it also reveals what the eye *cannot* see. It is quite true that the photographic plate is not sensitive to the same light rays as the human retina.[3] And that peculiarity is not of a solely physicochemical nature, since it raises the whole problem of the constitution of knowledge through the instrument of sight. So it is a theoretical factor which cannot be ignored, even a factor of civilisation.

Perhaps one of the most important aspects of this 'factor of civilisation' was that it provoked a rift, one already foreshadowed in Baudelaire's article of 1859, in which he described photography as 'industry's imbecile revenge upon art'.[4] Now, in the period of 1870 to 1914, the full concrete significance of the rift became apparent. It could perhaps be summed up, in a word, as a rift between the absolute and the ideal. The absolute nature of photography (its objective, neutral and scientific nature) destroys whatever is ideal (the artistic ideal and the subjectivity of the artistic view). Walter Benjamin seemed to be supporting, albeit distorting, the idea of that rift when he suggested that photography, by making it possible for images to be reproduced, 'forced religious values into second place in every domain'. The implication was that photography was *essentially* scientific; its fundamental contribution to late nineteenth-century culture might be summed up as bringing about *the end of the aura*, the end of the 'unique',

subjective experience of the object and its 'religious' significance.[5]

But in reality, this view, repeated so often as to become a commonplace, is justified neither in relation to Benjamin's analysis of the situation (which is infinitely more subtle and complex[6]) nor in relation to photographic processes as they actually developed within the scientific field between 1870 and 1914. Photography was certainly an extraordinarily productive objective tool. However, the progress and potentialities of a technical tool cannot be measured by the degree of its automatism nor by the specific determinacy of its role. On the contrary, they depend upon its margin of *indeterminacy*.[7] Now, photography was above all an experimental tool, that is to say it was bringing to light the *variability* or relativity of visible phenomena, not their narrow 'positive' qualities. But at this period science was still 'positive' or 'positivist' and, in consequence, in many cases there was a considerable divergence between on the one hand scientific discourse, which was sure of the positive nature of its tool (it can be seen in the photograph, so it must be true) and, on the other, experimentation with photographic processes which were often chancy and sometimes produced quite unexpected results.

The scientists of the period nursed a deep – dogged, even frantic – hope that through photography they would be able to make visible all that escaped them, all that lay beyond the capacities of natural vision: all that was either too close or too far away, all that lay hidden in the deep recesses of the body, all that was transparent, all that was invisible – even the human soul. It was as if *to see what is invisible* to some extent became the new 'ideal' of scientific photography at the turn of the nineteenth century.

The near and the far

The first thing the camera did was extend the powers of the two great optical instruments elaborated during the epistemological revolution of the seventeenth century, the microscope and the telescope. The albums of scientific photographs displayed a whole world of forms ranging from the infinitely small to the infinitely large, but it was a world in which it had been possible to abolish or put aside the notion of scale. As Marey put it, one of the greatest advantages of photography was to make it possible to reduce or amplify forms and movements, at will, to the scale desired.[8]

The results were spectacular. The 'unsuspected world' – as it was often called at the time – of histology, cytology, bacteriology and cristallography, this whole invisible world acquired a new value now that it could be put on show and used to transmit knowledge. Traditional engravings of scientific works were now replaced by photographic illustrations. In default of colour, prints were for a time touched up with paint. Crookshank was photographing bacteria. In his practical treatise on microphotography (1886), H. Viallanes used as his frontispiece a 'fine microscopic section through the brain of the larva of a fly' magnified four hundred times. The technique was further developed and systematised by Huberson, Moitessier and Montpillard.

But photography made it possible to do more than simply

focus upon details with the aid of a microscope. It also enabled man to gauge the exact measure of the whole of space. It became the major instrument used for topographical surveys in which context it was known as *metrophotography*. By 1861, Aimé Laussedat had tried out a system of 'photogrammetry', which was subsequently put to use by geographers and archaeologists. Between 1888 and 1892 Deville used this method to produce a composite map covering an area of 5200 square kilometres in the Rocky Mountains. Other devices and techniques also helped to extend the field of what could be recorded: curved plates (as used in Moëssard's 'cylindrograph'), hot-air balloons, kites, even rockets. Thirty years after Nadar's first experiments in a balloon (1856), his son Paul — assisted by the Tissandier brothers — obtained some excellent aerial photographs of Paris. It is interesting to note that the years marking the beginning and the end of this period are telling ones for the development of the photographic *survey*:

A. QUINSAC MICROSCOPIC SECTION OF THE BRAIN OF A FLY LARVA (enlarged about 400 times), 1886. *Photolithograph.*

Frontispiece for *La photographie appliquée aux études d'anatomie microscopique* by H. Viallanes, Gauthier-Villars, Paris.

Collection of the Bibliothèque Nationale, Paris.

LEWIS RUTHERFURD
THE MOON

photographed with a telescope with an aperture of $11\frac{1}{4}$ inches and a 14-foot focus, constructed and adjusted by the artist on 6 March 1865, at New York.

Collection of the Musée des Techniques, CNAM, Paris.

in 1870, the Prussian high command set up a detachment of field-photography outside Strasbourg; between 1914 and 1918, aerial photography played a crucial role in the strategy of trench warfare.

Finally, the spatial field, and thereby the very limits of the universe, came to be probed in depth. As early as 1839, François Arago had envisaged the possibility of using photography to map the moon. In the second half of the nineteenth century his dreams were realised through Rutherfurd's experiments (1862–3) and the achievement of Maurice Loewy and P. Puiseux in producing a *Photographic Atlas of the Moon*, published between 1896 and 1910.[9]

But the far distant — the enigmatic organisation of the heavens — also meant the evanescent. In America, Winlock and Wipple photographed the 1869 eclipse of the sun. Gunther in Germany, and Walter in Belgium, captured the form of atmospheric lightning (and demonstrated its similarity to the sparks from an induction coil). Meteorologists decreed 1896 to be the 'Cloud Year', with a view to setting the photographic enquiry on a 'world footing'. The introduction of dry plates around 1880 must certainly have allowed astronomical photography to make considerable progress. In 1882, both Henry Draper and A. A. Common managed to

photograph the nebula of Orion. It was also thanks to these plates treated with gelatine–bromide that, in 1881, Jules Janssen obtained one of the earliest photographs of a comet and was prompted to comment that not only was photography rigorously accurate but 'it can inform us about structural details that telescopes do not reveal'.[10] In other words, it possessed a great *revelatory* power.

Movement

Photography reveals structures we cannot see: it discovers them and captures their appearance. The analysis of movement was, without doubt, one of its best known 'victories' between 1870 and 1914. This was the period (associated with the names of Muybridge, Marey, Eakins, Anschutz, Londe, Janssen, Worthington and Mach) when a number of hitherto fumbling lines of research reached a successful conclusion.

The problem was a challenging one: technically, it was a matter first of achieving a maximum reduction in exposure times, in order to get as close as possible to the mythical, *instantaneous* image (mythical in the sense that it had never, strictly speaking, been achieved) which would reveal the

structure of a body in movement. In 1892, it is true, Boys was successful in 'seizing' a bullet at the height of its trajectory.

But the instantaneity of a snapshot (or, to be more precise, the extreme brevity of the time of exposure) did not resolve all the theoretical questions surrounding the representation of movement.

E. Muybridge and E. J. Marey came up with one of the earliest solutions to the paradox of the representation of movement when they tried *to multiply a sequence of instantaneous snapshots*. By 1878 Muybridge had designed a battery of twenty-four camera obscuras by means of which it was possible to obtain a series of pictures of a body in movement, the interval between one picture and the next varying from one second to one-hundredth of a second. Meanwhile, Marey was putting together a 'photographic gun' (1882) which produced a succession of images seized at a speed of $\frac{1}{720}$ of a second – which was quite stupefying at the time.

These experiments made it possible to *analyse* movement, although its essential structure could be glimpsed only by studying a whole series of pictures, not through a single image. Marey took a further step forward when in 1882 he produced a single and *synthetic* image of movement: his 'chronophotograph' produced ten images per second on a single plate. The resulting print certainly did convey the 'structure' of movement, but it is worth noting that it did so at the cost of a kind of destructurising in which *the body itself disappeared*: it was as if the 'truth of movement' devoured its appearance and form, substituting in its place a kind of aura.

ETIENNE-JULES MAREY
A HIGH LONG JUMP BY MONSIEUR . . .
in *Station physiologique, méthodes et appareils*, 1886.

Marey was a physiologist interested in locomotion, who used photography to study the mechanics of the movements of the body. To this end, he would have a man dressed in white pass in front of a black screen, and would register his successive positions at regular intervals of $\frac{1}{10}$ of a second.

Collection of the Bibliothèque Nationale, Paris.

Body and soul

Georges Demenÿ made acknowledgements to Marey's work when he suggested that 'to give the photographic portrait what it lacks, that is to say life, one must take a series of instantaneous shots and then synthesise them'.[11]

The idea that the photographic image in itself possessed a power of synthesis and revelation lent a new lease of life to a principle derived from the old-fashioned study of physiognomy: namely, that the form of a body and, above all, the composite features of the face reveal its soul. In 1871, Charles Darwin used the photographs of Duchenne de Boulogne to support his physiological theory concerning the expression of emotions.[12] Demenÿ's defence of the 'life' of a portrait was reinforced in 1883 when Galton (Darwin's cousin) demonstrated the general 'truth' of the *facies* that could be obtained by superimposing a number of separate portraits one upon another.

The introduction of the photographic medium into the field of medicine – principally into the study of mental illness – may be understood in the context of a similar hope: psychic or neurophysiological developments and symptoms in general indicate their presence through morphological details that are frequently not immediately detectable to the naked eye. H. W. Diamond, a specialist in mental illness and also president of the Royal Photographic Society, had taken the earliest calotypes of mental patients as early as 1851. In 1867, the Paris Medico-Physiological Society met to discuss the theme of 'the application of photography to the study of mental illness'. In 1873, the hospital of San Clemente in Venice compiled a photographic register of its patients; thousands of photographs were taken for the purpose.

In Paris, at the instigation of Jean-Martin Charcot, La Salpêtrière became a major temple of the photographic science – or possibly art. Between 1875 and 1900, first Paul Regnard, then Albert Londe, produced a series of astonishing pictures of hysterical women in which the clinical accuracy of the camera is always accompanied by the effect of an *aura*, resulting from the very real disturbance of the patient and connected with the frequently hypnotic conditions in which the picture was taken.[13] It is as if, in producing these images, science had itself been torn between on the one hand its

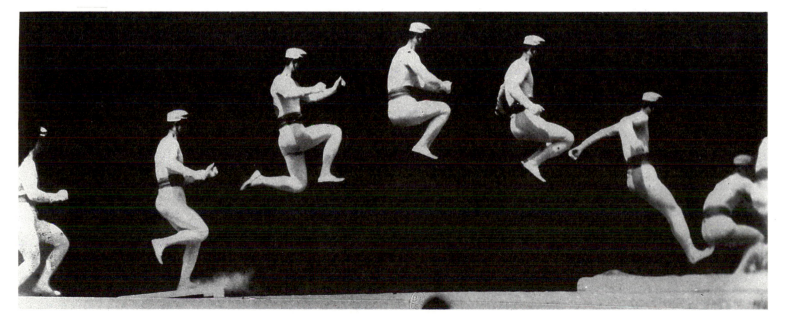

DUCHENNE DE BOULOGNE

A place from *Le Mécanisme de la physiologie humaine ou analyse électrophysiologique de l'expression des passions*, produced in collaboration with Adrian Tournachon (Nadar's brother), between 1852 and 1856. It appeared in 1862.

Collection of the Bibliothèque Nationale, Paris.

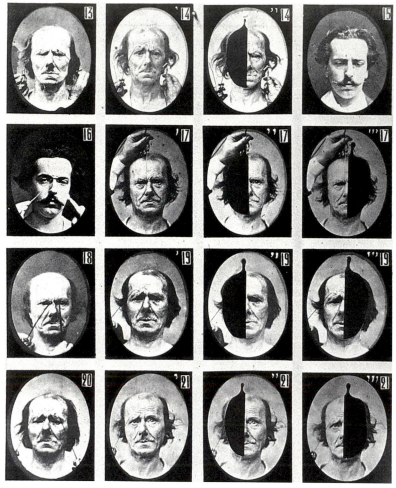

this way came to cloud the scientific use of photography. Frequently – despite the positivist postulates upon which it was founded – 'scientific' photography went so far as to produce truly aberrant collections of pictures and experiments. One example is provided by the 'optograms' that a few legally-minded doctors produced in 1868. The idea was to photograph the internal retina of the murdered victims, in the hope of obtaining an image of the scene of the crime – or even a portrait of the murderer – as if (at the moment of death) the eye became a veritable camera which for a few hours retained an exact image of the last moment of life.

BOURNEVILLE AND REGNARD
CATALEPSY
Plate XXIV in *L'Iconographie photographique de la Salpêtrière* (M. Charcot's service), Paris, 1879–80 (vol. III).

Collection of the Bibliothèque Nationale, Paris.

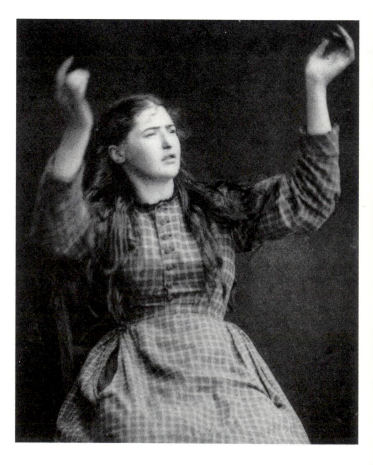

fascination with the theatricality of the symptom (which invested the picture with a beguiling effect of improvisation and beauty) and, on the other, its quest for a purely neurophysiological explanation (which would equate the 'positive' or 'informative' value of an autopsy of the brain with that of these portraits).

The connection between the portrait and the autopsy emerges even more clearly from the judicial and medico-legal uses to which photography was put. The first photographic service ever to be set up in a police station was established in Paris in 1872. Alphonse Bertillon, the founder of 'descriptive anthopometry', organised the system in the studio and archives of his 'Identification Service', where 90 000 snapshots were filed between 1882 and 1889 alone.[14] In Italy, Cesare Lombroso was meanwhile assembling a collection of photographic portraits and skulls of murderers, in the hope of discovering some formal or physiognomic law governing the essence of the origins of crime.

The fantasy of 'seeing everything' (seeing to the bottom of things, seeing the soul, seeing origins and foreseeing ends) in

From the diaphanous to the beyond

In the last analysis, the photographic medium was credited with the extraordinary powers of rendering visible what was invisible, even time itself. This is why, during the late nineteenth century, the applications of photography were constantly zig-zagging between the methods of fruitful scientific experimentation and those of other endeavours which had more to do with science fiction or even mysticism. In the field of photographic experimentation, the dividing line between positivism and magic was often extremely tenuous.

Thus, when Wilhelm Conrad Röntgen discovered X-rays in 1895, the notion of an invisible light that could leave its impression upon the photographic plate deeply affected not only scientific circles[15] but also the considerable number of spiritualist experimenters who were in search of ethers, auras and fluids of every kind. Röntgen himself had described his discovery in terms of 'a vibration of the ether', a concept that was generally invoked throughout the nineteenth century whenever difficulties arose in the field of optics.[16] It is fair to say that a magic or mediumistic use of X-rays was even written into the scientific birth certificate of the phenomenon.

The work of Hippolyte Baraduc, in the last decade of the century, provides another example of the kind of shift that occurred from a strictly positivist use of photography to experimentation of a pseudo- or parascientific nature. Baraduc, a doctor and a member of the best scientific societies and close to the Salpêtrière school of medicine, took an interest in both radiography and the study of the nervous phenomena of hysteria, hypnosis and electrotherapy. He took quite literally the classic notion that mental illnesses stemmed from impressionability. This led him to undertake research into – or rather to invent – the photosensitive effects of affective manifestations: thus he claimed that by suspending a photographic plate above a sleeping 'impressionable' subject, in the dark and without any photographic apparatus, he was able to obtain 'the aura of his nightmares'.[17] At La Charité hospital in Paris, Dr Luys was making similar experiments. Meanwhile, reciprocally, photography, regarded as a spiritual and miraculous instrument, was constantly pressing into service the scientific alibis of electromagnetism, ether and so on.[18]

Clearly, in the cases of Marey, Röntgen, Charcot and Baraduc alike, the 'scientific' essence of photography by no means excluded its use for other, fictional, magical or deluded purposes. The fact that it was considered to provide authentification frequently suggested that it had a revelatory value. To put it another way, photography was not content to reproduce what was visible; it set out to make imaginary objects visible (this was, so to speak, its demiurgic side) while at the same time providing experimental 'proof' for them (its positivist side). The problem probably hinged upon the concept of the experimental method that prevailed at the time: Claude Bernard had declared that it consisted in 'putting facts to work', in other words, that it was a matter not so much of exhibiting the phenomena but rather of playing upon their extreme variability in order to produce new forms from them.

At all events, far from annihilating the *aura* or 'religious' experience of its subjects, photography sometimes laid the foundations for a belief in their religious or even miraculous qualities. One example is provided by the holy shroud of Turin which in 1898 – the year when Secondo Pia first photographed it – acquired a theological and liturgical importance that it had hitherto not possessed. The first

X-ray photograph of the hand of Professor LUCIEN LOUIS DE KONONCK, a member of the Association Belge de Photographie.
Produced in the Physics Laboratory of the University of Liège, in 1899.

Photographic archives of the Musée de la Vie Wallone, Liège.

photographs of the shroud were regarded not only as scientific authentification of the relic but even as holy relics themselves (in that they had 'touched' the light and body of Our Lord).[19] Paul Claudel was later to go into eloquent ecstasies over them: 'This is a transfer image, an image that carries its own guarantee. It is more than an image: it is a presence! And it is more than a presence, it is a photograph, something printed and imperishable. . . .'[20]

So it was that the intervention of photography into the field of knowledge simply had the effect of rendering our idea of reality even more complex.

SECONDO PIA
THE HOLY SHROUD OF TURIN (1898).
From the heliogravure plate which appeared in *Le Linceul du Christ* by Paul Vignon (publ. Masson, Paris, 1902).

By kind permission of M. Pierre Vignon.

Photography and the press

Before 1840, only weekly or monthly magazines, such as *The Observer* and *The Weekly Chronicle* in Britain, from time to time reproduced wood engravings. Daily newspapers hardly ever carried illustrations.

Mechanical printing processes

The first surge of press illustrations dates from the 1840s. As the daguerreotype made its triumphant progress through the world, many popular illustrated magazines came into being. They carried wood engravings made from original drawings.

The first of the new illustrated periodicals was *The Illustrated London News*, founded in May 1842 by Herbert Ingram who, in one of the first issues, promised his readers 'a continuous record of important world events, social progress and political life'. For many years it was to remain well ahead of the other periodicals which, following its appearance, proceeded to multiply in both Europe and the United States. Between 1855 and 1860, it increased its circulation from two hundred thousand to three hundred thousand copies. So successful was it that it set up a team of sketch artists, some of whom were despatched to the front to cover first the Crimean War and subsequently the American Civil War, the Franco-Prussian War and the Paris Commune. The artists worked in collaboration with teams of engravers. Thus, nineteen men worked for two months on a large folding engraving with a total surface area of one square metre, featuring a panoramic view of London. On the other hand, news illustrations, such as those of the funeral of Benjamin Disraeli in 1881, were published on the very next day. When *The Graphic* was founded in London in 1869, Ingram's paper began to face serious competition.

In France, *L'Illustration*, founded in 1843, numbered among its collaborators artists such as Gustave Doré, Grandville and Jean-Louis Meissonier, while Honoré Daumier and Cham were producing drawings for *Le Monde Illustré*. The *Illustrierte Zeitung* was one of the leading periodicals in Germany. In the United States, *Frank Leslie's Illustrated Newspaper*, launched in 1855, sought to offer 'the most interesting illustrated account of events to be found in the two hemispheres'; it soon faced serious competition from *Harper's Weekly*, founded in New York in 1857.

Thanks to the improvements being made in engraving and printing techniques, the dailies were accommodating more and more illustrations in their columns. Towards the end of the nineteenth century, there existed in the city of New York alone over ten thousand illustrators and engravers, all employed by newspapers or publishing houses. During this period photography, which was much more economical in terms of time, began to be used in the press as an auxiliary tool for engravers. During the Civil War, many of the shots taken by Mathew Brady's team of photographers were used as 'primary visual material' in the engraving studios of *Leslie's* and *Harper's*. By about 1880, sketch artists were carrying portable cameras with them on their assignments, for the purpose of 'taking notes'.

The photographic process facilitated the production of engravings in another way too: after being developed, the layer of collodion would be detached from the glass plate and transferred to a wooden one, making it possible to produce an engraving directly from the original photograph. It was also possible to project photographic negatives onto wooden plates which, covered by a photosensitive layer, thus received a positive image.

But by 1890 photomechanical methods of reproduction were at last in a position to supplant wood engravings: both the speed and the lower cost of halftone reproduction from photographs represented advantages over the engraving method, when it came to the mass diffusion of images.

Photomechanical printing processes

The earliest attempts to produce printing blocks by photomechanical means used the relief method. Hippolyte Fizeau, among others, tried to engrave the daguerreotype plate in order to use it as a printing forme. Around 1850, the intaglio process was used in the reproduction of photographic images, often of remarkably fine quality, in luxuriously illustrated books. Towards the end of the nineteenth century, Karel Klič helped to perfect the process by introducing a 'grid-patterned screen' with intermediary inking rollers.

Flat surface processes such as photolithography and phototype were also being developed during the 1850s, particularly in Paris, where Rose-Joseph Lemercier and Alphonse Poitevin were reproducing photographs using printer's ink in the form of plates that were of high quality[1] but printed separately from the text, to be used as illustrations in books or in collections.[2] Meanwhile, in 1864, Walter Bentley Woodbury in Britain took out a patent on a method of reproduction and printing called Woodburytype or photoglyphty. Adolphe Braun used the method for the art books which he produced in Dornach, as did Goupil & Co. and Ludovic Baschet in Paris, for the plates to be included in a contemporary portrait gallery which, between 1876 and 1884, appeared in thirteen volumes comprising portraits of 'eminent men' such as Baudelaire, Zola and Victor Hugo. The portraits had been taken by Nadar, Carjat, Adam-Salomon and Franck.

A few magazines – *Paris Artiste*, *Paris-Théâtre* and *The Picture Gallery of British Art*, for example – also inserted into their pages of text free-standing plates printed by the photoglyph method. The exquisite, screenless printing in brown or sepia tones was of such high quality that they were sometimes taken for 'real photographs'. However, the method, which involved inking by hand and printing by means of a manually operated press, was both slow and costly.

The drawback that all these different processes shared was that they required paper of special quality and a separate press for printing the image, whereas newspaper and magazine illustration by means of the photographic image called for reproduction methods which would make it possible to produce large numbers of both images and text on a single press and using ordinary newsprint. This became possible only with the use of halftone relief blocks.

The first attempts at relief printing were made by Firmin Gillot, Charles Nègre and Edouard Baldus and the results were published in Paris in *La Lumière* between 1853 and 1856.

Different types of screens were then tried out by Alfred-Jean Berchtold, Paul Pretsch and Gillot, in Europe, and Frederick Ives, Stephen Horgan and the brothers Louis and Max Lévy in the United States.

In 1870, William Leggo printed screened images, but without any text, on the cover of the *Canadian Illustrated News*. Later, in 1878, in Paris, Charles-Guillaume Petit launched his process for halftone reproductions, known as similigravure. Then, in 1880, Horgan reproduced a facsimile photograph in the New York *Daily Graphic* and in the following year a halftone picture produced by Frederick Ives was printed with a grid-patterned screen in the *Philadelphia Photographer*. Eventually, in 1882 Georg Meisenbach patented his own method, known as 'autotype', in Germany, and proceeded to print directly upon newsprint in the *Illustrierte Zeitung* in Leipzig, in 1883.

Over ten years earlier, in 1871, Carl Gustaf Vilhelm Carleman, a Swede, had already reproduced a halftone image in the July issue of the *Nordisk Boktryckeri-Tidning*, using a grid-patterned screen. This was probably the first time that a text and a screen-printed halftone image were ever printed simultaneously in a popular magazine. Later, a few illustrations produced by his method appeared in the French press – notably, in the issue of *Le Monde Illustré* which came out on 10 March 1877. Conscious of the importance of the image screen-printed by halftone relief, Carleman had in 1871 declared: 'Only by this method can photography penetrate the masses [and become] the most powerful of levers to raise the level of true human culture.'[3]

Photographic illustrations in the press

Despite the excellent results obtained from various processes for reproducing halftone prints from originals, it was some time before photographic images were published regularly and in large numbers in the illustrated press.

Photographs – sometimes whole pages of photo-sequences – appeared during the 1880s in magazines such as *Harper's* in the United States, the *Illustrated London News* in Britain, the *Eigen Haard* in Holland and *Le Monde Illustré* in France. On 15 March 1884 the *Illustrierte Zeitung* printed a series of snapshots of the Imperial manoeuvres in Hamburg, photographed by Ottomar Anschutz, who later also produced a sequence which appeared in January 1886, showing the phases in a horse's jump, taken with an exposure of $\frac{1}{1000}$ of a second at intervals of $\frac{1}{16}$ of a second. The Nadars, father and son, produced a photographic interview with the chemist Michel-Eugène Chevreul in *Le Journal Illustré* of 5 September 1886; and the photographer S. W. Westmore's 'picture-story' of prison life appeared in *The Illustrated American* of 8 March 1890. All are examples of early photojournalism.

During the 1890s, wood engravings thus gradually gave way to halftone prints taken from photographs, but these were often coarse-screened and poor in detail. During this intermediary period, artists attempted to compete with photographs by executing their own 'instant' sketches while engravers produced the most delicate cross-hatching and vignetting effects. A kind of intercurrence was taking place: engravings resembled 'photo-realism' more and more closely while photographs, often very much retouched and in heavy halftones, really did come to look like engravings.

The work of photographers was, in its turn, much influenced by the tradition of sketched reportage, which affected both their choice of subject and also the composition of their photographic images. It can surely be no pure coincidence that Jacob A. Riis, the journalist who specialised in criminal life, began to photograph the underworld of New York in 1889, that is to say but one year after *Leslie's* published a series of ultra-realistic engravings showing the homeless children and overcrowded immigrant quarters of lower Manhattan.

Photoreportage made its breakthrough in the press in 1898, at the time of the Hispano-American War. James Henry Hare and John C. Hemment provided *Collier's* and *Leslie's* with many pages of pictures of the fighting in Cuba and were soon followed by James Burton and F. Pagliuchi, working for *Harper's*, and William Randolph working for *The World*. James Henry Hare was one of the pioneers of photographic reportage. Before 'covering' the First World War, between 1900 and 1914 he had photographed the Boer War, the Russo-Japanese War and the revolts in Central America. From the time of the Russo-Japanese War of 1904–5 his pictures, like those of Robert Dunn, James Ricalton and William Dinwiddie, were not only widely reproduced in the American

THE ILLUSTRATED AMERICAN
REPORTAGE IN THE NUMBER DATED 8 MARCH 1890, BY THE
PHOTOGRAPHER S. W. WESTMORE, INSIDE THE STATE PRISON
OF JOLIET (Illinois).

The press photographer was expected to enlarge the visual and
imaginary world of the readers, by introducing them into unknown or
mythical places.

The Library of Congress Collection, Washington.

the content of these reports bear comparison with the coverages of the German illustrated press which, ten years later, marked the famous 'birth of modern photojournalism'.[4]

Meanwhile, in Britain, the illustrated weeklies converted to photography during the 1890s. In 1898, E. A. Stanton was working in the Sudan for the *Graphic*, which also published over six hundred photographs taken by Reinhold Thiele, Horace Nicholls and others during the Boer War in South Africa. However, the British dailies made very little use of photographs during the 1890s. The *Daily Mirror* was the first daily newspaper to print several pages of pictures by the halftone relief screen process every day, from 1904 onwards. By 1914 it was printing 900 000 copies a day.

In Germany, the number of photographic illustrations to appear in the *Illustrierte Zeitung* was increasing, as it also was in other illustrated periodicals started in the nineteenth century. In 1890, the *Berliner Illustrierte Zeitung* was launched. When Kurt Korff took it over in 1894, it became the most important illustrated weekly in Europe to appear during the pre-Hitler period. It acquired a circulation of roughly two million and could count upon the collaboration of Germany's very best photographic reporters: Eric Salomon, Umbo, Felix H. Man, Willy Ruge and Martin Munkacsi.

However, the great majority of German dailies were making no use of the halftone photographic image in the early years of the twentieth century. St Petersburg's *Novoje Vremja* was years ahead of them, as was the local newspaper of Sankt-Pölten in Austria. Both had already started producing halftone pictures, the former in 1887, the latter in 1893. Meanwhile, in Belgium too, *Le Petit Bleu* printed no less than 164 within four months in the year 1897.

In France, photographic illustrations made a relatively late appearance in the press. The first pictures printed by the halftone process appeared in 1902 and even then only in *Le Français* and *Le Matin*. But in 1910, Pierre Lafitte launched *L'Excelsior*. Its entire front page, and frequently several inside ones too, carried news pictures. In the years before the First World War, the European pioneers in photojournalism were *L'Excelsior* and its British counterpart, the *Daily Mirror*. *L'Illustration*, for its part, carried a selection of frequently sophisticated pictures produced by photographers such as Gervais Courtellement and Jean Clair-Guyot and also by Seeburger and the Rol agency. *La Vie au Grand Air*, a sports magazine founded in 1898, developed an entirely new concept of page layout, using photomontage and detailed images inset into larger views. Jacques-Henri Lartigue himself recognised that this magazine, so rich in images full of movement, of aerial flypasts or motor or cycle races, provided a source of inspiration to him at the time of his first photographic endeavours.[5]

Despite its more traditional layout, *Paris moderne* introduced a concept of photojournalism that looked forward to Salomon, Kertész and Cartier-Bresson. In his editorial for the first issue, which appeared in the autumn of 1896, Auguste Deslinières declared that the magazine had been 'launched at just the right time' to be 'not an imitator, but an innovator and pioneer'. He was determined to allow the snapshot to play a major role and thus to create a hitherto undreamed-of means of documentation, 'an extraordinarily realistic reflection of life in all its forms'. He believed the days of 'Keep still!' to be over and done with. The first task of an illustrated magazine was 'to portray events full of life'. And with their heavy, clumsy portable cameras, the magazine's photographers did indeed

press but also sold to illustrated periodicals in Europe. The bases of the international diffusion of photographic images were now established.

In the United States, many dailies converted to photographic illustrations between 1900 and 1914. But already in 1897, on 21 January, the *New York Tribune* had for the first time carried on its front page a portrait produced by Stephen Horgan's halftone method: this was the very first halftone block image accompanied by a text in rounded stereo moulding for rapid printing on a rotary typographical press and onto ordinary newspaper. In 1900, the *Chicago Tribune* reproduced whole pages of pictures taken from Jacob A. Riis's photoreportage on the slums of New York and in the following year the dailies devoted considerable space to photographs of the assassination of President McKinley. In the years before the First World War, the daily press used more and more pictures and in 1914 the *New York Times* launched an illustrated supplement entitled *The Mid-week Pictorial*, containing news pictures of the war in Europe. In 1919, *The Survey* published Lewis W. Hine's 'picture stories' on the wretched plight of the refugees in the Balkans, in a remarkably modern page layout. Both the presentation and

manage to capture scenes of amazing vitality. The November issues of 1896 were devoted to the 'quais de Paris'; those of December 1896 to the Tsar's visit to Paris and a report on military life in the camp at Châlons; the January and February issues in 1897 produced a study of Les Halles.

But whether *Paris moderne* had really been launched at the right moment remains an open question, since it was forced out of business after only six months.

However, the collapse of *Paris moderne* coincided with the beginnings of the printing of photoengravings of both images and text on the rotary press devised by Karel Klič. Mertens further developed the process in Germany and in 1910 the Easter issue of the *Freiburger Zeitung* was printed with two combined rotary cylinders, one for the text, the other for the pictures. Then in 1912 the *Weltspiegel* — a supplement to the *Berliner Tageblatt* — printed 250 000 copies on a rotary press with the pictures and the text both engraved on the same cylinders. In France, a number of illustrated magazines adopted the rotogravure method of reproduction: for example, *Le Miroir* in 1912, and *L'Illustration* and *J'Ai Vu* in 1914. The introduction of this technique marked the beginning of the modern age of the illustrated press and by the time the First World War broke out it was already fully developed and capable of diffusing large quantities of high-quality photographic images of news events and picture stories. A new professional category, consisting of press photographers and 'photojournalists', came into being. As negatives became increasingly sensitive to light, and with increasingly lightweight portable cameras — the Sigriste and the Gaumont-Spido in France, the Speed Graphic in the United States and the Nettel-Deckrollo in Germany — and ever-faster lenses — the Goertz *f*/4, the Zeiss Planar *f*/3.5 and the Zeiss Tessar *f*/4.5 — these professionals were able to provide up-to-the-minute coverage. By 1914, the photographic images produced by the media had become a powerful lever which could be used for the purposes not only of information but also of propaganda.

LA VIE AU GRAND AIR
REPORTAGE ON THE OLYMPIC GAMES HELD IN LONDON, 26 July 1908 (inside page).

Press photography was now required not just to represent; this involved new kinds of page layouts. The view of the jumper in action, and the way the figure is superimposed on to the rest of the composition within its frame, emphasise the exploit.

Collection of the Bibliothèque Nationale, Paris.

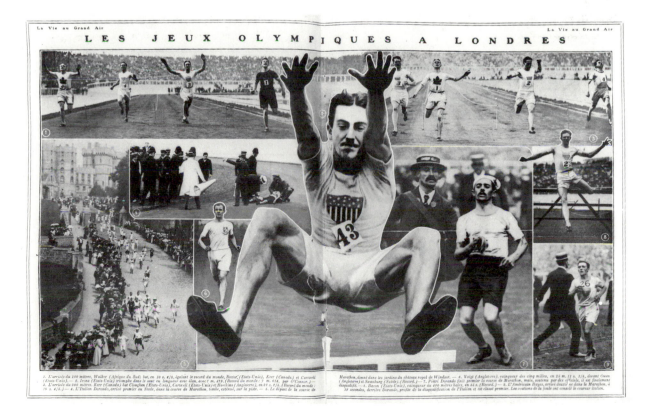

Amateur photography

By the outbreak of the First World War, photography had already become a relatively widespread activity, as ever since the beginning of the century the photographic industry had been striving to lower its prices and improve its products, so as to acquire a clientele of amateurs. Photography shops specialising in the sale of cameras and laboratory work for amateurs sprang up everywhere.

During the first decades of photography, its practice by amateurs was a costly and complicated business and was limited to a well-to-do minority. Some of them – David Octavius Hill, Julia Margaret Cameron and Count Olympe Aguado, for example – occupy a place of the first importance in the history of photography. Then, thanks to technical improvements and, above all, to factory-produced dry plates which were easy to handle, the practice of photography became simpler and the behaviour of amateur photographers changed. Now their major concern was perhaps not so much to create images of a high aesthetic quality, but rather to assemble documentary evidence relating to the social life of their time. Jacob A. Riis, for example, taught himself the rudiments of handling a camera, dry plates and the magnesium flash only just before embarking, in the late 1880s, upon his series on the immigrant quarters of New York by night.

In the United States, the richness of the photographic documentation still available today on the daily life of those who went west and cleared the land, built their ranches and set up their commercial companies and agricultural concerns shows that in many cases a camera would go along with them. The distinction between the professional and the amateur photographer is often difficult to establish since skilful amateurs would sometimes sell their pictures while, as a sideline to the running of their studios, some professionals produced excellent documentary studies of, for example, the threatened existence of the Indians.

Still in the United States, a work such as Jeffrey Simpson's *The Way Life Was*,[1] devoted to the changes taking place in society and family life at the turn of the century, was illustrated for the most part by photographs taken by Erwin Smith and L. W. Halbe, both amateurs, while two women photographers, Chasonetta Emmons and Alice Austen, were responsible for some of the illustrations in Olivier Jensen's *American Album*.[2] Most of the photographers to whom we owe the pictures of this period are unknown today. Nevertheless, they, and many other amateurs, contributed much to the development and diffusion of documentary photography.

The preoccupations of the photographic societies and associations were of a more aesthetic nature. Here painting was often the term of reference. The salons of the 1900s exhibited pictures produced by special methods, involving the use of gum bichromate and carbon. These temples of pictorialism, which claimed an affinity with 'art', made a point of establishing their distance both from the photography of the professionals, which they regarded as commercial and stereotyped, and also from that of the amateur photographers whose numbers were rapidly increasing, thanks to the introduction of 'box cameras' which were so simple that they could be used for family photographs.

It was above all George Eastman, in the United States, who played a crucial role in the development of popular photography and, in so doing, laid the foundations of the multinational empire of Kodak.

One phase in this development was marked by the introduction of the pliable celluloid film. In 1887, Hannibal Goodwin spread a photographic emulsion, sensitive to light, on to a transparent foundation with a basis of nitrocellulose and camphor. In the following year, John Carbutt produced a similar film. It was also at this time that Eastman launched his first box-shaped photographic apparatus, the Kodak, which could be loaded with a film – known as the 'stripping' – rolled onto a length of backing paper, with room for one hundred exposures. Kodak's slogan at this point was, 'You press the button, we do the rest.' And, at this juncture, it was indeed necessary to send the entire apparatus to the factory, where the film was developed and the camera reloaded. In 1889, Eastman's choice alighted upon film rolled onto a celluloid base.

The Kodak camera enjoyed a huge commercial success. Its advertisements proclaimed: 'It is now perfectly easy for anybody of normal intelligence to learn how to take pictures in no more than ten minutes' and with an 85 per cent chance of success. In 1892, another camera manufacturer claimed that whoever was capable of pressing a bell button and turning a key in a lock was also capable of taking photographs with his camera.

In the early 1900s new photographic machines came on the market for amateurs. They were simple folding cameras which would fit into a jacket pocket or a lady's handbag. Amateur photography by now constituted a sizable market for European camera makers such as Agfa, Voigtländer and Gevaert. The years leading up to the First World War thus witnessed the first ever large spate of photographs taken on the occasions of christenings, festivals and holidays, most of which were of interest only to the family concerned but which today have a great documentary value, since they provide a

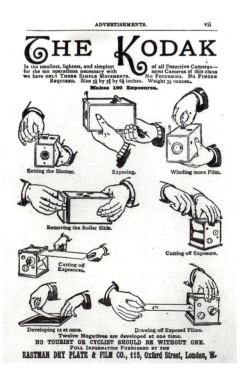

KODAK PUBLICITY for the first easy-to-handle box camera (1895), truly the ancestor of a whole generation of 'instant' cameras which brought photography to amateurs world-wide.

Rune Hassner Collection, © by Kodak.

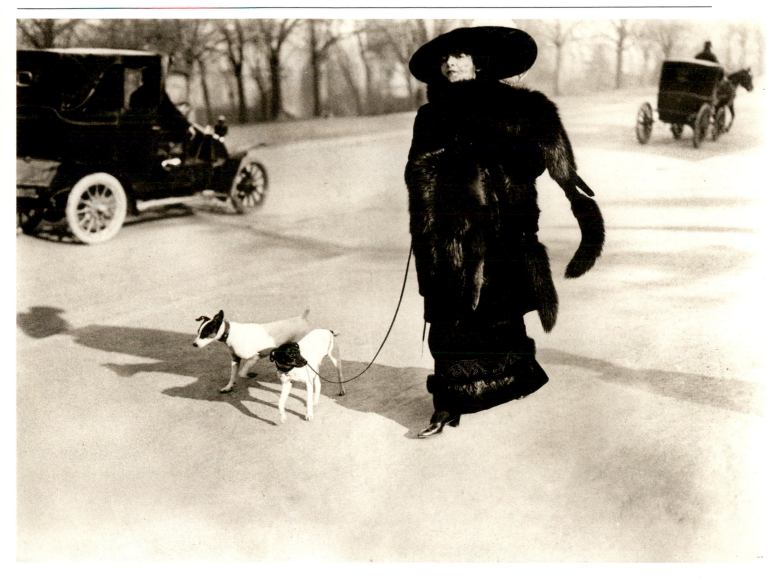

JACQUES-HENRI LARTIGUE
15 JANUARY 1911: AVENUE DU BOIS DE BOULOGNE, PARIS.

Association des Amis de J.-H. Lartigue, Paris.
© J.-H. Lartigue/SPADEM.

record of the mores, clothes and framework of the life of the period.

Of course, unlike the work of a Jacques-Henri Lartigue, most of this abundant production of photographs could claim no more than a private value. All the same, as from the last decade of the nineteenth century, its effect was such as to lead to a radical upheaval in the figurative norms of photography and to the reopening of the question of its status. A new generation of amateurs (my own) was born when a new small camera, the 24 × 36 mm or 'miniature', became generally available. Significantly enough, the prototype for this type of camera had already been developed by 1914, in the Leitz factories of Germany: it was the famous Leica, designed by Oskar Barnack.

AMATEUR PHOTOGRAPH, 1906.
MM. Barbey, Tardiveau, the deputy mayor, and M. Lehoc, the mayor of Deauville, in *Album de Trouville*.

Collection of the Bibliothèque Nationale, Paris.

Beyond reality: art photography

Between 1890 and 1910, photography was drawn into an international movement which forced it to completely revise its aesthetic position and to explore techniques, materials and effects that it had never before considered. History has dubbed the movement *pictorialist photography*. The formal metamorphosis that photography underwent at this time was such that, having incurred biting criticism from later photographers, pictorialism was subsequently, for many years, regarded as an unfortunate parenthesis in the history of the mechanical image. But pictorialism was anything but a parenthesis. Rather, it should be regarded as the link connecting two different panels in the unfolding history of photography.

Pictorialism: an international art movement

Pictorialist photography was born from the convergence of two uncertainties: one as to the nature of reality, the other as to the nature of photography. Such answers as were forthcoming to these two questions did not dissipate the unease they provoked: the pictorialists opted to bury reality and dress up their images.

In a famous essay entitled *La photographie est-elle un art?*, Robert de la Sizeranne advised amateur photographers who wished to produce 'artistic works' to wander 'through places devoid of monuments, at times when there is no sun, and to halt before a space containing no "sites", a nowhere'.[1] This rejection of anything notable was an indication that while reality may be necessary, it was no longer considered to be enough. In the creation of images, something else was now needed, something over and above reality and that could be superposed upon it, burying it underneath a thick layer of sedimentation.

Photographers were questioning the nature of photography. In the Salon corridors they spoke of charcoal, wash-tints, etching and other engraving processes. 'It is not a question of knowing whether photography possesses the same qualities as other processes, but whether it possesses any at all that are worthy of comparison.'[2] So what photography needed to do was not to draw inspiration from already established images, borrowing from them whatever it did not itself possess, but instead to enter into competition with them, staking everything on the value of its own specific qualities, even at the risk of being confused with those other images and reduced to an appearance which disguised its true identity. This kind of photography would play the game of masking its own origins even to the point of seeming to destroy itself. 'Let the amateur photographer use as much oil, gum or platinum as he likes; let him touch up his photograph with paint or attack it with a scraper: that is perfectly all right with me, so long as he shows me a picture such as the next man could not produce. . . .'[3] And elsewhere, Robert Demachy confessed: 'Perhaps we will be accused of effacing the specific *character of photography*. That is indeed our intention. . . .'[4]

To submerge reality and disguise the photographic image constituted the ultimate aspirations of the pictorialist ethic. But those two vectors originated in two movements that predated the emergence of pictorialism proper, namely *academicism* and *naturalism*. Academicism contributed the following notion, forcefully expressed by Oscar Rejlander, its most illustrious representative: 'The time will come when a work will be judged by its merits and not by the method of its production.'[5] Naturalism inherited such notions but at the same time clung to the principle of the specificity of photography, as demonstrated by the work of Dr Peter Henry Emerson, its defender.

We can see from academic photography and naturalist photography that pictorialism represented the meeting point for a number of ideas and theories, some old, some new, which resulted at the beginning of the twentieth century in the creation of an image in some respects in tune with the modernist movement. Those ideas testify to a reaction against reality, a phenomenon that pictorialism proceeded to exacerbate.

Academicism: decomposing reality

In 1856, on the occasion of an exhibition of the artistic treasures of Manchester, Queen Victoria purchased from the painter–photographer Oscar Gustav Rejlander a photographic picture entitled *The Two Ways of Life*. Her action did not constitute an official recognition of the photographic medium as such, simply of photography as practised by Rejlander. The work consisted of a heterogeneous studio photograph which grouped together a number of prettified mythical figures arranged in mannered attitudes. It was produced from several negatives linked together by skilful retouching and a whole gamut of painterly techniques. It was, in short, a 'demechanised' photograph and a unique product.

In line with the academic tradition, *The Two Ways of Life* was more concerned to express an *idea* than to copy nature. Morality provides the picture's equilibrium: on the left, vice, depravity and death; on the right, virtue, wisdom and salvation. The two sides of the scales flank the central, dominating figure of the father, the origin of everything, whose two sons have embarked upon opposite paths.

The ideological purpose of the image is explicit. It is the justification for its symmetrical composition, for the orientation of its lines of force and the opposition between them, for the selection of the figures, the pose of the models, the construction of the setting and the choice of the accessories. Rejlander's method of work served the pre-eminence of the idea. He sketched his compositions before setting them up and photographing them. In this fashion, he dominated reality down to the last detail. The picture expresses a moral idea through the selection and organisation of a number of objects and figures which, when arranged all together, create a unity of meaning.

But photography was a medium that was recognised to offer a faithful portrait of the world. To manipulate a photograph, retouch it and take it apart, in order to reconstitute it in an order acknowledged to be artificial, was tantamount to manipulating the world itself and to dominating its disorder. The task of taking reality apart and reassembling figures within the world of the image could be compared to the task of moral law, which separates good from

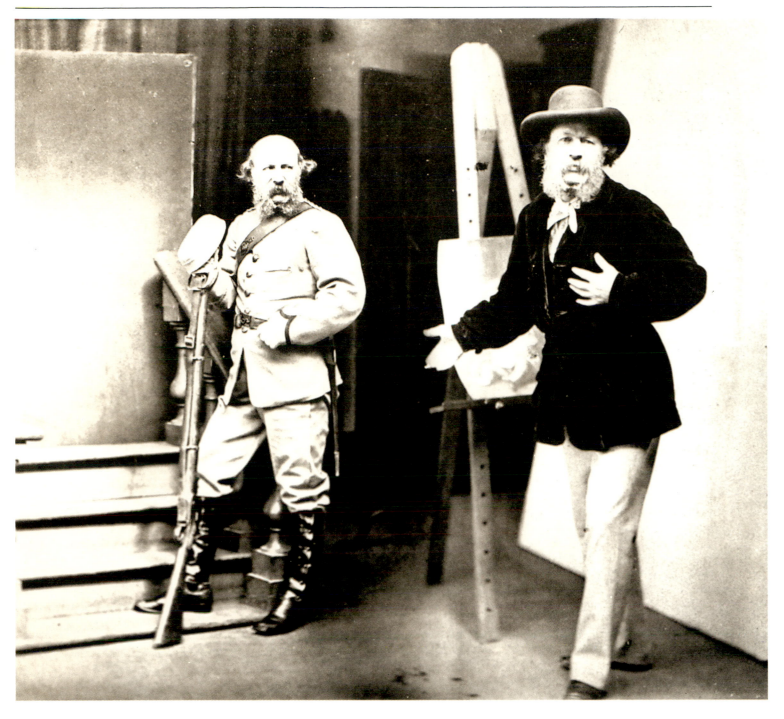

evil and saves the world by imposing a new order upon it. Rejlander's picture thus illustrated the power of moral law even as it seemed to be the product of it.

Rejlander felt personally associated with moral law given that the power that it exerted over the world was similar to that which he exerted over his photograph. In a curious self-portrait which he composed in the early 1870s, the author, sporting a broad-brimmed artist's hat, stands before his easel making a sweeping and reverential gesture of introduction in the direction of an individual dressed in the uniform of a volunteer, who is none other than Rejlander himself: art pays homage to patriotism and both are prepared to sacrifice themselves for the prestige of the Empire. The artist and the soldier are both heroes and the combination of the two uniforms represents civic duty in its highest form. The explicit nature of the moral message stems from the double representation of one of the figures in the picture – Rejlander himself.

OSCAR GUSTAV REJLANDER
'REJLANDER THE ARTIST INTRODUCING REJLANDER THE VOLUNTEER', about 1871.
Academicism is not fundamentally alien to photography. The ideological impact of this image (showing the artist and the soldier ready, as one man, to serve the Empire) depends entirely upon illusion of a kind only photography could produce.

Royal Photographic Society Collection, Bath.

The *illusion* of that double representation fractured the homogeneity of reality, was the hallmark of the photographer's intervention and also guaranteed the uniqueness of the product and the non-mechanical nature of the process. Above all, this specifically photographic manipulation operated, over and above the rules of academicism, as the guarantor of the magical, quasi-supernatural power that art and moral law exercise over the order of the world.

Naturalist photography: reality visualised

Courbet said: 'I paint what *I* see.' Dr Peter Henry Emerson might well have replied: 'I photograph what *my eye* sees.' *My eye* instead of *I.* A viewpoint is in the first place physiological. Emerson, who had been much impressed by Hermann von Helmholtz's scientific research into human vision, defined the physical limits of photographic vision as follows: the single viewpoint of the subject and the distance separating the subject from the object seen. Given that whatever predominates in the subject's field of perception must also predominate in the field covered by the image, in any photographic image the viewpoint and the distance are the two vectors which co-ordinate the perspective of the composition.

Three theories, which were to persist among photographers of the first half of the twentieth century, derive from the 'logical first principles'. The first establishes the indispensable presence of a *seeing subject* (photographer and at the same time spectator); the second, a corollary of the first, postulates *limits to the representation of reality* since, like the hand of the painter, the lens of the camera depends upon human vision and its limitations; the third theory concerns the image itself, whose quality depends upon how accurately it reflects the *scale of values*, that is to say the relations between colours, tones (from black through to white) and lights. How these are rendered individually is less important than the quality of the relations, whether of contrast or not, by which they are harmonised.

Faced with a landscape, a photographic camera unilaterally seizes upon the combination of elements that compose that landscape: objects, different planes (close or further away), lights (bright or dim) and the colours that it translates into different tones (from black through to white). Through focus, sensitivity of emulsion and diaphragm aperture (among other things), the film–camera combination makes a preliminary selection among whatever is presented to it (eliminating the darker zones, movements that are too rapid, and so on). This selection, which is dictated by technical necessities, would be subject to contingency and would be arbitrary were it not controlled by the camera operator.

The human eye, on the other hand, picks out a single feature in this landscape from the scene as a whole: an object, a plane, a light, etc. The eye has the advantage of continuous vision, but it is a continuity that functions in spurts, jumping from one object to another, from one plane to another. It embraces the entire horizon of a landscape but can seize only upon one object or plane at a time. The individual looking at a landscape chooses, sifts, retains or rejects objects, planes, lights and colours, as his impressions dictate, depending upon whether or not he is moved by them. His selection is no longer physiological but psychological.

Passing from the camera to the human eye and from that eye to the individual who is looking, a retraction takes place as an inexorable selection is made, progressively removing all that is *de trop* or useless, eliminating the excess in reality.

Once he had reached that conclusion, Emerson set out to make the photographic image resemble human vision as closely as possible. To that end, he played down contrasts, manipulated the depth of field and deliberately blurred both the more distant planes and the areas immediately surrounding the main object, which the human eye perceives only indirectly. Making use of reflected lights, he emphasised certain details in the shadows. In short, in his image he determined upon a centre of vision which he then reinforced through the treatment and composition of the main guiding lines in the picture, tending to make his angle of vision coincide with the span of vision of the human eye.

For the first time in the history of photography, the question of the representation of reality was of no more than secondary importance. The new debate concerned the image, or rather the images and the relations that obtained between them. For Emerson, faithful to the precepts of von Helmholtz, the only legitimate image was that which the eye perceived, in other words, the retina image. The referent for his photographs was not reality itself, but reality as already pictured by the eye and captured as an 'impression' by the photographer. His photograph rendered the initially received impression 'on another scale'.[6] Photography was no longer a matter of representation but one of adequation or equivalence. Emerson opened the door to photographic modernism.

Pictorialism: reality rendered in an image

For about fifteen years, from around 1875 onwards, two developments were simultaneously taking place, the one technical, the other socio-political, that in the early 1890s resulted in a radical transformation of the conditions in which photographic images were produced. The appearance on the market first of the 'dry plate', then of small, easily handled cameras (such as the famous 'detectives' and the first Kodaks) and finally of emulsion on film produced a veritable technical revolution during the 1880s and brought photography within the reach and means of many more people. A huge market in cameras and equipment progressively supplanted that of photograph images themselves. Instead of buying photographs, the general public were now buying the means of producing them. Alongside the industrial photographers, the journalists and portraitists, a new class of practitioners emerged: the amateurs. For them, photography was no longer necessarily a professional affair, but a leisure pastime, a means of pleasure.

This extension of the class of practitioners hardly affected the popular strata of society. The price of cameras and material, while much more reasonable, nevertheless remained prohibitive to the working class. Most of the new photographers came from the middle classes and the new bourgeoisie which emerged as a result of the social and political upheavals of the last quarter of the nineteenth century. This was a period marked by a decline of liberalism and the accession to power of the democratic parties which now, throughout most of Western Europe, introduced universal suffrage. In France, the republicans legislated in favour of freedom of the press (1881), authorised professional associations (1884) and introduced compulsory education (1885). Above all, these last years of the century saw the workers organised into political parties (the French socialist party was founded in 1880, its Belgian equivalent in 1885) and trade unions (the Confédération Générale du Travail was set up in 1895). In the industrial sector, violent social conflicts erupted, causing the ruling classes considerable alarm.

Meanwhile, the profession of photographer was hard hit by the economic crisis that had been developing since the

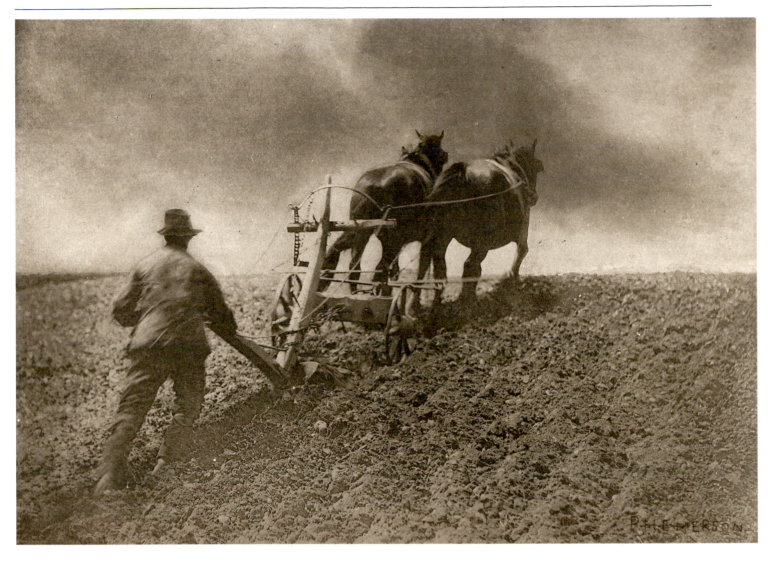

PETER HENRY EMERSON
A STIFF PULL.
Photogravure (plate 4) from the album, Pictures of East Anglian Life, *published in London in 1888.*

Emerson's naturalist photography illustrates a particular philosophy of perception: reality does not exist in itself, only when it is perceived. Photography should correspond to the retina image, with all the imprecision that characterises it.

Collection of the National Museum of Photography, Film and Television, Bradford.

early 1870s. Many large studios closed down. Young photographers tried to get things going again, but business was difficult, as Charles Chambon confirmed in a letter to Nadar: 'Is business thriving in Marseilles? Here, it certainly is not. The trade in general is in a bad way. All these amateurs are certainly doing us considerable harm.'[7]

Within this framework of political and social change and economic recession and in a context of upheaval in the industry, market and practice of photography, there was one group of amateur and professional photographers who regarded it as their duty to take a stand against the proliferation of images which they considered to be of little value since they were subject to no aesthetic constraints. Most members of this group belonged to the new ruling class. They sought to promote a particular class etiquette, social status, political choice and line of philosophical thought, together with certain aesthetic affinities. In other words, they sought to *represent* themselves in a particular way. Under the aegis of progress and science, photography had represented above all the liberal classes; now, for different reasons, it represented the rising bourgeoisie.

Since science had placed photography within reach of everybody, it was now necessary to place the mechanical image under the aegis of a master capable of guaranteeing the privileges of the few, a master situated in polar opposition to science, with the magical and prestigious name of art.

This reaction on the part of bourgeois photographers

found expression, in 1891, in the first exhibition held by the Camera Club of Vienna, whose criteria of selection were claimed to be 'artistic' rather than technical. Alfred Stieglitz was one of the twenty-five photographers chosen from among the three hundred and fifty candidates. In 1890, after studying in Berlin, with the chemist Vogel, he had returned to New York, where he became one of the most ardent defenders of art photography in the United States. Although his thinking was extremely pertinent from an aesthetic point of view, it was nevertheless stamped with the élitism that prevailed at the time: 'In the photographic world today are recognised but three classes of photographers: the ignorant, the purely technical and the artistic. To the pursuit, the first brings nothing but what is not desirable, the second, a purely technical education obtained after years of study, and the third brings the feeling and inspiration of the artist, to which is added afterwards the purely technical knowledge.'[8]

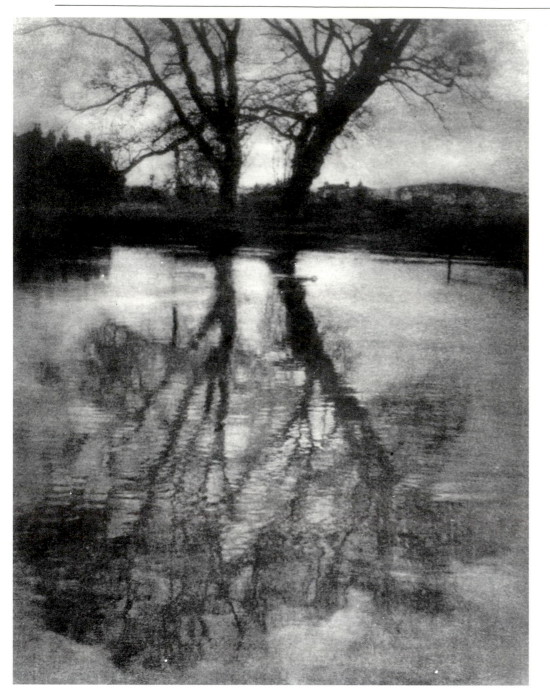

GEORGE DAVISON
POND AT WESTON GREEN,
REFLECTIONS, about 1898.
Photogravure from a gum print.

Twilight, shadows and reflections: the
pictorialists multiplied the veils seen
through which reality is no more than a
shadow of itself. Or, to put it another way:
reality is nothing but an image of itself and
that image is a photograph.

Royal Photographic Society Collection, Bath.

The new photographer was quite different from his peers. He worked by intuition turning his back on accepted rules and methods and placing his faith in the one thing that made him special in everybody's eyes: his *inspiration as an artist*, his own particular feeling. The quality of his work depended solely upon the quality of his inspiration. The performance of his materials, the canonical rules governing the taking of a picture, even the reality photographed, were no longer of any importance since their role no longer predominated in the realisation of an image which stemmed from the artist's 'innate gift', something that no amount of training, no handbook however detailed, could ever inculcate. Faithful to this principle, Robert Demachy and Constant Puyo accordingly offered the following advice to amateurs using the gum bichromate process: 'A gummist must, in the hallowed phrase, be self-taught. A treatise can no more teach the secret of a perfect gum than a grammar can teach the art of writing.'[9] The barriers erected by privilege were by now insurmountable.

Coming barely three years after the appearance of the famous Kodak box-camera of 1888, the Vienna exhibition was in itself an event so remarkable that it was testimony enough of the emergence of a new system for producing photographic images and of a reappraisal of the aesthetics of photography. It official marked the birth of the movement which history dubbed *pictorialism*.

As if photography needed to absolve itself from its 'original sin' – of having brought about the death of painting – pictorialism pointedly set out to re-establish the eternal relationship between painting and photography. Although the bases of the pictorialist aesthetic are not necessarily associated solely with this problem, it is worth attempting to define the nature of that relationship. Contrary to what has often been believed, it was not a matter of photography, bedevilled with an inferiority complex, slavishly imitating painting which was so superior to it as to be its ever-unattainable model. Rather, it was a competititive relationship

CLARENCE H. WHITE
THE CAVE, 1901.
Platinotype.

The American school discovered
its own originality through
pictorialism and contributed to its
evolution before eventually
rejecting it. This image by White
forges a surprising link between
the bucolic frivolities favoured by
Puyo and the natural abstractions
that Ansel Adams was to reveal
in the 1940s.

in which photography strove not to imitate painting but to raise itself to the same level and claim the same prestige, on an equal footing. The great goal of pictorialism was to have photography recognised as one of the fine arts.

The etymology of the word *pictorialism* confirms the nature of its aspirations. The word comes from the English expression, 'pictorial photography', the adjective 'pictorial' being derived from the noun 'picture' meaning 'image', but not necessarily 'painting'. Some French translations, such as *'photographie pittoresque'*, *'photographie picturale'* or *'pictural-isme'*, are thus unsatisfactory. The presence of 'picture' in the English conveys the initial aim of the movement: to win recognition for photography as one image among others.

But that aim, with all its aesthetic implication, was in reality motivated by socio-economic considerations which played a by no means inconsiderable role in the establishment and organisation of the pictorialist movement. From a commercial point of view, there could be no competition between on the

one hand the mechanical, impersonal images circulating in the market of current petty consumer goods and, on the other, the graphic or pictorial images, signed and personalised, that were circulating on the much more prosperous market of luxury goods. If the sale of photographic images was to recover the profitability that it had lost in the economic crisis then it would have to cater for a different market. Although these amateur photographers were for the most part not plagued by financial worries (Demachy was the son of a banker, Misonne a man of private means) and they were probably quite sincere in their desire to see photography officially recognised, they realised that such recognition presupposed photography becoming integrated into the art market and, by the same token, into the fine-arts system. Besides, both these possibilities were altogether in line with the 'prestigious image' that the new ruling class was determined to promote. That is why, over and above the personal aims of the individual photographers, the pictorialist

movement is inseparable from the financial and social interests that were expressed through the lawyers and journalists who were its ambassadors, through its patrons and, of course, through all those who actually produced the images.

In Europe, a number of national 'schools' sprang up around the new amateur associations that were now entering into competition with the old 'photographic societies'. According to Ernst Juhl, a businessman and patron of artistic photography in Germany, only five associations were true representatives of the European pictorialist movement: the Vienna Camera Club (the rival of the Photographische Gesellschaft), the Photo Club de Paris (which stood in opposition to the Société Française de Photographie), the Linked Ring Brotherhood (founded in London as a rival to the old

CLARENCE WHITE
STILL LIFE, 1907.
Platinotype.

White carries the aesthetics of distancing to extremes, using the very subject of the photograph, the crystal ball, as the screen through which to filter a distant blurred reality and drown it in diffractions of light.

THEODOR AND OSKAR HOFMEISTER
GEWÄSSER MIT KIRCHE (Pool with Church).
Gum bichromate published in Hamburg in 1904.

Tit for tat: the water reflects what lies out of sight, creating a doubly distancing effect: an example of a specifically photographic use of framing in the composition of the image.

Photographic Society of Great Britain), the Association Belge de Photographie, and finally the Gesellschaft zur Förderung der Amateur Photographie (Society for the Encouragement of Amateur Photography) that Juhl himself had founded in Hamburg.[10] In New York, the Society of Amateur Photography and the New York Camera Club merged in 1896, to found the Camera Club. Alfred Stieglitz was its vice-chairman and was responsible for the publication of the association's magazine, *Camera Notes.*

By extending a welcome to the most distinguished foreign photographers, the prestigious Linked Ring Brotherhood acted as an 'international forum' for the pictorialist movement. This association had been founded in 1892 by, among others, George Davison, Lionel Clark, H. Hay Cameron (the son of Julia Margaret), Alexander Horsley Hinton and Alfred Maskell. Its membership included the most important British photographers of the day, such as James Craig Annan, Frederick Evans, Frederick Hollyer, Alexander Keighley and Frank M. Sutcliffe. The Linked Ring was an extremely exclusive circle (at its dissolution it comprised no more than one hundred and forty members) and it was counted an honour to be admitted to it, as were the Americans Alfred Stieglitz, Edward Steichen and Clarence White, the Frenchmen Robert Demachy, Constant Puyo and René Bègue, the Germans Theodor and Oscar Hofmeister, and the Austrians Hugo Henneberg, Heinrich Kühn and Hans Watzek. The criteria for affiliation were so severe that only photographers of the highest calibre were admitted, a fact which both accounted for the originality of its productions and also

tended to minimise aesthetic disparities within the group, so that pictorialism gave the appearance of a solidly established international group.

These prestigious associations, with their wealthy members, were rich. And they were also powerful, for many of those members were mayors or deputies, magistrates or army officers. Some, such as the Association Belge de Photographie, which enjoyed the protection of King Leopold II and elected Prince Albert as its honorary chairman, maintained excellent relations with the political powers. Administrative and financial organisation ran smoothly; subscriptions were received, committees were elected and regular meetings were held, at which an external lecturer would be invited to address the members. New techniques were discovered, new products and materials examined; the results of new experiments were disclosed, local and international publications were exchanged and, above all, photographs could be compared.

However, they would be compared chiefly in the context of prestigious exhibitions which attracted a large and assiduous public. The most important were the annual salons,

which put on view a selection of the best works produced over the past year by members of the association. The Vienna Camera Club held its first salon in 1891; its example was followed by the Association Belge de Photographie in 1892, the Linked Ring in London in 1893 and the Photo Club de Paris in 1894. In the United States, annual shows known as the Joint Exhibitions had been taking place since 1884, held in New York, Philadelphia and Boston in rotation. They were based upon competition and publicity for both the works shown and their authors, and Stieglitz first criticised and then abandoned them, in the name of amateur photographers as a whole and the freedom of expression which he considered should be inseparable from the freedom to exhibit.

Then there were the large international exhibitions which, each year, were organised by one or other of the associations. The most famous of these, the one that was the first to reflect the homogeneity of the movement, was held in 1893 when Alfred Lichtwark, the director of the Hamburg Kunsthalle, was the first to open the doors of such a museum to photography. This exhibition, 'The Art of Photography which is Secretly Flourishing', was an important event. It showed six thousand photographs taken by some four hundred and fifty photographers and for the first time included the work of the Americans, led by Stieglitz. In the eyes of photographers, the coverage afforded by this public exhibition and the quantity, quality and widely diverse origins of the works exhibited there lent it the weight and value of an aesthetic manifesto.

Frequent competitive contacts of this kind resulted in the establishment of rigorous criteria for the selection of photographs and made for a certain aesthetic homogeneity. Ernst Juhl cites the example of the Hofmeister brothers, Theodor and Oscar, 'who were so impressed by the quality of our annual exhibitions that, within the short space of two years, we have seen them completely alter their procedure, moving on from sharp, shiny documentary prints to the powerful and superb pictures that they are exhibiting this year.'[11] Salons and exhibitions in this way oriented the various photographic trends and, above all, demonstrated the existence of a united pictorialist movement which was both coherent and also remarkably well organised.

A similar function was performed by an abundant production of photographic literature comprising exhibition catalogues and portfolio albums such as the famous *Die Kunst in der Photographie* which, between 1897 and 1908, was published four times a year, with eight photoengravings in each issue. The reports of the associations were published on de luxe paper, were abundantly illustrated with photographs and regularly carried new articles. Each association subscribed to the magazines produced by fellow associations and sometimes themselves reproduced passages from articles which they considered to be of major importance. Finally, many practical handbooks were produced, as were technical monographs[12] and, above all, articles which constantly returned to the theme: 'Is photography an art?' The best known of these, by Robert de la Sizeranne, appeared in 1898 in the *Revue des deux Mondes*.[13] That famous question elicited a wide variety of answers. Many were sophistic, many fastened upon minor

HENRY PEACH ROBINSON
COMPOSITION STUDIES, 1860.
Drawing with a photographic print pasted onto it.

Robinson was not interested in reality. He used photography as a
puzzle in which each piece was fitted into an imaginary design, here
sketched in in pencil. It was a naïve way of reconstructing the world
according to a new order.

Gernsheim Collection, Harry Ransom Humanities Research Center, University of
Texas, Austin.

points or expressed narrow views, but overall, whether
satirical or militant in tone, they reinforced the united façade
of international pictorialism, a movement working to gain
recognition for photography as one of the fine arts.

 Thanks to their efficient organisation, which enabled them
to mount exhibitions and sell photographs, and their publi-
cations, in which they could illustrate their point of view and
defend it, these associations were taken sufficiently seriously
to be accepted as partners in many business ventures. Ernst
Juhl, the patron of the photographers of Hamburg, actively
promoted the diffusion of photographic images, declaring:
'On the occasion of the last exhibition of art photography in
Hamburg, we produced a number of artistic postcards: within
two days, the entire edition, comprising as many as twelve
hundred cards, was sold out.'[14] The associations also entered
into negotiations with public bodies and organisations
devoted to the promotion of works of art, for example, the
Great Exhibitions held in Paris in 1889 and 1900, Antwerp in
1894 and Liège in 1905, where photographers could exhibit
their work under the auspices of their respective associations.
In 1896, the director of the National Museum of the United
States concluded the first-ever purchase of photographs as
works of art, for a sum of over 300 dollars. In that same year,
the Belgian government set up a photographic museum
attached to the Royal Museums of Art and History.
Furthermore, these photographic associations enjoyed special
relations with all the galleries and agents of the art market.

 And a new market was coming into being, one which
promised well financially and was now beginning to reach a
clientele which had been alienated by the democratisation of
photographic products. The Photo Club de Paris organised its
first Salon at the Durand-Ruel gallery, responsible for
bringing the Impressionists to the notice of the public; in the
Rue Tronchet, a boutique much patronised by amateur

HENRY PEACH ROBINSON
FADING AWAY, 1853.
Silver salts print using five different negatives.

Death is the supreme expression of chaos; it shatters the continuity of
life and eludes the rational mind. Photographing an arranged death-
scene rather than death itself was a way to quell the horror of this
radical discontinuity of being. It was also a way of 'controlling' it.

Royal Photographic Society Collection, Bath.

photographers sold framed, limited-edition prints from negatives which had been destroyed, of the work of Demachy, Puyo, Bergeon, Le Bègue and others. In New York, one of Steichen's prints, sold by Stieglitz, fetched in the region of 50 to 60 dollars. It seemed, for photography, a utopian return to the days of the unique work of art. It was as though they could recapture by commercial means what Walter Benjamin calls the *aura* of the unique work.

The business of raising the prestige of photographs and competing with the graphic or pictorial arts within the fine arts system involved plunging photography into the arena of culture and philosophy. Many famous names were invoked: Velasquez, Delacroix, Constable, Rousseau, Corot, Millet, the Pre-Raphaelites, the impressionists and, above all, the highly revered James Whistler. References were made to the aesthetic theories of Kant and Hegel, to the works of Winckelmann and Berenson, the art historians, and to the critiques of John Ruskin. Pictorialism, born in Britain, became as widely successful as art nouveau and was certainly familiar with the modernist theories put forward by William Morris.

The pictorialist movement realised that it had a historical role to play. For the first time, a retrospective view was taken of the work of earlier photographers, some of whom the movement recognised as its precursors. In 1890, James Craig Annan unearthed the original calotypes of David Octavius Hill and reprinted them as photo-engravings which Alfred Lichtwark then exhibited in Hamburg. Meanwhile, Robert de la Sizeranne was citing extracts from *Annals of My*

ROBERT DEMACHY
LE GRAND PALAIS: A MEMORY OF
THE 1900 EXHIBITION.
Gum bichromate.

While photography may have the power
to keep memories alive, Demachy
reminds us that memories are always
diffuse, obscure and distant. He lifts no
more than a corner of the black curtain
that oblivion casts over everything.

Collection of the Société Française de
Photographie, Paris.

Glass-House, the journal of Julia Margaret Cameron, who was now credited with not only talent but also courage, for having struck out, away from the technical norms. Lastly, the divergent theories of on the one hand Emerson and, on the other, the academic photographer Henry Peach Robinson, a follower of Rejlander, fuelled the aesthetic polemics of the day, for which their writings became the required works of reference.[15]

Pictorialism benefited from its homogeneous social composition, pursued theoretical goals which it was at pains to justify and gathered beneath its banners an excellently structured photographic movement. As such, it naturally produced images affected by a common system of clearly stated aesthetic values.

The role played by the associations in the standardisation of the photographs produced cannot be denied, but their influence became apparent only *after* the event, as the years passed. The pictorialist movement was not initially set up on the basis of any aesthetic manifesto and it produced a wide variety of works which differed perceptibly from one country to another. Some were manifestly conservative, others incredibly modernist, their styles ranging from the most mannered and bizarre to the most original and constructive. So, to set the record right, we must redefine the pictorial aesthetic, taking account of the national divergences and disparities by which the movement was fundamentally divided, but at the same time underlining the major choices taken within it over the years, for these convey a general idea of its character.

One conviction must have brought comfort to the amateur photographers of the 1890s: namely that since the invention of photography and following its systematic use over the past fifty years, reality had been totally conquered. It was a delusion, of course, but one that seemed altogether justifiable in the last years of a century saturated with images. Amateur photographers realised that photography had virtually fulfilled the programme assigned to it by Arago in 1839. It had served the physical sciences, optics, astronomy and photometry; it had come to the aid of explorers and had revealed many facets of the universe; it had helped to crack the secrets of movement and human and animal locomotion and even to reveal things that the eye itself barely glimpses or sees not at all. In 1886, Mach and Salcher took a picture of a bullet from a rifle hitting a target at 500 m/s; the shock waves were clearly visible.

More generally, the feeling that reality had been photographed in its full totality stemmed from the specific quality of photographic realism. Whether or not it applauded it, the nineteenth century public recognised photography's excellence in the rendering of details. In some minds, that *qualitative* excellence may create an illusion of quantitative 'perfection' or totality. If photography could reveal 'a multitude of tiny details', it could just as easily reveal the multitude of elements that go to make up reality as a whole.

Under the impression that reality as such had already been conquered, amateur photographers now felt driven to convey reality differently in their images. At the end of the nineteenth century, some people found their change in attitude shocking and provocative: 'If an old professional of the camera obscura follows what they do and observed them, he is amazed and scandalised . . . he discovers with horror that his young colleagues are violating every rule in the profession.'[16] Robert de la Sizeranne's grouch homes in on the heart of the

ALVIN LANGDON COBURN
GEORGE BERNARD SHAW, 1904.
Print from gum and platinum.

A fervent defender of the art of photography and a caustic, sometimes peremptory critic, Shaw was the leading literary ally of the pictorialists who were fighting to gain recognition for photography as one of the fine arts.

Royal Photographic Society Collection, Bath.

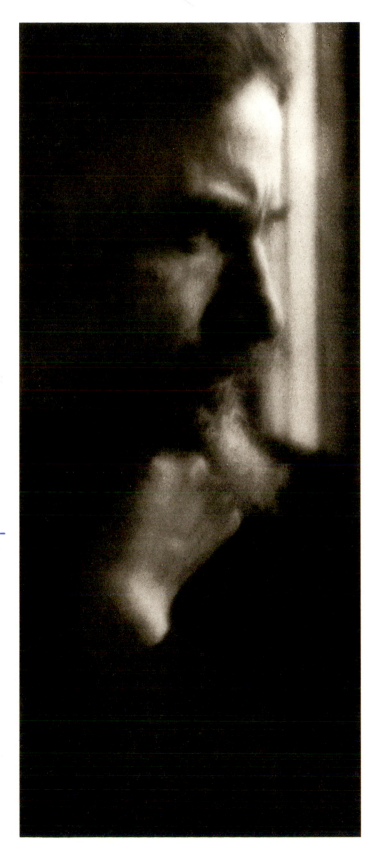

HEINRICH KÜHN
PORTRAIT OF ALFRED STIEGLITZ, New York,
1904.
Gum bichromate.

Kühn was a keen user of the gum printing method,
the technical principle of which — liberating the
image from the pigments in which it was enveloped
— was perfectly suited to the aesthetic principle of
the distancing of reality.

Collection of the Staatliche Landesbildstelle, Hamburg.

DR ALFRED KIRSTEIN
NOTTURNO, 1902
Heliogravure from gum bichromate.

From 1900 onwards, the Hamburg school took to
exaggeratedly emphasising the pictorial effects of the
gum process (in particular the warm, dense blacks),
stripping the images of any photographic character,
but lending them a quite unequalled majesty.

Collection of the Museum für Kunst und Gewerbe, Hamburg.

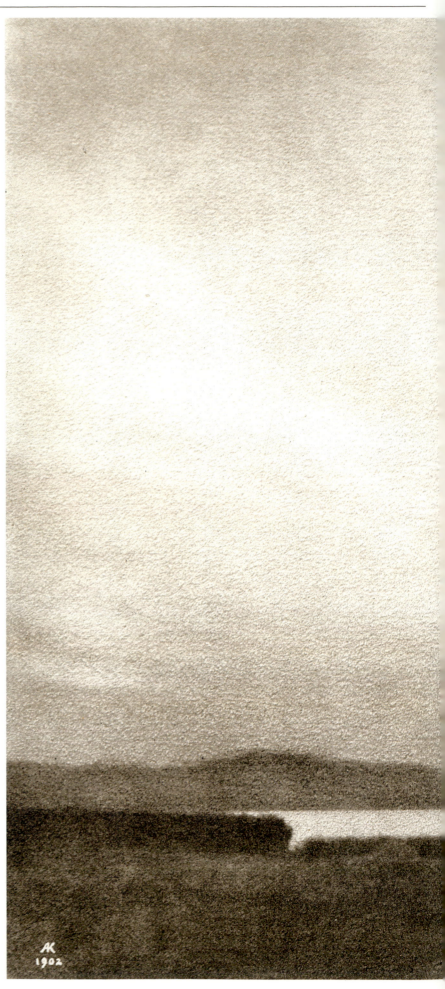

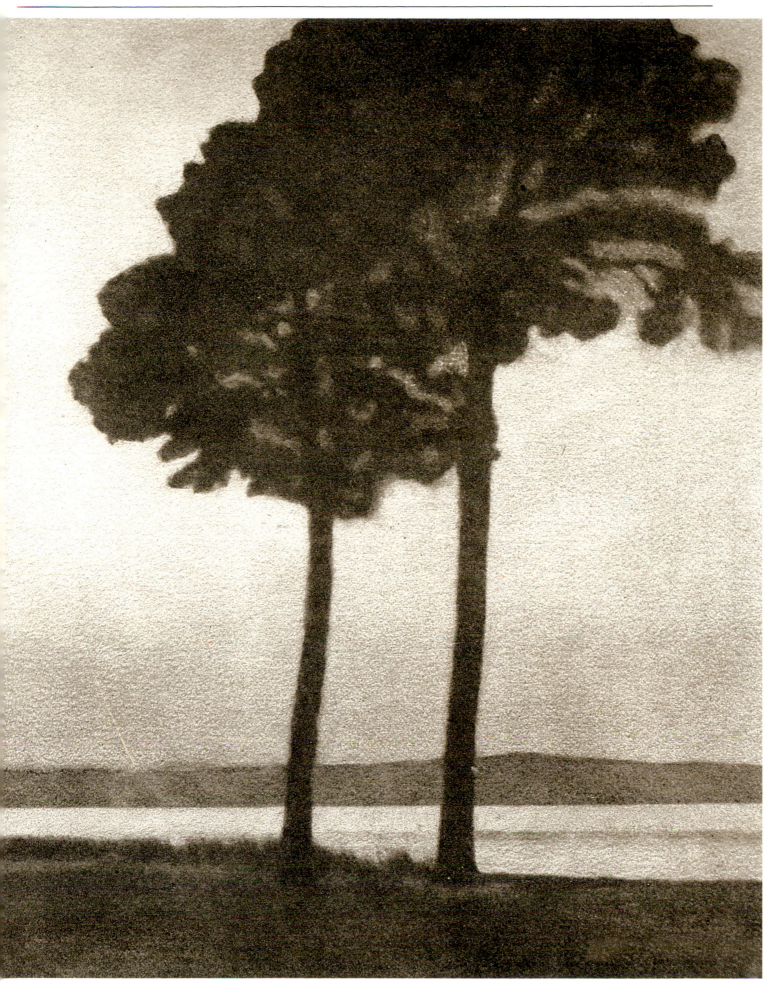

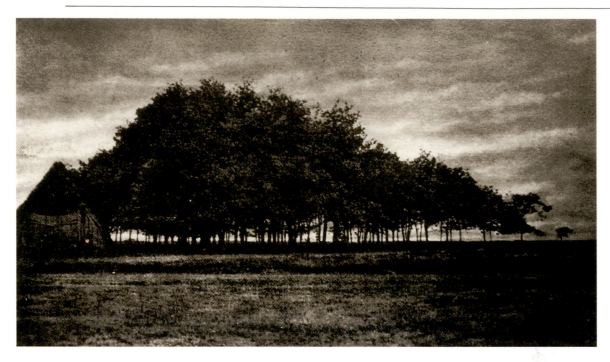

BERNARD TROCH
GROUP OF TREES WITH
HOUSE, 1903.
Printed with aniline.

Troch revolutionised the
classic landscape as conceived
by Alfred Horsley Hinton. He
did not favour striking
foregrounds or distant
horizons, obscure perspectives
or huge expanses of sky: just
the light filtering through
between two dark, disquieting
masses.

Collection of Foto-Historama
Agfa-Gevaert, Leverkusen.

pictorialist revolution: its violation of the rules of the profession, that is to say the deontology of the very *act* of photography. Hitherto, photographers' action upon reality had taken one form only: it had been an action of *identification*. But once the photographer put a part of himself into the act of photography, once he introduced his own presence into the necessary relationship that connected reality to his image of it, once he lent a personality to the gaze of his lens, then the image became autonomous in relation to its subject, receiving the stamp of the particular impressions that were evoked in the camera operator himself at the sight of his subject. The act of photography became an act of *confrontation* between the individual and reality and the image produced bore the mark of that clash.

To endow his image with the particular quality of his own relationship with reality, the photographer had at his command a whole series of *distancing techniques*. The function of all of them was to erect a series of screens and veils through which reality could be filtered or sifted, and transformed into an image. Some of those screens were natural ones that reality itself provided. The pictorialists' predilection for damp, rainy, misty or snowy weather is well known. Another way of rejecting reality was to engineer corridors at the end of which a distant perspective could be glimpsed, as in the cathedral interiors photographed by Frederick Evans.

In 1904, Gustave Marissiaux produced a photographic report on the collieries around Liège, in Walloon Belgium. He had been commissioned by the directors of the mining companies to mark the occasion of the Great Exhibition to be held in Liège in 1905. Objectivity being *de rigueur*, Marissiaux produced his series of pictures using stereoscopic transparencies. Although this commission did not afford him the same freedom of action as his 'artistic work', Marissiaux managed to make the most of the possibilities offered him for introducing into his images screens, filters, corridors and effects produced by means of chiaroscuro and photographing into the light in such a way as to hold reality at a distance. In the context of a publicity campaign of this kind, it would, besides, have been tactless to reveal certain aspects of social reality. Marissiaux's photographic reportage presented a

quite exceptional panorama of the mining world, but in no sense did it constitute a faithful documentary record of the peculiarly harsh conditions of mining.

The magazines of the amateur associations were constantly busy keeping up to date with a famous altercation: the quarrel between *fuzziness* and *sharpness*. It was not a new quarrel, but the pictorialist movement so much exacerbated is that to this day it is still known as the 'fuzzy school'. Optical blurring, particularly blurring produced by the famous 'artists' lenses' so favoured by Puyo, was but one of the distancing techniques favoured by some photographers. In Alvin Langdon Coburn's portrait of George Bernard Shaw, taken in 1904, it was not so much a matter of the photographer keeping his distance, rather of the writer refusing to surrender himself. Reinforcing the positioning of the frame, the soft focusing provided a fictitious veil behind which the writer could take refuge.

Many photographers evacuated a high proportion of reality from their pictures by their judicious use of light and chiaroscuro. Degas' portraits taken using an oil lamp are a good example, as are Steichen's pictures taken against the light, among others his famous portrait of *The Man Who Resembled Erasmus*, in which the head alone emerges from the shadows, framed with light. Léonard Misonne went so far as to declare: 'The subject is of no importance, the lighting is everything,' and went on to apply the idea literally in a photograph which he appositely entitled '*Who Is It?*', in which a figure in the foreground catches sight of two shadows at the other end of the road.

In his view of the Grand Palais taken from the Seine,

PIERRE DUBREUIL
FILLETTE DANS L'ESCALIER (Little girl on the stairs), about 1900.
Platinotype.

Dubreuil was a precursor of modernism, who rejected the all-enclosing frame handed on from painting, preferring a frame that cut out a particular detail, which he considered more suited to photography. He isolates instead of composing, fragments reality instead of surrounding it.

Collection Provinciale Museum voor Fotografie, Antwerpen (Antwerp).

Demachy plays with the smoke belching from a little tug stationed in the foreground. The print, which was produced using gum bichromate, makes the smoke opaque and heavy, hewing it into shape as though it was still coal. The dark spirals hang obstinately at eye level, hiding the palace, so that all that can be seen are a few gleaming streaks of the façade. Demachy employed two techniques to produce this image. He made use of the smoke to set a screen between himself and the palace that he was photographing, then further emphasised the effect by means of the print's own pigmentary matter.

The pictorialists were keen on printing techniques which allowed for their manual intervention and, above all, they favoured 'stripping' techniques which allowed the image to emerge gradually, as the photographer stripped away the excess clutter around it. In the gum bichromate printing process, light darkens the bichromate which holds the pigments, producing an image actually embedded in the layer of pigment. To make the image appear, the surplus matter in which it is buried is then simply washed away with water. The photographer can control how much matter he evacuates from reality by varying the pressure of the jet of water used to dilute it. The 'stripping' was rather like an archaeological excavation in which the photographer dug up an object initially covered by a number of layers, which would vary according to how far distant it was. The object itself was, as it were, a ruin, never more than partially revealed; the portions that had disintegrated would remain unknown for ever.

In the work of unconditional partisans of manipulation, the distancing is an effect of the violent treatment to which they submitted their pictures, brushing, painting, and scratching the surface. An extremely expressionist photograph by Demachy entitled *La Chevelure* (*The Head of Hair*) shows the staring face of a woman whose waving tresses merge into the dark pigment in such a way that one cannot tell whether they are visible or whether they disappear into it. In some cases, it was the substance in the base material used (laid paper, for instance) that imparted a rhythm to the picture, as in Heinrich Kühn's portrait of Stieglitz.

But distancing techniques also played another role, serving the pictorialists' need to establish photography's place within the ranks of the fine arts, with a status to equal that of painting. The screens they interposed between reality and its image, whether natural, optical or chemical, allowed them to work upon the gradations of shading, tones and contrasts, welding the internal parts of the image together into a harmonious, unified whole. So there was a certain ambivalence to these distancing techniques: on the one hand they expressed a relationship between different forces, the *conflict* which, through the picture, opposed the photographer to the reality he was photographing; on the other, they linked the various internal elements of the picture together, consolidating them so as to achieve a *harmony* in the picture. The structure of pictorialist photography in the first decade of the twentieth century stemmed from this interplay between an external conflict and an internal harmony.

The aesthetics of pictorialism evolved rapidly from 1900 onwards. Its second-generation photographers went even further in their application of the techniques of distancing and evacuating reality. The evolution did not take place evenly, but within certain more progressive national schools, such as the American school led by Stieglitz, the Hamburg school grouped around Ernst Juhl and the Viennese school rep-

resented by the 'Clover Leaf' trio, Henneberg, Kühn and Watzek. It was also reflected in the work of certain isolated photographers such as Berssenbrugge in Holland, whose *Amsterdam, bej het Centraal Station* is an oil print produced in 1906 from a snapshot; or Demachy, when he decided to leave his studio and seek his subjects in the street. A turning point in this evolution was reached in the work of Pierre Dubreuil, the most modernist of the French pictorialists.

In 1902, New York became the showcase for international pictorialism. With the co-operation of Edward Steichen, John Bullock, Frank Eugene, Dallet Fuguet, Gertrude Käsebier, Joseph Keiley and Clarence White, Stieglitz founded Photo-Secession, with the aim to 'loosely unite those Americans devoted to pictorial photography in their endeavour to compel its recognition, not as the hand-maiden of art, but as a distinctive medium of individual expression'.[17] The group published an extremely luxurious magazine, *Camera Work*, which carried articles by both photographers (Steichen, Keiley, Demachy) and critics (Caffin, Shaw), together with photo-engraving reproductions of the best American and European works. In 1905, at Steichen's suggestion, the group opened the Little Gallery at 291 Fifth Avenue, dispensing with competitions and exhibition selection committees. The exhibition hall was open to photographers, painters and sculptors alike and represented the spearhead of the European avant-garde in America, mounting exhibitions of the work of Rodin, Matisse, Cézanne, Brancusi, Picasso, Braque and Picabia.

It is hard to pinpoint the real reasons for the new energy manifested by pictorialism during the first decade of the twentieth century, but it certainly coincided with the birth of Photo-Secession and the welcome that it extended to the pictorial avant-garde, and undoubtedly benefited from these transatlantic exchanges. In 1900, Fred Holland Day organised an exhibition devoted to the 'New American School'. It was shown first at the Royal Photographic Society in London and then in Paris. All the great American pictorialists were represented, including Steichen and Coburn, but for some reason which remains obscure Stieglitz was not invited. International contacts multiplied. Ernst Juhl had his portrait taken by the Englishman Hollyer, Stieglitz was photographed by his Viennese friend Heinrich Kühn. Steichen moved to Paris where he made preparations to exhibit the French artists in the 291 Gallery. Meanwhile, in 1904, Coburn, who was a member of Photo-Secession, took up definitive residence in London. Two American women, Anne Brigman and Gertrude Käsebier, were admitted to the Linked Ring, as was Pierre Dubreuil from France, who was currently working for the Belgian Association of Photography. The movements of Frank Eugene typify the ever-closer ties that were being established between the various schools: he had studied in New York, then in Munich, was admitted to the Linked Ring in 1900, helped to found Photo-Secession in 1902 and 1913 went to teach at the Leipzig Academy.

By 1902, American photography had won its spurs and was ready for exportation. When Stieglitz had returned to New York in 1890, he had lamented the fact that 'the American amateur was not producing such fine photographic pictures as his English brother'.[18] Ten years later the boot was on the other foot and the English were singing the praises of the American photographers.

It was probably this need to establish an American identity, and not solely from a photographic point of view, that led

CHARLES ADRIEN
NUDE
Autochrome, 1912.

The pictorialist photographers of the 1910s seized upon autochrome as
a new opportunity for drawing closer to the painting of their own
period, in particular the *pointilliste* style.

Collection Société Française de Photographie, Paris.

EDWARD STEICHEN
SOLITUDE, 1901.
Photogravure published in Camera Work *in 1906.*

Collection Musée d'Orsay, Paris. Cliché des Musées Nationaux.

Stieglitz in 1903, Steichen in 1904, Coburn in 1907 and Paul Haviland in 1910 all, in almost obsessive repetition, to photograph one of the first of New York's skyscrapers, built on a triangular plan and known as the Flat Iron. It was a specimen of American architecture which, as it seemed to cleave the earth and skies, stood as a symbol of America poised to conquer the world. These photographs remained within the tradition of classical pictorialism. Steichen drowned the building in mists and made the most of a slight back light to emphasise the shadows of the trees in the foreground. Coburn used a blurring effect to give life to the passers-by beneath the Flat Iron, whose unbudgeable mass towered above them. Stieglitz, for his part, set up his camera in a neighbouring park and used the snow to obtain the greyish tones that he favoured in his pictures. But something new is detectable in this photograph by Stieglitz. The first thing to strike one is the deliberate opposition set up between the imposing sky scraper and the frail tree trunk which occupies the right side of the picture. The opposition rests upon a number of contrasts: mass–lightness, plane–line, grey–black, But these contrasts are further reinforced by another formal relationship. Stieglitz has not settled for just any tree in the

park. He has chosen the one with a trunk which subdivides into two branches, forming a fork or, from another point of view, two sides of a triangle. In this way, Stieglitz sets up a relationship of forces between the two main elements of his picture, which stand in opposition to one another by reason of a series of formal contrasts, yet at the same time complement each other through the symbolic play of the triangular shape which characterises both of them. It is this relationship of forces, a combination of attraction and rejection, that creates all the internal tension of the picture, whose two parts interact with one another to create not a harmony but rather a clash. On the other hand, given that its strength lies within itself rather than in the old kind of tension that set reality and the photographer in opposition, the image is liberated from the visual axis upon which the photographer constructed it and also from the relationship of conflict in which it was taken. As a result, the structural bases of the pictorial photograph of the first decade of the twentieth century are here reversed: the conflict becomes internal to the picture, the harmony external. Such was the step forward achieved by the second-generation pictorialists; it was to open the door to the previsualising photographers of the first half of the twentieth century.

ALFRED STIEGLITZ
THE 'FLAT-IRON BUILDING', WINTER, 1902–1903.
Printed with bromide.

Through the relationship that he sets up between the building and the tree, visually suggesting the triangular plan that gives the skyscraper its name, Stieglitz invented a new way of framing and structuring a photograph.

Alfred Stieglitz collection 1949. © National Gallery of Art, Washington.

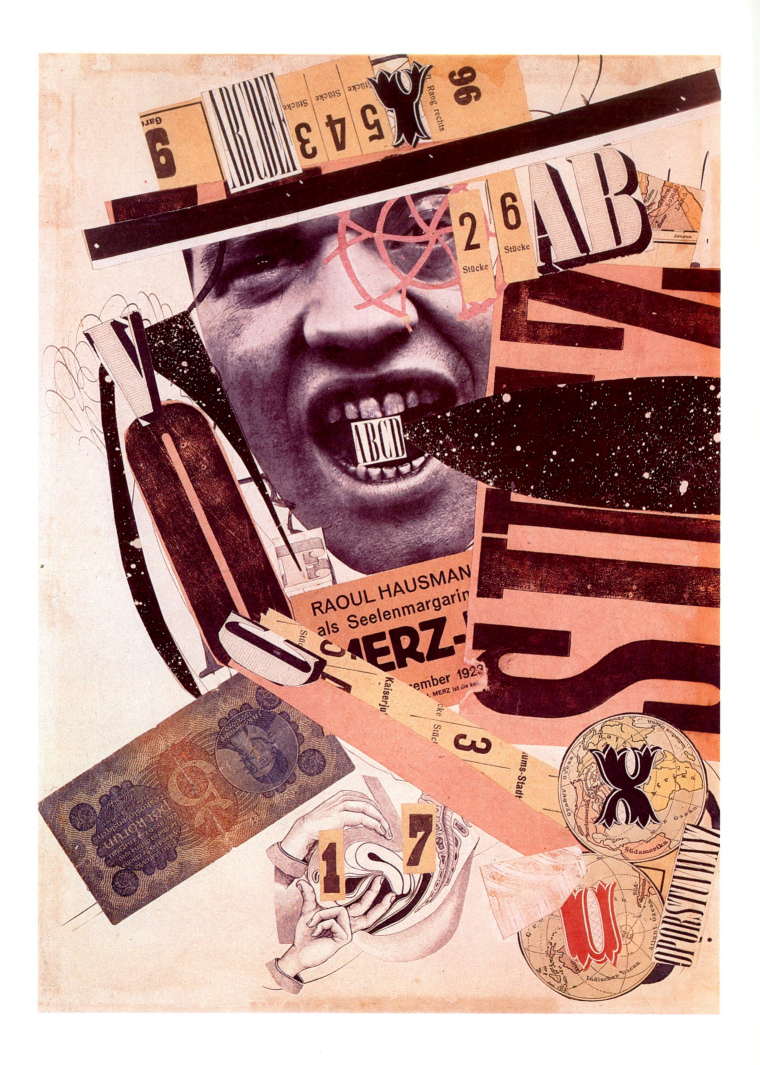

6

Photography, Art and Modernity

(1910–1930)

RAOUL HAUSMANN
ABCD, PORTRAIT OF THE ARTIST, 1923.
Collage on paper.

Collection of the Musée National d'Art Moderne, Centre Georges Pompidou,
Paris.

Just before the First World War photography acquired a new dimension: it entered the avant-garde. It would remain an active, contributing member of the avant-garde for the next twenty-some years. In America this passage was effected through the agency of the pictorialist societies, but the American pictorialist societies did not themselves become avant-gardes. Certain pictorialists like Alfred Stieglitz branched out, pulling photography into a partnership with avant-garde painting and sculpture, and leaving pictorialism behind. In Europe it tended to happen otherwise. Avant-garde artists there sought out the photographer. They did so partly because they saw modernism as necessarily involving the modern media, partly because they wanted to be the ones to make the breakthrough, to forge a new culture with technology, and partly out of friendship.

It should be fairly obvious, even from such a cursory sketch as this, that one ought not to generalise too much about the avant-gardes nor try to collapse them into one monolithic notion of *the* avant-garde. Avant-gardes came in many species; they were forming and allying themselves in various ways for various habitats; the photograph was perforce absorbed and adapted into equally diverse programmes. All avant-gardes were not up to the same thing and neither were all avant-garde photographers. Still, we can isolate and study two general constants in this dense and sometimes contradictory field known as avant-garde photography, or, to put it more accurately, the avant-gardes' photography:

1. Certain photographers needed to join avant-garde groups. They wanted to work separately, with those separatists, on the modernisation of culture and to publish their results along with the rest of the group in what we now call their little magazines.
2. This modernisation of the image is now called modernism. It led painters and photographers alike to work with the modern forms that had been developed for science and industry in order to try to make cultural sense of them. In pictorial terms this meant that they worked with the kind of image called the document.

We can use these two general points, the point about separation and the point about a technologically based modernism, to organise a history of the avant-gardes' photography. The separations and the technological bases will vary from avant-garde to avant-garde but they will establish the ground line to which we constantly return. We can use them to define what an avant-garde photograph was.

We need to begin however at the very beginning of the issue. We need to ask the question, What was an avant-garde? To answer, we need to examine the term itself.

By 1913 the term was used to designate both political and artistic movements wanting to make progress. It had originally been associated with left progress, or revolution, but gradually this meaning was eroded and by 1900 the word could cover any number of political positions, right or left. Only after the term achieved this political polyvalence did the art critics take it up as a regular feature of their discourse.[1] This happened just before the First World War.

In reality the term designated a cultural position that involved a much more complex idea of cultural politics. Avant-gardes were special-interest groups working together to produce a modern culture that would take hold in a free-market society. They tended to establish themselves in small art galleries, little magazines and decorative arts fairs. They worked the channels of private commerce and did not generally desire a close or exclusive relationship with state-sponsored forms of culture like the French Salon. They were independents, entrepreneurs and free-thinking revolutionaries of the marketplace, at least in the West. This meant that they defined their work in order to address the newly arrived, consuming public that shopped, read magazines and furnished its homes. Avant-garde work was put forward in such a way as to get the attention of this public, shake up its already modernising culture of the everyday and to give that culture an even newer form. Avant-garde artists reformed an existing modern culture to arrive at modernism. In the process they reformed the existing modern culture of the photograph.

Once this is understood, the following paradox becomes comprehensible and so dissolves: the photograph acquired a place in the avant-gardes at precisely the same time that it achieved its greatest degree of popularisation. The avant-garde photograph could not have existed without the mechanically reproduced, mass-media photograph; it cannot be understood in isolation from its vulgar but attractive counterpart. They were in competition. To write the history of the one is therefore to write the history of the other.

When in the 1880s it became possible to reproduce the photograph cheaply, illustrated newspapers and magazines moved to convert their images into photographic ones; by 1900 the photograph became associated with the news and the new; it gained greater currency and greater authority. The photograph did all kinds of work for the press, the magazine and gradually even for the book: sometimes it recorded the portraits of luminaries, sometimes it provided scientific evidence to illustrate the latest advances, sometimes it furnished the blunt documentation of the day's newsworthy events; little by little it came to provide the visual core of the advertisement. It was always called upon to furnish a true picture, not an aesthetic version of the truth. Consequently, the mechanical reproduction most prized by the media and the one uppermost in everyone's household reading matter was none other than the document, tailored now to suit a host of occasions, absorbed into the most basic functions of modern life, daily popularised and admired.

When the avant-gardes took on the modern culture of the everyday, expanded their means of production, took up technologically based media and the applied arts and decided to use the little magazine as a forum, it was logical for them, almost without thinking, to embrace a certain kind of photography. It was just as logical that they would not choose this moment to ally themselves with the pictorialists' societies, which wanted simply to elevate the photograph to the ranks of symbolist painting and to practice their photographic art the way fine artists had traditionally practiced theirs. The avant-gardes of the teens and the twenties were predicated on another idea of art practice and wanted other, more modern forms to represent their work. One thing is clear: the avant-gardes were not especially partial to photographs because they happened to mimic the forms of advanced modern *painting*. They were concerned with the kind of photograph using forms that were already deemed *modern* in photographic terms, which is to say, the forms of the documents that were being used to illustrate the mass media. The point is often omitted and needs to be stressed: avant-garde photographers built their photographs out of the most common of formal materials, the document, and did so because they needed to keep up with its modernity,

to criticise it and to surpass it in the eyes of a public conditioned to newspapers, magazines, billboards and brochures. The ordinary mechanical reproduction set the pace for the avant-garde photograph.

In the earlier part of this century all this was known and taken for granted. In 1938 Lincoln Kirstein said as much in passing during an essay on Walker Evans. In his opinion it was advertising that produced the historic alliance between painting and photography; but it is only an ironic aside: 'By 1900, however, mainly through the development of advertising as a "fine art", the photographer had been forced into a position in which his work was presented – in approach, potentialities and achievement – as the equal and even the superior of the painter's, to be criticised on the same philosophical basis.'[2]

It was an alliance produced by a common reaction to a mass-media challenger. It led to the creation of avant-gardes. But this alliance of reaction was temporary. Avant-garde photography never quite became one with avant-garde painting despite their many points in common and their same philosophical basis. There was always a distinction, a residual hierarchy to be maintained; painting took priority. Their collective endeavours within the avant-gardes are best understood by looking at the little magazines where photographs are reproduced alongside paintings but never confused with them. After 1930, when avant-garde groups took a less enthusiastic position on culture by technological means and rallied around another set of cultural debates over ideas of nation, medium and primal symbol, the photograph played a relatively minor role, if any. Yet in that more optimistic period between 1910 and 1930, the photographers' role in the avant-gardes was substantial; some of the best critical writing on modernism took photographs into account and the avant-gardes would not have been the same without them.

The futurists

The Italian futurists manifested themselves officially on the pages of a French newspaper, Le Figaro, on 20 February 1909.[3] Every detail here is significant. The futurists, though committed to the modernisation of Italian culture, had international-sized ambitions. Since Paris was considered to be the principal theatre of action for avant-garde art, they announced themselves there. Typically they exploited the regular mass media for their own purposes, using Le Figaro that time to issue a proclamation. They issued a set of ideals that fit well with the current fashions of the boulevard – the ideal of the speeding automobile, for one, and the aura of progress in any form, from street lighting to the philosophy of Henri Bergson. They placed this beauty of speed embodied in the racing car above the culture of the past; they went so far as to slander the Victory of Samothrace.

The futurists were galvanised by the poet Filippo Marinetti, who wrote the first manifesto and proceeded to gather together a diverse group of artists working in different media, the painters and sculptors Umberto Boccioni, Giacomo Balla, Gino Severini, Carlo Carra and Luigi Russolo. These specialists in the visual proceeded to issue their own technical manifestoes which proposed the modernisation of the means of art in order to give the traditional media a technological progress of their own. Art would then be able to capture other orders of reality: 'The gesture we wish to reproduce on the

canvas will no longer be that of an *arrested instant* in the universal dynamic flow. It will be quite simply *dynamic sensation itself*. Everything is in motion, rushing along, changing rapidly. A profile is never immobile before us but is constantly appearing and disappearing. Given the way images linger on the retina, mobile objects are multiplied, changing their shapes as they move, as do rapid vibrations, within the space they fill. Thus a galloping horse has not four legs but twenty, all of them with a triangular movement'.[4] Movement, to put it more concisely, could and should be represented by taking recourse to geometry, staggered lines that gave a good picture of the new optical experience of speed. In the opinion of the futurists, this was the technical problem for all truly modern artists. The futurist technicians were initially fine artists, meaning painters and sculptors. Only in 1913 do we find photographers in their ranks, two brothers, Anton Giulio Bragaglia (1890–1960) and Arturo Bragaglia (1893–1962).

One would have expected their arrival sooner. The futurist painters were, like so many of their contemporaries, students of motion and were familiar with the chronophotographs of Etienne Jules Marey, documents which were in part destined for artists, to help them understand the true nature of movement in galloping horses, twirling ladies, bouncing balls, birds in flight, and so forth. The futurists' fascination with chronophotographs developed out this rather well-established artists' practice. They then went on to apply the lessons of the chronophotographic document in ways that their peers thought radical if not queer: they mixed those lessons with geometry. When they associated themselves with actual chronophotographers, it was not with any of the established professionals: the Bragaglias were hardly run-of-the-mill chronophotographers and would not have been happy to be classed as such. The Bragaglias were experimenting with the technique in order to develop it further into something more than a description of movement, something that had much in common with the futurists' work. Their research paralleled that of the futurist painters; it was begun independently; only eventually did it lead to a kind of affiliation with them.

Beginning in 1911, the Bragaglia brothers worked to find a technique that expanded upon that of Marey, whose writings had been translated into Italian for some time.[5] They took the problem of dissecting movement and distorted its terms; they dispensed with the measurement of regular movement and the determination of its component poses and looked instead at the uneven, erratic movements that could be superimposed on top of one another in the image as the action rolled on in front of the camera. Anton Giulio Bragaglia promoted the technique in print, wrote manifestoes and a book, *Fotodinamismo futurista* (1913). He exhibited the technique in his photographs, notably that of a typist. Here the sensations and snap of the typist are portrayed in a kind of demonstration piece showing modern hands at modern work, dematerialised while they type on a solid, shiny, intractable machine, or, better, pull away from typing at a steady pace, the way an occasional typist does, darting in to punch the right key, drawing back again to hunt before pecking. These erratic hands flutter over the machine; they register on the photograph as a blur, an accentuated, movemented blur that summarises the human nature of movement not by triangular patterns but by a sweep of reflected light and echoing outlines. A. G. Bragaglia's later work considers the entire

human figure in similar terms; he specialised in making the portrait photograph dissolve into motion, hoping to express the sensation, emotion and fine vibration of individual existence.

This kind of decomposition into a field of sensation was close to the research being undertaken by the futurists. The Bragaglias had in fact heard Boccioni lecture in May 1911, when he explained to the audience that his ideal of pictorial dynamism was nothing less than the representation of sensation. The futurist painters, Boccioni included, proposed the use of what they now called 'lines of force' to communicate the fundamental dynamic of the visible world, enveloping and transporting the spectator: 'These lines of force are what we must now draw, to make the work of art a true painting again. We interpret nature by rendering these objects on the canvas as the beginnings or continuations of the rhythms that these objects themselves imprint upon our senses.' This led them they explained, to'the painting of states of soul'.[6]

The work of the Bragaglia brothers on the rhythms of human objects was related to the stated (and well publicised) aims of the futurists but their photographs did not actually depend on the connexion between geometric lines of force and states of mind; they instead tried to represent the state of mind directly through use of the eccentric gesture and the pale blur. In 1913 Marinetti felt their work futurist enough to help finance it and contacts were made with the futurist painters. But the two strands of research on dynamic pictorial form were never fully synthesised, whether because of rivalry, technical difficulty or the lack of real collaboration, it is not clear. It would have been difficult to reconcile the painters' lines of force with the filmy motion registered by the Bragaglia's photographs; in any case the lines of force prevailed. Boccioni would not have photodynamism included in the exhibition of futurist painting held in Rome in February 1913. A separate exhibition for those photographs was sponsored by the futurists the following month and that spring the futurists sat for their photodynamic portraits. This was the extent of the real exchange between the painters and the photographers. By August Boccioni had published a condemnation of photodynamism in the futurist magazine *Lacerba* and the rupture between photodynamism and futurist painting was complete by the end of the year. The Bragaglias continued their work by themselves and after the First World War they were joined by others, like Antonio Fornari, Ivo Pannaggi and Fortunato Depero, who worked with a futurist programme that grew increasingly tolerant of photography.

However brief and unsatisfactory, the union of avant-garde artist and photographer in 1913 has great historical importance. It was the first time that the two worked on the same pictorial problem as artists and equals, on common ground and on the same footing. Each was pursuing a similar idea of the modern picture; each was using the scientific form available in the document as their point of departure.

The American avant-garde

The avant-garde photographer in America was also drawn to the idea of relating line to mind but the picture there took a different, not futurist, form and provided a focus for different cultural debates. The photographer likewise occupied a rather different position within the avant-group, namely, for we are speaking of Alfred Stieglitz (1864–1946), that of the centre.

Stieglitz had been an active organiser in American pictorialist groups for some time, founding Photo-Secession, magazines and the little art gallery at 291 Fifth Avenue, which came to be known by its street number, 291. In 1908 however he struck out into different cultural territory: he took the gallery's exhibition programme into modern painting. With the help of Edward Steichen who was living in Paris and in contact with the international circles of modernism, Stieglitz exhibited Rodin drawings in 1908, Matisse works on paper in 1908 and Picasso works on paper in 1911, this at a time when such work was totally unknown to the American public. The gallery also began to rally and to exhibit a group of American modernist painters, John Marin, Marsden Hartley, Arthur Dove, Max Weber, Alfred Maurer and Abraham Walkowitz.[7] The gallery quickly came to provide a physical and a social space for all those in New York City who cared about the new painting and, since there were not many supporters of this work in America before 1913, the gallery took on the characteristics of a crusaders' cell: sectarian, passionate and fiercely dedicated to principle. The place of photography in this new programme of 291 was not obvious. Stieglitz himself was devoting more and more energy to the care and maintenance of 291 and its 'spirit'; his own photographic production had slowed to virtually a standstill: between 1910 and 1913 he only showed three exhibitions of photographs out of a total of forty-seven. In the magazine Stieglitz put out to buttress the gallery's work, *Camera Work*, photographs still had an important place but beginning in the January 1910 issue reproductions of paintings were permitted. All this contributed to put the photograph into a new, somewhat hazy but identifiably avant-garde perspective that was not of its own making: *it* had no guarantee of a central place even though there was a photographer running the show. In reality its position in this new scheme of things was awkward.

In 1913 Stieglitz acknowledged and clarified this shift in the programme at 291. That same year the International Exhibition of Modern Art, called the Armory Show, a huge, Salon-sized exhibition, introduced modern art to America on a massive scale that 291 could never have managed. Stieglitz himself was not one of the Armory Show's organisers but he did give his public support to it. At 291 during the Armory Show he hung an exhibition of his own work. There was no formal connection between the two exhibitions; Stieglitz's views, for example *The Steerage* taken in 1907, looked plain in comparison with the avant-garde paintings from Europe like Marcel Duchamp's Cubist *Nude Descending a Staircase*, the scandal of the Armory Show. Stieglitz's views of New York, long views of labour, transport and skyscrapers, still used relatively soft focus and soft printing processes. They were a far cry from the hard futurist science of the Bragaglia brothers. But *The Steerage* is now taken to be the masterpiece of American avant-garde photography and Stieglitz's turning point toward modernism.

The Steerage does not look much like an avant-garde painting. Neither does it feature any one of its elements in particular. It draws back to show the mix of the crowd and the criss-cross of the ship's architecture. The brightest element in the piece is the straw hat which reflects white in the upper centre of the picture, its brim cradled in the arching chain-link of the catwalk or 'drawbridge'. It is a view from the first-class deck of an ocean liner into the steerage, perforce a distant view, but the image, Stieglitz felt, was profoundly telling; it is

ALFRED STIEGLITZ
THE STEERAGE, 1907.

Alfred Stieglitz Collection 1949.
National Gallery of Art, Washington.

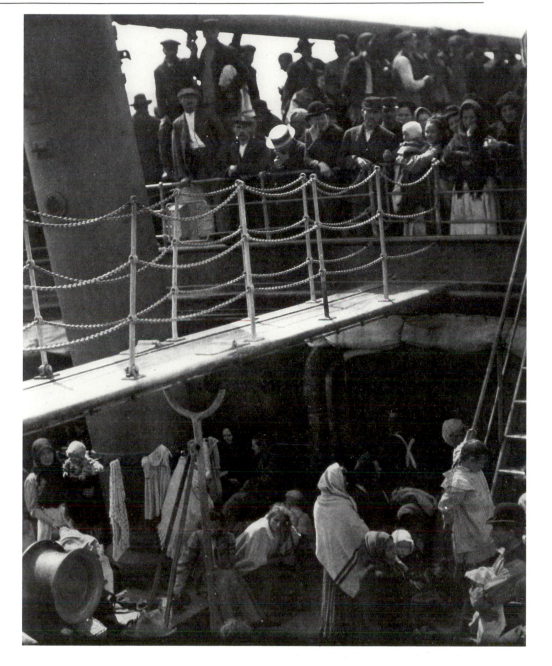

the one for which he wanted to be remembered. In his later years he would speak about the picture in terms that seem somewhat cubist or futurist to us now; he saw it as geometry: 'A round straw hat, the funnel leaning left, the stairway leaning right, the white drawbridge with its railings made of circular chains — white suspenders crossing on the back of a man in the steerage below, round shapes of iron machinery, a mast cutting into the sky, making a triangular shape. . . . I saw a picture of shapes and underlying that a feeling I had about life.'[8] Stieglitz did not lay all this out in writing in 1913. Indeed during that time he wrote little. But in 1913 on the pages of *Camera Work* appeared two essays on photography by his close associate, the critic Marius de Zayas, who put forward the idea that all photography aims to find and determine objective form and that artistic photography takes this one step further, using this form to convey emotion. He promoted Stieglitz's work by writing, 'Stieglitz has begun with the elimination of the subject in represented Form to search for the pure expression of the object. He is trying to do synthetically, with the means of a mechanical process, what some of the most advanced artists of the modern movement are trying to do analytically with the means of Art.'[9] In 1913, the *object* of the photograph, not its underlying geometry, was the part of the picture to be isolated and discussed. The object of *The Steerage* was simply the steerage, an unsentimental complex of spaces, chains and crowds.

After his one-man exhibition at 291, Stieglitz showed no other photographs there until 1916 when he gave the young Paul Strand (1890–1976) a one-man exhibition and published seventeen gravures after Strand's photographs in what would be the last two numbers of *Camera Work*. Stieglitz felt the reappearance of photography in the avant-garde programme of 291 to be significant enough to warrant an explanation, which he provided. He explained the forms in Strand's work in much the same way de Zayas had explained Stieglitz's, seeing first of all the direct registration of the object, and then life: 'For ten years Strand quietly has been studying, constantly experimenting, keeping in close touch with all that is related to the spirit of "291". His work is rooted in the best traditions of photography. His vision is potential. His work is pure. It is direct. . . . Devoid of flimflam; devoid of trickery and any "ism"; devoid of any attempt to mystify an ignorant

public, including the photographers themselves. The photographs are the direct expression of today.'[10]

Strand's *Blind Woman* was one of these direct, brutal pictures. It makes a simple portrait of a blind woman with one eye turned in, one out, a sign and a medal certifying her condition to be legally sightless. The viewer sees her, but she cannot legally see back. The photograph reinforces her position as an object for our gaze: her body is clearly rendered and centred; she fills the frame; she is identified by the signs within the picture; she is unofficially documented. This is hardly the kind of pictorialist photograph for which *Camera Work* had originally become famous but it and *The Steerage* represent the new kind of photograph, a straight, stripped, direct and virtually documentary photograph that in America came to be called avant-garde. It was labelled the straight photograph.

Strand also wrote to argue for the value of this objectivity. He could find it in photographs that showed abstracted, geometric shapes as well as those of down-and-outers. In the war he went to work as an X-ray technician for the army and

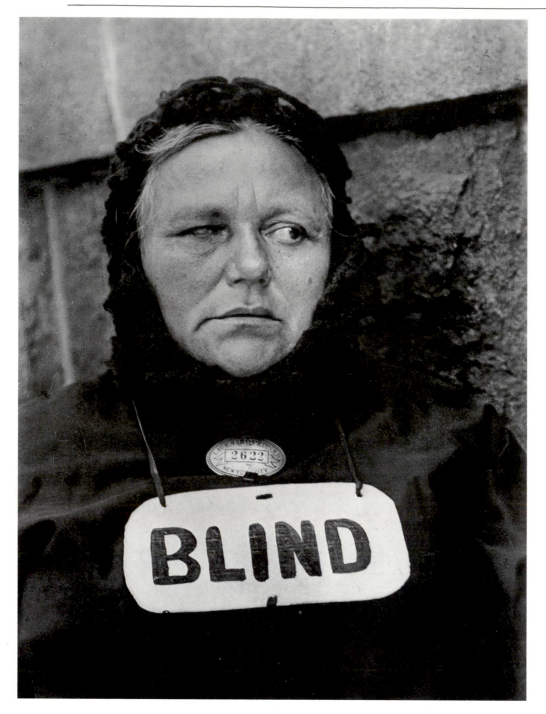

PAUL STRAND
BLIND WOMAN, NEWSPAPER
SELLER, NEW YORK, 1916.

© 1971, 1976, 1982. The Paul Strand
Foundation, as published in *Paul Strand:
Portfolio Three*, Aperture, Millerton, NY, 1982.

Fountains's photograph on its pages together with an apologia for the readymade (urinal): its industrial forms, said the *Blind Man*, were on a par with America's greatest contributions to civilisation, namely her plumbing and her bridges.[12] One could actually claim much the same for Stieglitz's reproduction of the piece: it too is clean, transparently clear and functional; it does not use any flimflam arty forms to describe the object; it is patently using the documentary forms that to the contemporary viewer designated objectivity. It is the quintessential straight photograph. If we are to call it avant-garde and class it with avant-garde painting, we must ask on what grounds.

afterward turned to film-making in addition to photography. He continued to associate himself with Stieglitz and continued to promote the idea of photographic objectivity, usually holding up Stieglitz's work as a model. But he saw the social bases of this objectivity more clearly than Stieglitz did. In an essay of 1923 he drew the connection Stieglitz had been repressing for years: 'Compared to this so-called pictorial photography, which is nothing but an evasion of everything truly photographic, all done in the name of art and God knows what, a simple record in *The National Geographic Magazine*, a Druet reproduction of a painting or an aerial photographic record is an unmixed relief.'[11]

Stieglitz actually made a documentary, Druet-like photograph in 1917 of Richard Mutt's (Marcel Duchamp's) *Fountain*, which had been obscured by the organisers of the Society of Independent Artists Exhibition in New York in 1917. A little magazine called *Blind Man* exhibited the

The forms of the avant-garde photograph in America were not reduced and laid bare in the same way as, for instance, the forms of Matisse's, Picasso's, Boccioni's or Duchamp's images were. Reduction in the modernist photograph meant simplicity, close-up and fragment; it meant the careful description of an object or a person. This could not be obtained by translating avant-garde painting into photography. It was instead distilled from the everyday document. The distillation produced the modernist photograph. The process of distillation varied from photographer to photographer. When in 1917 Stieglitz closed his gallery and discontinued the publication of *Camera Work*, he worked to transform the straight photograph into an aesthetic ideal. He began the portrait of Georgia O'Keeffe, whom he had persuaded to return to New York in 1918 to paint and exhibit there. The portrait of O'Keeffe was conceived as an endless, searching sequence of views that tried to capture her various aspects,

moods, changes of dress and season. It was bound up into their love affair; its exposition becomes passionate. It was by nature an unfinished portrait, the pictures could never adequately do justice to the loved one, but the portrait was continued anyway, in full knowledge of this impossibility. By inscribing this futility into his project, Stieglitz romanticised the document.

In 1923 he took the same serial approach to the photography of clouds. For roughly the next decade he made sequences of cloud formations that he first called *Songs of the Sky* and later *Equivalents*. In this work he was able to expose his forms with such purity that connoisseurs of modernism could see his photographs belonging to the same modern aesthetic as avant-garde painting; though all the while the photographs assert themselves as documents too, objective *and* aesthetic, true *and* beautiful.

Stieglitz immediately wrote an article to explain this work, all of it 4 × 5 inch contact prints, direct impressions which because of their small size tend to reduce the sky to wave patterns of sun, moon and cloud.[13] He explained that they derived from studies of clouds he had made in Switzerland in 1888 at the very beginning of his career in order to examine the landscape in pieces, *comme il faut*, to get the exposure times right for the different sections and eventually to assemble these studies into a full-scale composition. The *Equivalents* are extensions of study documents. At the same time however in the waves of atmosphere Stieglitz inscribed a higher order of form that aestheticians like Clive Bell called significant form, the kind of form that sometimes resembles geometry and always produces aesthetic emotion. The *Equivalents* are meant to make the bridge from form to feeling, a bridge similar to the Futurist project to move from lines to states of mind. But Stieglitz's means are different from theirs. Stieglitz's significant form cannot be seen as lines *per se*, like the diagram from a contemporary book on *How to See Modern Pictures*; the forms are apprehended as a meaningful tonal pattern whose sum awakens feelings, the same aesthetic emotion that the author of *How to See Modern Pictures* claimed could be received from the harmonies of his diagrammatic lines. Stieglitz recounts in his article how the composer Ernst Bloch upon seeing the first *Songs of the Sky* exclaimed, 'Music! Music! Why man, that is music!' The *Equivalents* lay out small sections of the universe, giving it a pictorial order that has a reassuring regularity, a discernible pattern, here a bright point of sun set between the scallops of a cloud. It is not a particularly geometric order, not the hard-edged circle of a straw hat and not a studied field of lines of moving force. It is, rather, a document of an order that can be only generally understood, not measured out into so many triangles. The photograph offers the abstract kind of truth; it puts the modern media and its significant form into touch with universals. With the *Equivalents* Stieglitz endowed the document with a traditional kind of grandeur, the old-fashioned kind of abstraction and an aesthetic legitimation.

This separated his documents from the ordinary. It was however a nineteenth-century-style avant-garde separation which used art to take its distance from a despised bourgeoisie. Stieglitz wanted the *Equivalents* to transcend the common experience, just as they transcended the common modernity. He wanted to transcend the social roots of the document and in so doing he forced the document into a contradictory position. It was still a straight photograph but all documents were straight photographs. To make them art,

ALFRED STIEGLITZ
EQUIVALENT, 1930

Zabriskie Gallery Collection, New York.

Stieglitz had to deprive them of their essential usefulness. Stieglitz could not countenance a hybrid picture that applied art to some useful purpose. In his mind it was all aesthetic or it was nothing. This kind of avant-garde art however was anachronistic in comparison with that of his European counterparts, whose documents kept their functions and their art together.

Stieglitz kept up his photography in the twenties. At the same time, in 1925, he opened another gallery called The Intimate Gallery and later, when this closed in 1929, he opened An American Place. Modernist painting and modernist photography were hung together there as separate but equal work. The galleries were not this time bolstered by a review directed by Stieglitz but it was no longer necessary. Modernism did not need to be promoted in the same way any more; support for it could even be found in the trade press and after 1929 in the Museum of Modern Art. Stieglitz's galleries still provided a meeting ground for artists and amateurs and Stieglitz himself became the touchstone for a whole generation of aspiring young photographers like Charles Sheeler, Edward Weston, Walker Evans and Ansel Adams, who made pilgrimages to see him and felt it necessary to pay their respects to him, whether they agreed with his brand of photography or not.

Before his meeting with Stieglitz in 1921, Edward Weston (1886–1958) worked first as a pictorialist photographer in California and then started to make straight photographs, including a group of pictures showing details of industrial architecture. Stieglitz encouraged him to continue the straight work and Weston recorded Stieglitz's words of advice in his day book: 'A maximum of detail with a maximum of simplification.'[14] Weston kept on with straight photography, renovated his technique, sharpened the focus, worked to get the maximum depth of field and perfected the kind of image for which he is now remembered. Stieglitz did not particularly take to this newer work. Still, his work and Weston's share

EDWARD WESTON
EXCUSADO, MEXICO, 1925.
Printed from silver salts, 24 × 19 cm.

EDWARD WESTON
ANITA NUDE, 1926.
Printed from silver salts.

2 © 1981 Arizona Board of Regents,
Center for Creative Photography, Tucson.

many of the same values: the belief in plain, sharp, objective views and the same unspoken faith in the document.

Weston actually worked out his straight photographs within another avant-garde context, the one which grew up in Mexico after the Revolution and included Diego Rivera, Jose Orozco and Tina Modotti. He lived between this Mexico and California between 1923 and 1927. He did not join any movement in Mexico but he socialised with Rivera's circle and was flattered by their praise of his photographs. These covered a range of subjects, portraits and landscapes mostly, but they establish Weston's lifelong preoccupation with the thing itself, things like pieces of rock, dunes, shells, halved artichokes, the human anatomy and bell peppers. The basic principles, the radically simple forms scaled to fit comfortably into the picture frame, the frame detaching these forms from their earthly context and the apparent suspension of the object that results, are all there to be seen in 1925 in his Mexican photographs, like his newly polished toilet bowl, *Excusado*, and the crouched *Anita Nude*. They represent Weston's idea of the modern photograph.

The *Excusado*, Weston wrote in his daybook, has no irony about it and nothing of the *Fountain*'s attempt to criticise fine art culture by countering it with the industrial. He regarded the toilet bowl as a significant form, or in his words that day, an 'absolute aesthetic response to form. . . . Never did the Greeks reach a more significant consummation to their culture, and it somehow reminded me, in the glory of its chaste convolutions and in its swelling, sweeping forward movement of finely progressing contours, of the *Victory of Samothrace*.'[15] This is a far cry from futurism but it was Weston's avant-garde position in 1925, a position that wanted precision documents to generate the most traditional aesthetic response. When he photographed the nude, a subject with a long historical tradition in painting, the same attitudes toward the image itself appear. The nude was Anita Brenner, whose book *Idols and Altars* Weston would be commissioned to illustrate the following year. His response to her form was also written into his daybook in the same, significant vocabulary, 'And then appeared to me the most exquisite lines, forms, volumes. . . .'[16]

Weston however did not much care for the potential of his medium to wander off into universal abstraction. He prized its realism, meaning by this a denatured, aestheticised realism. It was never the social realism of his Mexican colleagues. Weston's avant-garde position was an American one, based on the significant forms of the straight document and formulated long distance in Mexico, on a tangent from Stieglitz.

The modern document

This circling back to the document, whether it is called a chrono-photograph or a straight photograph, seems strange to us now. For one thing, we have no reason to be especially interested in the cultural potential of the document; our own scientific, political and newsworthy events tend to be filmed rather than photographed. Those photographic documents that we do still need to use as documents are not special events. It takes an effort to think back to the time when the document was fresh, modern, extraordinary and, at its best, a marvel. In 1910 the photographic document was all of those things. It attracted the avant-gardes, who in turn worked the

form of the document and tested its hidden powers. It seems fitting therefore to inquire further into the state of the document, to investigate it as a historical and pictorial form in its own right and to see how, uninflected by any aesthetic or avant-garde urges, it was developing its own rhetoric of the image and setting a certain standard.

Let us take the definition of the document cited on the occasion of the Fifth International Congress of Photography held in Brussels in 1910: 'A documentary image must be able to be used for all kinds of studies of nature . . . [The] beauty of the photograph is of secondary importance; all that is required is that the image should be very clear, detailed and carefully produced so as to withstand the ravages of times as long as possible.'[17]

It is a loose definition. It does not enclose the document within a battery of rules for form. The document became a document by virtue of the fact that it was used for some kind of technical work. In theory apparently all that it took to make a document was a certain amount of attention to detail and focus. In practice the document's technical functions determined the degree of liberty that could be taken with its form. So, in 1910, we can isolate the existence of various documents which can be divided after a fashion into genres: the architectural document, the nature study, the X-ray, the chrono-photograph, and so on. We can also recognise the existence of photographers, many of them anonymous, who specialised in the production of this and that genre of document.

Eugène Atget (1857–1927) was one of these. He devoted his entire career to the production of several kinds of documents at once. He had no desire to try his hand at pictorialist photography and, when given the opportunity in 1926 to ally himself with an avant-garde, the surrealists, he agreed to let them publish some of his pictures but he did not

EDWARD WESTON
NUDE ON AZOTEA, 1925.

allow them to use his name. He preferred, it would seem, to remain the photographer who made documents. It behoves us to take them as that and reckon with their innumerable virtues as a function of that form.

Atget was trained as an actor but by 1892 he turned from this to become a photographer of documents for artists.[18] Around 1897 he began his traffic in documents of Vieux Paris, that is, topographical views, architectural details and studies of local custom. At the same time he made landscape documents of which his *Ombelles* is one. It is a picture of two flowers and the space between them; the space between the two specimens is centred, the specimens de-centred. The nearer flower is shown in sharp focus; it is the one being well documented. Its details are attended to, its silhouette is perfectly legible, its profile punctuates the dull stone wall. The lens and the plate negative are set parallel to its stem so that the flower, stem and topmost leaves are seen head-on, the pose that reads 'without distortion'. The formal means of the photograph are used to give the straight picture of the flower. A more perfect image of the plant's anatomy could be taken by setting up a flat, neutral background behind the plant, taking it out of nature and launching it into a diagrammatic field, ready for abstraction. Atget ordinarily documented the thing in the world rather than the isolated thing itself. His wordly *Ombelles* belong to the great body of documentary

EUGÈNE ATGET
OMBELLES, before 1900
Printed with a gold tone, 24 × 18 cm.

The Museum of Modern Art Collection, New York. The Abbott-Levy Collection, partial gift of Shirley C. Burden.

photography that was being assembled for all kinds of abstract purposes during this period. We can take the *Ombelles* to represent the rest.

The *Ombelles* could serve as a document for a landscape painter wanting to study the pieces of a landscape in some detail before incorporating them into his larger painted view. The same picture could also provide a document for the decorator wanting to study nature in order to devise a floral ornament. Atget knew all of this and made a picture that he could sell to both, a picture for two kinds of futures, two kinds of looks, two different ways of seeing. The picture double-functioned. The same is true for most of Atget's documents. Sometimes the same forms in the photograph contain the functions for the various looks; sometimes the functions are spread across the picture, leaving gaps and peculiarly empty spaces between them – for example, *Au Tambour*, which served some of Atget's client viewers as a picture of a sign and some others as a picture of cabaret life which began with the figures in the doorway. Atget spent his career as a photographer tinkering like this with the forms of the document, pushing the functions into one another or pulling them apart. This practice resulted in extraordinary, oddly flexible documents, marvellous enough to draw the attention of the surrealists.

It was through the surrealists, specifically Man Ray and his then studio assistant, Berenice Abbott, that Atget was rescued from anonymity and his work entered into that part of the cultural field that has a written history. When Atget died in 1927, Berenice Abbott saw to it that his studio archive was saved (it is now in the collection of the Museum of Modern Art in New York) and she also superintended the publication of a book of his photographs, *Atget, photographe de Paris*, in 1930. The book realises Atget's own fantasy of authorship: he had always geared his documents toward the possible publication of a book, though this never materialised.[19] But Abbott's Atget book has had another effect on the history of photography: it prompted Walter Benjamin to develop his notion of a modern exhibition value, first in his book review, *A Short History of the Photograph* in 1931, and then at greater length in his essay *The Work of Art in the Age of Mechanical Reproduction* in 1936.[20]

Benjamin's history of the photograph, though short, has been enormously influential, enough so to warrant citing it at length. In the twentieth century this history was started with Atget: 'He was the first to disinfect the suffocating atmosphere with which all the conventions of the photographic portrait smothered a period of decadence. He purged the atmosphere, better still he purified it; it was he who liberated objects from the aura, and that is the most undeniable merit of the most recent school of photography.'[21] In point of fact, Benjamin describes not only the work of Atget and the avant-garde photographers but that of the documentary photographer generally, the photographer whose business it was to sell pictorial sections of the world. The sections were always fragments, cleaned up a bit, regularised and centred. Usually they were captioned or, as Benjamin would say, made literary. Benjamin used Atget's photographs to illustrate his point about the significance of the document and its exhibition value, but others could have served just as well to make the argument.

Exhibition value is by definition the essential quality of the document. Benjamin's insistence upon exhibition value can be used to speak for a much broader cultural phenomenon, the

EUGÈNE ATGET
AU TAMBOUR (At the sign of
the Drum), 1908.

Collection Caisse nationale des
Monuments historiques et des Sites,
Paris.
Atget/ © Arch. Photeb.
Paris/SPADEM

general desire to make greater sense of the document, the tendency to see it as the modern image *par excellence* and the otherwise inexplicable necessity for the avant-garde photographer to pay attention to the work of Atget and his kind. 'It becomes daily increasingly important to seize upon the object as close up as possible, both in the image and, above all, in the reproduction,' Benjamin concluded, but the reproduction of the object already had a history and a cultural place which was not primarily aesthetic.[22] At the same time that the document became a primary form for avant-garde work, it was taken up, quite independently, by the ad-men making publicity images for commodities. They turned exhibition value into advertising.

Advertising

Illustrated advertising was one of the great contributions of the late nineteenth century; it constructed a highly refined rhetoric of the image that survives to this day.[23] Initially advertisers employed a number of visual aids and means. The poster is the best known of these but there were also illustrated calendars, catalogues and printed space rented out in the regular press. By 1910 the ad-men recognised that the art nouveau poster was not an especially effective means of convincing a person to buy goods: the sales pitch had become tangled in the vines and curls of the design; the brand advertised had been eclipsed by the art.[24] Consequently the

advertisement was clarified, a new hierarchy of values was established and the commodity was shown first and foremost, isolated, centred, identified, indisputably branded. As one French ad-man insisted, there was a new rule to be followed: 'The advertisement publicises not the qualities of the thing that it recommends, but that thing itself.'[25] The picture of 'the thing itself' already existed, of course, and it, the document, was too perfect. It made eminent sense for the ad-men to appropriate the truth-telling document, full of absolute exhibition value, to persuade the viewer not only to buy but to believe in 'the thing'. The habits the viewer had already acquired by looking at documents would be transferred to the advertisement. The results were most satisfactory.

The ad-men were not content simply to appropriate the document. They were developing a regular science of persuasion through which a combination of text and image was used to work on the psychology of the viewer, producing a certain, preferably acquisitive state of mind. Advertising manuals went to some lengths to deal with this matter in terms that rival the technical manifestoes of the futurists. Initially the ad-men were working with the drawn image and the most prestigious advertising campaigns employed artists, not photographers, to do the visuals. But by the 1920s the photograph acquired status in the eyes of the ad-men and presumably in the eyes of the public as well. One was as good as another as far as the work of advertising was concerned. The pictorial theories in the manuals did not discriminate

LASZLO MOHOLY-NAGY
GLETSCHERSPALTE (Glacier crevasse), about 1931.

Collection Stedelijk Van Abbe Museum, Eindhoven.

between the media: they were applied to drawings and photographs, avant-garde and kitsch.

Those laws did not arrive by themselves. They were taken from the work of design theorists, the same source used for much avant-garde work on pictorial theory. The ad-men took this theory and outside of any avant-garde, often in advance of the avant-gardes, refined their own notions of significant form. In much of their work they sought the psychological significance. Consider, for example, the theories of an American ad-man named Harry Hollingworth: 'Mathematically,' he wrote, 'lines are lacking in quality as they are in width, but psychologically, even the simplest line, as it appears in sketching, has both feeling tone and symbolic significance. This feeling tone of lines can be utilised to advantage in representing advertised articles by both relevant and irrelevant cuts, and should be considered in the appropriate selection of type faces.' A little later he summarised: 'The lines, forms, relations, colours and distribution of elements should so far as possible reflect the character of the goods or the mood desired in the reader.'[26] The advertisement, then, was co-ordinated and its effect calculated. It was meant to have an emotional and unreflected impact on the viewer but this impact could be decoded and diagrammed in much the same way that Roland Barthes was to dissect a Panzani ad fifty years later in order to theorise a general 'Rhetoric of the Image'.[27]

Many of the techniques of the advertising photograph – photomontage, aerial shots or strange perspectives, odd juxtapositions of scale, the appeal to emotion, the straight photograph of the thing itself – had been visible in the illustrated magazines since 1900.[28] The document was implicated in both advertising technique and regular illustration. It enjoyed considerable prestige. Still, the adoption of these techniques and these assumptions about the image by the avant-gardes is really a postwar phenomenon. Once they were adopted by artists, a certain confusion was created over where the boundary between the significant form (art) and regular photography (the document) really lay. We can now safely say that the boundary was illusory, that the avant-garde photographers, even Alfred Stieglitz, were by and large working with the current rhetoric of the modern image, a rhetoric exhibited by the document and the document–advertisement and a rhetoric that grew to have not only exhibition but a peculiarly modern kind of aesthetic value.

The confusion between art and everyday life is evident on many fronts. In February 1922, Edmund Wilson told his good bourgeois readers in *Vanity Fair* that dada was laying hold on US advertisements and using them as models. He noted however that the electric signs in Times Square made the dadaists look tired.[29] In 1925 Laszlo Moholy-Nagy took an advertisement from the September 1922 issue of the same *Vanity Fair*, a regular ad for vacuum cord tyres that has a tyre making a triumphal arch over a busy city street. Moholy-Nagy used it as a model for students at the Bauhaus, though it must be said that to present it as a model photograph he cut away the English text and the featured 'Sound of Safety' cup.[30] But the model is identifiably secular, commercial and businesslike.

The avant-garde's famous separation from the regular cycles of bourgeois culture was often not radical; many of their formal innovations are best understood as extensions of ideas already in circulation. The extensions could turn to critique

LASZLO MOHOLY-NAGY
FOTOGRAMM, 1925–1929.

Collection Kunstbibliothek mit Museum für
Architektur. Modebild und Grafik-Design.
Staatliche Museen Preussischer Kulturbesitz,
Berlin, GFR.

(Stieglitz's document of Duchamp's *Fountain*) but they could just as easily turn to idealisation (Weston's *Excusado*). Often they could be taken as both commercial art and high culture. The avant-gardes worked with the same materials as everyone else. They worked to distinguish themselves, by banding into groups and by taking those materials further than most in order to promote a particular vision, a future for modern culture. The avant-gardes were basically energetic progressives. Collectively they pulled the photograph in several directions at once.

The avant-gardes in Germany

A number of avant-garde formations in postwar Germany sprang up, some working as incendiaries in shortlived galleries and magazines, others adopting more commercially viable forms of expression and soberer postures. The map of postwar modernism in Germany is dotted with activity but only two of the many avant-gardes will figure in this chapter since the history of this period is taken up elsewhere in this book. The two, Berlin dada and the Bauhaus, could not be more different from one another. The former was a small, mobile, highly politicised protest movement which worked in the negative to denounce the ways and means of bourgeois culture. The latter was a collaborative reform effort by artists, decorative artists and architects who in 1919 founded a school and a small company that was intended to produce a new level of industrial design, to provide a healthy décor for modern life and to improve its quality. The Bauhaus had the greater effect in the long run, mostly because it produced a generation of students who carreid on its precepts, notably to America where a new Bauhaus was established in 1937 four years after Hitler closed the old one down. Yet at the time of their inception both avant-garde groups were competing cultural forces concerned to make an impact on the present. In this context both saw fit to redefine the illustrated printed page, the mechanical reproduction, the received image. This is where we find the avant-garde photographer, the revolutionary and the reformer, at work.

Laszlo Moholy-Nagy (1895–1946) was a Hungarian painter who moved to Berlin in 1920 and came to teach under Walter Gropius at the Bauhaus in 1923, where he was put in charge of the metal workshop. He had begun to experiment with a constructivist-inspired photography in 1922 and is probably best known for his work as a photographer but he never actually offered a course on photography at the Bauhaus. Photography was only taught, there beginning in 1929, by Walter Peterhans, after Moholy-Nagy had left.[31] Nevertheless, Bauhaus photography is tied to the name of Moholy-Nagy, though we should acknowledge the work of his colleagues, Lux Feiniger, Umbo, and Lucia Moholy.

In much the same way that the Bauhaus as a whole directed its energy toward the construction and furnishing of the building (the *Bau*), Moholy-Nagy placed Bauhaus photography into the larger problematic of the picture: Where would the picture fit into modern industrial culture? What transformation or remodelling would be necessary? What would the new picture do? How would the new picture make sense? His work on photography is very much in keeping with the other research at the Bauhaus, research into new materials and new combinations for the new functions of modern life. Moholy-Nagy used the photograph to help him with his

KARL BLOSSFELDT
IMPATIENS GLANDULIFERA; BALSAMINE, SPRINGKRAUT, 1927.
Silver salts print.

Courtesy Galerie Wilde, Cologne.

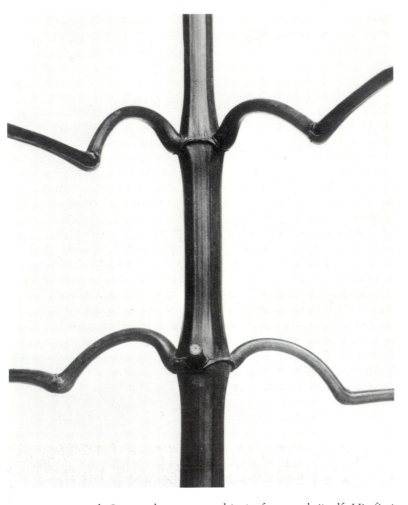

research. It soon became an object of research itself. His first set of findings was published in his Bauhaus book of 1925, *Malerei, Fotografie, Film.*

Photography was only one of the options for the modern image, Moholy wrote. It had its own special potential because of the particular qualities of the medium, its ability to give an objective picture and its spectacular use of sheer light to register this image in an instant. This led him to the following speculation: 'Thus in the photographic camera we have the most reliable aid to a beginning of objective vision. Everyone will be compelled to see that which is optically true, is explicable in its own terms, is objective, before he can arrive at any possible subjective position. This will abolish that pictorial and imaginative associative pattern which has remained unsuperseded for centuries and which has been stamped upon our vision by great individual painters. We have — through a hundred years of photography and two decades of film — been enormously enriched in this respect. *We may say that we see the world with entirely different eyes.* Nevertheless, the total result to date amounts to little more than a visual encyclopaedia achievement. This is not enough. We wish to *produce* systematically, since it is important for life that we create *new relationships.*'[32] Moholy-Nagy expected the document to create these new relationships and his book, like a primer, instructs the reader in the points of departure. The mechanical reproduction, he would say, should be produced each time anew, creating while producing and opening up new possibilities for human experience.

The photogram is one such image. Moholy-Nagy began to experiment with it in 1922. The photogram is nothing more than a direct print made by placing objects on a piece of photographic paper and then exposing the assembly to light in order to print the image. It exhibits these objects, here a little Eiffel Tower in a dark galaxy of unidentified geometric shapes. The photogram has visible affinities with the X-ray but they are superficial: the picture only looks scientific. But by virtue of its scientific look it seems to relay something about the inner life of inanimate objects, as if there were more to objects than meets the eye.

At the same time Moholy-Nagy was perfectly capable of using the photographic document as a straight reproduction to illustrate a point. His close-up of a Paris street pump exhibits the material properties of the elements, metal, paving stones and water, as they interact with one another in the gutter.[33] Like the photogram it is an investigation into matter. This is not unlike Karl Blossfeldt's investigation of nature in his book *Urformen der Kunst* (1928), where plant structure is studied, diagrammed and served up as a rarified but natural ideal. But Moholy-Nagy usually saw more than this in the photograph. Typically he extended his meditations on the document to a consideration of the industrial culture that was outstripping art as well as nature. Nature for him was simply a raw material for art and industry alike, a material to be seen with a camera, worked on and converted to the new vision. His hopes for the photograph have much in common with those nineteenth-century savants who saw the camera as a third, superhuman eye, an eye for scientific and industrial progress, an eye geared toward production.

There was yet another point to these theories of Moholy-Nagy. He was searching for ways to modernise the document and to give it a place among the new, functional pictures that were emerging from the Bauhaus studios. He did not propose decorating rooms with documents; that was a job for painting. Rather, he proposed to put the photograph to work at something he called typophoto, a happy combination of word and image that would revolutionise the rhetoric of the image and the printed page. By mobilising typeface and picture together, he hoped to make a more flexible text capable of greater, more beautiful and more economical communication. His thinking on the subject lags behind that of the contemporary ad-men like Harry Hollingworth but Moholy-Nagy was working on the same commercial art problem, a significant form capable of exact communication, something that could induce a state of mind. But typophoto did not in its ill-defined state have much impact on the development of the regular commercial image. It remained one of Moholy's projects, a vision.

Moholy-Nagy's research on typophoto was inconclusive, though one can say that the photo end of the problem revolved around the document. Moholy singled out the document as the form for the photograph of the future. He would have the document stretched, tipped, inverted and extended to the very limits of its ability to function as a socially acceptable image. His book sets out these forecasts for the future and at the same time embodies the principles he expounds. It is simultaneously a tract, a collection of good work by himself and others and an attempt to predict mass culture. It also sets out the basic principles of modernist photography with enviable clarity.

Meanwhile in Berlin in 1918, a group of dada artists, Richard Huelsenbeck, Raoul Haussmann, George Grosz, Hannah Höch, Johannes Baader, Wieland Herzfelde and John Heartfield, had gathered together and had begun to issue manifestoes, almanacs and exhibitions. They were committed to the revolutionary destruction of bourgeois culture and promptly seized upon bourgeois photomontage for their purposes. They took the photomontage principle and perverted it, cutting apart the received image, typographic as well as photographic, to mount satires of the smooth talk of the regular press. *ABCD* by Raoul Haussmann is a late but typical example of this strategy, a construction that deconstructs, a typophoto in reverse. Haussmann put his own head into the picture; gravel and calculated nonsense spout from his mouth (it is his poem *ABCD*).[34] One could say that Haussmann's own dada performance is depicted but it is also in the process of being disrupted by its competition: tickets for the emperor's jubilee sit in the same space as an invitation to one of Haussmann's appearances at a (dada) Merz evening organised by Kurt Schwitters. There is no ground, no perspective, no particular order: the alphabet begins and ends in a different typeface; somewhere along the way it has lost its middle. The globe and the obstetrical diagram further confuse the frame of reference. None of this resolves itself into a soothing significant form. Unity is impossible. The cuts in the image are too severe, the remains too fragmented; the point anyway was to spread chaos, to destroy the objective field and the authority of the printed page.

Instead of encouraging an aesthetic emotion in the viewer, the photomontage cut the viewer's emotional response into bits and sent out dislocated shocks. The shocks are twofold: they result from the desecration of the modern mechanical reproduction and from the absence of any traditional notion of art. Eventually John Heartfield was able to take this shocking photomontage and to make an extended critique of fascism with it. In the early twenties the dadaists did not yet have this skill but their violent dissent from the ideal of the document is consistently maintained. Their dissent is far more than an artistic position; it aims to inspire a cultural revolution. They saw the document as part of a political act.

French photographers and the avant-garde

The position of the avant-garde photographer in postwar France varied greatly. Some, like Man Ray and J.-A. Boiffard, worked closely with an avant-garde while simultaneously maintaining a commercial studio. Others, like André Kertész, Maurice Tabard, Germaine Krull and Emmanuel Sougez, worked around the avant-garde groups, photographing in line with some of their ideas but never settling down into a group. Advanced French photography moved back and forth between art and commerce, often blending the two. This made for a dynamic and extremely rich photographic culture, one that can be found on the pages of little and big magazines, in art gallery exhibitions and in the most classic private settings, in framed family portraits.

André Kertész (1894–1985) was a Hungarian, like Moholy-Nagy, but began his career as a photographer proper and remained a man of his medium to the end. He made his way to Paris in 1926 and set up shop as a portraitist and magazine photographer. He never signed on with any of the

ANDRÉ KERTÉSZ
DERRIÈRE NOTRE-DAME
('Behind Notre-Dame'), QUAI DE
BERCY, PARIS, 1928.

Collection Musée National d'Art
Moderne, Centre Georges Pompidou,
Paris. DR.

ANDRÉ KERTÉSZ
LA FOURCHETTE ('The Fork'), PARIS, 1928.

Collection Musée National d'Art Moderne, Centre Georges Pompidou, Paris.
DR.

Parisian avant-gardes; he simply fraternised with them. His work was understood to be generally innovative but difficult to label; someone called it 'surréalisante'.[35] Kertész was difficult to pin down but the fact remains that he worked with the same kinds of photographic problems as Moholy-Nagy, pushing back the limits of the document, taking pictures with aerial perspectives, diagonally patterned forms and difficult light. Unlike Moholy-Nagy, he did not speculate on the meaning or the future of all this; he just made the pictures, for the record, for commercial use and for exhibition.

Kertész was given a one-man show in a small Montparnasse gallery, Le Sacre du Printemps, in 1927. He exhibited in the first Salon des Indépendants de la Photographie in May of the next year with Berenice Abbott, d'Ora, Laure Albin-Guillot, Hoyningen-Huene, Germaine Krull, Man Ray and Paul Outerbridge, with retrospective sections of work by Nadar and Atget. Kertész's *Fork* appeared in this exhibition. He remembered later: 'There was a big controversy by a fashionable French photographer, who declared that everyone could take a picture of a fork and plate, but one publisher declared, "Yes, but Kertész made the first." *La Revue Hebdomadaire* wrote, "This was the only pure art work in the exhibition."'[36] But Kertész had built ambivalence into this picture: it was also used, with some additional, explanatory text, to advertise cutlery.[37] His *Fork* led a double life, moving across the border between art and commerce because it was a study of a fork, an off-centre but carefully composed document of the arched tines and the streamlined handle, whose simplicity was registered in the picture and pressed into service twice.

Kertész was to make a career out of his ability to unpretentiously register images like the fork. This has made for a series of beguiling pictures whose significance is built from documentary forms but whose effects were never codified. Kertész used a Leica for much of this work, which made his documents seem spontaneously generated, not hatched from some theory equating form and mind. Photographs like his do not however take themselves. The kind of order Kertész brought to the photograph can be seen in the series of photographs he made in 1933, the *Distortions*. The *Distortions* are shot from the reflections off a distorting mirror, a registration of an already registered image and as such the straightest of photographs. In the mirror Kertész posed the reflection of a female nude so that her anatomy becomes bloated and blurred in the calves and knees, but detailed and

normal-scaled elsewhere, notably her hands. The picture demonstrates very well just how the unified screen of any photographic negative is actually the sum of many visual signs; it is read piecemeal through the significant details, not as a single visual plane. The *Distortions* reveal the real unevenness of the photographic representation; they show the photographer's favouritism. Here this favouritism is confounded with the female body: the favoured hands stand as the sign for female sexuality. It is hardly an innocent picture. According to this photographer the straightest photograph can contain a distortion, that is to say, a subjective position.

The surrealists seized upon the direct registration and the mechanical reproduction, though they were certainly not the only avant-garde in Paris to do so; we could easily turn to the purists for another case in point. However surrealist photography actually grew out of a long cogitation on the nature of the visual. The photograph emerged from this cogitation as the picture which best emplified the realities of the modern image, a picture window whose view had been interrupted and reformed by an artificial industrial language, a civilising pane.[38]

The surrealists organised themselves into a group with a magazine, *La Révolution Surréaliste*, in 1924 and went through several stages of mitosis and permutation. There was always a collaboration between the producers of text and the producers of images and there was always a magazine at the centre of things. The magazines were attempts to make interventions in the larger theatre of the mass media and their intentions were perfectly clear from the form they took. *La Révolution Surréaliste*, for example, copied its design layout from the venerable science magazine, *La Nature*. The surrealists took nothing else from *La Nature*; rather they took apart those and other mass-media forms. They were unsystematic in this but theirs is the most sustained effort at such a critique by any of the avant-gardes.

The surrealists recognised that the photographic image was capable of exhibiting more than the average, prescribed exhibition value. They demolished the notion of exact communication and pointed out the coexistence of different

ANDRÉ KERTÉSZ
DISTORSION 40, PARIS, 1933.

Collection Bibliothèque Nationale, Paris, DR.

LE PHÉNOMÈNE DE L'EXTASE PAR SALVADOR DALI

messages emanating from the same document. They exposed the sexual element in the psychology of the advertiser's theory; they delighted in the document's ability to misfire, to produce mistaken identifications and outright error. Their interest in the document is a tribute to its cultural authority in the postwar period; their analysis led to a technical appraisal of its shortcomings. The surrealists took the instability of the document and gave it an erotic character.

Painters as well as photographers examined the document's forms. René Magritte and Salvador Dali even worked with photographic documents, though not in order to reproduce their paintings. Dali made this layout using others' photographs in order to demonstrate his ideas on ecstasy. The individual photographs are taken from another context; as a surrealist corpus, recaptioned and subjected to an overdose of analysis, the documents begin to create new meanings in relation to one another; they begin to prevaricate, the ears become unhinged. They are exhibiting the fulfilment, we are told, of Dali's desire. Certain of the documents here were taken by Brassaï, but they are not singled out or credited: all the documents have the same value in this demonstration, the exhibition of *Dali's* desire.

Brassaï (1899–1984), a Transylvanian who arrived in Paris in 1923, was introduced to photography by Kertész in 1926. He moved with the surrealists some of the time but not all. Best known is the series of documents he made for the surrealist magazine *Minotaure*, double-edged documents of crystals, involuntary sculptures, female backs and work by Picasso. But his reputation was made by the book he published with a non-surrealist press, Arts et Métiers Graphiques, in 1933, titled *Paris de Nuit*. The book takes a night walk through Paris, certainly a surrealist pastime though

SALVADOR DALI
LE PHENOMÈNE DE L'EXTASE ('The Phenomenon of Ecstasy').
Photomontage which appeared in no. 314 of Minotaure *(December, 1933).*

Collection of the Bibliothèque Littéraire Jacques Doucet, Paris. Ph. © Salvador Dali © by SPADEM, 1986.

BRASSAÏ
THE WALL OF LA SANTÉ PRISON, PARIS, 1932.

Collection of Gilberte Brassaï.

MAN RAY
LE SOUFFLE

From the 'Electricity' portfolio.

Collection of the Bibliothèque Nationale, Paris.
Ph. © Man Ray © by ADAGP, 1986.

others roamed the streets after dark, as the book makes clear. The book points out the nocturnal population on the streets and points out the sights that are only visible after the sun has set. They are sights like the prison wall of La Santé onto which the wintering boulevard trees project their shadows. But the prison wall cannot contain the projection; the silhouette is cut. Brassaï photographed the sight more than once. This particular photograph is not the one chosen for the book, which shows the same wall and the same idea shot from the other direction. The caption Brassaï devised for the idea completes the image: 'It is before the wall of the Santé prison, under the trees of the boulevared Arago, that the guillotine beheads those condemned to death.'[39] One could also read the prison wall as a picture of a natural phenomenon, an 'Urform der Kunst' by night that has lost most of its precision and so loses the viewer, who needs to be guided to get the point. This is the accomplishment of the surrealist photograph, or as Brassaï would argue, of photography generally. In 1932 he wrote a newspaper article for *L'Intransigeant*, explaining that the photograph exhibits and at the same time denies one access to knowledge: 'What attracts the photographer is precisely this possibility of penetrating the phenomena, of denuding their forms. Ah! That impersonal

presence! That perpetual incognito!'[40]

Man Ray (1890–1976) took this perpetual incognito as an avant-garde form and more than any other of these photographers, his work is identified as unimpeachably surrealist, published by them and read in that context. Man Ray's avant-garde activity began during the war in New York and then in 1921, when he moved to Paris, took root there. He joined up with Paris dada, met André Breton and went with him into the surrealist movement in 1924. He worked as a dadaist with the photogram, which he called rayograph, in 1922 and it became a dada form. Man Ray generally took sexually significant objects for his rayographs and played with the X-ray-like qualities of the image to suggest that the photograph could penetrate solid matter and produce a kind of je-ne-sais-quoi. When he became a surrealist, the rayograph became surrealist too. This did not prevent him from using the technique to make a portfolio for the Compagnie Parisienne de Distribution d'Électricité in 1931, appearing to photograph the electric current moving through the object of everyday life, like the fan. The portfolio was used by the company as a promotional device; it also made an advertisement out of the group of rayographs laid out side by side just like dutiful documents.

There could be contradictions like this in Man Ray's work because his career as an avant-garde artist went side by side with his commercial studio business, most of it society portraiture. He gained much practical experience with the ordinary bourgeois expectation for photographs, experience which he used to good effect in his surrealist work. He organised his surrealist photographs into a book, with a preface written by André Breton, published in 1937 and titled *La Photographie n'est pas l'Art*. The book contains twelve photographs, most of them documents, given extravagant titles, though the *Carnet acheté d'un mendiant* is not excessive. The thesis of the title overrides any arty tendencies of the photographs themselves: according to the thesis, the carnet's blots are not to be used as equivalents, or significant forms or prompters of aesthetic emotion. They are what they are, the printed cover of a notebook bought from a beggar. Man Ray points this out in order to unmask the aesthetic rhetoric that had been devised for the document. In effect he calls an end to the avant-garde fascination with the photograph.

The photograph lost its appeal as an avant-garde form of art in the thirties. One can only speculate as to why. Perhaps because the ordinary document had been successfully tamed and commandeered by the avant-garde; perhaps because

MAN RAY
LARMES (Tears), about 1930.

The catalogue for the 'Man Ray' Exhibition at the Centre Georges-Pompidou (1981–2) reads as follows: 'The make-up of the dancer called for these tears (of glass) which express no emotion at all;' detail of the left eye from a photograph which originally showed a French cancan dancer seated on the floor.

Bibliothèque Nationale, Paris.
Ph. © Man Ray — Bibl. Nat./Archives Photeb © Adagp, 1986.

mass culture did not want to be led by an avant-garde. The separation between the forms of avant-garde and mass culture widened into an open opposition. Since the photographer was never really granted the same avant-garde status as the painter, once the painter lost interest in taking over the technologies of mass culture, the painter lost interest in the photographer, at least for the purposes of collaborating on an avant-garde programme. Photographers were left to make other alliances and to find other places in which to do their work. This resulted in different, not so clearly aesthetic forms of photographic practice and in the development of a modern photograph based on the traditions inherent in the medium itself.

7

Photography and the state between the wars

LEWIS HINE
Photograph produced for Vacuum Oil, 1924.

International Museum of Photography Collection at George Eastman House.

By now photography had conquered the entire world, producing representations of it that proved it capable of constituting as it were a faithful visual double, like Borgès' mad cartographer. Never again could it hope to pass as discrete and innocent. It was no longer possible for it to escape the possessive attention of the political machine. No organisation whose business was government could afford not to take an interest in an instrument so eminently suited both to denounce injustice and to elicit belief in pre-established truths.

Initially, photography had been regarded as an incorruptible mistress of truth, then as a legitimate defender of good causes. Now people began to realise that it could equally well be pressed into the service of bad causes.

In 1871, Eugène Appert had produced grossly faked pictures as anti-communard propaganda. By 1914, it was clear to all and sundry that even the most direct and sincere photographs could be 'tailored to any point of view' and distorted to suit any camp or party. The rise of photographic advertisements, perversely oscillating as they did between proof and seduction, supported that same conclusion.

Even the progress of photographic artistic expression helped to tarnish irremediably the image of its early innocence. People were beginning to realise that it was just as capable of undermining as of consolidating our way of seeing things.

Photography was now increasingly regarded as a tool which could become a weapon, in the same way as a hammer or a knife can be used for good, or equally for evil, purposes; it was certainly a tool that it would be prudent to acquire before others did.

Modern societies were increasingly organised, uniform and moulded (whatever their political form) by technology, economics and the administrative powers. Now photography too became the concern of the State, which controlled and coordinated all these sectors. Throughout the diversely interpreted wars, upheavals and revolutions of this period, the historian is bound to recognise the constant and implacable progress made by the State: whether it favoured or opposed maximum individual liberty, the power of States continued to grow. Fascists exalted it for itself, democrats distrusted it and communists plotted its destruction; but whatever the circumstances, the State emerged victorious. In the political, economic and social domains, it became virtually identified with modernity.

From the beginning of the twentieth century onwards, States, whether bent on oppression or liberation, had to reckon with photography. At the very moment when, thanks to the rise of the illustrated press, photography was triumphing on every side, it revealed its profound ambiguity. Human societies immediately reestablished their control over this instrument of testimony that they had brought into being and initially left to its own devices.

Faced with such a universal phenomenon, it would have been over-fastidious to examine each of even the most important countries of the world, one by one. Instead, let us simply consider a few aspects of the problem, each one typical in its own particular way.

First, the Soviet Union, which carried State control to the limit but at the same time gave it a relative dimension by setting it in a revolutionary perspective.

Fascist Italy idolised the State, but was obliged more or less to accommodate its prestigious cultural heritage of creative liberty.

The break between the Weimar Republic, the model of a weak State, and the National-Socialist Reich, the model of a strong State, was such that we have devoted two separate chapters to Germany: a country where photographic inventiveness was particularly brilliant but which suffered the shock of totalitarianism in a particularly brutal fashion.

Democratic America lived through the paradoxes of a liberalism which may sometimes have allowed the mediocrity of the masses to smother the creative spirit but which encouraged that spirit when the State once more took society in hand.

Photography played a central part in the contradictions by which all these countries were assailed. In the Soviet Union, under the cover of a constant dogmatic attitude, it was regarded now as a means of radical, libertarian subversion, now as a means of subjecting and controlling the masses.

In Italy, the spectacular and very visual side of fascism to a certain extent favoured the exploitation of the innovations of the avant-garde.

In Germany, the separation between the two stages in photography was brutally marked by its exiles and concentration camps. From having been thrity years ahead of its time, Germany, like the rest of Europe, fell thirty years behind.

In the United States, the development of photography depended on the interplay between an oppressive liberalism and the liberating role adopted by the State, and vice versa.

But despite all the vicissitudes of history and all the follies of mankind, the new art continued more or less to grow in self-awareness and to place itself at the service of the truth.

It was definitely no longer possible to believe in the objective truth of what photographs told us. On the whole, they left an ambiguous impression, as do advertisements: we know it is a false image but for the time being it is comforting to believe it. Meanwhile, those seeking to understand photography were becoming increasingly conscious that, having lost its innocence, photography could do no better than delve ever deeper into the question of its own unique nature.

J.-C.L.

The Soviet Union

'. . . we must set out – and we shall surely find – a new aesthetics, able to express in photography the aspirations and pathos of our new socialist reality.

Alexander Rodchenko, 1928

The history of Soviet photography in the inter-war years not only reflects a period of intense change which was 'to shake the world' but owes its very nature to the building of socialism itself.

In the 1920s, all over Europe, the avant-garde cut their links with the past. Avant-garde photographers put forward their theories of a new vision, an industrial vision of the world by which, in the end, photography would be freed from its lifelong dependency on painting.

In the West, however, the search for a new aesthetics evolved in a political and economic order which remained unchanged, whereas in the Russia of 1917 – this backward and underdeveloped agrarian country – a new society was to rise. For the Soviet avant-garde, being an artist meant to participate with artistic means in the implementation of a policy aimed at transforming the very essence of society. Their crusade against the academic traditions in the arts, where the 'easel picture' soon became synonymous with prerevolutionary and hence reactionary attitudes, was based on the belief that the new social structure, founded on the concept of collectivity, the abolition of exploitation and the planning of economy, could only be expressed by new forms.

The impassioned debate on a new, socialist photography, in tune with the new era, which took place between 1927 and 1932 must be seen in the light of these ideas.

A 'utilitarian' art

In 1927, ten years after the October Revolution, the central committee of the Soviet communist party reopened the debate on cultural revolution, and thereby on literature and the arts and their function in the building of socialism. For the first time, the question of social change and its photographic representation was ardently discussed: was photography simply to reflect these changes or was it rather to organise and shape reality?

However, the idea of influencing the awareness of the masses by artistic means, of revolutionising society by a revolutionary art, was not a new one. Long before 1917, it was the Russian formalists, futurists, cubo-futurists, suprematists and constructivists who formed the most lively and radical avant-garde of all Europe. But it was the October Revolution which finally made it possible to put theory into practice. The radically new concept of art broke entirely with tradition, ushering in a proletarian art form, a proletarian culture (*proletkult*). For the first five years after the Revolution, Russia was not only the stage of experiments and fundamental changes in the realm of politics and economics but equally in the arts. It was the 'productivist artists' who in 1921 called for a 'fusion of art and life':[1] the artist was to become 'productivist', in other words, to turn to production; he was no longer simply to portray reality but to *construct* it. Art was to pass from an aesthetic category into a *utilitarian* one; the concept of science was to replace the illusionary world of art.

This move towards the material elements of industrial culture was first evident in typography, in industrial design and in film. In the mid-twenties, the members of the Left Front of the Arts (*LEF*),[2] in their magazine *Novyi Lef*,[3] started reflecting on the 'specific means of photography'[4] necessary to comply with the demands of 'productivism'. Among them, to mention only a few, were literary critics such as Ossip Brik, once a formalist, futurist poets such as Mayakovsky and 'factographers', including Boris Kushner and Sergei Tretyakov, who was also a photographer.

However, only the photographic experiments of Alexander Rodchenko,[4a] a former constructivist painter and now a member of Lef, and his provocative statements on a 'new vision', dating from 1928, turned the debate into one of attack and counter-attack. This debate was soon to leave the confines of literary and photographic magazines and have a strong influence on the work of Soviet photographers. The style of Rodchenko at the time, also known as the style 'à la Lef' – characterised by enlarged or telescopic views and unexpected vantage points – was soon adopted by other photographer who in 1929 formed the photographic section of the October Group[5] (B. Bogdan, B. Ignatovich, B. Kudoyarov, E. Langman and others, with Rodchenko at their head).

This debate was closely linked to the rapid industrialisation programme, announced by the central committee in 1928, which was expected to put an end to the New Economic

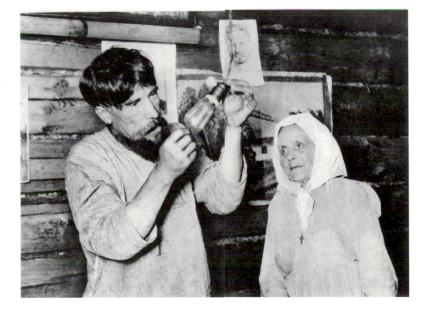

ARKADI SHAYKHET
ILYITCH'S LIGHT: THE ELECTRIFICATION OF THE VILLAGE OF OGONEK, 1925.

ALEXANDER RODCHENKO
CONIFER, 1928.

Part of the photographic sequence, 'Pushkin's Forest', Novyi Lef, 1928.

© Alexander Rodchenko. DR.

Policy[6] and culminate in the construction of socialism. For the avant-garde, it was much more than merely an optimistic allegiance to science and technology; they truly believed that industrialisation according to socialist principles would, at the same time, bring about a change in the very fabric of society. The idea, however, that science and technology were a *conditio sine qua non* for the building of socialism was agreed upon by everybody from the very beginning.

As early as 1921, Lenin's definition of communism as 'soviets plus electricity' voiced the hope that industrialisation alone would help Russia to emerge from its chronic backwardness. Some of the first photographs in the Soviet illustrated press express the same hope.

Electricity would bring light to peasants' cottages and open their eyes to a new world of learning. Thanks to technology, information and knowledge would be accessible even to the illiterate. The radio, films and photography would all contribute to the dissemination of knowledge and culture on which depended, in the final analysis, the realisation of a socialist society.

During the first years after the Revolution, there was no

illustrated press. Nevertheless, new means were devised to use photography for information, agitation and propaganda purposes. Photographs were to be seen in 'agit-showcases' in the main squares of every big city. These weekly photographic series on the latest events were then taken by special 'agit-trains' and 'agit-steamers' to all parts of the country, together with films and popular scientific exhibitions. At conferences, photographs and whole albums were handed out to the delegates.[7] Those series were produced by such well-known photographers as Karl and Victor Bulla or Pyotr Otsup, who had formerly worked for the Tsarist press and were now working for the People's Commissariat for Enlightenment. These measures clearly show the importance the Soviet government attached to photography and films as a medium for propagating its ideas, despite a serious lack of material and equipment.[8]

In the early days, Soviet photography was primarily geared to enlightenment, by means of pictures showing the living and working conditions of people from all walks of life; in this way even the illiterate were to become aware of being part of a new social order and a new state.

Documentary photography, both objective and authentic, was considered an integral part of the mass-education campaigns, designed to free the Russian peasants from their deep-rooted prejudices and habits. This gradual process of learning and adaptation to the modern world corresponded with the Leninist notion of cultural evolution.

1928, however, was the great turning point. That year, the government decided to launch the first five-year plan, a programme of accelerated forced industrialisation which transformed hitherto evolutionary changes into revolutionary ones. When Michael Farbman first visited the Soviet Union in 1929, he was not sure whether he was moving in an atmosphere of revolution or one of war: 'The enthusiasm and the vibration of temperament were symptomatic of an upheaval; but the concentration of effort, the intensity of activity, the appeal, and even the imperative demand, for making the supreme effort and sacrifice — all recalled the experience of the war years.'[9]

Under the slogan 'All efforts for the implementation of the five-year plan', artists and writers as well as photographers were called upon to invest all their energies in the industrialisation programme. Brigades of writers, film-makers and photographers were sent to construction sites throughout the country to report on the building of socialism.

For the avant-garde, photography was much more than merely a means of documentation. For them, photography was to 'revolutionize visual thinking'. The way of looking at the world had been stamped by the academic traditions of bourgeois realist painting. In photography this was the 'navel standpoint', as Rodchenko called it, 'with man looking straight ahead, . . . the camera on his belly'.[9a] But the new industrial society required a new consciousness, and in this context photography was 'the new and perfect means to discover the contemporary world of man's science, technology and everyday life'.[10]

The artistic techniques of 'estrangement',[11] showing usual things in an unusual way, were to serve the purpose of generating an awareness of man's new relationship to the world. The unusual perspectives, the close-ups and dynamic viewpoints were to break the unconscious way of seeing and thus deepen man's insight into his everyday environment and enhance his knowledge of it: 'When I picture a tree, looking

up from below, as an industrial object, a chimney, in the eyes of the petty-bourgeois and admirers of traditional landscapes, this is revolution. In doing so I enlarge our knowledge of ordinary everyday objects.'[12]

In their fascination by the beauty of machines and in the amazing affinity between nature and technology, the Soviet avant-garde photographers resembled experimental photographers in the West. Some of their pictures recall the work of photographers belonging to the Bauhaus (Moholy-Nagy for instance) or to the 'new objectivity' (Renger-Patzsch). However, in the Soviet Union the 'new vision' did not merely imply the adaptation of aesthetics to the new industrial era; it had an even stronger sociopolitical dimension: it set out to teach man to look at the world from all possible angles, from an 'industrial' viewpoint which, for the avant-garde, *was* the 'socialist' viewpoint. 'What's the point of giving a general view of a factory, viewing it from a distance, instead of looking at it closely, from inside, from above, from below?'[13] They believed that the socialist viewpoint was a matter of looking at an object with fresh eyes.[14] Objects were not there to be contemplated but to be *analysed*. The dynamics of their *construction* was to express the dynamics of the socialist society in the making.

Rodchenko was by far the most successful photographer in applying these principles, managing to compile in the field of photography a 'biography of objects' which the 'factographers' had called for in literature.[15]

It was on the grounds of the formal resemblance of some Soviet avant-garde pictures to photography in the West that the Soviet left was soon to be accused of 'formalism', 'western decadence' and plagiarism.[16]

The search for a new aesthetics, in the arts as well as in literature, was above all an ideological problem. As the aesthetics of a society reflect its ideology, the survival of prerevolutionary forms and techniques bore witness to the continuation of the prerevolutionary ideology. Tretyakov believed that the only situation in which the aesthetic prewar norms could, in all fairness, be 'served up' was when they corresponded to their social purpose: 'to distract thought and emotions away from the urgent tasks of reality'.[17]

A new content demanded a new form, as 'any fixation of an object with traditional methods condemns us to cling to the old ideology.'[18] However, in a constantly changing society, there were no more 'eternal and universal values and truths' but only 'new fields of work which were renewed every day';[19] hence photography was the only medium able to keep apace with the ever-changing realities of the industrial world.

In advocating new aesthetics in photography, the avant-garde aimed at breaking with the highly conservative approach of Soviet photographers. Above all, they sought to put an end to bourgeois realist painting under a socialist guise,[20] as it was practised by the Association of Artists of Revolutionary Russia (AKhRR),[21] which, since the New Economic Policy, had seriously been gaining ground. (After the period of War Communism, the NEP in 1921 reintroduced private enterprise and a market economy on a limited scale; in culture, this meant a policy of *laissez-faire*, which resulted in a revival of traditional bourgeois art forms.)

Collective photography

It is against this background that we have to view the manifestos and statements put forward by the 'productivist' artists and the 'factographers', who called for an end to literature as fiction and the replacement of painting by photography.

They indeed considered themselves as avant-garde, as 'shapers of the communist vision of the world' (Tretyakov); yet their idea of an aesthetic appropriation of reality, leading to its actual domination, could be realised only on a collective basis.

Human experience was no longer to be enshrined in literary art forms; everybody would begin to give an account of everyday life, every worker and peasant would become a correspondent. Human experience was no longer to be reflected on canvas; everybody would reproduce his own reality by means of photography; every worker and peasant would become a photographer. Technical progress paved the way for this democratic artistic activity. 'Raphaels without hands' could 'now become productive.'[22] On this basis, 'Every young boy with a camera wages war against the easel painters, and every little reporter–factographer can turn his pen into a mortal weapon against literature.'[23]

The participation of all the Soviet people in artistic activities was to bring about their emancipation, an idea supported both by the State and by the trades unions, which

A. TERESOW
UNTITLED, 1928.

© A. Teresow.

BORIS IGNATOVICH
THRESHING MACHINE WHEELS, 1929.

From the photographic sequence 'Wheat', *Projektor*, 1929.

© Boris Ignatovich. DR.

did their utmost to promote Soviet amateur photography.

In 1926, in the first issue of the magazine *Sovetskoye foto*,[24] Lunacharsky, the People's Commissar of Enlightenment, expressed his optimism in an all-embracing photographic activity involving every Soviet citizen: 'Every progressive comrade must not only have a watch but also a camera. In the Soviet Union, we shall not only have a general education, but also a photographic education, and this is going to come about much earlier than the sceptics would believe.'[25]

Amateur photography developed with the revival of the Soviet economy during the NEP period (1921–7), and with the reappearance of an illustrated press. In 1923, the first photographic circles were formed, some under the guidance of the trades unions, some encouraged by the Society of

Friends of Soviet Film and Photography (ODSKF).[26] In the same year, the State Academy of Arts reopened its department of photography and the Russian Society of Photographers (RFO)[27] resumed its activities and published its magazine *Fotograf*.

In its early days, Soviet amateur and art photography was not much more than a revival of prerevolutionary traditions, concentrating on still-life, landscape and portraits. This was due partly to the influence of former studio photographers now working as instructors in photographic circles; on the other hand, *Sovetskoye foto* also followed mostly traditional patterns of photography.

August 1928 opened a new period in Soviet photography: the Bureau of Agitation and Propaganda decided to turn the amateur movement into a movement of photo-correspondents: 'The Soviet amateur no longer takes pictures for his gold-embossed family album, neither for his private collection, nor for exhibitions; he photographs for the press.'[28]

ARKADI SHAYKHET
DRYING SHEEPSKINS, 1930.

Foto-Al'manakh, no. 3. Moscow 1930.

'. . . The subject of the photograph becomes
a combination of lines and luminous
shapes . . . the social importance of the
object is of secondary importance, even
obscure, resulting in purely formalist effects'
(Fridland, 1931).

© Arkadi Shaykhet DR.

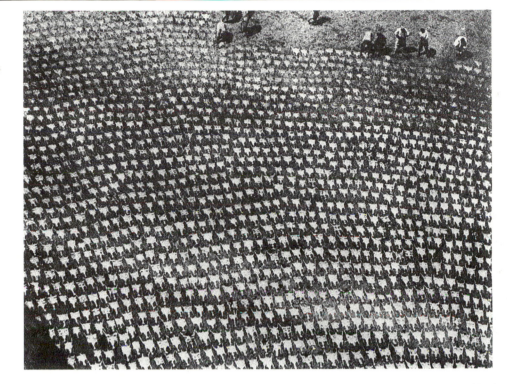

This policy set out not only to transform a personal hobby
into a socially useful activity, but, above all, to lay the
foundations for true socialist mass communication *for* the
masses *by* the masses.

This decision was obviously prompted by practical con-
siderations. In 1928, there were only about 30 professional
photojournalists in the Soviet Union. Calling upon the
amateurs to photograph for the press was to fill the lack of
photographic information. This plan, however, met not only
with material but also with ideological problems.

There was a pitiful shortage of photographic material and
equipment; assuming that one had a camera, there were often
no films, chemicals or paper at hand.[29] Photographic circles
where more than ten people had to share one camera were no
exception. This explains why it was quite difficult for many of
the amateurs to master handling a camera.

Campaigns to encourage amateurs to cover the 'new
Soviet topics', industrialisation and collectivisation, found
little response. However, several talented young amateurs
were discovered – mainly through competitions organised by
Sovetskoye foto – and subsequently trained as photographers at
the State Film Institute (GIK)[30] in Moscow. As a result, the
number of 'photo correspondents'[31] rose to more than 500 in
less than four years.

The photographs taken during the first years of the five-
year plan depict industrialisation as a truly dynamic process.
This total dedication to the goals of the plan can be seen in the
physical effort and muscular tension of the workers as well as
in the determined step of the miners on their way to work.
Whereas the oblique pattern of the scaffolding (recalling the
constructivist style) brings out the courage of the construc-
tion workers, the slanting lines of the men building a wall

MAX ALPERT
DONBASS. MINERS GO TO WORK,
1931.

Proletarskoye foto no. 3, vovember 1931.

© Max Alpert, DR.

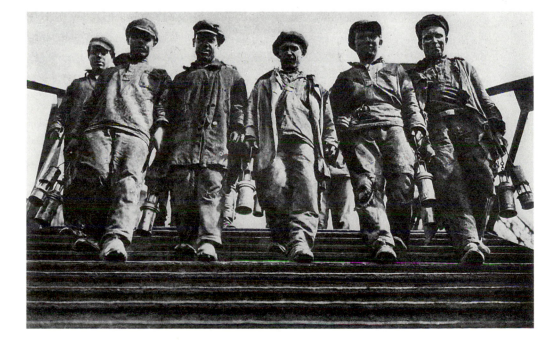

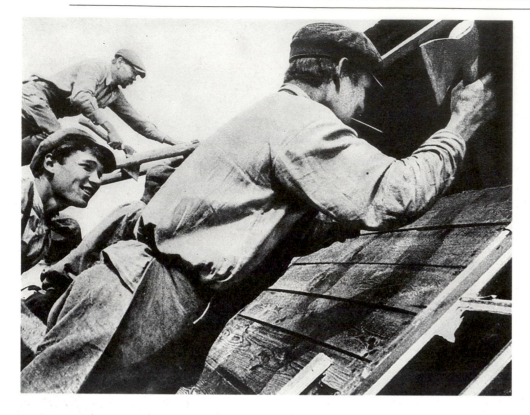

BORIS IGNATOVICH
BUILDING SITE, 1929.

© Boris Ignatovich, DR.

emphasise the success of collective work. In the workshops and assembly halls flooded with light, the all-pervading sun and the controlled power of the machine symbolise the fusion of nature and technology. The dynamic of progress also manifests itself in the rising and falling perspectives of factory shops and blast furnaces.

In a novel and convincing way, these pictures convey the enthusiasm, the revolutionary drive and pioneer spirit which permeated construction work at the beginning. They express the personal commitment of the photographers, their identification with the industrialisation programme and their hope of the better future it was to bring about.

There is no criticism of Soviet reality in these photographs. The unbelievably harsh working and living conditions of that time are not shown. Yet the optimism conveyed by these pictures has still nothing in common with the harmonious representation of reality dictated by the principles of socialist realism in later years.

BORIS IGNATOVICH
AT WORK, 1929.

© Boris Ignatovich, DR.

'Proletarian' photography

The enormous difficulties encountered during the implementation of the five-year plan, above all the serious lack of work discipline, prompted the party to take decisions by which individual performance took precedence over collective achievements. With awards, bonuses and privileges, the party tried to stimulate the effort of the individual worker. This policy was to help accomplish the five-year plan at any cost and gave rise to a new kind of model worker, the 'shock worker' (udarnik), both disciplined and efficient, incarnating the new standards and values of an industrial society.

It is in this context that the magazine Sovetskoye foto called upon photographers to create a 'proletarian photography' which was to concentrate on the worker, the hero worker 'who fought the heroic battle'. As Fridland claimed, 'One has to think of the people who create these new gigantic buildings, as man and his new relationship to work is the most meaningful and significant trait of our times.'[32]

The communist party in power, which considered itself the vanguard of the working class, referred to the workers as 'masters of technology', 'masters of nature' or 'socialist heroes'. To give an 'authentic and faithful' picture of Soviet society, the photographs had to show 'man dominating the machine' as this was an essential aspects of the socialist production process.[33] But photography could convey this relationship only by reversing the actual size ratio between man and the machine.

In replacing the horizontal viewpoint by the 'view from below', the worker became the giant he was expected to be.

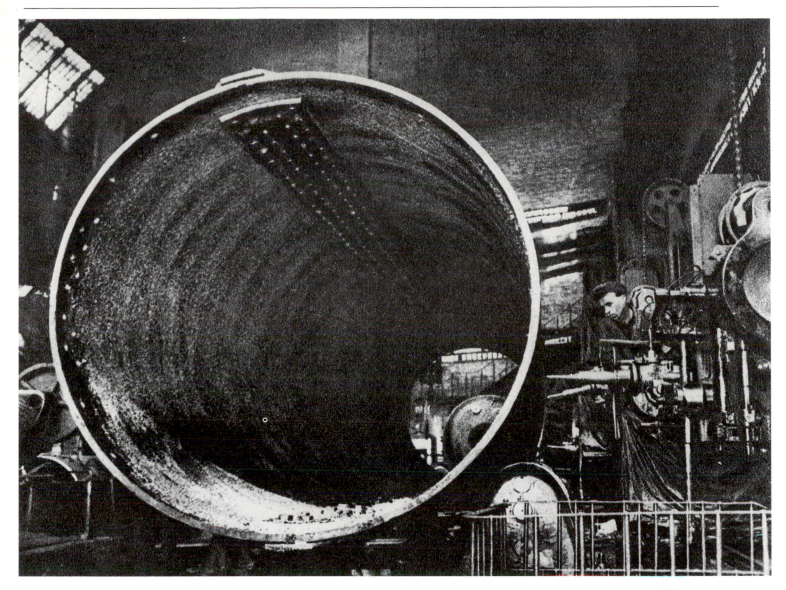

ARKADI SHAYKHET
WORKSHOP AT THE 'STALIN' ADVANCED TECHNICAL
SCHOOL.

Proletarskoye foto, 1931

© Arkadi Shaykhet.

At first sight, these techniques appear to resemble the ones used by the avant-garde. Yet, in this case, the 'distortion' no longer serves to analyse the represented object but simply makes the viewer 'look up' to it, thus creating a hero and lending credibility to the existing social structures and realities.

In the beginning of the 1930s the shock worker became the central theme of photography and all other fields of art and literature. However, there was still a debate as to how he should be depicted in 'proletarian photography'.

In 1930, the new generation of photo journalists of proletarian origin who owed their new social position to the party founded the Russian Association of Proletarian Photographers (ROPF).[34] Among its members were such well-known Soviet press photographers as Max Alpert, Arkadi Shaykhet and Semyon Fridland. With Fridland as their spokesman, they launched a 'heated attack against the left'.[35] The ROPF accused the left avant-garde of formalist ten-

dencies and of a 'fetishist attachment to technology and the machine', basing their arguments on a few photographs taken out of context. They reproached the Left for 'gliding mechanically over the surface' of objects and of imitating western bourgeois trends. They used a photograph by E. Langman showing a combine harvester on the horizon of a cornfield to prove that 'the Octobrists do not love the people who operate the machine'.[36] 'The grovelling empiricism [of avant-garde photography] might possibly show the objective relationship between man and his surroundings, but it does not reveal its heroic aspect.'[37]

For the avant-garde, the beauty of industry expressed itself in the sloping and slanting lines and in the striking effects of close-ups and oblique viewpoints. Beauty of this kind often had the effect of overwhelming the innocent onlooker who, stifled by the overpowering force of technology and the machine, simply 'felt lost'; upon seeing such a photograph, one worker made the following comment: 'In this picture everything turns and it is impossible to tell where the floor ends and the ceiling begins.'

Visitors at exhibitions sometimes expressed disapproval or indignation at seeing photographs taken by the Left avant-garde;[38] these comments served as a pretext for ROPF to denounce these pictures as 'incomprehensible' and hence as 'alien and harmful to the working class'.

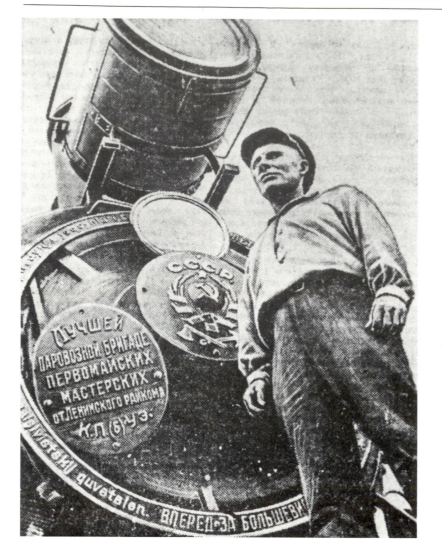

ANONYMOUS
WORKER HERO

Pravda, 1933.

© X.D.R.

and contents of tomorrow'.[45] These discrepancies automatically disappear as soon as the photographs set out to depict universal subjects, beyond our everyday and humdrum experience, such as the beauty of nature and mankind.

The relentless campaign against western decadence in Soviet photography came to an end in February 1932, when the October group submitted itself to self-criticism, confessing its 'reactionary attitude towards creativity as well as politics'.[46] In 1932 the central committee decided to dissolve all literary and artistic groups and associations,[47] among which were the groups of photographers. The controversy over the form and content of a proletarian photography was terminated by the mere stroke of an administrative pen.

All in all, this so-called 'creative' debate on the aesthetics of photography was a sham; power-political considerations overrode those of an aesthetic nature. In its last phase, it was but a stratagem devised by the party to win over the proletariat by taking advantage of their deep-rooted prejudice against intellectual art, thereby swelling its ranks and extending its power basis. The party, which claimed to be the political vanguard of the working class, could now assume the same position in the field of aesthetics.

These criticisms were also levelled at the 1930 manifesto put out by the photographic section of the October group[39] which was the last public statement of the left, calling for photography on a collective basis and denying the 'stagecraft' and 'false pathos'[40] used to depict reality.

The members of ROPF, self-appointed spokesmen of the party, advocated 'comprehensible forms' and the 'priority of content over form';[41] they took a firm stand against the 'photography of mere facts' and called for a return to 'composition'. Pictures based on 'long-term photographic observation' (as proposed by Tretyakov in 1931)[42] were to be compiled in *narrative series* to portray the progress of Soviet society.

The best-known example of such *realistic* representation is the illustrated history of 'Twenty-four hours in the life of the Filipov family',[43] which depicted social reality in everyday working and living conditions. However, it was the 'realistic' and not the 'estranged' aspect of these pictures which aroused the readers' protest. They particularly objected to the half-empty tramcar, in which Mr Filipov was seen going to work, which was far removed from their personal experience of hopelessly overcrowded transport. They criticised this picture as 'distorting and giving a false image of Soviet reality'.[44]

As long as the subject matter of the photographs lent itself to comparison with real-life situations, one could hardly expect the uninformed reader to understand the idea behind this 'mise en scène': 'to show in the light of today the contours

The 'new' realism

In 1932 there was a revival of art photography, that same photography which three years earlier had been reviled and declared alien to the working class on the grounds that it did not serve the cause of agitation and propaganda for the programme of industrialisation.[48] Photography was now raised to a separate art form:[49] 'Photography has become an independent art because of its specific methods and techniques'.[50] Soviet photography was to eliminate the traditional differences between press and art photography: 'Grandiose achievements and grandiose subjects require grandiose forms of expression . . . the great ideas of Soviet reality must therefore be moulded with artistic means, with art photography.'[51]

After 1934, all arts were bound, according to the principles of socialist realism, to give a harmonious, optimistic and peaceful image of reality; yet, this picture was in striking contrast to the prevailing social and economic conditions: continuous shortage of foodstuffs (bread was rationed from 1929); forced collectivisation of agriculture (from 1929); the deportation of millions of peasants to camps (which result in a disastrous famine in 1932). In short, there was an overall deterioration in the general standard of living, alongside a gradual tightening up of disciplinary measures and the establishment of a system of political control. It was only in photography that the Soviet workers and peasants could have

a glimpse of the future society they had been promised, free from pressures and constraints.

We may well ask ourselves to what extent these images, depicting a world free from worries and conflicts, compensated for the day-to-day hardships. They certainly fulfilled the aspirations of the new class of state officials who, through the illusionary world of art, could make themselves believe in a socialist community free from contradictions.

In 1932 Stalin declared that the Soviet Union had entered the period of socialism. The class struggle was replaced by a new principle of harmony, the 'unity of the peoples of the Soviet Union'. This was evident in sport, where all national and social differences were eliminated. Parades and sporting events bore witness to society's ability to organise and plan social life.

The revival of traditional principles in the arts undoubtedly satisfied the innate visual conservatism of the majority. However, this synthetic vision of the world, declared by the party to be the only true vision, masked the conflicts and contradictions inherent in the process of industrialisation. At the same time, it deprived the Russian people of the possibility of developing any analytical and hence critical ways of seeing. The history of Soviet photography is indeed paradoxical: photography found itself once again bound by the very same academic standards from which it had so ardently set out to free itself.

The debate on formalism was taken up once again in 1936, at the time of the great purges. The former members of the October group were forced to acknowledge their past errors. Even Fridland, one of the 'proletarian' photographers from the very beginning, publicly regretted his 'formalist deviations'.[52]

A. Rodchenko and B. Ignatovich were among the few remaining members of the former left avant-garde, who had resisted all attacks and survived the many trials and tribulations of Soviet photography. It is in their work that we can clearly follow all stages of Soviet photographic style; the analytical approach gives way to 'heroic representation' and, finally, to the portrayal of universal and timeless subjects.

The happy smiling kolkhoz woman, the happy smiling sailor and the happy smiling worker — all correspond to Stalin's maxim of a happy life 'in major and not in minor key': 'Life has become better and more joyful.' (Stalin, 1935.)

These pictures represent the communist future 'already present in man'.

In the end, we return to the idyllic landscapes of Russian birch forests: 'Where are we? In which blessed corner of the earth has Oblomov's dream led us? What a beautiful land this is!'[53]

M. KALACHNIKOV, S. KORCHUNOV
FESTIVAL OF STRENGTH AND COURAGE, Moscow, 1935.

Projektor no. 7, 1935.

© Kalachnikov and Korchunov, DR.

ПРАЗДНИК СИЛЫ И МУЖЕСТВА

В Москве, на Красной площади, 30 июня состоялся традиционный парад 120 тысяч физкультурников, трудящихся московских заводов, фабрик, учреждений, учащихся. На наших снимках показано оформление колонн различных районов Москвы, заводов, спортивных организаций во время прохождения колонн через Красную площадь

Фот. М. Калашникова и С. Коршунова

Fascist Italy

The problem for the historian is to understand how a nationalistic cult of the state mixed with professedly socialist pretensions and modernist exaltation can have maintained all the ambiguous relations with avant-garde groups that history has recorded.

Was that avant-gardism really, by and large, no more than a veneer? It is important to reject the stereotyped image of an Italy immured within its deeply provincial cultural self-sufficiency. In reality there was no lack of progressive tendencies in Italy. Our description of this period must accordingly be a balanced one.[1]

The styles of this period

Italian photography during the fascist period can to a large extent be set within the framework of modernism bequeathed by the Bauhaus and also by avant-garde experiments undertaken by independent photographers such as Luigi Veronesi, a pupil of Fernand Léger, friendly with the Abstraction-Creation group in Paris and the author of a number of abstract photogrammes and solarisations. Similar photographic experiments were made by, for instance, Franco Grignani,[2] to whom futurism came so naturally that he was inventing new lines of a typical dynamism before he ever read Boccioni's *Dinamismo plastico*. Then there were Achille Bologna's compositions designed in the manner of Rodchenko, such as his poster for the 'Fascist Revolution' exhibition; the photomontages of Bruno Munari and those of Marcello Nizzoli who in 1933 devoted himself to a study of Malevitch and El Lissitzky; and Giuseppe Pagano's photographic references to Herbert Bayer, Raoul Hausmann and Andreas Feininger.

In short, Italian photography during this period included a bit of everything. Among the determining influences we should also cite the typographic and graphic innovations of Paul Renner, the example of Xanti Schawinsky and the formalist and monumental photography of the Soviet Union in general, along with the contributions of American photography, including reportage.

Among the progressivists, Antonio Boggeri, Emilio Sommariva, Guido Pellegrini, Alfredo Ornano and many distinguished amateurs rate a mention. But the photographic panorama of the period also included the pictorialist photographs exhibited in 1929 at the Monza International Exhibition of decorative arts;[3] the architectural and photographic stage designs of Giuseppe Terragni; the creative annual of photography *Luci e Ombre*[4] published in Turin, and the witty and delicate pictures of the magazine *Fotografia*[5] of Milan, which did not hesitate to jolt the traditionalism of Italian publishers by setting before them the work produced in the French *Arts et Métiers Graphiques*. The panorama should also take in the extremely forthright industrial photographs of G. Bombelli and the quasi-cubist ones of Florence Henri, who had been acquainted with Marinetti and had photographed Rome. Then there were the journalist Orio Vergani's photographs for his book *Sotto i Cieli d'Africa* (1936)[6] which today

may, with hindsight, be compared to those of Cartier-Bresson; and Albe Steiner, an example of whose work is his photograph produced as an advertisement for Bemberg umbrellas.[7]

But clearly most of the vast quantity of photographs produced in Italy during the fascist period by many more or less obscure photographers had little to do with all this culture and all these aesthetic theories. We should remember that 36 per cent of the Italian people were illiterate, 50 per cent worked on the land and the general standard of living was very low. Such photographic imagery as reached this public would not be purveyed by the brilliant avant-garde. To consolidate its position, the fascist regime made abundant use of much more anodine images, ones unlikely to be charged with such cultural and strictly photographic references.

Photography and the regime

The disintegration of traditional Europe following the First World War engendered fascism and gave rise to a new social type: the veteran soldier. Fascist propaganda had been rehearsed in the course of the great conflict, when the minds of the military and civilians alike were hammered into shape and indoctrinated in an increasingly intensive and organised fashion.

The photographs of civil war could still be called images of direct documentation: destroyed trades-union and party headquarters, pilloried politicians and printing works burnt down. But as early as 1919 the first fascist photographs began to take on the look of pious images, showing the hallowed, if secular, protagonists of the fascist revolution.[8]

The newspaper press and speeches constituted Mussolini's primary weapons. The Italian press was swamped with peremptory prefectorial decrees and announcements from the press offices of first the Head of Government, then the Minister of Popular Culture. It all helped to construct a skilfully organised image of the Duce and fascism. But 'official memoranda' represented no more than an early stage in the strategy of totalitarian information. It was to be completed by a programme for forming public opinion in which, alongside all the government announcements and directives, the cinema and radio played a role of the first importance, inseparable from that of photography, in the moulding of public opinion.

The first Italian wireless station was set up in 1924 by technicians from the Marconi Company and the Italian Unione Radiofonica, but its political creator was the fascist Costanzo Ciano, whose son Galeazzo was to become Mussolini's son-in-law. The eloquence of the dictator could now reach the masses. The cult of Mussolini pervaded the news programmes and the documentaries – that had by law to be shown in all cinemas – put out by the national institute LUCE (the acronym of the educational cinematographic union) which was directly dependent upon the President of the Council (that is to say Mussolini himself), the Press Office and the Minister for Popular Culture. In 1926, the regional press associations were suppressed. The regime replaced

ANONYMOUS
LAYING THE FOUNDATION
STONE FOR THE
HEADQUARTERS OF THE
ISTITUTO NAZIONALE
L U C E in ROME, 1937

The fascist regime made use of
not only the cinema but also
radio and publications, in which
photographs played a major role:
the photographs produced by
LUCE and also by amateur clubs
and those for which prizes were
awarded in competitions
organised by the National
Intellectual Association, which
considered itself to represent
fascist culture and art.

Collection of the Istituto LUCE, Rome
DR.

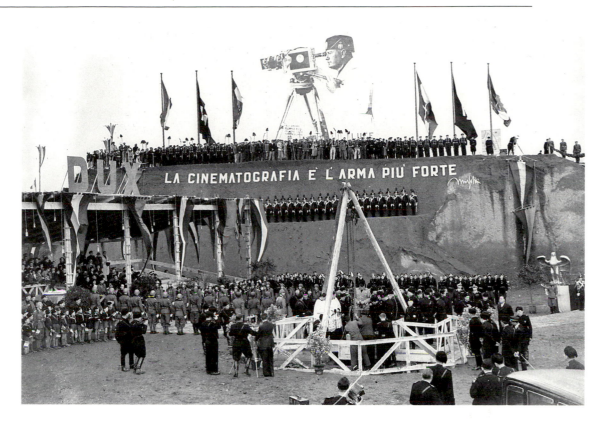

them with regional organisations of a corporatist nature from which the professional categories of photographers, designers and model-makers were excluded. LUCE was made responsible for setting up a professional framework for photographers and a National Photographic Institute was created. LUCE proceeded to appropriate the photographic archives of private individuals such as, for example, those of the inspired and skilful photojournalist Adolfo Perry Pastorel, who was driven to become an illustrator of guides and encyclopaedias.

In 1932, the LUCE Institute published *L'Italia Fascista in Cammino*, a special album of 516 photographs, under the patronage of the Ministry of Popular Culture, known as the MinCulPop.[9]

Here are a few examples of the 'memoranda' which the regime used to control the press:

26 March 1928: 'It is forbidden to publish photographs of delinquents, murderers, thieves, adulterers, corpses or macabre remains or, in general, any photographs relating to crime.'

1 March 1935: 'The *Piccolo* (newspaper) has been reprimanded for having printed in yesterday's edition photographs of women wearing very scanty clothing. Count Ciano has declared such pictures to be antidemographic.'

26 August 1936: 'Do not print photographs in which the Duce appears in the presence of monks.'

6 April 1940: 'The authorities wish the *Messaggero* to print in tomorrow's edition two or three photographs of the Duce's visit to Nettunia. They particularly recommend printing photographs which show the artillery set up in firing positions.'[10]

It was during the colonial war in Ethiopia that fascism's use of photography was at its most blatant. The pictures of the Ethiopian adventure reveal clearly the point to which the success of the fascist colonial plans depended upon the preliminary internal colonisation of the colonising country itself.[11] It was necessary to get everyone to identify with the enterprise. To this end, the authorities resorted to a huge spectrum of images, more than could be provided by professional photographs alone. Between October 1935 and May 1936 some one thousand photographs must have been produced by the LUCE cinematographical service for Italian East Africa, the Army cinematographical services and those of the East African administrative authorities. But abundant use was also made of photographs taken by soldier or civilian amateurs. For instance, 90 per cent of the photographs in a work on the operations of the 128th Legion of Blackshirts were provided by the soldiers and officers of that unit.[12] While of little aesthetic interest, they are nevertheless useful when it comes to reconstructing the stage management involved in the reporting which the regime was presenting as objective.

A survey of the illustrated press

Triumphalistic and militaristic photography was not the exclusive preserve of newspapers committed to fascism, such as the *Illustrazione fascista* (which first appeared on 15 November, as a supplement to the Mussolinian daily *Il Popolo d'Italia*) or *Gente nostra* (the weekly organ of the Opera Nazionale del Dopolavoro which was later, in 1931, to merge with *L'Illustrazione fascista*). Even an illustrated weekly with monarchist leanings, catering for the upper bourgeoisie, such as the long-established *Illustrazione Italiana* was at pains to indicate its support for the regime.

On the other hand, the fascist 'diktats' were subtly held up to ridicule in *Tempo* (the first issue of which appeared on 1 June 1939), a weekly owned by Alberto Mondadori.[13] One of its editors was Francesco Pasinetti, a maker of films, cinema critic, photographer and intellectual who had already made a

ELIO LUXARDO
ACCIAIO, about 1940.

Luxardo was a well-known portrait photographer who had developed his own personal style in that field; he then became an impressive photographer of nudes, a field in which he often appears as a precursor to artists such as Sam Haskins, Robert Mapplethorpe and others.

Collection Fototeca 3M. DR.

name for himself. It carried the work of, among others, Federigo Patellini, one of the best Italian reporters both at this point and in the postwar period. Nor should *Tempo*'s special correspondent Lamberti Sorrentino be forgotten: his articles were complemented by photographic reportages which were as telling as they were comprehensive. The polemical air of this weekly won it a circulation of one hundred thousand in its German language edition (it also appeared in Albanian, Croat, French, Greek, Rumanian, Spanish and Hungarian), whereas the Italian language edition of the German *Signal* had very little success. Initially, *Tempo*'s model had been the American magazine, *Life*. But after a few numbers, under the artistic direction of Bruno Munari, the photography and word–picture layout began to reflect not so much the American style but rather that of the budding neo-realism of films such as Alessandro Blasetti's *1860* (1933) and *Quattro passi fra le nuvole* (1942) and Luchino Visconti's *Ossessione* (1942).

However, of all the Italian periodicals of this period,

Omnibus, the weekly produced by Leo Longanesi, one of the fathers of Italian twentieth-century journalism, was the most outstanding by virtue of its quality and style and its original use of photographs. Cesare Barzacchi was one of the photographers of this period, but the photographs carried by newspapers hardly ever bore the photographer's name.[15] Longanesi's drawers were full of a wide variety of shots ranging from the best to the worst and he himself would shamelessly comb through them for eye-catching images to which he would match an amusing or sarcastic legend. Longanesi regarded photographs more or less as treasure-trove in a world of mascarade. The *Omnibus* did not come to an end when it was forced to close down in 1939. Its heirs are to be found among many of the most prestigious post-war weeklies: *Oggi* and *L'Europeo*, for example, both of which first appeared in 1945, and *Il Mondo* (1949), even if, in them, Longanesi's surrealism was definitely replaced by the photography of neo-realism.[16]

The quest for art

The 'Fascist Revolution' exhibition which opened in Rome on 28 October 1932, to mark the tenth anniversary of the march on Rome, for the first time clearly revealed the regime's specific determination to impose a mystical image of itself[17] and it consequently became clear that the role it assigned to photography was of the first importance. Photographs were everywhere: the laboratory of the LUCE Institute had produced 3127 photographic reproductions, 2170 square metres of photographic enlargements each measuring over one square metre, 1030 photographs with measurements ranging from 50×65 cm to one metre square and over eight thousand with the dimensions of 13×18 or 24×30 cm. These were not presented as the work of specific photographers, but as the production of state institutions or various organs of the fascist party, whether public or private. Set in a context that rid them of all the ambiguity of individual photographs, they took on the air of monuments to the era. They became souvenirs, in the same sense as the relics, guns, drums and bloodstained standards which were arranged alongside them. The painter Nizzoli covered the silhouette of an impressive-looking infantryman striking the famous Mussolini pose with medals, newspaper cuttings from *Il Popolo d'Italia* and a variety of photo-collages. Not to be outdone, the architect Terragni filled Room 'O' with an extraordinary photographic sculpture, conveying considerable plastic energy, in which photography, presented as objective, was used to lend the symbol authenticity. The emphasis of these enlarged photographs, sometimes blown up to the point of deformity and presented as the secular icons of the 'revolution', were designed to exalt a glorious past and allowed of no other interpretation.

But novelties of this kind were totally absent from the second wave of futurism, the futurism of the thirties. The photodynamism of the Bragaglia brothers, Anton Giulio and Arturo,[18] remained an isolated phenomenon and was never more than superficially assimilated. On the other hand, the photography shown at the 1931 experimental exhibition of futurist photography in Turin[19] and then in Trieste played with the techniques of photomontage, superimpression, double exposure and the camouflaging of subjects but it never quite found its own identity. It clashed on the one hand with

the Italian amateurs' abiding taste for pictorial effects and on the other with objective or realist photography.

Among the photographers concerned with independent original expression mention should be made of Guglielmo Sansoni, known as Tato,[20] a talented individual who, with a combination of cleverness and naïvety, imbued his pictures with a jaunty surrealism, a touch of dadaism and something of a metaphysical slant.

But among the non-specialist public only three photographers became really well known. All three were portraitists: Ghitta Carell from Hungary, Arturo Ghergo and Elio Luxardo. Ghitta Carell, who settled in Italy in 1924, managed through her portraits of high-ranking fascist civil servants, big industrial bosses, church prelates and wealthy and educated tourists to give a face to the class that had assumed power.[21] The reference point for the portraits of Ghergo and Luxardo, who arrived in Rome in 1929 and 1932 respectively, was the cinema, the world of the 'stars'.[22] Their pictures reflect the cinematographic models that were in vogue, where the actor and the character that he played merged into one. However, they did impart new life to the genre by means of their set-up shots and their handling of artificial light which, in the case of Luxardo's portraits, achieved a degree of formal sensitivity which was astonishing for the period.

Publicity, connected as it was with the evolution in production, was the domain in which independence from the prevailing ideology could best be expressed. During the thirties, Italian publicity photography benefited from the rich exchanges that were taking place between Italian photography and other European and international aesthetic movements. That was partly because these were years when industry and trade were beginning to make a recovery. The prevailing economic dynamism favoured a gratuitous quest for aesthetic excellence in which the role of the photographic image was no longer limited to simply mirroring the article represented. It was a lucid and well-informed endeavour, as can be seen from the magazines *Fotografia* and *Campo Grafico* and, among others, the visual experiments of Luigi Veronesi, who was active in spheres ranging from painting to photography and from drawing to the cinema. Veronesi was an emulator of Moholy-Nagy, rather than his disciple. In Moholy-Nagy's photograms, the main concern is space; in Veronesi's it is objects.[23] In its few issues to appear, *Fotografia*, under the direction of Guido Pellegrini and published thanks to the intervention of Gio Ponti, promoted the idea of photography considered as an 'other reality'. *Campo Grafico*, first under the direction of Attilio Rossi, then successively Luigi Minardi, Carlo Dradi and Enrico Bona, and with the collaboration of Boggeri (the manager of the studio which employed Scawinsky, Bayer, Carboni and Huber) was published between 1933 and 1939. This magazine for 'graphic aesthetics and techniques', as its subtitle put it, expressed theories concerning photography's role in modern graphics. It returned to the theme in several of its issues, producing a number of impressive arguments, including – inevitably – a contribution by Veronesi.[24]

But over and above the cultural tensions caused by the rapid advance in techniques of communication and industry, there was another aspect to photography of this type: it championed the culture already expressed by other avant-garde artists in the face of the conformism and complacent optimism of fascism. After the magazine *Corrente* had been

LUIGI VERONESI
IMAGE no. 30, 1936.
Photogramme on negative.

Veronesi, with his original experiments with photogram, is an example of a photographer who had strong links with the European avant-garde and who possessed considerable dignity as an antifascist artist.

Collection Luigi Veronesi.

forced to close, it published a slim volume containing twenty-six photographs, entitled *Occhio Quadrato*.[25] Its author was Alberto Lattuada, a young man of twenty-seven, already confident of his future as a film-maker. The short-lived magazine *Corrente*, which first appeared in 1938 and which the regime was to suppress in 1940, was intended to provide an organ for a group of intellectuals of various cultural and political origins, all claiming the arts' rights to freedom of criticism and plurality of expression. Lattuada's photographs, in which the human presence takes the form of 'a memory tired of our daily life and the traces of fatigue upon the objects which accompany us' (Lattuada's own words, in the preface to his book) stand in opposition to the mystiicatory and bombastic rhetoric of fascism, so full of its own magnificent destiny. Lattuada may with justification be regarded as an early precursor to photographers such as Robert Frank, with their empty world and disenchanted gaze.

Photographs of totally fascist inspiration were the exception rather than the rule, but there were certainly some, such

ANONYMOUS
GYMNASTICS IN THE GIL COLONY (GIOVENTU ITALIANO DEL
LITTORIO), RIMINI, 1940.

Leni Riefenstahl had produced the film *Olympische Spiele* for the Berlin
Olympic Games of 1936. The lesson was observed by this anonymous
LUCE photographer: the sun-cure more or less embraced the myths
and rites of dance and the martial arts encouraged by a movement of
classicism which aimed for a timeless image.

Collection of the Istituto LUCE, Rome DR.

as that showing the shadow of the word 'Dux' superimposed
upon the crowd photographed by Giuseppe Parisio,[26] those
of the 1932 exhibition devoted to the 'Fascist Revolution',
Mario Bellavista's 'Me ne frego' (I couldn't care less),[27] the
unintentionally sinister 'political portrait of the Duce'[28]
produced by the Bertieri studio, and the photographs
celebrating Diego Spagnesi's presentation of gold to the
fatherland.[29]

While concerned to make documentary photography serve
its own propaganda, fascism also encouraged the use of
photography as an easily manipulated art for the masses. It
favoured sunsets, dawn scenes, mists, studies of the faces of
children, old people and young girls, all in a rustic style.
Photographic competitions were organised to promote the
use of the radio in country areas or to advertise the Motta
panettone (a Milanese speciality)[30]: it was a tranquillising kind
of photography.

Amateurs or not?

But excellent photographers were also to be found among the
amateurs: the lawyer Giuseppe Cavalli, with his high-quality,
rigorously composed pictures; Feruccio Leiss, with his
photographs devoted to celebrating Venice; Mario Finazzi,
who was successful in determining the technical criteria for
solarisation at about the same time as Man Ray was also
working on the problem; and Federigo Vender, who also
produced publicity photographs and portraits. For these men,
taking photographs was, among other things, a way of posing
questions about the nature of photography itself.[31]

In fact, it is not possible to draw a hard and fast line
between these cultivated amateurs and the professional
photographers: Cesare Giulio, Stefano Bricarelli, Alfredo

Ornano and the architect Pagano,[32] with his constructions of
different materials, were just as passionately devoted to the
truth of forms.

Among the photographers whose work appeared in
Fotografia,[33] the annual published by *Domus* in 1943, were
Cavalli, Ornano, Pagano, Vender, Finazzi and many others:
the publicity photographer Mario Bellavista, who had at one
time declared himself in favour of photography as dictated by
fascism; Claudio Emmer, who started his career as a pho-
tographer of architecture at the beginning of the Second
World War; Bruno Stefani, whose pictures were used by the
Italian Touring Club; Riccardo Moncalvo, whose experi-
mental work was closely related to that of the photographers
of the Neue Sachlichkeit; Emilio Sommariva, a portraitist with
a delicate touch; Federigo Patellani and Vito Latis; Alex
Franchini Stappo who in 1943 wrote an *Introduzione per una
estetica fotografica* in collaboration with his friend Giuseppe
Vannucci Zauli;[34] Vincenzo Balocchi, founder of an institute
which specialised in the reproduction of works of art during
the twenties. Ermanno Scopinic was a painter, critic and
publicity photographer. Carlo Mollino, an architect, interior
decorator and photographer, in 1943 wrote an excellent book
entitled *Il Messaggio della camera oscura*.[35] The pictures in this
work testify to the existence in Italy of photography of a
European standard, managing to survive by keeping its
distance from the political and social situation, and produced
by an enlightened section of the bourgeoisie which rejected
the fascist slogans on the Italian people.

The photographs which convey the best idea of the face of
Italy which fascism sought to conceal, and of the disasters of
the forties, are the identity pictures, the anthropometric files
kept on political prisoners and the souvenir snapshots of
those exiled or detained under surveillance.[36] And then there
is the reportage which the communist Eugenio Curiel
produced in 1936–7 on the housing provided for agricultural
workers in the underdeveloped countryside around Padua.[37]
Finally, we should not forget the personal photographs of the
antifascist Franco Antonicelli, showing his own marriage
while living under surveillance and other intellectuals in the
Biella region,[38] nor those of obscure village photographers
who would not give up taking pictures of poor folk, such as
Lorenzo Antonio Predali, who exercised at one and the same
time the professions of both innkeeper and photographer,
under a sign which read 'The Bad Wine Inn. Photographer' at
Marone, a hamlet on the eastern shore of Lake Iseo (Brescia).[39]

In the history of photography, historical events and places
of significance have not always been recorded by photo-
graphs particularly notable for their aesthetic qualities, as so
many pictures from this period testify: the tragic photographs
of the Alpine infantry units in their retreat across the snows of
Russia;[40] the unpretentious pictures of the partisans and the
terrible ones of the massacres; the devastation by bombing as
seen by Patellani; the Germans in Milan; the rout of Italian
soldiers recorded by Vincenzo Carrese; the liberation, and the
reprisals taken in the towns by the partisans: collaborators
arrested, Germans surrendering, women with shaven heads
and the execution of Starace in the Piazzale Loreto.

The adventure of black-shirted fascism came to an end and
the picture-chroniclers were there, with their cameras, to
record it all. Some were the very same who, in the course of
their professional duties, had but yesterday been photograph-
ing the fascist youth rallies and the high dignitaries and
ceremonies of the regime.[41]

Germany: the Weimar Republic

On 9 November 1918 the Kaiser was forced to abdicate. The timid attempts on the part of the military general staff to introduce reforms designed to democratise the monarchy had failed to prevent the workers and soldiers from revolting. This revolutionary movement directed against the representatives of the Kaiser's empire was countered by the social democrats with their policies of compromise, policies which were to prove decisive in the evolution of the Weimar Republic.

The end of Kaiser Wilhelm's empire dealt a sharp blow to the structure of German society. The new republican government had introduced universal suffrage. To ensure the protection of workers, the trades unions managed not only to enforce a law covering wage agreements but also to set up workshop committees to represent the workers. These social changes alarmed the bourgeoisie whose position was made worse by the serious economic and poitical difficulties in the years following the First World War. As a result of the economy's commitment to the production of armaments during the war, unemployment increased once peace was restored. Inflation too, increased alarmingly, reaching its peak in 1923.

But the radical social changes of the early twenties not only bred insecurity, they also challenged writers, artists and photographers to focus on contemporary developments in their work. The works and social impact of artists in the early twenties are stamped with a rejection of the past and a burning desire to pass beyond the culture of the Kaiser's time. This determination to turn away from the old traditions and the history of individual figureheads gave rise to many new ideas and utopias. The theme for reflection now was a 'new world' directed towards the future.

The 'new objectivity'

The quest for a new perspective in the domain of photography was expressed in slogans like 'a new point of view', 'the new photographer', 'a new perception'. But the determining notion – and not only in photography – was that of 'Sachlichkeit' (objectivity). This meant a type of photography that no longer represented its subjects in a diffuse fashion but instead aimed for precision, a precision that was accentuated with smooth, even glossy, paper. It thus stood in sharp contrast to the earlier 'art photography' which had been characterised by soft-focus images and subtle printing processes.

The new photographers refused to mask the technical

FRIEDRICH SEIDENSTUCKER
SANDABLAGERUNGEN (sand deposit).

Collection Bildarchiv Preussischer Kulturbesitz, Berlin.

AUGUST SANDER
DER MALER FRANZ WILHELM SEIWERT (the painter F. Seiwert),
COLOGNE, 1928.

Fotografische Sammlung Museum Folkwang, Essen.

interest that Renger-Patzsch took in the original form of each of his subjects prompted him to select these from the industrial sector as well as from the natural world. The second direction was advocated by Laszlo Moholy-Nagy, a master of the Bauhaus and the most fervent champion of photography as a means of visual expression. He was also the most influential theoretician of the twenties. He defined this technical medium in terms of its interdependence with light: luminosity was the key to widening man's field of perception.

Both trends seized upon the exactitude of photography as a technical means of expression; it was an attitude that clearly reflected the ideology of objectivity current at the time.

These positions gave rise on the one hand to an abstract realism and, on the other, to a type of realist photography modelled on the commercial exploitation found in illustrated magazines. Between these two poles was the photography of the 'new observers', who were bent upon innovation.

In the field of the plastic arts, a number of groups were formed within which the socio-political role of the artist was discussed. Concurrently, political attitudes hardened within the movement of worker-photographers, the difference here being that those involved were themselves undertaking to represent their own situation.

August Sander

The Cologne group of the 'progressive artists' included a rather marginal photographer whose methods of operation were not representative of the avant-garde. His name was August Sander.

He began to produce his series of portraits of German people, which he planned to publish as albums, in the early 1920s. It was a time when studio photographers were suffering from a fall in orders, a phenomenon due largely to the changing economic fortunes of the middle class. August Sander had left his native Linz in 1910 to establish himself in Cologne, where he had set about attracting a clientele drawn from outside the urban zone. This he found among the rural population of the Westerwald and the Siegerland. Perhaps his changing style resulted in part from this return to a landscape familiar to him since childhood, combined with the new conditions of photographing outside the studio. It was during these early years that he took a number of portraits of peasants, portraits which were free from all traces of sentimentality, and which he later included in his album devoted to 'Germans'.

In 1925, Sander wrote to Erich Stenger, the collector and historian of photography, seeking to interest him in his album, then in preparation. By this time he had already joined the group of 'progressive artists' mentioned above. It was in this circle of artists who sought to make photography an art with a social orientation, and in particular with one of its members, the socialist painter Franz Seiwert, that Sander was able to discuss his own conception of 'twentieth-century man' and his own photographs. He explained his ideas to Erich Stenger as follows: 'Pure photography allows us to create portraits which render their subjects with absolute truth, truth both physical and psychological. That is the principle which provided my starting point, once I had said to myself that if we can create portraits of subjects that are true, we thereby in effect create a mirror of the times in which those subjects live. . . . In order to give a representative glimpse of the

nature of their means of expression any longer; they also rejected all the romantic imagery that had been popular hitherto. The concept of the 'neue Sachlichkeit' (new objectivity), defined in 1925 by G. H. Hartlaub as characterising the realist techniques of a number of painters of the twenties, was subsequently also applied to contemporary photography. The term expressed the desire for impartial analysis with the underlying hope that this objectivity would have a positive, clarifying effect. With changes in the social structure in Germany, a shift in the attitude towards technical progress also developed. In the mid-twenties, the hostile, almost fearful attitude previously manifested towards technical progress gave way to an enthusiasm bordering upon euphoria. As Germans looked with great interest towards the United States, technical achievement came to be regarded as not only the determining factor in social evolution but also the solution to all current politico-economic problems.

Exactitude in reproduction and the rediscovery of precision were the unmistakable hallmarks of the style of the 'new photographers' of the twenties. Two major tendencies emerged around the middle of this decade: the first, whose principal representative was Albert Renger-Patzsch, set out to exalt the object in its structure, making full use of the photographic means that could underline that intention. The

AUGUST SANDER
MAURERMEISTER (master mason),
COLOGNE, about 1932.

Fotografische Sammlung Museum Folkwang,
Essen.

present age and of our German people, I have collected these photographs into various portfolios, starting with the peasant and ending up with representatives of the intellectual aristocracy. This is then paralleled with an album which traces the evolution from village to modern urban concentrations. By using absolute photography to establish a record both of the various social classes and of their environments, I hope to give a faithful picture of the psychology of our age and of our people'.[1]

By about the mid-twenties, Sander had already started work on several albums, taking photographs of a series of people in the Rhineland.

Sander described himself as a documentary photographer but with the difference that he used the documentary truth of photography to create a representation of higher interest. His vast plan for his photographs made it necessary for him to photograph with a consistency that would allow comparisons between his subjects. His method is essentially characterised by a deliberate confrontation between the photographer and the model facing him. The subject of the photograph is thus free to strike a pose. He is always shown in the context of his work and in his normal daily environment. The photograph thus conveys information about the original setting in which it was taken. Furthermore, the subject is always shown as part of his own environment, and usually with a serious expression – which indicates the unfamiliarity of most of the people with being photographed.

In his *Men of the Twentieth Century*, Sander attempted a portrait of society, showing professions and social strata and classes, and thereby revealing the hierarchies which divided Germans of the Weimar Republic. In contrast to many of his colleagues, Sander was relatively unconcerned with experimental creativity and individual expression. In his work, the author remains in the background. He realised that the

ALBERT RENGER-PATZSCH
WARMING IRONS FROM THE
FAGUS WORKSHOP.

Courtesy Galerie Wilde, Cologne.

personal influence exerted by the documentary photographer lay not in creating an inventive image but in choosing it, in making a deliberate selection from reality. Without the particular gift for observation with which Sander surveyed the social scene of the twenties, this work of portraiture would not have succeeded in characterising the citizen of the Weimar Republic. The fact that comparisons between the portraits are possible gives each one an extra dimension within the context of the work as a whole, for the social role of the individual becomes comprehensible only in relation to the other portraits, which constitute a system of reference.

In 1927 Sander for the first time exhibited samples of his work, at the Cologne Kunstverein. The exhibition was followed by a first volume of photographs comprising sixty selected portraits, the last of which showed one of the unemployed (the volume came out in 1929). In 1934, the nazis confiscated the remaining copies of the edition, and the projected composite album, which was to have comprised forty-five collections of twelve photographs each, was discontinued. Over the next few years, Sander devoted more of his energies to landscape photography. His photographs were used to illustrate a number of slim volumes bearing the title *Deutsche Lande, Deutsche Menschen* (German places, German people), a theme in which he had already shown an interest and which could be marketed without attracting suspicion in the world of publishing and the press.

He continued to produce photographs for his great enterprise up until 1945. They included, among others, *Gefangene Politiker der Nationalsozialisten* (Political Prisoners of the National Socialists) and *Verfolgte Juden* (Persecuted Jews).

Publicity

It would be difficult to form a judgement on German photographic production of the twenties without taking into account its fields of application and its market outlets. August Sander, the documentary photographer, earned his living partly by accepting commissions from industry. The enthusiasm that photographic images aroused at this time – an enthusiasm by no means limited to Germany, of course – stemmed in part from the 'Weltanschauung' then undergoing such transformations and which regarded technical progress as holding the seeds of a better society. Photography was more than simply a medium through which to prove the existence of this 'new world' of architecture and industry, with all its new products and new means of production; it was a technical process increasingly used in new, expanding markets and it thus became an item of merchandise with a thousand possible applications. Photography's new clients included editors of illustrated magazines, designers and industrial businesses; while advertisements, brochures, posters, books and above all magazine reportage all testified to the new uses to which it could be put.

The London Convention of 1924 set out plans not only for revising the German monetary system but also for securing reparation payments in accordance with the Dawes Plan. Following this, between 1924 and the world economic crisis of 1929, Germany enjoyed a phase of relative stability: 'For the Entente powers have realised that only a prosperous German economy can guarantee that the reparation payments are made.'[3] It was also to that end that, in May 1924, a Wall Street consortium put up a loan of over 100 million dollars, which was followed by a new influx of foreign capital.

During this phase of relative stability, Germany was able to regain a footing in fields which it used to dominate, such as the chemical and the electrotechnical industries. 'The export offensive rested to a large extent upon the activity of large concerns such as I. G. Farben, Siemens, AEG, etc., in which a large measure of economic power was concentrated.'[4] By the mid-twenties, this power had been reinforced by concentrations of capital. The mergers that took place engendered not only concentrations of interests but also alliances with other branches of industry and with banks. The effect was to promote 'rational economic organisation' as well as cost-cutting through organisational restructuring.

In the early twenties many businessmen gave encouragement to contemporary artists by giving them advertising work. It was now that many artists who were experimenting in the field of photography discovered the promotional strengths of the photographic image. They utilised the photograph as an element of montage, as a photogram, or as a documentary shot in their advertising work. Many businesses of the period produced advertisements that testify to this use of photography; they include the following firms: Kaffee-Handel AG, Brême (Kaffee Hag), Günter Wagner Hanovre (Pelikan) Bahlsen, Hanovre (Bahlsen Kekse), Rosenberg and Hertz, Cologne (Forma Miederwaren [Forma Corsets]), and Bochumer Verein, Bochum (Bergbau und Gusstahlfabrikation [mining industry and cast steel manufacturing]). Max Burchartz, El Lissitzky, Richard Errell, Albert Renger-Patzsch and Maurice Tabard all either worked for these firms or offered them their photographs. The painter, designer and photographer Max Burchartz also wrote about the advertising techniques of modern times: 'The basic principle of advertis-

ing is invariably one of an active willing, using particular methods of suggestion, all of which proceed in fundamentally the same fashion, in order to guide other wills – in fact, the greatest possible number of wills – towards particular well-defined actions. . . .'[5]

In a piece of *pro domo* publicity, Richard Errell, a colleague of Burchartz, congratulated himself on being able to reach the masses: it was here that the secret of success lay. In that respect nothing has changed; what has changed, though, is advertising practice. Today, advertising campaigns are preceded by market research studies. But even in the twenties an attentive eye was kept on the example of America, where spending on advertising was high and methods of diffusing publicity were discussed as seriously as were specialised methods of production.[6] The spectacular evolution of advertising in the twenties was related to the expanding market for newspapers, which were the basic vehicle used by the advertising industry.

The press

New newspapers and magazines were founded in Germany both immediately after the First World War and also in the

MAX BURCHARTZ
WERBUNG (advertisement), about 1925.

Fotografische Sammlung Museum Folkwang, Essen.

mid-twenties. By the end of the Weimar Republic, three large newspaper groups existed: the conservative Hugenberg-Scherl syndicate and two republican presses, Ullstein and Mosse. Alfred Hugenberg was the commercial adviser who was chairman of the board of the Krupp firm in Essen from 1909 until the beginning of the First World War. He was also chairman of a number of business associations and, having recognised the peculiar power of the press even before the outbreak of the war, had taken action accordingly. In 1913, he had bought up a majority of shares in the Berlin publishing house of Scherl; he then set up a number of other publishing firms and also the Deutsche Lichtbildgesellschaft (German Photographic Company) and became a partner in a number of telegraph and advertising agencies and film companies. The 'Konzern Hugenberg' became the subject of many articles and much criticism during these years. The fears of his critics were confirmed in 1933, when Hugenberg became a minister in the first cabinet formed by Adolf Hitler.[7]

To form a clearer picture of the particular applications of photography, it may be useful to draw attention to the creation of the following newspapers: in 1923, the *Münchner Illustrierte Presse*; in 1926, the *Kölnische Illustrierte Zeitung*; in 1924, the magazine *Uhu* and *Die Koralle*. Some papers were connected with particular political parties: the *Arbeiter Illustrierte Zeitung*, founded in 1925, was close to the KPD (communists) and the *Illustrierte Beobachter*, founded in 1926, was the organ of the NSDAP (nazis).

It was not only the widening range of possible clients that enabled the new generation of photographers to become active in new fields, but also new developments taking place in photographic techniques.

The Ermanox camera came into production in 1924 with a lens aperture of *f*/2, later improved to *f*/1.8. In the previous year the Leica had come out, in thirty-one models, and as from 1930 was available with interchangeable lenses. Furthermore, the photosensitivity of photographic material increased to 17 DIN (40 ASA). The new instruments helped to transform the photographer's faculty of perception and to extend his field of operation. Pictures could now be taken at higher speeds and in extreme light conditions.

There were as yet no photographers employed on the staff of illustrated magazines. In certain cases individual publication contracts were signed. When Walter Bosshard went off to India in 1930 to produce a report on Gandhi, the contract the *Münchner Illustrierte Presse* negotiated with him gave it the exclusive German rights.[8]

When a photographer worked with a photographic agency, the latter would normally retain 40 to 50 per cent of the profit from publication of his work. This allowed him to leave the commercial side of his profession to others and gave him more time to devote himself to photography. On the other hand, it reduced his personal control over the way that his pictures were presented and distributed. In 1928, Simon Guttmann and Eduard Marx founded 'Dephot' (the German photographic service) in response to the growing demand for photographic documentation. The first to collaborate with this agency, which specialised essentially in the production of photographic stories, were the retoucher Hans Baumann (Felix H. Man), who had been an illustrator at Ullstein's, and Otto Umbehr (Umbo) from the Bauhaus. Among others who worked for it later, in some cases only for a short period, were Walter Bosshard, Kurt Hübschmann and Lux Feininger.

Up until the mid-twenties, the presentation of photographs in magazines remained much the same as in the prewar years. In 1926, photographic series were still being presented in a very static fashion. Meanwhile, however, it had become customary for the photographs which were supposed to attract attention to be set out framed in geometrically shaped spaces. Clearly, most effort was put into the layout of the cover, which was designed to persuade the customer to buy. Here, a number of different extracts and varying points of view on a single subject would deliberately be chosen and these would be accompanied by two or more photographs intended to underline the contrasts and links between the subjects treated. The reader's curiosity was aroused by two means: on the one hand, the cover's suggestion of a theme which made him want to read the report, and, on the other, the unusual form of presentation, which awakened a kind of voyeuristic curiosity.

By about 1929, the German bourgeois press could count on the services of a whole series of eminent 'observers'. International politics were the province of Erich Salomon. The Gidal brothers were especially adept at rendering visible the most diverse froms and levels of human comminication. Umbo would produce an interesting report on any subject. André Kertész and Alfred Eisenstaedt took their photographs

UMBO (OTTO UMBEHR)
HORCH EMBLEM, 1930.

Collection Bildarchiv Preussischer Kulturbesitz, Berlin.

as distant observers. Martin Munkacsi concentrated on producing photographs each of which possessed a balanced form of its own and Wolfgang Weber favoured foreign travel. One of the photographers most in demand was Felix H. Man, who specialised in nothing in particular but was commissioned to produce for publication photographs covering the widest range of subjects among both the currents and the undercurrents of the times.

In the two principal German illustrated magazines, the *Münchner Illustrierte Presse* and the *Berliner Illustrierte Zeitung*, the trend was to peep into the corridors of power ('hinter den Kulissen') to spy upon politicians ('belauschte Politiker') or else to report on exotic foreign parts. Everything had become 'photographable' and the competition that existed between the various newspapers speeded up the headlong chase after anything sensational. Photographers revealed familiar things from new angles and were expected to discover new ways of looking at everyday social life. The most striking feature was the rich disparity of the photographs.

'The juxtaposition of photographs makes it impossible for the conscious mind to establish links between facts. The very idea of photography does away with ideas.' That is how the critic Siegfried Kracauer in 1927 denied the illustrated magazine any virtues at all in making known the state of the world. But for him, the evil lay in photography itself since the resemblance between the image and what it represents 'blurs the historical outline of the latter'.[9]

The worker–photographers

At the opposite end of the spectrum from the bourgeois press, the *Arbeiter Illustrierte Zeitung* (AIZ), with communist leanings, appeared in the mid-twenties. It was founded in 1925, as an offshoot from *Russland im Bild*, a magazine which had been founded in 1921 under the auspices of the Internationale Arbeiter Hilfe (International Labour Defence) and which appeared in 1923–4 under the title *Hammer und Sichel* (Hammer and Sickle). The magazine, founded by and under the direction of Willi Münzenberg, was associated with the KPD although never a direct organ of the party. It appeared weekly in 1927, reaching a circulation of 240 000 copies.[10]

To realise Münzenberg's aim of making this political illustrated magazine counterbalance the bourgeois press, it was necessary to obtain photographs which illustrated the lives and working conditions of the proletariat, and not enough of these were forthcoming from the photographic agencies. Münzenberg had long since glimpsed the potential force of propaganda conveyed through pictures and had written a brochure explaining his views: 'Pictures are effective above all upon children, young people and the general as yet unorganised mass of workers, agricultural workers, small peasants and other similar strata who still think and react in a primitive fashion; as well as (producing) illustrations in the dailies and newspapers aimed at young people and at children, at women and at peasants, it is absolutely imperative to create and organise illustrated magazines aimed at the workers.'[11]

In the following year, 1926, the editorial staff of the *Arbeiter Illustrierte Zeitung* launched a competition, inviting their readers to provide the newspaper with photographic documentation. The same year, it was announced that a centre had been set up for workers who were amateur photographers. Its aim was 'to create an information sheet for the

BERLINER ILLUSTRIERTE ZEITUNG (BIZ), no. 23, 8 June 1924.

Private collection. © XDR.

purpose of exchanging experiences and passing on individual photographic commissions to the workers' press as a whole.'[12]

On 1 September the first issue of *Der Arbeiter Fotograf, Mitteilungsblatt der Vereinigung der Arbeiter Fotografen* (The Worker Photographer, Journal of the Association of Worker Photographers) appeared. From the eighth issue onwards it adopted the subtitle of *Offizielles Organ der Vereinigung der Arbeiter Fotografen Deutschlands* (Official organ of the Association of the Worker Photographers of Germany). Willi Münzenberg was its chief editor and director.

The editors of the *Arbeiter Illustrierte Zeitung* lost no time in using the organ to communicate to the amateur photographers ideas and tips relating to the practical aspects of photography: 'The worker photographer must become a reporter! When something happens at his place of work that is of interest to workers as a whole, he should look

DER ARBEITER FOTOGRAF, no. 4, April 1931.

Private Collection. © XDR.

into it and produce an eyewitness account consisting of five or six pictures.'[13]

In practice, the *Arbeiter Illustrierte Zeitung*'s movement of worker–photographers set little value upon single photographs. The workers' findings were expected to be recorded in a series of pictures. As well as practical photographical advice, the worker was given information concerning his rights as a photographer and the 'illicit' practices of the police, who might sometimes seize his photographic material. From 1925 onwards, the Berlin police issued passes to photographers when cultural or other events took place. In 1928, this authority was handed over to a commission composed of representatives of the police and the professional organisations. From 1933 onwards, the only photographers admitted to such events were those who belonged to the compulsory association known as the 'Reichsverband Deutscher Presse' (Association of the German Press of the Reich) or to the 'Reichsausschuss der Bildberichsertatter' (Committee of the Photographer–Reporters of the Reich).[14]

The documentary photographs produced by the worker–photographer movement fell far short of fulfilling the hopes of the AIZ, even in 1929. After the May demonstrations, having received no more than six usable photographs, the AIZ launched an appeal to the photographers.[15] In her biography of Münzenberg, Babette Gross, who in 1926 became the first woman president of the movement, summed up the situation as follows: 'The photographs submitted by the worker–photographers were seldom fit for use and were on the whole of a quality far inferior to those of the press.'[16]

In contrast to the liberal press's practices regarding page layout, the AIZ editorial staff elaborated a synthetic montage technique for displaying its pictures. They recognised the extent to which the meaning of a photograph could be manipulated and thus used to convey a political message and to influence. They put their points across by deliberately combining and juxtaposing both texts and images or by setting in opposition photographs of contradictory content and explaining the contradiction in an accompanying text. Historical documents and photographs were frequently reproduced alongside contemporary photographs, to reinforce the persuasive force of the latter, and the text no longer confined itself to describing the photographs but further produced an interpretation of them that reflected the party line. The agitational methods of the AIZ assigned the photograph less inherent information value than did the bourgeois press. When it was a matter of representing abuses of justice, for example, photographs reflecting personal situations would be printed and it was only in an accompanying commentary which conveyed the party line that the general social implications of the image would be drawn, with the aim of getting the reader to identify himself with the situation, and, if possible, take action.

In 1933, the worker–photographer movement was decimated by the national socialists. Its last official publication appeared in March. The newspaper staff continued to operate illegally and for a short period produced the *Reporter* magazine, in a reduced format, in order to circulate information. In its last issue, Erich Rinka, the secretary of the VDAFD ('Vereinigung der Arbeiter Fotografen Deutschlands') (Association of the Worker–Photographers of Germany), urged his readers to continue the struggle against the nazis. The editorial staff of the AIZ emigrated to Prague where it battled on until 1938, under the aegis of the editor-in-chief, F. C.

Weiskopf, adopting the title *Volks-Illustrierte* in 1935. (In 1939, Willi Münzenberg, who had fled to France as a refugee, was confined, as a German, in an internment camp. In 1940, he committed suicide there, when he learnt that the Vichy authorities were about to hand him over to the occupying power.)

John Heartfield

From 1930 onwards, John Heartfield was one of the principal collaborators of the AIZ. (He had changed his German name of Herzfelde to its English equivalent in protest against the excesses of the prevailing German chauvinism.) His photographic compositions appeared monthly. They always referred to current political events and were printed in a central position or as leaders. With hindsight, we can today read into them a history lesson that went unheeded.

Since becoming a member of the KPD in 1919, Heartfield had been working for magazines and producing posters and brochures. Later, he also lent his services to the party's graphics studio in Berlin. Working with his friend the painter George Grosz, in the framework of the Berlin 'Club Dada', Heartfield put together the earliest photographic collages. Together, the two worked on numerous projects of which their 'dada montages', their collaboration on a number of magazines and their work with animated film represent but a small fraction. In 1917, in partnership with his brother Wieland Herzfelde, Heartfield founded the Malik publishing house, for which he produced photomontages to be used as book covers.

In 1924, he produced his first historical photomontage: *Nach zehn Jahren—Väter und Söhne* (Fathers and Sons Ten Years Later). It was exhibited in the window of the publishing house on the anniversary of the beginning of the war. That same year, together with Grosz and Erwin Piscator, he founded the 'Rote Gruppe' (Red Group) which later gave rise to the 'Assoziation Revolutionärer Bildender Künstler Deutschlands' (the Association of Revolutionary German Artists).

John Heartfield's creative work in the twenties was manifold. He always adopted a political slant, whether working in the cinema, in the theatre (as a designer), as an artistic collaborator on books, magazines or exhibitions, or (from 1930 up until the end of his exile in Prague) on the permanent staff of the *Arbeiter Illustrierte Zeitung*. This newspaper, with its vast circulation, provided his provocative statements with the vehicle and the distribution they needed. In the context of this study, John Heartfield must be seen as a marginal figure since he was not himself a photographer, but rather an artist who used the photographic image. His function was political and his work acquired meaning only through its application and distribution: to that extent he also remains an exception in the artistic context of the Weimar Republic.

Germany was not the only country where the practice of photography during the twenties played a determining role in the later evolution of photography and the extension of its field of application. As the political debates and social changes which mark the first phase of the Weimar Republic took place, changes were also taking place within the field of photography, where there was a noticeable reaction against earlier trends that had sought to mask the technical nature of photography behind a screen of conventions borrowed from painting.

By the mid-twenties, German photography was changing its relationship to reality. It swung optimistically towards technicality and the new objectivity which was to give rise to new modes of perception and representation. It was only in the late twenties that photography, now a means of representation with its own particular formal laws, was to acquire an economico-political significance, thanks to the growing outlets of the cultural market which helped to make it a more marketable commodity.

In the field of publicity and photographic illustration, both rapidly expanding, a fair number of photographers could, in the early thirties, style themselves 'perfekte Gestalter' (perfect creators) or 'entdeckende Reporter' ('discoverer' reporters). They were equipped with all the technical and aesthetic know-how and capabilities that photography could bring to bear in support of an idea.

All the same, the credit for the creation of illustrated reportage, starting from the basis provided by the photographic illustrations of the prewar magazines, should not go to photographers alone: their clients, magazine editors and managing directors, had been quick to recognise the photo-story as a method of representation that could exert a strong influence upon the public. The communist workers' movement had been quick to perceive the political effectiveness of the illustrated bourgeois magazines and had reacted accordingly. In its own paper, which was backed by the Republic's left-wing intellectuals as well as by the newly founded worker–photographer movement, it retaliated against the liberal and conservative press with its own political use of reporting, embracing the proletariat's point of view. 'And since a photograph can say more than a thousand words, every propagandist knows how to calculate the effects of tendentious photography. Right across the board, from the advertisement to the political poster, the image can attack, throw punches, strike right at the heart and, if well chosen, can express a new truth, but always only one.'[17]

The national socialists found ways of generally perverting forms by having them convey a new content: for instance, May Day was declared to be the Day of National Labour; and they certainly discovered particularly favourable conditions for doing so in the field of photography. The forms of representation and possible applications of photography which had been tried out during the years of the Weimar Republic were later put to effective use by the Nazi propaganda machine. Hitler's regime expelled the best journalistic photographers and the best editors of illustrated magazines; it wiped out the worker–photographer movement and, through its oppression, helped to smother further experimental approaches and visual progress in the field of photography.

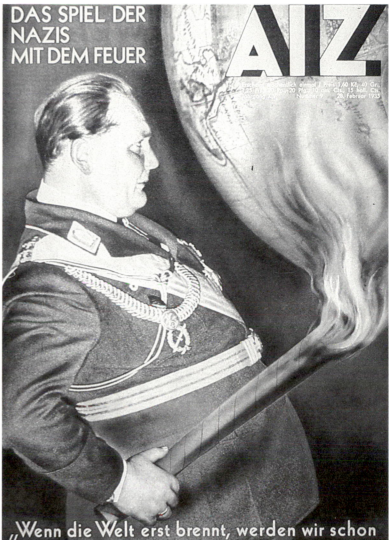

JOHN HEARTFIELD
PHOTOMONTAGE
in *AIZ*, 28 February 1935.

Private collection. © J. Heartfield. DR.

Germany: the Third Reich

'Photography today is accomplishing a lofty mission in which every German should collaborate by buying a camera. The German people is ahead of every other in the technical domain and, thanks to its exceptional qualities, the small camera has conquered the whole world. It is used by scientists, scholars, researchers and tourists from every country. The conditions thus exist for art, technical progress and the photographic industry to unite in a great national endeavour: to create a labour front evolved from the vast domain of photography. Much is at stake here from the point of view of popular consumer goods and, furthermore, photography has a particularly important political role to play.'[1]

Those were the words used by Joseph Goebbels, the Minister for Information and Propaganda, at the opening of the Berlin Photography Fair, 'Die Kamera', on 4 November 1933. They expressed the idea of the use of photography entertained by the Third Reich which, between 1933 and 1935, proceeded, albeit without any coherent strategy, to set up a system of propaganda based upon it.

In reality, the newly created Ministry of Propaganda had absolutely no idea how to classify this rapidly expanding means of expression. Since the late twenties photography had become so much a part of daily life (through photographic reportage, associations of amateur photographers and the industrial manufacture of cheap cameras) that it was difficult to see how the state could make a concerted intervention into the production of images on such a vast scale.

It was quite a different matter in the case of the cinema, which was far less difficult to control, and in that of radio, since it was easy to keep all the wavelengths under surveillance.

Amateur photography: economic and political possibilities

As soon as it was set up, the Ministry of Propaganda created a 'Photography Section' in the department of the 'Positive Conception of the World', under the direction of Heiner Kurzbein, a former national socialist student leader. Kurzbein was twenty-three years old and was totally unqualified in photography.[2] He was supposed to concentrate upon two essential points: photography used to purvey information, in particular political information; and amateur photography, which could be used as a propaganda instrument of crucial importance.

It was in 1933 that photography was placed in the same category as information. The closure of printing firms and publishing houses owned by Jews and political opponents had dealt a severe blow to the organisation of the press.[3] Photography was, among other things, expected to fill the gap thus created. But, apart from a few summary instructions relating to the constitution of photographic archives for the use of a number of local or national NSDAP party authorities, and the hiring of a few photographers to set these up, during the early years of the Third Reich photographic reporters received few directives. It was a situation that was soon to change radically.

On the other hand, the Ministry of Propaganda regarded the encouragement and supervision of amateur photography as a matter of primary importance, for two interconnected reasons. The first was the great impact made by the diffusion of photographs combined with the great possibilities for controlling information purveyed through images, both of which had been underlined by the earliest studies of mass-communications undertaken in the United States during the twenties. The second was the fact that this means of expression available to all and sundry could be used to justify an anti-intellectual attitude which alone could bring about the dissolution of the individual within the mass: 'It is to this deep conviction (of the individual's capacity for self-denial) that the Aryan owes his position in the world, and it is to mankind that you owe the world. It alone, springing from the mind, has forged the creative energy which, thanks to strong hands and human genius, has built the monuments of human culture.'[4]

The already existing organisations did not hold out sufficient guarantees of rapidly setting in motion effective measures of propaganda. Like the Association of German Amateur Photographic Clubs, they were mostly of a private nature. Accordingly, at the beginning of 1933, the 'Reichsverband Deutscher Amateur-Fotografen' (the National Association of Amateur German Photographers) was set up. It was organised along the lines of the two worker–photographer associations, the one social democrat, the other communist.[5] The new association promptly set out a number of guiding principles which turned the camera and national photography generally into an essential task for the German people as a whole. By 1933, Germany was already a country turned in upon itself:[6] its frontiers were closed and the restrictions imposed upon the export of currency made it impossible for Germans to leave the country except for short periods.

National photography found itself officially allotted tasks of a documentary nature. It was, of course, expected to testify to the beauty of the fatherland but also to record the dilapidation of public buildings and other examples of war damage. Another of the duties assigned to amateur photographers was to put together a picture of men at work. This was made to correspond with the key phrase 'the workers' struggle', which was now represented through an adoption of revolutionary communist strategy that was purely formal.

The industrial fairs

By the end of the nineteenth century, photography had acquired its place in a vista of industrial development, for the new aesthetic concepts that it introduced brought about technical developments which in their turn led to economic success. The industrial fair was an ideal instrument for diffusing industrial progress: such exhibitions made it possible to gauge the importance and range of manufactured products as well as to demonstrate their value and use.

LOTTE ZANGEMEISTER
BOY DRINKING WATER FROM A *HAFF*,
about 1938.

This shot shows how the specific
characteristics of avant-garde photography
were reflected in amateur photography: the
diagonal composition, no horizon,
reflections in the water which provides the
picture's structure.

Collection Bildarchiv Preussischer Kulturbesitz,
Berlin.

'Kipho', the first fair devoted to photography, took place in Berlin in 1925. The 'Photokina' fairs which have been held regularly ever since 1950 testify to the success of such a formula.

Nazi members of the *Deutscher Werkbund* had planned to organise, in Berlin in 1933, an exhibition along the lines of the 'Film und Foto' exhibition put on in Stuttgart in 1929, in which the avant-garde photography of the twenties had been displayed, thus changing the whole of the DWB into NSDAP form. Once the Werkbund had been sent packing, the Ministry of Propaganda, supported by the Central Association of Artisan–Photographers and by industry, saw to it that the exhibition was converted into an industrial fair ('Die Kamera', mentioned earlier), in which the photographic section was presented in a national socialist hall of honour. This fair was one of the earliest manifestations of Third Reich propaganda. It was prompted by the idea that mass propaganda purveyed through spectacular isolated demonstrations was more effective than a long build-up. 'Die Kamera' was so successful that it was decided to repeat the exhibition in Stuttgart in March 1934. A comparison between the two catalogues already reveals a number of superficial signs of the regime's consolidation:[7] the Berlin catalogue produced by Herbert Bayer still strongly reflects the principles of the Bauhaus, whereas the anonymous designer of the Stuttgart catalogue, full of gothic characters and printed on ordinary paper, was clearly conforming with the uniform style imposed by the Reich.

For financial reasons, the organisers of the Stuttgart fair agreed to include a few index pages in the catalogue. This produced an element of visual confusion which by no means helped to foster the respectable appearance that had been expected in the catalogue.

Both exhibitions had included a 'hall of fame' with a large number of photographs of parades, designed to demonstrate the size of the crowds that had attended national socialist demonstrations. In a second room there was a single large photograph providing the point of focus: it showed an SA column against a dark background, and its legend ran:

'Comrades, the red front and reaction have been killed.' It was a manifestation of the growing arrogance of the national socialists. The role and presence of professional photographers was much in evidence: all the photographers of Stuttgart, from Lazi and Jllenberger to Jentz and Eisenschink, were present, as were all the leading figures from the worlds of art and philosophy.

A number of other fairs similar to those of Berlin and Stuttgart were held during the Third Reich – one in Düsseldorf in 1936 and another in Berlin in 1937. Others, planned to follow, were prevented from taking place by the Second World War. They were all organised within a framework of close co-operation between industry, the party and the regime. Virtually all innovations were instigated by political imperatives (e.g. the country's economic independence) or direct commands issued by the state. The introduction and development of the Agfa colour process provide a typical example. Research undertaken in the field of colour printing during 1934 was considerably undermined in 1935 by the production and sale of Kodachrome film. After a vain attempt to introduce Agfa colour film at the time of the 1936 Olympic Games, it eventually came on to the market in October of that year, to the accompaniment of a huge publicity campaign. For propagandist reasons, its price was kept so low that it did not even cover the costs of production and development. Yet, throughout almost the entire war, German soldiers were, for preference, equipped with colour film.[8]

Many firms spontaneously took part in propagandist actions, for obvious political reasons. At opportune moments, they would launch competitions, put on exhibitions or produce albums which were always strictly in line with party strategy. At the time of the Anschluss, for example, K. P. Karfeld, an advertising agent for Leitz, commissioned a book of photography on the march east from the Salzburg photographer Stephan Kruckenhauser.[9] Firms producing photographic material organised competitions on suitable themes. One such was 'Give me four years,' an allusion to one of Hitler's famous sayings, pronounced in 1933 and by 1937

ARTHUR GRIMM
ABOARD *THE OCEAN*, a 'Strength
Through Joy' cruise in a Norwegian fjord,
1936.

The salute towards the coast is not merely
symbolic: very few of the passengers were
authorised to set foot on land.

Collection Bildarchiv Preussischer Kulturbesitz,
Berlin.

used as a slogan appealing to all economic forces to help
prepare for the coming war; another was 'beautiful streets,
their buildings and life'. Prizes of photographic material and
money were offered. Once again, it all underlined the
extremely close association between state propaganda and
the economic interests of industry and manifested the
particular concept of individual liberty purveyed by this
national socialist regime and, above all, the definitions of
beauty – and hence also of ugliness – that it imposed.[10]

There were two main ways of opening the eyes of the
ordinary Third Reich citizen to such concepts: first, through
the visual impact of demonstrations such as the 'Parteitage', or
party meetings; secondly, through the new leisure opportu-
nities offered by the state through its 'Kraft durch Freude'
movement (Strength through Joy).

Like sporting festivals, parades and other collective dem-
onstrations, the 'Parteitage' exerted a more immediate and
powerful influence upon the public than long-drawn-out
propaganda campaigns. Photography and the cinema were
supposed to confer an aura of eternity upon these fleeting
events. But such abuse of photography was only possible
provided the photograph was regarded as a simple item of
documentation, never as a work of art. Documents belong to
history, not to politics. In adopting such methods, Goebbels
drew his inspiration from research carried out in the United
States during the twenties. When Leni Riefenstahl's film (of
the Olympic Games) was made, the architect Speer had to
reorganise the setting when it was announced that the best
places were to be reserved not for important personages but
for cinema-directors and photographers. As for the ordinary
citizen, faced upon arrival with all the problems of finding
lodgings and food, he was incorporated into an interminable
march-past and expected to derive comfort from the thought
that he was taking part in a great historical fresco which had
nothing to do with ordinary, everyday life. As yet all that was
called for were the simple crafts of photography and the
cinema, operating without artifice, to turn the formal perfec-
tion of this docile crowd on the march into art. At this point

the cameraman or photographer at work clearly regarded
himself as apolitical: *his* work had nothing to do with the
political implications of these demonstrations of power. He
did not feel personally involved in these parades. Even if the
event was steered in the direction of his camera, he was
nothing but the link connecting the manifest beauty of this
human creation and the dissolution of individuality that
underlay it.

The attempts to organise the free time of the German
citizen also implied an annulment of individual initiative in the
name of state control. The 'Kraft durch Freude' organisation
provided the framework for all leisure activities, most of them
in the form of well-organised mass tourism. Photography may
not have been the essential component in this vast enterprise
but it was certainly indissociable from it. Not only on prestige
tours, such as sea cruises to Madeira, but also on almost all the
holidays provided by this organisation, whether by ship, train
or coach, a photographer was sent along to point out which
details to snap. Political commentary may well have slipped
into that kind of advice. We need only cite the well-known
example of the passengers aboard one ship who were told
that all pictures taken of the island that they were passing
should show the vessel's railings in the foreground.[11]

The function of mentor which fell to the professional
photographer was fundamental to the didactic propaganda
based on amateur photography and it was strongly en-
couraged by both the state and industry. The more pres-
tigious the 'Kraft durch Freude' holiday was, the better known
the accompanying photographer would be. The fame of a
photographer depended upon the publicity he enjoyed – and
that, in its turn, was determined by economic factors. The
magazines produced by some firms, such as *Agfa-Photoblätter*
and *Leica*, achieved huge circulation figures. Others, such as
Photofreund, the magazine of the association of amateur
photographers, *Die Linse* and *Der Satrap*, around the mid-
thirties judged it profitable to double their number of pages.
Their circulation figures ranged from five thousand to eighty
thousand copies.

The reich and the avant-garde photographers

The consolidation of the national socialist regime was to have dire consequences for the lives and work of a number of photographers who had made a name for themselves during the twenties. Most well-known photojournalists of either Jewish origin or left-wing sympathies left Germany between 1933 and 1938 and their places were taken by photographers of the new generation: Hilmar Pabel, Hans Hubmann, Bernd Lohse. A few – Alfred Eisenstaedt, Fritz Henle, Felix H. Man and a number of others – returned to Germany on short professional trips. Not many suffered the tragic fate of Dr Erich Salomon, who was arrested by the Nazis in Amsterdam, where he had taken refuge, and was murdered at Auschwitz.

Many avant-garde photographers either abandoned photography or left Germany, but there were some exceptions. Herbert Bayer, Max Burchartz, Kurt Kranz and other Bauhaus photographers and members of the group from the Folkwang Schule (both schools were attended by national socialist groups of students) became involved in publishing propaganda books, magazines and newspapers. Herbert Bayer was the most active of these until the end of 1938, when he left Germany for the United States where he organised a vast anti-Nazi campaign. Hans Finsler also went into exile in 1933. Laszlo Moholy-Nagy emigrated to the United States in 1934 but continued to return regularly to Germany up until 1937. Anton Starkowski and Heinrich Heidersberger were in 1937 obliged to leave Switzerland and Denmark respectively, whither they had fled from Germany. Herbert List and L. Fritz Gruber both lived in London until the end of 1939, only to be caught in Germany at the outbreak of the Second World War.

Some photographers of the New Objectivity – Albert Renger-Patzsch, Hein Gorny, Fritz Brill, Willi Zielke (who later became Leni Riefenstahl's cameraman) – and many others received official approval from the regime since their styles could easily be adapted to propaganda purposes. Albert Renger-Patzsch was the object of particular attention from the press (up until 1944) and in 1943 was even authorised to mount a rare personal exhibition of his work in Essen. He also published a number of books. Walter Hege, the master photographer of fascist architecture in the ancient Greek style, had as early as 1930 been detailed to organise the photography class of the Weimar Kunstgewerbeschule (which had replaced the Bauhaus), under the directorship of Paul Schultze-Naumburg and was in general supported by the regime.

Apart from press photographers, the only professional photographer to be persecuted by the Nazis was August Sander. His books were destroyed, not because of their contents, but on account of the anarchist tracts which Sander had printed in collaboration with his son Erich, who later died in a concentration camp. The publication of his works was forbidden but he was allowed to continue to work and run his studio. He turned to landscape photography, meanwhile endeavouring to continue his portrait series (of both Nazis and persecuted Jews).

The official photographers

The Third Reich produced no more than a dozen or so great photographers, of whom the unchallenged master was

FRANZ EMMERICH GREGORA
PHOTOFREUND, inside page, 1938.

The author shows the propagandist use to which amateur photography could be put. When Austria was invaded, the SS confiscated the films in the possession of anyone owning a camera.

Collection Agfa-Gevaert Leverkusen, DR.

certainly Dr Paul Wolff who was extremely active from 1933 onwards, publishing both articles and photographs. As a photographer, he operated from an agency where he usually worked with three assistants. He specialised in books of photographs illustrating a single theme, comprising not only large photographic plates but also a didactic section with precise instructions on how to take such photographs. Wolff worked on all his themes with professional models and nearly always combined publicity photographs – for cars or swimwear, for example – with his main theme, producing what in effect became a guidebook. He himself undertook the arrangement of the pictures in his books: photographs of high aesthetic quality would alternate with more or less unexceptional images, giving the reader the impression that he could do just as well with his own camera. A glance into Wolff's archives would have set him right on that score. Each of the photographs, all on the face of it so simple, had been prepared for by a series of experimental studies and countless variations, using technical means to which an ordinary amateur could never have had access.

Paul Wolff pulled off his greatest success on 1 August 1937

ELIZABETH HASE
PHOTOBLÄTTER, cover of the June issue, 1939.

Just before the Second World War, strenuous efforts were made to popularise colour photography. E. Hase was an assistant to Paul Wolff.

Collection Agfa-Gevaert, Leverkusen, DR.

when the Ministry of Propaganda decreed that 'photojournalists who do not understand that the use and promotion of small modern cameras constitute a duty inherent to their mission should remove their official photojournalist armbands.'[12] Wolff's crusade in favour of the small camera resulted in the professional banning of photographers who remained faithful to the old classic camera. By the autumn of 1937 he was being inundated by requests to initiate press photographers into the handling of the small camera.[13]

The photographic work of Wolff and the other photographers in his agency ranged from documentary news photographs to idyllic scenes which conveyed a 'timeless beauty'. Wolff seldom produced news reportages; these were the speciality above all of two agencies run by the reporter–photographers Hoffmann and Scherl. Apart from publicity, which was his favourite field, Wolff also devoted himself to landscape photography: his shots of the picturesque sites of Germany achieve a rare perfection. Wolff's photography established an image of the touristic glories of

the German's country, through which he was to travel extensively in his open-topped automobile.

Other photographers favoured the portrait. Portrait series produced during the twenties, along the lines of Sander's comprehensive studies, were soon being used as documentary evidence to support the concept of the 'Aryan race'. The photographic work of Erna Lendvai-Dircksen and Erich Retzlaff, a vast project designed to produce a record of their country and its inhabitants, betrays an overtly racist point of view, even more flagrantly evident in the text than in the pictures.[14] The directions and suggestions provided by photographic reviews such as these encouraged amateurs to produce similar collections for themselves.

Photography as a collective memory

Encouragement alone was not enough to ensure the success of this propagandist strategy; so in 1936 the Deutsche Arbeitsfront (the German Labour Front) instituted photography courses as a national and stimulating activity to complement the leisure pursuits of German citizens.[16] The propagandist intention is clear in a book written by one of the organisers of these courses: the passage may be regarded as expressing the creed of propaganda founded upon photography devoted to personal memories: 'Amateur photography is the patrimony of a whole people and it should perform a useful task the nature of which is more manifest in the Germany of today than it has ever been before. The education of the people includes photography and should provide each and every citizen with the technical knowledge to enable them to persevere responsibly in this domain and to control their own cameras. But they should not stop there. The skill required for handling a camera is not enough to create a true photographer but it does set up all the conditions necessary for his creation so that amateur photography may aspire to be one of the major factors in the history of civilisation. Furthermore, it makes it possible to leave to one's children and grandchildren a collection of images whose influence is far greater than that of any number of speeches.'[17] The instructions given in this book carried the same persuasive force. They were concerned first and foremost to prove the racial purity and superiority of Aryans through pictures of their daily life. The perception of the age bequeathed to children and their descendants through the medium of photography was supposed to be analogous to that conveyed by the aesthetics of fascist architecture, according to which the very ruins were expected to testify to the greatness of the Empire.

Architectural photography

The task of professional photographers was to reflect the greatness of the Third Reich and its Führer. Photographers of monuments such as Walter Hege, Hugo Schmolz, father and son, and Max Baur were kept fully occupied from 1936 up until well into the war years, filling their films with pictures of buildings produced by the regime and the dreams of Speer and his collaborators. From a qualitative point of view, this campaign of architectural photography was one of the finest achievements of the national socialist aesthetic. The monuments of the Third Reich made their impact more through the

widespread diffusion of these documentary photographs than through direct vision. Ingenious composition could increase tenfold the exaggerated proportions of most of the sites and vistas of these positively gigantic monuments, two examples being the Neue Reichskanzlei in Berlin and the Reichspar- teitagsgelände in Nuremberg. The classicism to which the architects so loudly laid claim was visible only in the photographs.

Also much in use were 'show photos' which brought to the public's attention the artistic and architectural designs for future building projects. Beginning in 1937, yearly 'Bauausstellungen' were held. These were large architectural exhibitions which gave rise to the creation of a supplement to the official magazine *Kunst im Dritten Reich* (The Architecture of the Third Reich). The exhibitions put on show models of building projects designed to show the majesty of future creations of Nazi architecture, flanking them with Walter Hege's photographs of Greek temples. In *Words of Stone*, a silent film with Wagnerian music, made in 1939, every imaginable artifice was employed to make these models look like real buildings. By the beginning of the Second World War no more than six of these colossal constructions had actually been completed, so the propaganda for Hitlerian architecture (a symbol of eternity) was perforce obliged to fall back upon these models.

DR PAUL WOLFF
FLOATING TIMBER.

From *My Experiences With a Leica*, 1939. Wolff not only set an example for all amateur photographers, but also showed how, by observing the aesthetic principles of the 1920s — in theory unaffected by political influences — it was nevertheless possible to obtain photographs with a marked propagandist character.

ERNA LENDVAI-DIRCKSEN
YOUNG MAN FROM JUTLAND, about 1940.

The author's series Portraits of the German People referred to a post-romantic tradition; but her photographs were used for the purposes of racist propaganda. Her pictures of Danes and other peoples were used to justify the invasion of their countries.

Collection Agfa-Gevaert, Leverkusen, DR.

Reportage

The most important field of activity for professional photo-graphy was without doubt that of photographic reportage, designed to meet the ends of political propaganda. Its role was twofold. In the first place, the pictorial commentary it produced on all national events constituted the basis of the information retailed to the population; secondly, the photo-graphs themselves became models for the amateur pho-tographer citizens. By 1935, pictorial information was being closely supervised and organised. The Ministry of Propa-ganda issued its directives at press conferences organised in Berlin, where all the major agencies had their headquarters. The 'Illustrated Press' service, an offshoot of the 'Pho-tography Section' mentioned earlier, controlled the National Association of the German Press to which all illustration editors were compulsorily affiliated. Whenever prohibitions,

HEINRICH HOFFMANN
NATIONAL SOCIALIST PARTY CONGRESS, 1933.

Hoffmann shows not only the vast size of these gatherings of troops
and people, but also the settings devised for the presentation of these
'spectacles' in the media.

Collection Bildarchiv Preussischer Kulturbesitz, Berlin.

recommendations or permissions were issued, the editor-in-chief was informed directly by his agent or by the local representatives of the National Association. The editor responsible for selecting the photographs to be put before the public was kept under particularly tight surveillance by the Ministry for Propaganda. All photographs of Hitler and Goebbels had to be submitted to its officials before publication. It is known that Hitler would snip off one corner of the photographs that he did not wish to see published.[18] Some were subject to special prohibitions: any photographs showing Hitler wearing spectacles or Goebbels's club foot soon became rarities in the editing rooms, and after 1933 they disappeared completely.

Hitler, for his part, had his own accredited photographer, Heinrich Hoffmann, who, as the rise of national socialism proceeded, took fewer and fewer pictures himself, but found himself at the head of a positive army of photographers. On the slightest of pretexts, Hoffmann would publish a whole series of books on Hitler, using a number of different publishing houses. These books, in a generally uniform format, are typical examples of how the media of the time interpreted national socialism. They consisted of the simplest type of photoreportage (with a few photographs of battles, as on the occasion of the annexation of the Sudetenland). The images, which were anything but artistic and frequently of a

quite mediocre technical quality, like those to found in family albums, were designed to prove the authenticity of the event and lend it credibility. These were followed by photographs of the Führer's triumphal appearances, always angled from below, in full daylight, with sharp contrasts of light and shadow, and by the official photographs of diplomatic events. The second part of the book contained scenes of nocturnal festivities, firework displays and the distribution of food and other provisions to the needy sections of the population, or pictures designed to demonstrate Hitler's popularity, in which he appeared with cheering children thronging round him.

The authenticity to which this photography laid claim was an extremely basic and low-level form of propaganda. Hoffmann himself does not appear to have felt entirely at ease with this kind of role; he preferred to direct the selection of works of art to be shown in large exhibitions or to play the diplomat, as at the signature of the German–Soviet pact. From 1933 onwards, all publications concerning Hoffmann were submitted to the authorisation of the Heads of National Security, and books of this type became increasingly rare.

When war broke out, amateur photography was still the mainstay of propaganda. But now it was felt necessary to engage professional photographer–reporters. The first PK or Propaganda Kompanie (Propaganda Company) was set up in 1936.[19]

The members of the PK wore a uniform, were issued with cameras and used a centralised laboratory in Berlin. At the beginning of the war, most of the young photographers who had taken the place of the ejected Jews volunteered for service in these companies: Hilmar Pabel and Hans Hubmann organised the team of the propaganda magazine *Signal*. Wolff Strache founded the magazine *Adler* (The Eagle) with a staff

that included Fritz Kempe, Bernard Lohse, Walter Lauten-bacher, Siegfried Lauterwasser, Wolfgang Reisewitz and Toni Schneiders. These propaganda companies, seven hundred units in all, each employed a photographer, a cinema operator, an editor and a designer.

All the countries involved in the war produced their own propaganda, but Germany's was particularly aggressive and abundantly financed and it proved remarkably effective.

In 1942, the oldest among the renowned photographers of the Third Reich received a 'Führeraufrag': they were assigned the task of compiling a photographic record of all the important monuments, mural paintings and documents of Germany. Dr Paul Wolff and Helga Schmidt-Glassner took colour photographs of baroque staircases and frescos; Walter Hege and others made records of the stained-glass windows of medieval churches, while Albert Renger-Patzsch was responsible for the old country houses of northern Germany. The purpose of the operation was to aid restoration when the war was over.

The irony was that in the terrible destruction suffered by Germany in, for example, the 'scorched earth' operation (Verbrannte Erde) and the Allied air raids, almost all this documentation was lost. But in any case, photographic documentation was powerless either to prolong the life of the Nazi regime or to recreate works of art once they were destroyed.

The use of pictures to provide information in peacetime was organised in such a way that already it had the air of the propaganda of a country at war: it involved a careful vetting of photographs, the idealisation of existing conditions and an active or passive censorship of the press. All the belligerence that permeated pictorial information from 1936 onwards emanated from a propaganda service of the Wehrmacht headquarters. The new 'Unit of War and Propaganda Correspondents' proved itself during the Spanish Civil War, and when Austria was invaded by the German troops a high-budget film was made of the operation. A large team of photographer–reporters followed the shooting of the film. From 1938 onwards, war correspondents were required to wear a uniform which would identify them to the people and at the same time indicate that they belonged to the army.

For example, at the time of the 'Anschluss' of Austria, efforts were made to exploit photography as propaganda to the utmost. The German troops were accompanied by a deployment of photographer–reporters of unprecedented strength. All camera owners were invited by the press and illustrated newspaper supplements to produce news pictures to back up their own material. Even so, the ownership of a camera meant less, ideologically speaking, than the active, positive relationship of each and every citizen to the political actions of the leader of the Third Reich. Here again, the fascist aesthetic is detectable: artistic activities were rated as of neutral (documentary) or apolitical significance (in their search for eternal beauty), but they could subsequently be exploited to legitimate political action. The amateur photographs which camp guards took of their Jewish victims bear out that thesis.[20]

JOE J. HEYDECKER
WARSAW GHETTO, February 1941.

As a soldier, Heydecker was able to photograph the Jewish ghetto. This document reveals the ambiguity of the position of the photographer who, while denouncing the living conditions in the ghetto, also sought (complacently?) to produce an 'aesthetic' affect, as can be seen from the pose and expression of this little girl.

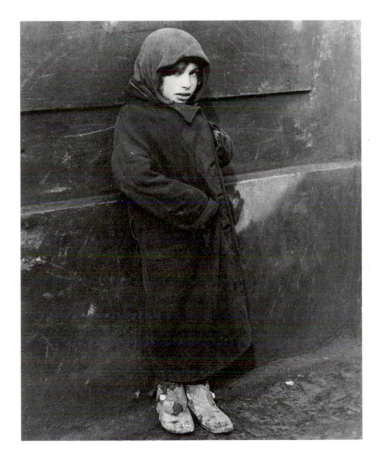

The United States: American society

In the twenty-three-year interval between the First and Second World Wars, American photography enjoyed a vitality seldom equalled in the decades that followed. The extraordinary range of photographic activity can be suggested by considering only the best-known tendencies of the period. One finds, for example, the influential codification of the 'straight' approach to art photography by Alfred Stieglitz, Paul Strand, Edward Weston and Ansel Adams; the importation of modernist visual idioms by such photographers as Edward Steichen and Paul Outerbridge, Jun.; the emergence of photography as a medium of deluxe magazine illustration in the work of Steichen, Anton Bruehl and George Platt Lynes, among others; the rise of press photography and photojournalism, exemplified by such disparate figures as Weegee and Margaret Bourke-White; the renewal of the documentary style by Berenice Abbott, Walker Evans, the FSA group, and New York's Photo League; and the introduction of electronic flash photography by Dr Harold Edgerton. Beyond this register of now-familiar names lie the countless unheralded commercial photographers, scientific photographers, camera club pictorialists, and amateur button-pushers

EDWARD STEICHEN
DOUGLAS CIGARETTE LIGHTERS, 1928.

International Museum of Photography Collection, George Eastman House.
Bequest of Edward Steichen, by direction of Joanna Steichen.

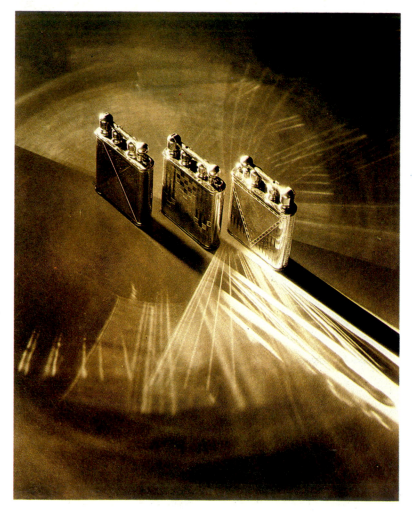

whose concurrent activities are only just being explored.

Looking back from the present, it can now be discerned that by the 1920s and 1930s photography had become deeply woven into the fabric of American social life — from the average family's habitualised snapshooting to the increasingly professionalised circulation of imagery by business and government. I wish to direct special attention here, however, to the unprecedented role played by photography in articulating central themes in the American public sphere during the interwar period. These years saw the 'new capitalism' of the 1920s launch a modernising assault upon traditional cultural values, provoking in response a wide-ranging critical reassessment of the American past — a phenomenon the writer Waldo Frank called the 'rediscovery of America'. These issues took on added urgency, of course, with the advent of a national economic depression in 1929. The interwar years thus offer a particularly striking manifestation of two powerful and enduring countercurrents within American culture: on the one hand, what Henry James ruefully described as the American penchant for the 'perpetual repudiation of the past'; on the other, a persistent yearning for continuity and community based on social memory.

Considered in the light of this thematic, two areas of photographic production suddenly move into provocative constellation: advertising photography and social documentary photography. By giving visible form to contending strains of the American social imagination, each proposed to a wide public alternative versions of the nation's past, present and future.

Yet at the same time areas of convergence emerge with equal force. Writing of the American 1920s, the neoconservative sociologist Daniel Bell has observed that 'a consumer society, one might say, finds its reality in appearances'. In this regard there may be some virtue in stating the obvious: during the interwar period the public claims made for *both* advertising photography and documentary photography aimed at obscuring the distance between reality and its photographic representation. The insistence on the immediacy, objectivity, and veracity of the photographic image provided a founding assumption about the photograph's truth value, one enabling carefully crafted persuasive communications to circulate in the guise of neutral information. Employing a number of shared techniques — the emphasis on the photograph as the tangible presence of its referent, rather than its representation; the meticulous description of surface detail; the use of fragmentary close-ups as metaphors and metonyms; the encouragement of personal identification with depicted characters — the American photography most particularly destined for public consumption during the interwar years urged its audience earnestly to believe in the reality of appearances.

The foundations of a new national culture were set in place in 1920s America, a modernising consumer culture which all but effaced the established American values of thrift, frugality and self-reliance. Instead, there was introduced the idea of individual gratification through the consumption of the *new*. As expressed with admirable concision by President Herbert Hoover's Undersecretary of Commerce, the central article of faith of the 'new capitalism' might be summed up in this way: 'Tradition is the enemy of progress.'[1]

Advertising photography

The role of advertising in promulgating the new consumption ethos was widely remarked on even at the time. In the words of one advertising executive, 'Producing customers is one of the legitimate concerns of mass production. . . . We engineered an adequate supply of goods. We can engineer an adequate supply of customers.'[2]

In the search for effective means of arousing and persuading the consuming public, it was quickly discovered that pictorial images provided a royal road to the mind of the new consumer. Because of photography's comparative speed and cheapness, and because of recent technical advances in photographic reproduction for the printed page, by the early 1920s photography had become a considerably more attractive medium for advertisers. At the same time, commercial photography became much more attractive to talented, ambitious young photographers. One highly publicised instance of this new attitude could be seen in 1923, when Edward Steichen, formerly a stalwart of the Photo-Secession, became chief photographer for the Condé Nast publications *Vogue* and *Vanity Fair*; at the same time he signed a lucrative contract with the J. Walter Thompson advertising agency. Steichen outraged his former Photo-Secession colleagues when he publicly announced his enthusiasm for commercial assignments, adding that he fully expected to 'express the best that's in me' through advertising photography.[3]

Thanks in part to the well-publicised example of Steichen, who demanded for each of his advertising photographs the princely sum of $500 (as well as a printed credit line), talented young photographers began to gravitate to advertising photography. During a decade when American business and industry attracted international admiration, few photographers, even those with artistic yearnings, found it demeaning to be associated with commercial enterprise.

Then, too, at a time when most American art museums and the most influential art critics remained adamantly opposed to modernism in the visual arts, American advertisers shrewdly calculated its usefulness and bestowed a cautious embrace. Already in 1920 advertising trade periodicals announced that 'ART is the new weapon of national and international competition. America is leading the world in the application of art to business.'[4] Many advertisers showed themselves willing to take advantage of the shock value of what they called 'futuristic monstrosities' inspired by modernist art. 'I want my advertising to pay,' wrote one businessman. 'We have jumped from conservatism to the most outlandish advertising. For my own part I dislike it greatly. It shocks and jolts me. But my advertising must pay.'[5]

One important characteristic of the advertising photography of the 1920s, then, was its assimilation of many of the devices of modernist art, but within the framework and attuned to the dynamics of a nascent consumer culture. One might note the association of many of the most successful young commercial photographers with the Clarence H. White School of Photography in New York, an institution founded in 1914 by another former member of the Photo-Secession movement. Here such ambitious young photographers as Paul Outerbridge, Jun., Anton Bruehl, Margaret Bourke-White, Ralph Steiner and Ira Martin learned how the visual idioms of modernist art might be applied to the needs of American cultural modernisation.

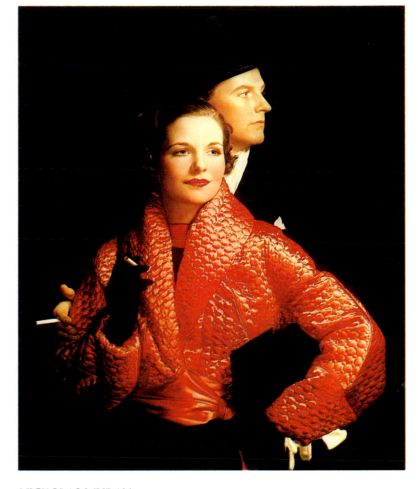

NICKOLAS MURAY
PUBLICITY PHOTOGRAPH FOR A CIGARETTE BRAND (CAMEL), 1932.

International Museum of Photography Collection, George Eastman House.

While motion pictures, primarily, introduced the new consuming public to the broad spectacle of modern opulence, it was the printed advertisements of magazine pages that channelled general desires toward specific purchases. Owing largely to the demand of advertisers, colour photography and colour reproduction techniques now made great strides. The introduction of the complex, expensive Carbro colour print process in the early 1920s, and the development by Anton Bruehl and Fernand Bourges of an elaborate colour transparency process for the Condé Nast publications in 1932, helped to drive home the message that was being sent to advertisers: 'Colour sells'. In the continuing battle to capture and hold the audience's attention, a host of innovatory photographic techniques was exploited. These included many devices simultaneously explored by avant-garde artists and photographers in Europe and America: collage and montage, double exposure and double printing, radical cropping of the image, unusual viewpoints and startling perspectives, dramatic lighting, extreme close-ups, retouching and airbrushing, and the patterned repetition of visual units.

But while some advertisers felt that such devices were necessary to overcome what was still regarded as the inherent monotony of the photographic image, in the end a seemingly transparent photographic realism proved a more effective means of addressing American audiences, whose historical preference for realistic imagery has often been noted. Here the long-standing popular tendency to confuse a photograph

with the object it depicted was decisively turned to commercial advantage.

Within this broad realistic mode of American advertising photography, several distinct photographic genres could be discerned by the end of the 1920s. Technically skilled studio photographers like Steichen and Anton Bruehl combined dramatic lighting, pinpoint focus, and bold graphic forms to evoke a glamorous, almost fetishistic aura around the manufactured products they depicted. 'No product is so commonplace, so cold and uninteresting, that the professional visualiser of advertising space cannot turn the material into real beauty,' boasted the advertising periodical *Printer's Ink*.[6] These visual methods were precisely analogous to those whereby theatrical and motion picture celebrities were photographically 'glamorised' for portraits in *Vogue* or *Vanity Fair*. A remarkable vision of the reigning physical and social ideal can be seen in the haughty, cigarette-wielding models presented by Nickolas Muray in the early 1930s. Whether gleaming metal or immaculate flesh, the 'truth of the surface' proclaimed by photography emerged as one of advertising's most effective persuasive stratagems.

Dramatic images of American industry in action provided an important subgenre of advertising illustration. Typically the human component of the work process was overshadowed by gigantic machinery, the latter often presented from the same unaccustomed perspectives that Rodchenko,

ANTON BRUEHL
TOP HATS, 1929.

International Museum of Photography Collection, George Eastman House.

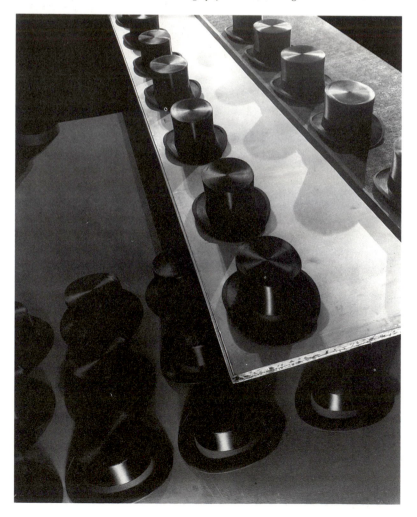

for very different reasons, was simultaneously introducing in the USSR. The unusual viewpoint, explained *Printer's Ink* in 1924, was determined 'not by whim, but by experiment, and represents that point of view from which the subject can "sell" itself to best advantage'.[7]

During this period, as Hollywood established itself as the nation's dream factory, a number of advertising photographers sought to follow suit, staging elaborate, fictionalised photographic tableaux in their studios. Frequently set designers, lighting crews, make-up artists and specialist phototechnicians would be called upon to realise these extravaganzas. One of the most interesting photographers working in this vein was Lejaren A. Hiller, who during the 1930s fabricated illusionistic scenes from all parts of the world in his New York studio. He went so far as to simulate, for example, a raging Amazon River with swaths of coloured cellophane, on which his hero was set adrift in a canoe. The air of romance or adventure conjured up by such photographs suggested an imaginary exit from the routines of everyday life into an extraordinary realm — one symbolised, of course, by the advertiser's product.

In counterpoint to such undisguised fantasy, by the mid-1920s advertising illustration had already absorbed its opposite term, a diluted version of social realism. In 1923, for example, the noted documentarian Lewis Hine began to produce photographs for the use of the Pennsylvania Railroad's promotional campaigns. In these straightforward, unpretentious portraits of the railroad's employees, Hine gave persuasive visible form to the railroad's dependability and responsibility. In 1924 and 1925 Hine was awarded medals by the New York Art Directors Club for his photographic work on behalf of six business concerns, and his photographs attracted considerable interest in the advertising community. Calls for the use of 'real people' with 'expressive faces' were issued in advertising trade periodicals. It was argued that 'realism is good salesmanship' since it conveniently coincided with commonly held beliefs regarding the evident truth value of the photograph.

This theme was underscored in a publicity campaign launched in 1927 by the Professional Photographers of America, who sought to encourage advertisers to rely to a still greater degree on photographic illustration. The campaign's slogan was: 'Photographs tell the truth.' Its central argument was couched in revealing terms: 'Photographs mingle romance and reality; present your wares exactly as they are; yet with a captivating charm that leads to bigger, quicker sales. Photographs are not discounted as the fanciful dream of an artist. They tell your story as an unprejudiced eye witness.'[8] As we will see, however, the intertwining of reality and romance via an appeal to the veracity of the eyewitness account was by no means the exclusive province of advertising imagery during this period.

The Wall Street Crash

The bursting of the stock market bubble in September 1929 and the advent of a catastrophic economic depression confirmed a whole generation of young photographers in a direction quite opposed to that of the commercial photography of the previous decade. In 1931 Walker Evans could write with dismissive certainty of the man popularly hailed as the 'world's greatest photographer': 'Steichen is photography off its track in our own reiterated way of technical impressiveness

and spiritual non-existence. In paraphrase, his general note is money, understanding advertising values, special feeling for parvenu elegance, slick technique, over all of which is thrown the hardness and superficiality of America's latter day, and has nothing to do with anyone.'[9]

Believing the 1920s a period of cultural disaster for America, literary and social critics like Van Wyck Brooks and Lewis Mumford set out on what Brooks called a 'search for a usable past'. They turned not to America's long-dominant but now-discredited puritan heritage, but to forgotten pockets of American folklore, literature, folk art, and local and regional (as opposed to national) history. Here, they argued, might be found alternative models for an authentic American expression.

For photographers like Evans, this longing for the reactivation of a long-buried past prompted a radical re-evaluation of long-forgotten photographic predecessors. This meant in particular looking back past the generation of Stieglitz and the flamboyant aestheticism of the Photo-Secession movement to earlier examples such as that of Mathew Brady, the photographer of the Civil War. In the judgment of the critic Lincoln Kirstein, one of the most influential partisans of the new documentary attitude, Brady's photographs provided 'an example of the camera's classic vision, austere and intense'. Kirstein detected in such unadorned images 'an esthetic overtone of naked, almost airless factual truth . . . of objective immediacy not possible, even if desirable, in paint'.[10] Berenice Abbott's simultaneous introduction of Atget's work, in which similar characteristics can be found, helped to propel her, Evans, and many other young photographers toward the exploration of a new documentary ideal.

The widespread urge to photographically explore the neglected margins of the nation's cultural heritage can no doubt be considered as one kind of critical response to the official 'progress and prosperity' rhetoric of the previous decade. This tendency should perhaps be distinguished from another, more politically committed documentary tendency, which sought to convey to the general public the harrowing impact of the Depression on millions of citizens. But in contrast to Germany, where the interwar years witnessed the growth of a worker–photographer movement with its own widely circulated publications, no comparably militant faction emerged in the American documentary movement.

New York's Photo League, founded in 1936 as an offshoot of the leftist Workers' Film and Photo League, might be regarded the most politically committed American photographic group of the 1930's. Under the guidance of founding members Sid Grossman and Sol Libsohn, it brought to American documentary photography a new concern with long-term, collaborative photographic projects – such as the four-year 'Harlem Document' (1936–40) carried out by a group led by Aaron Siskind. Yet the Photo League's professed social concern was limited in practice to a sympathetic, often romanticised portrayal of an urban working class beset by poverty and unemployment. Officially it downplayed partisan political engagement, emphasising instead the role of the photographer as a creative craftsman beholden to no political ideology.

The merging of these two broad documentary tendencies in a government-sponsored photographic project owed much to the resourcefulness of Roy Stryker, a former Columbia University economics instructor who in 1935 organised a team of talented photographers for the Farm Security

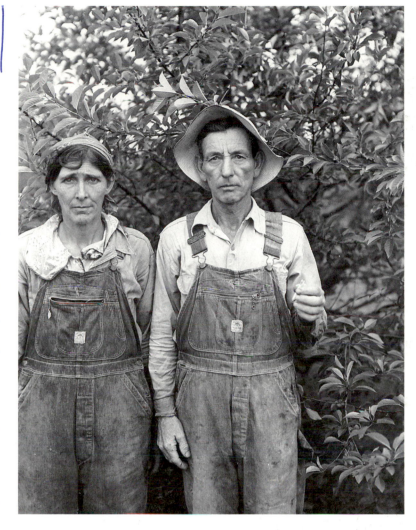

ARTHUR ROTHSTEIN
FARMING COUPLE, about 1938.

Library of Congress Collection, Washington.

Administration (FSA), a Roosevelt New Deal agency. While the primary impetus behind the FSA project was the need for photographic material that could be used to rally public support for the Roosevelt plan to aid the rural poor, Stryker's idea of the group's mission was far more ambitious. As he later put it, his real interest in photography lay in its use in the 'recording and interpretation of complex environments in extensive picture series'. To this end he encouraged his photographic staff – who included such figures as Walker Evans, Dorothea Lange, Ben Shahn, Russell Lee, Arthur Rothstein, and Marion Post Wolcott – to aim at nothing less than a panoramic portrait of everyday American life. Between 1935 and 1943 over 100 000 selected photographs were captioned, filed, and indexed in the FSA's vast picture file. In addition to their use in government publications and exhibitions, the images were also reproduced widely in magazines such as *Life*, in newspapers and in books.

In recent years considerable critical ingenuity has gone into the identification of the stylistic and thematic predilections of the individual FSA photographers. As a result, it has become possible to recognise that within the documentary style of the period there existed significant latitude for individual, interpretative camera work. The formal, frontal-view camera work of Walker Evans, for example, was perfectly suited to depicting as ironically eternal the vernacular architecture that

DOROTHEA LANGE
WOMAN OF THE HIGH PLAINS, TEXAS PANHANDLE, 1938.

Library of Congress Collection, Washington.

was his special subject. Evans's main encounter with human subjects during his FSA work came during his celebrated 1936 trip to Hale County, Alabama, in the company of the writer James Agee. After considerable difficulties, their account of their time with several sharecropper families was published in 1941 as *Let Us Now Praise Famous Men*.

Dorothea Lange, on the other hand, specialised in intensely realised encounters with individuals, often migrant farm-workers or the dispossessed. Russell Lee, a gregarious Texan, showed special skill in the use of flash to illuminate scrofulous shanty interiors. Arthur Rothstein, a former student of Stryker's at Columbia, evidenced an uncanny talent for dis-covering classic, gaunt American faces. Marion Post Wolcott, who joined the FSA group only in 1938, contributed studies of small-town life and the leisure activities of the very wealthy.

The most frequently reproduced FSA images still vividly evoke the grim Depression era — a time when nearly one-quarter of American workers were jobless, and when fore-closure and drought forced tens of thousands of farmers and rural workers off the land. But considered in a somewhat broader sense, it should be noted that the more than 1 306 000 prints filed as part of the FSA's continuing 'portrait of America' underwent a marked redistribution of thematic emphases as the project progressed. Three general periods

might be suggested. From 1935 to 1938, priority was given to portraying the plight of the 'lower third' of the population described by Roosevelt as 'ill housed, ill fed, and ill clothed'. Such images played a considerable role in mobilising public support for the government's controversial assistance pro-gramme, not simply by presenting incontrovertible evidence of widespread suffering but also by insisting on the stubborn dignity of men and women worthy of help.

By the end of 1938, however, Stryker advised his photographers that a more positive and wider-ranging viewpoint was required. Even though the ravages of the Depression had only slightly abated, it was now felt to be politically expedient to emphasise the beneficient fruits of the Roosevelt administration's policies. Further, with Europe and Asia sliding inexorably toward war, it was widely felt that a new sense of unity and confidence should be instilled in the American people. Consequently, the general direction of the FSA's photographic work veered away from social critique and toward an increasingly uncritical celebration of American life. As the 1930s closed, FSA images of the proverbial 'horn of plenty' in the nation's heartland, the snug comforts of small-town life, and the proud faces of farmers and industrial workers began to be filed and distributed in large numbers.

Finally, after America's official entry into the Second World War in December 1941, Stryker's photographic unit was transferred to the Office of War Information, and its duties were increasingly restricted to the production of visual images designed to rally the home front and spur the war effort. Even as Stryker was preparing to leave Washington, the example of his FSA unit influenced several of the nation's military services to form special photographic teams to 'document' the war in ways that might provide tangible public relations benefits. The most notable of these oper-ations, Edward Steichen's Naval Aviation Photographic Unit, was patterned directly after Stryker's organisation, and smoothly combined an appeal to the historical value of documentary photographs with a guarantee of their wide circulation to the nation's leading magazines and newspapers.

Stryker's own destination upon leaving government ser-vice in 1943 is suggestive of the social trajectory of American documentary photography during this period. His agreement to form a new photographic group (including several former members of the FSA team) for one of the nation's most powerful corporations, Standard Oil of New Jersey, took a number of his colleagues by surprise. Stryker's personal motives are not at issue here. What seems more important is that Standard Oil concluded that through the massive deployment of documentary-style photographs of the company's operations and especially its workers, it might recast its public image from 'predatory, secretive, greedy' to 'generous, honest, likable'. In Stryker's command of the persuasive apparatus of documentary photography, the company saw the means to solve what one executive euphemistically described as a 'human engineering problem'. Through his efforts to create a convincing human visage to lend credence to the public-relations theme 'oil is people', Stryker helped channel the documentary style of the 1930s as a major component — capitalist realism? — of the advertising imagery of postwar America.

WALKER EVANS
FARM KITCHEN, COUNTY HALE, ALABAMA, 1936.

Library of Congress Collection, Washington.

8

Photography sure of itself
(1930–50)

After the First World War, the distinction between practical documentary photography and artistic photography became increasingly difficult to draw. Used in the most utilitarian way, as publicity, photography interpreted and filtered reality; meanwhile, it was also a part of the great international movement of avant-garde art and, with the growing importance of the illustrated press, it acquired a power that the powerful themselves had to take seriously.

Around 1930, there occurred a short period when ideas and images were able to circulate with exceptional freedom. It was soon brought to a brutal end. However, an idealist and humanist conception of photography lived on. It was to reach its climax and end in the fifties.

The rise of photojournalism

Between the twenties and the fifties, up until its retreat in the face of television, photojournalism[1] enjoyed an extraordinary success thanks to the introduction of new techniques, new ideas and above all small cameras that were easy to handle and fast to operate. To be sure, cameras in which plates were used, such as the Contessa Nettel 6×9 cm, continued to provide competition, for they had the advantage of producing finer-grain contact prints. The most typical camera of the time, the 1924 Ermanox, still used plates, but its fat Arnostar $f/1.8$ lens and its roller-blind shutter permitted exposure times of $\frac{1}{1000}$ of a second and its use in difficult light conditions.

In 1923, Oskar Barnack, in Wetzlar, invented a camera adapted to operate with rolls of cinema film. This was the Leica,[2] which produced 24×36 mm images on roll film 35 mm wide. It went into commercial production in 1924 and was a great success. In 1932, it was further significantly improved with a rangefinder coupled with seven interchangeable lenses of varying focal lengths.

The Rolleiflex by Franke and Heidecke, which came out in 1929, was a reflex camera with twin lenses, using a roll of 117 mm film and producing pictures of 6×6 cm. These were small dimensions for the time.

Meanwhile progress was being made with lenses such as the Tessar and the Sonnar $f/1.5$ by Zeiss. They let in more light and so allowed for faster shutter speeds and clearer definition. At the same time, camera films were becoming increasingly sensitive. The Ilford Panchromatic (32 ASA) came out in 1929, followed in 1933 by the Agfa Superpan (100 ASA) and the Kodak Super Sensitive. Their advantage over plates was that they offered a run of thirty-six exposures without reloading. There was no longer any need to drag around a heavy box full of glass or the lighter but still bulky cut film or film pack. The reporter, thus relieved and now, thanks to the rangefinder, able to focus and shoot from eye level, could move around his subject, taking it from a series of different angles. The plunging and upward views favoured by Soviet photographers such as Rodchenko now triumphed in practice. Viewpoints were liberated.

The page layout of magazines was revolutionised. In the early twenties, the continuity of a story had been chiefly provided by the text. This would be accompanied by a number of isolated pictures, often from different sources, all illustrating the same theme. Photographic plates spelt discontinuity; the 35 mm roll of thirty-six exposures spelt continuity. Now the tendency was to print a collection of pictures taken by a single photographer in the same style. Furthermore, the layout designer was now less prone to crop images since with a 35 mm film, less finely grained than plates, the entire area should be used. The framing chosen by the reporter was thus increasingly respected. Furthermore, the layout designer, who now had more pictures at his disposal, created his effects by exploiting their interrelationships and emphasising their continuity. These new dynamics in the field of illustration originated in Germany with Stefan Lorant. In 1928, Lorant, a Hungarian, became editor-in-chief of the *Münchner Illustrierte Presse*, the bold layouts of which had a seminal influence. When obliged to flee from Nazi persecution, he settled in Great Britain where he continued to pursue a brilliant career, bringing the same flair to his direction of the *Weekly Illustrated* and founding *Lilliput* in 1937 and *Picture Post* in the following year. In 1940, he moved on to the United States. In 1928, in France, Lucien Vogel, also brimming over with new ideas and with generally left-wing views, founded *Vu* magazine. *Regards*, even more lively and politically committed than *Vu*, was founded in 1931 and meanwhile the venerable *Illustration*, a much more bourgeois but very luxurious magazine, continued to pursue a prestigious career with Emmanuel Sougez as its director of photography.

It was now becoming clear that it was in the photographic agencies, which mediated between the magazines and the photographers, that reportages were born: a case in point was the Dephot agency in Berlin, which was directed by Simon Guttmann, one of the first to conceive of reportage as an assembly of pictures that was coherent and complete in itself. Each reporter would set out with a plan of action. One of these agencies, Associated Press, originally known as Pacific and Atlantic, liaised with the United States. Photographers such as Tim Gidal, Felix Man[3] and the future Kurt Hutton (then still Kurt Hübschmann) met at Dephot, together with Umbo and others, in the late twenties and early thirties. In 1934, Dephot was obliged to cease to operate in Germany. But within the space of ten years the star reporter had been born: a colourful character, essentially international and, in many cases, also highly cultivated.

Erich Salomon,[4] born into a wealthy family in 1886, was a doctor of law. In 1926, he entered the publicity service of the firm of Ullstein, where he encountered photography. In 1927 he acquired his famous Ermanox and in 1932 moved on to a Leica. His cultivated manner enabled him to infiltrate the most exclusive places such as law-courts and diplomatic conferences. In Geneva, for example, with his tail-coat and white tie and his camera tucked into a briefcase, he won the amused indulgence of such a man as Aristide Briand. In 1930, while in the United States, he snapped Marlene Dietrich engaged in a telephone conversation. In 1935 he scooped a session of the Supreme Court, using a camera hidden inside a false bandage. Many of his photographs appeared in the *Berliner Illustrirte Zeitung*. In 1931, his book entitled *Berühmte Zeitgenossen in Unbewachten Augenblicken (Famous Contemporaries Caught Off Their Guard)* enjoyed a great success. He was to die in Auschwitz in 1944.

Felix H. Man, born Hans Baumann, was also a highly cultivated individual, an eminent historian of lithography, who in 1926 likewise joined Ullstein's in Berlin, initially as an artist. Using the Dephot agency as his base, he subsequently produced many photographic reports for the *Münchner* (from 1929 to 1931) and the *Berliner* (from 1929 to 1934). He resorted to his considerable ingenuity to photograph the

irascible Arturo Toscanini, slipping among the musicians of his orchestra and synchronising the clicks of his shutter with the louder passages of music; and also to bring off scoops such as his 'Day in the life of Mussolini' (*Münchner* No. 9, 1931). In 1934, Man left Germany and joined Stefan Lorant in Great Britain, where he shared the success of the *Weekly Illustrated* (1934) and *Picture Post* (1938). After the war, in 1948, he was one of the first photographers to produce major reportages in colour.

Kurt Hutton was born Kurt Hübschmann in Strasburg in 1893. After studying law and seeing courageous service at Verdun, he contracted tuberculosis and went into photojournalism. It was once again the Dephot agency that commissioned his first reportages. But his career as a reporter really took off in Great Britain, where he remained very loyal to both the *Weekly Illustrated* and the *Picture Post*.

Another German, Tim Gidal, worked at first in Germany but then travelled widely, settling in Palestine in 1936, where he became a British subject. Lorant asked him to come to Britain in 1938 to work on *Picture Post*. Because he was British he was not interned on the Isle of Man, like Man and Mutton. In the early years of the war he became for a period the most important photographer for both Lorant and his succesor Tom Hopkinson. He later worked for the British Army magazine *Parade*, published in Cairo and based on the French-language *Images*, founded in Alexandria in 1930, not long after *Vu* in Paris. He has completed in the region of two hundred reportages all over the world. A doctor of philosophy, he also wrote the first serious history of photojournalism. He too started his career with the *Münchner* and the *Berliner*.

The ranks of these great reporters also include the Swiss Walter Bosshard and the Austrian Harald Lechenperg.

In the course of his travels and even more because of his need for connections to protect him from the most brutal vicissitudes of war and politics, a reporter's nationality might undergo a number of changes. For example, Lucien Aigner, born in Budapest, studied in Prague and Berlin, then became a London press correspondent in Germany. From 1931 to 1939 he worked in Paris as a correspondent for many magazines, including *Life*. In 1939, he emigrated to the United States where he took out naturalisation papers in 1945. His portraits of Einstein, Mussolini and Roosevelt are famous.

But images of the world were also produced by countless regional photographers who stayed put, spending their entire lives representing the people, monuments and scenery of their own lands. Of the reporters who became famous, some also made a name for themselves in other branches so that it is hard to say where their deepest vocations lay.

Martin Munkacsi[5] started as a sports reporter in Budapest and in his last years returned to painting. In 1927 he began to work for the German magazines in Berlin but in 1934 he landed an advantageous contract with *Harper's Bazaar* which turned him into one of the foremost fashion photographers of his time. He introduced vitality, sport, fresh air and physical health into his pictures. His work places him at the intersection of sports photography, photojournalism, fashion and even purely artistic experimentation. He was to provide inspiration for Henri Cartier-Bresson, and later for Richard Avedon.

Otto Umbehr, known as Umbo, was a Bauhaus student from 1921 to 1924. He took up professional photography at the instigation of Paul Citroen, a creator of extraordinary surrealist collages. In 1928 he was working for the Dephot agency, meanwhile pursuing experiments of a surrealist nature in the plastic arts: these included collages, photomontages, multiple exposures and experiments on film with X-rays.

The work of André Kertész[6] – setting aside the amazing 'distortions' which he produced in Paris – in contrast possesses an overall unity. Kertész, who was born in Budapest in 1894, was attracted to photography at a very early age. He was working as a bank clerk with no particular vocation for his job when his photographs began to be published. In 1925 he arrived in Paris, where he was employed by French, German and British magazines. In 1927 he held his first one-man exhibition, which to be was an inspiration to his compatriots Brassaï and Capa. He acquired a great reputation as a portraitist and a photojournalist. In 1930 he left for New York, where he earned his living as a photographer in the worlds of fashion and interior decoration, with contracts from first Keystone, then Condé Nast. But in 1962 he shook himself free of such obligations. He became an American citizen in 1944 and died in New York in 1985.

The rise of nazism and its attendant perils around 1934 caused a break in the evolution of photojournalism which, hitherto centred in Germany, now continued its progress in Britain and the United States. We have noted the many changes in Munkacsi's career and the exiles of S. Lorant, Kertész and many others. But at a deeper level what was at work here was an underlying contradiction between the creative temperaments of these strong personalities and the manner in which ordinary press photographers were required to become increasingly servile to the average tastes of the general public.

Brassaï was another Hungarian. Born Gyula Halasz in 1899,[7] he first studied art in Budapest and Berlin, then moved to Paris in 1923, never yet considering turning to photography. It was Kertész who, in about 1930, showed him how photography could capture the rather seamy poetry of streetlamps glowing in the dark, wet paving stones, unsavoury hotels and street dancing that so fascinated him. His book, *Paris de nuit*, which appeared in 1933, marked a turning point for Brassaï. His pictures were now published in many magazines. He was still a talented draughtsman and sculptor and now became friendly with Picasso.[8] He also became a marvellous writer, using the French language (*Histoire de Marie*, 1949). He continued to live in France until his death in 1984. His keen awareness of the problems of plasticity revealed to him the power of graffiti[9] scratched on walls. The photographs he took of them are a cross between primitive art and surrealism and even contain elements of the conceptual art of the future.

Another giant of photography, Bill Brandt,[10] also found himself caught between editorial practice and purely artistic expression. Born in 1904, he studied with outstanding success in Germany and Switzerland. In 1929 he was working alongside Man Ray in Paris, discovering in surrealism the source of photographic inventiveness. He met Brassaï, and came upon the work of Atget. Having returned to Britain in 1931, he devoted himself principally to reportages on the harsh social realities and to portraits of writers and artists. His pictures appeared in the popular magazines *Weekly Illustrated* and *Lilliput* and also in the French avant-garde *Verve*. But most of his best work went into books: *The English at Home* (1936) and *A Night in London* (1938). During the war, he showed the

same indistinct masses of people sleeping in heaps and shelters that appear in the drawings of Henry Moore. In 1945, he embarked upon his great series of nudes – but, as with Brassaï's *Graffiti*, these fall into what must, strictly speaking, be termed the contemporary period.

Little by little, a development was taking place along lines that ran in the opposite direction to those of the twenties: single photographs, in isolation, were becoming increasingly important, but now they were regarded as the original works of creative artists. Brassaï's images of Paris and Brandt's of London were now seen as part of a unified project devised by the photographer himself, not simply as a commission.

A photographer's ambition would now be to produce a book representing the sum of his research, rather than an illustrated article, the erstwhile mark of professional success. The same pictures began to reappear all over the place, more as representative of a work complete in itself than by virtue of their documentary value. Brassaï's pictures of prostitutes published in *Regards* on 31 December 1936 had already appeared in *Paris de Nuit* in 1933. They were once more to be seen in *Camera de Paris* (1949) and again reproduced (provoking considerably less criticism) in *Secrets de Paris des années trente*. In similar fashion, Brandt's work was soon better known through his books than through his articles; it was not until after the success of his books that he began to work extensively for *Picture Post* and *Lilliput*. His pictures for them, such as his street scenes in Halifax, had a strong social slant and were not well received by his subjects, who wrote to *Picture Post* complaining that they would rather have seen more cheerful images of their smoky city. Despite his humanitarian intentions, Brandt was obliged to return to the solitude of his artistic experiments.

The recognition of the photograph as a separate work and individual achievement was largely due to photographic year books, anthologies of photographic images. Nowadays, it is perhaps difficult to understand their importance during the thirties. *Das Deutsches Lichtbild* first appeared in 1927 and remained an important record even after 1934. In France, *Photographies* (published by Arts et Métiers Graphiques) also came out from 1930 onwards, under the guidance of Emmanuel Sougez. In Great Britain, the publishers of *Studio*, a modern art periodical, in 1931 brought out *Modern Photography*, directly inspired by C. G. Holme. In 1935, *Photography* magazine launched *Photography Year Book*, under the direction of the Hungarian T. Korda. It contained a stimulating mixture of press, journalistic and art photography. In the United States in 1935 *US Camera* was the first in a series of marvellous yearbooks which continued to appear until the early fifties under the combined direction of Tom Maloney and Edward Steichen. The more traditional yearbooks, foremost among them the venerable *Photograms of the Year*, although somewhat old-fashioned, continued to be appreciated by amateur photographers. It was the beginning of the elevation of the single photographic image into a work of art.

In the first decade of the heyday of photojournalism, from 1925 to 1935, photographic artists had begun to be respected for their individual qualities. But soon the growing importance of ideologies, the battle for men's minds and the outbreak of war introduced all sorts of restrictions to their freedom of expression. In Great Britain and Germany photojournalists became war correspondents. In France, only photographs depicting the frivolities of Parisian life were tolerated.

The movement that had started in Europe now continued in the United States and Canada. Even the creation of the quintessentially American *Life* magazine,[11] in 1936, reflected the influence of refugees from Germany such as Kurt Korff, previously editor of the *Berliner Illustrirte*. The same went for the photographic agencies: the Black Star agency in New York was a reincarnation of the Mauritius agency of Berlin. The prosperous and enterprising American business world constituted the public at which a magazine such as *Fortune* was aimed. In this thick, glossy production, its boss, Henry Luce, spared no pains to make it a vehicle worthy of its heavy advertising charges. But *Fortune* was more than this: it was a test-bed for *Life*, particularly in the field of reportages, such as the study of Russia produced by Margaret Bourke-White. She was the first photographic star and was sometimes accompanied on her assignments by Luce himself, who brought back copies of the *Weekly Illustrated* from Britain in order to study their page layout.

Life was the first magazine to be coherently planned from start to finish. Henry Luce wanted a 'shiny magazine', in every sense of the expression, with gleaming pictures on coated paper. He wished to 'advance the art and function of pictorial journalism' and was 'a ready purchaser of the best product of the best freelance cameramen'; but he also worked with a team of five or six accredited reporters, which was something quite new.

The magazine's name was chosen from a long list of runners, some of which were tried out in dummy issues. In his prospectus, which appeared in June 1936, Luce set out his views: high-quality printing and reports constructed around two cornerstones: the big news stories of the week and the big special feature. The latter was supposed to introduce the reader into the intimate life of some famous figure or into the way that some great institution worked. The aim was 'to see and take pleasure in seeing, to see and be amazed, to see and be instructed. . . . Thus to see and to be shown is now the will and new expectancy of half mankind. . . . The Show-Book of the World . . .'. We were entering a world in which reality, with its concrete problems and all its sometimes inadmissable aspects, was to be replaced by a double, reproduced on the cinema screen or the pages of a magazine.

The first issue of *Life* appeared on 19 November 1936, with an impressive cover photograph by Margaret Bourke-White[12] showing a proud symbol of determination and achievement, the Fort Peck dam.

The team of McAvoy, Stackpole and Vandivert working alongside Bourke-White was also brilliant. Alfred Eisenstaedt[13] had arrived in the United States in 1935, already experienced from his newspaper work in Berlin and Paris. His reports on the war in Ethiopia (1935) confirmed his reputation. Carl Mydans, who had come from the Farm Security Administration, specialised in the Far East, while Fritz Goro, from the *Münchner Illustrirte*, increasingly devoted himself to scientific photography. John Phillips was everywhere with his reports before, during and after the war. But relations between the photographers and the management of *Life* were not always as idyllic as Henry Luce suggested: that much is clear from the passionately committed life of one of the great photographers of all time: William Eugene Smith.

Gene Smith[14] was born in 1918 in the town of Wichita, Kansas. He started off working for local newspapers, studied photography at the University of Indiana and received his first important commissions from *Newsweek* in 1937. His great

WILLIAM EUGENE SMITH
SPANISH VILLAGE, 1951.

Taken from his reportage, 'The Spanish Village'.

Collection of the Bibliothèque Nationale, Paris.

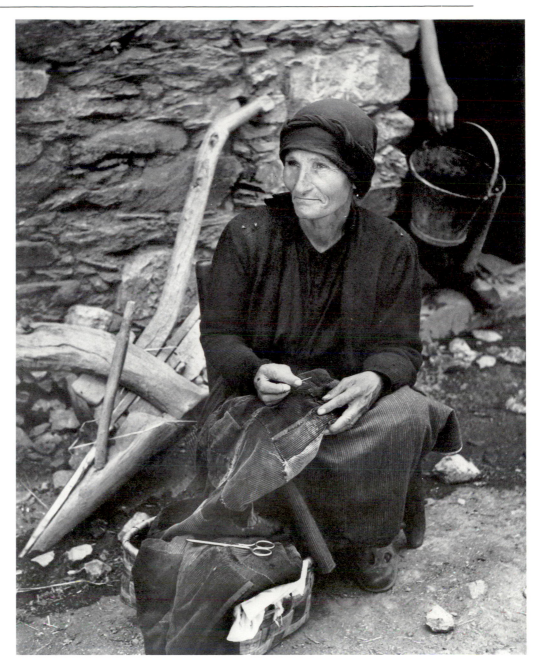

hero at the time was Martin Munkacsi. In 1938 and 1939 he was working for the Black Star agency, supplying photographs for *Life* and for *Collier's*. In 1939, he joined the *Life* team. Now he was in the big time, but he left the paper in 1941. During the war, he worked as correspondent in the Pacific. His photographs were both admirable and tragic, particularly those of the island of Saipan. But he was anxious to make his own position clear: 'It made no difference to me as a news event that an island was being taken, what I wanted to bring out were the emotions behind the taking of that island.' He was seriously wounded in Okinawa and took two years to recover. In 1947 he returned to *Life*. This was the period of his most famous reportage essays: 'Country Doctor' (1948), 'Spanish Village' and 'Nurse Midwife' (1951), paralleled by the equally distinguished essays of Leonard McCombe: 'New York Secretary' (1938), 'Cowboy' (1949), 'Navajo' (1951), etc. But in 1954, after editorial disputes concerning his reportage on Dr Schweitzer, Smith broke with *Life*. In 1956, he was awarded his first Guggenheim Prize and Stefan Lorant, who

had arrived from Europe in 1940, hired him to work on an ambitious project: its subject was to be the great industrial town of Pittsburgh. The book eventually appeared in 1964 but its aspirations were not completely fulfilled. Since 1955 Smith had been a member of the Magnum agency but in 1958 he left it to devote himself to a huge autobiography planned to contain 340 pages and 450 photographs but which, in the event, proved impossible to publish. He then went to work for the Hitachi firm in Japan and in 1961 published a book in Tokyo. From 1966 to 1969 he was the art director of the magazine *Visual Medicine* and from time to time gave lectures in universities. At the time of his last great reportage in Japan, the purpose of which was to denounce the scandalous pollution of the village of Minamata, he was roughed up by thugs and again seriously injured. In 1975 his book *Minamata* was nevertheless published. He died in 1978.

In the world of photojournalism, Smith is regarded as a saint—martyr figure. The force and grandeur of his pictures, violently expressionist and printed with extreme care and

skill, have an epic quality. His life was dominated by two contradictions at once terrible yet productive. First, there was his moral intransigence regarding the use of his pictures. He wished to keep control of them from start to finish, including their publication, and would tolerate no intervention. 'I want no unavoidable inadequacies of presentation to mar that work. . . . I seek understanding before I photograph, I photograph with passion of my intent [sic] and I examine the results and their utilization with cold, dispassionate discipline. Then I allow passion to return.' However, the tensions to which Smith submitted others as well as himself proved intolerable. Despite receiving a full-time salary from *Life* from 1952 to 1954, during that period he worked on no more than eight commissions, only six of which were eventually published. A project on the Metropolitan Opera, in 1952, involved months of work and hundreds of photographs, but

Smith was never satisfied and refused to hand it over to *Life*.

Secondly, Smith was conscious of the profound clash that was inevitable between the objectivity of photojournalism and the subjectivity of a photographer who was a great creator of images: 'I am constantly torn between the attitude of the conscientious journalist who reports facts, and the creative artist who knows that poetry and literal truth seldom go together.' Through his professional intransigence on the one hand and his heroic and dramatic style on the other, W. E. Smith embodied the classic contradictions of reportage at their climax. His was perhaps both the highest and the last achievement of photo-reportage.

To escape from exploitation and pressures of every kind, one group of press photographers decided to form a co-operative. This was the Magnum agency, founded in Paris in 1947 by Robert Capa, Henri Cartier-Bresson, David Seymour (known as Chim) and George Rodger. In the following year it opened another office, in New York.

Robert Capa[15] was the founding father of Magnum. Born Andreas Friedmann in 1913 in Budapest, in 1931 he was obliged to leave Hungary on account of his alleged communist sympathies and went to study in Berlin. He began to work as a photographer for the Dephot agency in 1931. In 1933 he was forced, as a Jew, to flee to Vienna and then Paris, where he

ROBERT CAPA
SPANISH CIVIL WAR, 1936.

Taken during the Spanish Civil War.

© Agence Magnum, Paris.

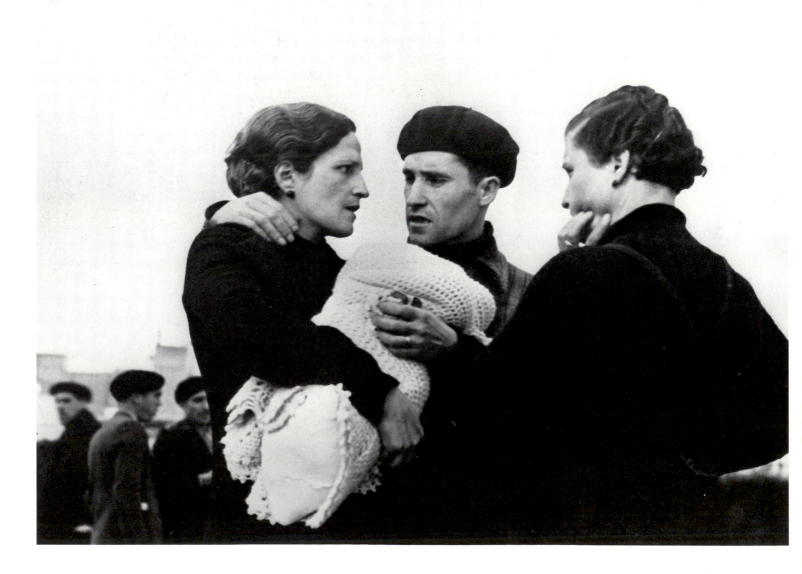

WERNER BISHOF
WOMAN IN THE PROVINCE OF BIHAR,
1951.

Famine in India

Collection of the Bibliothèque Nationale, Paris.

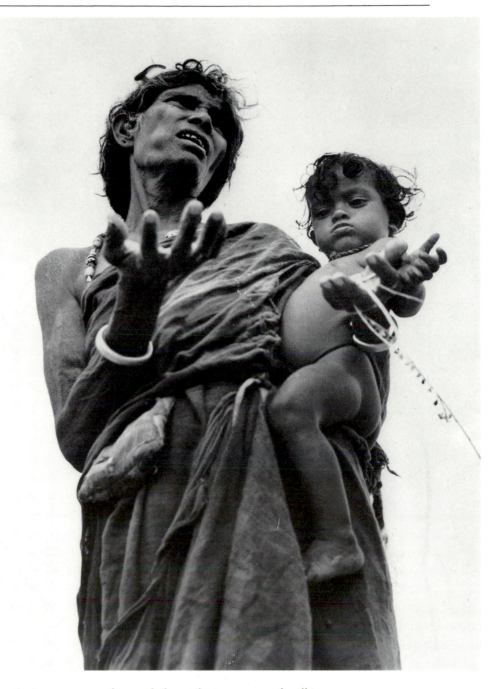

shared a dark-room with Henri Cartier-Bresson and Chim. In 1936 he began his incomparable career as a war correspondent in Spain; next, it was China and the Second World War as a *Life* correspondent. Despite his desire to be 'an out-of-work war correspondent', there were always wars and he was kept busy: Israel[16] was followed by Indo-China, where he was killed by a mine in 1954.

George Rodger was another great war correspondent, although his best-known pictures are probably the ones he took of the black tribesmen of Central Africa.[17]

David Seymour,[18] who succeeded Capa as the president of Magnum, was killed during the Suez invasion in 1956. Finally there was Werner Bischof,[19] whose photography had been of a very aesthetic nature when he was working with Hans Finsler in Zurich; later, he travelled as a reporter and joined Magnum in 1949. He brought back admirably harmonious pictures from India, China, Japan and Peru, where he died in a car crash in 1954. But even all these deaths could not put a stop to Magnum. It continued to expand, establishing more

and more links with America, and still remains open to new talents today.

The genius of Henri Cartier-Bresson[20] was involved in the Magnum adventure but not contained by it. He was born in 1908 into a cultivated upper middle-class family and was passionately interested in painting. He studied under first Jacques-Emile Blanche, then André Lhote, and was friendly with the surrealists and Tériade, the great publisher. Throughout his life he was to concentrate on the rigour of forms. He visited Africa, acquired his first Leica, then travelled in Mexico and in the United States, where he studied film-making with Paul Strand and held his first exhibition at the Julien Levy gallery in 1932. When he returned to France, he continued to make films for a while with Jean Renoir and Jacques Becker. Then, in Spain in 1933, he produced his first great reportage pictures. He realised that he had a brighter future catching 'decisive moments' such as these than with images that were fabricated and cerebral. In 1940 he was taken prisoner, but escaped to photograph the Liberation in Paris. His first great

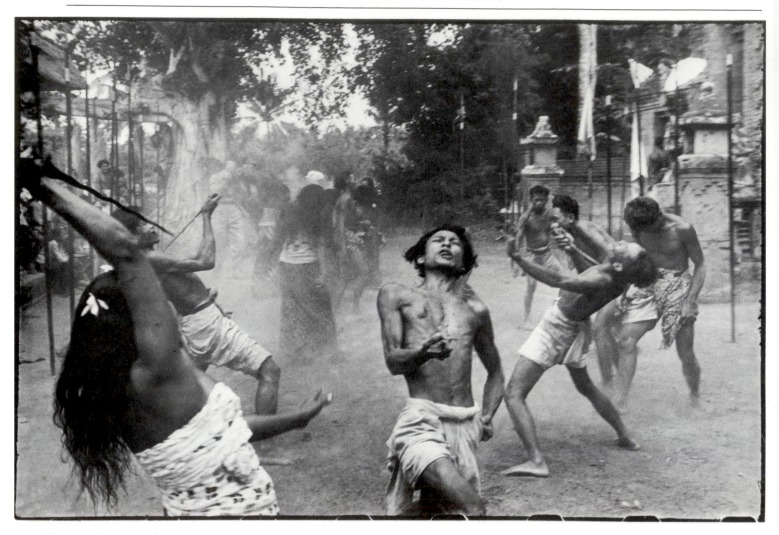

HENRI CARTIER-BRESSON
POSSESSION DANCE, BALI, INDONESIA, 1949.

book, a classic, was *Images à la Sauvette* (1952). For twenty years he travelled the world over, considered as the greatest reporter of his time. Eventually he returned to drawing, for him simply another way of tackling the essential problems of reality and vision.

It is Cartier-Bresson who had produced the most perfect definition of the reporter's action in taking photographs: 'Photography is the simultaneous recognition, in a single instant, of on the one hand the significance of a fact and, on the other, the rigorous organisation of the visually perceived forms which express and give meaning to that fact'.[21] What he was interested in was capturing a moment of reality and getting forms to hang together. The result has been rather distant pictures of a delicate elegance, which neither praise nor condemn but dissect reality and impress a style upon it.

Thus, even as it triumphed, reportage carried within it the seeds of a clash between the photographer who sought to express himself and the ideological systems that used his images to affect the masses. The few reporters who managed to retain contact with the raw truth did so by rejecting all attempts to muzzle their freedom of expression.

Arthur Fellig, known as Weegee,[22] came to New York with his parents from Galicia. He had grown up in poverty and became a jack-of-all-trades. He saw photography as a possible means of setting up in a little business. He started off with passport photographs, spending long days in his darkroom. To escape from this, he became an independent reporter, realising that it was as an independent that he could get closest to his sensational subjects, provided he was the first to arrive on the scene and then make it back to the newspaper. He set up a laboratory in the boot of his car but would, if necessary, develop his plates on the floor of an ambulance, in a taxi or even in the subway. He used a 4×5 inch Speed Graphic focused at 10 feet with the shutter set at $\frac{1}{200}$ second and the aperture at $f/8$. He stamped his prints 'Weegee the Great'. In this fashion he nearly always managed to be the first to snap the corpse in a pool of its own blood, people escaping at full speed down the staircase of a burning house, the murderer as he was thrown into the Black Maria or, even more strikingly, the terror in the faces of the gaping bystanders. By using infra-red film he captured the unconscious mimicry of audiences in darkened theatres. He would have laughed all the way to the bank at being called an artist, but the absolute honesty of his pictures, shocking and upsetting as they were, even attracted the attention of the Museum of Modern Art which in 1944 organised an exhibition of them. His book *Naked City* was received with rapturous acclaim in 1945. He

was now employed by *Life*, sometimes even by *Vogue*, and was invited to give many lectures.

In the later evolution of modern photography, Weegee may be regarded as the first in a line which would include not only Diane Arbus but even William Klein. First, though, it passed by way of Lisette Model,[23] as delicate and refined as Weegee was – or wished to appear – vulgar and insolent. She was born into a highly cultured and cosmopolitan family in Vienna, where she studied music and painting with the very best masters. Upon her arrival in France as a refugee, she studied photography as a means of earning her living and in 1937 produced a series of pitiless portraits of people on the Promenade des Anglais in Nice. It was on the strength of these powerful pictures that Ralph Steiner, the photography director for *p.m.*, engaged her when she moved to New York. Then Alexey Brodovitch, the artistic director of *Harper's Bazaar*, offered her employment. Fashion photography, which was seeking renewed vigour from the vibrant blood of

reportage, turned to her, as it had to Martin Munkacsi in 1933 and subsequently to Weegee. In 1950 Lisette Model became a professor at the New School for Social Research. The uncompromising stance and manifest truculence of her figures broke through the boundaries between documentation and personal expression. The consequences were to be far-reaching.

Virtually wherever violence flared, there would now be photographers to show it. The most naïve of them were perhaps sometimes the most effective. The rediscovery of the Mexican archives of Augustin Victor Casasola,[24] founder of the country's first press photography company in 1911, revealed pictures of the early twentieth-century revolutionary upheavals of that country of a strikingly forceful character.

Many photographers wished to escape from turning life into an empty spectacle, as the amateur exhibitions and photographic politics of newspapers demanded. Banding together in order to safeguard their artistic independence, they

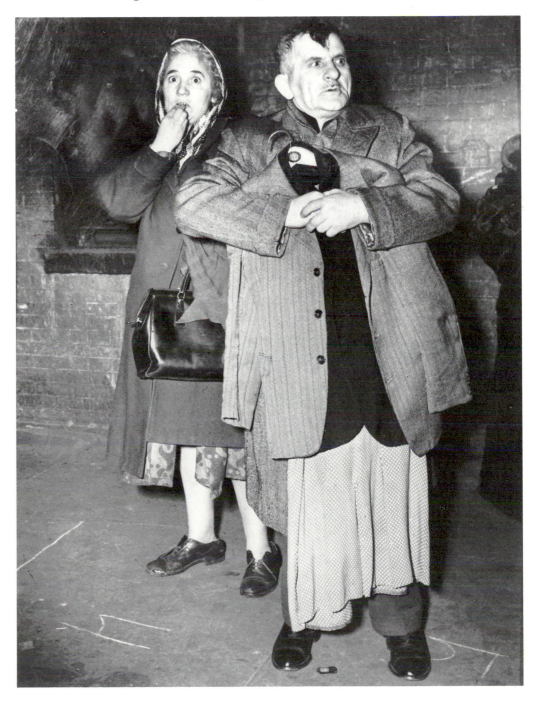

WEEGEE
EVACUATION (THEIR HOUSE IS ON FIRE), 1945.

Collection of the Bibliothèque Nationale, Paris, DR.

formed the New York Photo League.[25] Its origins can be traced back to the German worker–photographer movement of the twenties, set up by Willi Münzenberg, whose purpose had been to keep the left-wing press supplied with images taken by the workers themselves. The League, whose principal founders, Sid Grossman and Sol Libsohn, were both politically inclined to the left, was set up in 1936 and developed into an organisation for the defence of both quality and sincerity in photography. With the aim of denouncing social injustice and revealing the undisguised truth, a number of groups were set up to study problems such as that of the New York slums. Their members included Morris Engel, Jack Manning, Walter Rosenblum and Aaron Siskind. The League engaged in many activities: it rescued Lewis Hine's archives and organised the earliest exhibitions of artistic photography. It extended a welcome to Eliot Elisofon, a pioneer of colour photography on *Life* magazine, and also to Dan Weiner who was soon working for *Colliers* and *Fortune*. From the early forties onwards a number of the League's photographers, Aaron Siskind among them, lost their faith in direct photography and turned to experimental work instead. At about the same time, it also took in photographers with views as far apart as Ansel Adams and Richard Avedon, as is testified by

FRANCIS BRUGUIÈRE
PAPER CUT-OUT, undated.

Victoria and Albert Museum Collection, London.

their 1948 exhibition, 'This is the Photo League'. The League was now tending to become a general organisation for all United States photographers. It was at this point that, in the inquisitorial wind that was blowing through the country, the US Attorney General placed the League on the list of organisations alleged to be 'totalitarian, fascist, communist or subversive'. Some photographers, grouped around the League's president Gene Smith, tried to fight back. But in vain: in 1951 the League was disbanded.

The destinies of the avant-garde

In 1915, Paul Strand[26] had been one of the first to take 'abstract' photographs (that is to say photographs in which the subject could not be recognised). He then abandoned this line and produced books on a series of countries ranging from the Hebrides to Ghana. The quality of his work is such that nobody could deny the modernity of his landscapes and portraits, nor that they belong to a trend of photographic purism stretching from Weston to Ansel Adams and including figures such as Sheeler, Bourke-White and Cunningham in America and Renger-Patzsch, Kertész and many others in Europe.

In photography, the abstract is often figurative, as can be seen from the experiments of the American Francis Bruguière.[27] These followed lines parallel to those of the European avant-garde but it was nevertheless two Americans, Stieglitz and Frank Eugene, who persuaded Bruguière to explore the purely plastic potentialities of photography. By 1912 he was working on superimpositions which led him to abstraction. His professional work as a theatrical photographer led him to manipulate light for its own sake, experimenting with lighting on paper cut-outs (which put one in mind of Moholy-Nagy's 'light modulators') to produce his *Light Abstractions*, *Light Rhythms*. He was particularly productive between 1929, when he settled in London, and 1940, at which point he abandoned photography for painting. 'A photograph can be something in itself,' he declared. 'It can exist independently, as a photograph, regardless of its subject. It can have a life of its own.'

Charles Sheeler,[28] another American, is as famous as a painter as he is as a photographer. When reproduced, his works, with their trenchant lines and gently graduated shadows, could as well be taken for photographs as for paintings. The unity of his compositions is most impressive: a world made up of the smooth surfaces of machines and the bold lines of sky-scrapers.

When she died in 1976 at the age of ninety-three, Imogen Cunningham[29] was regarded as the revered grandmother of American photography. She had made her début in 1901, working as assistant to Edward Curtis, the photographer of the Indians, and had then become a pioneer of pictorialism on the West coast. Eventually she joined the F.64 Group.

Paul Outerbridge's 'The Detachable Collar',[30] which appeared in the July 1922 issue of *Vanity Fair*, was cut out by Marcel Duchamp, who pinned it up on the wall of his room. Rigorous arrangement and lighting accentuated the suddenly unusual aspect of this 'objet trouvé'. Outerbridge had been a pupil of the sculptor Archipenko, and his photographic work is probably closer than anybody else's to cubism. Although convinced that photography is an art which is sufficient unto itself, he expresses the force of volumes through the strict

IMOGEN CUNNINGHAM
TWO CALLAS, before 1929.

Collection of the Bibliothèque Nationale, Paris.

interplay of shadows and light. As was often the case in this period, the severity of his formal constructions seemed ideally adapted to the needs of publicity. By 1929 Outerbridge was working with colour, printing his pictures by the carbon process, and was also acknowledging his sexual fantasies with a humour well ahead of his time.

Scientific photography frequently lends itself to experimentation with forms. Since 1930, the engineer Harold Edgerton[31] had been perfecting the stroboscopic shot (a succession of high-speed electric flashes), achieving exposures of one-millionth of a second, which added a new dimension to the visual world. His pupil Gjon Mili[32] used this technique to produce elegant and musical linear rhythms.

The arrival of Moholy-Nagy in the United States in 1937 and the foundation of the New Bauhaus in Chicago grafted the radicalism of the European avant-garde onto the spontaneity of the formal experiments of the Americans. The department of photography was organised by Arthur Siegel, who introduced colour photography along with other experimental ideas already tried out in Europe.

The New Bauhaus was later known as the Chicago Institute of Design and in 1950 became a part of the Illinois Institute of Technology. Two of its most illustrious teachers were Harry Callahan and Aaron Siskind.

Harry Callahan,[33] trained as an engineer, came to photography as an amateur and later worked in the photographic laboratories of a number of large industrial firms. In 1946 he began to teach at the Chicago Institute of Design, working as director of the photographic department from 1949 to 1961. Under the influence of Ansel Adams, he too was for a brief period interested in photographing the landscapes of the West but, as he himself observed, 'in the deepest marrow of my puritan bones there is something that I loathe in all this richness. What I love is the austere, immaculate, monotonous appearance of landscapes that are pearly-grey.' Callahan was moving towards images pared down to the barest essentials (such as the pure line of a blade of grass against a white background), while at the same time (through his work on double exposures, etc.) encouraging the spirit of experimentation that stemmed from the Bauhaus but was still excep-

HAROLD EDGERTON
THE TENNIS PLAYER, undated.

Collection of the Bibliothèque Nationale, Paris.

tional in the United States at this time. His series of photographs of Eleanor is a hymn to the woman he loved, as are Stieglitz's portraits of Georgia O'Keefe.

Aaron Siskind,[34] who had been left dissatisfied by his experiences as a reporter with the Photo League, passed through a period of self-reassessment between 1940 and 1943, in the company of his painter friends Barnett Newman, Willem de Kooning and, above all, Franz Kline, who were all three set to become the masters of American abstract expressionism. The detailed wall surfaces and the stained and crumpled pieces of paper which Siskind photographed often pointed the way for them. Meanwhile, Siskind for his part gave the title 'Homage to Franz Kline' to one of his series of graffiti in which he managed to contain the brutal spontaneity of energy and movement within a composition of assurance and precision bounded by a rectangle. The framing reinforces the reality of the graffiti, at the same time detaching them from their habitual context and giving them a life of their own. 'It is no longer a matter of expressing reality, but of expressing what one feels about reality.' Siskind taught at the Chicago Institute of Design from 1951 to 1971, then moved on to join his friend Callahan at the Rhode Island School of Design.

Through the pupils of these two men, abstraction, in the wide sense that we have given it, was to triumph, carrying America into the avant-garde of world photography.

Situated as it is between subjective sensitivity and objective chance, photography was bound to take an interest in the great current of surrealism,[35] and vice versa. The problems peculiar to photography may not affect the work of Marcel Duchamp directly,[36] but everywhere they underlie it. However, a surrealist photograph is hard to define. All surrealists are committed to a disrespect for rules. Worse still, everything is surrealist to whoever can see it thus, and the very transparency of photography infinitely multiplies the possibilities of turning reality into visions. With its freedom not only to challenge accepted techniques but also to discover mystery in everyday banality, surrealist photography is just as likely to lead to entirely manipulated compositions (collages and so forth) as to deliberately spare statements of the unexpected to be found at the street corner. But surrealist photography seems above all to stem from a visual subconscious capable of delivering the eye and mind from their routine behaviour. It is a sort of visual automatic writing 'the purpose of which is not to adorn walls . . . but to strip the eye bare'.[37] Finally, the surrealist, with his desire to override the distinctions between the classical arts, found in the photograph a means which appeared to be available to all and sundry and was, on that very account, still – in the twenties and thirties – arousing cultural alarm among the bourgeoisie. You could be a surrealist in your way of taking photographs just as you could in your way of doing anything else.

Hence the splintering and wide dispersion of the surrealist phenomenon as soon as photography is involved. As Edouard Jaguer has shown, many surrealist poets have at some point resorted to photography in creating their fantasies. The photocollages of André Breton, Paul Eluard, Jacques Prévert, Georges Huguet and many others are well known. Wherever groups of surrealists formed in the world, photographers of like mind immediately materialised. Within those groups poetic invention was often extended in photographs which were not far from being 'objets trouvés'. The first photographs by Atget to be published were treated in this way in *Révolution surréaliste*, no. 11, in 1928, without acknowledgement. Meanwhile, André Breton had been illustrating his text of *Nadja* with the photographs of Jacques-André Boiffard who, in a surrealist gesture, had chosen to use an 'anonymous' photo (in reality taken by Man Ray) of a wrapped-up fashion dummy to evoke 'the enigma of Isidore Ducasse' in the first issue of that same periodical. In more recent years, the poet Gherasim Luca was also extending his poetic means of expression through his collections of 'objets trouvés' (*Le Vampire passif*, Bucharest, 1945), or images cut into tiny pieces and reassembled haphazardly so as to demonstrate formal tensions (*Cubomanies*, 1945), or as he collaborated with Gilles Ehrmann on his audio-visual creations.

In their desire to overstep the frontiers between the arts, many surrealist painters have from time to time made use of photography. Paul Citroen,[38] a pupil of Johannes Itten, who later became professor of drawing in The Hague, was influenced by the montages[39] of the German dadaists and produced *Metropolis* (1923), a dizzying tangle of images of the skyscrapers, nightmare and fascination of the modern city, which Fritz Lang three years later evoked in a film by the same name. René Magritte sometimes amused himself, *en famille*, by

taking provocative and disturbing pictures. Max Ernst's photographic collages (the first of which date from 1919) developed along the same lines as his earlier collages of drawings. He was always trying to 'exploit the fortuitous meeting of two separate realities in an unsuitable context'.

Man Ray always regretted being more famous as a photographer than as a painter. In answer to that old, old question, he declared: 'Photography is not art' because 'art is not photography.' He had already become friendly with Duchamp in New York, when he moved to Paris in 1921. He was both a painter and a designer. In that same year, he produced 'rayographs' by placing transparent objects upon sensitised paper – a technique that the German dadaist painter, Christian Schad, had 'invented' in Geneva in 1918 (and returned to work with in 1960). In 1922 Man Ray published some of these in *Champs délicieux*, with an introduction by Tristan Tzara. In 1929 his assistant, Lee Miller, unintentionally 'rediscovered' solarisation, or the Sabatier effect, and Ray used it sometimes to make forms overlap, sometimes to accentuate the purity of a profile. He also laid his prodigious imagination at the service of fashion and publicity.

The dadaist Raoul Hausmann, who had already made a name for himself in Germany, settled in Spain (in Ibiza) in 1934 and moved to France in 1938. His work on the relation of body-mass to light ranges from very direct and pure photographs to experiments with photograms and infra-red rays. His essential preoccupations led him to his melanographs (1931, not published until 1969). In these, he would use light to project the shadows cast by a chair, showing how photography could reconstitute reality with designs formed by black lines. Wols, a pioneer of 'informal' painting, learned how to make photograms with Moholy-Nagy. In 1933 he moved to Paris where he mingled with avant-garde groups but never felt properly understood. Although he also used photography as a way of earning a living (as through the World Exhibition of 1937), the plastic or dream-like cross-references which fill his pictures often form organic compositions similar to those which were to constitute the basis of his paintings from 1940 onwards. Hans Bellmer,[40] a pupil of the expressionist painter George Grosz, was another German who arrived in Paris in 1936. Already in 1934 he had used a doll, his 'articulated woman', to evoke the sexual obsessions upon which his sinuous and sensual drawings also centred. In 1939 he published *Les jeux de la poupée* in Paris, 'illustrated by texts' by Paul Eluard and tinted by hand.

In 1935 the Belgian painter Raoul Ubac started to work on photomontages close in spirit to the world of de Chirico's 'petrifications' and 'fossilisations'. His initial inspiration came from the chalky rocks of the Dalmatian coast whose image he was able to capture using the photographic 'bas-relief' technique (a slightly offset superimposition on negative upon posi-

HARRY CALLAHAN
ELEANOR, CHICAGO, USA, 1949.

Collection of the Bibliothèque Nationale.

AARON SISKIND
NEW YORK 3, 1947.

Collection of the Bibliothèque Nationale, Paris.

tive). Around 1939, André Breton regarded this technique as the key to the future of surrealist 'painting'. But these abandoned photography in 1946, thereafter devoted himself to sculpture on slate, using the grey shadows cast upon its grey surface as he had done in his photography. Between 1930 and 1946 the English painter Paul Nash[41] produced photographs of strange, random and fascinating articles. Too numerous and too well organised to be regarded simply as preparatory studies for his paintings, they now, in the wake of minimal art and conceptual art, appear as instances of internal life beneath their documentary disguise.

It is difficult to draw a hard and fast distinction between painters and photographers who were surrealist in the strict sense of the term. Brassaï[42] made one useful point on the question of whether he was a surrealist when, after producing *Paris de nuit* (1933) and collaborating on *Minotaure*, he refused to become a member of that group, saying 'I was only trying to express reality, for nothing is more unreal.' Yet his prophetic works are situated at the meeting point between abstraction and brutal art and even testify to a conceptual willingness to appropriate the works of others: Siskind, Dubuffet and Boltanski.

Herbert Bayer[43] was professor of drawing at the Bauhaus in Germany from 1925 to 1928. In 1938 he emigrated to the United States and worked for *Vogue*. His 'photoplastic' works are full of smooth volumes that hover between the geometric and the organic and compose a haunted space similar to that to be found in the paintings of Yves Tanguey. Herbert List[44] travelled widely as a businessman but became fascinated by 'metaphysical' painting and began to photograph still-life compositions in the surrealist manner. In 1936, while travelling in Greece, he decided to become a photographer. The white torsos of ancient statues in the blinding light and mineral landscapes of Greece opened a new world to him.

The Czech Jindrich Styrsky was working in Paris in 1934 (*L'Homme aux oeillères*; *The Man with Blinkers*) and 1935 (*Après-midi parisien*; *Parisian Afternoon*), producing photographs of subjects that caught his eye during his visionary wanderings through the city streets. In the manner of Rimbaud ('J'aimais les peintures idiotes, dessus des portes, décors, toiles de saltimbanques . . .': A. Rimbaud, *L'Alchimie du verbe*), his pictures fall somewhere between those of Atget and those of Vilem Kritz and have features in common with Walker Evans's taste for tattered advertisements, although less strictly composed.

International life

If we consider the situation country by country rather than from the point of view of aesthetic schools, one becomes aware of the essentially international character of photographic research from the mid-twenties up until the war. Like photoreportage, artistic experimentation was flourishing in Prague, Budapest, Paris, London and Berlin (although in Berlin creative forces were generally checked as early as 1933 by the rise of nazism).

Between the wars Paris was an incomparable forum for ideas and creative works. Man Ray[45] was there by 1921; Kertész[46] and his fellow Hungarian Brassaï arrived in 1925. But the animated and diversified photographic scene there is difficult to seize upon, for it found expression neither in explicit doctrines, as painting did, nor in schools of teaching, as happened in the United States. Individuals worked on their own, among friends. There were close ties linking painters and photographers but the latter sought no official artistic affiliation.

By the time the refugees from first Germany, then central Europe, began to arrive, in 1933, the American art enthusiast Julien Levy[47] had already tried in the United States to draw attention to the kind of photography being produced in Paris, showing Atget's work in 1930 and that of many others too in his 1932 exhibition 'Surrealism'. Maurice Tabard epitomises the American–French connection: in 1914 he had emigrated to America where he became an admirer of Steichen; he did not move back to France until 1928, although he meanwhile made many visits there. Fascinated by painting and light, he showed great interest in the work of Man Ray and himself manifested a deft touch in his many experiments involving solarisation, superposition and unexpected angles. His pupil Roger Parry devoted himself to illustration, working for André Malraux and the Gallimard publishing house.

Eli Lotar, of Rumanian origin, was an admirer of Kertész and for a time worked as assistant to Germaine Krull. He published some boldly graphic images in *Vu* and *Bifur*, but could never decide whether to devote himself to photography or the cinema.

Florence Henri,[48] who had studied briefly at the Bauhaus, arrived in Paris in 1928 and became a photographer. She was friendly with Mondrian and Kandinski and produced images that seemed, through the play of mirrors, to be broken up into different layers. They constituted intelligent photographic approaches to cubism. In 1935 she returned to painting.

A taste for metallic architecture, beautiful machines, cogged wheels and a smooth steel was characteristic of this period which still had faith in the benefits of industry. It is evident in the work of Paul Strand, Albert Renger-Patzsch, and Laszlo Moholy-Nagy and is illustrated most strikingly of all in the book entitled *Metal* (1927) by Germaine Krull, who had come to Paris, by way of the Netherlands, in 1924. She also produced some very fine portraits.

Ilse Bing[49] arrived in Paris in 1930, having started to study photography in Frankfurt. She too showed the power of metallic columns, but also produced images of torn posters and blurred effects of movement.

There were plenty of exhibitions of high quality. (There were not to be so many again until the 1970s.) Jean Slivinsky's gallery, Au Sacre du Printemps, exhibited the work of Berenice Abbott in 1926 and in the following year showed the work of Andre Kertész whom Lucien Vogel discovered there and hired to work on *Vu*. In 1928 Louis Jouvet threw open the Comédie des Champs Elysées theatre to an independent salon of photography which became known as the 'Salon de l'Escalier', after the staircase where the photographs were hung. In 1930 the witty fantasies of Carlo Rim's photographs chosen for the Salon de l'Araignée were counterbalanced by an exhibition of the vigorous work of the Deutscher Werkbund at the Grand Palais, where the rich range of the German avant-garde was revealed. In 1936 the Musée des Arts décoratifs housed a vast show of thousands of works, including the most recent, which drew the attention of the public to the fact that photography now had a history. But this exhibition had a retrospective rather than a forward-looking orientation.

A particular current of criticism was at this time finding expression in Pierre Mac Orlan's and Paul Morand's introductory articles for the debate opened in 1929 by Florent Fels in the magazine *L'Art vivant*: its theme was 'Is photography an art?', and similar views were expressed in Gisèle Freund's doctoral thesis, *La photographie en France au XIXe siècle* (1936, published in 1940).

The tendency in these critical pieces was to argue that photography's claims to absolute realism were mythical, and to justify its independence of expression. Using Man Ray's images to support his thesis, René Crevel maintained that what photography reveals above all is the relativity of reality; Pierre Bost declared that photography alone is capable of isolating and fixing the visual itself; Pierre Mac Orlan, that the most direct photography is also the most fantastic since it brings death to a tiny instant in the flow of life. In his preface to the book on Paris by the mysterious Moï Ver,[50] Fernand Léger contrasted photography to the cinema from the point of view of the former's ability to fix and keep a hold upon time. In 1939 Paul Valéry[51] celebrated the centenary of the great invention by declaring that there was no longer any need to 'describe that which registers itself of its own accord'.

Following the example set by the *Deutsche Lichtbild*, Charles Peignot in 1930 brought out the first number of *Photographie*, a special issue of the *Arts et Métiers graphiques*. Over the next ten years, this yearly production carried an enlightened selection of the best photographic works, with first Lucien Vogel and then Emmanuel Sougez acting as advisors. Single photographic images were now recognised as works of art. In the fourth issue Louis Cheronet put the case for a museum of photography. Two years later, the Musée des Arts Décoratifs organised their great exhibition. However, it was not until the post-war years that official institutions at last faced up squarely to the matter.

The young and short-lived Czechoslovakian Republic[52] situated at the confluence of the Germanic and the Slavic worlds, was further enriched by influences from France – up until the Munich crisis of 1938. Numerous avant-garde groups were set up there, ranging from the surrealists of the Manès group to the leftwing intellectuals of the Leva Fronta (the Left Front). Photographic research was particularly flourishing here, where it was recognised to be a pioneering aspect of modern art in general. Experiments of every kind

BRASSAÏ
GRAFFITI: MAGIC, WARRIOR, 1933.

Collection of the Bibliothèque Nationale, Paris.

took place: collages, images formed by burning, by cut-outs, photograms, chimigrams. Well before the First World War, the pictorialist aesthetic found expression in the gum-bichromate images of Frantisek Drtikol[53] and Augustin Skarda (1911).

The aesthetic theories of the American avant-garde, Stieglitz and his friends, were introduced by Drahomir Ruzicka who had returned in 1921 from the United States, where he had studied under Clarence White.

The chief disseminator of Bauhaus ideas was Karel Teige, who had also come under the influence of Rodchenko. His own speciality was collage work and from 1927 to 1931 he was the director of the magazine *Red* which published avant-garde photographs and attempted to analyse the relations between the different arts, in particular photography, cinema, typography, in a fashion similar to that of German magazines at this time. Teige's articles exalted pure and functional forms but also praised the diffuse and enigmatic poetry of the surrealist Man Ray. Constructivism and mystery were to be the two extreme and equally fruitful aspects of Czechoslovak photography. The photography of Frantisek Drtikol shows the mingled influences of cubism, constructivism and a certain neo-classicism and, although it maintains a very high quality, it sometimes evokes the French art deco style. Drtikol's portraits brought him international renown. But from 1911 onwards and following the hiatus of the war years, his personal interests carried him in the direction of nude studies. They were published in France in 1929. Deeply concerned with harmony of line, Drtikol combined his studied poses with large geometric forms cut from wood, that look as though they belong in a cubist painting. The printing techniques he evolved, combining photolithography with oil processes, bestow a warm solidity to the surface of his prints. He abandoned photography in 1935.

MAURICE TABARD
SOLARISATION, 1930.

Collection of the Bibliothèque Nationale, Paris.

FRANTISEK DRTIKOL
WOMAN WITH ROSES AND SKULL, 1929.

Collection of the Bibliothèque Nationale, Paris, DR.

The Devetsil avant-garde group was founded by architects and poets but was soon joined by the photographers Rössler and Funke. Jaroslav Rössler was a pupil of Drtikol but also owed much to Rodchenko and Moholy-Nagy. His abstract experiments began in 1922, with his photographs of paper cut-outs. Between 1926 and 1935 he lived mainly in Paris, producing a famous series of views of the Eiffel Tower taken from unconventional angles. It was also during the early twenties that Jaromir Funke evolved his spare and strongly constructed style. His early work was with the hard, massive forms of industry but later on he increasingly turned to objects penetrated by light: sheets of glass and folded paper, similar to those favoured by the German Willy Zielke. After 1930 he was also much affected by surrealism and the poetry of 'objets trouvés'. The plastic rigour of his compositions has rendered them totally resistant to the test of time.

Through his teaching at the Prague School of Graphic Arts, Funke exerted a strong influence upon the younger generation. In the same school, Karel Novak was encouraging a systematic study of the relations between light and geometric forms. Hans Finsler's teaching in Zurich was at this time following similar lines.

Josef Sudek[54] was the most famous of the Czech photo-graphers. He had been a pupil of Ruzicka, Novak and also Funke. In 1917 he lost an arm at the front, but that did not prevent him from continuing to handle large cameras. His first important work was on the Cathedral of St Guy in Prague, in 1924. In these pictures of the cathedral the rigour of the architecture is perfectly married with the enchanting effects of light. Her whole life was spent working in his studio in Old Prague but he maintained close links with European avant-garde artists. In 1936, he took part with the surrealists in an international exhibition organised by the Menès group. His portraits, still-life compositions amid the bric-à-brac of his studio and his vast, sometimes panoramic landscapes are always imbued with an intense, transfiguring poetry and a mystic light. When he was weary, at the end of his life, he

JOSEPH SUDEK
WINDOW OF MY STUDIO, 1944

Collection of the Bibliothèque Nationale, Paris, DR.

contented himself with photographing his little garden through a misted window: the fusion of light and matter achieved in these pictures is sublime.

Another country with an already rich photographic tradition was Hungary,[55] which moved from avant-garde pictorialism to a photography orientated towards folklore, which was more vigorous if not fundamentally different. With the triumph of nationalism over the crushed socialist republic in 1920, many artists who might have encouraged the avant-

garde movement there were obliged to flee. The pioneer magazine *Ma* went into exile in Vienna. It used sophisticated processes inherited from pictorialism mainly to produce scenes of traditional rural life. A typical representative of this type of photography is Rudolph Balogh, with his landscapes of the vast Puszta where wild horses gallop free beneath dramatic skies.

But in the late twenties and early thirties the geometric style of the 'new objectivity' began to make an impact. Josef Pecsi moved on from pictorialism to pictures of nudes with a solid simplicity and to stark still life compositions. In 1930 Moholy-Nagy returned to his native land to give a lecture in Budapest. In 1925 Lajos Kassak, the founder and director of *Ma* magazine, painter and poet and the author of many dada and surrealist collages, had also returned to Hungary. Around the magazine *Munka* (1929–39) he formed a new group of young people as passionately interested in photomontages as in social revolution, as is testified by the works of Lajos Lengyel, a photographer and typographer and admirer of Moholy-Nagy. Scenes of wretchedness would be shown in enlargements of simplified forms; some images, such as those of peasants driven by poverty from their land, bear a remarkable resemblance to those which the FSA in the United States was producing at this time.

In Poland too,[56] a nationalist type of photography which sought to preserve an image from the past coexisted alongside a very internationalist photography open to aesthetic revolutions of every kind.

Jan Bulhak had studied under the portraitist Hugo Erfurth in Dresden and was a friend of the French Constant Puyo, but he passed beyond the pictorialist aesthetic both in his writing and in his artistic works, focusing his attention upon the fundamental phenomenon of the relations of volume to light. Inspired by patriotic ideals, he also compiled a visual encyclopaedia of the monuments and landscapes of his country. Mieczyslaw Szczuka was equally determined not to remain 'a vain ornament to society'. Influenced by both constructivism and expressionism, he devoted his energies to photomontage, which he regarded as a source of new artistic dimensions and a vehicle for his socialist ideas. He organised and illustrated the avant-garde magazines *Blok* (1924) and *Dzwignia* (1927), but in 1927 was killed in an accident.

In this period so rich in unusual personalities, Stanislaw Ignacy Witkiewicz, sometimes known as Witkacy,[57] must surely have been one of the most bizarre. Having grown up amid the arts, he became a painter, writer, philosopher and photographer and elaborated a theory of how 'pure form' could give direct expression to the inner life. In 1924, however, he abandoned painting and set up a photographic portrait studio in which he produced portraits ranging from the ultra-conventional (no doubt in a spirit of irony) to caricatures of tortured existentialist *Angst*. In September 1939 he committed suicide.

Between the wars and even into the fifties, the aesthetic currents expressed through reviews, yearbooks and artistic societies circulated widely. For example, Spain[58] emerges as a productive crucible for most of the international trends. It would be easy to set up a comparison between the photographs of plants by the scientific photographer Emili Godes and those of Imogen Cunningham, or between the metal constructions of Esteve Terredas and those of Germaine Krull or Jaroslav Rössler. Nicolas de Lebuona, whose photomontages put one in mind of Pierre Boucher's, was strongly

influenced by both the Soviet avant-garde and surrealism. Pere Catala Pic produced photograms similar to those of Man Ray and modernist publicity. The purism of Josep Sala is sometimes reminiscent of Charles Scheeler's work. The doctor Joaquim Pla Janini became a photographer whose many talents sometimes combined to produce works, such as his 'cubist' still-life compositions, which may — with hindsight — be seen as heralding the sensibilities of the eighties.

As in Germany, the unfortunate political developments were to paralyse this exceptional surge of intellectual vigour. Joseph Renau was to attack fascism in his powerful propagandist photomontages, very much as John Heartfield did in Germany. The war reporter Agusti Centelles came back from the front with pictures which both sides proceeded to exploit.

Until recent years, the name of Jose Ortiz-Echague[59] was the only one to win renown beyond the frontiers of his country. He was a distinguished officer and pioneer of Spanish aviation who also devoted himself to producing pictures of the customs, costumes, monuments and landscapes of the Iberian peninsula (*España, Tipos y Trajes*, 1930 and 1933). His vision, like his ideals, looked back to traditional ways but his dignified compositions and sumptuous carbon prints lack neither energy nor grandeur.

A humanist photography

Photography now occupies a position of such importance in society that no cultural institutions can ignore it.

American legislation exempting donations from taxation has given strong encouragement to the establishment of many photography departments and collections in universities and museums. University administrators, competing for benefactors, realised that while it had become virtually impossible to lay their hands upon the paintings of the old masters, they could still fill their galleries — and at less cost — with the masterpieces of photography: as good an investment as the college football team, after all! The George Eastman House museum founded by Kodak in Rochester (New York State) in 1949 became a model for collectors.

In Britain, Charles Gibbs-Smith at the Victoria and Albert Museum had plenty of enlightened ideas about the future of photography in his museum, but little support and even fewer funds. The Royal Photographic Society was still engaged in a crisis of identity, unable to decide whether it was a club for hobbyists or a learned institution. In the London Science Museum, Dr Thomas, despite other pressing duties, made time to show the old equipment and processes. The Kodak Museum at Harrow, near London, similarly lacked financial resources. The Stadelik Museum in Amsterdam and the Bibliothèque Nationale in Paris were both manifesting goodwill but a woeful lack of funds.

The level of studies on photography improved. Josef Maria Eder's 1890 *Histoire de la Photographie* had been mainly devoted to photographic techniques. The pioneer German work was by Heinrich Guttmann in the thirties. In 1945 Raymond Lécuyer's work appeared in France. It was followed in 1949 by that of Beaumont Newhall which had started off as the catalogue for the 'Photography 1839–1937' exhibition at the New York Museum of Modern Art.

All these histories were necessarily based upon the collections that existed, the finest example perhaps being that put together by Helmut Gernsheim and his wife Alison in

1955. Europe was fortunate in the interest in photography displayed by the Swiss publisher C. J. Bucher, who produced the magazine *Camera* in three languages and in 1950 appointed a brilliant editor-in-chief for it, the Frenchman Romeo Martinez.

It seemed to be becoming easier to reconcile the profession of photographer, for so long ill-recognised if not despised, with the highest ambitions of human thought and art. For a while, the success of photojournalism had seemed to confer upon photography the prestige of not just a witness but even a moralist: photography seemed to be there to give expression to great human truths, to be eminently humanist. It is a view that found expression in two phenomena very different from each other but equally telling: the XV Group in France and 'The Family of Man' exhibition in the United States.

In France, the defence of the creative aspect of the profession of photographer had between 1936 and 1938 been taken up by the Rectangle exhibitions, set up by Emmanuel Sougez with the assistance of Pierre Jahan. After the

EMMANUEL SOUGEZ
SARDINES I, 1932.

Collection of the Bibliothèque Nationale, Paris.

IZIS
PARIS DES RÊVES, 1949

Collection of the Bibliothèque Nationale, Paris.

Liberation, things got going again in 1946 with a meeting at the home of André Garban, a painter and photographer who was to be the irreplaceable leader of the XV Group[60] for the next ten years.

As well as Sougez and Jahan, we should mention Marcel Amson, Lucien Lorelle, the fashion photographers Philippe Pottier and Jean and Albert Seeberger; Yvonne Chevalier; René Jacques, illustrator to Carco and Montherlant; Daniel Masclet, an intensely talented portraitist, himself highly educated, demanding and uncompromising; Jean Michaud, for his portraits of children; Jean-Marie Auradon for his impeccable flowers and nudes; Marcel Boris; Willy Ronis; Thérèse Le Prat for her powerfully stylised actors' masks; Henri Lacheroy. Numerous exhibitions were held – twelve between 1946 and 1956, one of which, in 1948, was devoted to book illustrations by photographers. The public's interest was caught by the wide creative dimensions of photography for the XV Group encompassed a wealth of styles, ranging from reportage to abstraction. The members of the group set out to defend the quality and dignity of their calling, aiming for something higher than professional prettiness and amateurism. They respected surrealism, but most of them sought to be rid of 'vain aestheticism'. Emmanuel Sougez,

with his admirable still life contact prints from 30 × 40 cm negatives, had ever since the thirties identified with Garban's words: 'It was necessary to give photography its true meaning: precision, and . . . to turn that fidelity, that very dryness into style.' Henri Lacheroy, the group's father figure, worked for Michelin, for the Comité des Forges and for the *Acier* magazine. His views of the Eiffel Tower may be set alongside those of Rössler and Ilse Bing and the machines of Sheeler and Renger-Patzsch and Piet Zwart and Germaine Krull's images for *Metal* (1927): in fact, all the poets of metallic form.

Today, however, what we remember best is a particular kind of Parisian poetry: wet cobblestones, lonely streetlamps, a pearly grey morning light falling on uneven paving stones and naïve shop-window displays: the Paris of humble folk and accordion music, the province of true poets such as Marcel Bovis, Willy Ronis (*Belleville-Ménilmontant*, 1954) and Iziz, who did not belong to the group but whose *Paris des Rêves* (1949) remains, together with Brassaï's *Paris de Nuit* (1933), a nostalgic evocation of a whole epoch.

The most famous representative of this current of photography is Robert Doisneau (*La banlieue de Paris*, 1949), with all his humanity, tact and tenderness. Doisneau's path to some of the great moments of pure photography was his humble way of paying attention to other people.

The XV Group was a free association of original personalities, and it spontaneously disbanded in 1956. In 1952, already, it had provoked adverse criticism by the fatuous futility of the theme chosen for its exhibition: 'Monsieur est amoureux' (The gentleman is in love). In 1956 an attempted transfusion of new blood – Sudre, Boubat, Dieuzaide – had not been successful.

The climax of the great humanist and idealist current of photography came with the 'Family of Man' exhibition organised by Edward Steichen in 1955. It was the most remarkable exhibition ever mounted. But, as often happens, the climax also turned out to be the limit; and it is fair to say that the later reaction against 'Family of Man' ushered in the period of truly contemporary photography.

The director of the New York Museum of Modern Art was Alfred Barr, a man of vision with wide interests that included Russian constructivists as well as modern photography. Upon Edward Steichen's return from the war, Barr appointed him to oversee the development of the museum's photography department which had been set up by Beaumont Newhall. He could thus count on enthusiastic support.

Steichen had already mounted a number of exhibitions of war photographs[61] but remained dissatisfied by the superficial reactions of the public. He came to the conclusion that 'what was needed was a positive statement on what a wonderful thing life was, how marvellous people were and, above all, how alike people were in all parts of the world.'[62]

Steichen was convinced that an exhibition of photography, more than any other kind, could be given a layout conducive to the expression of dominant ideas, so he saw to it that he master-minded the entire operation personally. He made a long preparatory trip through Europe to ascertain that material was available there, as it was in the United States. He found it. With his assistant Wayne Miller, he produced more than two million images, retained ten thousand, then whittled these down to five hundred and three, from sixty-three different countries. With the help of the architect Paul Rudolph he created an impressive setting in which to display

these works, manipulating distances, angles and all the coefficients of enlargement. The magnificent catalogue remains testimony to the high quality of the selection of photographs. It was based upon the major moments and aspects of human life: birth, love, work, death.

The exhibition was a triumph, drawing some ten million visitors from sixty-nine countries. It had to be repeated six times to satisfy public demand. The catalogue was a sell-out. In his introduction to it, Steichen had emphasised 'the essential unity of the human race throughout the world'.

Steichen was present in Moscow to see the crowds flocking to the exhibition there and underlined his universal humanism, declaring: 'Of all the people I have visited, the Russian people is the one that most resembles the American people.'

It was in 1956, in Paris, that the exhibition received its greatest critical acclaim. Yet in that same year, the philosopher Roland Barthes evened the score on the suspect ideology lurking within this photographic manifestation. He did so as

follows, in a collection of essays entitled *Mythologies*:[63] 'The failure of photography seems to me to be flagrant in this connection: to reproduce death or birth tells us, literally, nothing; . . . [it] only make[s] the gestures of man look eternal the better to defuse them.' Reality lies in the particular historical and social situation of this Bantu mother or that Eskimo one, in the injustices that assail them, the individual progress that they might make, not in the exaltation of a general and abstract 'maternity'. That is why Barthes was concerned to analyse how photographs too skilfully taken and too cleverly endowed with significance mislead us by blocking the imagination.

During that same year, 1956, a young, as yet little known photographer called Robert Frank was travelling through the United States. He was made aware of his individual isolation within an indifferent society. He perceived that what photographs convey are not fine general ideas but the irreducible and banal particularity of each being and of each situation.

ROBERT DOISNEAU
UNTITLED, 1935.

Collection of the Bibliothèque Nationale, Paris.

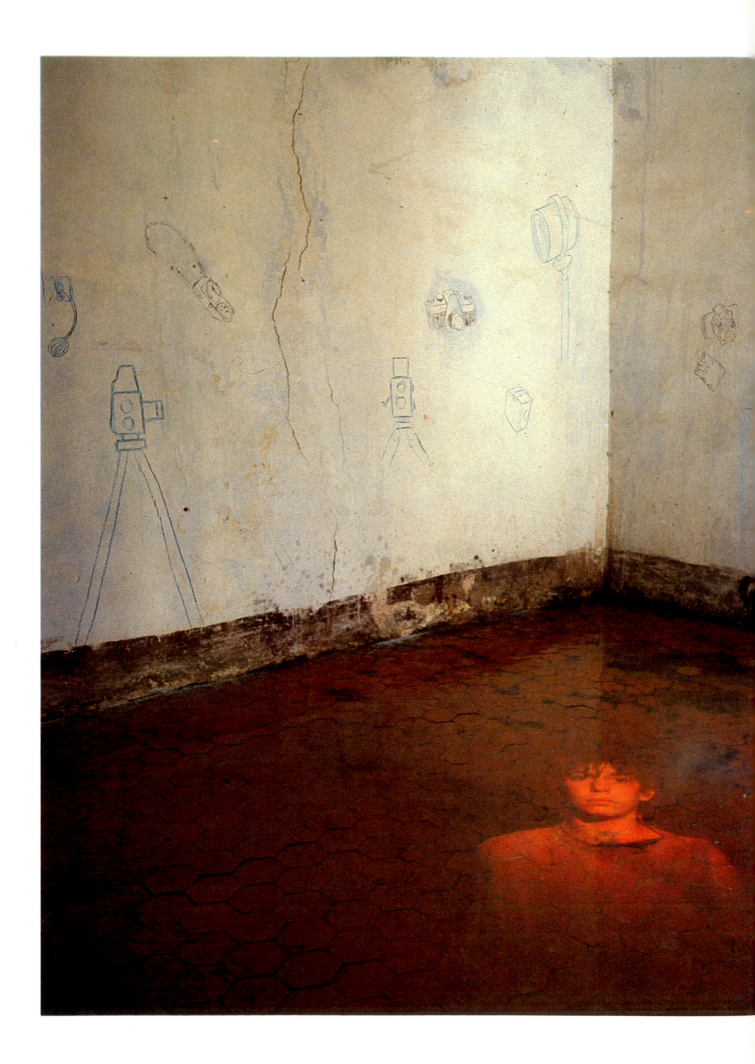

9

Photography unsure of itself

(1950–80)

Following the impressive world tour of the 'Family of Man' exhibition, photography seemed at last to have won acceptance both as a judge and a witness of human values and behaviour and as a powerful mode of expression at the service of the individual. But it was precisely at this point that a number of works were produced which engendered a greater humility and a deeper and less complacent self-awareness. Pondering upon both its spiritual genesis and its material substance, photography was at last to rise above the clash of preoccupations that had hitherto divided it: form or truth, abstraction or documentation. It could now divert freely into all kinds of experiments that would involve it with the other arts.

Quite unconsciously, photography had been producing conceptual art all along. With the rise of conceptual art,

photography benefited from the strong current which at last set it on an equal footing with the other arts. But the trouble was that this movement denied the existence of frontiers between the various arts: only behaviour mattered; techniques and methods were of little importance. Emerging at last from relative obscurity, photography was, as a result, immediately in danger of losing its identity. It would be second best if autonomous, disfigured if triumphant: how was it to escape from this dilemma? Perhaps the historian may, exceptionally, at this point venture a prophecy: in the confusion of artistic genres now prevailing, might not photography be the only one to retain a craftsmanship, to produce images and to relate to reality? Could it be that it holds the as yet hidden key to the recovery of art's material identity?

The fifties: the founders of modernity

In a shattered Europe, where the war-torn setting of rubble and restrictions took several years to change, creative photography soon entered upon a brilliant renaissance.

Individual expression, which totalitarianism had attempted to crush, now revived, reconstruction surged ahead dynamically and avant-garde painting (Picasso, abstract art), until recently dismissed as raving mad, now triumphed definitively: such was the atmosphere in which 'Subjektive Fotografie' developed.

'Subjective photography' and the rise of abstract art

The movement was born in Germany, rising from the ashes of the cultural effervescence of the twenties and thirties. But it soon became a European phenomenon.

The Fotoform group took shape in 1949, with Peter Keetman and Wolfgang Reisewitz, both pupils of Adolf Lazi in Stuttgart, and they were soon joined by Dr Otto Steinert and Heinz Hajek-Halke, a veteran of prewar dadaist photomontages. Their contribution to Photokina, the international fair held in Cologne in 1950, was regarded as definitively seeing off the last remnants of pictorialism. Their works were stamped with a strict formalism bordering on total abstraction, achieved through the play of light effects and negatives superposed one upon another.

The group was never strictly organised and in 1957 it fell apart, with the powerful personality of Dr Otto Steinert moving to the fore.

Otto Steinert[1] had qualified as a doctor of medicine in 1939, taught himself photography, set up as a portraitist in 1947 and founded a course of photography at the Saarbrücken School of Fine Arts in 1948, then, in 1949, another at the Essen Folkwang-Schule, where in 1959 he installed a photographic collection. He was personally responsible for selecting the works shown in the three 'Subjektive Fotografie' exhibitions (1951, 1954, 1958). He described them as 'embracing every domain of personal photographic creation, from abstract photograms to reportage, that was well

constructed visually and also psychologically profound'. These exhibitions were widely international, showing works by Daniel Masclet from France, Bill Brandt from England and Americans such as Ansel Adams, Wynn Bullock, Harry Callahan and Minor White. Reporters were also represented: Henri Cartier-Bresson, Dorothea Lange, Robert Doisneau, and others such as Edouard Boubat and William Klein, who were still virtually unknown.

In Steinert's view, it was not fine words and equipment that counted, but the teacher and the work he produced. A whole generation of young, creative, European photographers began their avant-garde experiments under him: the Germans Arno Jansen, Heinrich Riebesehl, Detlef Orlopp and the Belgian Pierre Cordier, who produced his first chimigramme in 1956; also reporters such as the Germans Guido Mangold and Jürgen Heinemann, the Dutchman Gerard Klijn, and the French Claude Perez and Françoise Saur.

Steinert's own work, set up as a model, was extremely diverse and always technically impeccable. He produced some impressive portraits, rendered rather stiff by their very perfection, and many combinations of images, often as negatives (which enhanced the sculptural solidity of forms), ranging from surrealism to abstraction; they sometimes put one in mind of Picasso's unfailingly controlled versatility. Around the sixties, these began to be replaced by tentative new approaches which looked forward to the experiments of the eighties.

Steinert produced the clearest definition of his doctrine in a commentary for the 'Subjektive Fotografie 2' exhibition. By and large, he was attempting to arrive at an objective definition of the limits of photographic objectivity. As he saw it, these lay in the framing, which set the picture in isolation; the photographic perspective, which differed from human vision; the neutrality of the photographic image, which, unlike the human eye, selects no more than a restricted range of grey tones; and the instantaneity which freezes the flow of reality.

But Steinert also observed: 'Photography gives us for the first time a feeling of the structure of things with an intensity which the eye, limited by its accommodation, had hitherto

OTTO STEINERT
SAAR, 1954.

Collection of the Bibliothèque Nationale, Paris.

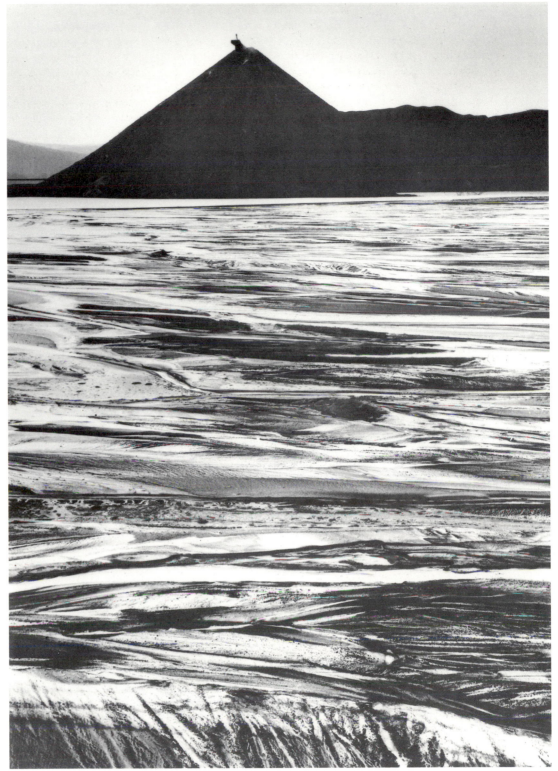

been quite unable to perceive.' During this same period, the Americans Aaron Siskind and Harry Callahan were, for their part, trying 'to show the object in a new way which renders it more intense' (H. Callahan).

Photography should always refer to the means that it employs and that are peculiar to it, so as to derive from them modes of expression worthy of rivalling the revolutionary discoveries of contemporary painting.

Faced with the traditional photographic societies and the routine of the Salons, the young photography of the 1950s was rising in revolt more or less everywhere in Europe.

In 1949 and 1952, at the Van Abbemuseum of Eindhoven, in Holland, Martien Coppens organised exhibitions which dispensed with selection committees, to show the 'new vision' and photography as a 'means of expression'. In 1950, he met Otto Steinert in Cologne and joined the Fotoform group and Subjektive Fotografie. But from 1958 onwards he became increasingly disillusioned with Steinert, who was reintroducing selection committees and the allocation of awards.

In Britain, the venerable Royal Photographic Society was still using its prestige to spin out the days of gum bichromate

and bromoil, in a spirit alien both to the brilliant and fashionable work of Cecil Beaton and to the austere and profoundly serious studies of Bill Brandt. But now the photographer and historian Helmut Gernsheim and the ageing Emil-Otto Hoppé (born in 1878) set about encouraging young photographers keen on technical purity to form a new group, the CS (Combined Society). It remained active until well into the sixties.

In Italy,[2] photography was part of the post-war intellectual revival (which included neo-realist cinema and abstract painting). As early as 1942, the photographers Cavalli, Finazzi and Vender had had the idea of setting up an association along the lines of the French Rectangle Group, but they were forced to wait until the end of the war. They were then joined by the Venetian Francesco Feruccio Leiss,[3] the poetic author of many atmospherically misty and mysterious views of his city.

Soon Luigi Veronesi[4] joined them. He had been a pupil of Fernand Léger's and a member of the Abstraction–Creation group (Paris, 1934) since when he had been pursuing his own experiments in abstract photography along lines parallel to and in harmony with his work as a painter.

In May 1947 Cavalli's manifesto for the La Bussola group appeared, in the luxurious magazine *Ferrania*: 'Anyone maintaining that Italian photography should be solely documentary . . . would be committing the same amazing error as any artistic or literary critic who tried to oblige painters and poets to draw their inspiration solely from specific things and events, forgetting the fundamental axiom that, in art, the subject is of no importance.' The group was inspired by the idea of pure form, an aesthetic formulated by Moholy-Nagy, and it shared the latter's concern to make a place for photography in the irresistible movement that was sweeping modern art towards abstraction. The group attracted many young people such as Fulvio Roiter and Marco Giacomelli. But it also provoked criticism from the 'neo-realists', who were sensitive to the pressing problems of Italian society at this time.

In France, the routine activities of the photo-clubs were beginning to exasperate a number of talented photographers who were anxious to explode the so-called rules that governed photographic competitions. Thus, in 1963, in Digne, on the occasion of a salon for experimental photography, Pierre Riehl found himself at the centre of a group of figures which included Jean Dieuzaide, Jean-Claude Gautrand, Georges Guilpin and André Recoules, all determined to get things moving. The Libre Expression Group expanded rapidly, mounting its first exhibition in Paris in March 1965. It provoked some heated polemics but made its mark. A number of talented photographers who had already made a name for themselves, Denis Brihat, Jean-Pierre Sudre, Frédéric Barzilay (the author of a series of pure and luminous nudes) and Roger Doloy, the forceful organiser of the Club des 30 × 40, rallied to the group. Its last exhibition, held in 1971, included the work of a number of illustrious foreigners: Paul Caponigro, Jerry Uelsmann and Heinz Hajek-Halke. Major influences came from not only Otto Steinert but also the Americans and Jean-Claude Gautrand, the principal organiser of the exhibition, quoted Minor White: 'Let the camera metamorphose and, in exercising its transforming power, be true to itself, relative as that fragment of truth is.'

During the fifties, Rolf Winquist in Sweden was evolving towards a more direct form of expression and away from the pictorialism which had endured for so long in this country. He encouraged his young assistants to strike out away from the beaten track. Some, such as Rune Hassner in 1949, made their way to Paris where they became an enthusiastic element in the life of creative photography as embodied by the Magnum agency, Brassaï, Paul Strand, etc. When they returned to Sweden they set up the Unga group (The Young Ones) and in 1950 met Otto Steinert in Saarbrücken. This was the starting point for Lennart Nilsson's creative scientific photography which explored the inside of the human body, the graphic purism of Lennart Olson and the formal experimentation of Hans Hammerskiöld.

The great current of subjective photography recognised its links with the creative effervescence of the twenties and thirties. Steinert acknowledged his debt to Moholy-Nagy and Man Ray and to the surrealists Herbert List and Herbert Bayer. The movement claimed to exalt above all the individual free will of each creator. Existentialism provided its framework, stressing the radical liberty of human beings. But it was a liberty which knew its own conditions, the fundamental conditions imposed by photographic techniques. Like the new objectivity of pre-war Germany and the American F.64 group, subjective photography wanted to depend solely upon the purity of the medium, this time however with the emphasis laid on the purity of the process itself, rather than on that of its results. 'My goal is to produce creative photography through its forms, making use of all the possibilities peculiar to its techniques,' Otto Steinert declared. But now those means were defined above all by their limits, which were also the limits' of photographic realism. The freedom of the 'subjective' photographer rested upon the specific conditions of photographic techniques which, like the techniques of the painter, precluded any absolute resemblance and so allowed for all kinds of deviations from traditional vision. Creativity no longer rested upon extra-photographic fantasies, as in the work of the pictorialists at the beginning of the century, but was based upon a deepening understanding of its material characteristics, in the same way as contemporary abstract painting.

There were nevertheless some who took the view that this way of moving beyond pictorialism still amounted to pictorialism of a sort and that it was incapable of assuming the humility of a Renger-Patzsch or a Weston before the photographic appearance of the subject itself. In his book *Totale Photographie* (1960), Karl Pawek, who organised a number of exhibitions in the 'Family of Man' mould, pointed out that even if there is a subjective aspect in photography, it still remains the modern means of taking in the truth of the world about us.

In contrast, Steinert and his disciples evolved a hierarchical view of photography, distinguishing a series of 'stages of perfection in photographic creation': simple reproduction, personalised reproduction, creation which remains figurative and absolute photographic creation, in other words constructivist abstraction.

It was impossible not to regard all this as a rejection of the creative virtues of direct, spontaneous photography and an abandonment of the hope that the path of creation might one day lead to a united photography.

It was in the United States — where the 'Subjektive Fotografie' exhibition was reviewed by Minor White — that a new source of renewal was to arise for the young photographers of the sixties and seventies.

Minor White and the surge of mysticism

With Minor White[5] photographic creativity ceased to be assessed in relation to pictorialism. Pictorialism was no longer a model and now provided no hierarchical standard. For White, expression stemmed from the heart of the act of looking, not from the manipulation of any material means. He sought to transfigure immediate reality without needing to distort it. The way for photography to become art was no longer through the intercession of any plastic system but through certain special states of soul attained by the maker of images looking at his subject.

Minor White was born in Minneapolis in 1908 and was introduced to photography by his grandfather. At university he chose to study botany and meanwhile privately wrote poetry. In 1938 he was in Portland (Oregon), where he received his first commissions for photographs of an architectural and theatrical nature. During the war he served in the Pacific. Under the strong spiritual influence of an army chaplain, he converted to Roman Catholicism. In 1945 he studied history and philosophy of art in New York, where he collaborated with Beaumont and Nancy Newhall at the Museum of Modern Art, met the best photographers of the day, including Edward Weston, and was, like many others, much impressed by the personality of Alfred Stieglitz. In 1946 he taught at the San Francisco Art Institute, alongside Ansel Adams. In 1952, together with the Newhalls, Ansel Adams and Dorothea Lange, he founded the magazine *Aperture* whose major organiser he soon became. In the following year he returned to join Beaumont Newhall's group at George Eastman House, the Kodak museum in Rochester, and in 1955 became Professor at the Rochester Institute of Technology. In 1964 he moved to the Massachusetts Institute of Technology (MIT) and settled in Boston. His major book, *Mirrors, Messages, Manifestations* appeared in 1969. He died in 1976, bequeathing his estate and archives to the University of Princeton.

For Minor White, to move from poetry to photography was to switch media but involved no essential change. Until now it had been assumed that the photographic image was incapable of rising above the prose of reality except by dint of extra manipulations. White revealed it to be a self-sufficient vehicle of poetic expression. There was no need to manipulate it externally to make it say significantly more than was initially apparent: for Minor White, if a camera records superbly, it transforms even better.

White was first and foremost a mystic. Catholicism, which does not seem to have held him for long, Japanese Zen, the Chinese i ching, hypnosis and Gurdjieff's teaching on self-

MINOR WHITE
ROCKS, 1964.
From the series EVERYTHING GETS IN THE WAY.

Collection of the Bibliothèque Nationale, Paris.
Courtesy the Minor White Archive, Princeton University.
© 1985 Trustees of Princeton University.

knowledge all contributed to his creative impulses, which for him were in themselves a way of drawing closer to God.

The taking of a photograph involved first creating a void within oneself, putting oneself in a state of extreme receptivity. There were four reasons for taking photographs: (1) to possess reality, (2) to subject it to a metamorphosis, (3) thereby to learn to accept it and (4), above all, to become conscious of the presence of the divine within oneself.

In the course of his ascetic development, White meditated in particular upon the concepts of sequence and equivalence. Ever since the forties he had been arranging his works in sequences, not narrative sequences as Duane Michals was to do later, but as poems expressed through images each of which operated as a single word. The mysterious space and time which separate these images lead whoever looks at them to take part in the work, spiritually. Symbolic relationships arise out of the tensions between them.

The concept of equivalence, which Minor White borrowed from Stieglitz, was even more important. It lay at the very heart of his photography, for it allowed it to transcend its banal utility as a mechanical recording method. A photograph functions as an equivalent when it acts as a symbol and metaphor for something quite independent of the subject photographed: the rugged bark of a tree evokes a rugged personality. In this fashion, photography communicates things which cannot be seen.

A constant circulation is thus set up, linking matter and spirit. For White (as for other great contemporary photographers, Cartier-Bresson and Denis Brihat, for example), the master text was *Zen in the Art of Archery* by Eugen Herrigel.[6] Like the archer who, to hit the mark, needs not to evaluate whatever lies between it and him, but to 'become' that mark itself by identifying with it, the photographer must efface himself totally before the presence of things. But, at the same time, his spirit merges with that presence, coincides with it, and things become spirit in a truly mystic process of confusion and effusion: 'What seems to be matter becomes what seems to be spirit.' (Minor White.)

And it is true that frequently, in Minor White's works, different surfaces and the nuances connecting them are so sumptuous, intense and rich that they seem suddenly to swing over into immateriality: a wooden door or a blotchy rock can seem to be a starry sky. They become images of contemplation, like the Holy Sacrament or the Holy Grail which, whatever the subject, in every instance evoke the divine.

One of White's constant preoccupations was to communicate his works through a spiritual communion which he tried to establish through his teaching, the *Aperture* magazine and the exhibitions that he organised.

White was a demanding technician, a disciple of Ansel Adams's 'zone system' method, about which White himself wrote a book. However, his teaching laid greater emphasis upon the spiritual enrichment of his pupils. The importance of photography ended up by being no more than relative, for his entire esoteric culture was involved. Since 1959 he had been studying hypnosis, seeking, like Gurdjieff, to bring head, heart and body into a state of harmony. A photograph was required to make whoever looked at it or made it aware of his or her own body. A course of White's at MIT ended up by resembling a dance class.

His influence was immense, not so much by reason of his theories, which were too personal, but through his practice of the internalised photographic act, a form of poetry and spiritual discipline. Among his many pupils mention should be made of the landscapist Paul Caponigro; the surrealist, Jerry Uelsmann; the publisher Michael Hoffmann, who succeeded White as director of *Aperture*; Peter Bunnell, a historian of photography and professor at Princeton; and the Englishman Raymond Moore.

Although it never again possessed White's intense mysticism, nature photography in the American tradition, with its legacy of all Edward Weston's and Ansel Adams's splendid wholesomeness, did become imbued with a sense of mystery, a mystery already present in Weston's book *My Camera at Point Lobos* (1950).

The work of Wynn Bullock[7] became a meditation on the passage of time and the relativity of all things. Eliot Porter celebrated the glories of American nature and defended the peculiar qualities of colour in exemplary works such as *Baja California* (1967), his view being that *In Wilderness is the Preservation of the World* (the title of another of his books, which appeared in 1962).

However, Minor White's most remarkable pupil was probably Paul Caponigro.[8] Free from his master's theoretical obscurities, he presents us with an image of nature that is musical, delicate and pure, from the fragile raindrop on the tip of a branch to the powerful volumes of rock formations. Tactfully, he effaces himself before the simple beauty of natural things, revealing Mozartian harmonies within them (*Portfolio One*, 1960).

William Clift's landscapes and clearly ordered architectural photographs and his sensitivity to fine grey spaces carry on and develop the classic tradition of Ansel Adams, as do the earlier pictures of Oliver Gagliani, which bring an intense gaze to bear upon the individuality of every moment and thing.

In Britain, Raymond Moore[9] established the link between America and Europe. He trained as a painter, turned to abstract art and admired Otto Steinert's formalist movement. Minor White, whose pupil he was in 1970, helped him to see photography's power to reveal another world hidden within this one and to reflect the inner soul. Passing from the Zen so dear to his master to the mystery of his own Celtic landscapes, he brings contemporary photography's spiritual adventure full circle.

Robert Frank and the revolution of meaning

One photographer, Robert Frank,[10] and his book, *Les Américains* (1958), exerted upon the young a quasi-mythical influence all the more fascinating given that, like Marcel Duchamp in the domain of painting, he has since deliberately ceased to take photographs, or at least to exhibit them.

Robert Frank was born in 1924 in Zurich, where at the age of eighteen he went to work as an apprentice photographer and became friendly with the great Swiss reporter, Gotthard Schuh. In 1947 he left for the United States, where Alexey Brodovitch engaged him to work for *Harper's Bazaar*. He also worked for *Fortune* and *Life* magazines, among others. But the dependence of the reportage photographer and the banality of fashion photography were irksome. He travelled. From Peru he brought back a book on which he had collaborated with Werner Bischof and Pierre Verger: *Indiens pas morts* (Indians Not Dead) (1959). In Europe he visited many

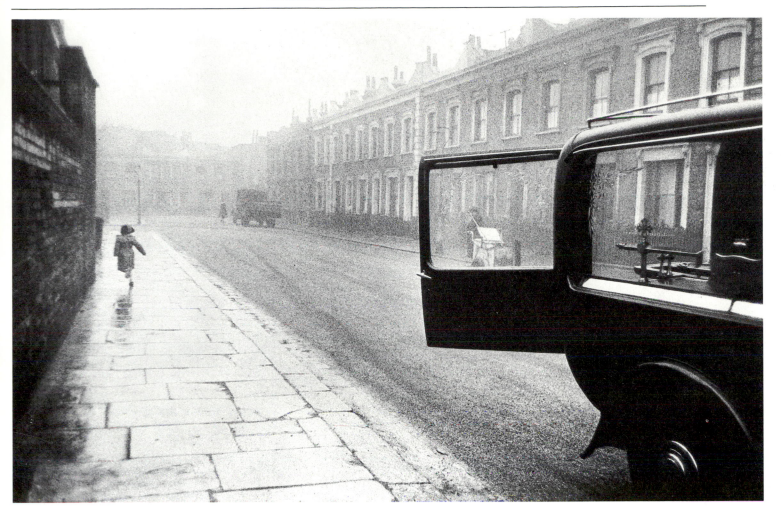

ROBERT FRANK
LONDON, 1952.
From the series THE LINES OF MY HAND.

Courtesy of Pace/Macgill Gallery, New York.

museums. Back in New York, he worked as a publicity photographer and also helped Edward Steichen to prepare his famous 'Family of Man' exhibition. Walker Evans persuaded him to put in for the Guggenheim bursary, which he was the first non-American photographer ever to win, in 1955. He then travelled the length and breadth of the United States to work on a project that he had in mind: *Les Américains* appeared in 1958, with a text by Alain Bosquet, published by his publisher friend, Robert Delpire, who had included photographs of his as early as 1952 in the magazine *Neuf*. A second edition, *The Americans*, appeared in New York in 1959, published by Grove Press with a text by Jack Kerouac whom Frank had recently met and who had been 'on the road' before him.

For Frank, photography was 'a lonely journey'. The bursary he had won was first and foremost a means for him to escape from professional drudgery. But he also set out with the idea of producing images which could dispense with words and render 'all explanations unnecessary', a point upon which Walker Evans was to congratulate him. Initially, the results were ill received: his disillusioned images were seen as an attack on American optimism. But there was much more to it: in the world of an individual's solitude in the face of a reality fragmented and devoid of meaning, he certainly captures the insincere play-acting that the traveller encounters wherever he goes, but also moments of unpredictable, idiotic and intense poetry – a reflection in the road's surface, a television screen frenetically flickering in a deserted bar, faces caught in a crowd. 'A slow gaze . . . a weary fascination . . . a vision which can only meet the frenetic modern pace with a slow or

vaguely lethargic reflex.' (Arnaud Claass.)[11]

Many have exclaimed over Frank's subjectivity; but his extreme objectivity is just as remarkable. Frank acknowledges all the unfinished, blurred, dirty, ill-defined things that make up the fabric of what we see. He does not set himself up as the master of what should be seen and what should be admired. He is on our side, like each one of us, alone in the crowd. He shares it all with us, forcing us to acknowledge what is most true and also most commonplace in what we see in our ordinary everyday lives.

It is no longer a matter of judging qualities from the outside. In the case of every image, 'you would think he was inside it and came out just to take it.' (Denis Roche.)[12] No longer a matter of taking the great order of the world by surprise in one of those fleeting instants when it seems to crystallise. No longer a matter of 'decisive moments'. What count are the moments 'in between', in between the ones which appear to be full of significance and harmony. Until now, as Victor Burgin explains,[13] the photographer regarded himself as a hunter after significant moments, like so many rabbits in a wood to track down, shoot and carry home. After Frank, photographers knew that there were no significant moments. It is we who give them significance. Photography's opportunity lies not in catching out a world flagrantly refusing to conform with our own ideas of it but in seizing it

as it is in itself, in all its absurdity, a world before thought and meaning.

Photography now aimed to show an existence which constantly exceeded the bounds of our expectations and predictions, an existence out of control, beyond the reach of ideas (*The Americans* is another version of Sartre's *La Nausée*). According to Walker Evans, the best photographs always retain a kind of residual mystery. In describing this, one cannot be content with a formula as meaningless as 'the artist's crucial choice of the moment'. Cartier-Bresson's pertinent definition of photography, 'seizing upon . . . the meaning of a fact and the rigorous organisation of forms . . .' is found wanting in its weakest link. 'Facts' no longer have 'meaning' and besides, there are no 'facts'. Or, to put it another way, there are so many possible different meanings that there is no point in choosing one. 'Closed' photographs (to use Robert Doisneau's expression) now give way to 'open' ones, to photographs open to every possible interpretation, including that of having no meaning at all.

Opening oneself to banality, to whatever crops up, does not mean abandoning self-control. With Frank, photography depends less and less upon chance and more and more upon the photographer's internal discipline: whatever is essential should not come from movements, as the decisive moment does, but from inside. In 1952, Frank was much struck when he saw the painter Willem De Kooning devoting more time to thinking than to painting. Although Frank always declared his admiration for Walker Evans and Bill Brandt and for his own friend Louis Faurer, he paid even more attention to the painters of lyrical abstraction: De Kooning, Franz Kline, Jasper Johns, Larry Rivers. As in their works, possible accidents – a splash of paint, a dazzle of light in the lens – turn out to be controllable. Like them, he pays great attention to the distortions and drifting quality of what is seen out of the corner of one's eye.

In 1972 another book by Frank, *The Lines of my Hand* (published by Ralph Gibson), presented a retrospective view of his life; it was conceived as a collection of photographs. Then, fearing to repeat himself and fed up with always making his escape with his little image safely in his box, Robert Frank turned to the cinema, remarking, 'In making movies, nothing comes easy, but I like difficulties and difficulties love me.'

William Klein and the revolution of form

For William Klein,[14] as for Robert Frank, what mattered was to 'make photographs as incomprehensible as life itself'. But whereas Frank seems to neglect form, Klein emphasises visual effects. While Frank destroys the hierarchies of meaning, Klein destroys the rules of technique.

William Klein was born in New York in 1928. He studied sociology but wanted to be a painter. After military service in Europe, in 1948 he began to work in Fernand Léger's studio. In the early fifties he took to using photography to help him with his experiments in abstraction. In 1954 he returned to New York and in 1956, with moral the support of the French photographer Chris Marker, he brought out his book, *New York*, published by Seuil. He was engaged by *Vogue* to take fashion photographs, but meanwhile continued his own work and in 1960 published *Rome*, followed in 1964 by *Moscow* and *Tokyo*, with the backing of a Japanese publisher. In 1959 he had made a film on the lights of Broadway. After 1962 he moved away from photography to devote more time to the cinema and made several films which brought him a certain renown, among them *Who are you Polly Magoo?* and *Mr Freedom*.

As a young painter, William Klein admired the impressionists, Cézanne and Picasso. In Léger's studio he encountered painting that accepted the cold technology of the contemporary world but was at the same time inspired by the calm plasticity of the architecture of pre-Renaissance Italy. Seeking to seize upon abstract and dynamic forms, Klein darkened his photographic paper with strokes of light. His preferences in photography were for the direct documentary pictures of the FSA, Lewis Hine and, above all, Walker Evans. He did not like the poetico-sentimental trends of the European photography of the fifties.

His work was thus to reflect a number of tendencies ranging from harshly geometric abstraction to the spontaneity of street life, and to establish a balance between modern violence and a sense of timeless solemnity.

As he took his photographs, William Klein was already thinking of the book, the layout and even the aggressive typography of the sensationalist press. 'I wanted to do something altogether vulgar.' The black-and-white aggression of his pictures balances and imparts a solid equilibrium to the apparent vulgarity and abrasiveness of the images, with their blurred movements and coarse grain and the spatters of ink that appear to be hurled straight at them. Some critics expressed indignation, failing to appreciate the almost obsessive meticulousness with which Klein supervised the subtle nuances of his prints and the published versions of his images. His pictures convey the intense dynamism of certain moments in reality, not in the same manner as the isolated still from a film, but by cutting into the black, quivering flesh of photographic matter itself.

'Quite deliberately, I did the opposite to what was usually done. I thought that an absence of framing, chance, use of the accidental and a different relationship with the camera would make it possible to liberate the photographic image. There are some things that only a camera can do. The camera is full of possibilities as yet unexploited. But that is what photography is all about. The camera can surprise us. We must help it to do so.' (William Klein.) In contrast to the view of the camera accepted by many other photographers, for Klein the camera did not limit freedom of invention; rather, it was an extraordinary instrument capable of summoning up completely new forms. It had hitherto been considered to be sterile and passive in itself, until such time as the photographer imprinted his plastic will upon it, but now the image in the viewfinder was revealed to be a gushing source of unexpected inventions. The usual pattern of the creative process was reversed.

Between *New York* (1956) and *The Americans* (1958), the forms and meanings of photography were liberated and a new horizon of possibilities opened up.

Robert Frank and William Klein administered a shock to the young. They resubmitted the whole of photography to question, but only photography itself, without concerning themselves with theories. The two could hardly have been more dissimilar, but one thing they shared in common: both regarded photography not as a collection of practices and doctrines to be judged from outside, but rather as something directly lived, inextricably mingled with the existence of the photographer involved.

WILLIAM KLEIN
CANDY STORE,
AMSTERDAM AVENUE,
NEW YORK, 1955.

William Klein Collection.

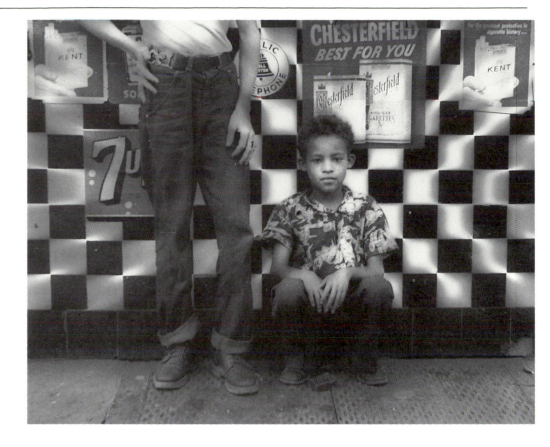

From the sixties to the seventies:
the expansion of photographic culture

In the sixties, photography became a part of the world of museums, higher education, the art market and culture in general.

The activities of many American museums persuaded the general public to accept creative photography: George Eastman House in Rochester, founded in 1949, the great, now classic collections of the Library of Congress in Washington, the Metropolitan Museum in New York, the Museum of Philadelphia, the Fogg Art Museum in Boston, the Chicago Art Institute, the Museum of Art in San Francisco. Large funds were devoted to the creation of new centres while great collections of photographic works still remained available. In 1964 the University of Texas in Austin acquired the collection of the historian Helmut Gernsheim. In 1976 the Center for Creative Photography in Tucson, Arizona, began to assemble the works of great photographers such as Eugene Smith and Ansel Adams. Meanwhile, Julien Levy's collection went to the Art Institute in Chicago. In 1984, the Getty Foundation decided to devote large sums to the acquisition of such collections as were available, even abroad. In Canada we should mention the growing importance of photography in the National Gallery in Ottawa, and the activities of the National Film Office; in Australia, the efforts of the Australian Centre for Photography in Sydney. In Europe, the financial situation was far less encouraging. Nevertheless, old institutions such as the National Portrait Gallery in London, the archives of the Monuments Historiques de Paris and the Hamburg Museum all discovered that they possessed hitherto unrecognised treasures. In London, the Victoria and Albert Museum showed its interest by mounting a big exhibition, 'From Today Painting is Dead', in 1972. In 1971 the Bibliothèque Nationale opened a permanent gallery fronting the street.

The establishment of cultural institutions

Curators began to play a role of increasing importance to the creative process. In 1964 John Szarkowski, Steichen's successor at the Museum of Modern Art in New York, mounted 'The Photographer's Eye', an exhibition which established its distance from the journalistic spirit of the 'Family of Man'. Szarkowski's thinking and his book, *Looking at Photographs* (1973), encouraged an American view of photography centred upon the pure nature of the medium and much more in sympathy with a conceptual approach than with paraphotographic experiments involving a mixture of techniques.

In Europe, specialised departments were soon set up at the Folkwang Museum in Essen, the Ludwig Museum in Cologne, the Prentenkabinet in Leyden, the Stedelijk Museum in Amsterdam, the Moderna Museet in Stockholm, the Museum of Decorative Arts in Prague, in Lodz in Poland and in Siauliai in Lithuania. In France, the Niépce Museum in Chalon-sur-Saône and the Château-d'Eau municipal gallery in Toulouse testified to the dynamism that existed in the provinces. The Réattu Museum in Arles has become indissociable from the annual festival which, since 1970, has become the major

international forum for photographers and photography enthusiasts.

In the United States, where the first generation of students were now becoming teachers, photographers were paying less attention to the contents of magazines such as *Life* and *Look* and more to articles in *Art Forum, Art News* and *October*. The Society for Photographic Education, founded in 1962, had a membership of fifteen hundred teachers in the early seventies, when photography courses were introduced into virtually all university programmes. In 1961 Harry Callahan left the Illinois Institute of Technology (the heir to Moholy-Nagy's Bauhaus), which had failed to free itself from the spirit of 'design', and moved to the Rhode Island School, where Aaron Siskind later joined him. In 1967 Arthur Siegel returned to teach at the Illinois Institute of Technology, this time insisting upon courses in the history of photography and a study of avant-garde work. Garry Winogrand's stay there in 1982 made an important impact. The personalities of some professors influenced whole generations of students. Henry Holmes Smith had played an important role in the setting up of the New Bauhaus in Chicago in 1937; in 1947 he began to teach at the University of Indiana. Among his pupils may be mentioned Robert Fichter, Betty Hahn, Jerry Uelsmann and Jack Welpott. Nathan Lyons, who had become curator at George Eastman House in 1957, left it in 1969 to found the Visual Studies Workshop and its magazine *Afterimage*. This studio, open to all lively aspects of visual creation, was a forum where many ideas were aired. Frank Van Deren Coke, based from 1962 onwards at the University of New Mexico in Albuquerque and from 1979 onwards at the San Francisco Museum of Modern Art, always complemented his teaching activities with the work of setting up collections and exhibitions. In 1974, Cornell Capa created the International Center of Photography in New York, to house the work of the great photographic reporters and its importance was considerably enhanced by the lecture courses he organised there.

Also in 1974, Claudine and Jean-Pierre Sudre moved their private lecture course from Paris to Lacoste in Provence. It was one of the few top-quality courses on photography that existed in France at this time. Not until the creation of the École Nationale de Photographie in Arles, in 1982, did France possess an official institution alive to the problems of creation. The institution of a Rome Prize for photography was another indication of a certain awakening of official interest. The teaching of F. M. Neusüss in Kassel, in Germany, and that of Paul Hill, David Hurn and Ron McCormick in Britain also deserve a mention.

For a long time there was no market for original prints.[15] All the attempts of a pioneer such as Julien Levy to blaze a path in this field had been in vain. In 1954, in New York, at Helen Gee's little Limelight Gallery,[16] a meeting place for poets and artists, Weston's photographs on sale for 50 dollars had found no buyers. Nor was the Underground Gallery, which opened in 1960, a financial success. The first breakthrough came in 1969, with Lee Wirkin, also in New York. The second phase began in 1971, when Harry Lunn converted his Washington art gallery to photography, deliberately raising prices. Now galleries began to spring up rapidly, even in Europe where it remained much more difficult to run them profitably: Lanfranco Colombo's Il Diaframma in Milan in 1967, Die Brücke in Vienna in 1970. The magazine *Print Letter* (Zurich) listed eighty-four photographic galleries in Europe in January 1976, one hundred and six in January

1977. Not all were of equal standard. But it is interesting to note that from 1970 a number of famous art galleries – Castelli, Sonnabend, Marlborough, Zabriskie – began to deal in photographs too and to produce portfolios of original prints. Naturally, prices rose fast. A Kertész shot from 250 dollars in 1973 to 500 in 1976; a Bill Brandt from 150 dollars in 1973 to 400 in 1976. And that was just the beginning; but it should be pointed out that this market boom chiefly affected nineteenth-century photographs or those whose authors were already recognised masters. The public remained distrustful, given the possibility of prints being indefinitely multiplied. It had to be won round by the artifice of limited, numbered editions. Subtle distinctions were introduced into different kinds of editions: after the death of Imogen Cunningham in 1976, a picture printed by herself cost 600 dollars; one simply signed by her, 400; and one printed after her death, 150 dollars. Big private collectors of contemporary photographs were few and far between.[17] The market depended chiefly upon the purchases made by museums and universities. There were even some banks which, as circumspect investors, began to build up collections. The Exchange National Bank in Chicago spent 250 000 dollars between 1968 and 1977 on two thousand prints, the value of which soon far exceeded that sum. In Vienna, the Österreichische Landerbank began its collection in 1976.

Salerooms were opening their doors to photography in Great Britain, Germany and the United States, but not so much in France. A sale held by Parke-Bernett in 1967 was a great success, with photographs selling easily for 100 or 200 dollars. In 1971, Sotheby's joined in. In 1975, in an explosion of prices, a Stieglitz sold for 4500 dollars, while Atgets, Westons, Evanses and Arbuses all made over 1000 dollars.

During the eighties it has thus become accepted that the work of a twentieth century master may reach thousands of dollars, that of a young but famous photographer hundreds. In his first exhibition, an unknown talent might begin by asking 100 or 150 dollars. However, the economic crisis and the budgetary restrictions of the American government led to prices flattening out and even falling. Although some new galleries opened, many disappeared, while many of the best remained in business thanks only to the personal sacrifices made by organisers more interested in photographic images for their own sake than in financial profit.

But financial considerations should not be thought alien to the spiritual life of photography. Everything is connected. With the diffusion of teaching on photography in the universities, many theses or studies on different aspects appeared. The history of photography is now less concerned with techniques and more with ideas. We are shown how photography reflects upon itself: *Photographers on Photography*, by Nathan Lyons (1966); *The Photographer's Choice*, by Kelly Wise (1977). Journals devoted to the history of photography have appeared, particularly in Europe: for example *History of Photography* and *Photographies*. Critical reviews of exhibitions are current in newspapers such as the *New York Times* or the leading French papers.

There have been a number of remarkable analyses such as Susan Sontag's collected articles in *On Photography* (1978) and Roland Barthes' *Camera Lucida* (1982), but they are out of touch with the realities of creation. Notwithstanding the efforts of journals such as *October*, in the United States, and *Cahiers de la photographie*, in France, there is still a need for more theoretical studies of photography.

The paths of experimental photography and the imaginary

In the fifties, experimental photography took up the challenge of abstract art, as was demonstrated by two exhibitions held in the New York Museum of Modern Art: 'Abstraction in Photography' (1958) and 'The Sense of Abstraction' (1960). During the years that followed, that tendency mingled with others, making photography more adaptable to styles which still owed much to external influences.

1961 saw the publication of Bill Brandt's *Perspective of Nudes*,[18] the result of fifteen years of research. The arrangement of forms and the surrealist atmosphere complemented each other in this specifically photographic exercise. The book provoked an outcry ('How dare he deform the female body!'), despite the fact that these swelling and tapering volumes put one in mind of the sculptures of Henry Moore, already a famous artist. Basically, what was deemed scandalous was the fact that these monumental masses had been obtained through rigorously photographic and, supposedly, objective optic means. Brandt had chosen the nude, not as a theme for plastic variations, but because it could best be made to flow into the curvatures of space, the essential subject of his study. These masses, balanced or twisted according to the rules of the camera lens, did not set space in order in the way that a sculpture dominates a landscape; rather, they bloomed there as if thrown up by deep movements within it.

Working along parallel lines in Japan, Eikoh Hosoe, fascinated by the text of Genesis and inspired by Zen, was producing his nude studies, *Man and Woman* (1960; the book appeared in 1961), in which the sensuality of lines and surfaces complements the full volumes. Between 1956 and 1960, in France, Jean Dieuzaide[19] was working on his 'encounters with pitch', a black, heavy, viscous tar produced from coal. Not until 1968 did he decide to show these images that evoke bellies, thighs and lips. In all these works, abstraction is no longer in retreat from the concrete. Volume precedes shape. The beauty of outlines comes as an extra; heavy mass is what is given first.

Photography, which renders the thrust of volumes by means of shadows, also tends to flatten space by reducing its different planes to a single surface. That was the property which from the early sixties onwards attracted the attention of landscapists such as Franco Fontana[20] in Italy, Detlef Orlopp in Germany and Max Mathys in Switzerland. Fontana reconstituted space by means of bands of colour. Orlopp built up his rocks and stretches of water as powerfully hewn walls. Mathys conveyed the expanse of the countryside using repeated geometric forms and, in a manner that could already be described as conceptual, he also evoked the rhythms of passing time, by photographing the same spots in different seasons.

The sensuality of matt colours in Fontana's work, the vibrations of grain in Orlopp's and the introduction of the temporal dimension in Mathys's show that abstraction did not involve abandoning authentically photographic material in favour of arid graphics; on the contrary, it made use of that material to restore body to a lucidly reconstructed reality.

This becomes evident in works produced with no model in the external world, with no lens or camera even, such as those of Pierre Cordier and Jean-Pierre Sudre.

Pierre Cordier, who had studied under Steinert, discovered the principle of the chimigram in 1956. In 1964, he mounted

JEAN DIEUZAIDE
From the series MON AVENTURE AVEC LE BRAI ('My Adventure With Tar') 1956.

Collection of Jean Dieuzaide.

the first exhibition of this process, in Brussels. His method was an inside-out photograph, in which forms become visible through the chemical properties of revelatory products, instead of through light being filtered through an optic device. Infinitely delicate and varied networks blossom on the sensitised paper already touched by light. They have the immediate impact of marble or enamel surfaces.

Jean-Pierre Sudre's works also make an immediate impact. The negative is constituted by a culture of crystals on a glass plate. Light passes directly through the object itself, whose image is thus imprinted upon the sensitised surface. Mordant toning can further emphasise the solidity of the matter presented to the eye, as can be seen in his series of *Diamantines* (1964), *Apocalypses* (1970) and *Paysages matériographiques* (1975). Landscapes (*paysages*) they are indeed, these crystalline formations in which the imaginative eye can see forecasts, mountains, glaciers and a star-studded sky.

During the sixties, the combination of abstract forms and material density often conjured up the imaginary. What is abstract is given body, while what is material turns out to be rich in dreams. The teaching of Minor White was thus expanded and embodied, but without its mystic trappings.

Dreams can also well up from the most rigorous of

JEAN-PIERRE SUDRE
PAYSAGE MATÉRIOGRAPHIQUE ('Materiographic Landscape'),
1975.

Collection of the Bibliothèque Nationale, Paris.

scientific techniques, as in the aerial photography of William Garnett;[21] or the veritable reportages from inside the human body which Lennart Nilsson produced, using fibre optics and miniaturised lenses. His book, *A Child is Born*, made a huge impact in 1965.

Edward Weston's last great book, *My Camera on Point Lobos* (1950), introduced a dreamlike dimension into a life's work always devoted to the beauty of forms. It proved that photography could evoke mystery simply through carefully judged framing and lighting and without the aid of scissors and paste. In 1953, Ralph Eugene Meatyard,[22] an amateur photographer and optician by profession, largely self-taught despite a few lessons from Van Deren Coke, Holmes Smith and Minor White, embarked upon a work of great sensitivity, left unfinished when he fell ill and died in 1972. Taking his own family and friends as his models and using the simplest of means, he created images charged with mystery, in a quite everyday setting, a kind of Beyond, yet still immediate and familiar.

Jerry Uelsmann[23] is generally regarded as the greatest representative of surrealism, understood as the creation of oneiric worlds using strictly photographic methods. Having studied under Minor White and Holmes Smith, in 1959 he embarked upon his own personal research and has been teaching at the University of Florida since 1960. He combines different negatives or fragments of negatives and projects them onto the same sheet of photographic paper which he moves from one enlarger to another in his vast laboratory. Uelsmann connects and unifies spaces in theory irreconcilable. As with Bill Brandt, his surrealism is fundamentally that of optic spaces. But with Uelsmann, fantasy runs rampant: trees float in the sky, leaves sprout from the ground, depth and height shift and oscillate; anything can happen in this universe full of symbols which are not really symbols since all that they refer to is the oneiric power of photography itself.

In 1966, the Swiss Rudolf Lichsteiner was awarded the Niepce prize for his surrealist combinations of images which, like Uelsmann's, conveyed the most bizarre hallucinations through the juxtaposition of heterogeneous spaces. In the Soviet Union, the Latvian Wilhelm Mikhailovsky and the Lithuanian Vitaly Butyrin were producing comparable montages at about the same time.

1966 was also the year which saw the first photographs arranged by Leslie Krims and the first sequences by Duane Michals.[24]

In little sepia images, in which the very air seems artificial, Leslie Krims meticulously — and sometimes provocatively — recreates his most intimate fantasies. His simulations of sexual crimes (*The Incredible Case of the Stack o' Wheat Murders*, 1972) and his image of his fat naked Mammy (*Chicken Soup*, 1972) are not really any more upsetting than his pictures of a group of dwarfs (*The Little People of America*) or of deer hunters (*The Deerslayers*, 1972). In the one group as in the other he is out to show that a photograph undermines reality more than it confirms it. It can make you believe anything or nothing at all. For, as Krims puts it, it is possible to give concrete form to all the images in our minds.

Duane Michals's 'Whoever sees my photographs sees my thoughts' echoes his point. Michals started off with a remarkable series of portraits taken in the Soviet Union. He was then deeply shaken by the loss of people dear to him. They had been there. Now the place was empty; it seemed like a set awaiting the absent actor; 'So I began to invent the sets for my own photos.' But the reality is never there, it has always been swept away by time. Thus, his work consists of sequences of disjointed images which, although they tell a story, are the more enigmatic in that the time injected between one and the next engenders uncertainty as to the meaning of the way they follow one another.

Arthur Tress,[25] who began his career in 1966, gave himself the title *The Dream Collector* (1972). He reconstituted his dreams and the dreams of others in front of the camera. For him, photography has the power to make one believe in a reality far more intense than reality itself, as some nightmares do. His own shadow is enough to bring convincing fantasies to life (*Shadow, A Novel in Photographs*, 1975).

In 1969, Eikoh Hosoe illustrated an old Japanese legend (*Kamaitachi*), the discontinuity of which leaves each one of us free to imagine a story of our own. As in Duane Michals's work, and in contrast to a cinematographic account, the role of time here is not to help us go along with the story, but to remind us that 'it's all in the mind' (Minor White).

These photographs turn the habitual order of things upside down by reversing the traditional notion of photographic objectivity. Every aspect of reality is fabricated, then recorded. This photography proves nothing but what the photographer sets out to make it say. It is an even better means of showing our fantasies than of showing our surroundings.

On the threshold of the seventies, two great contrary, if not contradictory, truths thus emerged. For photographers such as Robert Frank and William Klein, photography in both form and meaning always exceeds that to which we attempt to reduce it. In contrast, for this group of manipulators, it proves possible for it to coincide with the decisions that our minds take on their internal and private stages. Photographers such as Cartier-Bresson and Boubat had achieved a perfect harmony between chance and construction. But now all that

JERRY N. UELSMANN
ROOM, 1963.

Collection of the Bibliothèque Nationale, Paris.

R. E. MEATYARD
UNTITLED, 1962.

Collection Bibliothèque Nationale,
Paris.
With the kind permission of
Christopher Meatyard.

was exploded. For young photographers, those astonishing correspondences between form and content could never be repeated without looking both artificial and hypocritical. The photographer was now faced with a choice: either photography could admit the formless contingency that surrounds us, or else it could give concrete form to our internal visions. Within the cultural framework of conceptual art, photography could no longer avoid that self-polarisation.

The paradoxes of fashion photography

Alexey Brodovitch had been artistic director of *Harper's Bazaar* ever since 1934, and in 1959 he retired. His influence had been immense. Not only was he a spiritual father to Richard Avedon, Hiro, Art Kane, Irving Penn, Georges Tourdjman, Peter Turner and many others, but furthermore it was he who had recognised and published in his luxury magazines works of pure creation, such as those of Bill Brandt, Brassaï, Cartier-Bresson, Louis Faurer, Lisette Model and Maurice Tabard; also, he had discovered talents such as Robert Frank and Bruce Davidson. Full of contradictions, he purveyed no doctrine; but he speeded on their way many gifted young photographers endowed with a spirit of free inventiveness coupled with professional rigour.

Now the question posed was that of the place of fashion photography – applied photography – in relation to experimental and creative photography. Was all this effervescence of flair and inventiveness with colours and acrobatic page layouts going to allow fashion photography to overflow and intermingle with the currents of photography directed towards museums and galleries? And, from the other angle, given the unease naturally associated with creativity, would art photography manage to make room for these wide areas of photographic activity hitherto (not without regret) regarded as separate from art?

Despite a certain willingness on both sides, the time did not seem ripe for such a fusion. It would only take place when fashion photography was recognised to possess a historical dimension of wider scope than the simple business of recording successive fashions, or, in this case, successive fashions of fashion.[26]

The sixties saw the culmination of a spirit of nonconformism and provocation, the truly revolutionary impact of which today seems open to doubt. The London of Mary Quant and Carnaby Street, men with long hair and women in miniskirts, are inseparable from the myth of the young, successful fashion photographer swinging through life yet forever tormented by the mystery of creativity – as he appears in Antonioni's film, *Blow-Up* (1967). David Bailey himself admitted to having no style of his own, yet he became a cult personality. Terence

Donovan and Brian Duffy were almost as famous. In New York, Bert Stern exhibited his work in a studio of dumbfounding luxury.

Richard Avedon,[27] who had been fascinated by Martin Munkacsi's outdoor, sporty images, did not reject the resources of movement but moved towards more and more artificial lighting, commenting 'I would feel I was lying if I photographed in daylight, in a world of airports, supermarkets and televisions. Daylight is something that I seldom see, something that I must do without.' He was given carte blanche for the April 1965 issue of Harper's Bazaar in which, with his top model Jean Shrimpton, he evoked astronauts, pop art and op art, all of them asepticised subjects.

By 1968 there was a reaction. Couturiers and fashion designers, for whom clothes had by now become no more than a vague pretext, launched a counter-attack in the name of taste and elegance. Letters poured in from the public too: people had had enough of models forever perched on toilet bowls.

In the seventies the situated changed. The vitality of London and New York passed to Paris. By very reason of their wide diffusion, American magazines were more vulnerable to the average public's rejection of exaggerated eccentricity. When Diane Vreeland, the editor-in-chief of Vogue, left the magazine, Penn and Avedon no longer worked for it except on an occasional basis. The Parisian Vogue was now the more inventive, giving a free hand to Guy Bourdin and Helmut Newton. A former editor of Harper's Bazaar, Deborah Turbeville, and a former model, Sarah Moon, both became photographers themselves. It now went without saying that a fine image depended upon the talent of its photographer; other extravagances were no longer called for.

And a few strong personalities managed to combine creativity brilliantly with their technical know-how.

Richard Avedon was also a fine portraitist. Against their blank, white backgrounds, his portraits make a massive impact, situated as they are on the borderline between elegance and cruelty. His pitiless series showing his father's face as he slipped towards death achieves as great an intensity as the work of Diane Arbus.

With the help of his model Lisa Fonssagrives and the support of his editor at Vogue, Alexander Liberman, the cultivated and sophisticated Irving Penn managed to produce some of the most acute black-on-white compositions to be found. In 1974 his book Worlds in a Small Room presented a collection of portraits of extremely exotic models, photographed all over the world, always in the same transportable studio-tent. It is another fine example of the way in which extreme technical skill can be sublimated into simple creativity: that is to say a simple testimony to the truth.

Hiro, who arrived in New York from Japan in 1954, was a pupil of Brodovitch's and Avedon's assistant at Harper's Bazaar from 1965 to 1975, with a flair for getting the most out of colour and draperies, using shots from unexpected angles. He had an even more powerful creative urge, and worked with an 'open flash', a means of overlaying a body's bloom with a subtle morbidity.

William Klein distanced himself from the techniques of fashion photography right from the start. Between 1955 and 1965 he directed his plastic genius into images which continued to play the fashion game but always with an imperturbable irony.

Bob Richardson managed to recapture the naturalness of intimate family photographs. His spacious yet full compositions for the Parisian Vogue were particularly remarkable between 1964 and 1968. 'To look at Richardson's work is to share a moment of tenderness, an instant of intimate and fragile happiness.' (Nancy Hall Duncan.)

Guy Bourdin, who like William Klein was also a painter, became a stage manager of scenes, such as his famous 1966 series advertising Jourdan footwear, that could be disturbing and bizarre. The image was constructed with great sweeps of colour but the encroaching shadows seemed somehow menacing. Enigmatic clues were dotted here and there. These images are not far removed from the experiments on the ambiguities of photographic narration of a Duane Michals or a Les Krims.

In her famous publicity work for Cacharel, Sarah Moon invented a world of pastel sweetness. Deborah Turberville's models almost seem real flesh and blood women, but ones who are worried, threatened or overcome, in a cold, dripping environment. She used Polaroid test pictures to produce her book Maquillage (Makeup) in 1975, explaining that this was her 'art'.

The new paths of direct photography

While some photographers were pursuing imaginary worlds, others contented themselves with direct, unretouched shots of the subjects of classic reportage: the settings of life, people's behaviour. But Robert Frank had already passed that way. The time for images symbolising great timeless truths was over. Now one could only record, without passing judgement.

The presence of the author of the picture was now to be felt in the forms he used, not in his moral comments. And although perfectly recognisable, those forms could be very reminiscent of the rigorous constructions of abstract art. The aim was, by pure chance, at the street corner, to seize upon visual coincidences of such perfection as to evoke the carefully elaborated compositions of painting liberated from the fortuitousness of reality. With echoes both of Frank's sidelong glance and Klein's looming surprises, it was a method which could arrest reality at the point where it was organised into a rigorous formal composition, but one quite free from superposed idea.

Like the great jazz musicians, Lee Friedlander[28] and Garry Winogrand[29] aimed to combine a maximum of spontaneity with construction of the most exact nature. But each had his own particular way of doing it. Friedlander's precise patchworks form a contrast to the teeming abundance bordering on anarchy in Winogrand's work. Friedlander demonstrates his virtuosity while Winogrand does all he can to have it pass unnoticed. Friedlander fits everything into lines and volumes, an avowed artist. Winogrand likes to brush up against a moment 'when the contents are on the point of spilling over from the form'. He stakes his all on vision.

Lee Friedlander, who became a professional photographer in 1955, appears to break the scene into multiple fragments, then stick them together again in an arrangement as perfect as it is unexpected. Yet it is all done within the space of the click of a shutter.

Garry Winogrand abandoned painting, which was too slow for him, in 1952, and became a reporter for the Pix agency. But in 1955, shaken by the impact of Walker Evans,

he set out on a trip across the United States. Robert Frank was engaged upon similar travels at this time. Although they did not meet until later, when they did, Frank confirmed Winogrand in his inclination to pursue his search for a photography that left style behind. Unlike Friedlander, Winogrand undertook a busy teaching programme in the second part of his life, brutally cut short by cancer in 1984.

Winogrand loved human contacts as much as Friedlander loved solitude (*Self-Portrait*, 1970). His books, *The Animals* (1969), *Women are Beautiful* (1975) and *Public Relations* (1977), clearly use zoos, pretty girls and socialite gatherings simply as pretexts to produce images which he himself always regarded as 'still-lifes', devoid of any commentary one might be tempted to supply.

For a long time the notion of modern art was indissociable from geometric simplification. The abstract aesthetic was initially bound to reject photography. But painting evolved. Artists such as Tobey, Pollock, Bissière and Vieira da Silva evoked the inextricable abundance of certain scenes. Meanwhile, in photography, the intense disorder of the urban landscape defied the classic reporter seeking the right angle

and moment for a clearly stated image. Friedlander was to construct his photographs by emphasising the very confusion of the spectacle. Their immediate impact was made through the multiplicity of objects and planes, through visual chaos. Only later would the eye detect that this was not anarchy, but a wealth of structures. Yet the immense disorder of today's suburban sprawl is undeniable, so although such works refrain from passing any judgement, they nevertheless do have a social impact.

'Toward a Social Landscape' was the title of the exhibition organised in 1966 by Nathan Lyons, to show works by Bruce Davidson, Lee Friedlander, Garry Winogrand, Danny Lyon and Duane Michals (his 'Sequences'). The word 'social' is misleading to Europeans, who are accustomed to associate the term with the traditional protests of organised workers. In these photographic spaces, by contrast, man seems to have been ejected altogether, to be replaced by cars, posters and posts. But if the new photography rejected specific meanings, it did not necessarily withhold recognition: recognition that meaning has been lost in a world in which, however much mankind multiplies and crowds together, it still becomes invisible.

In these photographs, the human being has become just one object among many others, in a world stuffed with objects to a nauseating degree. And in the stark, harsh light of the United States the passer-by passes by others without seeing them (as with Robert Frank and Harry Callahan). He himself seems diminished, obscured by all that happens to be there, in between the photographer and himself. Photography had

LEE FRIEDLANDER
UNTITLED, 1977.

Collection of the Bibliothèque Nationale, Paris.

GARRY WINOGRAND
UNTITLED, 1975.

Collection of the Bibliothèque Nationale, Paris.
Courtesy Fraenkel Gallery, San Francisco,
and the Estate of Garry Winogrand.

always tried to eliminate whatever stood in the way of its theme; but Friedlander photographs precisely all that is in the way, beginning with his own shadow, since it happens to be there (in *Self-Portrait*, 1970), instead of undertaking all the furtive manoeuvres of reporters of 'the decisive moment'.

In *American Monument* (1976), Friedlander assembles a collection of images of official monuments, all of them perfect, all insolently indifferent to the message that those monuments proclaim. Devoid of lyricism, intention or meaning, such a series declares literally nothing. It turns the world into photography more surely than any manipulation would. Photography represents reality, so is not itself reality. It is a representation which is added to reality, in the real world.

Walker Evans' great message comes through clearly. In 1966, Leslie Katz, who published *American Monument*, had produced Evans' *Message from the Interior*. Winogrand felt that he had been transformed through Evans: 'Evans's photos concern what is photographed, not any preconceived idea of what a photograph should look like. They also show how whatever is photographed is changed by being photographed and the way that things exist in a photograph.'

'I photograph to find out what something will look like photographed.' That aim of Winogrand's constitutes the most fundamental definition of what was somewhat vaguely called sometimes 'social landscape', sometimes 'the American style' – a style which marked a whole line of direct photography and took over from the classic reportage of the thirties, forties and fifties.

The title of Elliott Erwitt's book, *Photographs and Anti-photographs* (1972) indicates the extent to which the new manner of photography sometimes seemed paradoxical even to those who practised it. (In France, Jean-Philippe Charbonnier was also speaking of 'non-photographs'.) But in Erwitt's work the anxiety prompted by Robert Frank's heritage is laced with a sense of humour rarely found these days. Working in a more brutal register, Mark Cohen seizes upon faces and bodies as they loom up in the sudden light of a flash. When it came to distinguishing between Burk Uzzle's *Landscapes* and Charles Harbutt's *Travelog*, both produced in

1973 and shown at the Arles festival, the selection committee was hard put to do so. These two American photographers seize with an equal exactitude and impassivity upon the tense relations between things and people in modern life, although there is a trace of acid irony detectable in Uzzle and a slight quiver of emotion in Harbutt.

The world of chaotic American suburbs tackled by Friedlander is also depicted, in the realm of colour photography, by Stephen Shore. Joel Meyerowitz (*Cape Light*, 1978) is more affected by the atmosphere of deserted seaside resorts, in the evening, with the street lights shining in the cold air and the sky reflecting neon illuminations. Langdon Clay, like Robert Frank, is attracted by the gleaming, sinister cars parked along sidewalks; while Joel Sternfeld prefers busy crowds frozen in the electric light of a 'retarded flash' which brings out the drawn expressions on the faces.

Because of the fixity of the photographic image and the precise and haunting nature of its testimony, the objective truth it contains is always on the point of slipping into a hallucinatory dream. In this sense too, as well as by reason of its negative–positive nature, photography is 'a kind of flapping' ('*un battement*'), to borrow Henri Vanlier's expression.

The work of Ralph Gibson, born 1939, assistant to the great Dorothea Lange and a friend and collaborator of Robert Frank, provides the most striking illustration. In 1969 Gibson set up his own publishing house, Lustram Press. Each of its books of photography becomes an autonomous means of expression, making its effect through the succession, juxtaposition and rhythm of the images, and it constitutes an end in itself. His famous trilogy, *The Somnambulist* (1970), *Déjà Vu* (1973) and *Days at Sea* (1974), was extended in 1983 by *Syntax*, which may be seen as a model for the art of putting images together. Between *The Somnambulist* and *Days at Sea* a controlled shift takes place, moving away from visions still surrealistic and dreamlike towards almost minimal foreground forms, veritable photographic bas-reliefs. But the tension between the oneiric content and the material presence is never broken. The aim is to evoke an internal obsession with

RALPH GIBSON
UNTITLED, 1975.

Collection of the Bibliothèque Nationale, Paris.

maximum intensity and a minimum of concentrated spatial effects. That endeavour is central to the double nature of photographic expression: on the one hand it can convey the imaginary, on the other it reports.

In Europe, precursors to this internalised reportage may yet remain undiscovered. But there are images by Cartier-Bresson which date as far back as the thirties which we should not forget! Jacques Darche (1920–65), who was killed in an accident, was known as a draughtsman and book-designer.[30] It was only after his death that a number of 24 × 36 rolls of film which he had not had time to print came to light: they reveal a Parisian on foot, with little time for the anecdotal and the picturesque but extremely sensitive to the stillness of silent, intense forms. The Englishman Tony Ray Jones (1941–72), who also died prematurely, had been a pupil of Brodovitch's and had retained constant relations with the United States, but his was the most British version of this new sensibility.

Here humour, the traditional British 'understatement', was perfectly in tune with the clear, cold composition of planes and volumes (*A Day Off*, 1974). The work of his compatriot David Hurn is also often impressive as it describes the mores of a people always ready to laugh at itself (*David Hurn Photographs*, 1976). In Italy, Roberto Salbitani focused on the

fantastic aspect of everyday life, suggesting strange dualities in the spaces within the tough framework of modern cities. The German Verena von Gagern, after training as an architect, also began to work as a photographer in the early seventies. She too excelled with those instants of suspended magic which, for those who know how to look, encompass the absurd relationships between things and people today. The Frenchmen Bernard Descamps (born in 1947), Edouard Kuligowski (born 1946), Bernard Plossu (born 1945) and Bruno Réquillart (born 1947) all show that photography that is direct yet very structured, that contains no message yet is very subjective, is now seen as the field of experimentation for a new generation.

In Tokyo in 1956 the veteran Ken Domon saw the first exhibition of Ikko Narahara's work, devoted to life on a desert island, and he declared that 'the first phase of realism is now completed'.[32] Soon Ikko joined Shomei Tomatsu, Eikoh Hosoe and others to form the Group of Ten, whose work was exhibited in the late fifties. In 1959 the group turned itself into a collective agency of six photographers known as Vivo; it continued to mount exhibitions up until 1962. Ikko then set off on a long world trip and subsequently returned to the United States many times. He was as sensitive to the presence of the past (*Where Time has Stopped*, 1967) as he was to the timeless modernity of America (*Where Time has Vanished*, 1975). But central to his work was space, whether enclosed and confined or wide open to the great expanses. Shomei Tomatsu, also a former member of Vivo, combined his commitment to the aftermath of war (*11.02 Nagasaki*, 1962)

and the social crisis of Japan (*Oh, Shinjuku!*, 1962) with an intensely personal plastic means of expression. In his case too, human testimony and plastic abstraction ceased to clash.

In Latin America,[33] an impressive revival of creative photography took place at the end of the seventies. Until then, only the name of the Mexican Manuel Alvarez-Bravo was well known. He was a disciple of Weston, but was deeply attached to his native land. One cannot but admire his sober, as it were self-absorbed images, whose only equivalent is perhaps to be found in the sovereign simplicity of the work of the great Kertész. He was an inspiration to many of his compatriots, in particular the excellent Graciela Iturbide, and it was in Mexico in 1978 that the first congress for Latin American photography took place, thanks to the energetic efforts of Pedro Meyer. The greatest difficulty was to combine the duty of denouncing social injustice with, on the one hand, the need to seek aesthetic models in the international currents of photography and, on the other, the tradition of exotic picturesqueness peculiar to these tropical countries. The Cuban Raul Corrales exalted the social struggle while the Venezuelan Paolo Gasparini turned to the taut, abrasive aesthetic of Northern Americans to depict the modernised environment. In Brazil, Claudia Andujar and Maureen Bisilliat celebrated the beauty of the last of the Amazonian Indians, while Boris Kossoy was drawn by surrealism. In Mexico, Carlos Blanco depicted traditional costumes, while his brother Lazaro composed rigorous images in the geometric style. Meanwhile, the work of Jesus Sanchez Uribe, with his taste for deep mysterious blacks, was closer to the most recent tendencies of European and Japanese photography. On the palm-fringed beaches of Panama, Sandra Eleta celebrated the sweetness of life and love, like some kind of Boubat in a black-skinned world.

Expression

The dominant trend of the sixties and seventies may have been to set reality at a distance by seizing upon it in strictly formal terms. But that had nothing to do with another, inevitable tendency which was very much alive. 'For me, the subject of the picture is always more important than the picture,' declared Diane Arbus (1923–71), whose personality dominates the 'human' side of contemporary photography.[34] Diane Nemerov was born into a wealthy family and led a protected (over-protected, according to her) childhood. Then she married the photographer Allan Arbus and they both pursued successful careers as fashion and publicity photographers. She knew many artists, including Robert Frank and Walker Evans. Between 1955 and 1957 she was taught by Lisette Model, whose own crudely realistic, even caricatural, work owed much to the insolent power of Weegee. Diane Arbus sought out the most intractable of subjects: abnormal people, transvestites, idiots. But she was not just a portraitist of monsters: she also taught us to see that we are all monsters. In 1971, Diane Arbus committed suicide. She had learnt from Lisette Model that the better one seizes upon whatever is particular, the better one also reaches what is general. Perhaps that sums up the royal progress of photography. But this intensification of the particular endows every subject with such an overwhelming presence that each being becomes unique and consequently abnormal, terrifying. 'I mean if you scrutinise reality closely enough, if in some way you really, really get to it, it becomes fantastic,' Diane Arbus remarked. As a result of the concentrated gaze produced by photography, it even turns out that 'it's what I've never seen before that I recognise'. But although photography seizes something about reality, about human faces, it never exhausts them. On the contrary, for 'Photography is a secret about a secret. The more it tells you, the less you know.' This photographic scrutiny simply manifests the unfathomable difference of others. Diane Arbus went on to say that what she was trying to describe was the impossibility of getting out of one's own skin into that of someone else. Neither cruelty nor tenderness here, just observation. That is as photographic as it is possible to be.

In 1963 Diane Arbus was awarded a Guggenheim bursary, followed by another in 1966. In 1969 the public was much

BERNARD PLOSSU
PORQUEROLLES, 1972.

Collection of Bernard Plossu, Paris.

struck by her 'New Documents' exhibition, with Lee Friedlander and Garry Winogrand, at the New York Museum of Modern Art. Her last works showed the inmates of a mental hospital having a party, all in fancy dress: all aboard for the last judgement. One year after her tragic death, Diane Arbus became the first photographer to be given an official exhibition at the Venice Biennale.

Success has seldom been so great or come so quickly. Yet, however fascinating her work, Diane Arbus is seldom imitated. But there were a few disciples, such as Rosalind Salomon, and there is a certain similarity in the diquiet expressed by a number of other portraitists. In *Women and Other Visions* (1975), Jack Welpott and Judy Dater produced delicately sensitive images of freakish figures on the margins of society. In 1976, Starr Ockenga published the admirable *Mirror after Mirror*, a series of portraits of women, pervaded by light both internal and external. Death stalks among the tense effigies in Peter Hujar's *Portraits of Life and Death* (1976) and Larry Fink, a pupil of Lisette Model and friend of Larry Clark, seizes upon the stereotyped gestures and suddenly nightmarish expressions in receptions where the sophisticated conventions simply accentuate the grotesque character of individuals. In her studio on 42nd Street, Joyce Baronio[35] photographed poor working girls, pick-ups and bar-girls, finding a way to express a kind of dignity that came through their limited psychology and naïvely erotic costumes. The Frenchwoman Martine Barrat,[36] established in New York, produced images of extremely tough sectors of life, such as the world of child boxers, in an impressively downbeat style. In Paris, Jean-François Bauret[37] sometimes abandoned fashion for nude portraits or, to be more precise, pictures of people without their clothes, whose faces nevertheless still bear the expressions suited to society life. Equally disturbing, although in a quiet different fashion, the compositions of the Czech Jan Saudek combine a baroque eroticism with a deep human understanding. In Germany, a long tradition of intense and incisive portraiture, stretching from Cranach down through Sander, surfaces again in André Gelpke's effigies of monks and in the passers-by snapped by Helmut and Gabriele Nothhelfer.[38] In total contrast, Bernard Poinssot (1922–65) was a portraitist who rejected all posturing, all grimacing, to allow an internal serenity (or emptiness) to come to the surface: whatever is left once all the masks have been dropped. In his little workshop in the Rue Dauphine, he would make no concessions either to life or to his clients. Aiming for extreme simplicity and perfection, he left behind a model of great purity.

Japanese photography also has its extremely expressionist aspects. To the eyes of Westerners, it seems to accept a certain stylisation of reality from the outset, without it being possible to make out quite how much results from an intelligent assimilation of plastic influences from the West and how much is owed to exotic manners and forms. Brutal juxtapositions of violence and gentleness are common, imparting what is to our eyes a somewhat theatrical air, although it is hard to determine whether it stems from what might be called a collective surrealism or rather from exacerbated individual expression. Daidoh Moriyama, a pupil of Eikoh Hosoe, consciously reflects the influence of William Klein in his way of reconstructing traditional space to express the anarchy of cities. In his beautiful and mysterious book *Zokushin, Gods of the Earth* (Yokohama, 1976), Hiromi Tsuchida mingles past and present and sacred and profane in a disturbing but gripping fashion. Masatoshi Naitoh, a chemist turned anthro-

DIANE ARBUS
TEENAGE COUPLE ON HUDSON STREET,
New York, 1963.

Collection of the Bibliothèque Nationale, Paris.
© The Estate of Diane Arbus, 1963.

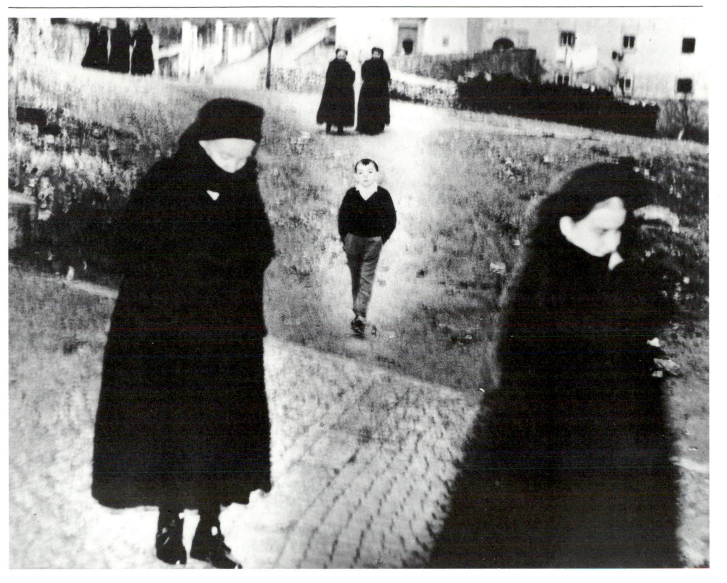

MARIO GIACOMELLI
SCANNO, 1957.

Collection of the Bibliothèque Nationale, Paris.

pologist, studies mummies. In search of a semi-mythical woman, known as Yohko, Masahisa Fukase crosses nocturnal landscapes full of crows, as if passing through time, with the Beyond encroaching.

It is always difficult to describe expressionist tendencies as movements, since they stem from such personal original talents. Thus the Italian Mario Giacomelli[39] must be accounted one of the great photographers of our times even though he leaves no direct heirs. The quality of his work might perhaps be compared to that of a William Klein, but this man of letters, an admirer of the sombre poetry of Leopardi and the austere still-lifes of Giorgio Morandi, has never left his native birthplace of Senigallia, where he embarked upon his photographic career in 1955. *Death Will Come and It Will Have Your Eyes* is the title of his terrifying series of pictures of old people's homes: they are almost unbearable in their realism, yet the violent contrasts, the seeping blacks and the distended empty spaces come close to abstraction. His pictures of seminarists playing in the snow (1962–3), with their slightly mad dancing shapes, are not so much amusing as disturbing.

It is an inevitable paradox that in its attempt to plumb the extremities of violence in real life, visual testimony may find extreme forms of expression which tell us more about the photographer than about his subjects. Joseph Koudelka,[40] Czech by origin, left his country in 1969. His admiration for Cartier-Bresson detracted nothing from his own powerful originality. For many years he studied the gypsies, nomads and bohemians like himself, little concerned with comfort. The space of his clearly structured images seems to pulsate spontaneously with emotion and, frequently, pity. Every one of his models reflects the tragic nature of life. His art, with its almost theatrical lyricism, seems quite independent of all major contemporary trends, but equally irreducible to the currents of the past in its treatment of forms moulded by angles and viewpoints which are freely invented.

The crisis of reportage and the enduring nature of testimony

The sixties and seventies were years of great crisis in traditional reportage. They witnessed the death of many

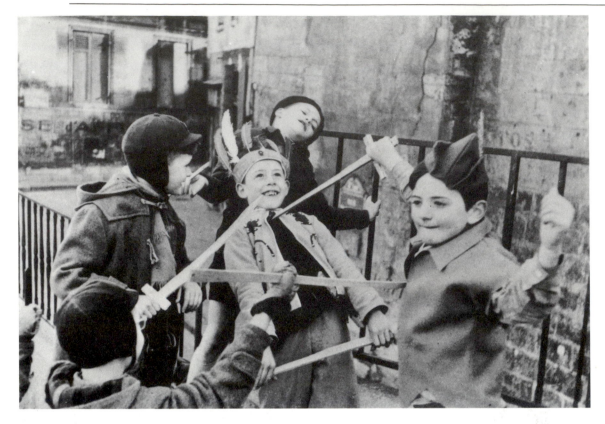

EDOUARD BOUBAT
PARIS, ILE DE LA CITÉ, 1954.

Collection of the
Bibliothèque Nationale, Paris.

illustrated magazines, including *Colliers'* in 1957 and *Life* in 1972. In France, *Réalités*, a magazine run by a string of remarkable artistic directors, was gradually deserted by its best photographers: Gilles Ehrmann, Edouard Boubat[41] (in 1965), Jean-Philippe Charbonnier (in 1974). Now only the rapid expansion of photography in professional, trade-unionist and advertising publications, and so forth, ensured a living for the photojournalist. The competition of television was clearly an important factor, for printed photographs tended to reach the public long after the news had been televised. But reportage soon discovered a new life in which it sought not so much to capture the sensational event but rather to reflect upon the way that people lived.

The lesson of Robert Frank, who did not consider photography's role to be to transmit pre-established meanings, was now to be discovered through their own experience by other reporters.

The great tradition of balance between form and meaning reappears in the deft and elegant style of Marc Riboud and the Swiss René Burri. In Japan, Ihei Kimura was already a specialist in 35 mm images and a well-known portraitist when he was profoundly influenced by the Cartier-Bresson exhibition in Tokyo in 1961. Hiroshi Hamaya, his compatriot, had worked as a photographer throughout the world but was chiefly known for his images showing the living conditions of Japanese peasants battling against snow, dust and mud. The Indian Raghu Raj was a brilliant exponent of this classic tradition, particularly well represented by the photographers of the Magnum agency.

Edouard Boubat's serene and glowing works reflect nothing of the ugliness and vulgarity of the modern world. He seems blessed with the gift of finding equilibrium and beauty wherever he looks (*La Survivance*, Paris 1976). It is perhaps because of Gilles Ehrmann's modesty and his rejection of all contrived or sensationalist effects that his rare qualities have not received the acclaim that they deserve.

But massacres and violence go on, and direct, courageous and tough witnesses are essential. Some war reporters, such as Larry Burrows and Gilles Caron, lost their lives at their task. Don McCullin (*The Destruction Business*, 1971) shows us the slaughter of Cyprus and Vietnam with an epic force which even bears comparison with the lyricism of one such as Eugene Smith.

The reportage of Micha Bar-Am is indissociable from the struggles of Israel. By the age of thirty-two, the American Susan Meiselas had published two books which soon became famous: *Carnival Strippers* (New York, 1976) and *Nicaragua* (New York, 1981), in which the sordid lives of fairground strippers seem no less taxing than the bloody episodes of civil war. Horror and humiliation are to be found on every side, as can also be seen from the tough, nocturnal images of Leonard Freed's *Police Works* (New York, 1981) and the Swedish Anders Petersen's raw enquiry into Hamburg's cabarets of ill-repute (*Cafe Lehnitz*, Munich, 1978).

In *Vietnam Inc.*, a book of great intensity, the product of three years spent among the combatants, Philip Jones-Griffiths turned his back on aestheticism of any kind, remaining at the level of reality and yet, in so doing, seems to have brought the legend of the reporter to a close. In 1967, Lee Friedlander had suggested going to Vietnam to photograph not the fighting, as everyone else was doing, but daily life in Saigon. He was turned down. But in 1983 Sophie Ristelhueber, in Beirut, preferred, in the interests of authenticity, to show nothing but the ruined façades of buildings. War, as a spectacle, conveyed through all the modern communication media, cheapens the interest of those media themselves.

Underlying this evolution in reportage lurks the upsetting idea that the worst thing about our age might not, after all, be all those recurrent wars and famines, but the bleak inanity of modern cities. The Swede Ralph Nykvist shows the sad side of a society said to enjoy a high standard of living. In

California, Bill Owens[42] records the compacent and stupid optimism of the lower middle class (*Suburbia*, 1973), with its restaurant waitresses who, through mimetism, resemble advertisements for toothpaste. But in Bruce Davidson's[43] great book *East 100th Street* (1970), in which he shows the poor in the Puerto Rican quarter of New York, the author remembers the lesson learnt from one old black who flung at him: 'You may call this a ghetto. I call it my home.' Rejecting a depiction of studied wretchedness, Davidson instead shows the dignity and humanity of people whose real misfortune may turn out to be that they are destined eventually to become absorbed into the general mediocrity. Milton Rogovin also respects that same dignity in his strong, simple portraits of workers. And it was an American black, Roy De Carava,[44] initially a painter, and the winner of a Guggenheim bursary in 1952, who attained the highest level of this kind of sober pessimism and restrained grandeur, which quite eludes both a distractingly lyrical approach and also an insistent harping upon poverty.

Despite the tough character of his subjects (motorcyclists and ex-convicts) Danny Lyon, another member of Magnum, also shuns dramatisation in his depiction of the simple truth about those with whom he went off to live in order to understand them better (*The Bikeriders*, 1968; *Conversations with the Dead*, 1971). The reporter Claude Sauvageot[45] produced some horrifying images of the wars of Indo-China and Africa, but prefers to record the harmony of gestures of everyday life. In 1972, in Paris, Claude Raimond Dityvon, Guy Le Querrec, Martine Franck, Hervé Gloaguen and François Hers set up the Viva agency for the production of photographic information of a more considered kind, opposed to sensationalism and attentive to people's everyday problems. For several weeks, each of them lived among one of the human groups they were studying. The exhibition which resulted, 'Familles en France', enjoyed a great success. But the trouble was that their work was increasingly to be seen on billboards while it proved hard to find outlets in the press,

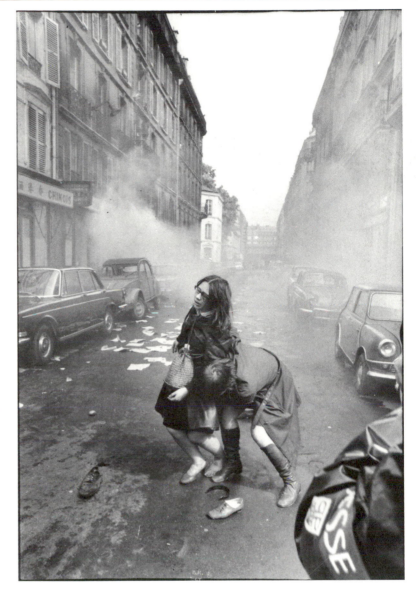

GILLES CARON
6 May 1968: TEARGAS.

Collection of the Bibliothèque Nationale, Paris.

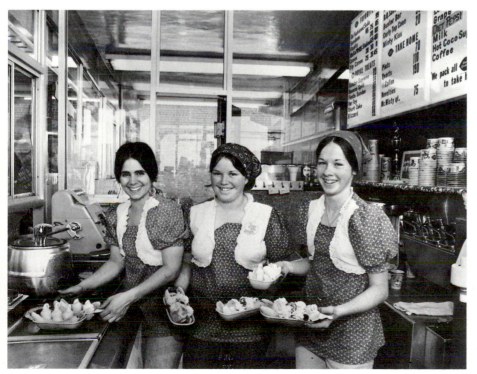

BILL OWENS
THE THREE WAITRESSES, 1977.

Collection of the Bibliothèque Nationale, Paris.
By kind permission of Bill Owens.

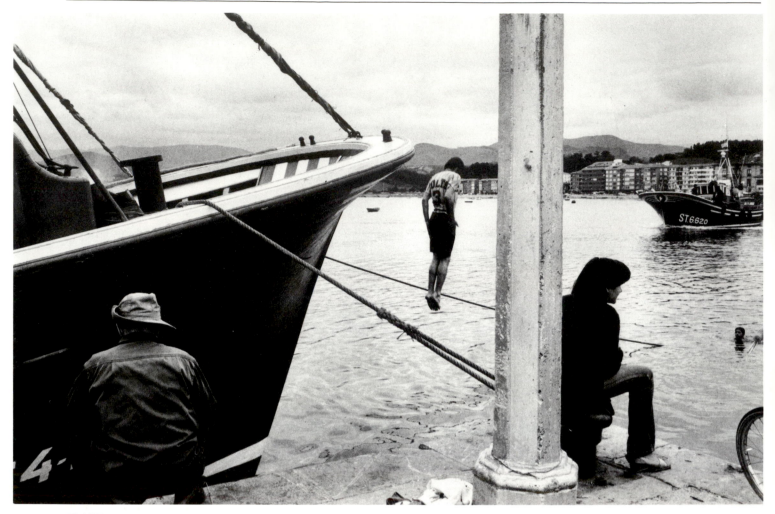

CLAUDE RAIMOND-DITYVON
PORT OF SAN VICENTE DE LA BARCERA, 1978.

Collection of Claude Raimond-Dityvon.

seemingly incapable of adjusting to cope with them. The impasse proved insurmountable, despite a few isolated but laudable efforts such as those of Robert Delpire, who put the *Nouvel Observateur Photo* at the service of creative and even, in particular, poetic photography; and those of the journalist Christian Caujolle, who tried to get the daily *Libération* to open its pages to photography as photography.

Reportage sometimes comes close to expressionism (Koudelka, Giacomelli). However, on the other side, it sometimes borders upon the conceptual tendency which is infiltrating so many aspects of the art of today.

Heinrich Riebesehl,[46] a pupil of Steinert's but also a reporter for the *Hannoversche Presse* in 1967 and 1968, echoes Robert Frank's notion of the 'in between': 'The short time before or after the "right moment" can be just as powerful in its statement. In fact, it is often more powerful. Before and after come from a period of activity; they allow the imagination to consider what could happen or has already happened.'[47] Riebesehl is the author of a quasi-conceptual sequence, *Menschen im Farstuhl* (1970), which shows people taken without their knowledge, at moments of total, empty indifference. In the same year, the American Barbara Crane went to the trouble of systematically snapping everyone who emerged from one hotel door (*People on the North Portal*).

Meanwhile, in Cologne Chargesheimer photographed his city, quite empty, at one particular moment in time (*Köln, 5 Uhr 30*), each picture taken with the same focus and at the same level, 'not for formal reasons but in the interests of the greatest possible objectivity'. The Australian David Moore moved on from reportage to abstraction, feeling that the time of the voyeur reporter was over and that now he was more concerned with 'the soft spread of time rather than the selected moment'.[48]

Even for those who for a long time remained wary, fearing (sometimes with good cause) a return of élitism, it began to seem increasingly preferable to hang photographs on walls, in galleries and museums, rather than show them in magazines leafed through hurriedly and distractedly. The English Roger Mayne declared, 'My primary interest is . . . the print to be exhibited or contemplated on a wall. However . . . a confusion has arisen . . . because the subject matter was superficially photojournalistic. . . . The dividing line is a . . . subtle one.'[49] Did he know that he was using the same word as Walker Evans who, when interviewed by Leslie Katz in 1971, warned: 'When you say "documentary" you have to have a sophisticated ear to receive that word. It should be documentary style, because documentary is police photography of a scene and a murder . . . That's a real document. You see, art is really useless and a document has use. And therefore art is never a document but it can adopt that style. I do it. I'm called a documentary photographer. But that presupposes a quite subtle knowlededte of that distinction.'

Basically, the new reporter could no longer deceive himself about the large measure of subjectivity inherent in his work,

and preferred to admit it frankly. In the future, such attitudes may produce the most authentic testimony on our times yet. The Frenchman Gilles Peress, a member of Magnum, has reached the conclusion that 'the closest thing to objectivity is to recognise subjectivity'. His book on the events of Iran (1984) conveys the gravity of the facts by means of a deliberately personal layout of the images. Raymond Depardon,[50] from Gamma, then Magnum, and François Hers, formerly of Viva, published in *Libération* photographs relating not to a particular news event but to their own memories or states of mind. Reportage seemed to be irresistibly turning into autobiography. In 1981, Hers published *Le Récit*, an account of his own life. In 1983, he became advisor for the photographic enquiries commissioned by L'Aménagement du Territoire (DATAR) and did his best to hire photographers capable of expressing themselves freely and with originality on subjects which seemed hitherto to have been reserved for a completely impersonal kind of recording.

It was a photographer quite above suspicion on the score of scientific objectivity, the Italian anthropologist Marialba Russo, a specialist in the rites and customs of the peasants of southern Italy, who said of her images: 'They would like to remain at the same level of liveliness, of ambiguity as the figures and events that provoked them.'[51]

The problem of commitment

While news reportage was in a state of crisis, a wave of confrontation caused many photographers to reassess their role in society and politics. In the United States, the Vietnam War and the struggle for black civil rights provoked unrest which Ben Fernandez recorded in his book *In Opposition* (1968). Charles Harbutt's *America in Crisis* (1969) was a bitter anti-war pamphlet. In 1970, Jill Freedman's *Old News Resurrection City* showed the struggle against racism led by Martin Luther King. Feminism inspired books such as Abigail Heyman's *Growing Up Female, a Personal Photo-Journal* (1974).

However, between the now unfashionable extrovert, lyrical style of Eugene Smith, on the one hand, and the introverted, ironical manner of Robert Frank, regarded as too subjective, on the other, the photographer wanting to fight for a cause found himself faced with difficult choices. In many cases, he opted for a pseudo-scientific impassivity, hoping that the images would speak for themselves. But could they do so? Views on the subject differed.

Some, Susan Sontag for instance, denied photography the ability to prove anything or to be militant. 'It is doubtful whether a photograph can help one to understand anything,' she remarked, for it submits things to a 'beauty treatment' which spikes the accusatory guns. It disconnects historical continuities. Already in 1964 Marshall McLuhan had written in his *Understanding Media*, 'Photography turns people into things and their image into a mass consumer product.'

Meanwhile, others were attempting to analyse the problem in more depth: John Collier in his *Visual Anthropology. Photography as a Research Method* (1967), Allan Sekula in the magazine *Art Forum* (1974) and Howard Becker in *Afterimage* (1975). It is true that aestheticism can abet oppression. But is documentary photography capable of elucidating social problems? For a sociologists's work to have scientific value, he must undertake patient enquiries, submitting a whole social group to a scientific questionnaire. The photographer still seems a long way from doing this. The seven months spent by Geoff Winningham among professional wrestlers, gathering material for his book *Friday Night in the Coliseum* (1977), does not seem very long even for a limited social group. Perhaps it is after all artistic photography that can tell us the most.

In the midst of these contradictions, photography was to split into three principal tendencies. The first was that of the avant-garde: the converging influences of semiology, conceptual art and the mixed media produced symbolic set-up scenes as those in *Michael Semak Monograph* (1974) or esoteric comparisons between various texts and images as in the work of the English Victor Burgin. But these exercises for the 'happy few' were not of a kind to satisfy the groups of young militants who were after results. In 1976, the Half Moon Photography Workshop, of Marxist orientation, was set up in London and began to publish *Camerawork*, a magazine entirely devoted to recording the social struggle in pictures. In Germany, the editorial committee of *Volksfoto* embraced confrontation in all forms, carrying this policy to its logical conclusion in their own case: autodestruction in its last issue, *Photo Kaputt* (1980). Faced with certain forms of nihilism, one may be forgiven for wondering whether the most effective social and political statements are not, after all, those that are the most purely artistic and attentive to the rigour of forms. Thus, Joel Deal and Chauncey Hare (*Interior America*, 1978) in the United States, and Wilhelm Schürmann, in Germany, show the sadness of modern urbanism; as Larry Clark (*Tulsa*, 1971) shows drug abuse and Bill Owens (*Suburbia*, 1973) the inanity of suburban life.

The scourge of pollution is also well suited to this kind of talented reportage, as can be seen from the great example of Eugene Smith's *Minamata* (1973). And in 1980 Smith wrote the preface to *River, Its Shadow of Shadows* by Jun Morinaga (Japan). Giorgio Lotti similarly denounces the pollution eating away the monuments of Venice and Milan. As for Roger Mertin's nudes wrapped in plastic (his *Plastic Love Dream* series, 1969–70), does not their beautiful surface appearance hold a warning about the disappearance of humanity in the artificial environment of the modern world?

It is admittedly rare to find photographic testimony produced from within the oppressed milieu that it reflects. But one fine exception is the work of Peter Magubane,[52] a black South African who forcefully proclaims the injustice done to his people.

On the threshold of the eighties: fertile contradictions

In the late 1960s and early 1970s, two diametrically opposite and equally flourishing attitudes existed side by side in artistic circles. The one favoured total political commitment, the other absorbed art into itself and art became self-sufficient to the point of losing all tangible existence.

Photography now found itself in an exceptional strategic position, for it seemed to be, as it were, the 'zero degree' of expression, a transparent medium. We should at this point distinguish between on the one hand those artists who used photography to pursue an enquiry into art in general and, on the other, those who concentrated their research upon the nature of photography in particular.

Photography as theory

Which of the first group should strictly be considered as photographers remains an open question. Already, in 1962, when the Californian Edward Ruscha presented his first brochure of photographs, entitled *Twenty-Six Gasoline Stations*, the monotonous shades of grey and the repetitive multiplication of the photographic document began to be seen as modes of expression. By 1972 Ruscha had published about fifteen of these booklets, under titles such as *Thirty-Three Parking Lots* or *Nine Swimming Pools*, all with equally unpromising subjects and produced in an equally unpretentious fashion. 'I wanted to create something akin to black humour', he confessed, going on to say, '. . . I like this simple, dry and somehow non-artistic side to photography', which was, of course, also a way of suggesting that, somehow, it *was* artistic. Ruscha also explained that he had started with the notion, dear to Marcel Duchamp, of the 'ready-made', 'but instead of calling a gas station art, I called it photo art.' But he added that it was the gas station that really interested him, not the photograph. (One wonders!) And that was just a beginning. In 1959, Bernd and Hilla Becher began putting together a collection of photographs intended to provide useful documentation on industrial architecture. They chose the most head-on and natural approach, avoiding artistic effects. Then they realised that the photograph is the only means of preserving the accidental beauty of constructions which are not made to last but which it is possible to arrange according to a typology at once monotonous yet varied (water towers, blast-furnaces, etc.) in the manner of a naturalist classifying his specimens. The images they arranged in series seemed less and less like architectural documentation and more and more like sculpture–photographs or photograph–sculptures (*Anonyme Skulpturen*, 1970).

The work thus, of its own accord, slipped out of its role of neutral and transparent intermediary and itself became the focus of interest. It was a fruitful shift, destined to be frequently repeated, in particular by the Englishman Hamish Fulton,[53] who hiked indefatigably across lands as yet unpolluted and whose work *was* this journey, recorded in the ephemeral sculptures constituted by the photographs he took as he passed.

Was this the latest form of lyricism? Frank Gohlke, who has produced pictures of the mechanised landscapes of the American plains, says: 'If I was forced to come up with one word to characterise my photography, it would be "lyrical" and yet my ideal style involves the disappearance of an obvious "style" altogether. Pure transparency is the goal, but of course it's unattainable. It is the effort toward that goal that feeds the imagination.'[54] This hitherto almost unimaginable disassociation between lyricism and style has now become a characteristic feature of much contemporary photography. Style has become an element of content, something to be altered at will; it is no longer a spontaneous adjunct to self-expression.

This is a tendency that stems not only from the strong influence of avant-garde artistic circles but also from the photographic tradition of the introspective works of Minor White. White's interest in Japanese philosophy was spreading in photographic circles in the early 1970s. In 1969 Robert Leverant published *Zen in the Art of Photography*. In Britain, John Hilliard began photographing his own sculptures in about 1967 but soon the means became an end and he then engaged upon a series of experiments concerning the visual paradoxes peculiar to photography: positive–negative, depth of focus, framing, etc. His compatriot Victor Burgin, a professor of semiology, simultaneously applied and tested out his ideas in images incorporating texts. Here the writing, which was not a legend to the pictures but a parallel meditation, constituted a recognition of the mismatch between ideas and reality and also of the equivocal roles that photography plays in the human problems of the modern world.

The series entitled *Verifiche* (1973) by the Italian Ugo Mulas,[55] who until then had specialised in portraits of contemporary artists (*New York, The Art Scene*, 1967) concentrated more and more upon the problems of photography itself. Mulas condensed the various aspects of photography into fourteen points: enlargement, display, the role of the legend, etc. It was a systematic assessment, the ultimate effect of which was to open up, rather than to limit, the possibilities of his art. Mulas attached a text to each image (in one case even replacing the image by a description of it). The American Ken Josephson[56] re-examined the concept of photography, using nothing but photography to do so. Adopting a very neutral manner, and avoiding preoccupations of an aesthetic nature, he demonstrated the relativity of any photographic testimony. Thus, in his wooded scene (p. 214), what we take to be dappled sunlight is in truth snow, so the picture reminds us that in photography reality is always a matter of more, or less, shadow or light. In Germany, Floris-Michael Neusüss devoted himself to studying the extreme possibilities of his art. For example, he made imprints of human bodies directly on sensitised paper in a manner reminiscent of Yves Klein. His teaching at the University of Kassel concerns the theory of photography and the major exhibition, 'Photography as Art – Art as Photography', which he mounted in 1975 and which they circulated widely, reflects many of the themes of these advanced researches. Also in 1975, George Eastman House was showing 'The Extended Document' and in the following year Van Deren Coke, at the

University of Albuquerque, put together 'Peculiar to Photography'. As so often happens in the history of the various arts, abstract reflection upon basic premises and ultimate aims is not just so much hot air but exalts the value of even the most material and specific qualities of the art in question.

From a conceptual point of view, the activity of the artist is what constitutes the work. In his *Cancellation* series, Tom Barrow scores his images with a couple of crossed strokes of the pen which, among other things, evoke the fragility of the notion of a work of art and once more bring into question the nature of space within a photograph. Paul Berger reverses yet confirms the conceptual attitude, turning the sums written in chalk on a blackboard into an overlapping assemblage of photographic images (*Mathematics*, 1976). Eve Sonneman juxtaposes two colour images taken of the same place in the same circumstances, but with a few subtle differences (*Real Time*, 1976). Since 1978, the Spaniard Rafael Navarro has been producing his *Dipticos*, pairs of images between which there is both a tension and a harmony. In 1977 the young

Englishmen Chris Steele Perkins and Mark Edwards mounted an exhibition from forty rejected snippets of film picked out of a total of five thousand similar fragments, applying to photography the principles of the 'ready-made' and objective chance. But such principles may also be integrated into the work of a single photographer, as in the case of Andreas Müller-Pohle, whose book *Transformance* (1984) is composed of photographs picked at random from thousands of his own views taken in a quite haphazard fashion.

The appeal to chance is, in truth, highly systematic, constituting an apologia for methodical choice. The critic Jonathan Green[57] has rightly noted that conceptual photography ought really to be called 'scientific realism' since it is concerned not so much with subjective ideas but rather with the objective procedures of counting, measurement and analytical observation as practised by scientists. The almost repetitive series, which fascinate by reason of the very slight variations from one image to the next, are a common feature of contemporary photography. In 1970 the Japanese Ken

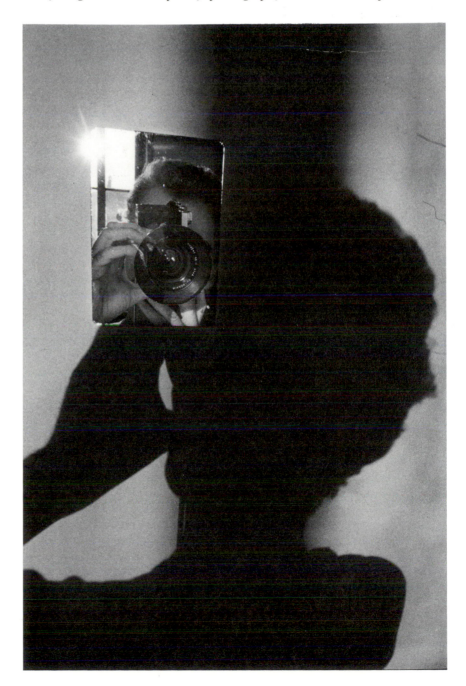

UGO MULAS
SELF-PORTRAIT, 1970.
From the series VERIFICHE.

Collection of Signora A. Mulas, Milan.

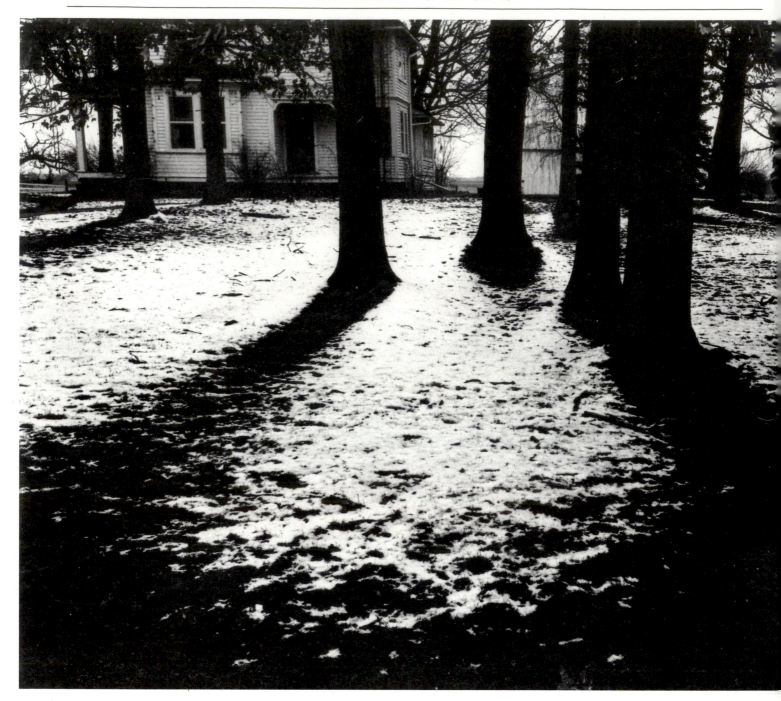

Ohara published *One*, an impassive sequence of faces taken in close-up, all similar yet all different. In 1975, the Italian Mario Cresci portrayed a single town, Matera, from virtually every possible aspect. As Denis Roche has observed in *La Disparition des lucioles* ('The vanishing fire-flies'), if one takes photographs at all one should take them of everything. In 1978, the American Reed Eastabrook produced a photograph 3 miles and 3 yards long, by joining up twenty-one thousand continuous views taken on a journey from San Francisco to New York. James Friedman's *History of the World* (1981) is made up of reproductions of all kinds of transparencies of various origins, scattered on a luminous table.

These cerebral aspects of photography, which are connected with conceptual art, stand in contrast to others more involved with the confused but moving flow of life as it is lived. During the 1960s, artists began to think of art as an affirmation of life rather than as a means of setting chaos in order. 'A painting is always more powerful when it appears as something inevitable . . . not as a memory or an arrangement.' (Robert Rauschenberg.) Of course that too is a theoretical statement, but it can be supported by the ambivalence that is a quality of all photographs, opening both outwards and inwards as they do. Thus, Ikko Narahara declares, 'Photography is a window with my mind within, the world without.' Thus, for many contemporary photographers there is no separation between their work and their life and Harold Jones can declare, 'My work is an unfolding biography.'[58] Now, however, it is a matter not of romantic or sentimental confessions but of a reassessment of the paths that art is taking and its traditional limits. As early as the 1950s, Ruth Orkin was photographing all that she could see from her window (*A World through my Window*, 1978). Towards the end of the 1960s, photography discarded a measure of the rigour it had inherited from the abstract avant-garde and began to acknowledge nudity and sexual fantasies more openly (Diane Arbus, Leslie Krims).

FLORIS MICHAEL NEUSÜSS
'TRAUMGESICHT, MUNCHEN' (Dream face, Munich), 1964.

Collection of the Bibliothèque Nationale, Paris.

KENNETH JOSEPHSON
INDIANA, 1972.

Collection of the Bibliothèque Nationale, Paris.

In 1971 one isolated book administered a shock: *Tulsa* (Lustrum Press), by Larry Clark, showing the world of young drug-addicts. Free from moralising attitudes, pathos and cynicism, it shows things as seen from inside by someone who has lived them. His next book, *Teen Lust* (1981), was devoted to the child prostitutes of New York. Robert Frank's *The Lines of my Hand* (1972) brought his own personal photographic adventure to a close with a retrospective view of his life expressed through his photographs. The mystery that each person is to himself constituted the work of art. Charles Gatewood's *Sidestripping* (1975) and *Forbidden Photographs* (1981) were more provocative, with an element of crudity that effaced the habitual boundary lines between the normal and the abnormal.

Charles Gatewood's work is reminiscent of expressionism, Emmet Gowin's[59] of surrealism. But their work also betrays a cold deliberation which links them with the theoretical aspect of modern art. Emmet Gowin, a disciple of Frederick Sommer

and Ralph Meatyard, also photographed his family in the most banal circumstances of everyday life. But his images are pervaded by a kind of magic, almost a mystique, that emanates from the figures and places that they show (*Emmet Gowin Photographs*, 1976).

In this deliberate confusion of art and life, Bill Dane sends his works, in the form of postcards, to correspondents of his choice, as he produces them. Dismayed by the massacre of wildlife, Peter Beard photographed the animals of Africa (*The End of the Game*, 1965). When he returned to the United States, he included in the thick albums of his *African Diaries* all kinds of images he had come across, cut-outs, drawings, retouched and shaded photographs, so that these books resemble microcosms of other possible worlds, to take the place of the one that had disappointed him.

It mattered little whether Peter Beard had himself taken the photographs that he stuck in his albums, for he made them his own. And now, as photography concentrated upon itself, it

discovered as yet unexplored zones within itself. Seeing itself as art, it now tended to see itself as nothing but art. Yet in some of its forms, in fact often in those most commonly and widely practised, it continued to elude art — spontaneous, naïve, tourist photography, for instance, or family snaps or even photography destined for scientific, technical or industrial ends. And these areas provided a fine chance for artistic exploration and experimentation!

1973 saw the publication of Michael Lesy's *Wisconsin Death Trip*. Lesy had selected images and texts from the local archives, then manipulated and reshaped them, overlapping one with another in his own way so as to turn them into some kind of dark, mysterious tale, something like a myth, which somehow revealed all the anguish hidden behind the respectable facade of this provincial society: fire, blood, sex and death.

Also in 1973, the Canadian Dave Heath invented his *Grand Album ordinaire*, a huge collection of transparencies like those accumulated by amateur photographers. It was similarly by slipping inside the skin of an ordinary amateur that William

LARRY CLARK
From the series, *TULSA*, 1971.

Collection of the Bibliothèque Nationale, Paris.

De Lappa put together his *Portraits of Violet and Al*, which appeared in *Creative Camera* in 1977: family photographs like those to be found in any ordinary American woman's handbag or dressing-table drawers: unpretentious, clumsy, enigmatic and, in the last analysis, deeply moving images by reason of all the unfathomable secrets that they suggest about the lives of even the most ordinary people.

Anonymous photography, perhaps better than anything, stimulates thought on the problem of the photographic author. Ken Graves and Mitchell Payne, both pupils of Minor White, went from door to door requesting to be allowed to look at family albums. In their *American Snapshots* (1977) they published an amazing selection of these images. As you turn the pages, you come upon Arbuses, Meatyards, August Sanders. And you feel you have discovered unrecognised, solitary geniuses, never to be known except through a single image. Photographic culture has turned in on itself, proclaiming its own relativity. Also in 1977, two other American photographers, Larry Sultan and Mike Mandel, published *Evidence*, a collection of photographs selected from thousands scrutinised in scientific and technical archives. As presented there, devoid of explanation or context, reduced to images pure and simple, they emit a remarkable plastic energy. Barbara Norfleet plays a similar if even more perverse game of substitution, with a collection of pictures taken by commercial photographers. Naïvely skilful, 'well composed', and openly proclaiming their artifice, their equivocacy is doubly striking (*Champion Pig*, 1979). In France, in 1982, Pierre de Fenoys selected the material for his *Chefs-d'oeuvre des photographes anonymes du XIX^e siècle* from the photographs collected by Jean Henry: they reopen the question of what a masterpiece really is rather than provide a reassuring answer.

Amid all the current efforts to expand the notion of a work of art, perhaps photography goes the furthest, since it already possesses so many ambiguities of its own, all of them ready to blossom into creative uncertainties.

Crossing boundaries

One trend in contemporary photography inclines towards austerity, a taste for spareness, theoretical rigour and even a return to the poverty of the earliest days. But this is balanced by an opposite tendency: a taste for baroque effusion and a longing to break down the barriers between the different genres. Traditional American photography did not tread that second path: its inclination was to turn its back upon anything other than pure silver salts and gelatine, or even contact printing.

The spirit of a liberty which recognised no bounds sprang from a European graft, to wit, the implantation of the Bauhaus in Chicago. But its success was by no means immediate. The surrealist manipulations of a photographer such as Edmund Teske found scant acceptance; the experiments of one such as Gyorgy Kepes were dismissed as a Central European importation. Superpositions such as those produced by Harry Callahan and Jerry Uelsmann were for a long time the exception rather than the rule. But around the mid-1960s, at a time when Europe remained relatively unadventurous, an explosion of experimentation took place in the United States, and it was accompanied by a rejection of the traditional frontiers between the arts. Many of the artists involved worked in the Rochester area:[59] Betty Hahn, Syl Labrot, Joan

EMMET GOWIN
NANCY, Danville, Virginia, 1969.

Collection of the Bibliothèque Nationale, Paris.
By kind permission of Emmet Gowin.

Lyons, Bea Nettles, Keith Smith; but it was in California that an increasing number, among them Robert Heinecken, were developing the libertarian spirit.[60]

In 1967, it was once again an exhibition organised by Nathan Lyons in Rochester, 'The Persistence of Vision', that revealed the richness of the new current of photography. It also found expression in 'Photo Media' in New York in 1971, 'Photography into Art' in London in 1972, and 'Une autre Photographie', organised by Christian Gattinoni in Paris, in 1982.

Bea Nettles, who in 1977 published *Breaking the Rules, a Photomedia Cookbook*, did not actually take photographs but built up her images using 'thread, fabrics, plastic, pencils and painting, on an equal footing with photographic paper and film'. Betty Hahn also worked on delicate photo-embroideries, betraying a nostalgia both for the naïve needlework of our grandmothers and for the warm, rich tones of the photographic materials of the nineteenth century. Susan Jahoda weaves trailing threads into her sumptuous coloured images

of mysterious tracts of space.

But the technique most commonly employed is painting on photographs. One can even buy special types of paint for the purpose. Donald Blumberg and Charles Gill openly divided the work between them, Gill painting on photographs taken by Blumberg. (Their work was shown in 1966 at George Eastman House.) Gail Skoff's prints, for the most part retouched with acid or pastel shades, attracted many emulators. Elisabeth Lennard, working in Paris, preferred to illuminate massive, architectural prints. David MacLay uses a few carefully disposed touches of paint to express the monumentality of space. In France, Marc Le Mené has, since the early 1980s, been making a name for himself with his intimately appealing and luminous still lifes.

This mingling of genres does not necessarily lead solely to preciosity, as Robert Heinecken's robust work has been demonstrating ever since 1961 (*Are You Rea*, 1968). Trained as a plastic artist, he freely assembles magazine cuttings to form the boldest of montages, evoking violence and sexuality. The Englishman Nigel Henderson, who started as a painter, sticks together, superposes and manipulates images conveying the filth and chaos of modern landscapes.

The problem is how to work in harmony with plastic

LUIGI GHIRRI
DANGER, CHILDREN, 1973.

Collection of the Bibliothèque Nationale, Paris.

qualities which stem from very different traditions: the drawn line, the dab of paint, the sensitive photographic surface, and so on. When in 1969 Jim Dine and Lee Friedlander published their *Work from the Same House*, with Dine's drawings arranged facing Friedlander's photographs, they were already posing this question. Benno Friedman combines photographs with drawings on the same paper. Rick Dingus scores heavily across his photographs of rocks, using black lead which sets off the silvery shades and lends a dramatic emphasis to the space encompassed by the picture. Meanwhile, Doug Prince, drawing his inspiration from the optical experiments of the nineteenth century and the work of Jerry Uelsmann, and having worked on combining different transparencies, has produced three-dimensional montages, superposed images enclosed in boxes: they were much admired at the 'Photography into Sculpture' exhibition which Peter Bunnell organised in 1970. Robert Heinecken has also worked extensively on creating pictures in relief, rearranging different planes in a manner freely inspired by cubism.

Such experiments have led to a resurrection of processes used in the early days of photography, such as platinum printing, not seen since World War I but which George Tice has been teaching since 1971. Many photographers, Mark Power among them, aim to recapture its gentle yet solid effects. In France, Gilles Rochon, a pupil of Jean-Pierre Sudre, has been experimenting with emulsions and base surfaces. In

Spain, Toni Catany has been producing calotypes reflecting the poetic moods of our own times. Two American women working in Paris, Elisabeth Sunday and Nancy Wilson-Pajic, have rediscovered gum bichromate. The former produces large, impressive images showing forms distorted by mirrors; the latter, delicate miniatures which capture the interplay of light and shadows in compositions bordering on abstraction. The last few years have revealed the rich work of Paolo Gioli, an Italian who uses a combination of techniques in images saturated with shapes and colours which constantly refer back to the old masters of photography: Niépce, Bayard and Poitevin.

The study of printing processes may lead to profound revolutions, once their relationship to photographic printing has been recognised. One early experimenter in this field was Scott Hyde (*S. Hyde Photo-Offset*, 1960), who resorted to the intermediary technique of cheap flat printing which made it easier for him to study the effects of his superpositions and transparencies in a freely chosen range of colours. His ultimate intentions were subversive: 'What value can an image have as art if there are thousands of copies of it, unsigned but not reproductions? That is the question that interests me.' He would sometimes print as many as five thousand copies, so that the cost of each became quite derisory. Syl Labrot has also worked with offset and serigraphy, with a liking for the matt surface and flattened texture, where space is conveyed by colour alone (*Pleasure Beach*, 1976). Joan Lyons (married to Nathan Lyons) has also used, among other processes, photocopying, lithography and offset, calling her first book *Self-Impressions* (1972). She refuses to separate the idea of

FRANCO FONTANA
LOCARNO, 1981.

Collection of the Bibliothèque Nationale, Paris.

photography from that of engraving. Keith Smith is a professor of engraving at the Visual Studies Workshop: his photographs undergo a metamorphosis as he endows them with all the rhythms and emphases that stem from the processes of engraving and dry-point etching. John Wood also resorts to many different processes, completely transforming the images or fragments of images with which he starts out.

A fascinating tension has been set up between the single and the multiple image. In 1960 for instance, the 'Photo as Printmaking' exhibition stressed the irreplaceable beauty of an example of fine printing. But that desire to exalt the beauty of the photograph's surface leads photographers to enrich it by means of processes borrowed from engraving or lithography. As a result, one may obtain either an image that is truly unique (as in the 'One of a Kind' exhibition in Boston in 1979) or else one that is even more easily multiplied than by the classic photographic processes: in this case a situation in line with that of book printing.

At this point, a familiar question resurfaces: perhaps photography should, after all, be printed in books rather than displayed on gallery walls. But in that case, processes must be found which do not simply imitate (for an imitation is never any more than an approximation), but can transpose the qualities of the fine silver-salts print into another register with whatever effects of grain, or even of half-tone screening, the artist desires. Jon Goodman, a friend of the outstanding printer Richard Benson, went to Switzerland to study the secrets of helio-engraving by hand. Pierre Brochet resuscitated that same fine technique in France. Irwin Dermer,

an American working in Europe, decided, after much research, that he preferred offset to convey the luminosity of his transparencies (in his portfolio, *A Time to Play*, 1976). The Visual Studies Workshop has become a centre for the production of such images.

The explosion of colour

The amazing explosion of colour photography during the 1970s has completely transformed the traditional scene, in the domain of creative photography.[61]

After the Second World War, colour photography became widespread among the public with the use, in particular, of reversible Kodachrome film for transparencies. This became the film normally used for family and tourist photography. Fashion (Cecil Beaton before the war, Irving Penn by 1943) and publicity had made use of it as soon as it became available. Even reportage adopted it (Alfred Eisenstaedt was using it by 1945, Felix H. Man by 1948.)

During the 1970s there was a second leap forward, thanks to a concentration of the major photographic firms. Ferrania was taken over by 3M; Agfa and Gevaert merged. Ciba took over Lumière in 1963 and Ilford in 1969. Developing processes became standardised, falling into line with the Kodak process. It became possible to take photographs even

in poor light. Following the pooling of the research under-taken by Ilford and Ciba, in 1969, Cibachrome paper came on to the market in 1975. Colours could now be better preserved. The sale of black-and-white films dropped from 80 million in 1970 to less than 30 million by 1980. However, predictions that black-and-white film would soon disappear altogether turned out to be ill founded. The fact is that the authors of images of quality are faced with a choice not between two unevenly matched processes but between two means of expression that are potentially equally satisfying.

In 1953, Edward Weston, in an introduction to some of his colour photographs taken in 1947 and reproduced in his *Modern Photography*, wrote that it was foolish to imagine that colour would kill black and white. The two were different means to different ends. They had nothing in common. He was right. Colour photography presents the creative photo-grapher with challenges that can be solved only by means that are peculiar to colour.

Hence the tendency for all colour photography to incline either towards a refined aestheticism, or, alternatively, towards a kind of second-degree populism inspired by the naïve spontaneity or even the unconscious bad taste of ordinary amateur photography. Let us take two opposite and revealing examples: Franco Fontana and Luigi Ghirri.[62] Both are Italian, both from the town of Modena and both won international fame during the 1970s. Fontana, who is self-taught, embarked upon his work of simplifying reality and setting it in order in 1961. From a welter of useless accidents, he lifts out the simplest of forms, the most uniform swathes of colour, to compose an image in which a balanced harmony is achieved between the few lines and the few tones retained, the result being a triumph for formality working on form. Luigi Ghirri operates in a world of ironic coincidences. And since the modern world is full of misleading appearances, in plastic forms, in tourist advertisements, on the cinema and television screens, he uses colour photography, which can be so strident and so artificial, to acknowledge — somewhat wryly — how impossible it has become for us to get at the truth of things (*Paesaggi di Cartone*, 1974; *Kodachrome*, 1978). Colour can thus be used with effect to pursue two diametri-cally opposed paths, so long as they are followed right through in an intelligent manner.

Between these two extremes may be situated a host of brilliant works, many of them produced by talented amateurs; but perhaps the peak of excellence is reached by that great professional Ernst Haas in *The Creation* (1971). This frequently reprinted book is the best example of the 'beauty treatment' (Susan Sontag) that photography, and in particular colour photography, is capable of administering to reality.

The public's overwhelming preference for colour in maga-zines and other publications often raises problems. Many reporters prefer black and white but are obliged to work in colour to keep their audience. Nevertheless, photographers such as Bruno Barbey, Hervé Gloagnen, Marc Garanger and Hans Silvester are skilful enough to keep the risks under control and turn them into visual advantages. Mary Ellen Mark did so in her poignant inquiry into the prostitutes of Bombay (*Falkland Road*, 1981); and the Belgian Harry Gruvaert, less concerned by human problems, transformed Morocco into a sumptuous arrangement of coloured tones.

But is colour photography of high quality really con-demned to manifest itself only in the opposite fields of extreme stylisation on the one hand or extreme cerebral irony on the other? Some photographers have certainly taken up the challenge. Colour is an element in reality, so why should photography not be able to cope with it in a direct manner? Already by 1959, Helen Levitt was photographing street life and children's games in New York with a spontaneity and poetic feeling which were enhanced rather than obscured by the peculiar qualities of colour. In 1976, John Szarkowski for the first time devoted an exhibition in the New York Museum of Modern Art to a colour photographer (William Eggleston). Szarkowski believed he had at last found the photographer capable of moving beyond the need to choose between colour that was unnecessary, on the one hand, and subject matter that was empty, on the other (*William Eggleston's Guide*, 1976). There was much disagreement as to whether or not his hope had been ill-founded, and whether Eggleston's dye-transfers did not, once again, lead back to the aestheti-cism of pretty colours and insignificant subject matter selected to display them. At all events, many young photographers were now loath to use colour to treat classic subjects, in particular landscapes. Among them were Joel Sternfield, Mitch Epstein and Len Jenshel: the appeal of their spacious images was to dreams; it was a modern return to romanticism.

In Europe, the French John Batho[63] and the Belgian Mark De Fraeye, in particular, strove to keep in contact with reality without forgoing the assets of colour. Their efforts took very different forms.

Batho has been above all concerned with the solidity of things. A correct level of colour saturation builds up planes and volumes. De Fraeye renders the colouring of the spaces between things, the lightness of air. Recently, however, he has moved towards more structured images while Batho, in his series of merry-go-rounds (1980), has shattered forms into a joyous explosion of fireworks. Perhaps the work of the veteran photographer Harry Callahan demonstrates the finest balance between the various constraints of colour, using it with great force yet at the same time very naturally. He started to work with colour as early as 1942; since 1977 it has been his main concern. His book, *Harry Callahan: Photographs in Color* (1980), demonstrates the depth of his art, which passes far beyond all deliberately assumed aesthetic positions.

Theory, often merely hinted at, is more to the fore in the work of the Canadian Gabor Szilasi in Quebec, who since 1977 has been recording house interiors in colour but people in black and white. A similar approach was adopted in the exhibition mounted by François Hers and Sophie Ristelhueber in 1981, at the Georges Pompidou Centre. Hers's colour photographs convey the discreet and naïve charm of the homes of the lower middle class, while Ristelhueber's black-and-white images convey the massive presence of individuals. Similarly, André Dimanche, a friend of many poets, likes to set a colour version alongside a black-and-white one of a single view, to get us to reflect upon the subtle but essential differences between them. Joachim Bonnemaison uses skil-fully arranged devices to explore the paradoxes of a space which closes in upon itself.

By dint of rehearsing its fundamental problems, colour photography has come a long way in the last twenty or thirty years. In 1949, the Dane Keld Helmer-Petersen, a student of Harry Callahan's, published *122 Colour Photographs*. In this work he sets out images of objects or details of objects of the humblest kind, raising them to the level of works of art, in particular abstract art, thanks to the artist's calculated choice of angling and framing. In 1977, the painter Sol Le Witt

published *Photogrids*, an impassive series of 414 documentary colour photographs of the transport networks and mass-produced objects that pervade our daily lives. Here a serial artist provided information, leaving his own subjectivity or personal taste out of account. He carefully deconstructed exactly what Helmer-Petersen had constructed. What Helmer-Petersen had turned into art, Le Witt removed from that sphere. But he did not do without art altogether. For now it was the artist's very attitude that became art. In both cases, colour played an essential if opposite role. In the first it exalted the artist's plastic deliberations; in the second it confirmed the neutrality of his statement. In neither could it be called innocent.

The fabricated image

For a long time photography was considered as something that it was impossible to detach from reality as given, something in which it was impossible to give free rein to the imagination. But now much of contemporary photography is devoted to reversing that old belief and to turning the situation completely upside-down. Meticulously stage-managing whatever he imagines and wishes to communicate, the photographer now appears to be the only artist capable of conveying even the most improbable of his fantasies; and his control is such that there will be no distortion due to an unsteady hand or the use of unsuitable materials. 'Fabricated photography' or 'staged photography' is directly descended from the conceptual movement and from surrealist inspiration. Leslie Krims and Duane Michals, sometimes misunderstood during the sixties, especially in their own country, suddenly look like great precursors. It was they who showed that photography is an even better means for pinning down our dreams than for describing our environment.

Fabricated photography of this kind becomes possible when the most important thing for the author is no longer to invent beautiful objects but to demonstrate his own concept of art. Given that it is now his own practice that is the object of his research, he deliberately chooses the method that will enable it to be recognised most clearly: his purpose is to construct something completely artificial. Doubt is thus cast upon the objectivity of all photography. However, it is no more than a doubt, since, after all, it is the very realism of photography that makes it possible for the author of the image to give concrete form to his endeavour.

Ralph Meatyard's series, *The Family Album of Lucybelle Crater* (1970–2, published in 1974), illustrates the life of an imaginary woman embodied, like those who surround her, by Meatyard's own family and friends dressed up in carnival masks. Meatyard describes how he had to 'set up a stage-set, as for a little play', before arranging his stationary actors upon it.

The conceptual attitude lived on in arranged shots of this kind. We have seen how, in the early 1960s, Max Mathys was systematically recording every variation in one particular landscape. Since 1969, the Dutchman Ger Dekkers has been setting out *polders*, totally man-made landscapes, in quasi-repetitive and deliberately monotonous sequences, moving perfectly naturally from *Landscape Perceptions* (1972) to *Planned Landscapes* (1977). It would be wrong to confuse his work with that of his compatriot Jan Dibbets, despite the fact that they both play with horizons, perspective and progress-

ive displacements. The fact is that in Dibbets's work the photographs that provide his starting-point become the base material upon which he then inscribes his own elegant and formal designs. His art may be situated on the borders of the conceptual and the abstract, that of Dekkers on the borders of the conceptual and the fabricated image.

Also from Holland, Michel Szulc Krzyzanowski[64] proceeds by creating sequences in which he evokes or reveals space through the movements of his own body, as he paces out and measures it, forcing the expanse involved to reveal both its paradoxes and its fascinating correspondences.

But the still life is even better suited to the fabricated image than is the landscape. For centuries the still life has hovered between objectivity and artifice. Already, by the 1950s, the Czech Vilem Kriz[65] had introduced America to the rich tradition of Central Europe. His images, crammed with a variety of objects and textures, are illuminated by a magical aura. Jan Groover,[66] based in New York, trained as a painter, then in 1971 turned to photography. She became increasingly interested in spaces that were crammed, saturated with volumes and reflections, and seems to have managed to accommodate richness of colour together with massive bulk. Allan Chasnoff's colour still lifes tackle the problem of photography's relationship to the thick surface of the still lifes produced by painters. He attempts to resolve the problem by painting the surface of the actual objects that he photographs. The same concern with richness of texture is evident in Stanley Bowman's objects laid flat against each other and in the skillful heteroclite arrangements shown in Robert Fichter's large-format Polaroids. The Spanish Toni Catany surrounds his flower vases and bouquets with a gently poetic atmosphere. In contrast, Robert Cumming (*Studio Still Lives*, 1978) creates an experimental atmosphere, making no attempt to disguise his photographic equipment and the scaffolding he has used.[67] In similar fashion, the film-maker David Haxton finds inspiration for his colour and transparency studies in the paraphernalia left behind in the film studio. In the work of all these artists one detects a continuity between the still life set on a table, the arranged interior scene and the landscape. In California, Leland Rice makes increasing use of the empty gaps between the objects that he arranges here and there to haunt the space of his images. In Paris, Georges Rousse, another painter, photographs walls on demolition sites, manipulating colour and optics to turn these ephemeral places into imaginary ones. Michael Bishop[68] constructs his images from all the hard, rigid objects which increasingly come to litter our urban and even our rural landscapes.

Since 1974 John Pfahl[69] has been deeply interested in the relativity peculiar to human vision. Introducing extra streaks or a few carefully positioned objects into his landscapes (without tampering with the photographic equipment in any way), he disrupts our habitual way of seeing things and shows how little is needed to turn a real landscape into an impossible, imaginary one (*Altered Landscapes*, 1981). *Zuma Beach* (1977) is the title of John Divola's variations of coloured images of a burnt-out house on the sea shore. Like Georges Rousse, he adds his own touches of paint to the real scene, evoking new relationships between the indoors and the outdoors through his gaping windows giving onto the sky. Gregory Mac-Gregor is inspired by his scientific training to invent crazy, pointless or disturbing experiments which alter the surrounding countryside (*Deus ex Machina*, 1975; *Explosions*, 1980).

MARK DE FRAEYE
STUDY ON YELLOW, 1980.

The monumental simplicity of this composition in no way
excludes depth. It remains a photograph. It is not so much
through the colour that saturates the surfaces that it evokes
the third dimension, rather through the space vibrating with
coloured light that separates one shape from another.

Collection of the Bibliothèque Nationale, Paris.

JOHN BATHO
MERRY-GO-ROUND, 1980.

Central panel of a triptych.
For a long time Batho devoted himself to expressing the
substantial union of matter and colour in calm, structured
compositions. Here, he moves to the very heart of
movement, where colour becomes as dynamic for him as it
used to be static.

Collection of the Bibliothèque Nationale, Paris.

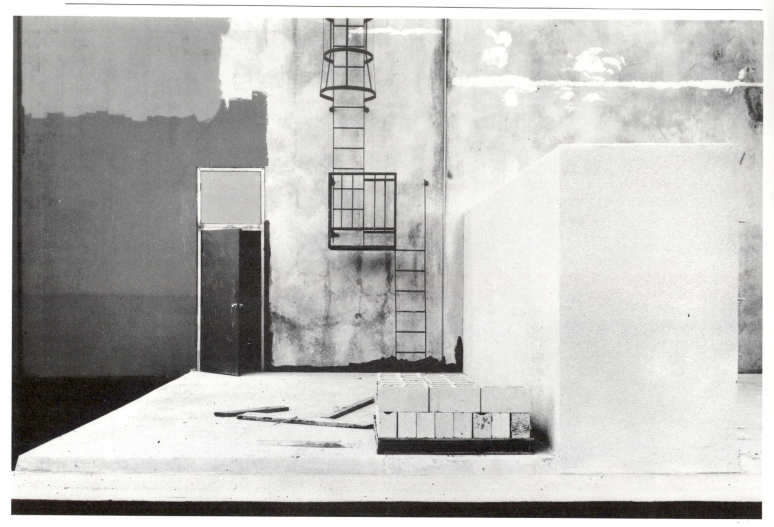

LEWIS BALTZ
'Construction, detail, wall East Xerox, 1821 Dyer Road, Santa Ana, no. 27'
From the series THE NEW INDUSTRIAL PARKS NEAR IRVINE, CALIFORNIA, 1975.

Collection Bibliothèque Nationale, Paris.

Graham Howe, an Australian who emigrated to California in 1972, has moved on from his geometric still lifes which deliberately defy visual common sense to produce *Manipulated Landscapes* (1978). Like Arthur Ollman, Michael Mitchell started with colour photography by night without illumination. Through his photographic intervention he thereby summoned up, if not actually created, landscapes otherwise invisible. Then he took to introducing into the natural scene a black cube which, since it constituted an absence of light, created a gap in the fabric of the real scene photographed. In what could be seen as an opposite yet parallel fashion, the Belgian Raoul Jacobs deploys a large mirror. And over the past twenty years countless other photographers have also introduced mirrors into their images, for the most part simply holding them out at arm's length. Even more frequently, they incorporate their own hands pointing towards the horizon, measuring the illusion that we call reality. They include Ken Josephson, Michel Szulc Krzyanowski and Gary Beydler, to name but three.

Even subjects the artist does not tamper with may, at the limit, be included in this movement towards the fabricated image. For, in the first place, in conceptual art the very naming of a picture amounts to intervention. In the second place, the modern world is such an inextricable mixture of the natural and the artificial that everything seems fabricated anyway. In 1975, this problem was demonstrated by the 'New Topographics' exhibition mounted at George Eastman House. It showed the series produced by Becher but also the – at first sight – classic landscapes of Robert Adams, who, despite his pleas for a return to the simple beauty of things (*Beauty in Photography: Essays in Defence of Traditional Values*, 1981), admits to recognising the inevitable presence of human industry in his views of the vast expanses of the American West. Lewis Batz, in his three series (*New Industrial Parks*, 1975; *Park City*, 1980; *San Quentin Point*, 1983) shows nature industrialised, parcelled out and eventually turned into a rubbish tip, an inextricable jumble of natural matter and fabricated objects. These are images of pollution, but the artist's controlled eye rules out any hint of melodramatic commitment.

The arranged portrait, like the still life, is an extremely ancient genre to which the vogue for fabricated photography has now imparted a remarkable new lease of life. Eikoh Hosoe was already a trend-setter when he produced his *Kamaitachi* series and he made a similar impact with the baroque richness of his arranged portraits of the writer Mishima, completed in 1963 but not widely known until 1971, when *Ordeal by Roses* was published. In 1978 the German Holger Trülzsch published *Oxydationen*, in collaboration with Vera Lehndoftt who painted her body so as to have it merge with the colours of the peeling walls. The Belgian Ben Hansen also submits the

human body to the demands of his photographic projects: he turns his models into statues of mud; meanwhile the French Pierre Mercier has been transforming them into statues in the conventional style of the nineteenth century. Hansen aims for, and achieves, profound human emotion; Mercier, in contrast, conveys an abrasively ironic view of the relativity of the fine arts. Tom Drahos openly fabricates his models with modelling clay, then sets them on stage in a little theatre put together with photographs from furniture catalogues (*Metamorphoses*, 1980). It is impossible to tell where the truth of fabricated space begins and where the illusion of reproduced space ends. Although these works might be classed as still lifes, they really belong to the portrait category. Once again the various genres have been shuffled up by the perverse strategies of fabricated photography. Meanwhile, Nicholas Nixon's magnificent groups, produced in room-size format but in the spirit of 24 × 36 mm images, transcend all those old distinctions, combining the vivacity of the snapshot with the organised dignity of the posed portrait.

When the portrait becomes a self-portrait the modernity of the enterprise becomes even more apparent. In the 1980s Cindy Sherman has rapidly become known through a series of utterly dissimilar pictures of herself, the earliest taken in black and white, the later ones produced as colour enlargements. Not only do they pose the question of what the truth really is, but they do so by bringing into play a number of photographic conventions: 'star' photography, family photography, reportage photography, etc. In contrast, the Italian photographer Rosella Bellisci, working in Paris, undertakes a frank, even pathetic confrontation with her own body. The 'long-line' Finno-American photographer Arno-Rafael Minkkinen exploits all the resources of his own body to produce images of which he is, in a sense, the author twice over. Lucas Samaras has also frequently used himself as model for his Polaroids upon which he works manually to give them the look of antique enamels.

Until recently, contemporary photography manifested scant interest in the narrative, for it was considered contrary to the neutrality of the photographic process and to encourage anedotal approach. But in an astonishing reversal, fabricated photography brought it back into fashion. Following the path blazed by Duane Michals, narratives became deeply internalised. The purpose of the arrangement was to emphasise their enigmatic quality. The Dutch Paul De Nooijer[70] resorts to every conceivable means, first and foremost tampering with reality, in his patient construction of a dream world full of his recurrent obsessions. In France, Bernard Faucon uses shop-window dummies to compose his dreamy, arrested, adolescent world of pastel colours.[71] Eileen Courin, on the other hand, floods her reconstructed scenes with harsh electric and neon light, showing the tense relations that exist between ordinary people in the privacy of an apartment or the promiscuity of a living room: her images are like memories which linger in the mind in all their detail, giving one the feeling that 'something must have happened', although we don't know what.

In all these complicated compositions, form is becoming increasingly important, making a comeback on every side.

Sandy Skoglund has worked with conceptual art, minimal art and the experimental cinema, only to reach the conclusion that they all led too directly back to herself. Her new technique, as she herself admits, wavers between sculpture and photography. Using dummies and other salvaged or fabricated articles, she sets up scenes which might be described as immobile happenings. Sometimes she shows them the way they are arranged in space; sometimes she photographs them, then blows them up into colour enlargements. A desire to recapture the dense substance of things is also manifested — almost to the point of exaggeration — by the Belgian Ludo Geysels. His orgies of dappled bodies combine the animated force of the old masters of the Flemish school with the savage mysticism of the masked dancers of Oceania. The American Joel Peter Witkin — another who has made a name for himself during the 1980s — similarly employs all kinds of techniques and fantasies, building up his nude figures in layers of deep, viscous greys. In Paris, Pascal Kern paints assorted objects, then photographs them in colour to convey their material presence with the maximum force.

The return of matter

Conceptual art and arrangement are not the only motivating drives in contemporary creative photography. More important still, perhaps, is the desire to produce photographic images with increasingly deep textures of every kind, ranging from the smoothest to the roughest or the most indefinite, exploiting the image's malleability to the full. It is no longer a matter of adding on a misty atmosphere. The very 'grain' of the picture can be clear and neat; even a 'blurred' image can be precise in its texture. Emotion may be conveyed by the weight of masses, the outlines and confused composition of which may be indistinct but which nevertheless make their

TOM DRAHOS
From the series TROGLODYTES, 1981.

Collection of the Bibliothèque Nationale, Paris.

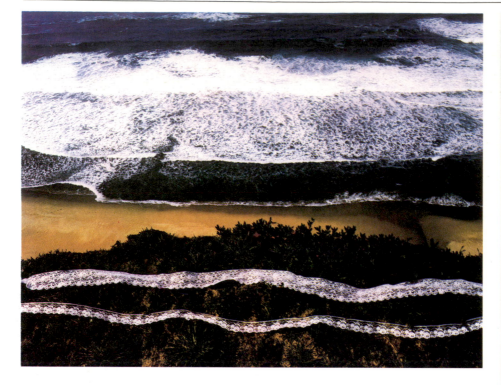

JOHN PFAHL
'WAVE, LAVE, LACE', PESCADORO BEACH, CALIFORNIA, 1978.

Working patiently and meticulously, Pfahl intervenes in a landscape, adding a few accessories which, given the angle chosen for the shot, make the spectator become aware of the relativity of photographic realism. A delicate poetic feeling may also be conveyed.

Collection of the Bibliothèque Nationale, Paris.

ALLAN CHASANOFF
UNTITLED, 1983.

Rendering the depth of matter has always been a problem for photography, given that it has very little depth in itself. Chasanoff paints directly, with thick strokes of paint, onto the objects which he then photographs, or onto transparent sheets slipped between the objects and the camera. In this way he restores to photography one of the essential richnesses of painting.

Collection of the Bibliothèque Nationale, Paris.

JOHN DIVOLA
From the series ZUMA BEACH, 1977.

Divola adds to the natural colours of the walls of a burnt-out house touches of paint which both enrich the reality and render it fantastic. The flash in which the photograph was taken makes the relationship between the outdoors and the indoors ambiguous, by making the sky with its sunset appear to be a coloured picture hung on the wall.

Collection of the Bibliothèque Nationale, Paris, DR.

impact strongly felt. This emotion is no spiritual vagary but an intense objectivisation of reality.

Once again the lead was given by William Klein and by some of Robert Frank's apparently confused images in his book *The Americans*. For these artists, the most unexpected visual coincidences provided the greatest creative chances. Ralph Eugene Meatyard often used blurring to provide a sudden revelation of the mortal nature of the living.

It is interesting to compare Steve Kahn's *Stasis* (1973) with Andreas Müller-Pohle's *Performance* (1984). Kahn's book is a solemn hymn to the massive, dark presence of things glimpsed in a dim twilight. The vibrating lines emphasise the volumes, and Kahn did indeed later turn to sculpture. Müller-Pohle's book is composed of thousands of snapshots taken at random, without aim, the moment and the circumstances of the taking quite forgotten. All his art lies in the subsequent choice of the images. We pass from Kahn's anxiety in the face of abstract art to Müller-Pohle's anxiety in the face of

KEIICHI TAHARA
From the series WINDOWS, 1975.

Collection of the Bibliothèque Nationale, Paris.

conceptual art. But in both cases, the end-result is more than ever a mastery over form. Another driving force has been expressionism, as can be seen from *The Face of Love* (1972), an intense little book produced by the Dutchman Sanne Sannes before his early death.

The Japanese Keiichi Tahara[72] started working on his *Windows* in 1975. Taking his photographs through a grimy window-pane, Tahara produced a sensual rendering of the intense, concentrated vibration of light. He seems to immerse himself in the flow of light, following its course as if it were a palpable, material substance, with a dense consistency of its own, rather than an immaterial intermediary. Things are perceived by an eye which plunges, floats and sheers off into its very heart. Ray Metzker,[73] already well known for his experiments with multiple images, began work on his *Pictus interruptus* series in 1977. Here, the expected relationships between the blurred and the clear, the near and the far, the full and the empty, are turned upside-down and photographic liberty seems to acquire a new dimension. 1977 was also the year when Nancy Rexroth's little book, *Iowa*, appeared, for which she deliberately used a plastic lens to reconstitute the half-faded but haunting world of childhood memories. In 1979, Linda Connor collected the essential body of her work in *Solos*.

Thanks to the technique of the retarded or open flash (an exposure followed by a brief flash of light), photography is able to produce strange images in which velvety shadows, distended by blurring effects, are combined with a clear, piercing flash in which every object acquires an electric aura. The Americans Richard Margolis and Roger Mertin, and the American–Norwegian Jim Bengston,[74] have progressed the furthest in their investigations into such worlds of fantasy.

The Frenchman Tom Drahos, who first studied in Prague and then embarked upon a series of experiments, is now concentrating upon the qualities of photographic material as such — its grain, its smeared effects, its layering of blacks, its muted or transparent greys, to produce images which defy reproduction. Also in France, quite recently, a group has been formed of young photographers — such as Frédéric Gallier, Patrick Toth and Hervé Rabot (Niépce Prize 1985) — a school as it were, studying the potentialities of movement, 'flow' and 'blurring'. In Barcelona, Manuel Serra works along similar lines. Having broken with the reassuring habits of a clearly defined, stable world, some photographers — the Canadian Alexander Newmann, the Dutchman Eric Van der Schalie and the Frenchwoman Tania Mouraud (in her *Palace* series, from the name of a famous Parisian night-club) — have been treating their prints as if they were paintings, or almost paintings, so as to allow the tactile qualities of photographic blurring to become fully appreciable. This irresistible quest after the material texture of whatever can be seen is also reflected in work as powerfully stable as that of Ruth Mayerson-Gilbert or Regina Schmeken.

The photography of the Japanese Jun Shiraoka rejects all compromise. His images, so dense as to be almost indecipherable, demand extreme concentration. Shadow and light take on such depth that they can be seen both as space for dreams and as tactile substances, a combination that makes them intensely photographic.

Space both separates and connects things; but it is also determined by the material structures and substances of those things. Images of foliage provide a good illustration. We are all familiar with the old quarrel over whether each leaf on the

NANCY REXROTH
From the series IOWA, 1970.

Collection of the Bibliothèque
Nationale, Paris.

tree should be painted separately. In photography, everything down to the tiniest twig can be rendered in detail. The lens absorbs the complexity of reality in such profusion that the photographer is clearly in no position to control the ordering of the forms in his image down to the last detail. Geometric reference points tend to disappear; and what is most photographic in photography – traces of reality registered in their raw state – win out. The vegetation which has been invading the images of many photographers since the late 1970s seems to indicate that photographers are now accepting the risk of taking on disorder and confusion, of allowing form to overflow. Perhaps, despite the difference in subject matter, it is a risk not so far removed from that accepted by one such as Garry Winogrand.

Vegetation was already rampant in 1970 in the work of the Englishman John Blakemore,[75] the American Thomas Cooper and the Canadian Robert Bourdeau, one of Minor White's pupils. In 1978, John Gossage's *Gardens* appeared, showing a garden prostrated by sunlight but seized in all the disturbing intimacy of a living, almost animal, jungle. Meanwhile, in parallel fashion, Lee Friedlander, in a complete shift of environment, was working on his *Flowers and Trees* series (the book came out in 1981). Here, Friedlander's erstwhile deliberately composed network of lines becomes so indistinguishable that one wonders if it is there at all. Everything is

in suspension, nothing emphasised, nothing asserted, nothing added to spoil the simple beauty of the truth, no constraints imposed upon the innocent interplay of things left to themselves.

Photographers of foliage have arisen on every side. Some – such as the Turk Tuna Ciner and the German Holger Trülzsch – are particularly interested in the graphic aspect; others – such as the Frenchman Arnaud Claass – in the imprints left by man. Yet others – such as the American William Sutton and the Frenchman François Puyplat – surrender themselves utterly to the density of these bushy tangles. The critic Jean-François Chevrier has even felt obliged to coin the word 'feuillagisme'. For Werner Hannappel, in Germany, it proved a way to combine conceptualism and romanticism. In Britain, Gerry Badger reacted very consciously against the fashionable trend of minimalism, to show instead the rich textures of an abandoned garden or the banks of a stream running through a forest. For him, photography is 'intensely physical'.[77]

Contemporary photography, for so long understandably fascinated by the extreme cerebrality of the photographic act, thus now seems deeply impelled to return to the concrete truth of those surfaces touched by light on which its existence depends.

10

Photography and contemporary art

PIERRE BOOGAERTS
SCREEN SERIES: STREET SKIES, WILLIAM STREET AND JOHN STREET, New York, 1978/9.
9 colour photographs mounted separately on masonite, each 42 × 61 cm; overall format 230 × 255 cm.

National Gallery of Canada Collection, Ottawa.

The question of the relations between photography and contemporary art involves a creative field that is both open and complex. What makes it all the more difficult to define its limits (historical and aesthetic) is that one characteristic of the artists who operate within it is deliberately to disregard any such limits. It is an old – even a generic – problem: here are two areas of expression, *art* and *photography*, each of which is relatively autonomous but between which, *right from the start*, a complicated relationship has existed, involved at once attraction and repulsion, assimilation and rejection, on both sides.[1] This chapter will examine the form that these ambiguous relations have taken during the contemporary period (which I will take to stretch back as far as Marcel Duchamp and the 'historical avant-garde movements' of the 1920). It will concentrate above all upon the *modalities* taken by the mutual references between art and photography and upon what is essentially at stake in the works so produced.

The first important point to make is that the relations between art and photography have by now acquired a *global orientation*: just as, during the nineteenth century, photography could be said to aspire to become art, similarly, in the course of the twentieth century, art has tended to absorb certain aspects of the rationale of photography (formal, conceptual, perceptual, ideological, etc.). This reversal of attitudes seems to me to indicate the guidelines to be followed in the present chapter: we will not be examining the extent to which contemporary photography may be regarded as art – for that whole question is no longer relevant and is today hardly of pertinent significance.[2] Rather, we will be examining the extent to which contemporary art has become fundamentally marked by photography. We will be less concerned with photographers who are 'artistic' than with artists who, in all sorts of ways and for all sorts of reasons, 'work photographically'.

From a historical point of view, this reversal seems to me to stem initially from the early and a contrario link represented by the so-called 'pictorialist' movement (1890–1914), for that marked the culmination of photography's aspirations to turn itself into painting and its theoretical and practical inability to do so (see Chapter 5). Its next point of anchorage, this time a positive one, is to be found in the work of Marcel Duchamp – seminal for the entire modern movement – which we will take as our starting-point in this chapter. The next matrix – paradoxically enough – is provided by the work of the pioneers of 'abstraction', above all El Lissitsky and Malevitch, with their 'suprematist' concept of space inspired by aerial photography. Finally, that reversal also stems, deconstructively, from the *(photo-)montage* operations of the dadaists and the surrealists, with whom we shall conclude our introductory survey of the precursory role that the historical avant-garde played, as early as the twenties, in the relationship between photography and contemporary art.

Marcel Duchamp

If Marcel Duchamp seems to introduce a completely new departure at the dawn of the twentieth century, that is above all because he insisted upon abandoning everything to do with what he called 'retina art' (that is to say, all 'classic' representation, including its more 'revolutionary' forms such as impressionism and cubism, phases through which Du-

champ himself rapidly passed, never to return to them). What he favoured instead was a concept of art essentially based upon the logic of the artistic act itself, the experience, the subject, the framework adopted, the referential implications: the very logic which photography had helped to discover. Borrowing Charles Pierce's terminology, I have elsewhere[3] dubbed it 'index logic' and have demonstrated the extent to which it provided the ontological basis for the status of the new photochemical mode of representation which stood in opposition to the classic (manual) form of representation which remained entirely governed by 'icon logic'. The art of Duchamp and photography share at least one common feature: the essential principle of the way in which they function is to produce images which are not so much mimetic or analytic but should rather be regarded as a simple imprint left by a presence, a mark, a signal, a symptom – as it were a physical trace of being there, or having been there: an imprint without significance in itself but which derives its meaning from the existential – and often opaque – relationship which connects it with whatever provoked it. A number of important studies, in particular those of Rosalind Krauss,[4] have in recent years emphasised the particularly determining role played by Duchamp's work in forging links, of both an original and a primordial nature, between photography and whatever has, in the course of this century, turned out to constitute the most innovative tendencies of contemporary art: *The (photographic or pictorial) act has become what is absolutely essential: the work itself represents no more than its trace.*

Admittedly, Duchamp was never a photographer in the strict sense of the term. Rather, whenever necessary he made use of the talents of his friend Man Ray, even for his 'self-portraits' and other self-disguises. Nevertheless, the whole of his work may be considered to be 'conceptually photographic', that is to say it is permeated by 'index logic', the logic of the trace left, the sign which is physically linked with its referent rather than being a mimetic representation of it. That holds true for, among other examples, all his works constructed on the basis of the shapes of 'cast shadows' (his series of profiles cut out as silhouettes, like so many 'rayographs' or contact-images, direct and frozen projections of his own face); also for those which imply some kind of 'mould', works as profound as they are ironical, which he produced in great numbers (*Objet dard*, *Feuille de vigne femelle*, *With my Tongue in my Cheek*, etc.); for those produced by means of 'tracing' or 'transfers' (*Trois stoppages étalons*, 'images' of a cable one metre long which had fallen from a height of one metre and the shape of which had then been fixed, transferred and reproduced in wood, etc.); for those constructed by chance, simply by being 'deposited' and then 'fixed' (his *Élevages de poussière*, which are traces left by time); and even for his 'ready-made' pictures themselves, which may be considered as extreme cases since not only does the final product not resemble the external object 'to be represented', but it is not even its physical trace: it is that very object itself, which has been turned into a creative work by virtue of an act of decision on the part of the artist, simply through an operation of selection, of singling out that particular object from the continuum of reality and incorporating it into the realm of art (the 'ready-made' is the very quintessence of photography).

The large picture *Tu m'*, which Duchamp produced in 1918, probably provides our best example in this respect: not only is it Duchamp's last oil painting (his farewell to 'retina art'), but

it also provides a panoramic view of the various forms of index possible. In it, we can pick out the images of a number of familiar 'ready-made' objects (a bicycle wheel, a corkscrew, a hatstand), all obtained in a process of indexing (by fixing the shadows cast on to the canvas by these articles); we can also pick out representations carried over from his *Trois stoppages étalons*: a realistic hand with a pointing index (!) finger, intended to convey this principle of physical connections; and a *trompe-l'oeil* effect which presents the illusion of a rent in the canvas, cobbled together by whatever came to hand — a parody of the shortcomings of illusionist representations, which are undermined by the scars left by reality, etc. In short, Duchamp's work, complex and many-faceted though it may be, certainly appears from a historical point of view as the touchstone for the relations between photography and contemporary art. Both spatially and temporally, it constitutes the framework within which a shift took place from the familiar and often reiterated idea that the effect of photography was to liberate painting from its 'iconic' ties to the newer and more paradoxical notion that art might discover within the epistemic conditions of photography totally original ways of renewing its creative processes and its major aesthetic goals.

Suprematism

Alongside Duchamp, we may detect a second major historical influential trend in the area that interests us: the beginnings of abstract art, principally in the Soviet Union, which were connected with the 'revolutionary' work of El Lissitsky, Kasimir Malevitch and the so-called 'suprematist' movement. On the face of it, nothing could be further from photography, always in some sense concerned with reality, than abstract art, which appears to reject all connections with any kind of representation of the world. Yet there is a definite linking thread between those two extremes, as can be shown historically. One of the central components of suprematist abstraction — affecting its perception, its conception and its representation of a 'new space' — stems entirely and explicitly from a particular kind of photography, to wit aerial photography (or its opposite, anti-aerial photography).

As always in times of war and in the wake of revolutions, the years from about 1914 to about 1929 constituted a period of extremely rapid development in technology and engineering, particularly in the domains of armaments, aviation and optical instruments. Perhaps we have not yet taken sufficient account of the impact made by these technological developments upon the very concepts of space and time that emerged during this period. Studies such as those by Paul Virilio[5] have begun to reveal a whole new perspective in this area, in particular in connection with such telling convergences as are indicated by the fact that, while on the one hand we create amazing new flying machines which make it possible for us to leave the earth and move freely in the skies, on the other we equip these machines with aggressive armaments and ultra-powerful photographic equipment (instruments for taking pictures and for taking life), thereby revealing our ways of both thinking and seeing.

However that may be, from 1914 onwards artists such as Lissitsky and Malevitch began to show an interest in aerial photography: first, in views actually taken from aircraft, showing barely recognisable landscapes, devoid of horizons and depth, hollows and peaks — landscapes geometrised, seemingly abstract, rendered as textures and formal or chromatic configurations, etc; and second, by contrast, in pictures taken from the ground, more or less vertically, showing squadrons of aeroplanes flying overhead, inscribing curious hieroglyphs against the screen formed by the sky.

Such photographs accompany or illustrate many of Lissitsky's works (for example, his famous *Prouns* of 1921) and also those of Malevitch (he included many in his book entitled *Le Monde sans objet* ('The World Without An Object'), 1927). Their writings make constant use of the mathematical theories of axonometry and metaphors of flying, detachment or suspension, some of them with cosmic or interplanetary implications, such as Lissitsky's legend for one particular study of axonometric perspective in his *Prouns* series: 'Construction navigating in space, projected, together with the spectator, beyond the limits of the earth . . .'[6]. Their drawings, paintings and other works themselves reflect their interest in such problems: consider, for example, the titles of some of Malevitch's compositions: *Suprematist elements expressing the sensation of flight* (1914—15); *Suprematist composition conveying a feeling of universal space* (1916). In short, aerial views did, in these circumstances, truly become 'basic elements' (Malevitch) in suprematism and these pioneer abstract artists did indeed use them as a starting-point from which to elaborate plastic and theoretical notions of, for example, 'new kinds of space' — 'irrational', 'universal', 'floating', 'twisting', etc.

Clearly, the most important point about this aerial vision of the world is that it involves a mode of perceiving and representing space that is completely different from that of the monocular, classical or Renaissance viewpoint — a new type of relationship between the artist–observer and the world. With traditional perception and representation, everything visible is determined by the same orthogonal, fixed and inflexible structure (the point of view is that of a person standing upright, fixed to earth and contemplating the horizontal world that stretches out before him). In contrast, in an aerial perspective, the relationship becomes a floating one, twisting, moving, no longer anchored to any fixed structuration. There is literally no sense (or direction) to an aerial view. It may be looked at from any position and always remains coherent. It involves a suspended and mobile point of view: the observer is not restricted to one position, and the space he observes is never determined once and for all: the relationship between the two is one of independence, instability, mobility. Hence, the intense feeling of freedom aroused by the aerial point of view, and the new sensations that accompany it — all of which Nadar had already intuitively perceived when he photographed Paris from his hot-air balloon fifty years earlier, and all of which is also reflected on the other side of the Atlantic, in the United States, in Alfred Stieglitz's experimental studies: the famous photographs of the sky and clouds which he took over a period of nine years in the later part of his life and entitled *Equivalencies* (1923—32).[7]

As well as that sensation of suspension, liberty and mobility, there was another dimension to aerial photography which could not fail to interest the founders of abstract art: the fact that aerial photography, in contrast to the usual, 'earthbound' forms of photography, turns reality into a coded world, a 'text' which may be read and deciphered; as Rosalind Krauss has explained with great clarity:

MARCEL DUCHAMP
'TU M''.
Oil and crayon on canvas with a pipe cleaner,
three safety-pins and a screw.

With his impassive intellectualism, Duchamp
explored the limits of art. He used
techniques which minimized the effects of
both the unsteadiness of the artist's hand
and the sensuality of materials. He allowed
preestablished data to make their own
impression, adding nothing of his own
except his intelligence. In the final analysis,
what is left is, to paraphrase his own
conceptual disciples, 'art as form'.

Gift of the estate of Katherine S. Dreier, Yale
University Art Gallery, New Haven.

© ADAGP 1986.

What is so striking is that, unlike most photographs, the aerial view raises the question of interpretation, of how to read the picture. It is not simply that, seen from high above, objects are difficult to recognise – although they certainly are. More particularly, it is that the sculptural dimensions of reality are rendered extremely ambiguous: the difference between hollows and hills, between what is convex and what is concave, is obliterated. Aerial photography confronts us with a 'reality' transformed into something that needs to be decoded. There is a disconnection between the angle of vision from which the photograph was taken and that which it is necessary to adopt in order to understand it. Thus, aerial photography reveals a rent in the fabric of reality, a rent which most landbound photographers strive earnestly to mask. While photography as a whole may promote and deepen our illusion of a direct contact with reality, aerial photography tends – by the same means peculiar to photography – to prick the bubble of that daydream.[8]

That too is an essential feature of aerial photography. It explains how it was that this particular type of photography provided conceptual tools for the early attempts to produce abstraction in art. Many of the later experiments in contemporary abstract art were also to be based upon such features.

Before coming to the third form taken by the historical avant-garde, we should note that the role played by aerial photography in the founding of abstract art was in a sense continued, after Malevitch and Lissitsky, by constructivist art and the Bauhaus school. It now took the form of what has been called 'oblique counter-composition', which originated in the 'plunging' and 'counter-plunging' photography so characteristic of artists such as Alexander Rodchenko and Moholy-Nagy. We will not pause for long to consider these important artists (since they have been studied more fully in earlier chapters). Let us simply note that their 'aerial representations' were dictated by different preoccupations, ones of an aesthetic rather than an epistemic nature. That is particularly clear in the case of Moholy-Nagy's photographic work, much of which is constructed by means of 'counter-composition' ('make everything look smaller, photograph from above, along an oblique axis'). Through his many 'close aerial' views

(such as the series taken at Belle-Isle in 1925, those taken of the Bauhaus at Dessau in 1926–8, and those taken of the urban conglomerations of Berlin, of the port of Marseilles and of the beaches of Sellin in 1929), he presented an extremely coherent plastic universe based upon the principles of creative obliqueness and compositional dynamism which hints at the spectator's fantasies of flight, liberty and mobility, etc. Some aspects of these works also show an affinity with the formal and theoretical preoccupations of the abstract painters of the same period, not only the constructivists and members of the Bauhaus but also the founders of the Dutch *De Stijl* movement, in particular Théo Van Doesburg, the author of *Peinture: Composition et contre-composition* (1927).[9]

In short, Moholy-Nagy, who was not only a painter but also a sculptor, photographer and film-maker, among other things, must certainly also be deemed to have played an essential role, during the twenties, in forming the relationship between photography and contemporary art. That is chiefly because he systematically worked on the basis of two major principles which define that relationship. One was the principle of the trace or index (consider his pronounced taste for shadows and imprints, etc., conveyed in their purest form by the photogram). The other is that of 'aerial' space with all its corollaries, both plastic (oblique counter-compositions) and abstract (the world read as a text in light).

Dadaism and surrealism

The third and last great historical avant-garde influence in this field came from dadaism and surrealism. Without going into details (for which see the earlier chapters of the present work), it is first worth noting that this third influential movement of precursors is connected intimately with the first two mentioned above. Duchamp is extremely close and Man Ray ('the Ray Man') establishes the link. The logic of the trace (or index) is forcefully demonstrated in his famous 'rayographs', as in other techniques used in the transformation of reality: solarisations (Man Ray), superimpressions (Magritte), fossilisations (Ubac), rubbings (Max Ernst), and transfers (Dominguez), etc. The fantastical trend to which these gave rise soon took on a fetishist character (automatism, oneirism, etc.). Meanwhile, the link with Moholy-Nagy was also deliberately

MAN RAY
RAYOGRAPH.

By placing transparent objects directly on
sensitised paper and illuminating them
under an enlarger, Man Ray obtained the
most direct photographs possible, since they
resulted from the objects themselves
touching the paper and the light passing
through them. Nevertheless, the results are
often fantastic: rayographs may evoke
fireworks, protozoa under a microscope, the
dynamism of futurist designs . . .

Collection Lucien Treillard, Paris.
© ADAGP 1986.

RAOUL UBAC
'LE COMBAT DE PENTHÉSILÉE' ('The Battle of Penthesilaea').

Collection of the Musée National d'Art Moderne, Centre Georges-Pompidou, Paris.
© by ADAGP 1986.

underlined, not only through the use of experimental photograms but also, and above all, in the area of photographic montages.

With their taste for the provocative and their cult of the 'surreal', dadaism and surrealism strongly encouraged *associationism* (that is to say metaphors, collages, assemblages of images, montages, and so on). This is the third great founding element in the relationship between photography and contemporary art. A photograph is a physical imprint of a presence and an abstract surface detached from all spatial references, and it is also truly a material, an iconic element in its raw state, to be manipulated like any other concrete substance (it may be cut out, combined with other elements, and so on). As such, it can be integrated in all kinds of artistic compositions in which the interplay of associations (whether or not of an unexpected nature) can make the most of all its potentialities. Photomontage is the most obvious form taken by associationism, our third essential element. Photomontages were, to be sure, produced, especially among the dadaist group, for many different purposes. They ranged from the Berliner John Heartfield's works, photomontages in the strict sense of the term, explicitly designed as political denunciations, to Raoul Hausmann's more plastic compositions or those of Hannah Hoch or Max Ernst, with their more poetic emphasis; and from the formally controlled compositions of a Moholy-Nagy to the more cynical and aggressive 'multi-media' combinations of a Kurt Schwitters or a George Grosz. Over and above the particular aims of each of these artists, the works shared a kind of twofold general purpose: first, to integrate the photographic image, with all its own peculiar characteristics, with a great mixture of base materials, as if the photograph needed to be desanctified, reduced to the status of a simple object (virtually a consumer article) or even a piece of rubbish – at the very least, a leftover, an unexceptional ingredient that could be incorporated into a composition of any kind; second, to set up correspondences between these amalgamations of heteroclite materials and a whole network of symbolic combinations: the associations set up between

fragments of photographs made full use analogy, comparison and the association of ideas, whether in order to express political defiance and criticism or to create positive and expansive (poetic) metaphors. The photomontages of the dadaists played an important role in the logic of the collage and other polyphonic amalgamations. A number of important tendencies in contemporary art were to reflect that fact in the development of their own new techniques — for example, those favoured by American art from the 1950s onwards.

American art

As is well known, the American art which emerged at the end of the Second World War was known as action painting (or abstract expressionism). Of the movement's first generation, it was Jackson Pollock who made the greatest mark: his huge canvases covered in blotches produced by the drip technique might seem a far cry from photography. Yet, as Rosalind Krauss has shown in her perceptive analysis,[10] Pollock's relationship to the base material of his picture at the moment when he is painting it — walking across his vast canvas stretched out flat on the floor, allowing the paint to dribble on to it, without ever touching the surface with a paintbrush, hardly stepping outside the rectangle within which he moves to and fro, twisting with no point of attachment, almost unseeing — that relationship is in effect just like that established in aerial photography as described above: a floating point of view with no pre-established, fixed framework, wheeling in every direction, with the ground below turned into an indecipherable, formal structure, a surface covered with marks that are so many traces left by the movements, passage and gestures of a body in action.[11] Then comes the final switch, the moment when, with the 'dripping' completed, Pollock *picks up* his canvas, hangs it vertically on the wall and only then looks at it, reads it, deciphers it and understands it.

Of the movement's second generation of artists practising this kind of 'lyrical abstraction', the most important name from our point of view is assuredly that of Robert Rauschenberg. Unlike Pollock, he does not concentrate upon the surface as it lies flat, seen purely from above. Working on a similarly large scale but more in the dadaist collage tradition, he transforms his vast surfaces into heteroclite accumulations, truly a layering of superpositions: on top of the base materials come layers of paint, images, textures, more materials, even objects: levels of plastic sedimentation, overlapping sweeps of pictures, symbolic and material strata, layered compositions where every visible representation covers another or several others 'underneath', each of which is more or less clearly, more or less dimly detectable, legible, depending upon the relative density or transparency of the screens that mask it. In these 'geological assemblages', as wild, lyrical and expressive as they are skilfully arranged, photographs seem to have a double status. On the one hand, they are just objects like any other, a material ingredient on the same footing as the rest, the cardboard containers, the pieces of tarpaulin, the wooden lattices, the fabrics and objects of all kinds; but at the same time, by virtue of being photographs and because they can still be glimpsed through all these filters, they somehow express the symbolic soul of Rauschenberg's constructions. They are, so to speak, palimpsests. They are the layered skins of America. In short, the first point to be made about

Rauschenberg's work — as a 'painter', not his parallel work as a photographer[12] — is that here photographs on the one hand are *objects*, used as a concrete, material base and, as such, literally gobbled up, incorporated by and within the painted work; while on the other they constitute a *metaphor* for the work and the way that it has been put together: it is all a matter of scales, veils and screens, a stratification of images, flakes scraped off the surface of reality.

Rauschenberg's 'combine paintings' are governed not only by the logic of montage and assemblage but also by that of the trace and the index. In the first place, the photographs are integrated into these pictures according to the technical principles of veritable physical transfers (fabric printing and half-tone screen photogravure by means of the technique of photographic transference used by Warhol as early as 1960): as a result, the vast surfaces become, as it were, second-degree 'photographs', photographic 'ready-mades'. Secondly, these photographs may also be regarded as *objets trouvés* or flotsam, abandoned as rubbish, or ruins, frozen, decomposing elements in the representation. Most of the snapshots used refer to documentation that is symbolic, clichés and stereotypes: photographs already printed elsewhere, taken from newspapers and magazines, which partially piece together a whole section of the imaginary side to American social life, with its archetypes, its models and all the pressures to which it is submitted from the media, etc. Rauschenberg's works thus resemble archaeological excavation sites in which the leftovers of a whole image-fixated civilisation lie deeply buried: the ghostly imprints culled from the fantasies of their lyrical subject.

Following in the footsteps of this 'abstract expressionism', and at the same time a direct reaction against it, the 'pop art' of the 1960s also marked a definite move towards the use of photography in contemporary art, as is clear from the work not only of Andy Warhol (its most radical exponent) but also that of James Rosenquist, Tom Wesselman, Roy Lichtenstein, etc. Over and above the varied personalities of the artists involved and the various individual ways in which they express themselves, pop art as a whole is characterised by a whole network of complex and well-known distinctive features:[13] in particular, an emphatic rejection of all aestheticism and all lyrico-subjective expressionism. It reflects a cult of impersonality ('I want to be a machine,' Warhol said, over and over again); an increasingly loudly declared taste for presenting images of consumer articles, stereotypes, off-the-peg objects, whatever is ordinary and everyday (flowers, soup cans, Jackie, Marilyn, Elvis, etc.); a major interest in all that is mass-produced by processes of transformation, repetition, variation, reproduction, in a plain matt format (as is instanced by the systematic use of the techniques of the serigraph, the facsimile and photographic transference, etc., and also by the production of pictures in series or repetitions of images identical except in respect of one or two details: reproduction is the very quintessence of pop art). It is also characterised by the abandonment of any attempt to produce an effect of depth, overlapping or palimpsests, for a cult, instead, of the surface, with all its opaqueness and immediacy; a cult, even, of superficiality. In violent contrast to Rauschenberg's amalgamations, his layers superimposed one upon another and his symbolic associations, Warhol works on the principle of setting in stark isolation objects which he has neither assembled nor associates with anything else. Rather, he cuts round them, lifts them out on their own, selects specific

ROBERT RAUSCHENBERG
'RUSH I', 1980.
Mixed technique on wood, paper on aluminium.

Collection of Leo Castelli, New York.
© by SPADEM 1986.

elements and presents each one on its own, even if in a repeated series, as coded evidence of what is there to be seen, in its raw, dry, unadorned state. His great series entitled *Death and Disaster*, entirely made up of 'sensational' reportage photographs, perhaps provides the best example in this respect. Set out in a succession of repeated views, it shows images of road accidents, railway accidents, air crashes, electric chair executions, and so on. Clearly, the relationship between pop art and photography is a quite special one. It is neither simply utilitarian nor aesthetico-formal, but almost ontological. Photography virtually sums up the 'philosophy' of pop art. You might say that pop art is the Polaroid of painting.

We will bring this rapid review of American art between 1950 and 1970 to a close by considering the third significant trend, known as hyperrealism and all too frequently confused with pop art. Connections between the two certainly exist, if only to the extent that both feature a strong element of representation borrowed from the social image of daily American life (although in preference to consumer goods in the strict sense, the hyperrealists tend to favour urban spaces traversed by reflections, transparent surfaces and shifting

lights glancing off window-panes, signs, cars, motor bikes, gleaming lines of automobiles and so on). Another common feature is a style of painting geared to smoothness, clean lines, shining surfaces, colours diffused and then fixed, a conventional order involving deliberate selection and framing, and so on.

Nevertheless, over and above these superficial similarities, it is clear that the general aims of the two are quite different and that consequently their relations with photography run along different lines. The first point to make is this: hyperrealism sets out not to reproduce, but to *represent*: the work of artists such as Chuck Close or Richard Estes is concerned with representing the means of representation, above all by accentuating its essential elements. Hyperrealism plays the card of an *excess* of mimetism, *too much* evidence of the representational means. It piles it on, 'goes over the top'; its figurative excess flings a challenge at figurative representation. That is why photography is so important in hyperrealism. The artist projects the slide on a huge canvas and paints in the projected image, outrageously magnified, pushing the parameters and codes of representation – the blurring, the grain, the lighting – to their extreme limits, showing an excess of reality. You could say that hyperrealism creates the original by working back from the reproduction or – if you like – that in the history of the relationship between photography and art, exactly the reverse of pictorialism is what is represented by hyperrealism: here, painting strives to become even more photographic than photography itself. What is excessive here is an excess of photography in painting.

Europe and France

While these American movements (action painting, pop art and hyperrealism) were developing, a new type of figurative art was being independently elaborated in Europe, in France in particular. It soon won recognition from the critics.

Pierre Restary was the first to devote his attention to it in his articles on *Les nouveuax réalistes* ('the new realists', 1960–5). The first generation included names such as Yves Klein (first and foremost), César, Arman, Tinguely, Spoerri, etc.

Then, between 1965 and 1970 (and continuing to the present day), came the next movement known variously as *nouvelle figuration, figuration narrative, figuration libre, mythologies quotidiennes, etc.*[14] represented by artists as diverse as, for example, Valerio Adami, Roy Adzak, Edwardo Arroyo, Leonardo Cremonini, Errò, Gérard Fromanger, Monory, J. Rancillac, A. Recalcati, Sandorfi, G. Schlosser, P. Stämpfli, Henri Télémaque and V. Velickovic, among many others. All these artists have developed more or less close and intense relations of various kinds with photography, although it is, of course, impossible to describe them all in the present chapter.

First, a word about the work of Yves Klein, a somewhat meteoric but interesting figure who died in 1962 at the age of thirty-four. He was famous for his many 'monochromes' (either two- or three-dimensional) and his 'blues' (ultramarine); for his work with atmospheric materials (rain, wind and fire: producing an architecture of the air, which prefigured some of the later works of land art – paintings executed with a flame-thrower or a gas burner, which suggest an almost alchemical transmutation of the materials involved, as in the fires that destroyed Hiroshima, where the 'shadow' of disintegrating bodies was imprinted on stone by the atomic

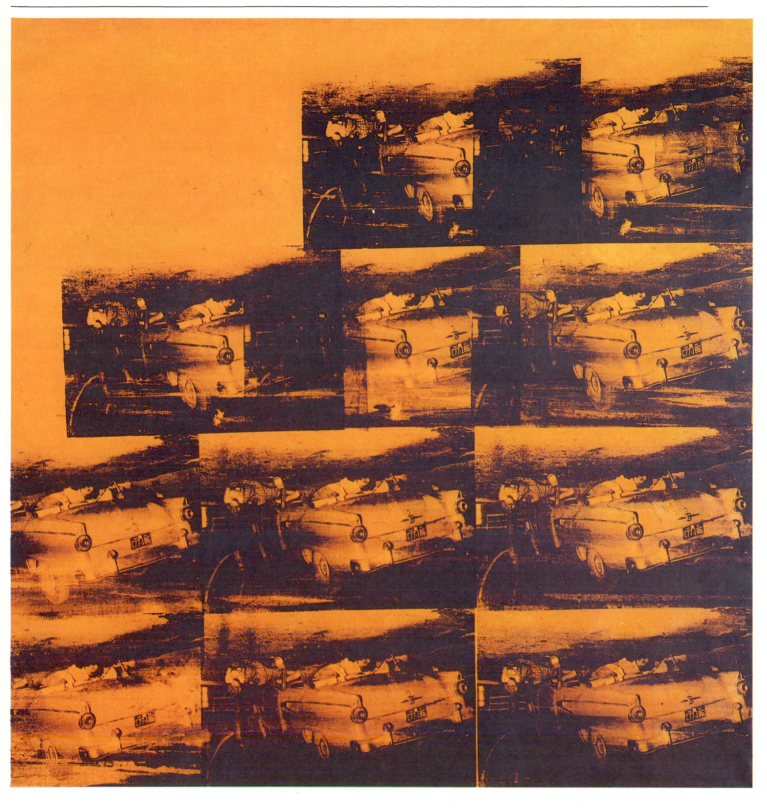

ANDY WARHOL
'ORANGE CAR CRASH', 1964.

The 'spectacular' element and the repetition of the subject
together with the chromatic treatment (monochrome)
emphasise the feeling of derision, but also unease, evoked by
these crude, sometimes violent and often provocative images
of contemporary society.

Museum of Modern Art, Turin.
Ph. © Mario Gerardi.
© SPADEM 1986.

flash). He was also well known for his 'Anthropometries': for these he used the bodies of naked women coated with wet blue paint as 'living paint-brushes' which he deployed during public sessions ('pre-happenings'), directing them by word or gesture to press themselves against the work's base material so as to leave a positive imprint of their bodies there; the second stage of the process involved spraying the same blue paint around these bodies pressed against the canvas so that, when they moved away, negative imprints of them were left there, superposed upon the original positive ones: a way of playing the holy shroud game, the positive–negative game, in short a kind of photography. Klein's activities were clearly governed by the logic of *acts* and *traces*: the logic of the *index* in its most striking form.

As for the artists of *nouvelle figuration*, it is not possible to

CHRISTIAN BOLTANSKI
'THE AUTHOR PLAYING WITH BUILDING BLOCKS, 1946' and 'THE AUTHOR'S BUILDING BLOCKS REDISCOVERED IN 1969'.

Combination of two photographs included in 'Recherche et présentation de tout ce qui reste de mon enfance' ('Discovery and Presentation of All That Remains of My Childhood').

Collection Christian Boltanski.

christian boltanski jouant aux cubes – 1946.

cubes de christian boltanski retrouvés en 1969.

describe the specific role played by photography in the work of each one of them. It is fair to say, in general terms, that in some cases what is important is their work on the ideas of *imprinting*, contacts, vestiges, impregnations, transfers, etc. (Adzak, Recalcati, Kermarrec, Stämpfli); in others, photography as such is used as an *instrument* (both technically *and* symbolically) essential for the elaboration of the work: it may function as a pretext or as an instigator, a model or an operator, a subject or a lens, a witness or a citation, a façade or a base canvas – in short, an instrument constantly reinvested with new powers, reinterpreted, adapted, manipulated, more or less violently or insidiously, by means of the framing, the colouring or the montage, etc. For example, Adami starts off with historical photographs (one of Freud travelling to London, or a portrait of Diane Arbus, for example), from which he first produces drawings composed by subtly reframing it, deframing it, splitting it up, altering the scale, rearranging the layering of planes: then he transfers these to his canvas in greatly enlarged format; as a last stage, he paints them in intense, flat colours and encloses them within capsules outlined in black.[15] Arroyo takes as his starting point supercoded cultural images (Rembrandt's *Night Watch* or some famous picture taken by Cartier-Bresson), reproduces them on his canvas, transforms them, adding various features, often of an ironical or metacritical nature. Similar procedures are adopted by Errò, with his figures crowded, lumped, heaped together; by Fromanger, with his models in splendour; by Gilles Aillaud, with his interplaying lights, reflections and mosaics; by Peter Klasen, with his enclosed, formal, coloured, terribly cold images shown in close-up; by Jacques Monory, with his dire, tragic, imaginary associations; by Schlosser, with his bodies laid bare and his way of framing them; and by Velickovic, with his decompositions of bodies in motion.

For all these artists, most of them painters, photography is an instrument that is indispensable to their work, not simply on a technical level, for the construction of their pictures, but even more from a symbolic point of view. The work of art is elaborated, that is to say *constructed* and *thought out* by means of photography (based upon it and pursued through it), each individual artist then being free to make it reflect his own particular universe. In the end, invariably, the photographs as such disappear, incorporated into and consumed by the canvas: they were no more than instruments used in a process.

Finally, in a rather different medium, we should mention the work of a whole group of artists, photographers as much as painters (whatever their own claims), who practise and use photography directly, as the essential basis and medium for their work, playing with it in all kinds of different ways. In their case, photography is not absorbed into the process of creation but constitutes the work itself in its immediate physical manifestation, whatever the manipulations involved. These artists, whose preoccupations tend to be of a social nature, usually practise, so to speak, an 'everyday art' (*art du quotodien*): in a relatively systematic fashion, they feature their own bodies or, to be more exact, the imaginary relationship between their own bodies and all that surrounds them or represents them sociologically or ideologically. Throughout, however, they continue to use photography as photography, as a means to set up a kind of reassessment of art (involving questions such as the relationship between texts and images, the concept of collections, etc.). From this group of artists we should mention Christian Boltanski (his albums of family

photographs, his model images, his reconstructions, toys, objects, inventories, etc.); Didier Bay (*Mon quartier vu de mon fenêtre, C'est l'amour*, etc.); Annette Messager (the woman who collects things, the woman who is jealous, the woman who is mad, the one who is a housewife, a gardener, in love, a murderer, etc.); Jean Le Gac, with his pictures of 'the painter' in all his various states (sleeping, dreaming, painting, reading, camping, and so on); and Paul-Armand Gette, 'the classifier', passionately committed to Linnaeus, to landscapes, plants and travel.[16]

In the case of all these creative artists, both those of *figuration libre* and those just cited, the intellectual and formal relationships between photography and contemporary art are quite complex and vary from one case to another. There are no a priori rules, no principles according to which the one is judged to be superior to the other. Instead, the relations between photography and art are infinitely varied, determined by no clear axes. They take many forms, ranging from the closest copying to the most extravagant distortions, from the most physical of confrontations to the most abstract of analogies. In this relationship, each artist, maybe in each of his works, *tries something out*, feels his way, explores a path, introduces a new ploy. It is these experiments, these explorations, these ploys that constitute the essence of contemporary art.

Photography and contemporary trends

So far, we have rapidly considered the various trends in creative art, in the United States and Europe between 1960 and 1980, trends which have exploited art's special relationship with photography: pop art, hyperrealism, *nouveau réalisme, nouvelle figuration, art du quotidien*.

The next few pages will be devoted to a survey of the same period and the same countries from a different angle, a view rather like a negative of our earlier form of examination. Shifting our attention, we will now concentrate not so much upon representation conceived as the finished product of an artistic activity (and, as it happens, a relatively realistic, figurative or optic one – what Duchamp would call 'retina art'), but rather upon the creative operation itself, the generating process, the idea and the act: in short, a survey of the works regarded not as object (completed) but as processes (taking place).

To be more precise, we shall now attempt to distinguish rapidly and synthetically the state of the relations that exist between photography and contemporary artistic practices such as conceptual art, environmental art (land art, earth art), body art and the art of happenings and performances.

First, a few remarks of a very general nature, to sum up what the reader will already have understood from what has been said in the opening pages of this chapter; namely, that the fundamental principles behind all these artistic practices, without exception, are based upon a logic which is the very same as that of photography: *the logic of the index*. Photography itself is essentially first and foremost a process. A photograph is also admittedly an image, but one that is absolutely and ontologically inseparable from the action that brings it into being: the photograph is a trace.

So between photography and the various practices that we

JOSEPH KOSUTH
'CHAIR', 1965.

Collection of the Kunstmuseum, Lucerne, DR.

will be mentioning there is a basic relationship, a primary link which is both fundamental and a matter of principle, an essential logic, an *episteme* which is shared in common: the *index*. That means that it is impossible to conceive of the artistic product without also (indeed above all) taking account of the process of which it is the result.[17]

That being said, over and above this general and fundamental connection, there also exist more particular and more superficial links. That is to say, each of the artistic practices we will be considering *uses* photography, in a number of different ways and for a variety of purposes. Let us consider them briefly, one by one.

In *conceptual art*, the role of photography may not be of the first importance (compared with that played by verbal language, for example: see, as a whole, the work of the 'art-language' group); it nevertheless does have a direct part to play, as in the works of Douglas Huebler (*Duration Pieces, Variable Pieces*, etc.), in which he makes use of photographic series of images, each one slightly different from the one before; or in the better-known works of Joseph Kossuth, his *Investigations*, for instance. Most of these present, side by side, three different kinds of representations of a single, real object. One such is his very famous *One and Three Chairs*, an archetypal example of conceptual art, another his *One and Three boxes*, both produced in 1965. What they show, juxtaposed, are the *real object* (the box or the chair), a full-sized black-and-white *photographic image* of the same object and, enlarged and printed on a board of the same size, a *linguistic representation* of that same object (giving the word that refers to it in the dictionary, accompanied by a phonetic and semantic definition). As can be clearly seen, in this work the purpose of the photograph, like that of the verbal language or the object that is the referent, is to set up a conceptual enactment of the very concept of 'representation'.

The practices of *environmental art* (land art, earth art art, paysage, etc.) also directly pose the question of its relations with photography and do so in a particularly interesting manner. As is well known, this type of artristic work,

EDUARDO ARROYO
'GILLES AILLAUD OBSERVES REALITY
THROUGH A HOLE, ALONGSIDE AN
INDIFFERENT COLLEAGUE', 1973.
Oil on canvas.

A photograph only conveys presence, never
sense. Thus the painter Arroyo could
'remake' Cartier-Bresson's photograph. It is
the unique play of shadow and light in the
photo that interested him: it is only one of
several possible forms of design.

Collection H.R. Astrup, Oslo.

HENRI CARTIER-BRESSON
'THE SPECTATOR-VOYEURS',
Brussels, 1932.

Collection Magnum, Paris.

JACQUES MONORY
'UN AUTRE' ('Another'), 1966.
Acrylic on canvas.

Jacques Monory worked for many years as a documentary researcher,
collecting photographs for publishers. He is himself a remarkable
photographer. He resorts to painting probably, among other reasons,
because of his need to experience fully and intensely images which
haunt him and which he wishes to make his own.

Galerie Maeght-Lelong, Paris, Ph. © Galerie Maeght-Lelong.
© by SPADEM 1986.

particularly flourishing during the 1970s, rests, all in all, upon the principle of taking as one's object (that is to say, as framework, as base surface, as material and as the work itself) the landscape as it stands, with all the elements that go to make it up. This kind of art, which lies somewhere between architecture in nature and sculpture in nature,[18] encompasses projects that range from the modest to the gigantic: in some cases, it is simply a matter of moving an object from one spot to another within a natural space; in others, it involves the very complex manipulation of huge quantities of natural materials, whether to capture and control various elements, to mark out particular sites, or to build extremely elaborate constructions, etc.

In the early stages, photography clearly has a useful role to play in such projects, as a means of compiling an archive, recording the work of the artist *in situ*, particularly since that work is in most cases carried out in a quite unique place (and sometimes at a quite unique time), a place that is isolated, completely cut off and more or less inaccessible — in short, a place and a piece of work which, without photography, would remain virtually unknown, a dead letter as far as the general public is concerned. Robert Smithson's *Spiral Jetty* (1970),

ROBERT SMITHSON
'SPIRAL JETTY', 1970.

Neue Galerie–Collection Ludwig, Aix-la-Chapelle.

whose coil, some 500 metres long, unwinds upon the waters of the Great Salt Lake of Utah, the huge *Observatory* (1971), of wood and earth, that Robert Morris set up in the middle of the Dutch Zuiderzee, and the numerous long *Lines* of stones that Richard Long has set out in various deserted parts of the world (on a high plateau in Peru, in the Himalayas, across the hills of Scotland, etc.), the sculpting of hills and the infilling of valleys which Michael Heizer set about in the Nevada desert (*Double Negative*), the damming of the Australian coast opposite the Great Barrier Reef and Christo's pink covering to the ocean around a few island off the coast of Florida: today, all these works are chiefly known to us through photographic records of them which have circulated and multiplied the images of the traces left by them. But of course that is by no means where the role of photography ends.

It very soon became clear that, far from being merely an instrument for making a documentary recording of the work once it had been accomplished, photography was from the outset comprehended and integrated within the project as conceived, to such a degree that not a few environmental creations in the last analysis came to be elaborated *on the very basis of* certain properties of the photographic process.

For example, some works of land art were originally conceived on the basis of principles such as that of monocular perspective, with all that that implies. Such was the case with many of Richard Long's *Lines* of stones, which only assume their full force as 'integrated lines', that is, lines that strike a harmony with the greater structures of the landscape, when they are seen *along the correct axis*, that is to say from a strictly determined viewpoint which fixes their orientation in both a

behind a deal struck three years ago by the San Jose Museum in California, which gave New York's Whitney Museum some $4.4 million for a series of four long-term shows drawn from the Whitney's collection. Originally planned to run 18 months, the third show, "Alternating Currents: American Art in the Age of Technology," will be up for only a year, beginning Oct. 18—in reaction to dwindling attendance during the final months of the previous two shows. The preceding show, "American Art 1940-1965: Traditions Reconsidered" shut down almost two months early. "It was up long enough," explained museum spokesperson Diane Maxwell. Like Josi Callan, San Jose's director, Rifkin of the High said he was willing to pay a large fee to a major New York museum to boost his own institution's income through increased visibility and attendance.

Picasso is the second of three High Museum shows to be drawn from MOMA's collection. The long-

term collaboration arose from the High's desire to come up with "something powerful and dramatic to follow our Olympic exhibition"— last summer's 125-work international loan show, "Rings: Five Passions in World Art," organized by J. Carter Brown, former director of the National Gallery of Art in Washington. "We were operating in a partial vacuum after the Olympics," observed Rifkin. "The circus came to town and then the circus left." The solution: a 140-work Matisse show [Nov. 2, '96-Jan. 19, '97], which plucked from MOMA during the holiday season such plums as *Landscape at Collioure*, *The Red Studio*, *The Blue Window* and *The Piano Lesson*, as well as the large and elaborate *Swimming Pool* mural of blue paper cutouts, not on view at MOMA since 1992. Retaining *La Danse* and *The Moroccans* for its own audience, MOMA "never got any complaints" about the missing masterpieces, according to Lowry. This supported

his conviction that MOMA's permanent collection is rich enough to weather the much longer upcoming Picasso shortage.

The High's next MOMA mega-show, opening in fall 1998, will focus not on a single artist but on an entire movement (selected but unannounced at this writing). Two additional major shows are slated to open at the High in fall 1999 and 2000—the first drawn largely from another, as yet unannounced, institution; the second to be self-organized. The five-show series, "Great Forces in XXth-Century Culture," is designed not only to bring great works to the Southeast but also to whet the acquisitive appetites of Atlanta's young collecting community, according to Rifkin. "We are showing people that in 60 years MOMA created an exemplary art collection. . . . You can't go back and buy the great works of art of the past, but you can buy the great art of your time."

—Lee Rosenbaum

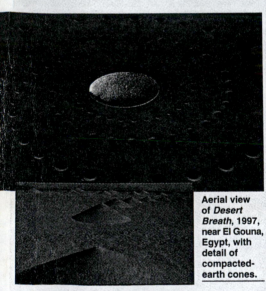

The work spaces of Sean Mellyn (left) and Joyce Pensato (right) during Exit Art's "La Tradición."

On Broadway: Studios Without Walls

Many art lovers tend to think of painting and performance art as separate genres, but a recent exhibition at Exit Art in New York suggested otherwise. For five weeks this spring, 10 artists were invited to go public by setting up their studios in the alternative space's sprawling galleries at 548 Broadway in SoHo. Titled "La Tradición: Performing Painting," the show offered a wide stylistic range of works in progress, from the bright, Pop-influenced portraits of Sean Mellyn to the controlled geometric abstractions of Lisa Beck. The studio spaces the artists carved out were equally diverse. Joyce Pensato's became a chaotic zone of charcoal dust and paint-spattered toys that she uses as models, while the working spaces of David Humphrey and Christopher Knowles remained pristine throughout the show.

The invitees also included David Scher, Susanna Coffey, Sam Gordon, Yigal Ozeri and Papo Colo. (Making it something of a party, the artists invited colleagues such as Nicole Eisenman, Ava Gerber and others to get in on the act.) The intense environment, somewhere between an art school and a zoo, was too much for Vahap Avsar, a Turkish painter who decamped during the first week. Others seemed to thrive on displaying their creative processes. One artist found himself painting more efficiently under the public gaze because he wasn't able to waste time staring at the wall. Another learned to avoid interruption by not making eye contact with visitors, comparing the experience to "being on the subway." Taking a more theoretical tack, co-curator and participant Colo spoke of "La Tradición" as a piece of "experimental theater" and an experiment in "cultural anthropology."

—Raphael Rubinstein

Earth Art Survives Desert Deluge

Aerial view of *Desert Breath*, 1997, near El Gouna, Egypt, with detail of compacted-earth cones.

interlocking logarithmic spirals—one of mounds, one of incised depressions— that center on a 100-foot-in-diameter artificial pool. The W-shaped interior of the fresh-water pool, from which the top of a semi-submerged cone protrudes, is to be filled to the rim four times per year via a nearly one-mile-long buried pipeline from a nearby oasis.

Viewers walking the nautilus-shaped labyrinth experience a subtle visual rhythm, as the cones change incrementally in size from a height (and depth) of 13 feet at the periphery to 1½ feet at the center. The mounds, evocative of barren peaks and of pyramids, were created with compacted sand displaced from the corresponding funnel-shaped holes, creating perfect positive-negative matches. Each above-ground cone is capped by a tiny mirror, reflecting the usually cloudless desert sky.

The project is the brainchild of three Greek women, known collectively as D.A.S.T.: Danaë Stratou, 33, a sculptor; Alexandra Stratou, 27, an industrial designer; and Stella

Constantinides, 28, an architect. In September 1995, the trio met with Samih Sawiris, president of the Egyptian-based development company Orascom P.T.D., who immediately accepted their proposal. He offered to supply materials and earth-moving equipment, plus the services of company experts and rotating crews of up to 70 workers. Over the next nine months, D.A.S.T. finalized its plan with Orascom surveyors and engineers. Actual construction began at the end of June 1996 and continued until Nov. 16. On that date, just 13 days before the work's projected completion, a natural catastope of biblical proportions struck the site.

During the next three days, an area that averages .04 inches of rainfall per year received almost 7 inches of downpour, causing severe flooding and erosion of the *Desert Breath* cones. Ironically, D.A.S.T. members had always conceived the natural deterioration process as an integral part of the work. (They intend to document future changes in photographs and films, just as they have done with the construction phase.) Barring future floods, the transformation of the pristine, hard-packed cones into more "organic" dunelike rises and hollows will now be accomplished primarily through wind erosion and the drifting of airborne silt over an undetermined period of months and years. —*Richard Vine*

Mar. 7-10, 1997, marked the second (and this time successful) inauguration of *Desert Breath*, a 25-acre configuration of earthen cones near the southeastern resort of El Gouna, Egypt. The intricately patterned land-art project, currently one of the world's largest, can be viewed either from the air or, more kinesthetically, on foot.

Situated on a plain between the Red Sea and its bordering mountains, 13 miles from the airport in Hurghada, *Desert Breath* consists of 178 geometrically precise cones. These forms are distributed in two

physical and a symbolic sense. Richard Long always insists upon photographing his constructions himself, in accordance with the principle of adopting a view strictly in perspective and along a particular axis. The works of an artist such as William Bennett are constructed along similar lines – his *Wedge (Stone Boat)*, for instance, and his Jamesville *Inverted Pyramid* (1976) – where the artist plays deliberately with the laws of perspective according to which parallel lines draw closer together (either speeding up the perspective or slowing it down), or with those that govern the reversibility of pyramids seen in perspective (making them appear either hollowed out or jutting forward). Some of Jan Dibbets's earlier works – involving landscapes and photography – are similar in conception: for instance, his 1968 series entitled *Perspective correction (Square with diagonals)*, where the *photograph* displays squares constructed and built into fragments of landscapes, squares which turn out not to be squares at all if they are seen from a point of view different from that which provided the photographic angle (a construction in monocular perspective in reverse).

Other land art works make use of other features of the photographic process. Take, for example, all the constructions on the earth's surface which, to be understood (or even, in some cases, to be seen in their entirety in such a way that the whole formal structure can be appreciated), need to be viewed more or less from the air, from a virtually vertical vantage point, a bird's-eye view being the only one which allows the work down below on the ground to be fully perceived. Such is the case, to varying degrees, with Robert Smithson's *Spiral Jetty*, Robert Morris' *Observatory* and even Christo's *Surrounded Islands* (1983), for all of them are configurations whose plastic impact is conveyed most powerfully by aerial photography.

Then there are other works which depend upon capturing an instant in time, in a manner made possible only by photography. One example is Andy Goldsworthy's *Tossing Sticks in the Air* (10 July 1981), where the 'work' of the artist consists simply in tossing a number of sticks one by one into the air, in a selected landscape, and taking photographs at exactly the right moment, that is to say at the point when all the sticks were fanning out against the background of the sky. Another is the spectacular and fascinating piece by Walter de Maria entitled *Lightning Field* (1977). In a semi-arid basin in New Mexico, where storms are particularly frequent, De Maria set up, as it were, a forest of some four hundred pointed steel staves about six metres high, bristling vertically from the ground, so as to compose a geometric figure spread over several kilometres of land. The site was chosen and the metallic spears pointing skywards were set up so as to catch the lightning flashes when a storm broke and to attempt, if not to control them, at least in some measure to attract and guide them. The 'Sky and Earth Art' produced some majestic effects in which the sublime (the spread of flashes inscribed against a leaden sky at sunset) was bound to be no more than a short-lived effect of circumstance. The instantaneous photograph (taken in a split-second flash) is certainly the only means of recording such magic, freezing both the flash and the moment.[19]

Finally, let us mention the – this time blatantly photographic – works of Michael and Barbara Leisgen, who carry these experiments a step further still. Their appositely named *Writings in Light* are produced by moving their camera from one position to another before a filtered sun in such a way as

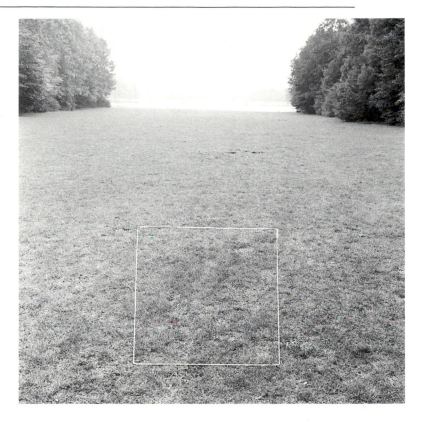

JAN DIBBETS
'PERSPECTIVE CORRECTION', 1968.

Jan Dibbets Collection.

to obtain on film legible traces which truly appear as luminous ideogrammes.

In the domain of body art and, in its wake, the art of happenings and performances, photography could be said to play exactly the same roles and for the same purposes as in environmental art. Thus, at first, photography was simply a documentary means of recording these staged actions of the artist, of reproducing them, storing them, demonstrating how the work took place, work in itself unrepeatable, ephemeral, unique in both time and space. What counted was the artistic act itself, the deployment of a body, the ritual performed before spectators; and the photographs (or film, or – later on – video) were of no more than secondary importance: just a means of storage in a memory bank – which some were quick to criticise as a negation or distortion of the original meaning of the work, which they considered to lie entirely in its status as a pure happening taking place here and now before those present, a happening which should have no extended or posterior impact, a happening that should be consumed in the act itself and then disappear, leaving no trace.

Clearly, though, this simple radicalism was soon challenged by experimental body art and happenings which make a quite deliberate appeal to photographic practices.

In some cases, it is a matter of integrating the taking of photographs with the action performed by the body itself: Gina Pane carries out her actions *before* spectators but *using* photographs according to a carefully thought-out and strictly controlled programme of moves from one spot to another, involving various framings, rhythms and snapshots. As she herself puts it, 'The photograph is my paintbrush.'[20]

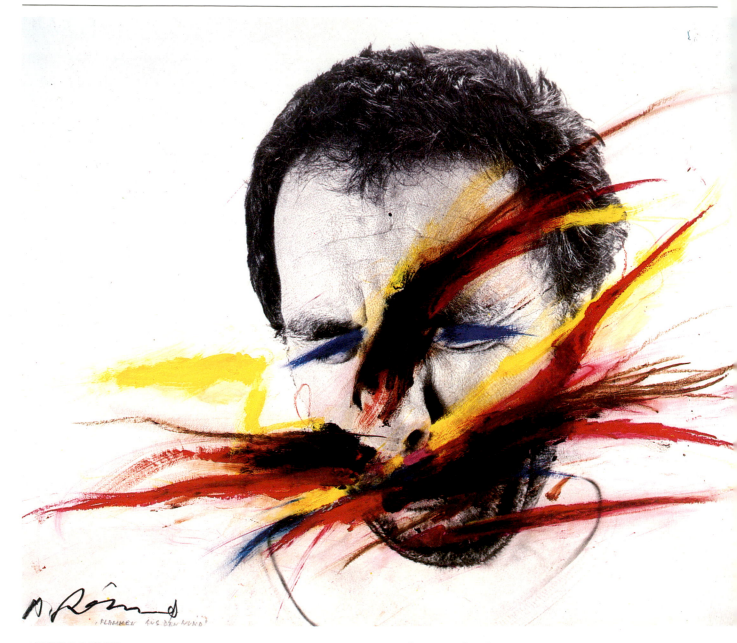

ARNULE RAINER
'FLAMMEN AUS DEM MUND' ('Flames on the Mouth'), 1969–1970.
Mixed technique on photograph.

Collection Galerie Stadler, Paris.
© SPADEM, 1986.

In other instances, it is a case of devising one's action to produce the best photographic results. Gina Pane once again provides an example. She plans and executes certain wounds on her own body — cutting the lobe of an ear with a razor blade, puncturing the inside of her arm with rose thorns, etc. — in order to obtain as 'expressive' as possible close-ups of that particular isolated fragment of the body, photographs which bring us as close as it is possible to get, even to the point of magnifying and amplifying it. Other artists, too, rely on the effects of close-up photography (evoking either fascination or repulsion): Vito Acconci, for instance, produces detailed views, which he calls *Trademarks*, of the teeth-marks left by the bites that he inflicts upon his own body, or the bodies of other people; and Dennis Oppenheim takes ultra-magnified shots of the nail shavings which he obtains by rubbing his fingers over an old plank of wood full of splinters.

Alternatively, the artist may set out to transpose strictly photographic processes on to his own body, as Dennis Oppenheim did for his *Reading Position for 2nd Degree Burn*, carried out in June 1970, when the artist exposed his torso to the sun for several hours, having first placed an opened book (entitled *Tactics*!) upon his chest. When he removed the book, a trace of its presence was left on the sunburnt skin: a white rectangle (a shadow in negative) on the reddened skin. Oppenheim thus turned his own body, his own imprinted skin into a veritable photographic film sensible to light. Two photographs were taken to record the action.

Finally — in a reverse process — it may be a matter of transferring the practices of body art to photography itself. Many artist–photographers mark, scratch, slash, wound, tear and scrape their bodies *by means of* photography, manipulating it in various ways. The most striking example is probably provided by Arnulf Rainer whose suffering body is constantly presented in images which destroy the effigy that they carry, being themselves scribbled over, scored through and covered with slashes and sweeps of paint.

As can be seen, with all these practices of contemporary art (conceptual art, land art, body art, happenings), despite the

fact that the original position adopted is poles apart from that of realistic figurative art and from the notion of a completed representation, they always end up by first *using* photography, simply as a 'second-hand' instrument, next *integrating* it (conceiving their artistic action specifically in terms of the characteristics of the photographic apparatus), then taking in and *absorbing the logic behind it* (the logic of traces, imprints, marks, etc.) and finally proceeding to a *reversal of roles*, returning to photography itself as to a primary artistic practice which, in its turn, proceeds to adopt some of the creative methods that stem from the logic of the various action arts.

So far, we have followed two major trends in the relations that have existed between photography and contemporary art since 1960: two trends on the face of it antithetical, consisting of on the one hand 'figurative' art (pop art, hyperrealism, *nouveau réalisme, figuration libre*), on the other the art of happenings (land art, body art, and performances). In the case of the former, the connection between photography and the practices of art seemed immediately obvious, given the 'realistic' preoccupations on both sides; in the case of the latter, it seemed equally immediately uncertain, even contradictory, since here the art practised was not only unconcerned with all forms of figurative mimetism but even went so far as a fundamental rejection of the very idea of representation. Yet, as we have noted, as soon as these two major trends are studied carefully, it becomes clear that their apparent and purely theoretical positions are soon belied by the facts. The so-called 'figurative' practices constantly move beyond the limits of a strictly photographic representation of things, either through their excessive degree of representation (pop art, hyperrealism), or through their rejection, distortion, manipulation and re-questioning of any representative function (*nouveau réalisme, figuration narrative, art du quotidien*). Meanwhile, conversely, as they have evolved, the practices of the so-called 'art of happenings' (land art, body art, performance, etc.) have, both materially and symbolically, increasingly incorporated the characteristic features of photography. As a result, in the long run it turns out that on the one side it is by no means the mimetic dimension to photography that links it to contemporary art (as was the case in the nineteenth century), but rather, indeed, a critique of that seemingly realistic dimension; meanwhile, on the other side, it is through its characteristics of a quite different order, that is to say more epistemic ones, that photography has drawn close to certain forms of non-representative art strongly influenced by its specific internal logic. Photography is no longer seeking to become painting. Rather, it is art that is becoming photographic, in the fundamentalist sense of the term.

Photo-installation

To round off this history of the links between contemporary art and photography, we must consider a set of resolutely modern practices which do not, in my view, strictly speaking originate from either of the two major trends examined above but which perhaps constitute the point at which those trends eventually converge in their most extreme forms, their paradoxical meeting ground. However that may be, I refer to a body of practices which together reflect the essential preoccupations of contemporary art and which, in their own way, literally obliterate the boundary lines between art and photography. I will call it *photographic installation* or *photo-installation*.

To start with a schematic remark, photographic installation may perhaps be very generally defined by the fact that here the photographic image has no meaning in itself except as something displayed in a particular place, at a particular time, that is to say that it is a part of a wider apparatus which bestows meaning upon it. The artistic work as a whole depends upon the way it is set up, upon the photographic 'installation'. To put it another way, the photographic installation always, although in infinitely variable ways, involves not only the photographs themselves (bearing their own particular message and impact) but also a space and a time that are carefully determined (i.e. a venue, a framework, an environment), an artist who conceives it all and manipulates it (the designer of the whole apparatus, who has not necessarily taken the photographs himself), a spectator who is the more or less direct focus of the entire machinery (to the point of sometimes being himself integrated into the work, or even being its very subject), and a kind of contract, an interplay in the relations between all these different elements.

Thus formulated, photographic installation can clearly assume the most diverse forms. After all, even an ordinary book or a photograph album (whether or not of family photographs) might be described as an installation: the album certainly implies a particular place and a particular time, a person who has arranged the photographs on the pages and who has thus set up the apparatus, a whole set of relations introduced by the way the photographs are presented in the album, and another person who, by looking through the book, gives the work an immediate role. Similarly, any exhibition of photographs (on the walls of a gallery or a museum, or, equally, gathered together in a portfolio) functions according to the same principle, not necessarily (indeed, very often not at all) as the result of any particular deliberation, but in some cases in accordance with more or less special arrangements designed to make the exhibition as such produce certain desired effects (as in all the exhibitions of the works of Deborah Turbeille, where the very hanging of the pictures constitutes a work of art in itself).

In short, generally speaking, if a photograph is looked at, it must be looked at by somebody, in a particular place and at a particular moment, and, consequently, a particular relationship is set up between it and its viewer. There is, after all, nothing out of the ordinary in all this. But the point is that 'ordinarily', when we look at a photograph or talk about it, we *forget* that it is presented to us in and through an 'apparatus' (however neutral and discreet it may be), which influences our perception of it. We do not usually pay (very much) attention to the dimension represented by the manner in which a photograph is shown to us or to whatever surrounds it, to whatever brings it to us, in short to whatever allows it to make its *statement* when it is contemplated. More often than not, we tend to disregard *the practical circumstances in which photographs are received*. But it seems to me important and significant that, over the past ten years or so, more and more photographers and artists have been systematically and concentratedly working on this pragmatic or practical side to the presentation of their photographs.

To begin with the most simple examples, we may mention the numerous works on which the installation amounts to no more than assemblage and montage, the setting out of a

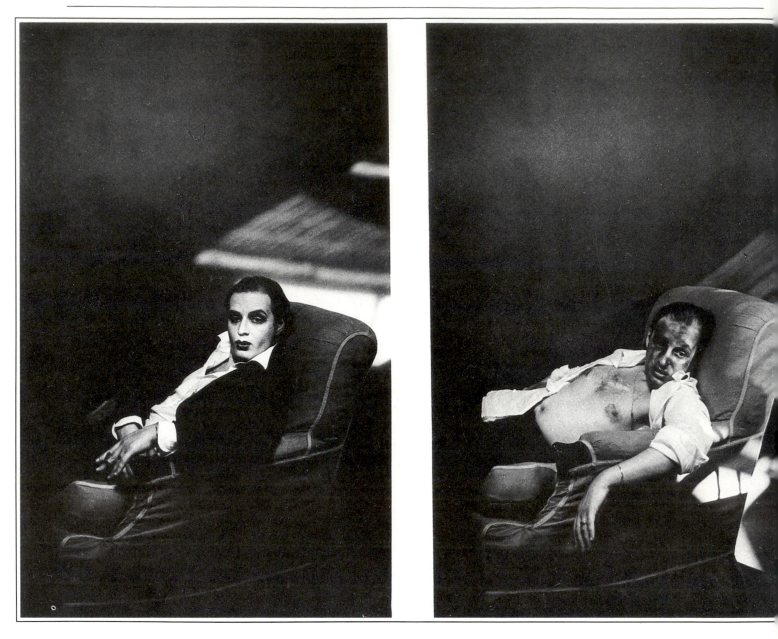

collection of photographs in a formal series. For example, we have already mentioned the assemblages put together by Annette Messager (*Les Portraits des amants*, 1977); certain series by Christian Boltanski (*Les 62 membres du Club Mickey*, 1972; *Les Enfants de Berlin*, 1975, etc.) and Didier Bay's work (*Mon Quartier vu de ma fenêtre*). We might also mention the disturbing montages of sequences of self-portraits by Urs Lüthi and those displayed in series by Klaus Rinke during the 1970s. Then there are the compositions of several images in which Gilbert and George create a setting in which to present themselves in a subtle and ironic way; and the extremely rigorous alignments of architectural constructions borrowed from the field of industrial archaeology composed by Bernhard and Hills Becher, originally as a typological study, which, simply through the manner in which they are set out, reveal a whole series of analogies and variants. These are but a few of the attempts being made to organise collections of images spatially (and sometimes temporally, too) in such a way as to suggest more or less calculated associations to the spectator, purely through the manner in which the images are arranged. In the presence of the work exhibited on the gallery wall or in the pages of some publication, the spectator finds himself somehow pressed by the apparatus to respond. Although he remains physically separate from the work itself (he is not a part of it, nor can he leave any material mark upon it; he remains simply the one who looks at it), he is placed in a position in which it is made possible for him to construct his own intellectual associations between the various photographs, working from indications provided by the montage. Installations such as these could be described as 'photographic sculptures'.

In some cases, these photographic sculptures assume a relatively elaborate form and the strategy for their setting produces effects of a quite sophisticated kind. In such circumstances the appeal made to the viewer is all the more intense. Let us select just a few examples from the many available to us.

Consider first the mosaics of Polaroids by the Belgian Stefan De Jaeger (although, in the same vein, one might cite David Hockney's *Paper Swimming Pools* and other cubist assemblages). These are vast 'paintings', composed of a large number of Polaroid photographs carefully laid out edge to edge. The immediate impression produced is one of tiling. And given that it is Polaroids — the most 'tactile' of all

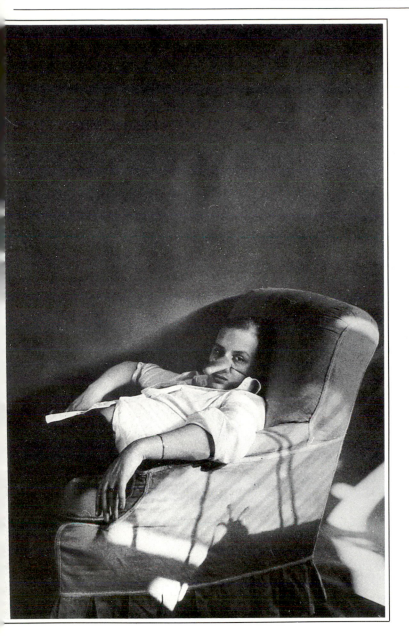

URS LÜTHI
'RETURN TO SENDER', 1975.
3 photographs each 140 × 110 cm.
Photographs on canvas.

Monsieur and Madame Isy Brachot's private collection, Brussels.

photographs — that are used, these compositions could certainly be described as 'photographic sculptures'. De Jaeger's purpose[21] is to decompose reality and reconstitute it *differently*; to make it palpable by means of a complicated and subtle arrangement of mismatches and dislocations. For that is the characteristic feature of these compositions: De Jaeger's mosaics make up a single picture yet at the same time constitute a multitude of separate representations. Each Polaroid is perceived both as an element in the composition as a whole and also as an image in its own right, and the connection between the overall image and the fragmentary ones that go to compose it is not simply cumulative, a matter of a unified and homogeneous combination. On the contrary, it is all a matter of shifting frameworks, shifting relationships and discontinuities. For example, the various Polaroids which together make up the representation of a model's body were not all taken from the same angle nor at the same time nor of the same position, and so on. And this perpetual variation in viewpoints introduces a plurality of spaces (and indeed of actions) into the work and, at the same stroke, makes *time* an element in the apparatus. If the *Self-Portrait with Dominique* is composed of 180 15 × 12 cm Polaroids, that means that 180

different moments are represented in the picture — and that implies a wide range of concomitant perceptional reactions on the part of the viewer. For he/she is affected by the fact that the installation puts him/her in a position in which it is no longer possible to apprehend the work from a single point of view; the viewer is no longer in a commanding position. The combination of a single place and a single time upon which such a position must depend is ruled out, shattered. The viewer is rudderless, no longer certain of how or when to applaud or look.

Another example of photographic installation is provided by the extremely rigorous work of the Englishman John Hilliard.[22] His works are at once simple in concept and complex in their effects: what he does is juxtapose two (or three) views of the 'same' reality, simply varying some parameter in the point of view so that, upon seeing these two (or three) snapshots, the spectator gets the feeling that he is perhaps looking at views of quite different objects. In other words, here again he is in some perplexity as to what he perceives and is prompted to wonder about the very conditions of vision and, above all, about the *photographic work* itself. In his first series, produced in the mid-1970s,

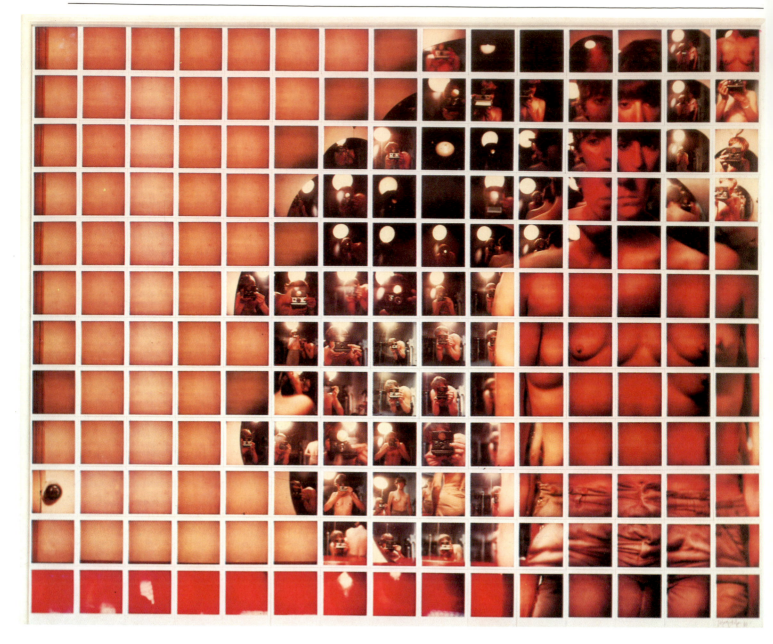

STEFAN DE JAEGER
AUTOPORTRAIT AVEC DOMINIQUE ('Self-portrait with
Dominique'), 1980.
Composition of 15 × 12 cm Polaroid snapshots.

Galerie Isy Brachot, Brussels–Paris.

Hilliard began by systematically varying the parameters of his photographic view, working in an extremely limited depth of field: *December Water* (1976), for example, presents three photographs of the same natural spot but the variations in the photographic treatment produce three different planes (foreground, middle distance and background) which seem to be so separate one from another and so distinct that some might believe these to be three photographs with no point in common. Later on, Hilliard moved on to work upon photographic parameters of different kinds (framing, speeds, lighting, range of colour). Some of his recent works (1981–4) are theatrical, long-range, large-format images and all relate to two separate moments in time. In fact, their main purpose is to study time (the temporal pulse) and *movement*. In many cases,

it is a matter of juxtaposing two views of the same object in motion: first the camera is fixed in a stationary position and in consequence the moving object leaves a luminous trace, a streaky vapour which indicates its path; for the next photograph, the camera is mobile, following the object as it moves along; the visual effect is to make the moving object seem to be immobile (since its image is clear) while the background (in reality immobile) seems to have moved (it is blurred). Examples of Hilliard's work of this kind are *Reflex* (1981), *Captive* (1982) and *Reflection* (1983).

It would be possible to continue to provide examples of photo-installations, analysing more and more complex types of apparatus that aim to elicit the viewer's reactions in an increasingly powerful and insistent manner. But we will select just a few, leaving aside the subject of their increasingly involved effects and possible interpretations.

Take, for example, the case of Pierre Boogaerts, a Canadian of Belgian origin. His series entitled *Série écran: ciels de rue, New York, 1978–79*[23] ('Screen Series: Street Skies, New York') displays his shots using the entire wall of the gallery or museum as the base material. The layout is chosen with the

aim of forcing the viewer to engage in a number of lines of reasoning, involving perception, analogies and symbolism. For example, *25th Street* is composed of eight colour photographs (each one 42 × 62 cm) mounted vertically on the white wall of the gallery like a column, its shaft composed of eight not quite continuous fragments which seem to display a section of blue New York sky 'framed' by the black skyscrapers which bound it, from a single point of view that takes in a vertical rotation covering the whole of 25th Street from one end to the other. From photograph 1 (at the bottom) to photograph 8 (at the top), the viewer's gaze, as it takes in the way that the work is mounted, is led to reconstruct exactly the space covered from the photographer's viewpoint. He is thus brought to realise that just as the photographic view is a matter of framing, bounding and carving out reality, so the symbolic architecture of Manhattan operates in a similar manner against the infinite backdrop of the sky: the photography, the architecture and the installation are all three *machinery* for seeing or, to put it another way, for moulding reality, for constructing it according to the interplay of a series of norms of perception, for rationalising it by means of a more or less comprehensive restructuring. To that extent, the photography and the architecture are used as powerful machines, capable, in their own ways, of imposing a structure upon the perverse polymorphous world.

As our last example of 'photographic sculpture', let us consider the *panoramic landscapes* produced by the Dutch Jan Dibbets in the early 1970s, which may be regarded as the historical and theoretical prototype of the genre.[24] In many respects, they prefigure the installations of an artist such as Pierre Boogaerts, but they are more 'structural' and less 'ideological'. In most of them, the panoramas are horizontal, not vertical as in Boogaerts' works, composed of a number of continuous shots mounted side by side, to reconstitute a view covering virtually 180° — often of quintessentially Dutch seascapes — sometimes with a few humorous touches added, as in *Negative–Mountain–Sea*, 1972. In these panoramas, the

perfect flatness of the horizon (of the Netherlands) is set off by an ironic 'depression' (as it were a mountain in negative) in the overall assemblage of photographs. But whatever the effect or theme (i.e. content), the primary concern in Dibbets's work is always the geometric rigour of the apparatus: the primary 'content' of his work consists of the structures of perception themselves, that is to say the principle behind the apparatus, the intrinsic elements in the construction, the montage as such, regarded as a model. In more recent years, Dibbets's work has become increasingly radical in this sense. Since 1975, he has been less and less concerned with themes or motifs and has instead been producing works such as *Structure Pieces*, *Colour Studies* and other *Structure Panoramas*.

Yet despite the differences between these artists, in Dibbets's work as in that of Boogaerts, and also (although in a different way) in that of Hilliard, De Jaeger and Hockney — in short, in all these examples of 'photographic sculpture' — the point of the exercise is to present the spectator of the installation with a double view: a 'normal' one, of each individual photograph; and a 'sculptural' one, of the apparatus as a whole, in which each image undergoes a structural manipulation that endows it with further meanings. The pleasure and the surprises that the installation holds for the viewer to whom it appeals lie in the connections between those two views.

Finally, let us consider one last type of installation: it involves not 'photographic sculptures' but what I will call the 'photographic environment'. I will briefly pick out a few general characteristics, then provide a few simply described examples.

The photographic environment is characterised by the fact that instead of being faced with a montage of photographs on a particular surface, where all the possible interconnections and surprises stem from the manner in which the images are assembled, the viewer is presented with an apparatus set up in a *three-dimensional space* in which the photographs constitute but one of a number of elements. Generally speaking, this

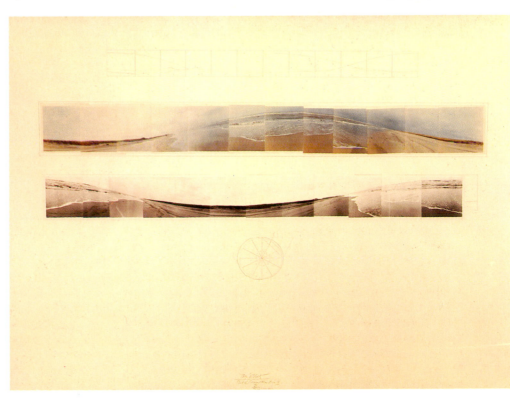

JAN DIBBETS
'DUTCH MOUNTAIN SEA', 1971.

Collection Bianca Dibbets, Amsterdam.

JOHN HILLIARD
DECEMBER WATER, 1976.
Triptych: from left to right: 'Running Black', 'Frozen White', 'Hanging Grey'.

J. Hilliard Collection.

means that the spectator is involved in a greater degree of participation, for he is able to take up a series of different positions in relation to this space, the better to appreciate its various aspects. Such environments present two further recurrent characteristics: (1) They frequently make use of a slide projector (rather than actual photographs), since this allows for a greater freedom of play with space and light. (2) They are systematically based upon the principle of creating a void where the various elements can play off one another, as in a circuit enclosed upon itself (generalised auto-referentialisation): the concept of the environment is simply itself, simply the representation of the conditions whereby it functions.

As a first example, let us consider one of the installations by the Belgian Bernard Queekers, his *Réfléchir* (Reflecting) (1980), which he has described in his own words: 'A projector situated between two identical mirrors sloping at different angles and facing each other. One of the mirrors is partially covered by a self-adhesive white screen. A space has been cut in it at the bottom, revealing the reflecting surface of the mirror. On either side of this cutout, a series of letters have been stuck, one above the other, on the screen (R, F, E, H, R, E, L, C, I). The slide is projected via the cutout (reflection 1) on to the mirror behind (reflection 2) and thence on to the whole surface behind (reflection 2) and thence on to the whole surface of the screen. The image projected is the one obtained by photographing that same screen, turned upside down.'[25]

Here is a second example: the installations of Pierre Ayot, from Quebec, such as *Certes, l'art est un jeu . . .* ('Art Is Certainly a Game . . .';1982), which comprises an effigy of Mikel Dufrenne. The art critic René Payant provides a clear description:

Certes, l'art es un jeu . . . shows a projector which, because the axis of projection is unusually low, illuminates several chairs before casting its beam on to the screen, which here happens to be a wall. The arrangement of the chairs, facing the projected image, suggests a specific scene: a slide show. The scene is an equivocal one not only on account of the unusual level of the projector, the obstacle constituted by the chairs and the absence of any spectators seated upon them, but also by reason of the image itself. This image represents a close-up of a head, as if the person represented was addressing an audience. Two situations thus seem to be telescoped into one: one is a slide show (a lecture accompanied by slides), while the fact that the projected image represents a person addressing an audience suggests a second (as if the image was not a projection at all but a person present in the flesh). The presence and arrangement of the chairs are in keeping with both situations and thus constitute the meeting- or intersection-point which connects the two situations and allows them to become interwoven. It is as if the first situation turned into the second, through the image itself, in a void setting in which what is being spoken of becomes the person speaking. . . .

When the spectator's eye fathoms the secrets of this work more deeply, it furthermore discovers that the projector is *pretending* to project a slide and is in reality simply projecting a beam of light which falls on a *painting* hung on the wall, in the manner of a projector illuminating a theatre stage. The beam of light does not show a slide but makes it possible to discern a painting which it picks out from the darkness surrounding it. The projector's beam, which, as lighting, creates the scene and makes it visible,

reveals a painting, and the coincidence between the level of the beam of light and the form of the painting, which is slightly asymmetrical, indicates that the angle of projection is not quite square but oblique, shifted slightly to the left. So now the first two readings are complemented by a third: the image is a painting set on show by the apparatus. The chairs invite the spectator to come and sit down to look at a painting. . . .

Upon drawing closer to the image displayed in the strong beam of light, the spectator discovers how it is made up. Seen close to, the image dissolves into a multitude of minute red, yellow and blue dashes and dots . . . which turn out to be arranged meticulously in a carefully controlled order. They are an accumulated sediment which marks a passage of time, bearing witness to the artist's carefully applied technique; but, above all, their texture is a familiar one, that puts one in mind of the structure of the coloured screens used in photographic printing. Here is a new level of interpretation, a new logic behind the image. As the successive grids of colours are accurately transcribed, by being projected upon the surface of the canvas, the whole operation gradually builds up an image: a photographic portrait.[20]

At this point we bring this panoramic survey to a close, knowing all too well that there are many other important figures working in the area of photographic installation who ought to be mentioned (the Englishman Tim Head,[27] for example, and the Canadian Michael Snow[28]), just as many others might have been cited in other fields that we have studied in the course of this rapid examination of the relations established between photography and contemporary art. But we have endeavoured, at least, to identify a number of different types of work and to classify them into various groups, in short, to concentrate on particular themes rather than on individual artists (although it is, of course, the latter who develop the former).

Similarly, photographic installation should certainly not be regarded as the final point in the relations between photography and contemporary art. It represents no more than a passing, if sometimes intense, phase, which has succeeded in erasing the barriers between the two areas of creative art with which we have been concerned. This is by no means the end of the road. Plenty of other new formulae remain to be developed. The history of the relations between art and photography remains open to the future.

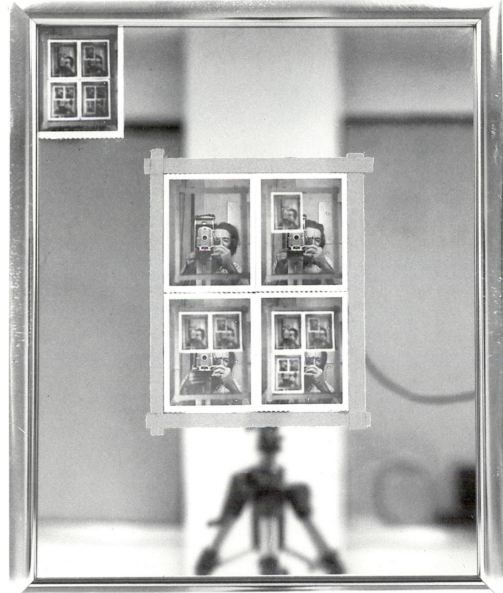

MICHAEL SNOW
'AUTHORISATION' 1969.
Black-and-white Polaroid photographs, self-adhesive tape, mirror and metal.

National Gallery of Canada, Ottawa.

PIERRE CORDIER
CHIMIGRAMME, 19/2/1971. II (detail).

Collection of Pierre Cordier.

Conclusion

Although short, the history of photography is rich, many-sided and complex, so it would have been foolish to attempt to be exhaustive in the present work. Rather than aim for an impossible, encyclopaedic summary, we have suggested a number of new approaches significantly different from those adopted by the authors who have hitherto devoted themselves to the historical study of photography. The task of producing a conclusion for a work devoted to a subject that is evolving as rapidly as the various modes of apprehending it is something of a challenge. But it is at least possible to underline a number of constant features and a few characteristics of current developments.

Regardless of the period or countries under consideration, and despite the many attempts to alter the situation, photographic practices are without exception characterised by the permanence of their craftsmanlike structures. Although increasing industrialisation certainly affects the production of photographic images all the way along the line (both upstream and downstream), those images remain a matter for solitary individuals. The manufacture of products and apparatus is now the concern of international companies, and the widest circulation of photographs is through the press. Still, photographers whose work consists of portraiture, reportage or fashion, let alone those who use photography as a means of artistic expression, remain to a greater or lesser degree craftsmen.

That continuity should not mask the extreme variety of images, which differ from one another depending upon whether they relate to the fields of art, industry, science, communications, publishing or leisure. We must consider photography in all these fields if we are to appreciate it in all its richness. It is perhaps this desire to widen the range of perspectives on photography beyond techniques and aesthetics that largely characterises today's historians, in particular the authors of this volume.

These different fields, all of which constitute essential elements in photography as a whole, particularly deserve our attention given their enormous productivity and the considerable changes that have taken place since the beginning of the twentieth century.

Before the First World War, the publication of photographs in the press was still something of an exploit. Today, in contrast, photography is an essential element in most newspapers and magazines. Yet one essential technical factor in this evolution, namely phototelegraphy, dates from before 1914. Following improvements in the speed of emulsions and the manoeuvrability of cameras, press photography addressed itself seriously to the problem of the transmission of prints which, if they were to meet the demands of modern journalism, had to be able to be moved from one side of the world to the other very rapidly. As early as 1905, the German professor Arthur Korn was using telegraphy for this purpose, as was Edouard Belin who in April 1914 produced the first newspaper publication of a picture transmitted by telegraph. By the eve of the Second World War, the major dailies were all equipped with Belinographs which could receive photographs of events taking place world-wide. This was the moment, before television established itself as a competitor to press photography, when the rapid circulation of images reached its peak.

Scientific photography was affected by a similar fate. During the nineteenth century, it was widely used by scientists, in conjunction with optical equipment: microscopes and telescopes. That technical association has been steadily perfected, being adapted to new technological refinements as they have become available and new scientific needs as they have developed. But photography's central role was increasingly supplanted, much as it was in the press, by the combination of computers and video. The photography of the infinitely small has become dependent upon the progress of the electron microscope; optics and new emulsions have made it possible to observe the most distant stars and to measure their spectra; in meteorology, photographs – whose use was first contemplated by Jules Janssen in 1885 – are now taken from satellites. Photography has thus become more integrated with sophisticated technical equipment but is no longer the key element that it used to be. A similar situation exists in medical photography. Lennox Brown's laryngoscope (1884) and the first pictures taken of the back of the eye by Gelezowski (1887) would today no longer be hailed as exploits. Whereas photographs of the stomach have proved technically difficult to produce because of problems of lighting and of miniaturisation, endoscopy is now practised regularly; but the images are now picked up on a cathode ray screen, not on emulsion. Technically, scanners bear little relation to photography. Photography for ballistic and aerodynamic studies, introduced by Mach and Salcher in 1887, was used by Harold E. Edgerton during the forties, with stroboscopic lighting, reaching exposure times of one-millionth of a second. But in this field as well less and less use is now made of photography when it comes to, for example, measuring a helix spiral or examining the rapid movements of machinery.

It would be an exaggeration to suggest that photography no longer plays more than a minor role in scientific representations. Nevertheless, it must be recognised that a change is taking place in technology, in which the mechanical–chemical image is being gradually supplanted by the electronic image produced by a computer.

However, this does not mean that photography is losing its social importance – rather, its area of application has altered, its uses and functions have changed. Faced with the growing competition of television, photographer-reporters are turning to the methods of cinema fiction. In order to show reality, they dramatise it, as if photographers were at last recognising the fictional dimension of their representation of reality. We can see the erosion of the myth of the photographer-reporter devoted to the ideal of representing the unvarnished truth, even at the cost of his life.

A reversal seems to have taken place. Press photography, which used to claim to be a way of knowing the world and life, can now be seen for what it is: a source of illusory, subjective, sometimes misleading images. The reporter who, between the wars, stood for the transparency of the photographic image,

nowadays tends increasingly to stress the subjectivity of his vision. In these circumstances, distinctions between different photographic procedures tend to become eroded. As the photographic image increasingly reveals itself to be not so much a true copy of reality but a methophor of it, documentary photography and art photography cease to be considered irreconcilable.

This state of affairs no doubt accounts for the meteoric rise of fashion and publicity photography, both situated at the meeting-point between the economic and the cultural sectors, in between the field of information and that of creation.

Fashion photography was born in Paris at the beginning of the century, in the studios of Nadar, Reutlinger, Talbot and Seeburger. However, it was with the magazines *Vogue* and *Harper's Bazaar*, in the twenties and thirties, that it really took off, thanks to photographers as diverse as Man Ray, Adolphe de Meyer, Edward Steichen, Paul Outerbridge and Cecil Beaton and, after the war, the Americans Richard Avedon and Irving Penn, the Japanese Hiro, the Frenchmen Guy Bourdin and Jeanloup Sieff, and Sarah Moon. Fashion photography has come a long way during the last two decades, what with the increasing numbers of magazines and the growing success of ready-to-wear fashions, first for women and then for men. The fact that William Klein practises reportage and fashion photography simultaneously, and, above all, that he treats the one in the same way as the other, is another indication of the changes taking place in contemporary photography.

Even more than fashion photography, publicity today represents an essential part of photographic creation – for creation it most certainly is, a major phase in a move to establish an alliance between art and industry, a move that has been taking place for a century and a half. Like fashion photography, publicity photography began in the 1920s and 1930, with Laure Albin-Guillot, Anton Bruehl, Lucien Lorelle, Nickolas Muray, Man Ray, Paul Outerbridge, Ralph Steiner, Maurice Tabard, Margaret Watkins and others. Initially a sector of modest proportions, publicity now plays an essential role in the commercial strategies of major companies, in the financial planning of magazines, in our daily environment and in the imaginary side to our lives, the more so given that now it may be a matter of promoting not just a product but a show, a travel agency, a political party or leader, a 'great cause' or even publicity itself. Publicity photography, itself a part of a vast, world-wide network of multi-media visual communications, thus tends to present a paradigm of contemporary photography. The goals at stake in the world of publicity force it to strive continuously for maximum efficacy in its frenetic quest for economic and visual profitability. Publicity designers and photographers are consequently obliged to be forever introducing innovations yet to do so without upsetting the expectations of consumers. They thus find themselves in a paradoxical situation of constant creativity coupled with an enforced observance of a set of strict formal and – all in all – classic rules.

In contrast to this area, where 'utilitarian' photography is subjected to constraints of a financial and – ultimately – also aesthetic nature, a different kind of photography emerged as early as the mid-nineteenth century: 'creative photography', with formal research for its own sake as its principal objective. Initiated by former painters and a few cultivated amateurs, it enjoyed its first successes with the pictorialist movement, then became closely linked with the artistic avant-garde of the inter-war period. However, the waning authority of painting in the realm of contemporary art over the last few decades has given rise to increasingly autonomous 'creative photography'. Now photographers claim legitimacy and specificity for their own practice, which they continue to reassess but without undue deference to the theoretical and practical schemata peculiar to painting. It is this total assumption of their own creative identity that has given rise to the recent appearance of books by artist–photographers, galleries specialising in photography, departments devoted to photography in museums, and so on.

Finally, although the images produced by amateur photography are intended for private, even intimate recipients, the staggering increase in its production confers upon it a role of the first importance in the context of contemporary photography as a whole: this role is in part economic, of course, and, within the family or particular group, in part symbolic, as Pierre Bourdieu has shown in his book, *Un Art moyen* (1964); but it is also partly aesthetic, and its effects upon other kinds of photography should not be underestimated.

Historical studies provide an incomparable means of understanding the present situation and the changes taking place in photography today, but only provided that the phenomenon of 'photography' is at all times considered in all its multiplicity, mutability and geographical diversity. That has been the aim of the present work. If it has been successful then it must be thanks to the participation of its diverse team of contributors who have provided a wide spectrum of different viewpoints in the hope of presenting photography in a new manner and opening up new possibilities in the ways of conceiving and writing its history.

André Rouillé

Appendices

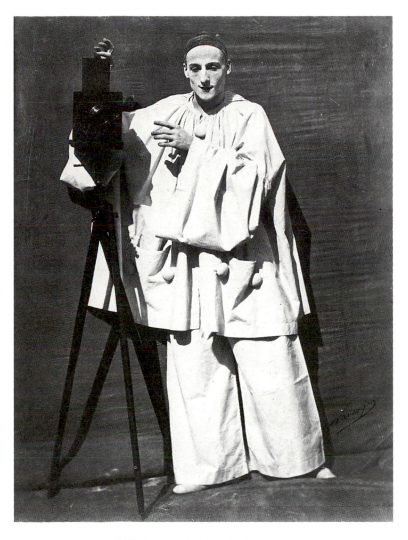

TOURNACHON-NADAR THE YOUNGER
JEAN-CHARLES DEBUREAU, 1855.

Collection of the Musée Carnavalet, Paris.

Chronology

In the fourth century BC Aristotle observed an eclipse of the sun in a camera obscura. In the eleventh century Alhasen (an Arab) spoke of a camera obscura. 1267: R. Bacon (GB) observed an eclipse of the sun in a camera obscura. 1290: G. de Saint-Cloud (F) spoke of the 'little hole'. 1515: Leonardo da Vinci (I): the 'camera obscura'. 1550: G. Cardano (I): the convex lens. 1620: J. Kepler (D): the collapsible dark tent. 1654: A. Kircher (D) described a magic lantern. Studies on the effects of light on silver chloride by H. Schulze (D) in 1727, W. Scheele (S) in 1777, J. Sénebier (CH) in 1782. 1802: Experiments with silver nitrate by Wedgwood (GB).

Abbreviations: P/ photographic image; **B/** book, publication; **E/** exhibition; **J/** journal; **R/** review, magazine; MMA, Museum of Modern Art, New York; IMP, International Museum of Photography; GEH, George Eastman House, Rochester; (A), Austrian; (B), Belgian; (CH), Swiss; (D), German; (E), Spanish; (F), French; (GB), British; (H), Hungarian; (I), Italian; (NL), Dutch; (PL), Polish; (R) or (USSR), Russian or Soviet; (S), Swedish; (USA), American.

Date	Works	Institutions, events and ideas	Technical innovations
1816			1st photochemical (negative) print by Nicéphore Niépce.
1826	Niépce (F): *La Table mise* (glass plate) and *Saint-Loup-de-Varennes* (tinplate)		Niépce: 1st photochemical prints on tin and glass.
1829		Partnership agreement between Niépce (who died in 1833) and Daguerre (F).	Niépce: *Notice sur l'héliographie.*
1834			Talbot's 'photogenic drawing' (GB).
1835			Daguerre's 'latent image'.
1839	P/ Daguerre (F): *Les Boulevards de Paris.* P/ Sachs: introduces the daguerreotype in Germany. P/ Van Klobell and Von Steinheill (D): Munich images (the Talbot process).	7 January: Arago announces the discovery of daguerreotypes to the Académie des Sciences in Paris. E/ June, Bayard: 30 photographs on direct positive paper, Paris. B/ Daguerre: *Historique et description des procédés du daguerréotype et du Diorama.*	Talbot addresses the Royal Society in London. Herschel (GB): fixing power of sodium thiosulphate ('hypo'). March, Bayard: direct paper positive.
1840	P/ Draper (USA): shots of the moon on a daguerrian plate. P/ Philipon (F): *Paris et ses environs.*	1st portrait studio in New York set up by Wolcott and Johnson, followed by Morse.	Petzval lens constructed by Voigtländer (A). Chevalier: the 'Photograph' with combined glasses. Wolcott (USA): camera with parabolic mirror. Fizeau (F): toning of daguerrian plate with gold chloride.
1841		Opening of daguerreotype portrait studios in London, by Beard (GB) and Claudet (F) and in Paris by the Mayer brothers (F).	Talbot (GB): calotype (or Talbotype): negative paper for latent image.
1842	P/ Stelzner and Biow (D): Dagguerreotype of the Hamburg fires. B/ Lerebours (F): *Excursions daguerriennes, vues et monuments les plus remarquables du globe* (engravings based on daguerreotypes).	Anthony (USA) opens a studio in Washington. B/ Lerebours: *Traité de photographie.*	Herschel (GB): cyanotype or ferroprussiate.
1843	P/ Hill and Adamson (GB): calotypes for the painting, *The Disestablishment of the Church of Scotland.*	Talbot (GB) sets up a studio in Reading.	Fizeau (F): printing from a daguerreotype using printer's ink.
1844	B/ Talbot (GB): *The Pencil of Nature.* P/ Foucault and Donné (F): Daguerrian photomicrographs.	E/ Palais de l'Industrie, Paris: 1000 plates exhibited in the section for chemical products. Brady (USA) opens a studio in New York.	
1845	B/ Talbot (GB): *Sun Pictures in Scotland.* Langenheim: 'Panoramic' views of the Niagara Falls. P/ Mayall (USA): *Pater.* Fizeau and Foucault (F): daguerreotype of the sun.		
1847		Creation of the Photographic Club in London.	Negative on albumenised glass by Niépce de Saint-Victor (F). Blanquart-Evrard's albumenised paper for positive prints (F).
1848	B/ Itier (F): *Journal d'un voyage en Chine en 1843–46.*		Projection of positive transparencies by the Langenheim brothers (USA). Colour image of the solar spectrum by Becquerel (F).
1849		E/ The Palais de l'Industrie, in Paris, exhibits paper photographs.	Brewster's (GB) prismatic stereoscope. Le Gray (F) suggests using collodion for negatives, to keep the silver salts on the surface of glass plates.
1850	B/ Brady (USA): *Gallery of Illustrious Americans.*	J/ *The Daguerrian Journal* devoted to the Daguerrian and Photogenic Art, New York.	Scott Archer (GB): wet collodion process (made public 1851).

Date	Works	Institutions, events and ideas	Technical innovations
1851		J/ *Photographic Art Journal*, New York. Foundation of the Société Héliographique in Paris. J/ *La Lumière*, Paris. *Mission héliographique* in France. E/ The Great Exhibition in London shows photographic prints, mostly daguerreotypes.	Le Gray: dry glazed paper. Blanquart-Evrard's printing works opens in Lille.
1852	B/ Du Camp (F): *Egypte, Nubie, Palestine, Syrie*.	E/ London: first exhibition devoted exclusively to photography.	Ferrotype by Martin (F).
1853	Delamotte records the buildings of the Crystal Palace at Sydenham. Von Szathmari (R): first war photographer in Crimea.	Founding of the Photographic Society of London. J/ *Journal of the Photographic Society of London*.	Heliogravure by Niépce de Saint-Victor and Lemaître (F). Stereoscopic camera with two lenses by Dancer (GB).
1854		Founding of the Société Francaise de Photographie (SFP). Disdéri files the patent for the 'carte de visite'. J/ *The Liverpool Photographic Journal*. J/ *Photographisches Journal*, Leipzig.	
1855	P/ Fenton (GB): first war photographs in Crimea, followed by Langlois and Méhédin (F), Robertson (GB).	J/ *Bulletin de la Société française de photographie*. E/ First exhibition by the SFP. Founding of an Institute of photography and chemistry at Jena. J/ *Revue photographique*. E/ The Great Exhibition in Paris: photography shown at the Palais de L'Industrie.	Taupenot's dry albumenised collodion. Poitevin's carbon paper.
1856	P/ Thomson (GB): the first underwater photographs, at a depth of 5 ft.	The Duc de Luynes' competition, organised by the SFP.	
1857	P/ Rejlander (GB): *The Two Ways of Life*.	King's College, London University, organises a course of lectures on photography.	
1858	P/ Robinson (GB) exhibits *The Dying Girl*. P/ Nadar (F): first aerial photograph, taken from a balloon. P/ Charnay: the Maya ruins. P/ Watkins (USA) photographs the Yosemite Valley.	J/ *The Stereoscopic Magazine*, London. Nottingham Photographic Society (GB).	Gum bichromate processed for positive prints by Pouncy (GB).
1859	P/ Lewis Carroll (GB): *Alice, Lorina and Edith Liddell*.	J/ *Photographic News Almanac*. E/ SFP exhibition in conjunction with paintings, at the Salon des Beaux-Arts. J/ *Photographic Journal* (GB).	
1860	P/ Bisson Brothers (F): series on Mont Blanc and its glaciers. P/ Brady (USA): *Abraham Lincoln*.	J/ *Photographisches Archiv*, Elberfeld. J/ *Zeitschrift für Fotografie und Stereockopie*, Vienna.	Camera for microscopic images by Dragon (F). Roller-blind shutter (placed in front of the lens), by Relandin (F).
1861	Nadar (F): magnesium photographs taken in the catacombs and sewers of Paris. Brady and his team cover the American Civil War.	J/ *La Moniteur de la photographie*. J/ *Bulletin belge de la photographie*.	Russel's (GB) dry tannin collodion. Trichrome projections using three magic lanterns by Clerk Maxwell (GB). Colonel Laussedat (F): first experiments with photogrammetry.
1862		B/ Disdéri: *L'Art de la photographie*. Creation of the Photographic Society of Philadelphia.	Poitevin is awarded the 2000F prize for the Duc de Luynes's 'minor competition', for his carbon process for producing positive prints (F).
1863	P/ Carjat (F): Portrait of Charles Baudelaire.	J/ *La Camera obscura* (Italian magazine). J/ *El propagador de la fotografia* (Spanish magazine).	
1864		J/ *Photografische Mitte lungen*, Berlin. J/ *Photografische Korrespondenz*, Vienna. J/ *Tijdschrift voor Photografie* (Dutch magazine).	Woodbury's Photoglyph or Woodburytype (GB).
1865	Gardner (USA): reportage on the conspiracy to assassinate Lincoln.		Discovery of celluloid by the Hyatt brothers.
1866	P/ Sutcliffe (GB): *Water Rats*. B/ Gardner: *Gardner Sketchbook of the Civil War* (USA).		
1867	P/ Cameron (GB): *Sir John Herschel*.	E/ Photography included in the Great Exhibition in Paris.	Poitevin wins the 8000F prize for the Duc de Luynes's 'major competition' for his printing process using printer's ink.
1869			Trichrome processes announced by Ducos du Hauron and Cros at the SFP.
1870	P/ Piazzi Smyth (GB): *A Poor Man's Photography at the Great Pyramid*.	A number of photographs of the Paris Commune are used by the police for repressive purposes.	Dagron (F): his principles of microphotography used in communications between besieged Paris and the outside world.

Date	Works	Institutions, events and ideas	Technical innovations
1871	**P**/ Jackson (USA): *The Old Faithful*. **P**/ Collard, Franck, Braquehais, Disdéri, L. Laffon, *et al.* (F): the ruins of Paris after the Commune.	Creation of the Deutsche Gesellschaft zur Förderung der Photographie, Berlin.	Maddox (GB): gelatine–silver bromide.
1872	**L**/ Rejlander illustrates Darwin's *The Expression of the Emotions in Man and Animals*.		Jonte (F): 'revolver' camera.
1873	**P**/ Thomson (GB): *Illustrations of China and its People*. **P**/ O'Sullivan (USA): *Ruins of White House, Chelly Canyon, Arizona*.		Mawdsley (GB): gelatine–silver bromide paper.
1874		Foundation of the Association Belge de Photographie.	Ducos du Hauron (F): chromographoscope.
1875	Cameron (GB) illustrates Tennyson's *Idylls of the King*.		Colonel Mangin (F): instantaneous perigraph.
1877	**B**/ Thomson (GB): *Street Life of London*.	**R**/ *Galerie contemporaine*, Paris.	Raynaud (F): praxinoscope.
1878	**P**/ Muybridge (GB): *Horse in Motion*		Edison (USA): light bulb with wire of carbonised bamboo. Guerry (F): camera shutter. Bennett (GB): maturation of emulsions.
1880		Foundation of the Lumière factory in Lyons.	Muybridge: the 'zoopraxiscope'. Busch (D): Pantoscope.
1881	**P**/ Janssen (F): a comet.	**R**/ *Dansk Fotografisk Dorening*. Eastman (USA) creates the Eastman Dry Plate Company.	Eder (D) and Pizzighelli (I): silver chloride paper.
1882	**P**/ Draper and Common: negatives of the nebulae of Orion.	Bertillon (F): first anthropometric card index with photographs.	Marey (F): photographic gun and chronophotograph; construction of the physiological centre in the Parc des Princes. Abney (GB): citrate paper.
1884	**P**/ Eakins (USA): *History of Jump*. **P**/ Anschütz (D): series of storks in flight. **P**/ Bretz (USA): *Breaker Boys, Eagle Hill Colliery*.	**J**/ *Illustrierte Zeitung* (D) prints snapshots by Anschütz (D).	Eastman negative paper (USA). Carbutt (USA): film surface on celluloid backing.
1885		**B**/ Bertillon: *Identification anthropométrique, instructions signalétiques*. **B**/ Marey: *Développement de la méthode graphique par l'emploi de la photographie*. Léon Gaumont founds the Comptoir Général de Photographie, in Paris.	Eastman–Walker metal slide. Moëssard (F): panoramic camera.
1886	**P**/ Emerson (GB): *Gathering Water Lilies*.	First photographic interview, by Nadar, of Chevreul in the *Journal illustré*.	Abbe (D): apochromatic lens. Eastman: American Stripping Film. Von Schlicht (D): momentograph.
1887	**B**/ Muybridge: *Animal Locomotion*.	Creation of the New York Camera Club.	Celluloid film put into commercial production by Graff and Jongla (F).
1888	**P**/ Primoli (I) photographs the aristocracy of Europe.	Creation of the Buffalo Camera Club (USA).	Eastman (USA): first Kodak camera. 'Express Detective Nadar'.
1889	**P**/ Stieglitz (USA): *Paula*	First international congress of photography.	Protar *f*/7.5 by Zeiss (D). Moëssard (F): cylindrograph.
1890	**P**/ Davison (GB): *The Onion Field*. **B**/ Riis (USA): *How the Other Half Lives: Studies among the Tenements of New York*.	**J**/ *Photo Gazette*, Paris. **J**/ *Berliner Illustrierte Zeitung* (BIZ), Berlin. California Camera Club, San Francisco. **B**/ Bertillon: *La Photographie judiciaire*.	Folding Kodak No. 4, Eastman. Rudolph (D): first anastigmatic lens.
1891		**J**/ *Paris–photographe* (Nadar). Creation of the Wiener Kamera Klub. **E**/ Artistic photographs at the Club der Amateur Photographien in Vienna.	Ducos du Hauron (F): Anaglyphy. Edison (USA): Kinetoscope. Lippmann (F): colour photography by the interference process.
1892	**P**/ Boutan (F): the first submarine photographs.	**J**/ *Vogue*, American edition. The Linked Ring, London (club). International Union of photography in Antwerp.	Carpentier (F): twin-photo with two lenses. Decaux (F): double drop-shutter.
1893		**E**/ 'The Photographic Salon', Dudley Gallery, London. **E**/ 'First international exhibition of amateur photographers' at the Kunsthalle, Hamburg. **R**/ *American Amateur Photographer*.	Richard (F): Verascope. Von Hoegh (D): Dagor *f*/6.8. Cooke (GB): Triplet *f*/3. Edison: perforated film 35 mm wide.
1894		Photo Club de Paris. **E**/ 'Première exposition d'art photographique', Paris.	Rouillé Ladévèze: gum bichromate.

Date	Works	Institutions, events and ideas	Technical innovations
1895	J/ *Photograms of the Year* (GB).	Pocket Kodak, Eastman Kodak Co. Lumière Bros. (F): Cinematograph.	
1896	L/ Loewy and Puiseaux (F): *Atlas photographique de la Lune*.	New York: the Society of Amateur Photographers and the New York Camera Club merge to form the Camera Club. E/ Martin (F): 'London by Gaslight', London.	P. Rudolph (D): 'Gauss' lens.
1897		J/ *Camera Notes*, Stieglitz (USA). National Photographic Record Association, London.	Rudolph: Planar *f*/3.8 constructed by Zeiss, Iena.
1898	B/ Annan (GB): *Venice and Lombardy*. P/ Holland Day (USA): *The Crucifixion*. P/ Hare (USA): the Cuban War.	E/ The Philadelphia Photographic Society organises a Salon at the Pennsylvania Academy of Art.	Sigrist (CH): Sigrist binoculars. Gaumont (F): Spido Gaumont.
1899	P/ Clarence H. White (USA): *Ring Toss*. P/ Johnston (USA): *Stairway of Treasurer's Residence and Students at Work*.	E/ 'Hamburg International Exhibition'.	Ducos du Hauron: Melanochromoscope.
1900		E/ 'The New School of American Photography', Royal Photographic Society, London.	No. 1 Brownie by Kodak. Pascal and Izerable (F): Pascal.
1901	P/ Käsebier (USA): Indians, *Everybody's Magazine*.		Lumière (F): Periphoto.
1902	B/ Nicholls (GB): *Uitlanders and Colonists who fought for the Flag 1899–1900*.	Steiglitz's Photo-Secession group, New York. E/ 'American Pictorial Photography', National Arts Club, New York, by Photo-Secession.	Rudolph: Zeiss Tessar lens *f*/6.3. Neuhaus (D): photochromy
1903	P/ Steichen (USA): *John Pierpont Morgan*.	R/ *La Revue de photographie*, Photo Club de Paris. R/ *Camera Work*, New York, by Photo-Secession.	Lumière: reversal development of an emulsion. Ives (USA): stereoscopic grids.
1904		R/ *Camera Kunst*, Berlin. R/ *La fotografia artistica* (I). Creation of the Société internationale des photographes picturaux.	König: panchromatic emulsions. Lumière: starch process for the reproduction of colours.
1905		Gallery 291, New York, opened by Stieglitz.	
1906	P/ Baron de Meyer (D): *Waterlilies*.		Duclos du Hauron: omnicolor.
1907	P/ Stieglitz: *The Steerage*. B/ Curtis (USA): *The North American Indian*. P/ Johnston (GB): *Liverpool: An impression*.	E/ 'Robert Demachy' (F) at the Royal Photographic Society, London.	Belin (F): belinography. Lumière (F): autochrome. Rosing (R): cathode television. Goldschmidt: microfilm.
1908	B/ Genthe (USA): *Pictures of old Chinatown*.		Lippmann (F): integral photography.
1909	P/ Kühn (D): *Artist's Umbrella*.	R/ Condé Nast buys up *Vogue*.	
1910		E/ 'International Exhibition of Pictorial Photography', Albright Art Gallery, Buffalo. J/ *Excelsior*. The London Salon Club takes over from The Linked Ring, London.	Wood (USA): experiments with ultra-violet and infra-red.
1911	P/ Hine (USA): *Breakerboys*. P/ Lartigue (F): *Avenue du Bois de Boulogne*.		
1912			Kodak pocket camera.
1913	P/ A. Keighley (GB): *Fantasy*. P/ P. J. Bellocq (USA): prostitutes in Storyville, New Orleans. B/ A. Langdon Coburn (GB): *Men of Mark*. B/ A. Bragaglia (I): *Fotodinamismo futurista*.	E/ 'Stieglitz' at Gallery 291. E/ 'Emil-Otto Hoppé' (GB), Goupil Galleries, London.	O. Barnack (D): prototype for the Leica. Whitfield: Paget Color.
1914	P/ Richard Polack (NL): *The Artist and His Model* (after vermeer).	J/ Illustrated supplement to the *New York Times: Mid Week Pictorial*. Clarence White School of Photography, New York, by C. White.	Autographic system, Kodak. Capstaff Kodachrome, Kodak.
1915			Agfacolour, Agfa company (D).
1916	B/ A. Genthe: *The Book of the Dance* (USA).	Group: The Pictorial Photographers of America. E/ 'Paul Strand', Gallery 291.	No. 3A Autographic Kodak Special.
1917	P/ V. Bulla and P. Otsoup (USSR): the October Revolution.		
1918	P/ C. Schad (D): Scadograph.		
1919		R/ *Der Dada* by R. Hausmann Society of German photographers (D).	Adamas and Haller: cryptocyanine.

Date	Works	Institutions, events and ideas	Technical innovations
1920	P/ Raoul Hausmann (D): *Tatlin at Home*.	R/ *Revue française de photographie*, Paris. First International Dada Fair, Berlin. R/ *Photo Ciné Magazine*, Paris. Keystone Agency, Paris. R/ *Vogue*, Lucerne (CH).	Louis Lumière: stereosynthesis.
1921	P/ Atget (F): photographs of prostitutes. P/ Man Ray (USA): rayographs.	R/ *Camera*, Lucerne (CH).	
1922	B/ E. O. Hoppé (GB): *The Book of Fair Women*. B/ Man Ray (USA): *Les champs délicieux*.		
1923	P/ Paul Citroen (NL): *Metropolis*.	J/ *Münchner Illustrierte Presse*, Munich.	Agfacolor. Zelger: reversible emulsion.
1924	P/ Alexander Rodchenko (USSR): *Portrait of Alexander Chevtchenko* (Russian painter).	Group: Rote Gruppe (D). R/ *Uhu* and *Die Koralle* (D).	Ernemann, Werke (D): Ermanox. J. Peter (D): Trichrome camera.
1925	B/ Laszlo Moholy-Nagy (H): *Malerei, Fotografie, Film*. P/ idem: photograms. P/ Imogen Cunningham (USA): *Magnolia Blossom*.	1929 Intimate Gallery, New York, by Stieglitz. J/ *Arbeiter Illustrierte Zeitung* (AIZ), (D).	Leitz puts Leica into commercial production. Seguin (F): electronic flash lamp. P. Vierkotter: flash bulb.
1926	P/ Atget's photographs in *La révolution surréaliste*, Paris. P/ F. Bruguière (USA): *Light Abstraction*.	The New York Metropolitan Museum of Art starts its collection of photographs.	Creation of the Zeiss-Ikon company.
1927	P/ Edward Weston (USA): *Shell*.		Creation of the Kodak-Pathé company.
1928	B/ A. Renger-Patsch (D): *Die Welt ist Schön*. P/ Paul Outerbridge (USA): *Legs in Stockings with Flowers*. P/ Umbo (D): *Legs and Slippers*.	J/ *Vu*, Paris. Dephot agency, Berlin.	Franke and Heidecke (D): Rolleiflex. J. Baird (GB): the principle of colour television.
1929	L/ A. Sander (D): *Antlitz der Zeit*. L/ G. Hoyningen-Huene (USA): *Hollywood Movie Stars*. P/ Boris Ignatovitch (S): *Le Premier Mai*. Tabard: fashion photographs.	An American Place, gallery created by Stieglitz. E/ 'The New Photography', Stuttgart. E/ 'Film und Foto', Deutscher Werkbund, Stuttgart.	Ostermeier: magnesium flash bulbs.
1930	B/ Cecil Beaton (GB): *The Book of Beauty*. Felix Man (D): reportage: *A Day with Mussolini*. P/ N. Muray (USA): fashion photographs.	ROPF (Russian Association of Proletarian Photographers). R/ *Photographie, Arts et métiers graphiques*, Paris. E/ 'Florence Henri' (F): Studio 28, Paris.	Leitz manufactures rangefinders. The Osram company puts the Vacublitz bulb into commercial production.
1931	B/ Helmar Lerski (CH): *Köpfe des Alltags*. B/ Eric Salomon (D): *Berühmte Zeit genossen in Unbewachten Augenblicken*.	Julien Levy Gallery, New York. E/ M. Alpert, A. Shaikhet, Tulesa: '24 hours for the Filippov family', Vienna.	Le Maton put into commercial production by the Demaria Company, Paris. Dufay (F): Dufaycolor. Rhamstine (USA): posemeter.
1932	P/ Aaron Siskind (USA): *Harlem*. B/ Lewis Hine (USA): *Men at Work*. B/ H. Bayer (USA): *Fotomontagen*.	F.64 group, San Francisco. Dissolution of artistic associations by the Soviet Central Committee. E/ 'Fascist Revolution', Rome.	Contax 1 by Zeiss Ikon AG (D). Prominent by Voigtländer (D). Weston (USA): photosensitive exposure meter.
1933	B/ André Kertész (USA): *Children*. B/ Brassai (F): *Paris de nuit*. P/ Martin Munkasci (H): beachwear.	Photographic fair in Berlin: Die Kamera. Rapho agency in Paris. R/ *Campo grafico* (I). Reichsverband Deutscher Amateur-photographen (D).	A. Kingston (USA): moulded plastic lenses.
1934	P/ Cartier-Bresson (F): *Enfants jouant dans les ruines*. B/ Hans Bellmer (USA): *Die Puppe*.	J/ *Lilliput*, London	Zeiss markets the first camera with a photoelectric cell. Agfacolor Ultra.
1935	B/ Anton Bruehl (USA): *Color Sells*.	USA: Creation of the Resettlement Administration, which in 1937 became the Farm Security Administration (FSA).	Kodachrome 16 mm.
1936	P/ Dorothea Lange (USA): *Migrant Mother*. P/ Arthur Rothstein (USA): *Farmer and Sons in a Dust Storm, Cimarron County, Oklahoma*. P/ Robert Capa (F): *Moment of Death*, Spain.	R/ *Life*, New York. Photo League, New York.	Wash-off relief by Eastman Kodak Co. New Agfacolor.
1937	B/ M. Bourke-White (USA): *You Have Seen Their Faces*. P/ Luigi Veronesi (I): *Fotogramma 6*.	R/ *Look*, USA. E/ 'Photography 1839–1937', MMA, New York. 'Le Rectangle' Group (F). Moholy-Nagy founds the New Bauhaus School in Chicago. E/ Berenice Abbott: 'Changing New York', Museum of the City, New York.	Pemberton Billing (CH): Compass, compact camera.

Date	Works	Institutions, events and ideas	Technical innovations
1938	P/ Ben Shahn (USA): Ohio for the FSA. B/ Ansel Adams (USA): *Sierra Nevada, The John Muir Trail.*	J/ *Picture Post*, London. R/ *Match*, Paris. E/ Bill Brandt: 'A Night in London', Arts et Métiers Graphiques, Paris.	Super Six-20 Kodak camera.
1939	P/ Gisele Freund (F): *Virginia Woolf.* P/ D. Lange (USA): *An American Exodus: A Record of Human Erosion.*	R/ *US Camera Magazine* (USA) J/ *Tempo* (I). E/ John Heartfield (D): 'One Man's War against Hitler', Arcade Gallery, London.	Edgerton (USA): Xenon portable electronic flash.
1940	H. Pabel, H. Hubmann (D): reportages for *Signal.* B/ P. Outerbridge: *Photographing in Color.*	Photography department opened at MMA, New York.	Synchronised shutters.
1941	B/ Walker Evans (USA): *Let Us Now Praise Famous Men.* B/ Barbara Morgan (USA): *Martha Graham: Sixteen Dances in Photographs.*	R/ *Du* (CH). E/ George Platt Lynes (USA): '200 Portraits and less Formal Pictures', Pierre Matisse Gallery, New York.	Kodak Extra camera.
1942	P/ Dimitri Baltermans (USSR): *Grief.*	E/ Gjon Mili: 'Dancers in Movement', MMA, New York.	ASA degrees. Agfacolor negative, Mannheim.
1943	P/ Louise Dahl-Wolfe (USA): *Lauren Bacall.*	E/ Helen Levitt: 'Photographs of Children', MMA, New York.	Ektachrome 10 ASA, Kodak.
1944	P/ Robert Capa (USA): *The Normandy Landing.*	Magazine Photographers, New York.	
1945	B/ Weegee (USA): *Naked City.* B/ H. P. Horst (USA): *Photographs of a Decade.*	Groupe des XV, Paris. E/ P. Strand (USA): 'Photographs 1915–1945', MMA, New York.	Kallmaun (USA): principle of automatic adjustment.
1946	P/ Edward Weston (USA): *Waterfront.* B/ W. Morris (USA): *The Inhabitants.* P/ W. Eugene Smith (USA): *The Walk to Paradise Garden.*	R/ *Popular Photography*, New York. Bibliothèque nationale collections classified photographically, Paris. E/ Cartier-Bresson retrospective, MMA, New York.	
1947	L/ Laszlo Moholy-Nagy (H): *Vision in Motion.*	Magnum Agency, Paris. La Bussola group (I).	Land (USA): Polaroid 95.
1948	P/ Bert Hardy (GB): *Two Boys in the Gorbals.* B/ David Seymour ('Chim') (PL/USA): *Children of Europe.*	E/ Boris Ignatovitch (USSR): 'Landscapes of my Homeland', Moscow.	Kalart Camera (USA). Professional Sinar camera (CH). Eclatron electronic flash, by Seguin, Laporte and Deribere (F).
1949	B/ Robert Doisneau (F): *La banlieue de Paris*, text by Blaise Cendrars.	International Museum of Photography, George Eastman House, Rochester (USA). Fotoform group, Saarbrücken (D).	
1950	B/ Paul Strand (USA): *Time in New England.* B/ E. Weston (USA): *My Camera on Point Lobos.* B/ Izis (F): *Paris des rêves.*	Top Agency, Paris. First 'Photokina' in Cologne.	First photodiodes. Reversible sheet-film 3200 ASA for Polaroid camera (USA).
1951	P/ W. Eugene Smith (USA): Reportage, *Spanish Village Life.* B/ David D. Duncan (USA): *This is War.* P/ Irving Penn (USA): *Colette.* B/ Munkasci (H/USA): *Nudes.*	E/ 'Five French Photographers: Brassaï, Cartier-Bresson, Doisneau, Izis, Ronis', MMA, New York. Club Photographique de Paris or Club des 30 × 40.	
1952	B/ Cartier-Bresson (F): *Images à la sauvette.* B/ Paul Strand (USA): *La France de Profil.*	E/ Subjective Photo 1 R/ *Aperture*, New York. R/ *Images*, GEH, Rochester.	
1953	Edouard Boubat (F): reportages on the United States, *Réalités.*	E/ 'Gordon Parks' (USA), Art Institute of Chicago.	
1954	B/ P. Halsman (USA): *Dali's Mustache: A Photographic Interview with Salvador Dali.* B/ Willy Ronis (F): *Belleville-Menil-montant.*	Limelight Gallery/Cafe, New York. The Association des Gens d'Images founds the Niépce prize and the Nadar prize.	
1955	P/ Andreas Feininger (USA): *The Photojournalist.* B/ Roy de Carava (USA): *The Sweet Flypaper of Life.*	E/ 'The Family of Man', MMA, New York. SIPA Press Agency, Paris. B/ Helmut Gernsheim (USA): *The History of Photography.*	Ektachrome HS, Kodak.
1956	B/ William Klein (USA): *New York.*		
1957	P/ Minor White (USA): *The Three Thirds.* B/ Lucien Clergue (F): 'Corps mémorables', texts by P. Eluard and J. Cocteau.	E/ 'Abstract Photography', American Federation of Arts, New York. E/ Brassaï: 'Graffiti', MMA, New York. E/ D. Seymour: 'Chim's Children', Art Institute of Chicago.	Brownie 44A, Eastman Kodak.

Date	Works	Institutions, events and ideas	Technical innovations
1958	P/ Richard Avedon (USA): *Ezra Pound*. B/ Robert Frank (CH/USA): *Les Américains*.	Tio Fotografer Group, Stockholm. E/ 'Abstraction in Photography', MMA, New York. E/ Harry Callahan Retrospective, IMP, GEH, Rochester.	
1959	B/ Werner Bischof (CH), Robert Frank (USA) and Pierre Verger (B): *Indiens pas morts*. B/ C. Mydans (USA): *More Than Meets the Eye*.	O. Steinert founds the photograph collection of the Folkwang Museum in Essen (D). R/ *Infinity* (USA): special issue on conservation of photographs.	Bessamatic with Zoomar lens by Voigtländer.
1960	B/ Chargesheimer (D): *Menschen am Rhein*. B/ Scott Hyde (USA): *Scott Hyde Photooffset*. B/ William Klein (USA): *Rome*.	E/ 'The Sense of Abstraction', MMA, New York. E/ First 'Photeurop' exhibition, organised by the photoclubs of Switzerland, France, Belgium, Britain.	Calypso underwater camera by Spirotechnique, Paris.
1961	B/ Philippe Halsman (USA): *Halsman on the Creation of Photographic Ideas*. B/ Bill Brandt (GB): *Perspective of Nudes*.	E/ 'Photographs by Irving Penn', MMA, New York.	Electric eye, shutter with photoelectric cell, Meopta Co. (CS).
1962	B/ Eliot Porter (USA): *In Wilderness is the Preservation of the World*. B/ Sam Haskins (GB): *Five Girls*.	Society for Photographic Education, USA. 'Riga' Photo-club (S). John Szarkowsky, Curator of Photography at the MMA, New York.	
1963	B/ Vilem Kriz (USA): *Conversation, une invitation au dialogue*. Ansel Adams: series: *Polaroid Land Photography*.	Fotogram Agency, Paris. E/ 'Lee Friedlander', IMP, GEH, Rochester. E/ 'The Photographs of Jacques-Henri Lartigue', MMA, New York.	Instamatic 50 by Kodak. Cibachrome.
1964	B/ Eliot Elisofon (USA): *The Nile*. B/ Robert Capa: *Images of War*. B/ Heinz Hajek-Halke (D): *Lichtgraphik*. B/ J.-P. Sudre (F): *Diamantines*.	Musée Français de la Photographie, Bièvres. 'Expression libre' group (F). E/ 'The Photographer's Eye', MMA, New York. E/ 'Walter Rosenblum, Photographs of Haiti' (USA), IMP, GEH, Rochester.	Vitrona, with incorporated electronic flash, by Voigtländer.
1965	B/ Lennart Nillson (S): *A Child Is Born*.	Groupe Photographie, Brussels.	Flash-Cube by Sylvania (USA).
1966	P/ Max Waldmann: *Marat-Sade*.	International Center of Photography (ICP), New York. E/ 'Towards a Social Landscape', IMP, GEH, Rochester.	
1967	P/ Arnold Newman (USA): *Stravinsky*. B/ Bert Stern (USA): *Marilyn Monroe*. B/ Edward Ruscha (USA): *Thirty Three Parking Lots in Los Angeles*. B/ Ugo Mulas (I): *New York, the Art Scene*.	R/ *Photo*, Paris. E/ 'The Persistence of Vision', IMP, GEH, Rochester. 'The Friends of Photography', Carmel (USA) Fund for Concerned Photography, (USA). Gamma Agency, Paris.	
1968	B/ Lucien Clergue (F): *Née de la vague*. B/ Cartier-Bresson (F): *Impressions de Turquie*.	E/ Cecil Beaton Retrospective, National portrait Gallery, London.	
1969	B/ Minor White (USA): *Mirrors, Messages, Manifestations*. B/ G. Winogrand (USA): *The Animals*. B/ David Bailey (GB): *Good Bye Baby and Amen*. B/ Charles Harbutt (USA): *America in Crisis*. B/ Lee Friedlander, Jim Dine (USA): *Work from the Same House*.	R/ *Creative Camera*, London. R/ *Afterimage* (USA). B/ Robert Leverant: *Zen in the Art of Photography*. Lee Witkin Gallery in New York. Société d'Art Photographique de Lituanie, Vilnius (S). E/ Tony Ray-Jones (GB): 'The English Seen', Institute of Contemporary Arts, London.	
1970	B/ Bruce Davidson (USA): *East 100th Street*. B/ Duane Michals (USA): *Sequences*. B/ Ralph Gibson (USA): *The Somnambulist*. B/ Lee Friedlander (USA): *Self-Portrait*. P/ Riebesehl (D): series: *Menschen in Fahrstuhl*. B/ Jill Freedman (USA): *Old News Resurrection City*.	E/ Cartier-Bresson: 'En France', Grand Palais, Paris. Image Bank Agency, Paris. First 'Rencontres internationales de la Photographie' in Arles (F). R/ *Zoom*, Paris.	Flash-Cube X for amateurs, by Sylvania, USA.
1971	B/ Larry Clark (USA): *Tulsa*. B/ George Tice (USA): *Goodbye, River, Goodbye*. B/ Danny Lyon (USA): *Conversations with the Dead*. B/ Philip Jones Griffiths (USA): *Vietnam Inc.* B/ Bern and Hilla Becher (D): *Die Architektur der Förder und Wassertürme*.	Foundation for Swiss photography, Zurich. Sonnabend Gallery, New York. Light Gallery, New York. The Photographer's Gallery, London. E/ Paul Strand Retrospective: 'Photographs 1915–1918', Philadelphia Museum of Art. Opening of the gallery at the Bibliothèque nationale, Paris.	

Date	Works	Institutions, events and ideas	Technical innovations
1972	B/ Les Krims (USA): *Making Chicken Soup.* B/ Robert Frank (CH): *The Lines of my Hand.* P/ Ugo Mulas (I): Series, *Verifiche.* B/ Elliott Erwitt (USA): *Photographs and Anti-Photographs.* B/ Lisetta Carmi (I): *I Travestiti.* B/ Arthur Tress (USA): *The Dream Collector.* B/ Bernard Plossu: *Surbanalisme.*	Midland Photography Group (GB). R/ *Afterimage* (USA). E/ Diane Arbus Retrospective, MMA, New York. Viva Agency, Paris. E/ Andreas Feininger (USA): 'Shells', American Museum of Natural History, New York. E/ Constantine Manos (USA): 'A Greek Portfolio', Art Institute of Chicago.	Pocket Instamatic by Kodak.
1973	B/ Charles Harbutt (USA): *Travelog.* B/ Michael Lesy (USA): *Wisconsin Death Trip.* B/ Bill Owens (USA): *Suburbia.* B/ Ralph Gibson (USA): *Deja Vu.* B/ Burk Uzzle (USA): *Landscapes.*	Sipa Press Agency, Paris. R/ *Black Photographers' Annual* (USA). R/ *Chroniques de l'art vivant* no. 44, special issue on photography. Sygma Agency, Paris, New York. B/ John Szarkowski: *Looking at Photographs.* E/ 'Henry Wessel' (USA), MMA, New York.	
1974	B/ Tony Ray-Jones (GB): *A Day Off.* B/ Robert Adams (USA): *The New West: Landscapes Along the Colorado Front Range.* B/ Ralph Meatyard (USA): *The Family Album of Lucybelle Crater.* B/ John Hilliard (GB): *Elemental Conditioning.* B/ Pierre Cordier (F): *Chimigrammes.* B/ Ralph Gibson (USA): *Days at Sea.*	E/ 'Mark Cohen' (USA), IMP, GEH, Rochester. 'Images' group (B). Canon Photo Gallery, Amsterdam. Jean Dieuzaide opens the Chateau d'Eau gallery in Toulouse. Cornell Capa, director of the International Center of Photography in New York. E/ L. Ghirri (I): 'Paesaggi di Cartone', Galleria II Diagramma, Milan.	
1975	B/ Jean-Pierre Sudre (F): *Paysages matériographiques.* B/ Eugene and Aileen Smith (USA): *Minamata.* Thomas Barrow (USA): series: *Cancellations.* B/ Sarah Moon (F): *Modinsolite.* P/ J. Philippe Charbonnier (F): *La piscine d'Arles.*	R/ *Contrejour*, Paris. Fox Talbot Museum, Wiltshire (GB). E/ 'Photography as Art—Art as Photography', Kassel. Galerie Agathe Gaillard, Paris. E/ Paul Hill (GB): 'Remnants and Prenotations', Arnolfini Gallery, Bristol (GB). E/ 'Women of Photography', San Francisco Museum of Art. E/ 'New Topographics', IMP, GEH, Rochester.	Free-floating, rubber-cushioned lenses. Visitronic automatic adjustment process, Honeywell (USA).
1976	B/ Neal Slavin (USA): *When Two or More are Gathered Together.* B/ Syl Labrot (USA): *Pleasure Beach.* B/ Nancy Rexroth (USA): *Iowa.*	E/ 'Otto Steinert: Der Initiator einer Fotografischen Bewegung', Museum Folkwang, Essen (D). Contact Press Images Agency, New York. E/ 'William Eggleston's Guide', MMA, New York. National Endowment for the Arts (USA). Prakapas Gallery, New York.	EK2 Instantaneous camera with instantaneous development on Kodak coloured paper. Gevachrome 710 by Agfa-Gevaert (D). Fujicolor, by Fuji, Japan.
1977	B/ G. Winogrand (USA): *Public Relations.* B/ Joan Lyons (USA): *Abby Rogers to her Grand-Daughter.* B/ Ken Graves and Mitchell Payne (USA): *American Snapshots.* L/ Sultan and Mandel: *Evidence.* B/ Geoff Winningham (USA): *Friday Night in the Coliseum.*	Photographic Centre, Athens. E/ 'Fashion Photography', IMP, GEH, Rochester. E/ Izis: 'Fête à Paris', Carlton Gallery, New York. The Photographic Resource Center, Boston. First Triennale in Fribourg, CH. Galerie La Remise du Parc, Paris. E/ 'Singular Realities', Newcastle upon Tyne (GB).	
1978	B/ Arnaud Claas (F): *Contretemps.* Rafael Navarro (E): series: *Dipticos.* B/ Ruth Orkin (USA): *A World through my Window.* B/ Ralph Steiner (USA): *A Point of View.* B/ Jean Dieuzaide (F): *Mon Aventure avec le Brai.* B/ Joel Meyerowitz (USA): *Cape Light.* B/ John Gossage (GB): *Gardens.*	E/ 'Tod Papageorge' (USA), Art Institute, Chicago. Fondation Nationale de la Photographie, Lyons (F). ARPA: Action et Recherche Photographique d'Aquitaine. E/ 'Robert Heineken', San Francisco, Museum of Modern Art. E/ 'Mirrors and Windows': American Photography since 1960', MMA, New York. E/ 1st 'Mois de la photo' by Paris-Audio-Visuel (Ville de Paris). E/ Galerie Agathe Gaillard, Paris.	Konica C35AF, 24 × 36 camera, entirely automatic, by Konishiroku Co, Japan. Polaroid SX 70, by Polaroid (USA).

Date	Works	Institutions, events and ideas	Technical innovations
1979	B/ Barbara Norfleet (USA): *Champion Pig*. P/ Rudolf Lichtsteiner (CH): *Zeit und Augenblick*. B/ Richarch Misrach (USA): *A Photographic Book*. B/ Bernard Plossu (F): *Le Voyage méxicain*. P/ Arno Jansen (D): *Tentakeln*. B/ Linda Connor (USA): *Solos*.	E/ Philippe Halsman Retrospective, International Center of Photography, New York. E/ Eliot Porter: 'Intimate Landscapes', Metropolitan Museum of Art, New York. E/ 'Boubat par Boubat', Fondation nationale de la photographie, Lyons (F). E/ Robert Doisneau: 'Les passants qui passent', musée d'Art moderne, Paris.	Fujica HD 1, by Fuji, Japan.
1980	B/ Greg MacGregor (USA): *Explosions: A Self-Help Book for the Handyman*. B/ Marc Riboud (F): *Instantanés de Voyage en Chine*. B/ David Bailey (GB): *David Bailey's Trouble and Strife*. B/ Lewis Baltz (USA): *Park City*. P/ Bernard Faucon (F): *Les papiers qui volent*. P/ Emmet Gowin (USA): *Edith*, Danville, Virginia. P/ Olivia Parker (USA): *Site I*. B/ Rosamond Purcell (USA): *Halflife*. B/ Morinaga (Japan): *River: its Shadow of Shadows*. P/ Heinrich Riebesehl: series: *Aquarlandshaften*.	R/ *Camera Arts*, New York. E/ 'Frederick Sommer at 75', California State University, Long Beach. E/ 'Andy Warhol: Photos', Lisson Gallery, London. E/ 'Jan Groover' (USA), Sonnabend Gallery, New York. E/ 'Roger Mertin' (USA), Light Gallery, New York. ANA Agency, Paris. Espace photographique contretype, Brussels. R/ *European Photography*, Göttingen (D). Galerie Texbraun, Paris. E/ 'Ils se disent peintres; ils se disent photographes', Musée d'Art Moderne, Paris. E/ 'Willy Ronis: Photographies 1945–1979', Rencontres Internationales de la Photographie, Arles (F).	Canon AF 35M, by Canon, Japan.
1981	B/ François Hers (F): *Le récit*. James Friedmann (USA): series: *History of the World*. B/ Leonard Freed (USA): *Police Work*. B/ Susan Neiselas (USA): *Nicaragua*. B/ Lee Friedlander (USA): *Flowers and Trees*.	E/ 'John Batho' (F), Zabriskie Gallery, New York. Galerie Junod, Lausanne (CH).	
1982	B/ Pierre de Fenoÿl (F): *Chefs-d'oeuvre des photographes anonymes du XIX^e siècle*. B, E/ Creation of Centre Nationale de la Photographie (F).	E/ 'William Wegman' (USA), Dart Gallery, Chicago. E/ 'Jerry Uelsmann', Witkin Gallery, New York. E/ 'William Larson, Laszlo Moholy-Nagy', Center for Creative Photography, Tucson (USA).	
1983	P/ Floris Neusüss (D): *Fotogramm*. P/ Lucas Samaras (USA): *March 19, 1983*. Lewis Baltz: series: *San Quentin Point*.	R/ *Clichés* (B). Pace/MacGill Gallery, New York. Galerie des Lichts, Berlin. E/ 'Frank Gohlke' (USA), MMA, New York. E/ Ralph Gibson: 'Syntax' (USA). E/ 'Henry Holmes Smith' (USA), Philadelphia College of Art. National Museum of Photography, Bradford (GB).	
1984	B/ Andreas Müller-Pohle (D): *Transformance*.	DATAR Photographic Mission (F). Musée de l'Élysée, Lausanne (CH). Musée de la Photographie, Charleroi (B).	
1985		E/ 'Todd Walker Retrospective' (USA), Friends of Photography, Carmel (USA).	

ANDREAS FEININGER
'THE PHOTOJOURNALIST', 1955.

© Andreas Feininger DR.
By kind permission of the Galerie Agathe Gaillard, Paris.

Technical Processes

The experiments that were undertaken with the aim of preserving the fleeting images of the camera obscura employed the most common of materials: paper, in association with silver salts, the properties of which were understood even in the Middle Ages.

Disappointed by the first negative, reversed, images he obtained and groping for a solution, Niépce tried out a wide range of base materials before he eventually abandoned silver salts for bitumen of Judea.

Fox Talbot, who was unaware of Niépce's research work, made the same initial choice. But he realized that he could use the negative image first obtained to re-establish a positive image on suitably treated paper and could thus multiply prints of it. All contemporary processes stem from this principle.

1812: Curtois discovers iodine.

Daguerre's ambitious drive led him to take an interest in phosphorescent powder – a truly poetic notion. But then, learning of Niépce's work, he deliberately set out to work with him and learned much from his experience and early discoveries. The understanding that he thus acquired regarding metallic plates, silver iodide and the way to develop an image by means of vapours enabled him to evolve the daguerreotype.

1819: Herschel discovers hyposulphite of soda (sodium thiosulphate).

1826: Bayard discovers bromide.

Bayard was dogged by ill luck. The fine prints produced by his process went virtually unnoticed and he was soon forgotten.

1839: Mungo Ponton uses potassium bichromate.

1846: Schönbein and Böttger discover pyroxylin or gun cotton, a component of collodion.

Niépce de Saint-Victor's knowledge of chemistry led him to exploit the properties of albumen in the preparation of his glass plates. Not long after, however, Scott Archer suggested a formula based on collodion and for the next thirty or so years this was what was used, undergoing a number of improvements.

Finally, with his introduction of gelatine bromide, Dr Maddox set photography on the path it still follows today.

A. Monochrome Processes

I. Direct process

1816–27
HELIOGRAPHY
Joseph-Nicéphore Niépce
The credit for the initial idea of photography must without question go to Nicéphore Niépce (and his brother Claude). At first he used chloride and silver nitrate on paper, but was disappointed when he found that his first images were negatives – that is to say that in them light and dark shades were reversed. He continued his research work in the hope of obtaining direct positive pictures. He abandoned silver salts and set about looking for other substances that would answer his needs, and, in 1820, used bitumen of Judea, first on a glass plate and then on polished tin. These tin plates could be etched with acid, which turned them into printing plates like those used in engraving. By these means he first reproduced a number of old engravings, then, in 1827, managed to photograph the landscape to be seen from his window. Two years later he entered into partnership with Daguerre who, after Niépce's death, carried on with this research work with considerable success.

1837–9
DAGUERREOTYPE
Louis-Jacques-Mandé Daguerre
Daguerre produced his first images, of still lifes, on copper plates, coated with highly polished silver. To render these plates sensitive to the action of light he placed them in a box containing iodine crystals the vapours of which formed silver iodide on the polished surface, turning it a golden-yellow colour and making the plates sensitive to the action of light. The picture then had to be taken within less than 1 hour. Next, the plate was placed in a developing box: a bowl at the bottom of the box contained mercury, which when heated produced vapours that made a positive image appear. This was fixed by means of sea salt, or, later, by sodium thiosulphate, then washed in distilled water and dried over the flame of a spirit lamp. In fine weather, an exposure time of about 10 to 15 minutes was necessary. The stability of the daguerreotype was subsequently much improved (Fizeau introduced gold chloride as a fixing agent), as was its sensitivity, by means of accelerating substances (Claudet: iodine bromide; Bingham: lime bromide). The photographic portrait now became possible.

1839
DIRECT POSITIVE PAPER WITH SILVER IODIDE
Hippolyte Bayard
Bayard referred to his first prints, which he produced on ordinary good-quality writing paper, as 'dessins photogénés' ('photogenic drawings'). He followed the method later used by Talbot, preparing the paper with silver nitrate, then darkening it by exposing it to daylight. Just before taking the picture, this paper was soaked in a solution of silver iodide, laid while still wet on a slate, placed in a camera obscura and exposed. Under the action of light, a *positive* image formed. This was fixed with sodium thiosulphate, washed in hot water and dried in the dark.

By 1839, Bayard was already obtaining an image in the space of 18 minutes, although he subsequently modified his formula.

1851
AMBROTYPE (known as 'amphipositives' in France, 'collodion positives' in Great Britain)
J.-R. Le Moyne
It had been noticed that a negative plate treated with collodion could appear positive when it was underexposed and placed against a dark background. J.-R. Le Moyne used Niépce de Saint-Victor's albumen process to produce direct positives. The albumenised glass plate was developed in a bath of iron sulphate heated to 90° and, when dry, was placed on a piece of black velvet or else given a coating of dark varnish on the back. Later, dark-purple glass plates were even made specially for this purpose.

July 1852
FERROTYPE (France), TINTYPE (Britain), or MELAINOTYPE (USA)
Adolphe-Alexandre Martin
This was another process for obtaining direct positive prints from a negative. The collodion was spread, not on glass, but on a plate of thin metal covered with a layer of black varnish.

The treatment took place in the usual manner; then the positive image was made to appear by means of bichloride of mercury. Brown or chocolate-coloured plates were also used or even plates to which no varnish at all had been applied, to produce an image which looked more like a daguerreotype, although it was much cheaper.

1947
POLAROID
Dr Erwin H. Land
The first Polaroid process used paper as the base material and the image produced was sepia in colour. The paper was manufactured in rolls, like ordinary camera films, but it could only be used in cameras of the Polaroid brand resembling the folding type in use fifty years earlier.

When the photograph was taken, one pulled on the tab of paper emerging from the bottom of the camera, thereby crushing capsules which contained the chemical agents necessary for the developing, which took round about 1 minute, depending on the prevailing temperature. The print was then varnished so as to preserve it better. A number of different emulsions were subsequently put on the market and the image was produced in black tones similar to those of modern prints. The earliest Polaroids measured $3\frac{1}{4} \times 4\frac{1}{4}$ inches (82.5×108 mm).

II. Negative–positive processes

1. Negatives

1834
PHOTOGENIC DRAWINGS
and

1839
CALOTYPE
William Henry Fox Talbot

When Talbot had the idea of using silver nitrate and silver chloride to sensitise paper, he at first obtained only imperfect or inadequately fixed negative images which it took from 30 to 90 minutes to produce. The oldest known negative dates from 1835.

When the discovery of the daguerreotype was announced, he hurriedly returned to his experiments and discovered a new method which he at first called the calotype, later renaming it the talbotype. The base material remained writing paper first brushed over with a solution of silver nitrate, then, when dry, dipped into potassium iodide. When washed and redried, this paper could be preserved quite well if kept away from air and light.

To obtain maximum sensitivity, just before the photograph was to be taken, the paper was plunged into a mixture of silver nitrate and gallic acid, then placed while still wet between two glass plates and immediately exposed in a camera obscura. The sheet of paper, which showed no visible image, was developed in a laboratory, in the same solution as had been used to sensitize it, and was then fixed by means of potassium bromide. The negative thus obtained was used to produce positive prints on paper treated with salt (silver chloride).

1847
ALBUMEN ON GLASS
Claude-Félix Niépce de Saint-Victor

The calotype was criticised for its lack of sharpness, due to the texture of the paper used. Niépce de Saint-Victor was successful in preparing plates of glass with albumen (egg-white) mixed with potassium iodide; they were sensitised in a bath of silver nitrate and acetic acid. After sensitising, they could be kept for up to 10 days. But their low sensitivity made it difficult to produce portraits, and, furthermore, preparing them was a tricky operation. Nevertheless, after improvements were made, they could compete with Daguerrian plates by virtue of their sharpness and lower cost.

1850–1
WET COLLODION
Frederick Scott Archer

To overcome the difficulties involved in treating plates with albumen, Scott Archer suggested using collodion, a kind of varnish composed of gun-cotton dissolved in alcohol and ether, with potassium iodide added. The glass plate was covered with this mixture and sensitised in a bath of silver. Then, just before the photograph was taken, it was placed, still wet, in a special sheath. After the exposure the operator hurried to his laboratory to develop it with iron sulphate or pyrogallic acid before the layer of collodion began to dry. Potassium cyanide, a highly toxic substance, was used for fixing, as was the classic 'hypo' (sodium thiosulphate). Exposure times in a studio varied from 3 to 12 seconds, depending on the luminosity of the sky. Thanks to this faster process, cheaper portraits now became available to the public, and the number of studios rapidly increased.

But these manipulations did nothing to facilitate outdoor photography: photographers were still obliged to carry a mass of heavy equipment with them. The better organised pushed a photographic handcart, while the wealthier used a horse-drawn mobile laboratory.

1851
DRY WAXED PAPER
Gustave Le Gray

The negative processes based on the use of paper underwent a series of improvements. Blanquart-Evrard turned Fox Talbot's calotype into a practical proposition. Le Gray, for his part, used virgin wax to stop up the pores in the paper and thereby increased its transparency, facilitating the production of prints and increasing their sharpness. Furthermore, this light material was well-suited to landscape or architectural photography which required exposure times of roughly 5 minutes in sunny weather. Its preparation was similar to that of other processes, except that after being sensitised the edges of the sheet of paper were pasted on to a piece of card or thin sheet-metal, before being placed in a sheath.

1854
PRESERVED COLLODION
De Poilly in France and Spiller and Crookes in Great Britain

Plates treated with wet collodion, which had to be used immediately, were not convenient. So attempts were made to prolong the collodion's permeability to liquids by the addition or certain substances, with a view to making it possible to delay exposing and developing them. It was no longer necessary to use laboratory tents on the spot. Once the principle was established, many new formulae were introduced, all producing similar results.

1855
DRY COLLODION
Abbé Desprats

1855
ALBUMENISED COLLODION
J.-M. Taupenot

1861
COLLODION WITH TANNIN
Major Charles Russel

Photographers now began to be liberated from the constraints imposed by wet or preserved collodion, thanks to the Abbé Desprats, who had the idea of adding resin to collodion, thereby making it possible to keep the dry plates for several days without deterioration.

Many modifications to this basic formula were subsequently introduced, the most important being Taupenot's (albumenised collodion) and Major Russel's (collodion with tannin). Using the latter formula, it became possible to preserve plates for several years, admittedly with considerable loss of sensitivity.

1864
COLLODION EMULSION
Sayce and Bolton

This was an even more practical process. It had the advantage of eliminating the sensitising bath of silver, thanks to the direct addition of silver nitrate to the collodion iodo-bromide (a method further simplified by Carey Lea in 1868).

1871
GELATINE–BROMIDE
Dr Richard Leach Maddox

The disadvantage of all the above-mentioned processes was a relatively low level of sensitivity, which limited photographers to static subjects.

Adding gelatine to the collodion was suggested on a number of occasions, but it was Maddox who discovered the formula the principle of which is still in use today. Many refinements followed, among them that introduced in 1878 by Charles Bennett, who, by warming the emulsions in preparation, improved their maturation. The plates treated with gelatine–bromide became forty times more sensitive than wet collodion plates. The way was now open for 'instantaneous' photography.

1884
NEGATIVE PAPER

1886
AMERICAN STRIPPING FILM
George Eastman

George Eastman invented the first plate-coating machine and produced rolls of negative paper which was made transparent, after developing, by the use of castor oil. In 1886, American Stripping Film was introduced: this too was negative paper in rolls, but it could be stripped and was more transparent. This facilitated the production of prints, which was still carried out in daylight.

1889
FLEXIBLE FILM
George Eastman and Henry M. Reichenbach

Hannibal Goodwin discovered a way of manufacturing a flexible, light, transparent base using a new material, celluloid; but his application to take out a patent was rejected whereas Eastman and Reichenbach's was accepted. The film was immediately put into production. It resulted in the rise of both amateur photography and the Eastman Company. When negative paper film was first introduced, cameras had to be loaded and unloaded in the Eastman factory, but in 1894 Eastman bought up Samuel W. Turner's patent and began to put into commercial production spools of film with black protective paper showing the numbers of the pictures to be taken.

2. Positive prints

It was not possible to print copies of Daguerre's images, nor of Bayard's. But Talbot used paper to produce his positive prints and this has remained the most commonly used base material, although it has, on occasion, been replaced by metal, glass, celluloid or even oilcloth.

In recent years, plastics have been widely adopted in the manufacture of base materials for positive emulsions.

It has proved possible to produce images with iron salts as well as with the salts of precious metals such as silver, gold and platinum; and many processes are based upon the use of potassium bichromate.

1834–41
SALTED PAPER
William Henry Fox Talbot

The manufacture of salted paper, which can produce extremely fine images, is quite simple. Talbot brushed a solution of sea salt over writing paper or drawing paper, then soaked it in a solution of silver nitrate to sensitise it. When dry, the paper was placed in a press under the negative to be printed and was exposed to daylight which darkened the paper where the

negative was transparent. When the image looked satisfactory, the paper was plunged into a fixing bath designed to stop it from deteriorating when exposed to light.

1839
PAPER TREATED WITH POTASSIUM BICHROMATE
Mungo Ponton
Mungo Ponton used the properties of potassium bichromate to prepare his paper. However, his process was little used, probably on account of the rather unpleasant yellowish tones.

1842
CYANOTYPE (blueprint)
John Herschel
Herschel's formula consisted in sensitizing paper with potassium ferroprussiate. When dry it was yellow in colour but it turned blue when plunged into water. For many years it was used in particular for printing architectural or industrial plans.

1847–50
ALBUMENISED PAPER
Niépce de Saint-Victor and Blanquart-Evrard
Albumenised paper differs from salted paper in that its surface may acquire a glossy or a satin finish, depending upon the method of preparation. It is less prone to 'bury' the shades of the images. It is manufactured in much the same way.

Blanquart-Evrard successfully adopted Talbot's formulae in his photographic printing works near Lille and evolved a much less time-consuming method for exposing the albumenised paper, which he developed using gallic acid, thereby obtaining a great variety of tones.

1855–66
CARBON PAPER
Alphonse Poitevin
Poitevin introduced many techniques, among them the use of carbon paper treated with a layer of gelatine bichromate mixed with a pigment made from powdered natural carbon. This layer was not developed after exposure but was washed in hot water which proportionately dissolved the lightest parts of the print, that is to say those which had been shielded from the action of light by the dark parts of the negative, since the gelatine bichromate became insoluble under the action of light and formed the image by retaining the carbon pigments.

Subsequent improvements were introduced by Swann, the Abbé Laborde, Fargier, and others, contributing to the creation of one of the finest of photographic materials, despite the difficulties involved in producing and treating it.

1858
GUM–BICHROMATE PAPER
John Pouncy
This differed from carbon paper in that gelatine was replaced by gum arabic. This made it possible to intervene manually to alter the shades of the images, a practice much favoured by the pictorialist school of the early twentieth century. The paper itself was very similar to carbon paper.

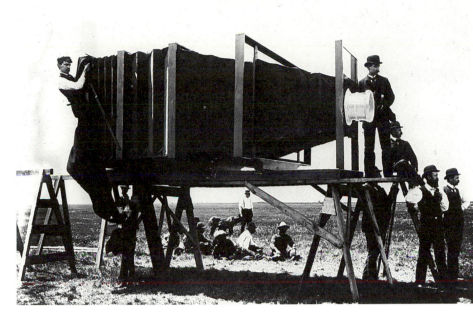

LAWRENCE
THE LARGEST PHOTOGRAPHIC CAMERA IN THE WORLD, 1918.
It weighed 634 kg and made it possible to take photographs
2.40 × 1.50 m approx.

Boyer-Viollet Collection, Paris.

1865
CELLOIDINE (collodion chloride) PAPER
G. Wharton-Simpson
This paper, covered with a layer of collodion, could be either matt or glossy. The collodion contained silver chloride and it too was printed in daylight.

1874
GELATINE–BROMIDE PAPER
Peter Mawdslet
This is the paper most widely used today. The method introduced in recent years is to spread the emulsion on a paper covered by a plastic film which prevents the liquids from being absorbed and speeds up processing, making it particularly convenient for industrial laboratories and press agencies.

1873–80
PLATINUM PAPER
William Willis
Platinum salts react to light as do silver salts and it was Willis who discovered this phenomenon. The paper he used was treated with potassium chloroplatinate. It was exposed in the usual fashion, then developed in a very hot bath of oxalic acid. The advantages of the process were that a wide range of tones could be imparted to the image and also that the grain and colour of the paper were a matter of choice. However, it was so costly that it was soon abandoned.

1882
CITRATE PAPER (gelatine chloride)
William Abney
Similar to albumenised paper, this was one of the first types of paper to be manufactured on an industrial basis, in response to the growing numbers of amateur photographers whom it

spared from a number of hitherto complicated manipulations. It lasted quite well and treating it in a bath for the combined purpose of toning and fixing was a very simple matter. The process continued to be popular up until the 1930s. Even simpler to use were self-toning papers which, thanks to the gold salts contained in their emulsion, resulted in richer and more attractive tones.

1884
GASLIGHT (chlorobromide) PAPER
Joseph-Maria Eder and Giuseppe Pizzighelli
These papers were admittedly not particularly sensitive but at least they made it possible to dispense with a whole laboratory. They were designed to be printed through contact with artificial light (hence their name). Some types produced warmer tones, some blue–black ones. One of the better known was Kodak's Velox.

1889
OZOTYPE, OZOBROME (Carbro)
Thomas Manly
A variant of the carbon process. For an Ozotype, a sheet treated with gelatine and bichromate was used; for Ozobrome, a gelatine–bromide print produced by contact or enlargement.

1904
OLEOBROM PROCESS
G.F.H. Rawlins
This process was similar to the phototype (see below) and derived from Poitevin's work. A soft roller made of gelatine is applied to a surface obtained on paper treated with bichromate, but not pigmented, as in lithography.

1907
BROMOIL
E. J. Wall and C. Welbourne-Piper
Instead of staining the surface with a roller as in the last method described, the operation was performed by hand: using a special brush, the ink was applied directly to a chemically treated gelatine—bromide print. This made it possible to intervene in all kinds of ways to modify the shades of the image.

Furthermore, this inked print could be reproduced on a sheet of engraving paper by means of a copper-plate engraving process, using a press at reduced pressure (which could be repeated, with a choice of colouring).

III. *Photographic printing processes*

1842
THE ENGRAVING OF DAGUERRIAN PLATES
Hippolyte Fizeau
Dr Alfred Donné was probably the first to obtain printed images from daguerreotypes. But Fizeau's delicate method produced more satisfactory prints. After a preliminary etching and a number of other manipulations, he deposited a 'grain' of resin, as in an aquatint, to give more 'depth' to the first phase of the process. The engraved print could be reproduced by means of electroplating.

1855
PHOTOTYPE
Alphone Poitevin
Following Talbot, Poitevin studied the properties of gelatine bichromate which, like many other gels, possessed the property of becoming insoluble when exposed to sunlight. When exposed under a negative, the gelatine becomes even more insoluble when it is in contact with the more transparent areas. It no longer absorbs humidity but can take in lithographic ink. When printed, the portions of the plate which correspond to the transparent parts of the negative thus retain the ink and appear as dark-tinted areas. Phototype has much in common with photolithography.

1865
WOODBURYTYPE
Walter Bentley Woodbury
This ingenious process made it possible to produce prints with a wider range of shades and sharper detail. A sheet treated with gelatine bichromate was printed with the image from a negative on glass. After treatment, this produced a plate which showed shadows as hollows and light areas as standing out in relief. This mould was then placed in contact with a sheet of lead and submitted to high pressure in a hydraulic press, producing another mould which, when filled with coloured gelatin and removed to a special press, produced an image on ordinary paper or even on glass.

B. Colour Photography

The earliest experiments were undertaken by Newton, who decomposed solar light by means of a glass prism, demonstrating that it was made up of radiations of different wavelengths.

After Newton, Young and Maxwell tried to recompose it. Charles Cros and Ducos du Hauron expounded the fundamental principles of colour photography. Early attempts were made to find a solution by the direct method but they were brought to a halt by the instability of the images produced. The indirect method depends upon the synthesis of three colours. In fact, there are two kinds of synthesis, additive and substractive. In the first, white light is reconstituted by the projection of three pencils of rays, coloured respectively blue, green and red (primary colours); in the second, three colours (pigments or dyes) are superposed which are the complementary colours of the preceding ones, yellow, magenta and cyan (turquoise blue). By adding coloured substances or subtracting coloured rays, according to whichever method is chosen, it is possible, through a combination of various proportions of the basic colours, to produce all the shades needed. This is the basis of all modern processes.

Only Gabriel Lippmann, in his interferential photography, and Lanchester and Wood, with their dispersion of the spectrum, have used the brilliance of luminous rays to form colour images, but their methods have never entered into common practice.

I. *Polychrome processes*

1840
COLOURED DAGUERREOTYPES
The earliest daguerreotypes were tinted by hand, sometimes with great delicacy.

1848
Attempts by Edmond Becquerel
Daguerre concentrated his efforts upon phosphorescent powders, but with little success.

Edmond Becquerel used metal plates partially treated with chloride, to copy engravings: but he never progressed beyond the stage of laboratory experiments.

1852
Abel Niépce de Saint-Victor
He was the first to obtain from the camera obscura results significant enough to win the admiration of his contemporaries. He produced colour photographs of dolls, on plates of silvered metal. Despite much research, he was not able to prevent his images from deteriorating. All the same, his two plates preserved in the Musée des Arts et Techniques are still decipherable.

1862
HELIOCHROMY
Alphonse Poitevin
Poitevin opted to use paper as his base material; but the weak sensitivity of the preparation made it impossible to use a camera obscura. So he turned to copying engravings, as had many from Wedgwood onwards, but he never discovered a successful fixing formula.

A number of other inventors worked along similar lines but with little success and quite soon abandoned their attempts.

1862–8
THREE-COLOUR SYNTHESIS
Charles Cros and Ducos du Hauron
For a long time colour photography was impossible both by the direct and by the indirect method, because emulsions were not sensitive to all the colours of the solar spectrum.

Practice thus lagged behind theory and these two men, who did not know each other and were each unaware of the other's similar experiments, announced the same method on the very same day, at a memorable meeting of the Société Française de Photographie! All the processes followed today stem from their findings.

II. *Transparencies with coloured grains*

The processes described below were founded upon the same principle. Grains of transparent, coloured matter are laid on a base material (of glass or some other substance), then covered with a panchromatic emulsion.

When the picture is taken, light passes through this mosaic of grains which act as filters.

After development the negative is printed in reverse, producing a positive image.

When the plate is subsequently examined with the light behind it, the white light passes through the coloured grains, again in proportion to the imprint received, and the tones of the subject photographed are placed in the correct positions.

The principle remains substantially the same for ruled networks.

1892
MacDonough's process
A powdering of blue, green and red grains of resin was applied to a glass plate covered with a layer of sticky varnish. The emulsion was then poured over this relatively rough mosaic.

1903
AUTOCHROME PLATE
Auguste and Louis Lumière
Based upon the same principle, the Autochrome plate was made up of a layer of tiny dyed starch grains scattered over a glass plate covered by a varnish, the interstices of which were filled in with powdered carbon. This layer was then laminated. A special yellow filter was used when the picture was taken and the first negative obtained had subsequently to be reversed. The general level of sensitivity was rather low.

1909
VERACOLOR
J. Szczepanik and K. Hollborn
AURORA plate
E. Fenske
These two processes appear never to have been widely used. The distinctive feature of the Aurora plate was that the mosaic was composed of triangular fragments.

1912
AGFA PLATE AND FILM
J. H. Christensen
These were manufactured with grains of coloured celluloid and were the only ones to have been truly commercialised.

1924
AGFA PLATE
This differed from the above in that the grains in the mosaic were made of resin.

1932
FILM-COLOR
The Lumière factories abandoned the glass plate in favour of a flexible base material composed of cellulose nitrate, which was much lighter and unbreakable. It was similar to the Autochrome process except that a filter was no longer necessary.

1933
AGFACOLOR ULTRA
This 35 mm film was different in principle from those mentioned above by reason of its special lenticular filter with three bands of colour, which had to be used when the photograph was taken. This made it necessary to increase the aperture as much as possible (to f/1.9 or f/2). The panchromatic emulsion was treated by being reversed. Another special three-colour filter was needed for projecting transparencies.

III. Processes using networks of lines

1894–7
Joly's process
Joly pursued the line of research started by MacDonough. Both men followed the suggestions of Ducos du Hauron. But instead of a three-colour mosaic, Joly used a three-colour network separate from the sensitive surface and composed of three bands of each colour per millimetre.

1895–1900
MacDonough's process
This was different from his first process using grains and more delicate than Joly's process.

1897
Dr Selle's process
Similar to the two mentioned above.

1906–7
OMNICOLOR PLATE
Ducos du Hauron, assisted by R. de Bercegol, had his Jougla factories manufacture his Omnicolor plate with an obliquely criss-crossed network which adhered to the sensitive surface.
However, it could not compete with the successful Autochrome and disappeared from commercial production.

1905–7
Krayn's process
In most network processes, a yellow filter had to be used to obtain true colours. In Krayn's process this was not necessary and, thanks to the special method for manufacturing the network, the latter could be applied to a flexible base material. However, in this case, too, the competition from Autochrome proved too powerful.

1908
DIOPTICHROME PLATE
The network for the Dufay plate resembled that of the Omnicolor one: it was criss-crossed obliquely.

1909
THAMES PLATE
The first network devised by Finlay was composed of red and green dots evenly distributed over a blue background.

1913–14
PAGET COLOR
Paget Color (already envisaged by Ducos du Hauron as early as 1868) depended upon a different principle discovered by G. Whitfield. The network was independent and formed of regular squares set out in oblique lines. Because it was more transparent, the sensibility of the plate was twice as high as in the Autochrome process. From an initial black-and-white negative a transparency was produced, upon which the colours ot the subject could be reproduced when another screen, designed for this purpose, with more saturated colours, was superimposed upon it.

1914
AGFACOLOR
Agfa used a network of lines, but applied it to rolls of film.

1931
DUFAYCOLOR
Dufaycolor was probably the last in a series of processes using networks of lines. It was composed of oblique wavy red lines superimposed upon rectangles of blue and green. It was the most sensitive and also the most expensive of colour films available at this time. It was put into commercial production in 1935 but came into competition with Kodachrome, which was already much more transparent and showed no grain when projected.

IV. Chromogenous processes

1935
KODACHROME
The research of Léopold Mannes and Léopold Godowsky resulted in the first Kodachrome, composed of three layers of emulsion in each of which a chromogenous development made the colours appear one by one. As well as its saturation, it offered the advantage of greater transparency and an almost total absence of grain. This process outclassed all the rest as soon as it came on the market.

1936
AGFACOLOR
Founded upon more or less the same principle of chromogenous development, like Kodachrome, it could be developed only in its own company's laboratories.

1943–6
EKTACHROME
This new emulsion, rather different from Kodachrome, was better suited to the needs of professional photography as it could be treated in specialised laboratories independent of the manufacturing company, or by independent photographers for themselves. The treatment comprised several phases: (1) black-and-white development to produce a negative image; (2) reversing the image; (3) plunging the positive image thus obtained into a bath of a chromogenous revealing substance which made the colours appear in the various layers of emulsion; (4) plunging this coloured image into a whitening bath which dissolved the black image; (5) fixing the image. After each operation the image had to be washed meticulously. Temperatures and timing had to be scrupulously observed throughout all the phases of the treatment, eighteen in all.

1961
KODACHROME II
The drawback of the first Kodachrome was its low sensitivity, which ruled out certain kinds of photography, even with a very wide-aperture lens. But in 1961 Kodak made available a new film which was one and a half times more sensitive. The Kodachrome used today is six times more rapid than that of 1935.

V. Negative–positive processes

1939
AGFACOLOR NEGATIVE
Agfa was successful in producing a negative film with colours complementary to those of the subject. This made it possible to produce contact prints or enlargements on paper.

1942
KODACOLOR
The principle was more or less the same as for Agfacolor. In similar fashion, it rendered it possible, while printing, to make the corrections made necessary by the spectral composition of light at the moment of the exposure, or by faulty estimation of the timing for that exposure. In the negative–positive process exposure times may be greater than with reversible emulsions. Other companies manufactured similar films (Ferrania, 1947; Telcolor, 1948). But, perhaps because of its costliness, colour photography was not to become widely popular until the 1960s.

1963
POLACOLOR
This was a process of direct photography based upon a new principle: transference by diffusion. It was quite complex. You tugged on the tab of

paper sticking out of the camera; this pulled the 'sandwich' constituted by the negative and the positive paper between rollers which crushed the capsules containing the necessary chemical products; these were thus spread over the surfaces and developing began: the chemical products were diffused throughout the different layers, thereby forming a positive image on the definitive base material, within the space of 60 seconds.

1970
FILM PR 10 KODAK
Conceived on the same bases as Polacolor but with a different process for forming the colouring agents, since these did not depend upon the reactions caused by the developing and the image now appeared on the back of the exposed film. The film was composed of eighteen superimposed layers (including the base material).

VI. Decoloration processes

1895
Otto Wiener
In 1895 Otto Wiener published a study of a direct process (Charles Cros's work had been forgotten). It had the merit of setting out the problem clearly but did not result in any concrete new discoveries.

1902
Dr Neuhaus and Karl Worel
The methods elaborated by these two scientists and published almost simultaneously were virtually identical. But they proved impossible to adapt to the taking of photographs and this line of research was not developed further until Christensen returned to the problem in 1918.

1891
INTERFERENTIAL PHOTOGRAPHY
Gabriel Lippmann's method produced excellent results as the colours formed did not depend upon dyes or pigments but stemmed from the rays of light themselves.

This might have constituted an ideal process had its elaboration not proved so complicated and the time necessary for exposure not run into more than 10 minutes in full daylight with a medium-sized aperture (12 minutes at $f/8$). It remained a fine scientific experiment with no commercial follow-up.

VII. Processes by spectral dispersion

1896 F.W. Lanchester
1899 R. W. Wood
1906 G. Lippmann
These processes, which used prisms or ruled screens, were never applied practically, so remained limited to the domain of pure science.

VIII. Processes for printing on paper

1876
PHOTOCHROMY
Léon Vidal devised a process for obtaining polychrome images (in flat tints) which called for much manual retouching on carbon paper coloured red, yellow and blue. He was a determined opponent of Ducos du Hauron's methods, but was soon forced to abandon the exploitation of his own, somewhat hybrid process.

1880
HYDROTYPE (or pinatype)
Working on the principle of three-colour selection, Charles Cros suggested a process based on gelatine bichromate and dyes which could be transferred to paper or glass; but at the time the method found no practical application. Many years later, it inspired Kodak's Wash-off Relief.

1905
TRICHROME CARBRO
Manly, also working on the principles of Ducos du Hauron and Charles Cros, used the Carbro process and carbon paper which, by dint of many manipulations, obtained prints on paper by transferring the three-colour positives. Despite the difficulties involved in registering the plates, it was a process which made it possible to obtain good enlarged prints.

1906
UTO
This was a paper for printing by means of decoloration, intended for contact-copying negatives onto Autochrome plates. It was initially manufactured in Zurich by J. M. Smith, on the basis of Szczepanik's formula, but was not well received. Having introduced improvements, Smith resumed its manufacture, under the name of Utocolor, in 1911 in La Garenne-Colombes. However, it continued to be criticised for its lack of brilliance and its imperfect fixability.

1923
JOS-PE process
In 1874, Ducos du Hauron constructed the first camera with simultaneous three-colour selection, the chromographoscope, which he replaced in 1899 by the melanochromoscope.

Josef Peter devised a similar, more modern camera with a much faster lens, which made instantaneous three-colour selection possible.

1936
WASH-OFF RELIEF
This was derived from the hydrotype process and was also based upon indirect colour selection. The process, which was promoted by Kodak, required three selection negatives to print three gelatine moulds which, once saturated with dyes, were transferred onto the definitive base material.

1941
KODACHROME PRINTS
In this process for printing Kodachrome transparencies, the base material sheet used was not paper but an acetate of white cellulose. The Kodachrome Print, produced chiefly in the United States, was followed by Ansco's Printon, in 1943.

1945
FLEXICHROME
This was a Kodak process for colouring enlargements using special transparent colours, originally designed for portraitists. Once applied to the base material, a colour disappeared if it was covered over by another.

1955
EKTACOLOR PAPER
Kodak, once again, manufactured a paper with three layers and chromogenous development for printing negatives of the same name. Like all colour photography processes, the treatment requires great care and a filtering apparatus adaptable to the conditions in which the picture is taken, not to mention the peculiar characteristics of the emulsion.

Kodak manufactured yet another type of paper for printing transparencies: Ektachrome 14 RC, for which the treatment was simplified.

1958
CIBACHROME
The Ilford Company, which took over the Lumière factories in France, produced a paper for printing enlargements in colour from transparencies. Ciba-Geigy spent many years evolving this decoloration paper, which stems from the research mentioned above. Recently further improved and now known as Cibachrome Print A–II, it makes it possible to obtain enlarged transparencies on a transparent base material.

Bibliography

Most of the nineteenth-century works devoted to the history of photography were motivated either by their authors' particular interest in the question of origins, and their assimilation of the first decades of photography to a golden age, or else by their often close connections with collections of early photographs.

In 1905, Josef Maria EDER published his *Geschichte der Photographie*, which was translated into English and reprinted several times (*History of Photography*, Dover, New York, 1978) but was written from a strictly technical point of view. Apart from a few very early and relatively inaccessible works (H. Gossin, *La Photographie, son histoire, ses procédés, ses applications*, Paris, 1887; Georges POTONNIÉE, *Histoire de la découverte de la photographie*, Montel, Paris, 1925), it was not until the end of the Second World War that the major histories of photography in French and in English appeared.

Raymond LECUYER (*Histoire de la photographie*, Baschet, Paris, 1945) was probably the first to attempt a synthesis. While from some points of view over-technical and too much centred on France, the book was extremely well researched and sumptuously illustrated.

Beaumont NEWHALL'S *The History of Photography* was first published in 1949, as an extension to an exhibition catalogue for the New York Museum of Modern Art (5th edition, Museum of Modern Art, New York, 1982).

However, the first extensive work devoted to the history of photography did not appear until 1958. This was Peter POLLACK's *The Picture History of Photography: From the Earliest Beginnings to the Present Day* (New York, Abrams, 1958). It was translated into Italian (1959), French (1961) and German (1962), but was too much centred upon a limited number of 'major figures' presented as emblematic.

In the late 1960s a long series of studies on the history of photography began to appear. It included, in particular, Michel BRAIVE's *L'Age de la photographie de Niépce à nos jours*, Brussels, La Connaissance, 1965) and above all the work by the collectors, Helmut and Alison GERNSHEIM: *The History of Photography from the Camera Obscura to the Beginning of the Modern Era*, London, Thames and Hudson, 1969. In 1967 André Jammes translated Beaumont Newhall's history into French and in the following year Emmanuel SOUGEZ published *La Photo, son histoire* (Paris, L'Illustration, 1968), followed in the next year by his second volume, *La Photo, son univers* (Paris, L'Illustration, 1969).

But all these high-quality works remain faithful to a technically based analysis of the history of photography ('the age of the daguerreotype', 'the age of the calotype', of collodion, etc.). In contrast, Aaron SHARF (*Art and Photography*, Allen Lane, The Penguin Press, London, 1968) sought to establish the formal links between photography and painting, and André VIGNEAU (*Une brève histoire de l'art de Niépce à nos jours*, Laffont, Paris, 1963) examines the effects of photography on artistic practice.

Later, in a work unfortunately without illustrations, André ROUILLÉ (*L'Empire de la photographie, 1839–1870*, Paris, Le Sycomore, 1982) set out to study the place of photography in nineteenth-century society, without dissociating its formal features from its economic, social and ideological functions.

There is only one general account of photography in the twentieth century, Peter TAUSK's *Photography in the Twentieth Century*, London, Focal Press, 1980. It presents an analysis, rather than a synthesis, of its various aspects. For recent tendencies, one may also consult the article *Photography* in the second supplement to the *Encyclopaedia universalis*, Paris, 1980.

For a general view, consult the later chapters of the major histories of photography, in particular that by Naomi ROSENBLUM.

Apart from the other works cited, there exists a dictionary devoted solely to contemporary photographers: *Contemporary Photographers*, Macmillan, 1982, with biographies, bibliographies, descriptions, collections and critical articles of a generally excellent standard.

There are two works which are concerned with all aspects of photography and which may serve as good guides to the enlightened amateur: *La Photo*, Denoël, Paris, 1976, by CHENZ and Jeanloup SIEFF; and the *ICP Encyclopedia of Photography*, Crown, New York, 1984.

Only one major work tackles the history theme by theme (landscapes, etc.): it is Arnold GASSAN's *A Chronology of Photography: A Critical Survey of the History of Photography as a Medium of Arts*, Athens (Ohio), Handbook Company, 1972, an interesting work although it unfortunately contains a number of errors of detail. Apart from this, for portraits see Ben MADDOW, *Faces*, Boston, New York Graphic Society, 1977, richly illustrated; for landscape: Estelle JUSSIM, *Landscape as a Photograph*, Yale, New Haven, 1985; for photomontages: Dawn ADES, Pantheon Books, New York, 1976; for fashion: Nancy HALL-DUNCAN, *Histoire de la photographie de mode*, Le Chêne, Paris, 1978 (on which we have drawn extensively); for surrealism: Edouard JAGUER, *Les Mystères de la chambre noire*, Flammarion, Paris, 1982, and the catalogue for the 1986 exhibition in the Centre Pompidou: *Explosante fixe*; for futurism: Giovanni LISTA, *Futurismo e fotografia*, Milan, 1980 and his catalogue for the exhibition in the Musée d'Art Moderne de la Ville de Paris, 1981.

The techniques of colour photography have been studied in an exhaustive work by Roger BELLONE and Luc FELLOT: *Histoire mondiale de la photographie en couleurs*, Paris, Hachette-Réalités, 1981. In the United States, the creative tendencies of colour photography are the subject of Sally EAUCLAIRE's *The New Color Photography*, New York, Abbeville Press, 1981.

We need not enumerate the studies produced country by country. However, the United States is so important that we should mention: John SZARKOWSKI, *Mirrors and Windows: American Photography since 1960*, Museum of Modern Art, New York, 1978, which is an exhibition catalogue; and Jonathan GREEN's highly informative *American Photography: A Critical History from 1945 to the Present*, Harry N. Abrams, New York, 1984.

In our own century, photography is increasingly accompanied by reflection upon itself. The best introduction to the concepts of photography is Henri VANLIER, 'Philosophie de la photographie', *Les Cahiers de la photographie*, special issue, 1983. Philippe DUBOIS, *L'Acte photographique*, Labor-Nathan, Brussels–Paris, 1983, is also very stimulating. Susan SONTAG, *Photography*, Farrar, Straus & Giroux, New York, 1973, is often severe but provides food for thought. Roland BARTHES, *Camera Lucida*, Jonathan Cape, London, 1982, is a brilliant essay but is not concerned with the historical aspects of photography. *La photographie, Histoire d'un art*, Skira, Geneva, 1982, by Jean-Luc DAVAL, which is well illustrated, consists mainly of a collection of thoughts and quotations.

The social impact of photography cannot be too strongly stressed. Pierre BOURDIEU's *Un Art moyen*, Editions de Minuit, Paris, 1965, remains important, as does Gisèle FREUND's *Photographie et société*, Le Seuil, Paris, 1974; and Ando GILARDI's *Storia sociale della fotografia*, Milano, Feltrinelli, 1976. It is a pity that the only book on the use of photography in magazine illustration, *Bilder för Miljoner*, Swedish radio–TV, Stockholm, 1977, by Rune HASSNER, has not been translated from the Swedish.

Two museum curators have written of their own reactions to the images chosen for particular collections: John SZARKOWSKI, *Looking at Photographs*, Museum of Modern Art, New York, 1973; and Jean-Claude LEMAGNY, *Photo créative*, Contrejour, Paris, 1984.

But more and more, photographers are themselves expressing their own attitudes and among the collections of interviews with them or specialist texts by them we should mention: David MELLOR, *Germany, The New Photography, 1927–1933*, Arts Council of Great Britain, London, 1978; Nathan LYONS, *Photographers on Photography*, Prentice-Hall, Englewood Cliffs, NJ, 1966; Thomas COOPER and Paul HILL, *Dialogue with Photography*, Farrar, Straus & Giroux, New York, 1976; Pierre BORHAN, *Voyons voir*, Creatis, Paris, 1980; and, in German, W. KEMP, *Theorie der Fotografie*, Schirmer-Mosel, Munich, 1980.

Notes

Chapter 1

[1] J.-A. Lesourd and C. Gérard, *Nouvelle histoire économique, vol. 1: le XIX^e siècle*, Armand Colin, Paris, 1976, p. 60.

[2] Letter from Claude Niépce to his brother, Nicéphore Niépce, 8 December 1825.

[3] Alhazen, Latinized form of Ibn al-Haitham (965?–1039), Arab scholar and philosopher; his studies in optics began to be known in the thirteenth century. Roger Bacon (?1214–94), English scholar and philosopher, in *De multiplicatione specierum* and in *Perspectiva*. John Peckham (*c.* 1230–92), Archbishop of Canterbury, in *Perspectiva communis*, 1279, translated in 1482 by Fazio Cardano. Guillaume de Saint-Cloud, Parisian astronomer, in a manuscript dated 1290, Bibl. nat. Paris, MS. 7281, fol. 43. Erasmus Reinhold or Rheinholt (1511–53), German mathematician, in the commentary to an edition of the work by Georg Peurbach, Dutch mathematician, *Theoricae novae planetarum*, Wittenbach, 1542. Reinerus Gemma Frisius (1508–55), Dutch physicist and mathematician and pupil of Reinhold's, in *De radio astronomica et geometrica liber*, Antwerp, 1545.

[4] Leonardo da Vinci (1452–1519) in several of his works: *Codex Atlanticus*, Milan, Biblioteca Ambrosiana, MS. D8; Paris, Institut de France, notebook (Morgan Library, New York).

[5] Giovanni Battista or Giambattista della Porta (1538–1615), Neapolitan scholar, *Magiae naturalis, sive de miraculis rerum naturalium*, Naples, 1558 (expanded edn 1589).

[6] Girolamo Cardano (1501–76), doctor, philosopher, Professor of Mathematics at Milan, Pavia and Bologna, *De Subtilitate*, Nuremberg, 1550.

[7] Friedrich Risner, *Optica*, Cassel, 1606. Athanasa Kircher (1602–81), Jesuit, Professor of Philosophy, Mathematics and Oriental Languages at Rome, *Ars magna lucis et umbrae*, Rome, 1646. Christoph Scheiner (1573–1650), Jesuit and pupil of Athanasa Kircher, *Rosa ursina, sive sol*, Bracciano, 1630. Johann Christoph Sturm, Professor of Mathematics at the University of Altdorf, *Collegium experimentale sive curiosum*, Nuremberg, 1676.

[8] Kaspar Schott (1606–66), German Jesuit, pupil of Athanase Kircher, Professor of Mathematics at Wurtzburg, *Magia universalis naturae et artis*, Wurtzburg, 1657.

[9] Johann Zahn, premonstrant monk from Wurtzburg, *Oculus artificialis teledioptricus, sive telescopium*, Wurtzburg, 1685, reprinted Nuremberg, 1702.

[10] Jacques Ozanam, *Récréations mathématiques et physiques*, Paris, re-edited or reprinted 1725, 1735, 1741, 1750, 1770, 1778, vol. I. Guyot, *Nouvelles récréations physiques et mathématiques*, Paris, 1769–70, re-edited or reprinted several times, translated into English, German and Dutch, vol. 3, *Illusions de l'optique*.

[11] Georgius Fabricius (1516–71), *De metallicis rebus ac nominibus observationes variae et eruditae*, Zurich, 1565.

[12] Giacomo Battista or Giambattista Beccaria (1682–?1766), Professor of Physics at the University of Turin, publication on the subject in 1757. Johann Heinrich Schulze (1687–1744), Professor of Anatomy at the University of Altdorf, a paper on the subject in 1727, posthumously published 1745. Jean Senebier (1742–1809), *Mémoires physicochimiques, sur l'influence de la lumière solaire pour modifier les êtres des trois règnes de la nature*, Geneva, 1782.

[13] Carl Wilhelm Scheele (1742–86), Swedish chemist, *Aeris atque ignis examen chimicum*, Uppsala and Leipzig, 1777, translated into French as *Traité chimique de l'air et du feu*, Paris 1781.

[14] Peter Galassi, *Before Photography, Painting and the Invention of Photography*, the Museum of Modern Art, New York, 1981.

[15] Albrecht Dürer (1471–1528), *Underweysung der Messung mit dem Zirckel und Richtscheyt*, Nuremberg, 1525. These *Instructions On How To Measure* contain two engravings on the subject in the original edition, four engravings in the second, German, edition (1538). Cf. Albert Dürer, *Lettres et écrits théoriques. Traité des proportions*. Texts translated and introduced by Pierre Vaisse, Hermann, Paris, 1964.

[16] Lionello Puppi, *L'opera completa del Canaletto*, Rizzoli, Milano, 1968, p. 87. Translated into French as *Tout l'oeuvre peint de Canaletto*, Flammarion, Paris, 1975.

[17] Lionello Puppi, *op. cit.*: the Correr museum in Venice contains a camera obscura with a lens and a screen of opaque glass which may have belonged to Canaletto.

[18] William Wollaston, 'Description of the camara lucida' in *Nicholson's Journal*, vol. 17, June 1807. Charles Chevalier, *Notice sur l'usage des chambres obscures et des chambres claires*, Paris, 1829. Father Jean Dubreuil, *La Perspective pratique*, Paris, 1642–9. Jean Antoine Nollet, *Leçons de physique expérimentale*, Paris, 1743–8.

[19] René Hennequin, *Avant les Photographies, les portraits au physionotrace gravés de 1788 à 1830*, J.-L. Platon, Troyes, 1932.

[20] Athanase Kircher, *Ars magna lucis et umbrae*, cf. note 7. J. A. Nollet, *op. cit.*, vol. v, p. 567–8.

[21] *Cabinet des fées ou collection choisie des contes de fées et autres contes merveilleux*, Paris, Amsterdam, 1785–9, 41 vols.

[22] Tiphaigne de la Roche (1729–74), a doctor and author of stories such as *Giphantie*, in Paris in 1760, in The Hague in 1761 and in an English translation, in London.

[23] The essays of Thomas Wedgwood (1771–1805) prompted a memoir published in the *Journal of the Royal Institution* (vol. 1, June, 1802).

[24] An announcement from Kew on 8 December 1827, issued by Niépce for the attention of the Royal Society of London and entitled 'Heliography, drawings and engravings' (Archives of the Academy of Sciences of the USSR). François Lemaître was thinking along similar lines; on 7 February 1827, he wrote to Niépce as follows: 'I hope with all my heart that your attempt will be crowned with full success, for this is a discovery which will surely be of great utility in the arts.'

[25] Report by François Arago to the Chamber of Deputies, made in the name of the commission responsible for examining the projected law relating to the acquisition of Daguerre's process, sitting of 3 July 1839.

[26] Boris Kossoy, *Hercules Florence, 1833: a descoberta isolada da fotografia no Brasil*, Faculdado de Communicação social Anhembi, Sao Paolo, 1977.

[27] *Hommage à Niépce*, Bibliothèque nationale, Paris, 1967 (catalogue prepared by Mme Chevalier and Cecile de Jandin). Paul Jay and Michel Frizot, *Nicéphore Niépce*, Centre Nationale de la Photographie, Paris, 1983. *Joseph-Nicéphore Niépce, correspondance*, 2 vols., Pavillon de la Photographie, Rouen, 1973–4.

[28] Letter from Nicéphore Niépce to his brother Claude, 16 September, 1824, published in *Dokumentii po istorii izobretenia fotografii*, USSR Academy of Sciences, Leningrad 1949.

[29] Correspondence between Daguerre and Niépce (12 to 23 October 1829), and between Niépce and Lemaître (12 to 25 October 1829).

[30] Correspondence between Niépce and Chevalier, from 1825 onwards. For Lemaître, cf. the letter of 17 January 1827, and for Daguerre, that of 2 February 1827, the postscript of which mentions the painter's letter to the inventor written in January 1826.

[31] Letter from Nicéphore Niépce to Francis Bauer, 30 November 1837.

[32] The 'Niépce–Daguerre' company was based upon a provisional agreement signed on 14 December 1829, registered on 13 March 1830, together with a *Notice sur l'héliographie* produced by Niépce in November 1829. After Niépce's death, at each stage of improvements Daguerre persuaded Isidore Niépce to sign a new agreement relegating his father to an increasingly subsidiary position. Cf. Victor Fouque, *La vérité sur l'invention de la photographie*, Paris, Chalon-sur-Saône, 1867.

[33] H. J. P. Arnold, *William Henry Fox Talbot, Pioneer of Photography and Man of Science*, Hutchinson Benham, London, 1977. Gail Buckland, *Fox Talbot and the Invention of Photography*, David R. Godine, Boston, 1980.

Chapter 2

[1] Letter from Nicéphore Niépce to his son Isidore, 2–4 September 1827.

[2] Marcel Chaigneau, *Jean-Baptiste Dumas, sa vie, son oeuvre, 1800–1884*, Guy Le Prat, Paris 1984.

[3] Maurice Daumas, *Arago*, Gallimard, Paris 1943.

[4] *Historique et description des procédés du daguerréotype et du diorama, par Daguerre*, Susse frères, Delloye, Paris, 1839; pp. 1–4: 'Exposé des motifs et projet de loi . . . présentés par M. le Ministre de l'Intérieure, séance du 15 juin 1839'.

[5] *Ibid.*, pp. 9–29, 'Rapport . . . par M. Arago, député des Pyrénées Orientales, Séance du 3 juillet 1839'.

[6] *Ibid.*, pp. 31–5, Joseph Gay-Lussac, Chambre des pairs, sitting of 30 July 1839, report.

[7] *Comptes rendus hebdomadaires des séances de l'Académie des sciences*, 7 January 1839, announcement by François Arago.

[8] 'Some account of the Art of Photogenic', *Athenaeum*, 9 February 1839.

[9] Girardin (Delphine Gay, Mme Emile de), *Oeuvres complètes*, Paris 1860, vol. IV, pp. 289–90, extract from a letter dated 4 January 1839. Louis Mayer and Louis Pierson, *La photographie considérée comme art et comme industrie*, Paris 1862, p. 29 (M. Senard's salon). Michel Gallet, 'La découverte de la photographie annoncée dans le salons de M. Irisson', *Terre d'images*, 1964, no. 1.

[10] Victor Fouque, *op. cit.*, p. 213: definitive agreement concluded in Paris between Daguerre and Isidore Niépce on 13 June 1837.

[11] Cf. the account given by Marc-Antoine Gaudin, *Traité pratique de photographie*, Paris, 1844, pp. 5–7.

[12] Annie-Dominique Denhez-Apelian, *La photographie à Montpellier au XIX^e siècle*, Université de Paris-Sorbonne, Paris IV 1983. Christian Debize, *La photographie à Nancy au XIX^e siècle*, Université de Paris-Sorbonne, UER d'art et d'archéologie, 1982. Marianne and Sylvain Morand, *Les débuts de la photographie à Strasbourg*, Strasburg, 1983 (extract from the *Annuaire de la Société des amis du vieux Strasbourg*).

[13] The three-monthly review, *History of Photography*, has published a number of studies devoted to eastern Europe: 1977: Poland, Romania, Finland, the Baltic states, Russia; 1978: Hungary, Georgia, Czechoslovakia, Bulgaria; 1979: Serbia; 1982: Albania.

[14] Bernard V. and Pauline Heathcote: 'Richard Beard: an Ingenious and Enterprising Patentee', *History of Photography*, October 1979.

[15] Francois Gouraud, *A Description of the Daguerreotype Process or a summary of M. Gouraud's Public Lectures according to the Principle of M. Daguerre*, Boston 1840.

[16] *Le Figaro*, Sunday 8 September 1839. *Le Charivari*, 10 September 1839.

[17] Nicolas Marie Paymal Lerebours, *Derniers perfectionnements apportés au daguerréotype, par MM Gaudin et N. P. Lerebours*, Paris, 1847.

[18] N. M. P. Lerebours, *op. cit.*, and the

subsequent editions. Charles Chevalier, *Recueil de mémoires et de procédés nouveaux concernant la photographie sur plaques métalliques et sur papier*, Paris, 1847.

[19] *Comptes rendus hebdomadaires des séances de l'Académie des sciences*, 23 September 1839 (first mention of Donné), 2 March 1840 (announcement on Jacoby).

[20] Alphonse Poitevin, *Traité de l'impression photographique sans sels d'argent* . . . Paris, 1862, pp. 1–24.

[21] *Le Moniteur universel*, 13 November 1839, report by Raoul Rochette.

[22] M. A. Gaudin, *op. cit.*, p. 192.

[23] Nicolas-Marie Paymal, *Traité de photographie*, Paris, 1846, p. 216.

[24] Michel Wiedemann, *Recherche sur la constitution du vocabulaire de la photographie, 1839–1870*, Paris, 1983 (extract from the Actes du colloque du Celex, ENS, Paris, 25–26 November 1983).

[25] *Annuaire général du commerce et de l'industrie ou almanach des 500 000 adresses*, Firmin Didot Frères, Paris; launched 1838, completed 1857 by the Almanach-Bottin, founded 1797. The new profession was mentioned in 1840 in the Firmin Didot and in 1844 in the Bottin.

[26] *Feuilles d'annonces et petites affiches de la Meurthe*, 29 May 1850, mentioned by C. Debize, *op. cit.*

[27] *Historique et description des procédés du daguerréotype et du diorama par Daguerre*, Alphonse Giroux & Co, Delloye, bookseller, Paris, 1839.

[28] *Le Charivari*, 10 September 1939: 'De deux nouveaux partis politiques, les daguerréotypophiles et les daugerréotypophobes.'

[29] *Aujourd'hui, journal des ridicules*, 15 March 1840.

[30] Francis Wey: 'De l'influence de l'héliographie sur les beaux-arts', *La Lumière*, 9 February 1851.

[31] Léon de Laborde: 'Rapport du jury central de l'exposition des produits de l'industrie en 1849', *La Lumière*, 23 February and 2 March 1851.

[32] L. Mayer and L. Pierson, *op. cit.* p. 45.

[33] N. M. P. Lerebours, 1843, *op. cit.*: the author reports that Claudet was preparing between thirty and forty plates each morning.

[34] *La Lumière*, 2 March 1851, article cited above.

[35] Felix Nadar, *Quand j'étais photographe*, Paris, 1900 (reprinted in *Nadar*, A. Hubschmid, Paris, 1979 vol. 2). Cf. the chapters entitled 'Balzac et le daguerréotype' and 'Clientes et clients'.

[36] Comte de Simony, 'Une curieuse figure d'artiste, Girault de Prangey, 1804–1892' in *Mémoires de l'Académie des sciences, arts et belles-lettres de Dijon 1934*. Jules Itier, *Journal d'un voyage en Chine en 1843, 1844, 1845, 1846*, Paris 1848–53, 3 vols. On Itier (1802–77), cf. A. D. Denhez-Apelian, *op. cit.*

[37] *Excursions daguerriennes, vues et monuments les plus remarquables du globe*, Rittner and Goupil, Lerebours, H. Bossange, Paris, 1842–4, 2 vols.

[38] *The Pencil of Nature*, 1844–6, 24 plates in six installments, photographs and text by Talbot.

[39] *Cours de microscopie complémentaire des études médicales, anatomie microscopique et physiologie des fluides de l'économie. Atlas exécuté d'après nature au microscope-daguerréotype*, Paris 1845, 86 aquatint engravings on 20 plates, from the daguerreotypes of Léon Foucault, assistant to Alfred Donné, who delivered the course of lectures.

Chapter 3

[1] *Official Catalogue of the Great Exhibition of the Industrial Products of All Nations, 1851*, Spicer Bros. and W. Clovers & Son, London, 1851.

[2] Roy Meredith, *Mr Lincoln's Cameraman, Mathew B. Brady*, Dover, New York, 1974, p. 49.

[3] Mayer and Pierson, *La photographie considérée comme art et comme industrie. Histoire de sa découverte, ses progrès, ses applications, son avenir*, Paris, 1862, p. 28.

[4] Louis-Adolphe Eugène Disdéri, *L'art de la photographie*, Paris, 1862, p. 28.

[5] Blanquart-Evrard, *La Lumière*, Paris, 13 April 1851, p. 37.

[6] Georges Ville, 'Introduction', in: Blanquart-Evrard, *Traité de photographie sur papier*, Roret, Paris, 1851, p. XXXV.

[7] Blanquart-Evrard, *La Lumière*, Paris, 13 April 1851, p. 37.

[8] Georges Ville, *op. cit.*, p. XXXV.

[9] *La Lumière*, Paris, 28 September 1851.

[10] *Exposition universelle de 1855. Rapports du jury mixte internationale, publiés sous la direction de S A I le prince Napoléon*, Paris, 1856, p. 1233.

[11] *Ibid.*, p. 1240.

[12] Thomas Sutton, *Photographic Notes*, London, 1857, pp. 103–4.

[13] *Exposition universelle de 1855. Rapports du jury* . . ., *op. cit.*, p. 1233.

[14] Ernest Lacan, *Esquisses photographiques à propos de l'Exposition universel et de la guerre d'Orient*, Grassart, Paris, 1856, pp. 45 and 204.

[15] *Exposition universelle de 1855. Rapports du jury* . . ., *op. cit.*, p. 1233, pp. 2 and 3.

[16] *Ibid.*, p. 1235.

[17] Cf. *La Lumière*, no. 17, 28 April 1855, pp. 68–9; no. 19, 12 May 1855, pp. 73–4; no. 28, 14 July 1855, p. 113.

[18] *Bulletin de la Société française de photographie*, Paris.

[19] *Ibid.*, p. 6.

[20] *Ibid.*, *op. cit.*, 1885, p. 216.

[21] *Ibid.*, p. 39.

[22] *Ibid.*, p. 63, reprinted in André Rouillé, *La photographie en France, 1839–1870, Les principaux textes*, Macula, Paris, 1986.

[23] Gustave Le Gray, *Photographie, Traité nouveau théorique et pratique des procédés et manipulations* . . . Lerebours and Secretan, Paris, 1852, p. 7; cf. André Rouillé, *op. cit.*

[24] *La Lumière*, no. 1, 9 February 1851, p. 3.

[25] *Exposition universelle de 1855, Rapports du jury* . . ., *op. cit.*, p. 1237.

[26] John Werge, *The Evolution of Photography*, London, 1890, p. 200.

[27] Leborgne, *Photographie, épreuves positives obtenues par collodion* . . ., Alexis Gaudin, Paris 1853.

[28] *La Lumière*, 3 September 1856.

[29] Paul Perier, 'Exposition universelle, 3ᵉ article', *Bulletin* . . . *op. cit.*, 1855, p. 194.

[30] Ernest Lacan, 'Galerie photographique de M. Disdéri', *La Lumière*, no. 45, 11 november 1854, p. 179. Cf. André Rouillé, *op. cit.*

[31] 'Renseignements, Mayer et Pierson', *Exposition universelle de 1862 à Londres, section française, catalogue officiel* . . ., Imprimerie impériale, Paris, 1862, p. 97.

[32] Dr Phipson, 'Correspondence d'Angleterre', *Le Moniteur de la photographie*, 15 March 1862, p. 5.

[33] Louis Adolphe Eugène Disdéri, *Application de la photographie à la reproduction d'oeuvres d'art*, Paris, 1861, p. 46.

[34] Henri d'Audigier, 'Chronique', *La Patrie*, 7 October 1862, p. 2; cf. André Rouillé, *op. cit.*

[35] Louis Adolphe-Eugène Disdéri, *L'Art de la Photographie*, Paris, 1862, p. 144.

[36] Alexandre Ken, *Dissertations historiques, artistiques et scientifiques sur la photographie*, Libraire nouvelle, Paris, 1864, p. 206, cf. André Rouillé, *op. cit.*

[37] See the 'Statistiques de l'industrie à Paris' for the years 1847–8 and 1860, and 'Enquêtes sur les conditions de travail (1872)', Chambre de commerce de Paris.

[38] Mayer and Pierson, *La photographie* . . ., *op. cit.*, p. 176.

[39] Robert Taft, *Photography and the American Scene*, Dover, New York, 1964, pp. 143 and 149.

[40] 'Renseignements, Mayer et Pierson', *Exposition universelle de 1862, op. cit.*, p. 96.

[41] Abbé François Moigno, 'Biographie', *Revue photographique*, no. 1, November 1855, p. 13.

[42] Paul Périer, 'Rapport sur le prix fondé par M. le duc de Luynes', *Bulletin* . . ., *op. cit.*, 1859, p. 127, cf. André Rouillé, *op. cit.*

[43] My book, *La photographie en France pendant la période 1839–1870, les principaux textes*, Macula, Paris, provides a detailed study of the controversial status of photography during this period.

[44] Blanquart-Evrard, *Traité de photographie sur papier* . . ., *op. cit.*, pp. 24 and 25; cf. André Rouillé, *op. cit.*

[45] Gustave Le Gray, *Traité pratique de photographie sur papier et sur verre*, Paris, 1850; *Nouveau traité théorique et pratique de photographie sur papier et sur verre*, Paris 1851; *Photographie, Traité nouveau* . . ., *op. cit.*, Paris 1852; *Photographie, Traité nouveau* . . ., 2nd edn., Paris, 1854.

[46] Gustave Le Gray, *Photographie* . . . *op. cit.*, Paris 1852, p. 70; cf. André Rouillé, *op. cit.*

[47] Francis Wey, 'De l'influence de l'héliographie sur les beaux-arts', *La Lumière*, 9 February 1851; cf. André Rouillé, *op. cit.*

[48] *Bulletin* . . ., *op. cit.*, 1855, pp. 2 and 3.

[49] Ernest Lacan, *Esquisses photographiques* . . ., *op. cit.*, p. 119.

[50] *Revue photographique*, 1862, p. 151.

[51] Louis Adolphe and Eugène Disdéri, *Renseignements photographiques indispensables à tous*, Paris, 1855, p. 6.

[52] Ernest Lacan, *Esquisses photographiques* . . ., *op. cit.*, p. 204.

[53] Henri Delaborde, 'La photographie et la gravure', *La Revue des Deux-Mondes*, 1 April 1856, cf. André Rouillé, *op. cit.*

[54] Louis Figuier, *La photographie au Salon de 1859*, Paris, L. Hachette et Cie, p. 2.

[55] Léon de Laborde, 'La vulgarisation de l'art est-elle ruine de l'art?', *Exposition universelle de Londres de 1851, Travaux de la commission française sur l'Industrie des Nations*, vol. VIII, p. 463.

[56] See Chapter 4, note 16.

[57] E. Paté, *Application de la photographie à la topographie militaire*, Paris, 1862. A. Jouart, *Application de la photographie aux levés militaires*, Paris, 1866.

[58] *Exposition universelle de 1855. Rapports du jury* . . ., *op. cit.*, p. 1240.

[59] Guillaume Duchenne de Boulogne, *Mécanisme de la physionomie humaine ou analyse électrophysiologique de l'expression des passions*, Renouard, Paris, 1862, p. 6.

[60] Philip H. Delamotte, *Recollections of the Art Treasures Exhibitions at Manchester, 1857*, Thomas Agnew and Sons, Manchester, n.d.

[61] John Hannavy, *Roger Fenton of Crimble Hall*, Gorden Fraser, London, 1975, p. 43.

[62] Ernest Lacan, *Esquisses photographiques* . . ., *op. cit.*, p. 119.

[63] Louise d'Argentcourt, *William Bouguerreau, 1825–1905*, Paris, Musée du Petit Palais, p. 102.

[64] Philippe Néagu and Françoise Heilbrun, 'Baldus, paysages, architectures', *Photographies*, no. 1, Spring 1983, p. 70.

[65] Ernest Lacan, *Esquisses photographiques* . . ., *op. cit.*, p. 39.

Chapter 4

[1] François Arago, 'Rapport à la Chambre des deputés, séance du 3 juillet 1839', *Historique et description des procédés du daguerréotype et du diorama*, Alphonse Giroux et Cie, Paris, 1839, p. 18.

[2] Noël-Marie Lerebours, 'Avis de l'éditeur', *Excursions daguerriennes, vues et monuments les plus remarquables du globe*, Lerebours, Paris, 1842.

[3] Ernest Lacan, *Esquisses photographiques à propos de l'Exposition universelle et de la guerre d'Orient*, Grassart, Paris, 1856, p. 20.

[4] Robert Herchkowitz, *The British Photographer Abroad: The First Thirty Years*, Robert Hershkowitz, London, 1980, p. 81.

[5] Maxime Du Camp, *Egypte, Nubie, Palestine et Syrie: dessins photographiques recueillis pendant les années 1849, 1850 et 1851, accompagnés d'un texte explicatif et précédés d'une introduction par Maxime Du Camp, chargé d'une mission archéologique en Orient par le ministre de l'instruction publique*, Gide et J. Baudry, Paris, 1852.

[6] Maxime Du Camp, *Souvenirs littéraires*, Paris, 1882, vol. 1, p. 422.

[7] Moulin, 'La photographie en Algérie', *La Lumière*, no. 12, 22 March 1856, p. 46.

[8] Isabelle Jammes, *Blanquart-Evrard et les origines de l'édition photographique française*, Droz, Geneva, 1981, p. 90.

[9] Louis de Cormenin, 'Egypte, Nubie, Palestine et Syrie, dessins photographiques par Maxime Du Camp (suite)', *La Lumière*, no. 27, 26 June 1852.

[10] Louis de Cormenin, 'Egypte, Nubie, . . .', *La Lumiere*, no. 25, 12 June 1852.

[11] Félix Teynard, *Egypte et Nubie, sites et monuments les plus intéressants pour l'étude de l'art et de l'histoire*, Goupil et Cie, Paris, London, Berlin, New York, 1858.

[12] Philippe Néagu, 'Note succinte sur la vie et l'oeuvre d'Alfred-Nicolas Normand (1822–1909)', *Alfred-Nicolas Normand architecte, photographies de 1851–1852*, catalogue by directors of the Musées de France, n.d., p. 5.

[13] Christiane Roger, *I calotipisti della Società francese di fotografia, 1840–60*, Marsilio, Venice, 1981, p. 15.

[14] Ernest Lacan, *Esquisses photographiques* . . ., *op. cit.*, p. 30.

[15] Eugène Durieu, 'Rapport', *Bulletin de la Société française de photographie*, February 1856, p. 50.

[16] Cf. above, chapter 3, note 55.

[17] Roger Fenton, 'Narrative of a Photographic Trip to the Seat of the War in the Crimea', *Journal of the Photographic Society of London*, January 1856.

[18] *Gardner's Photographic Sketch Book of the War*, Washington DC, Philip and Salomons, vols. I and II, 1866, new edition, Dover, New York, 1959.

[19] Désiré Charnay, *Cités et ruines américaines: Mitla, Palenque, Izinial, Chichen-Itza, Uxmal*, Gide, 2 vols., Paris, 1863.

[20] Désiré Charnay, 'Madagascar à vol d'oiseau', *Le Tour du monde*, July–December, p. 207.

[21] Désiré Charnay, *Cites et ruines* . . ., *op. cit.*, pp. 202–3.

[22] Moulin, *L'Algérie photographiée*, 'National publication, under the auspices of His Excellency the Minister of War and with the assistance of M. le Maréchal Count Randon, the governor-general of Algeria, the higher ranking officers and the Arab offices. This publication, intended to popularise Algeria, has been favourably received by HM Napoleon III, who has graciously allowed it to be dedicated to him . . .', Moulin, Paris, 1858.

[23] Cf. Chapter 3.

Chapter 5a

[1] For example, in his discussion of the annual street flood in Lambeth, Thomson remarks that the metropolitan authorities do nothing to prevent the disasters. In a later chapter on Italian street musicians, the writer recommends that the Elementary Education Act be extended to foreigners. See John Thomson, *Street Life in London*, Woodbury Permanent Photographic Printing Co., London, 1877, pp. 24 and 30.

[2] Riis published his autobiography, *The Making of an American*, in 1901. The book is a Horatio Alger-type account of his rise from poverty to renown.

[3] Sally Stein, 'Making Connections with the Camera — Photography and Social Mobility in the Career of Jacob Riis', *Afterimage*, May, 1983, p. 9.

[4] Jacob Riis, *How The Other Half Lives*, Scribner's Sons, New York, 1890.

[5] *Paris-Photographe*, No. 2, 1891, p. 81.

[6] Cited in Colin Ford, *Sir Benjamin Stone, 1838–1914, and the National Photographic Record Association, 1897–1910*, National Portrait Gallery, London, 1974, p. 6.

[7] Union Internationale de Photographie, *Annuaire — Manuel de la documentation photographique*, Paris, 1908, pp. 7–8.

[8] Bibliothèque Nationale, Cabinet des Estampes, Ad 993 (20) and Yf⁴ 698 I and II.

[9] In France, the carte postale format was legalised in 1872. In England and the USA, only state-printed cards were allowed before the 1890s. The boom in the production of privately printed cards dates from the 1890s: after 1894 such items were authorised in England. By 1910 there were some 123 million cartes produced annually in France. See Georges Guyonnet, *La Carte postale illustrée — son histoire, sa valeur documentaire*, Chambre Syndicale Français de la Carte Postale Illustrée, Paris, 1947, and Frank Staff, *The Picture Postcard and its Origins*, Lutterworth Press, London, 1966.

[10] Card No. 28 from this series, preserved in the collection of the Musée Sociale in Paris, is entitled 'Retour de la Mine' and contains a view of a blackened father embracing his family with the poem by the miner A. Lucas: 'Que joie pou les trois enfants, L'aller asjoint leu père, Qui tout en l'zimbrassants, L'zimpli ed noir poussières.'

[11] Peter Henry Emerson and Thomas F. Goodall, *Life and Landscape on the Norfolk Broads*, Samson Low, Marston, Searle and Rivington, London, 1886, p. iii.

[12] Peter Henry Emerson, *Pictures of East Anglian Life*, Samson Low, Marston, Searle and Rivington, London, 1888, pp. iii, 135.

[13] Sydney M. Kilgore, 'Emerson's Illustrated Books: The Relationships of Image to Text', unpublished seminar paper produced for my 1982 graduate seminar on 19th-century documentary photography.

[14] Cited in Alan Trachtenberg, 'Ever — the Human Document', *America and Lewis Hine — Photographs, 1904–1940*, Aperture, Millerton, NY, 1977, p. 132.

Chapter 5b

[1] Cited by Albert Londe, *La Photographie moderne*, Masson, Paris, 1896, p. 546.

[2] *Ibid.*, p. 650.

[3] Albert Londe, *La Photographie dans les arts, les sciences et l'industrie*, Gauthier-Villars, Paris, 1888, p. 8.

[4] Charles Baudelaire, 'Le public moderne et la photographie' (1859), in *Oeuvres complètes*, Paris, 1975–6, vol. II, pp. 617–8.

[5] Cf. W. Benjamin, 'L'oeuvre d'art à l'ère de sa reproductivité technique', translated by M. de Gandillac, in *L'Homme, le language et la culture*, Denoël/Gonthier, Paris, 1971, p. 152.

[6] Compare the text cited above with: 'On a Number of Baudelairian Themes', (1939), transl. H. Zohn, in *Charles Baudelaire, a Lyric Poet in the Era of High Capitalism*, published London, 1973.

[7] Cf. G. Simondon, *Du mode d'existence des objets techniques*, Aubier-Montaigne, Paris, 1969, pp. 134–47.

[8] E. J. Marey, *Le Développement de la méthode graphique par la photographie*, Masson, Paris, 1885, p. 2.

[9] Maurice Loewy and P. Puiseux, *Atlas photographique de la Lune*, Imprimerie nationale, Paris, 1896–1910, 12 instalments and an atlas.

[10] Jules Janssen, *Note sur la photographie de la comète b 1881, obtenue à l'observatoire de Meudon*, Gauthier-Villars, Paris, 1882, p. 2.

[11] Georges Demeny, *Le Portrait vivant*, Dechristé, Douai, n.d., p. 4.

[12] Cf. Charles Darwin, *The Expression of the Emotions in Man and Animals*, Murray, London, 1872.

[13] Cf. Georges Didi-Huberman, *Invention de l'hystérie. Charcot et l'iconographie photographique de la Salpêtrière*, Macula, Paris, 1982.

[14] Alphonse Bertillon, *La Photographie judiciaire*, Gauthier-Villars, Paris, 1890, pp. 26–45, 104–6.

[15] Henri Poincaré, 'Les rayons cathodiques et les rayons Röntgen', in *Revue générale des sciences pures et appliquées*, vol. VII, no. 2, 30 January 1896, pp. 52–9.

[16] Wilhelm Conrad Röntgen, 'Une nouvelle espèce de rayons', in *Revue générale des sciences pures et appliquées*, vol. VII, no. 2, 30 January 1896, p. 63.

[17] Hippolyte Baraduc, *L'Ame humaine, ses mouvements, ses lumières et l'iconographie de l'invisible fluidique*, Carré, Paris, 1896, p. 194; Hippolyte Baraduc, *Méthode de radiographie humaine. Force courbe cosmique. Photographie des vibrations de l'éther. Loi des auras*, Ollendorff, Paris, 1897, p. 21. Cf. G. Didi-Huberman, *op. cit.*, pp. 89–97.

[18] Cf. in particular Charles Richet, 'L'Homme et l'intelligence, fragments de physiologie et de psychologie, Alcan, Paris 1884.

[19] Cf. G. Enrie, *Le Saint suaire révélé par la photographie* (1933), transl. G. Porche, bursar of the Carmel, Paris, 1935, pp. 26–31.

[20] Paul Claudel, 'La Photographie du Christ', in *Toi qui es-tu?*, Gallimard, Paris, 1936, p. 12.

Chapter 5c

[1] Here a few examples: Charles Nègre produced heliographic prints from the negatives taken by Alfred de Luynes in the Eastern Mediterranean, which appeared in five volumes published by A. Bertrand in Paris between 1871 and 1875; *Voyages d'exploration à la mer Morte, à Patra et sur la rive gauche du Jourdain; Palais du Louvre et des Tuileries*, motifs de decoration tirés des constructions executées au Nouveau Louvre et au palais des Tuileries, Paris 1874, with heliographic prints by Edouard Baldus; *Recueil des principaux objets d'art à l'Exposition rétrospective de Lyon 1871*, printed by Perrin and Martinet in Paris and by Eude in Lyons in 1878, from negatives taken by the Dujardin brothers of Paris.

[2] For example: *Recherches historiques et archéologiques sur les églises romaines en Touraine du VIᵉ au XIᵉ siècle*, Ladevèze, Tours, 1869; *Nécropole de Camiros*, A. Detaille, Paris, 1875; *Huit jours dans les Vosges*, A. Bergeret, Paris, 1897; *La Sculpture française au Moyen Age et à la Renaissance*, Veuve A. Morel & Cie, Paris, 1884.

[3] Carl Gustaf Vilhelm Carleman, halftone engraving process in *Photography by Typographic Printing Press*, 1871.

[4] Rune Hassner, interview with Jacques Henri Lartigue, Opio, September 1978.

Chapter 5d

[1] Jeffrey Simpson, *The Way Life was — A Photographic Treasury from the American Past*, Praeger, New York, 1974.

[2] *American Album — How We Looked and How We Lived in a Vanished USA*. Jensen, Oliver, and Paterson Kerr, Joan, Belsky Murray, American Heritage Publishing Co., New York, 1968.

Chapter 5e

[1] Robert de La Sizeranne, 'La Photographie, est-elle un art?', *Revue des Deux-Mondes*, Paris 1.12.1898, reprinted in *Les questions esthétiques contemporaines*, Paris 1904, p. 149.

[2] *Ibid.*, p. 167.

[3] Robert Demachy, cited by R. Martinez, 'Propos sur le pictorialisme en Europe, 1890–1914', in *Camera*, no. 12, December 1970, p. 8.

[4] Robert Demachy and Constant Puyo, *Les procédés d'art en photographie*, Photo Club de Paris, Paris, 1906, p. 2.

[5] Cited by H. P. Robinson, 'O. G. Rejlander', in *Anthony's Photographic Bulletin*, 21 (22 February 1890), pp. 107–10, reprinted in *Photography, Essays and Images*, ed. B. Newhall, New York, Museum of Modern Art, 1980.

[6] Peter Henry Emerson, 'Photography, a pictorial art', in *The Amateur Photographer*, 3 (19 March 1886); reprinted in *Photography, Essays and Images, op. cit.*, p. 161.

[7] Cited by Jean Sagne, *L'Atelier du photographe (1840–1940)*, Presses de la Renaissance, Paris, p. 109.

[8] Alfred Stieglitz, 'Pictorial Photography', in *Scribner's Magazine* 26 November 1899, pp. 528–57, reprinted in *Photography, Essays and Images, op. cit.*, p. 163.

[9] Robert Demachy and Constant Puyo, *Les Procédés d'art en photographie, op. cit.*, p. 62.

[10] Ernst Juhl, 'Vᵉ exposition internationale de photographie artistique organisée à Hambourg par la GFAP', in *Bulletin de l'Association belge de photographie*, 1898, pp. 31–7.

[11] *Ibid.*

[12] See bibliography. In particular, Robert Demachy and Constant Puyo, *Les procédés d'art en photographie*, Photo Club de Paris, 1906.

[13] *Art. cit.*, note 1.

[14] Ernst Juhl, 'Les progrès de l'art et des arts industriels par la photographie', in *Association belge de photographie, XXVᵉ anniversaire de la fondation, 1873–1898, Album jubilaire*, Brussels, 1896.

[15] Henry Peach Robinson, *Pictorial Effect in Photography*, London, 1869 (1), 1879 (2), 1880 (3), 1893 (4). On Peter Henry Emerson, see his lecture of 1886, 'Photography, a pictorial art' (*art. cit.*) and his major work, *Naturalistic Photography for the Students of the Arts*, London 1889 (1), 1890 (2), 1899 (3), which remained Alfred Stieglitz's favourite reading for many years.

[16] Robert de La Sizeranne, *op. cit.*, p. 150.

[17] Alfred Stieglitz, 'The Photo-Secession', in *The Bausch & Lomb Lens Souvenir*, Rochester 1903; reprinted in *Photography, Essays and Images, op. cit.*, pp. 167–71.

[18] Alfred Stieglitz, 'A Plea for Art Photography in America', in *Photographic Mosaics*, 1892, pp. 135–7.

Chapter 6

[1] Nicos Hadjinicolaou, 'Sur l'idéologie de l'avant-gardisme', *Histoire et critique des arts*, no. 6, July 1978, pp. 54–5.

[2] Lincoln Kirstein, 'Photographs of America: Walker Evans', in Walker Evans, *American Photographs*, Museum of Modern Art, New York, 1938, p. 187.

[3] F. T. Marinetti, 'Fondation et manifeste du futurisme', *Le Figaro*, 20 February 1909; reprinted in *Futurisme: Manifestes, proclamations, documents*, ed. Giovanni Lista, Musée d'Art moderne de la Ville de Paris, 1981.

[4] 'Manifeste des peintres futuristes' (1910), Boccioni, Carrà, Russolo, Balla, Severini', reprinted in *Futurisme*, p. 170.

[5] The best history of futurist photodynamism is the catalogue, *Photographie futuriste italienne 1911–1939*, ed. Giovanni Lista, Musée d'Art Moderne de la Ville de Paris, 1981.

[6] 'Les exposants au public' (1912): Boccioni, Carrà, Russolo, Balla, Severini', reprinted in *Futurisme*, p. 170.

[7] William Innes Homer, *Alfred Stieglitz and the American Avant-Garde* (New York Graphic Society, Boston, 1977) gives a useful chronological history of the exhibitions held at Gallery 291. Jonathan Green, ed., *Camera Work: A Critical Anthology* (Aperture, Millerton, NY, 1973) provides a chronological index to all the articles and figures published by this magazine. See also Marianne Fulton Margolis, *Camera Work: A Pictorial Guide* (Dover, New York, 1978).

[8] Alfred Stieglitz, 'Four Happenings', *Twice-A-Year*, nos. 8/9 (1902), pp. 105–36, reprinted in Nathan Lyons, ed., *Photographers on Photography*, Prentice-Hall, Englewood Cliffs, 1966, pp. 131–3.

[9] Marius de Zayas, 'Photography and Artistic-Photography', *Camera Work*, no. 42–43 (July 1913), p. 14. See also his other essay, 'Photography', *Camera Work*, no. 41 (January 1913), pp. 17–19.

[10] Alfred Stieglitz, 'Our Illustrations', *Camera Work*, nos. 49–50 (June 1917), p. 36.

[11] Paul Strand, 'The Art Motive in Photography', *British Journal of Photography*, vol. 70 (1923), p. 612–15. See also his essay, 'Photography', *Seven Arts* (August 1917), p. 524–6; also in *Camera Work*, nos. 49–50 (June 1917), pp. 3–4.

[12] 'The Richard Mutt Case', *The Blind Man, P.B.T.*, no. 2 (May 1917), p. 5.

[13] Alfred Stieglitz, 'How I came to Photograph Clouds', *The Amateur Photographer and Photography*, vol. 56 (1923), p. 255. See also Alan Sekula, 'On the Intervention of Photographic Meaning', *Artforum*, vol. XIII (January 1975), pp. 36–45.

[14] Edward Weston, *The Daybooks of Edward Weston*, ed. Nancy Newhall, vol. 1, Mexico, George Eastman House, Rochester, 1961, p. 4.

[15] *Ibid.*, p. 132.

[16] *Ibid.*, p. 136.

[17] A. Reyner, *Camera Obscura* quoted in *Vᵉ Congrès International de Photographie, Brussels 1910. Papers, minutes, reports, notes and documents published*

under the care of Ch. Puttemans, L.-P. Clerc and E. Wallon (Bruylant, Brussels, 1912), p. 72. See also Albert Londé, *La Photographie moderne*, Masson, Paris, 1888.

18 For Atget's biography, see Maria Morris Hambourg, 'A Biography of Eugène Atget', *The Work of Atget, vol. II – The Art of Old Paris*, The Museum of Modern Art, New York 1982, pp. 9–31.

19 *Atget, photographe de Paris* (Paris and Leipzig, H. Jonquières, 1930, and New York, E. Weyhe, 1930), preface to the French and American editions by Pierre MacOrlan. Atget sold six boxed albums to the Bibliothèque Nationale, Paris, between 1910 and 1915; one of these was incorporated into the catalogue for the exhibition 'Eugène Atget, Intérieurs parisiens', with text by Margaret S. Nesbit and Françoise Reynaud, held at the Musée Carnavalet, Paris, in 1982.

20 Walter Benjamin, 'Petite histoire de la photographie', *L'homme, le langage et la culture*, trans. Maurice de Gandillac (Denoël, Paris 1971), p. 70. 'L'Oeuvre d'art à l'ère de sa reproductibilité technique', pp. 137–81.

21ᵃ Benjamin, 'Petite histoire', pp. 70.

22 *Ibid.*, pp. 70–1.

23 Raymond Williams, 'Advertising: the magic system', *Problems in Materialism and Culture*, New Left Books, London, 1980, pp. 170–95.

24 On this point, see J.H. Haendel, *La Pratique commerciale*, Doin, Paris 1911, p. 84–6.

25 *Ibid.*, p. 80.

26 Harry L. Hollingworth, *Advertising and Selling: Principles of Appeal and Response*, Appleton, New York and London, 1913, pp. 142 and 166.

27 Roland Barthes, 'Rhétorique de l'image' (1964), *L'Obvie et l'obtus: Essais critiques* III, Le Seuil, Paris, 1982, pp. 25–42.

28 On photomontage, see Sally Stein, 'The Composite Photographic Image and the Composition of Consumer Ideology', *Art Journal*, vol. 41 (Spring 1981), pp. 39–45.

29 Edmund Wilson, Jr, 'The Aesthetic Upheaval in France – the influence of jazz in Paris and the Americanization of French literature and art', *Vanity Fair* (February 1922), pp. 49, 100.

30 Laszlo Moholy-Nagy, *Malerei, Fotografie, Film*, Langen, Munich, 1925, p. 111.

31 See *Bauhaus Photography*, ed. Egidio Marzona and Roswitha Fricke, American translation by Harvey Mendelsohn and Frederic Samson, MIT, Cambridge, Mass., 1985.

32 Moholy-Nagy, *op. cit.*, pp. 28–9.

33 Moholy-Nagy, *Von Material zu Architektur*, Langen, Munich, 1929, p. 50.

34 Dawn Ades, *Photomontage*, Thames and Hudson, London, 1976, p. 12.

35 Brassaï, 'Mon ami André Kertész', *Camera* (April 1963), p. 8.

36 Anna Farova, *André Kertész*, Grossman, New York, 1966, no page numbers.

37 Herbert Molderings, 'Urbanism and Technological Utopianism: Thoughts on the photography of Neue Sachlichkeit and the Bauhaus', in *Germany: the New Photography, 1927–1933*, ed. David Mellor, Arts Council, London, 1978, p. 93. Kertész's photography was used to advertise Bruckmann's cutlery. See *Die Dame*, notebook no. 4, November 1929, p. 29.

38 See Dawn Ades, *Dada and Surrealism Reviewed*, Arts Council, London, 1978; Rosalind Krauss, 'The Photographic Conditions of Surrealism', *October*, no. 19 (winter 1981), pp. 3–34; Alain Mousseaux, 'Surréalisme et photographie: rôle et place de la photographie

dans les revues du mouvement surréaliste 1929–1939', in *L'Art face à la crise 1929–1939*, Université de Saint-Etienne, Centre Interdisciplinaire d'Etudes et de Recherche sur l'Expression Contemporaine, Saint-Etienne, 1980, p. 153–81.

39 Brassaï, *Paris de nuit*, Arts et Métiers Graphiques, Paris, 1933, preface by Paul Morand. See also: *Brassaï, Technique de la photographie de nuit*, Arts et Métiers Graphiques, no. 33 (15 January 1933), pp. 24–7; Rosalind Krauss, 'Nightwalkers', *Art Journal*, vol. 41 (spring 1981), pp. 33–8; Colin Westerbeck, 'Night Life: Brassaï and Weegee', *Artforum*, vol. XX (December 1976), pp. 34–45.

39ᵃ From the title of a book by Karl Blossfeldt (1928).

40 'Brassaï, Images Latentes', *L'Intransigeant*, 15 November 1932, p. 6.

Chapter 7a

1 Boris Arvatov, *Iskusstvo i proizvodstvo* (Art and Production), Moscow, 1926.

2 *Levyi front iskusstv* (Left Front of the Arts), LEF, a group of writers, literary critics and artists, former futurists, formalists, constructivists, led by Mayakovsky; from 1923 to 1925 they published a magazine bearing the same name.

3 *Novyi Lef*, the new magazine of the Left Front of the Arts, published from 1927 to 1928; in 1928 with Tretyakov as its editor.

4 Ossip Brik, 'Foto-kadr protiv kartiny' ('Photography versus painting'), *Sovetskoye foto*, no. 2, 1926.

4ᵃ See for example *Alexander Rodchenko*, edited by David Elliott, Museum of Modern Art, Oxford, 1979; *Alexander Rodtschenko. Fotografien 1920–1938*, ed. by Evelyn Weiss, Wienand Verlag, Cologne, 1978; and *Rodtchenko photographe*, Museum of Modern Art of the City of Paris, 21 June–20 Sept. 1977.

5 *Oktyabr* (October) – an association of constructivist artists founded in 1928.

6 *Novaya ekonomicheskaya politika* (NEP), 1921–7.

7 The best known of these albums, entitled 'October', was distributed to the delegates of the Third Congress of the Comintern. Today it is on display at the Museum of the Revolution in Leningrad.

8 In 1919, the photo and film industry was nationalised and the production of films and photographs was put under the supervision of the People's Commissariat of Englightenment (Decree of 27 August 1919).

9 Michael Farbman, *Piatiletka. Russia's 5-Year Plan*, New Republic, Inc., New York, 1931, p. 9.

9ᵃ A. Rodchenko, 'Krupnaya bezgramotnost' ili melkaya gadost'?', Open letter to the editor of *Sovetskoye foto*, published in *Novyi Lef*, no. 6, 1928.

10 A. Rodchenko, 'Predosterezheniye' (Warning), *Novyi Lef*, no. 11, 1928, p. 37.

11 Theory attributed to the formalist writer Victor Shklovsky (b. 1893) who applied it to literature before the October Revolution. It was later adopted by Bertolt Brecht.

12 A. Rodchenko, 'Krupnaya . . .', *op. cit.*

13 A. Rodchenko, 'Puti sovremennoy fotografii' ('Pathways of contemporary photography'), *Novyi Lef*, no. 9, 1928, p. 32.

14 *Ibid.*, p. 39.

15 S. Tretyakov, 'The biography of the object', *Literatura fakta*, no. 54, 1929, where he calls for 'books such as Forest,

Wheat, Coal, Iron, Linen . . . Locomotive, Factory' which 'can best be realised by applying the method of the "biography of the object"'.

16 For the first time in an anonymous letter (signed 'A Photographer'), published in the magazine *Sovetskoye foto*, no. 4, April 1928, p. 176.

17 S. Tretyakov, 'B'em trevogu!' (We sound the alarm!), *Novyi Lef*, 1927.

18 Ossip Brik, 'Ot kartiny k foto' ('From painting to photography'), *Novyi Lef*, no. 3, 1928, p. 35.

19 A. Rodchenko, 'Protiv summirovannogo portreta, za momental'nyi snimok' ('Against the synthetic portrait, for the candid photograph'), *Novyi Lef*, no. 4, 1928, p. 15.

20 B. Arvatov, *Ob agitatsionnom i proizvodstvennom iskusstve* (On Agitation and Productivist Art), Moscow, 1930.

21 AKhRR (Assotsiatisiya khudozhnikov revolyutsionnoy Rossii) – association of realist and naturalist painters, founded in 1922, in the tradition of the 'Wanderers' school of the 19th century.

22 'Mechanism and expression: The essence and value of photography', *Photo-eye*, 76 photos of the period, ed. Franz Roh and Jan Tschichold, Stuttgart, 1929, p. 14. Franz Roh's statement that 'not to be able to handle a camera will soon be looked upon as equal to illiteracy' recalls what Lunacharsky, People's Commissar of Enlightenment, said in 1926: 'He who does not know how to photograph will be the illiterate of the future.' (See also note 25.)

23 S. Tretyakov, 'Prodolzheniye sleduet' (To be continued), *Novyi Lef*, 1928.

24 *Sovetskoye foto* (Soviet Photography), a journal for amateur and press photography, published by the People's Commissariat for Enlightenment (*Narkompros*) from 1926 on. From September 1931 until 1935 it was published under the title *Proletarskoye foto* (Proletarian Photography).

25 *Sovetskoye foto*, no. 1, 1926.

26 ODSKF – Obchestvo druzey sovetskoy kinematografii i fotografii. One of the numerous voluntary organisations typical of the 1920s; others were, for example, the Association against Illiteracy and the Association of Friends of Soviet Radio.

27 RFO – Russkoye fotograficheskoye obchestvo, founded at the end of the 19th century in St. Petersburg.

28 See *Sovetskoye foto*, no. 8, 1928.

29 In 1928, production in the Soviet photographic industry reached only a quarter of the pre-war level. It was only thanks to the home industry (*kustary*) during the NEP period that an amateur movement on a large scale was able to develop.

30 This, however, already represented the first step towards a denial of the original concept of photography on a collective basis. This new trend towards professionalism and specialisation also took place in other spheres at the beginning of the 1930s.

31 In April 1932, by decree of the Central Committee, the amateur correspondent movement was dissolved and the most active amateurs were officially raised to the rank of professional photo correspondents.

32 S. Fridland, 'Za proletarskuyu fotografiyu' ('For a proletarian photography'), *Proletarskoye foto*, September 1931.

33 B. Zherebtsov, 'Sozdadim khudozhestvenny "fotografichesky film"', *Proletarskoye foto*, no. 12, 1932.

34 ROPF – Russkoye obchestvo proletarskikh fotografov.

35 Manifesto of the spearhead of ROPF,

Proletarskoye foto, no. 2, 1931.

36 Workers' comments on photographs of the Left have been compiled in *Sowjetische Fotografie 1928–1932*, ed. by R. Sartorti and H. Rogge, Hanser, Munich, 1975.

37 S. Fridland, *op. cit.*

38 See note 36.

39 'Programme of the Photo Section of the October Group', IZOFRONT. *Klassovaya bor'ba no fronte prostranstvennykh iskusstv*, OGIZ. IZOGIZ, Moscow–Leningrad, 1931, pp. 149–51.

40 *Ibid.*, p. 149.

41 The same demands were formulated by the Russian Association of Proletarian Writers (RAPP).

42 S. Tretyakov, 'Ot fotoserii- k dlitel'nomu fotonablyudeniye' ('From the Photographic series to long-term photographic observation'), *Proletarskoye foto*, no. 4, 1931.

43 A series of seventy-eight photographs taken by A. Shaykhet, M. Alpert and S. Tules, edited by Le. Mezhericher. It was sent on exhibit to Vienna, Prague and Berlin and was also published in the German magazine *Arbeiter-Illustrierte-Zeitung* in 1931.

44 Letters to the editor of *Sovetskoye foto* in 1931.

45 S. Fridland, 'Za proletarskuyu fotografiyu', no. 1, September 1931, p. 14.

46 Open letter from the October Group to the editor of *Proletarskoye foto*, no. 2, 1932.

47 Decree of the Central Committee of 23 April 1932, 'O perestroyke literaturno-khudozhestvennykh organizatsii' ('On the Transformation of the Literary and Artistic Organisations').

48 The art photographers were dismissed from their posts as instructors of photographic circles and in 1929 publication of the art journal *Fotograf* was discontinued.

49 V. Grishanin, 'Fotoiskusstvo na novykh putyakh' ('The art of photography: New directions'), *Zhurnalist*, nos. 31–32, 1932, p. 8.

50 G. Boltyansky, 'Na putyakh bor'by za tvorchesky metod' ('On the road of struggle for a creative method'), *Proletarskoye foto*, no. 2, 1932, p. 7.

51 S. Fridland, *Proletarskoye foto*, 1933.

52 *Sovetskoye foto*, nos. 5–6, 1936.

53 Ivan A. Goncharov, *Oblomov*, Moscow, 1859.

Chapter 7b

1 For the history of photography, see: Italo Zannier, 1922/1943, in *Il Diaframma Fotografia Italiana*, no. 203, May 1975, Editphoto, Milan, pp. 24–9; Ando Gilardi, *Storia sociale della fotografia*, Feltrinelli, Milan 1976, pp. 370–2; Carlo Bertelli, *La fedeltà incostante*, in C. Bertelli and G. Bollati, *Storia d'Italia – Annali 2 – L'immagine fotografica 1845–1945*, Giulio Einaudi, Turin, 1979, vol. 1, pp. 137–98, vol. 2, figs. 352–676 and pp. 286–303; Francesca Alinovi, 'La fotografia in Italia negli anni Trenta', in *Gli Anni Trenta – Arte e cultura in Italia* (catalogue) Mazzotta, Milan 1982, pp. 409–434; Angelo Schwarz, 'La photographie en Italie entre les deux guerres', in *1833/1983: Un temps pour la photographie*, proceedings of the colloquium on the history of photography, Musée Nicéphore-Niépce, Chalon-sur-Saône, 1983, pp. 59–76. See also: Ernesto G. Laura, *Immagine del fascismo*, Longanesi, Milan, 1973; Renzo De Felice, Luigi Goglia, *Storia fotografica del fascismo*, Laterza, Bari, 1981; Eva Paola Amendola, ed., *Storia fotografica del partito communista italiano*, Editori Riuniti, Rome, 1981.

[2] Giuseppe Turroni, *Franco Grignani – Il segno come matrice: Il fenomeno come variabilita analitica*, supplement no. 12 to *Il Diaframma Fotografia Italiana*, no. 235, March 1978, Editphoto, Milan, 1927.

[3] *L'Arte della Fotografia alla Terza Mostra Internazionale delle Arti Decorative, villa Reale di Monza*, May–October 1927 (catalogue), Rizzoli, Milan.

[4] Gruppo Piemontese per la Fotografia Artistica, *Luci e Ombre*, 'Raccolta annuale di fotografie artistiche italiane', Edizione d'Arte, E. Celanza, Turin, 1923. In 1924, *Luci e Ombre*, 'The annual of Italian art photography' was edited by the periodical *Corriere Fotografic*, Turin, which merged with the *Annuario della fotografia artistica* which it had hitherto been publishing.

[5] The first number of the bi-monthly *Foto Grafia*, under the aegis of the Circolo Fotografico Milanese and the *Domus* review, and directed by Guido Pellegrini and Gio Ponti, appeared in July 1932; it comprised twelve pages 23 × 33 cm; no. 7 (June 1933) had increased to thirty-two pages.

[6] Orio Vergani, *Sotto i cieli d'Africa, dal Tanganica al Cairo*, Treves, Milan, 1936.

[7] Carlo Bertelli and Giulio Bollati, *op. cit.*, vol. 2, fig. 591.

[8] Renzo De Felice, Luigi Goglia, *op. cit.*, chap. 1, figs. 1–88.

[9] *L'Italia fascista in cammino*, Instituto Nazionale Luce, 8 September X, 29 October XI, Rome: text and legends in Italian, French, English, German and Spanish.

[10] A collection of these 'memoranda' appear as an anthology in Francesco Flora, *Ritratto di un ventennio*, Alfa, Bologna, 1965, pp. 115–182; 'Non pubblicare che il Duce ha ballato' in *Phototeca*, a. II, no. 3, Milan 1981.

[11] On modes of creation and manipulation, including the use of photography and photographic images, see Adolfo Mignemi, ed., *Immagine coordinata per un impero – Etiopia 1935–1936*. On the relations between photography and colonialism, see the monograph in the number entitled 'Fotografia e colonialismo/2' in the *Rivista di storia e critica della fotografia*, a. IV, no. 5, June–October 1983, Priuli and Verlucca, Ivrea.

[12] *128ᵉ Legione Camicie Nere: Documentario Fotografico dell' attività svolta durante la campagna per la conquista dell'Impero Fascista*, July 1935, XIII EF, June 1937, XV EF.

[13] Angelo Schwarz, 'Tempo, un settimanale italiano', in Federigo Patellani and Angelo Schwarz, *Federigo Patellani, Documenti e notizie raccolti in trent' anni di viaggio nel Sud*, supplement 1 to *Il Diaframma Fotografia Italiana*, no. 224, March 1977, Editphoto, Milan.

[14] *Patellani: 25 anni di fotografie per giornali*, Aldo Martello, Milan 1965; Federigo Patellani and Angelo Schwarz, *op. cit.*

[15] On Cesare Barzacchi, Leo Longanesi and the photographs published in *Omnibus*, see Cesare Barzacchi, *L'Italia di Longanesi*, Edizioni del Borghese, Rome, 1964.

[16] On photojournalism and the use of photographic images in weeklies, see Angelo Schwarz, *Materiali per una ricerca sulla fotografia nei periodici illustrati italiani*, in Lanfranco Colombo, SICOF '79 – cultural section (catalogue), published by the GEXPO Society S.r.l., Milan, 1979, pp. 62–79.

[17] Dino Alfieri and Luigi Fredi (historical guide, eds.), *Mostra della Rivoluzione Fascista*, Partito Nazionale Fascista, Rome, 1933.

[18] Anton Giulio Bragaglia, *Fotodinam-*

isma Futurista, Giulio Einaudi, Turin, 1980, reprint of the third 1913 edition and a critical edition. For Carlo Ludovico Bragaglia on photodynamism, see Sandro Pandolfi, 'Intervista con Carlo Ludovico Bragaglia: Il Fotodinamismo Futurista', in *Galleria*, Cultural Centre for the image, Il Fotogramma, Rome, March 1983.

[19] *Mostra sperimentale di Fotografia Futurista* (catalogue), Turin, 1931.

[20] Filippo Tommaso Marinetti and Tato, *Manifesto della Fotografia Futurista*, 11 April 1930, and (Guglielmo Sansoni) *Tato raccon Tato da Tato*, Milan, 1940, in C. Bertelli and G. Bollati, *op. cit.*, vol. 2, pp. 286–7, 294–301, figs. 510–15.

[21] Maria Francesca Occhipinti, *Signori d'Italia nei fotoritratti di Ghita Carell*, Longanesi & C., Milan, 1978.

[22] Piergiorgio Dragone, *Arturo Ghergo: Ritratti*, supplement 23 to *Il Diaframma Fotografia Italiana*, no. 247, March, 1979, Editphoto, Milan; *Arturo Ghergo: Dive, dagli anni '30 agli anni '50* (catalogue), Sugarco, 1984, bilingual Italian–English text; Giuseppe Turroni, *Luxardo – L'Italica bellezza*, Mazzotta, Milan, 1980.

[23] Luigi Veronesi (catalogue), Centro Studi ed Archivo della Communicazione, University of Parma, Parma 1975; Paolo Fossati, *Luigi Veronesi: Foto-Grafia*, supplement 5 to *Il Diaframma Fotografia Italiana*, no. 228, July–August 1977, Editphoto, Milan; *Luigi Veronesi: Fotogrammi e fotografie 1927–80*, Giulio Einaudi, 1983.

[24] *Campo Grafico 1933–1939* (catalogue), Electa, Milan, 1983.

[25] Piero Berengo Gardin, ed., *Alberto Lattuada Fotografo – Dieci anni di occhio quadrato 1938/1948*, Alinari, Florence, 1982, a re-edition of Alberto Lattuada's *Occhio quadrato*, published by Corrente, 1941.

[26] *Luci e Ombre*, Corriere Fotografico, Turin, 1931.

[27] *Luci e Ombre*, Corriere Fotografico, Turin, 1936.

[28] *Mostra sperimentale di Fotografia Futurista*, p. 7, *op. cit.*

[29] Sauro Lusini, Fabrizio Tempesti, ed., *Foto di gruppo (1930–1950)* (catalogue), Assessorato alla Cultura e Centro Storico/Archivo Fotografico Toscano, Prato 1983.

[30] *Ibid.*

[31] On the photographers Cavalli, Leiss, Finazzi, Vender and others active in the post-war period, see Italo Zannier, ed., *Il dopoguerra dei fotografi* (catalogue), Grafis Edizioni, Bologna, 1942. On Leiss, see also Italo Zannier, ed., *Ferruccio Leiss fotografo a Venezia*, Electa, Milan, 1979.

[32] Cesare De Seta, ed., *Giuseppe Pagano fotografo*, Electa, Milan, 1979.

[33] Ermanno R. Scopinic, *Fotografia, Prima rassegna sull'attività fotografica in Italia*, Gruppo editoriale Domus, Milan, 1943, bilingual Italian–German text.

[34] A. Franchini Stappo, G. Vannucci-Zauli, *Introduzione per una estetica fotografica*, Cionini, Florence, 1943.

[35] Carlo Mollino, *Il messaggio della camera oscura*, Chiantatore, Turin, 1949.

[36] For example, Eva Paola Amendola, *op. cit.*, figs. 269–294.

[37] Alberto Folin and Anna Panicali, *L'esperienza antifascista da Eugenio Curiel a Elio Vittorini*, in Alberto Folin, ed., *Immagine di popolo e organizzazione del consenso in Italia negli anni trenta e quaranta*, Marsilio, Venice 1979, pp. 114–22.

[38] Massimo Mila, Alberto Papuzzi, *Ci fu un tempo, Ricordi fotografici di Franco Antonicelli. 1926–1945* (catalogue), Regione Piemonte, Turin, 1977.

[39] Roberto Predali, Giovanni Testori, *Lorenzo Antonio Predali: La faccia*

dell'uomo, Supplement 7 to *Il Diagramma Fotografia Italiana*, no. 230, October 1977, Editphoto, Milan.

[40] Franco De Poli, Ando Gilardi, Giuseppe Prisco, 'Dal Don al Nikolajewka', *Il Diaframma*, Milan 1968.

[41] Vincenzo Carrese, 'Un album di fotografie: Racconti', *Il Diaframma*, Milan 1970. On Vincente Carrese and his Publifoto agency, see also: Cesare Colombo, ed., *Professione Fotoreporter* (catalogue), Massimo Baldini, Milan 1983.

Chapter 7c

[1] August Sander, letter to Erich Stenger, 21 July 1925, Fotohistorama Collection, Leverkusen.

[2] See August Sander, *Menschen des 20: Jahrhunderts*, ed. Ulrich Keller and Gunther Sander, Munich, 1980.

[3] Hagen Schultz, *Die Deutschen und ihre Nation Weimar Deutschland 1917–1933*, Berlin, 1982, p. 39.

[4] Harm Schröter, Verena Schröter and Lars Lambrecht, 'Die wirtschaftliche Entwicklung der Weimarer Republik' ('The economic development of the Weimar republic'), in *Weimar Republik*, Berlin, 1977, p. 1974.

[5] Max Burchartz, 'Neuzeitliche Werbung' in *Die Form*, notebook 7, 1925, pp. 138–9.

[6] B. W. Randolph, *American Education in Advertising and Marketing*, Gebrauchsgraphik, 3rd year, notebook 2, 1926, p. 3.

[7] See also 'Publizistische Medien' in *Weimar Republik*, Berlin 1977, pp. 369–349.

[8] Tim Gidal, *Deutschland: Beginn des modernen Photojournalismus*, Lucerne, 1972, p. 22.

[9] Siegrid Kracauer, *Das Ornament der Masse*, Frankfurt, 1977, p. 34.

[10] See Sperling, *Repertoire des journaux et des périodiques*, no. 53, 1927.

[11] Willi Munzenberg, *Erobert den Film*, Berlin, 1925, p. 6.

[12] Joachim Büthe, Thomas Kuchenbuch, Günther Liehr, Friedhelm Roth, Jan Thorn Prikker, Alois Weber, Richard Weber, *Der Arbeiter Fotograf, Dokumente und Beitrage zur Arbeiterfotografie, 1926–1932*, Cologne, 1977, p. 34.

[13] *Der Arbeiter Fotograf* II, notebook no. 5, p. 5, 1928.

[14] Willy Stiewe, *Das Pressefoto als publizistisches Mittel*, Leipzig, 1936, p. 120–1.

[15] *Der Arbeiter Fotograf* III, notebook 7, 1929.

[16] Babette Gross, Willi Munzenberg, *A political biography*, Michigan State University Press, 1974, p. 163.

[17] Peter Panther (alias Kurt Tucholsky), *Ein Bild sagt mehr als 1000 Worte*, UHU, 3rd year, notebook 2, 1926/27, p. 83.

Chapter 7d

[1] Speech by Reichsminister Goebbels, in *Hefte der Betriebsausstellung Druck und Reproduktion* no. 1, Berlin, 1933, pp. 3–6.

[2] W. Werner, *Findbücher zu Beständen des Bundesarchivs*, vol. 15, R 55, Coblenz 1979, pp. VI–IX; see also Anon. 'Heiner Kurzbein', in *Photofreund*, 13/1933, p. 407.

[3] H. Biallas, 'Die Deutsche Arbeitsfront und "Die Kamera"' ('The German Labour Front and "Die Kamera"'), catalogue for the 'Die Kamera' exhibition, Berlin, 1933, p. 13–14.

[4] A. Hitler, 'In eigner Sache', in *Das Deutsche Lichtbild*, 1934, Berlin, 1933, pp. T5–T11.

[5] H. Kurzbein, 'Erste Richtlinien des

RDAF', in *Photofreund* 13/1933, pp. 367–8.

[6] Cf. R. Sachsse, 'Heimat als Reisland', in K. Pohl, *Ansichten der Ferne*, Reisephotographie 1850-heute, Giessen, 1983, pp. 128–50.

[7] Catalogue for the 'Die Kamera' exhibition, Berlin, 1933, Stuttgart, 1934.

[8] G. Koshofer, *Farbfotografie*, vol. 2, Munich, 1981, pp. 30–48.

[9] S. Kruckenhauser, *Verborgene Schönheit*, Salzburg, 1938; interview with S. Kruckenhauser, 17 July 1983, in Salzburg.

[10] G. Selle, *Die Geschichte des Designs in Deutschland von 1870 bis heute*, Cologne, 1978, pp. 143–58; see also H. E. Mittig, 'Die Reklame als Wegbereiterin des nationalsozialistischen Kunst', in B. Hinz et al., *Die Dekoration als Gewalt*, Giessen, 1979, pp. 31–52, and J. Heskett, 'Modernismus' und 'Archaismus' im Design während des Nationalsozialismus, pp. 53–60.

[11] L. Riefenstahl, *Hinter den Kulissen des Reichsparteitag-Films*, Munich, 1935, p. 31.

[12] Quoted from *Photofreund* 18, 1938, notebook I, p. 18.

[13] P. Wolff, 'Lebendige Gegenwarstfotografie mit der Kleinkamera', in *Gebrauchsfotografie*, 44, 1937, p. 222–5.

[14] C. G. Philipp, 'Erna Lendvai-Dirksen', in *Fotogeschichte* 3, 1983, notebook 7, pp. 39–56; R. Sachsse, 'Skizze zu Erich Retzlaff', in *Fotografie* 4, 1980, notebook 12, pp. 47–51.

[15] Cf. L. Strelow, 'Das Volkgesicht in der Photographie', in *Photofreund* 14, 1980, pp. 68–9.

[16] Cf. 'Die Photolehrgänge der Deutschen Arbeitsfront', in *Photofreund* 16, 1936, notebook 2, p. 29.

[17] A. de la Croix, *Photographierte Familiengeschichte*, Berlin, 1937, p. 3.

[18] H. Pecker and H. Hoffmann, *Hitler's Tischgespräche im Bild* ('Hitler's Speeches, Illustrated'), Munich, 1980, pp. 60–1.

[19] H. Barkhausen, *Filmpropaganda für Deutschland*, Hildesheim, Zurich/New York, 1982, pp. 202–11.

[20] D. Reifarth, V. Schmidt-Linsenhoff, 'Die Kamera der Henker', Fotografische Selbstzeugnisse des Naziterrors in Osteuropa, in *Fotogeschichte* 3, 1985, notebook 7, pp. 57–71.

Chapter 7e

[1] Dr Julius Klein, 'It's great to be a young man today', *American Magazine*, February, 1930, p. 12.

[2] Ernest Elmo Calkins, 'Consumptionism', *Printer's Ink*, 22 May 1930, p. 49.

[3] Quoted in Carl Sandburg, *Steichen the Photographer*, Harcourt, Brace and Co., New York, 1929, p. 54.

[4] *Printer's Ink*, 28 April 1920, p. 81.

[5] 'Futuristic monstrosities are all the rage', *Printer's Ink*, 12 November 1925, p. 60.

[6] W. Livingston Larned, 'Let the decorative designer turn your product into a pattern', *Printer's Ink*, 21 February 1929, p. 150.

[7] W. Livingston Larned, 'Making novel perspective the keynote of the campaign', *Printer's Ink*, 10 January 1924, p. 33.

[8] *Printer's Ink*, 16 May 1929, p. 137.

[9] Walker Evans, 'The reappearance of photography', *Hound and Horn*, Oct.–Dec. 1931; reprinted in Alan Trachtenberg, ed., *Classic Essays in Photography*, Leete's Island Books, New Haven, 1980, p. 186.

[10] Lincoln Kirstein, 'Photography in the United States', in Holger Cahill and Alfred H. Barr, Jr, *Art in America in*

Modern Times, Reynal and Hitchcock, New York, 1934, p. 86.
[11] Interview by Leslie Katz, *Art in America*, Mar.–Apr. 1971.

Chapter 8

[1] Tim Gidal, *Modern Photojournalism, Origin and Evolution, 1910–1933*, Collier, New York, 1972; Rune Hassner, *Bilder för Miljoner*, Swedish radio–TV, Stockholm, 1977, in Swedish.
[2] Paul Wolff, *My First Ten Years with the Leica*, B. Westermann, New York, 1935; *Prestige de la Photographie*, review, Editions e.p.a., Paris, nos. 1–6, June 1977 to 1979.
[3] Helmut Gernsheim, *Felix H. Man, Bildjournalist der ersten Stunde*, Grafik-Design, Berlin, 1983.
[4] *Erich Salomon, Porträt einer Epoch – Portrait of an Age*, Ullstein, Frankfurt, 1963, and Macmillan, New York, 1967; Peter Hunter, *Erich Salomon*, Aperture, Millerton, NY, 1978.
[5] Catalogue for the *Spontaneity and Style* exhibition, ICP, New York, 1978. Nancy White and John Esten, *Style in Motion: Munkacsi*, Clarkson N. Potter, New York, 1979.
[6] Sandra S. Phillips, David Travis and Weston J. Naef, *André Kertész of Paris and New York*, Art Institute of Chicago, Thames and Hudson, London, 1985.
[7] Henry Miller, *Brassaï*, Neuf, Paris, 1952; Brassaï interview, *Dialogue with Photography* by Paul Hill and Thomas Cooper, London, 1979; *Brassaï*, exhibition catalogue (introduction by Lawrence Durrell), Museum of Modern Art, New York, 1968.
[8] Brassaï, *Conversations avec Picasso*, Gallimard, Paris, 1964.
[9] *Graffiti de Brassaï*, Stuttgart and Paris, 1961.
[10] *Shadow of Light: A Collection of Photographs from 1931 to 1966* (introduction by Cyril Connolly), Viking Press, New York, 1966; *Bill Brandt Behind the Camera* (introduction by Mark Haworth-Booth), essay by David Mellor, Phaidon, Oxford, 1985.
[11] Edward Steichen, *Life Memorable Photographs*, Museum of Modern Art, New York, 1951; *The Best of Life*, Time-Life Books, New York, 1973; *Life 1946–1955*, Graphic Society, New York, and Paul Montel, Paris, 1984.
[12] *The Photographs of Margaret Bourke-White*, Graphic Society, New York, 1972; Jonathan Silverman, *For the World to see the Life of M. B. W.*, Viking Press, New York, 1983; Margaret Bourke-White, *Portrait of Myself*, G. K. Hall, Boston, 1985.
[13] *Witness to our Time*, Viking Press, New York, 1966; *Eisenstaedt on Eisenstaedt*, Abbeville Press, New York, 1985.
[14] Peter Bunnell and Lincoln Kirstein, *W. Eugene Smith: His Photographs and Note*, Aperture, Millerton, NY, 1969; William S. Johnson, *W. Eugene Smith, Master of the Photographic Essay*, Aperture, Millerton, NY, 1981.
[15] *Images of War*, Grossman, New York, 1964, Milan and Düsseldorf, 1965; Hachette, Paris, 1966; Anna Farova, *Robert Capa*, Grossman, New York, 1968; *R. Capa*, in ICP Library of Photographers, New York, 1974; Romeo Martinez, *Robert Capa*, Milan, 1979; Sylvie Messinger, *Robert Capa photographe*, Paris, 1985.
[16] *Israel: The Reality*, ICP, New York, 1969; Georges Soria, *Les Grandes Photos de la guerre d'Espagne*, Paris, 1980; Georgette Elgey, *Front populaire*, Chêne-Magnum, Paris, 1976.

[17] *Le Village des Noubas*, Delpire, Paris, 1955; Inge Bondi, *George Rodger*, London, 1974.
[18] Anna Farova, *Chim, A Monograph*, Prague and New York, 1967; D. Seymour in *The Concerned Photographer* series, ICP, New York, 1974; Henri Cartier-Bresson and Judith Frieberg, *David Seymour – Chim, 1911–1956*, Grossman, New York, 1966, and London, 1974.
[19] Manuel Gasser, *W. Bischof, Carnet de route*, Delpire, Paris, 1957; Anna Farova, *The Photographs of Werner Bischof*, Prague, 1964, and New York, 1968; Rosellina Burri-Bischof and René Burri, *Werner Bischof, 1916–1954*, New York, 1974.
[20] Yves Bonnefoy, *Henri Cartier-Bresson, photographe*, Delpire, Paris, 1980; no. 18 in *Cahiers de la Photographie*, 1986, with bibliography.
[21] In *Images à la sauvette*, Verve, Paris, 1952; reprinted in *Cahiers de la Photographie, supra*.
[22] *Weegee by Weegee*, Ziff Davis, New York, 1969; Louis Stettner, *Weegee*, Alfred A. Knopf, New York, 1977; Allene Talmey and Marvin Israel, *Weegee (Arthur Fellig)*, New York and London, 1978; John Coplans, *Weegee Violenti e Violenti*, Milan, and Schirmer-Mosel, Munich, 1978; *Le New York de Weegee*, Denoël, Paris, 1982.
[23] *Lisette Model*, Aperture, Millerton, NY, 1979, preface by Berenice Abbott.
[24] Gustavo Casasola, *Historia grafica de la revolucion mexicana*, catalogue in 10 vols., editorial Trillas, Mexico 1960; Carlos Monsivais, *Archivo Casasola, Pueblo en armas*, Mexico 1973.
[25] *Ovo Magazine*, 1981, vol. 10, nos. 40–41; *Creative Camera*, July–August, 1983, nos. 223–224.
[26] *Paul Strand. A retrospective monograph*, 2 vols., Aperture, Millerton, NY, 1972; Paul Strand, *Sixty Years of Photographs*, Aperture, Millerton, NY, 1976. Books by Paul Strand: *Time in New England*, Oxford University Press, London, 1950; *La France de profil*, with text by Claude Roy, La Guide du Livre, Lausanne, 1952; *Un Paese*, with text by Cesare Zavattini, Einaudi, Turin, 1955; *Tir a Mhurain, Outer Hebrides*, MacGibbon and Kee, London, 1962, and Grossmann, New York, 1968; *The Mexican Portfolio*, Da Capo, New York, 1962 and 1967; *Living Egypt*, with text by James Aldridge, Horizon, New York, 1969; *Ghana, An African Portrait*, with text by Basil Davidson, Chêne, Paris, 1976.
[27] James Enyeart, *Bruguière. His Photographs and his Life*, Knopf, New York, 1977.
[28] Martin Friedman, *Charles Sheeler, Paintings, Drawings, Photographs*, Watson-Guptil, New York, 1975.
[29] Margery Mann, *Imogen!*, Seattle, University of Washington Press, 1974; Judy Dater, *Imogen Cunningham, A Portrait*, Boston, Graphic Society, New York, 1979.
[30] Graham Howe, *Paul Outerbridge Jr: Photographs*, Rizzoli, New York, 1980.
[31] Harold Edgerton, *Flash! Seeing the Unseen*, Boston, 1939; Harold Edgerton, *Moments of Vision: The Stroboscobic Revolution in Photography*, MIT, Cambridge, Mass., 1979.
[32] *Gjon Mili: Photographs and Recollections*, Boston, 1980.
[33] John Szarkowski, *Callahan*, Aperture, Millerton, NY, and Museum of Modern Art, New York, 1976; Peter C. Bunnell, *Harry Callahan*, New York, 1978, exhibition catalogue, 38th Venice Biennale; *Harry Callahan, Color*, Matrix, Providence, 1980.
[34] *Places: Aaron Siskind Photographs*,

Light Gallery, New York, 1976; Carl Chiarenza, *Aaron Siskind: Pleasures and Terrors*, New York Graphic Society, 1982.
[35] Nancy Hall-Duncan, 'Photographic Surrealism', exhibition, Cleveland, 1970; *L'Amour fou: Photography and Surrealism*, Abbeville Press, New York, 1985.
[36] Jean Clair, *Marcel Duchamp et la photographie*, Chêne, Paris, 1977.
[37] Cited on p. 5 in Edouard Jaguer, *Les mystères de la chambre noire: Le surréalisme et la photographie*, Flammarion, Paris, 1982.
[38] *Retrospective Fotografie: Paul Citroen*, introduction by Michael Pauseback, Bielefeld and Dusseldorf, 1978.
[39] On montages, see the book by Dawn Ades, *Photomontage*, Chêne, Paris, 1976.
[40] *Hans Bellmer: photographe*, preface by Alain Sayag, Filipacchi, Paris, Centre Georges-Pompidou, 1983.
[41] Andrew Causey, *Paul Nash's Photographs: Document and Image*, Tate Gallery, London, 1973.
[42] Cited in Edouard Jaguer, *Les mystères de la chambre noire, op. cit.*, p. 216.
[43] Beaumont Newhall, *Herbert Bayer: Photographic Works*, Arco Center, Los Angeles, 1977.
[44] Günter Metken, *Herbert List. Fotografien*, Schirmer-Mosel, Munich, 1976.
[45] Roland Penrose, *Man Ray*, Chêne, Paris, 1975; Arturo Schwarz, *Man Ray: Soixante ans de libertés*, Eric Losfeld, Paris, 1971; *Man Ray photographe*, Centre Georges-Pompidou, Paris, 1981, exhibition catalogue.
[46] *André Kertész of Paris and New York*, text by Sandra Phillips, David Travis and Weston Naef, Art Institute of Chicago, Metropolitan Museum and Thames & Hudson, New York, 1985.
[47] David Travis, *The Julien Levy Collection starting with Atget*, The Art Institute of Chicago, 1976: to be consulted, together with the work cited in note 46, for the principal photographers in Parisian circles during this period.
[48] Suzanne Page and Herbert Molderings, *Florence Henri*, ARC, Paris, 1978.
[49] *Ilse Bing*, exhibition catalogue, Paris, Galérie des Femmes, 1982; Nancy Barrett, *Ilse Bing: Three decades of Photography*, New Orleans Museum of Art, 1985.
[50] *Paris*, ed. Jeanne Walter, Paris, introduction by Fernand Léger, montages and photographic superpositions by Moï Ver.
[51] In *Tout le reste est littérature*, published in a collection entitled *Vues*, Editions de la Table ronde, 1939, reprinted in *L'Arc*, no. 21, Spring 1963.
[52] Jaroslav Andel and Antonin Dufek, *Ceska fotografie 1918–1938*, Brno, Moravska Gallery, 1981. German translation: *Tschechische Fotografie 1918–1938*, Museum Folkwang, Essen, 1984; Daniela Mrazkova and Vladimir Remes, *Tschechoslowakische Fotografen 1900–1940*, Veb Fotokinovlag, Leipzig, 1983; catalogue *Photographes tchèques 1920–1980*, Centre Georges-Pompidou, Paris 1983.
[53] Anna Farova, *Frantisek Dritkol*, Museum of Decorative Arts, Prague, 1972.
[54] Sonya Bullaty and Anna Farova, *Josef Sudek*, Clarkson N. Potter, New York, 1978.
[55] Gabor Szilagyi, *Leletek: A. magyarfotografia történetébol*, Kiado, Budapest, 1983.
[56] Ryszard Bobrowski, *Fotografia Polska 1839–1979*, Polish Photography 1839–1979, New York, 1979; Adam Sobota, *Art Photography in Poland 1900–1939*, in *History of Photography*, vol. 1, no. 4, 1980.

[57] Urszula Czartoryska, *Présences polonaises*, exhibition at the Centre Georges-Pompidou, Paris, 1983.
[58] 'Ideas y Caos: Aspectos de la vanguardias fotograficas en Espana', exhibition, Madrid, 1984.
[59] Gerardo Vielba, *Jose Ortiz-Echague Photographies*, Chêne, Paris, 1979.
[60] Marie de Thézy, 'Paris 1950 photographié par le Groupe des XV', exhibition, Bibliothèque Historique de la Ville de Paris, 1982; *The Family of Man*, Museum of Modern Art, New York, 1955, catalogue.
[61] Exhibition *Road to Victory* and *Power in the Pacific*, thereafter devoted to the Korean war.
[62] *A Life in Photography: Edward Steichen*, W. H. Allen, London, 1963, chapter 13.
[63] Roland Barthes, *Mythologies*, Jonathan Cape, London, 1972, pp. 91 and 100.

Chapter 9

[1] Catalogue Otto Steinert, Museum Folkwang, Essen, 1981.
[2] Italo Zannier: *Il dopoguerra dei fotografi*, Casalecchio di Reno (BO), grafis, 1985.
[3] Italo Zannier, *Ferruccio Leiss, fotografo a Venezia*, Milan, 1979.
[4] Catalogue Luigi Veronesi, Parma, 1975.
[5] Minor White, *Rites and Passages*, Aperture, Millerton, NY, 1978.
[6] *Le Zen dans l'art chevaleresque du tir à l'arc*, Dervy-Livres, Paris, 1981.
[7] *Wynn Bullock: Photography: A Way of Life*, Dobbs Ferry, New York, 1973.
[8] *Paul Caponigro*, Aperture, Millerton, NY 1967; *The Wise Silence: Photographs by Paul Caponigro*, New York Graphic Society and Little Brown, 1983.
[9] *Raymond Moore*, Welsh Arts Council, Cardiff, 1968.
[10] *Robert Frank*, Aperture, Millerton, NY, 1976; *Cahiers de la Photographie*, nos. 11–12, 1983.
[11] In *Cahiers de la Photographie*, nos. 11–12, 1983, p. 52.
[12] *Ibid.*, p. 21.
[13] Victor Burgin, *Two Essays on Art, Photography and Semiotics*, London 1976.
[14] *William Klein*, catalogue, Centre Georges-Pompidou, Herscher, Paris 1983; Carole Naggar, 'Klein index', in *Anthologie de la critique en soixante-deux rubriques à suivre*, Creatis, Paris, 1982.
[15] On the photograph market: Jacob Deschin, *35 mm photography*, Spring 1976; Gerard Barrière, *Connaissance des Arts*, no., 293, July 1976.
[16] Helen Gee: *Photography of the Fifties: an American Perspective*, Center for Creative Photography, Tucson, 1980.
[17] An example of a great collection: *A Book of Photographs from the collection of Sam Wagstaff*, Gay Press, Washington 1978.
[18] *Shadow of Light*, London and New York, 1966; *Bill Brandt, Nudes 1945–1980*, London and Boston, 1980; *Bill Brandt Behind the Camera*, Phaidon, Oxford, 1985.
[19] Claude Bedat, *Jean Dieuzaide*, Université de Toulouse-Mirail, 1978; *Mon aventure avec le brai*, Saint-Pons, 1974.
[20] *Full Color*, Contrejour, Paris, 1983.
[21] *L'Amérique vu du ciel*, Chêne, Paris, 1983.
[22] *Ralph Eugene Meatyard*, Gnomon Press, Lexington, 1970; *Ralph Eugene Meatyard*, Aperture, Millerton, NY, 1974; Ralph Eugene Meatyard, 'Caught Moments, New Viewpoints', Olympus Gallery, London, 1983.
[23] Peter Bunnell, *Jerry N. Uelsmann*,

Aperture, Millerton, NY, 1970; *Jerry N. Uelsmann, Silver Meditations*, Morgan and Morgan, Dobbs Ferry, NY, 1975; *Jerry N. Uelsmann, Twenty Five Years, A Retrospective*, Graphic Society, Boston, New York, 1982.

[24] Among the publications of the works of D. Michals are: *Sequences*, Doubleday, New York and Milan, 1970; *The Journey of the Spirit after Death*, Winter House, New York, 1971; *Things Are Queer*, Wilde, Cologne, 1972; *Real Dreams*, Addison House, Damburry, NH, 1977; on Michals: Ronald H. Bailey, *Duane Michals, the Photographic Illusion*, cf. *D.M.*, Paris, Musée d'Art Moderne de la Ville de Paris, 1982; Thames and Hudson, London, 1975.

[25] Other books: A. D. Coleman, *The Theatre of the Mind*, Morgan and Morgan, New York, 1976; Michel Tournier, *Rêves*, Complexe, Brussels, 1980.

[26] The present paragraphs owe much to Nancy Hall-Duncan, *The History of Fashion Photography*, Chanticleer Press, New York, 1979. See also Polly Devlin, *Vogue Book of Fashion Photography 1919–1979*, Simon and Schuster, New York, 1979.

[27] James Baldwin, *Nothing Personal*, Atheneum, New York 1964; *Richard Avedon: Portraits*, Farrar, Straus and Giroux, New York and London, 1978; Roland Barthes, 'Avedon', in *Photo*, January 1977.

[28] *Lee Friedlander: Photographs*, Haywire Press, New City, NY, 1978.

[29] On the thought of Garry Winogrand, *Afterimage*, vol. 5, no. 6, December 1977.

[30] Dominique Auerbacher, 'Jacques Darche' in *Photographies* no. 8, Paris, July 1985.

[31] Sergio Leone, *Surbanalisme*, Chêne, Paris, 1972; J.-C. de Feugas, 'Bernard Plossu', in *Creatis* no. 2, Paris, 1977; Denis Roche, *Le Voyage mexicain*, Contrejour, Paris, 1972; *Bernard Plossu, Nueva Lente*, Madrid 1979.

[32] On Japan, see *New Japanese Photography*, Museum of Modern Art, New York, 1974.

[33] *Primer Coloquio latinoamericano de Fotografia*, Consejo mexicano de Fotografia, Mexico, 1978; *Hecho en latinamerica*, Consejo mexicano de Fotografía, Mexico, 1982.

[34] *Diane Arbus*, Aperture, Millerton, NY, 1972; *Diane Arbus*, Chêne, Paris 1973; Patrick Roegiers, *Diane Arbus ou le rêve du naufrage*, Chêne, Paris, 1985; Patricia Bosworth, *Diane Arbus a Biography*, A. Knopf, New York, 1984; *Diane Arbus photographe de presse*, Herscher, Paris 1984.

[35] *Joyce Baronio*, Contrejour, Paris, 1980.

[36] *Children Boxers in New York City*, l'Etoile–Cahiers du Cinéma, Paris 1984.

[37] *Portraits nus*, Contrejour, Paris, 1984.

[38] *Gabriele und Helmut Nothhelfer*, Folkwang Museum, Essen, Berlin, 1980.

[39] Arturo C. Quintavalle, *Mario Giacomelli*, Parma, 1980.

[40] *Koudelka-gitans: La fin du voyage*, Robert Delpire, Paris, 1977; Allan Porter and Danièle Sallenave, *Joseph Koudelka*, special issue of *Camera*, Lucerne, August 1979; *Edouard Boubat*, Belfond, Paris, 1982; *Pauses*, Contrejour, Paris, 1983.

[41] *Edouard Boubat*, Belfond, Paris 1982. *Pauses*, Contrejour, Paris 1983.

[42] Other books: *Working, I do it for the money, Our Kind of People, American Groups and Rituals*, Straight Arrow, San Francisco 1975; Simon and Schuster, New York, 1975.

[43] *Bruce Davidson, Photographs*, Simon and Schuster, New York, 1979.

[44] Langston Hughes, *The Sweet Flypaper of Life*, New York, 1956 and 1958; *Roy de Carava*, Carmel, Calif., Friends of Photography (Untitled no. 27), 1981.

[45] *Un autre monde*, Denoël, Paris, 1971.

[46] Jorg Krichbaum: *Heinrich Riebsehl, Situationen und Objekte*, Riesweiler, 1978; *Agrarlandshaften*, Bremen, 1979.

[47] Cited in *Contemporary Photographers*, p. 630.

[48] *Ibid.*, p. 531.

[49] *Ibid.*, p. 495.

[49a] *Art in America*, April 1971.

[50] New York correspondence, Ed. de l'Etoile, Paris, 1983.

[51] *Contemporary Photographers*, p. 652.

[52] *Magubane's South Africa*, Alfred A. Knopf, New York, 1978.

[53] Among the publications of Hamish Fulton are: *Hollow Lane*, London, 1971; *Ten Views of Brockman's Mount* (hill in Kent), Amsterdam, 1973; *Skyline Ridge*, London, 1977; *Nine Works, 1969–1973*, London, 1977; *Roads and Paths*, Munich, 1978.

[54] *Contemporary Photographers*, p. 294.

[55] *Ugo Mulas, Immagini e Testi*, University of Parma, Instituto di storia dell'Arte, 1973; *Ugo Mulas Fotografo, 1928–1973*, Kunsthaus, Zurich, and Musée Rath, Geneva.

[56] Ken Josephson, The Museum of Contemporary Art, Chicago, 1983.

[57] In *American Photography*, Harry N. Abrams, New York, 1984, p. 218.

[58] 'Harold Jones', by Van Deren Coke in *Creative Camera* (London), August 1969.

[59] Exhibition catalogue for *Photographie: Rochester (New York)*, April–June 1976 at the American Cultural Center, Paris.

[60] James Enyaert: *Robert Heinecken*, New York and Carmel, Light Gallery and the Friends of Photography, 1980.

[61] Roger Bellone and Luc Fellot, *Histoire mondiale de la photographie en couleur*, Hachette Réalités, Paris, 1981; Sally Euclaire, *The New Color Photography*, Abbeville Press, New York, 1981.

[62] Luigi Ghirri, University of Parma, 1979.

[63] *Coloriages*, Contrejour, Paris, 1984.

[64] *Séquences*, Euschede, 1984.

[65] Daniel Featherstone: *Vilem Kriz, Photographs*, Carmel, the Friends of Photography (Untitled no. 19), 1979.

[66] Jan Groover, Corcoran Gallery Art, Washington, 1976.

[67] James Alinder: *Cumming Photographs*, Carmel, the Friends of Photography, 1979.

[68] *Michael Bishop*, Columbian College, Chicago, 1979.

[69] *John Pfahl: Altered Landscapes*, Carmel, the Friends of Photography, 1981 (Untitled no. 26).

[70] *Paul de Nooijer*, Eindhoven, 1982.

[71] *Les grandes vacances*, Herscher, Paris, 1980.

[72] Bernard Lamarche-Vadel, *Tahara Keiichi*, 1984.

[73] Anne W. Tucker, *Unknown Territory: Photography by R. K. Metzker*, Aperture, Millerton, NY, 1984.

[74] *Photographs*, Rapoport, New York, 1978.

[75] John Blakemore, Arts Council of Great Britain, London, 1976.

[76] Lorraine Monk, *Robert Bourdeau*, Toronto, 1979.

[77] *Contemporary Photographers*, p. 35.

Chapter 10

[1] In a chapter in my book, *L'acte photographique* (Labor, Brussels, 1983, pp. 109–50), I have analysed this whole problem, which lies at the very origins of art. It can also be said, as a happy paradox, that *art* (painting, drawing, sculpture) is also, in an imaginary sense, born *from photography*.

[2] See chapter 9 by Jean-Claude Lemagny in the present work.

[3] Philippe Dubois, *L'acte photographique*, Labor, Brussels, 1983.

[4] Rosalind Krauss, 'Marcel Duchamp ou le champ de l'imaginaire', in *Degrés* nos. 26–27 (*Language et Ex-communication I*), Brussels 1981. Issue under the direction of Philippe Dubois, R. Krauss, 'Notes on the Index: Seventies art in America', in *October* no. 3 (part I), New York, 1977. On the same question, see also the useful work by Jean Clair, *Duchamp et la photographie*, Chêne, Paris, 1977.

[5] Paul Virilio, 'Logistique de la perception: Guerre et cinéma, l', *Cahiers du cinéma*, Ed. de l'Etoile, Paris, 1984, and *L'espace critique*, Christian Bourgeois, Paris, 1984.

[6] El Lissitsky, cited by Yves Alain Bois in his fine study of the 'aerial' (floating) dimension of suprematist space: 'Lissitsky, Malevitch et la question de l'espace' in the *Suprematisme* catalogue, galerie Jean Chauvelin, Paris 1977, pp. 29–48.

[7] On this subject see the study by Rosalind Krauss, 'Stieglitz/*Equivalents*' in *October* no. 11, New York, 1979, p. 133–4.

[8] Rosalind Krauss, 'Emblèmes on lexies: le texte photographique', in *L'Atelier de Jackson Pollock* (Hans Namuth), Macula, Paris, 1978.

[9] On this 'counter-compositional' aspect, see the monograph by Andreas Haus, *Moholy-Nagy: photographies, photogrammes*, Chêne, Paris, 1979. See also the writings by L. Moholy-Nagy, in particular *Malerei Fotografie Film* (1925) and *Vision in Motion* (1947).

[10] Rosalind Krauss, 'Emblèmes on lexies: le texte photographique', in *L'Atelier de Jackson Pollock* (Hans Namuth), Macula, Paris, 1978, pp. 15–24.

[11] On the triple nature of the sign in Pollock's work (icon, index and symbol), see René Payant, 'La libération de la peinture', in the collective work, *Jackson Pollock: Questions*, Musée d'Art Contemporain, Montreal, 1979, pp. 67–93.

[12] A recent album has been devoted to this artist: *Rauschenberg photographe*, Herscher, Paris, 1981.

[13] See, among others, Lucy R. Lippard (*et al.*), *Le Pop Art*, F. Hazan, Paris, 1969.

[14] Among many other publications, see, for example, the collective work *Figurations 1960–1973*, C. Bourgeois, 10/18, Paris, 1973, and the exhibition catalogues for *Mythologies quotidiennes 1* (1964) and 2 (1977) by the ARC – Musée d'Art Moderne de Paris, and reviews such as *Opus international*, *Art vivant*, etc.

[15] For an in-depth analysis of the work of Valerio Adami, see the monograph by Hubert Damisch and Henry Martin, *Adami*, Maeght, Paris, 1974.

[16] On Christian Boltanski, see *Les modèles*, Cheval d'attaque, Paris, 1979, and *Reconstitution*, Chêne, Paris, 1978. On Annette Messager, see the analyses by Gilbert Lascault in *Figurées, défigurées*, 10/18, Paris, 1977, and in *Écrits timides sur le visible*, 10/18, Paris, 1979. Didier Bay, Paul-Armand Gette and Jean Le Gac have published a number of books with the Belgian Yellow Now publishing house (*Mon quartier . . ., Le lac, Le peintre de tamaris*, etc.)

[17] See the study by Rosalind Krauss, 'Notes on the Index: Seventies Art in America', *art. cit.*

[18] R. Krauss has elaborated a theoretical model of these practices in her article 'Sculpture in the Expanded Fields', in *October* no. 8, New York, 1970, p. 30–44.

[19] A detailed description of many works of Land Art is given in John Beardsley, *Earthworks and Beyond*, Abbeville Cross River Press, New York, 1984.

[20] Gina Pane, interview with Bernard Marcade in *Ceci n'est pas une photographie*, catalogue FRAC-Aquitaine, 1985, p. 24.

[21] See, for example, Stefan De Jaeger, *Dimensions polaroïd 1979–1982*, catalogue of the galerie Isy Brachot, Brussels, 1982.

[22] See the catalogue for the *John Hilliard* retrospective exhibition, Kolnischer Kunstverein, Cologne, 1984; also, the article by Regis Durand, 'John Hilliard: scenes gelées par des temps différents', in *Art Press* no. 79, March 1984, pp. 11–13.

[23] See in particular the catalogue *Pierre Boogaerts: Série écran/screen series*, Canadian Cultural Center, Paris, 1982.

[24] See the catalogue of the complete photographic retrospective of Jan Dibbets, Van Abbemuseum Eindhoven, and ARC – Musée d'art Moderne, 1980.

[25] Bernard Queeckers, *Réfléchir*, 1980. Personal comment.

[26] René Payant, 'Pour le plaisir de l'oeil', in the catalogue *Pierre Ayot: propos et projections*, Atelier de la rue Sainte-Anne, Brussels, 1983.

[27] On Tim Head and his confusing environments, known as 'still lifes', see in particular the catalogue *Un certain art anglais . . .* (a selection of British artists 1970–9) ARC – Musée d'Art Moderne, Paris, 1979.

[28] I have given a detailed analysis of a photo-installation by Michael Snow, entitled *Authorization* (1969), in the introduction to my book, *L'acte photographique (op. cit.)*.

Index

This index lists the names of photographers, artists and personalities involved in the world of photography, as well as the names of movements, journals, galleries etc. cited in the text.

A number in **bold face** type indicates an important discussion, one in *italic* an illustration. The abbreviation Chr., followed by a date, refers to a year in the Chronology (p. 258).

Museums, galleries, journals, movements and groups are listed in alphabetical order by name; thus the Stedelijk Museum, Amsterdam, will be found under **S**, the Modern Museum, Stockholm, under **M**, the Armory Show under **A**, and the Great Exhibition under **G**.